UNITED STATES

SENATE

CATALOGUE OF GRAPHIC ART

For the artists, engravers, and printers
who brought pictorial reporting to America,
and to the senators who so often were their subjects.

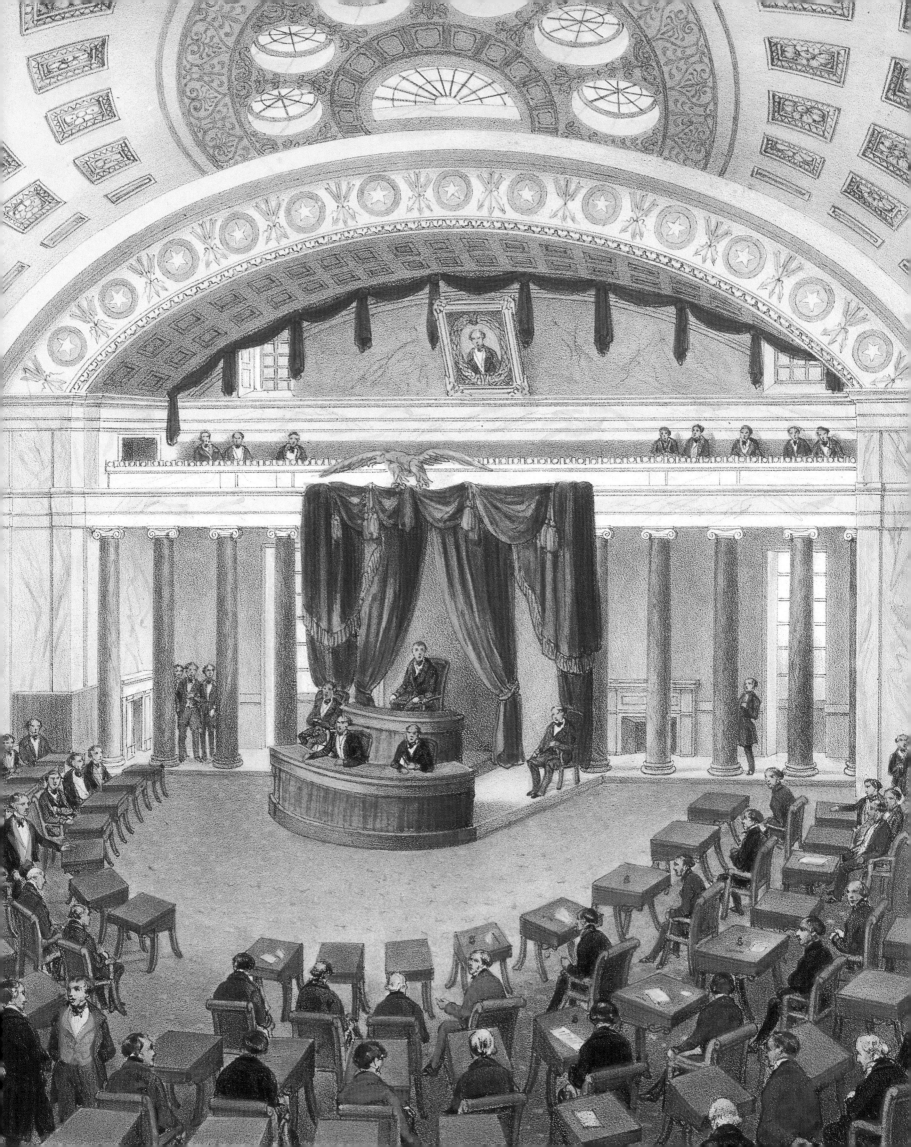

UNITED STATES SENATE
CATALOGUE OF GRAPHIC ART

Essays by

Diane K. Skvarla

Donald A. Ritchie

Prepared by the Office of Senate Curator
under the direction of the
U.S. Senate Commission on Art

U.S. GOVERNMENT PRINTING OFFICE

WASHINGTON, D.C. : 2006

109th Congress, 1st Session Senate Document 109-2

Printed pursuant to 40 United States Senate Code, Section 188b

Includes bibliographical references and index.

U.S. SENATE COMMISSION ON ART

Chairman:
William H. Frist, M.D., Tennessee

Vice Chairman:
Harry Reid, Nevada

Ted Stevens, Alaska

Trent Lott, Mississippi

Christopher J. Dodd, Connecticut

Executive Secretary:
Emily J. Reynolds

THE OFFICE OF SENATE CURATOR

Curator: Diane K. Skvarla

Associate Curator: Melinda K. Smith

Administrator: Scott M. Strong

Historic Preservation Officer: Kelly Steele

Collections Manager: Deborah Wood

Registrar: Jamie Arbolino

Associate Registrar: Theresa Malanum

Museum Specialist: Richard L. Doerner

Curatorial Assistant: Amy Elizabeth Burton

Staff Assistant: Clare Colgrove Hobson

The Office of the Senate Curator, on behalf of the Senate Commission on Art, develops and implements the museum and preservation programs for the United States Senate. The office collects, preserves, and interprets the Senate's fine and decorative arts, historic objects, and specific architectural features. Through exhibits, publications, and other programs, the office educates the public about the Senate and its collections.

All prints and historic photographs are in the Senate collection unless otherwise noted.

 Library of Congress Cataloging-in-Publication Data
United States. Congress. Senate.
 United States Senate catalogue of graphic art / essays by Diane K. Skvarla, Donald A. Ritchie ;
 prepared by the Office of Senate Curator under the direction of the U.S. Senate Commission on Art.
 p. cm.
 Includes bibliographical references and index.
 1. Prints, American—19th century—Catalogs. 2. Prints, American—20th century—Catalogs.
 3. Politics in art—Catalogs. 4. United States—Politics and government—Pictorial works—Catalogs.
 5. Prints—private collections—Washington (D.C.)—Catalogs. 6. United States. Congress. Senate—Art
 collections—Catalogs. I. Skvarla, Diane K., 1957- II. Ritchie, Donald A., 1945- III. United States.
 Congress. Senate. Office of the Curator. IV. United States. Congress. Senate. Commission on Art. V. Title.

 NE962.P64U55 2005
 769.973'074'753—dc22

 2005052522

CONTENTS

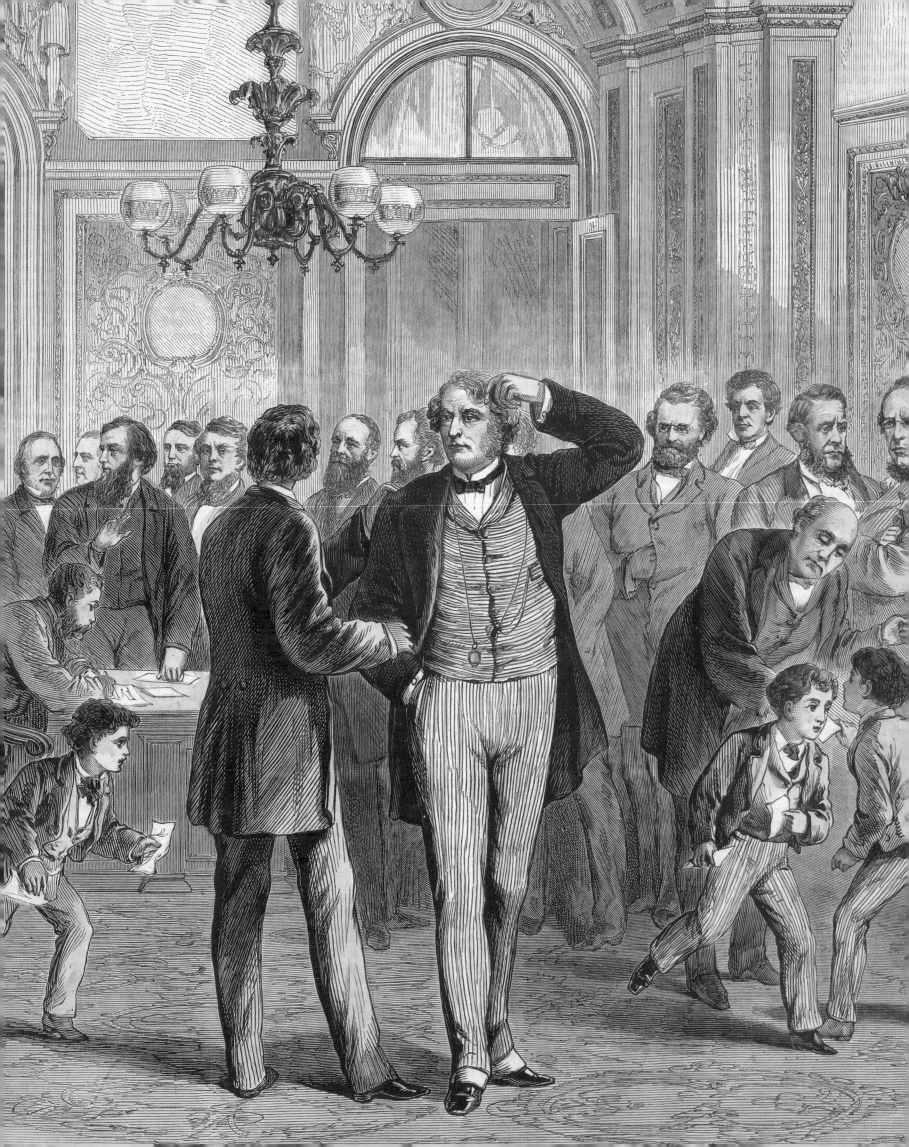

FOREWORD

*I*n today's age of electronic media and twenty-four-hour news coverage, we witness countless images of our democracy in action. They come in such a flurry that we barely have time to consider individual scenes. It wasn't always so. Not until the 19th century did printmaking techniques allow for the wide and relatively rapid dissemination of newsworthy pictures. These prints were created by sending an artist to an event to make a sketch, which was then transferred to metal, stone, or wood and printed in one of the great weekly news magazines of the day, such as *Harper's Weekly* or *Frank Leslie's Illustrated Newspaper*.

A skilled artist will always attempt to convey more than the mere depiction of a scene. The artists sent by *Harper's* and *Leslie's* to record events carefully crafted their sketches to communicate a sense of drama and immediacy to an audience that was removed from the scene by a thousand miles' distance and a week's time. No less important are the social and political contexts within which these artists worked. As works of art, these engravings portray more than just the cold facts: they are visual expressions of Americans' feelings toward the nation, its politicians, and our democracy. As such, they are worthy of careful study.

It would benefit us as Americans to reflect on the themes expressed in these pages. The prints serve as fitting reminders of the trials and crises faced by our forebears, and they teach us the resilience of our nation and our unique system of government. Although more than a century separates us from the images depicted here, the sense of pride in the greatness of our nation and in the institutions of our democracy is just as compelling today. It is our hope that these prints will inspire readers with that same national pride. ☟

The Honorable William H. Frist, M.D.
Majority Leader, United States Senate
Chairman, U.S. Senate Commission on Art

The Honorable Harry Reid
Democratic Leader, United States Senate
Vice Chairman, U.S. Senate Commission on Art

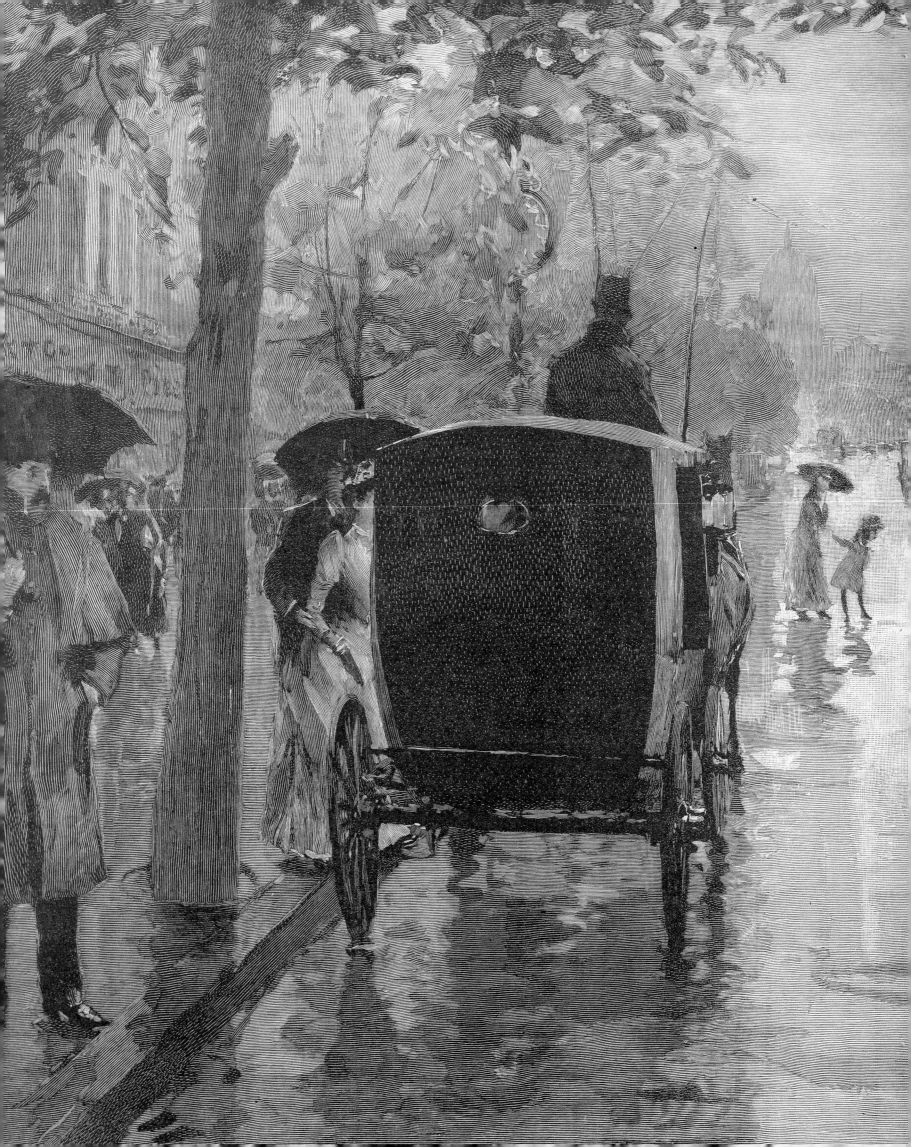

PREFACE

One of the great pleasures of my tenure as secretary of the Senate has been working with the United States Senate art collection. As executive secretary to the Senate Commission on Art, I have become familiar with the challenges of preserving and interpreting these historic artworks. While many people have at least a passing acquaintance with the Senate's fine art, few realize that the Senate also possesses an extensive collection of graphic art. What started 30 years ago as a source of historical documentation and exhibition material has grown to an impressive study collection. This volume marks the first comprehensive publication of the almost one thousand prints in the holdings of the United States Senate.

Dating from 1830 to the early 20th century, this graphic art collection illustrates the people, places, and events that mark the history of the United States Senate and the U.S. Capitol building. The collection also reflects the advances in printing technology in America during the 19th century, from simple woodblock engravings to delicate steel etchings and colorful lithographs. Some of the images are limited-edition prints, but the majority are from the popular illustrated news magazines, such as *Harper's Weekly* and *Frank Leslie's Illustrated Newspaper*. These inexpensive publications were one of the few sources of visual information about the events of the day. As such, they communicated important iconographic concepts about the Capitol, the Senate, and American democracy.

These illustrations record both the defining moments in the Senate's history and the rhythms of everyday life in the Capitol. They show women lobbyists using the Ladies' Reception Room to buttonhole passing senators to plead their cause. They offer glimpses of visitors dining in the Senate restaurant. They depict staff at work in the office of the secretary of the Senate and on the floor of the Senate. They remind us how much has changed and how much remains the same. They also provide charming images of the Capitol's surroundings. My personal favorite is the rain shower scene

on Pennsylvania Avenue, sketched in 1890. As you journey through the Capitol and consult this catalogue, you will surely find favorites of your own.

The Senate collection also contains scores of political cartoons from the famous humor magazines *Puck* and *Judge*, by such great satirists as Thomas Nast and Joseph Keppler. The use of the lithographic process in these publications imbues their images with rich, vibrant colors that are matched in intensity only by the lively, winsome, and sometimes scathing characterizations of the targets of their glee.

The United States Senate Catalogue of Graphic Art was produced by the Office of Senate Curator, which serves as staff to the Senate Commission on Art. Established in 1968, the Commission preserves, protects, and makes known the works of art, furnishings, historical objects, and specific architectural features that the Senate holds in trust for the American people. The graphic art collection was established in 1975 by James R. Ketchum, Senate Curator Emeritus, who recognized the importance of these prints as historical documents and had the vision to acquire the first engraving.

An earlier volume, the *United States Senate Graphic Arts Collection: Illustrated Checklist, Volume 1* (1995), presented all but the cartoon images then residing in the collection. A more recent Senate publication, *United States Senate Catalogue of Fine Art* (2002), features information on the 160 paintings and sculptures in the U.S. Senate. It is my hope that this new catalogue will become an indispensable reference for anyone interested in learning more about the Senate, the Capitol, and American political history. ☙

The Honorable Emily J. Reynolds
*Secretary of the Senate and Executive Secretary
to the Senate Commission on Art*

NOTES TO THE READER

The United States Senate Graphic Art Collection consists of almost one thousand historical prints. While the Senate's study collection contains examples of single-issued prints, the focus has been to document those images widely disseminated to the general public. For this reason, also included in the catalogue are select historical photographs, primarily in the form of cartes de visite and stereoviews, considered significant to the Senate collection.

ARRANGEMENT OF THE CATALOGUE

The catalogue is divided into eight thematic chapters: Senate Chamber, Capitol Interior, Capitol Exterior & Grounds, Senate Art, Portraits, Group Portraits, Beyond Capitol Hill, and Political Cartoons & Caricatures. Within each chapter the prints are arranged generally in chronological order by the date of publication, with the exception of the chapter on Portraits, in which the depicted individuals are listed alphabetically by the subject's last name. The Senate Chamber chapter contains prints depicting both old and current Senate Chambers. In the Senate Art section, each print is shown with its fine art counterpart from the U.S. Senate Collection. Senate-related individuals depicted in the Portraits, Group Portraits, and Political Cartoons & Caricatures chapters are identified as specifically as possible, although not always in the captions. All identifiable individuals, Senate-related or otherwise, are included in the index, as are the names of print creators and original artists for all Senate-related images. The appendix features select prints with their keys.

All image photography was done in color. Where the Senate collection contains multiple versions of the same print, the print with optimum resolution in the best physical condition was selected as representative. Identification information for each print consists of title, creator(s), publication or publisher, date of publication, printing technique, dimensions, and object catalogue number (cat. no.), defined as follows.

TITLE

Title expresses the primary text assigned by the publisher relating directly to a print. In the interest of space and clarity, particularly in the case of the political cartoons, any ancillary text is excluded. Spelling, grammar, and punctuation are transcribed literally except where front slashes (/) have been added to differentiate between separate titles or subtitles for which no punctuation appears on the print. Brackets ([]) are used to help clarify a depicted subject or person by denoting added words or letters not included as part of the printed title. A title contained completely within brackets was assigned to the print based on its subject matter. Foreign language titles have not been translated.

CREATOR

Creator identifies the full name, or names, of a print's creator (engraver, lithographer, photographer, etc.), followed by the name of the original artist of the image, if known. It is assumed that a print is based on a sketch or a drawing by an original artist unless otherwise noted (e.g., after photograph, after painting). The term "Unidentified" is used when the creator of an image is not known.

PUBLICATION/PUBLISHER

Publication/Publisher notes the full name of the newspaper, book, or individual that published the print. The term "Unidentified" is used when the publication or publisher of a print is unknown.

DATE

Date reflects a print's date of issue or publication. Dates conform to the format of month/day/year. When an exact date is not known, a circa date is used, suggesting a range of plus or minus five years. A print with a circa date or year-only date is listed near the end of other prints from that year.

PRINTING TECHNIQUE

Printing technique describes the process or technique used to create a print, followed by the type of coloring employed. A colored lithograph is referred to as "Lithograph, hand-colored" if it is not machine colored; otherwise, it is referred to simply as "Lithograph, colored," which denotes either entire machine coloring or a combination of hand and machine coloring. A "Metal engraving" denotes when a more specific metal type (steel or copper) could not be identified conclusively; and a print is simply noted as an "Engraving" if it could not be differentiated as being created in wood or metal. The term "Photomechanical process" is used to describe a variety of processes involving the transfer of a photographic image to a printed format.

DIMENSIONS

Dimensions specify the size of the image, including any directly related text; the entire page size is not noted. Measurements conform to the format of height followed by width, in both inches and centimeters.

CATALOGUE NUMBER

Catalogue number identifies each print with a unique United States Senate control number. Where the collection contains multiple versions of a particular print, the number corresponds to the specific print that was photographed for this catalogue.

Readers who can identify any missing information for prints are invited to submit the information to the Office of Senate Curator. The collection presented in this publication represents the U.S. Senate graphic art holdings as of January 2005. Additional information on the Senate collection is available through the Office of Senate Curator, or at www.senate.gov/art. ◑◊

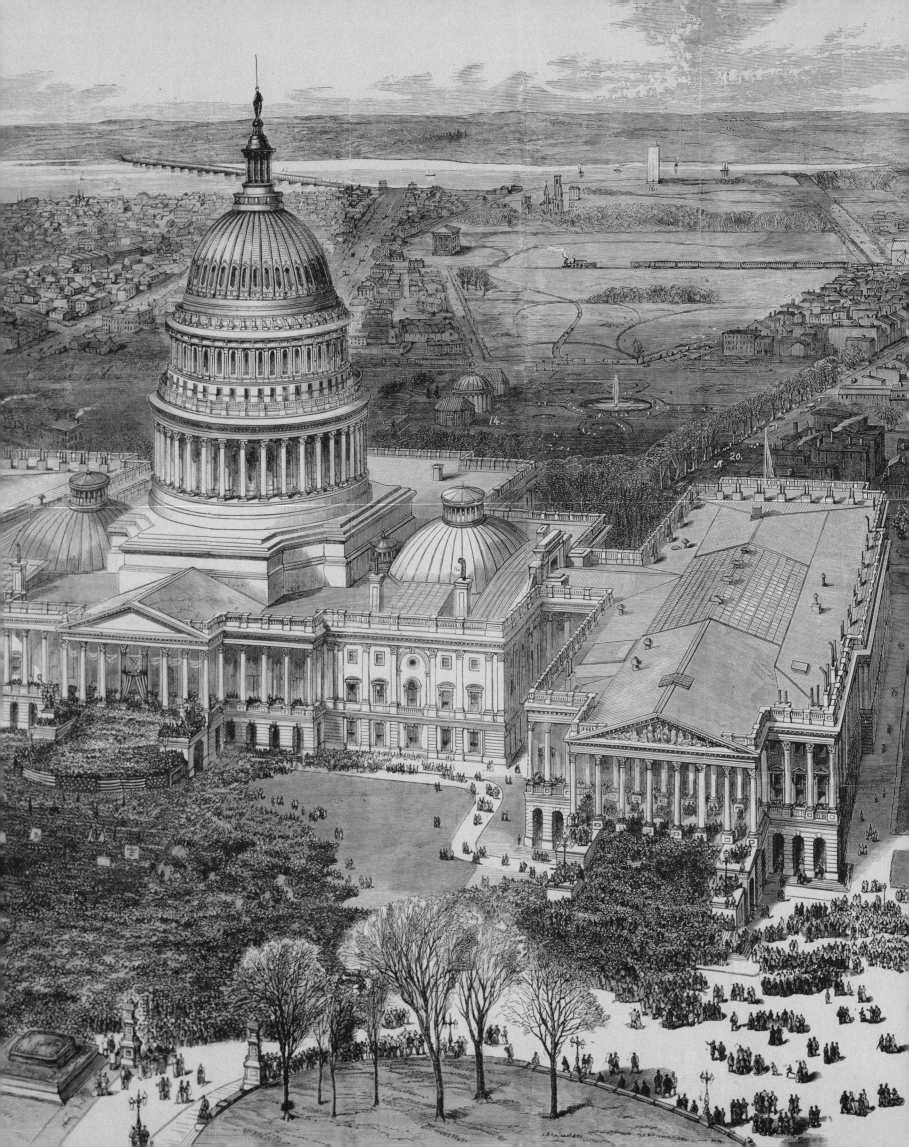

CATALOGUE OF GRAPHIC ART

THE ILLUSTRATED SENATE:
19TH-CENTURY ENGRAVINGS OF THE U.S. SENATE

Diane Skvarla

Visual sources have largely shaped the image that Americans have formed of the United States Senate. For over 200 years, paintings, engravings, photographs, and later television and film, have enabled those beyond Capitol Hill to draw judgments and opinions about this legislative body. The Senate has been depicted in many ways—it has been friend and foe, weak and strong, corrupt and incorruptible, moderate and extravagant. During the mid-19th century, the American public turned to illustrated newspapers for most of their visual information. *Frank Leslie's Illustrated Newspaper* and *Harper's Weekly* were just two of the popular illustrated weeklies that combined art, science, and literature with war and politics. These visual records of the United States Senate influenced people's perception of the government, and as such are important historical documents that tell us much about the dynamics of that era. In looking at these images today, we can step back in history and see the Senate as the country once did.

When the Senate held its first session in New York in 1789, little was known of the new government. Originally, the Senate met in closed session. Although it opened its doors to the public in 1795, its inner workings remained a mystery to the majority of Americans. Even though politics was the major subject in post-Revolutionary War newspapers, engravings of the government and its legislators were uncommon due to limitations in printing technology. The country was also predominantly rural, and with rudimentary transportation of the day, news from Washington, D.C., was infrequent and often several weeks (or even months) old when it finally arrived. With few illustrations of Congress available, and other types of prints expensive, most people

Early engravings of the U.S. Capitol depicted a grand building set on the brow of Jenkins Hill. (See p. 105)

simply did not have the opportunity to see pictures of the early Senate. For them, their view of the new government was formed through written or oral sources.

The first printed images of the Senate were simple portrait engravings of the members and views of the buildings that housed the institution: Federal Hall in New York, Congress Hall in Philadelphia, and the U.S. Capitol in Washington, D.C. Early engravings of the Capitol date from the 1830s and were printed in limited numbers. Some were by English artist William Bartlett, who traveled the countryside creating detailed drawings that were later published in his illustrated travel guide, *American Scenery*. His Capitol views show an idyllic setting, far from the reality of the day. In contrast, during his 1842 visit, Charles Dickens referred to Washington, D.C., as the "City of Magnificent Intentions." He found "spacious avenues, that begin in nothing, and lead nowhere, streets, mile-long, that only want houses, roads and inhabitants; public buildings that need but a public to be complete; and ornaments of great thoroughfares, which only lack great thoroughfares to ornament. . . ."[1] Artistic license aside, these early engravings helped ensure feelings of confidence and hope in the new government—a majestic Capitol symbolized stability and permanency.

As America ceased feeling uncertain about its recent independence, it began to take pride in its national figures and institutions, and the country's attention focused increasingly on the actions of Congress. The period from 1829 to 1833 has been called the "Coming of Age of the Senate."[2] It was during these years that the United States Senate became the focal point of the nation. Spectators jammed the Senate galleries to hear the great Senate orators of the day—Henry Clay of Kentucky, Daniel Webster of Massachusetts, and John C. Calhoun of South Carolina—debate such monumental

issues as slavery and states' rights. Those unable to crowd into the Senate Chamber to hear these historic deliberations and see their favorite senators now eagerly awaited news from Washington, D.C. Most importantly, advances in technology—from the daguerreotype to new printing methods—helped feed this growing interest.

The introduction of the daguerreotype in 1839 allowed the faces of Clay, Webster, Calhoun, and other notable senators to become familiar throughout the country. Daguerreotypists pursued statesmen in the belief that American ideals could be symbolized in photographic images of the eminent men of the time. In a nation that idealized the democratic process, it was natural that governmental officials should exemplify the successful operation of the country. Where earlier engravings of the Capitol symbolized strength and permanency, now the daguerreotype captured images of greatness and "godlikeness" in the senators. Daguerreotypes, and engravings based on daguerreotypes, were popular because of association with the photographic process, and thus guaranteed accuracy.

Along with these early views of the Capitol and its legislators were limited-edition prints of the Senate Chamber made as symbolic commemorations of great senators and the momentous events in which they participated. The making of these images was directly related to a general drive for symbolic nationalism during this period. One of the earliest of these prints was the 1846 mezzotint, *United States Senate Chamber,* by

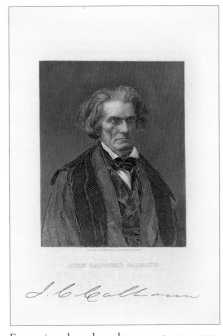

Engravings based on daguerreotypes were popular by the 1850s. (See p. 182)

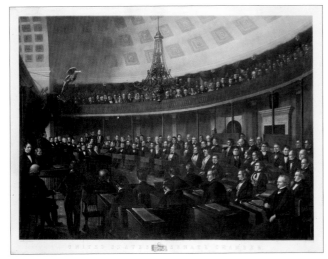

Thomas Doney's 1846 mezzotint of the Senate Chamber accurately depicts the faces of the nation's leaders and Washington's social elite. (See p. 15)

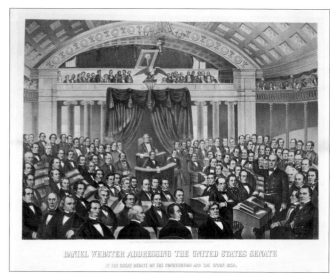

This engraving highlights the dramatic debates of 1850, with Daniel Webster shown delivering his famous "Seventh of March" speech. (See p. 21)

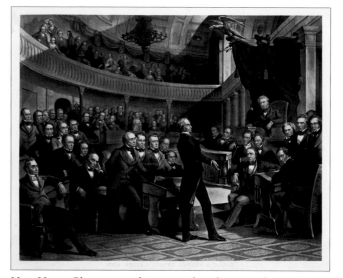

Here Henry Clay presents his series of resolutions as he attempts to save the nation from the disaster of disunion. (See p. 19)

Thomas Doney (38.00027.001, p. 15). The scene, which depicts Henry Clay's farewell address to the Senate in 1842, is based on over one hundred daguerreotypes taken from life by the studio of Edward Anthony. The print was enthusiastically recommended, and the plate was retouched for a second printing in 1847. Other commemorative prints of the period include *Union* by Henry S. Sadd after Tompkins H. Matteson (38.00019.001, p. 247) and *Daniel Webster Addressing the United States Senate* by James M. Edney (38.00016.002, p. 21), which pay homage to the efforts of these statesmen and others to stave off secession and civil war. *The U.S. Senate, A.D. 1850* by Robert Whitechurch after Peter F. Rothermel (38.00029.001, p. 19), perhaps the most dramatic of these prints, commemorates the moment that Clay rose in the Senate to introduce the series of resolutions that would later become known as the Compromise of 1850. These engravings of historic events in the Senate Chamber were hung on parlor walls and pictures of the more prominent senators were bought and displayed. Those who would never have the opportunity to see these men in person, or occasionally appreciate an oil or marble portrait in a private home or public hall, could now have their own images of them.

After the mid-1850s, the publication of illustrated journals further met the country's demand for picture news of the events and people in Washington, D.C. While limited-edition prints were popular, it was the news magazines, such as *Frank Leslie's*

Illustrated Newspaper and *Harper's Weekly*, that provided the general public with a timely glimpse of the events and people on Capitol Hill. Quick, accurate, and detailed drawings now accompanied stories. The magazines commissioned "special artists" to illustrate the debates in the Senate as they were taking place and to record the major activities of the members. New developments in the early 1850s reduced the time needed to make wood engravings, so pictures appeared within a week of an event, and later within days—a speed never before achieved. Previously, an artist traced an illustration onto a wooden block, but once completed only one engraver could work on it at a time. In the new process, the block was cut into sections so several engravers could work simultaneously, after which the sections were bolted together to form a finished plate. This process enabled publishers to produce engravings in hours rather

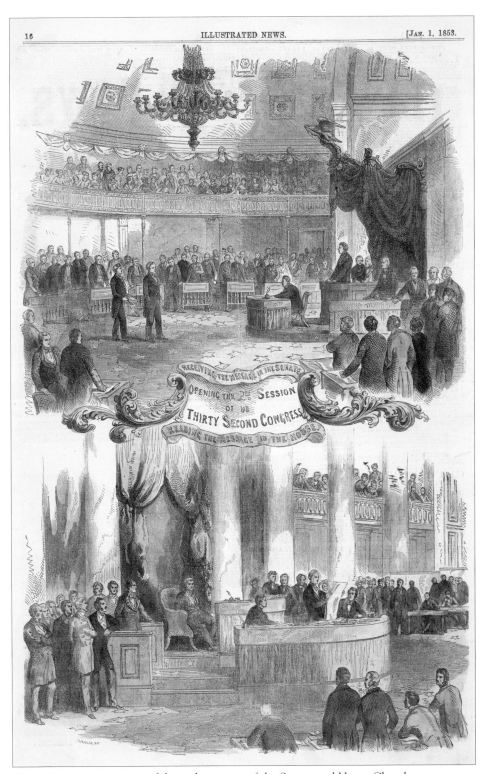

This 1853 engraving is one of the earliest views of the Senate and House Chambers to appear in an illustrated weekly. (See p. 17)

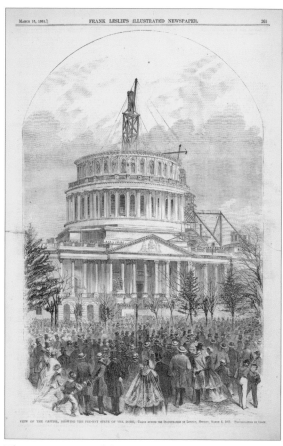

The construction of the new Capitol dome was pictured for all to see in an 1861 issue of *Frank Leslie's Illustrated Newspaper.* (See p. 122)

than in days or weeks. These "assembly line" wood engravings lacked the detail and subtlety of metal engravings, but ensured that prints could appear soon after an event—and at a nominal cost. The growth of railroads and improvements in roads provided for rapid dissemination of the images. Where once pictures of the Senate Chamber were limited, and only images of certain members popularized, now the "Illustrated Senate" became accessible to the entire county. Picture journals, such as *Harper's Weekly, The Graphic,* and *Frank Leslie's Illustrated Newspaper,* sold for 10 cents a copy and quickly reached circulations of over 100,000, climbing to 300,000 at times during the Civil War.

Some of these early images showed the Capitol exterior under construction: the new Senate and House wings and the monumental cast-iron dome that were added in the 1850s and 1860s. Architectural images aside, the majority of the engravings depicted the political and ceremonial events at the Capitol, the members of Congress, and tourists, lobbyists, and reporters.

Many of the prints in the Senate collection highlight the political events of the day. The wood engraving titled *The Assault in the U.S. Senate Chamber on Senator Sumner* (38.00292.003, p. 17), which appeared on the cover of *Frank Leslie's Illustrated Newspaper* on June 7, 1856, presents an important moment in history. The events leading to the infamous "caning" began on May 19, 1856. On that day, in his "Crime Against Kansas" oration condemning the spread of slavery into Kansas, abolitionist

Senator Charles Sumner of Massachusetts delivered a vicious verbal attack on Senators Stephen Douglas, James Mason, and Andrew Butler. Taking offense at Sumner's words, Representative Preston Brooks of South Carolina, a kinsman of Senator Butler's, brutally attacked Sumner with his cane as the Massachusetts senator sat at his desk in the Senate Chamber attending to correspondence. "Bleeding Kansas" and "Bleeding Sumner" soon became rallying cries for the North. Within days prints appeared both to promote and intensify antislavery sentiment. Most of these re-creations cannot be considered objective, although the engraving in *Frank Leslie's* presents one of the more accurate depictions of the event. The publication had already gained a solid reputation for rapid pictorial reporting, and the image appeared one week and one day after the event. In this engraving, the figures are relegated to the lower left of the print, with the Senate Chamber prominent in the picture. This may have been because the artist had stock images of the Chamber and was not present at the actual caning. But it also may have been a conscious decision, where the noble and grand setting of the Senate Chamber stands as a symbol of the institution; it will endure, despite the controversies of the day.[3]

Important and dramatic political events, such as the caning of Senator Sumner, were pictured in the illustrated weeklies. (See p. 17)

While one print can often tell a larger story, numerous prints of the same event also convey important information. The Senate's print collection contains more than 40 engravings depicting the 1868 impeachment of President Andrew Johnson. Throughout the trial, the weeklies illustrated the historic event as it unfolded—from the proceedings in the Senate Chamber to events outside the room. The trial mesmerized the nation for over two months.

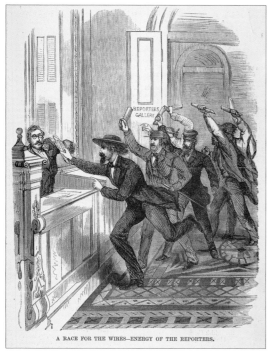

A RACE FOR THE WIRES—ENERGY OF THE REPORTERS.

The rush to get news to the public is evident in this 1868 print from the Andrew Johnson impeachment trial. (See p. 62)

The extreme interest in the proceedings is highlighted in the print, *A Race for the Wires—Energy of the Reporters* (38.00446.001, p. 62) by Theodore R. Davis, which shows the news reporters rushing to relay the event to their readers.

The weeklies also depicted ceremonial and commemorative events that highlighted the strong nationalist feeling of the country at the time. Take, for instance, *Interior of the Rotunda—Procession to the Portico* (38.00062.001, p. 54). This print portrays a decidedly minor event during the March 4, 1853, inauguration of Franklin Pierce. A crowd of dignitaries makes its way through the Capitol Rotunda to the East Front for the inaugural ceremony. This image is carefully composed to convey a theme greater than a simple procession. The figures recede almost to insignificance against the majestic backdrop of the soaring Rotunda. In fact, the visual theme of the print is not the assemblage of luminaries or the stately procession itself, but the grandeur and permanence of the magnificent stone edifice and the rich national history recorded in the monumental paintings lining its walls. This print boldly declares the importance and permanence of the event for which these dignitaries have gathered, the supreme pageant of American democracy—the peaceful transfer of power from one head of state to another, as dictated by the will of the people. When seen in the light of events that were then shaking the nation, the artist's intent becomes all the more poignant. The last and best agreement to stave off secession and civil war had been forged three years before in the Senate Chamber, only steps away from the scene of this print. Although the Compromise of 1850 would survive barely a decade, its ultimate failure could not have been known on that March day in 1853. It must have seemed then that nothing could threaten the repetition of the

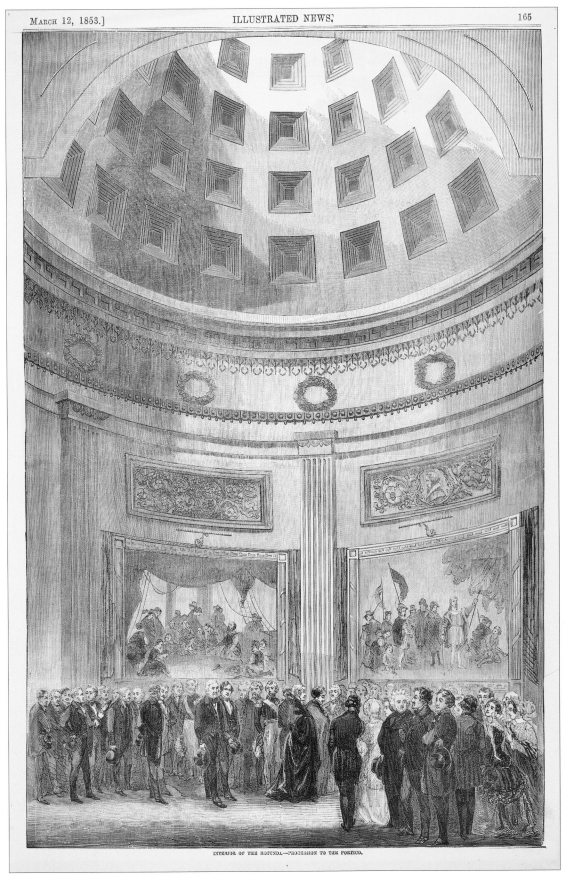

INTERIOR OF THE ROTUNDA—PROCESSION TO THE PORTICO.

Franklin Pierce's inauguration was one of the first inaugurals to be depicted in the weekly news publications. (See p. 54)

Along with illustrating dramatic political events, the weeklies also highlighted daily activities around the Capitol. (See p. 89)

Many 19th-century engravings were extremely accurate in their architectural and furnishing details, such as this 1888 image of the Capitol's Supreme Court Chamber. (See p. 89)

solemn tableau depicted here. It must have seemed that the government would stand as permanently, as firmly, and as grandly as the Capitol Rotunda itself, whatever passing dangers might be posed.

Along with such grand ceremonial events as inaugurations, views of everyday life in the building also were popular. Magazine illustrators were often drawn to the busy and varied nature of the legislative branch, as the Capitol corridors, crowded with senators and spectators, offered a glimpse into the Senate's 19th-century operations. Illustrations showed Senate pages delivering documents; messengers arriving from the House; senators taking lunch in the dining rooms; tourists gazing in awe at the Rotunda; scholars pondering volumes in the Congressional Library; and even an elderly doorkeeper using a broom handle to turn back the hands of the clock to give the legislators a few more minutes to conclude their business at the end of a session. Before, only the "greatest" statesmen and most historic moments in the Chamber were depicted, but now the everyday Senate was revealed. For those Americans who could not attend state ceremonies or wander through the Capitol corridors, these engravings offered vicarious experiences through the illustrators' eyes.

While the illustrated journals captured events as they unfolded in the Rotunda, Senate Chamber, and in the corridors of the Capitol, they also provided an important

pictorial account. These renderings tell us much about the decor of the Vice President's Room, the Senate Reception Room, the Refectory, the Supreme Court Chamber, and other spaces in the Capitol that have gradually changed over time.

Despite lacking the detail of photographs, these prints yield important information today to aid the historian, curator, and preservationist.

As the 20th century approached, dramatic changes took place that would ultimately signal the demise of the illustrated weeklies. Hand-engraved woodblocks and steel engravings were now replaced by the photographic linecut. While photography had existed earlier, it was not until later in the 19th century that printing technology was able to reproduce such images. This marked the end of the illustrated artist and eventually the illustrated papers. Outmoded by cheaper and faster technology and more accurate images, the last issue of *Franks Leslie's Illustrated Newspaper* appeared in 1902, while *Harper's Weekly* finally closed its doors in 1916. In their heyday these magazines, and other illustrated papers, offered unique experiences for the average American—they provided the most realistic depiction of the events and people of the day. ☟

Photography replaced hand-drawn illustrations in the weekly magazines. (See p. 148)

[1] Charles Dickens, *American Notes for General Circulation* (London: Chapman and Hall, 1842), 282.

[2] Robert C. Byrd, *The Senate, 1789–1989*, vol. 1 (Washington, D.C.: Government Printing Office, 1988), 105.

[3] David Tatham, "Pictorial Responses to the Caning of Senator Sumner," in *American Printmaking before 1876: Fact, Fiction, and Fantasy* (Washington, D.C.: Government Printing Office, 1975), 14.

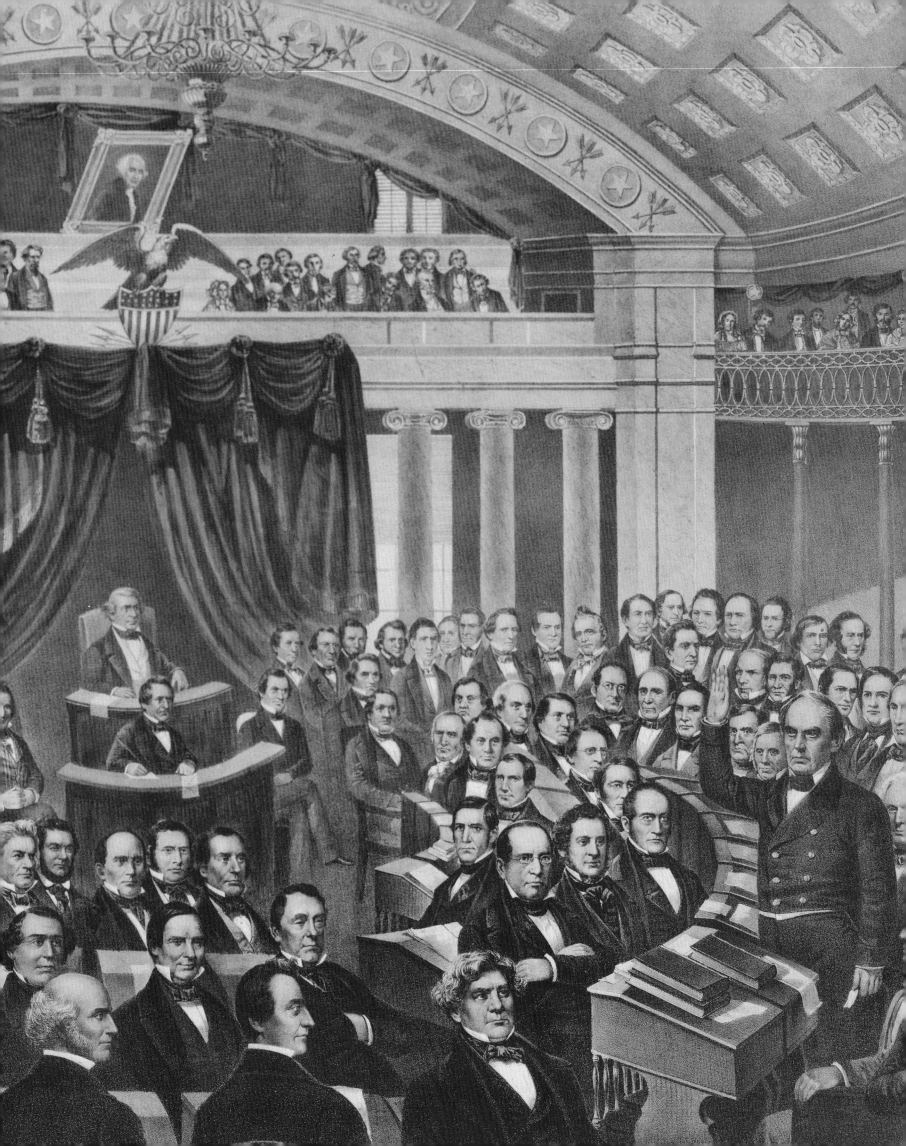

SENATE CHAMBER

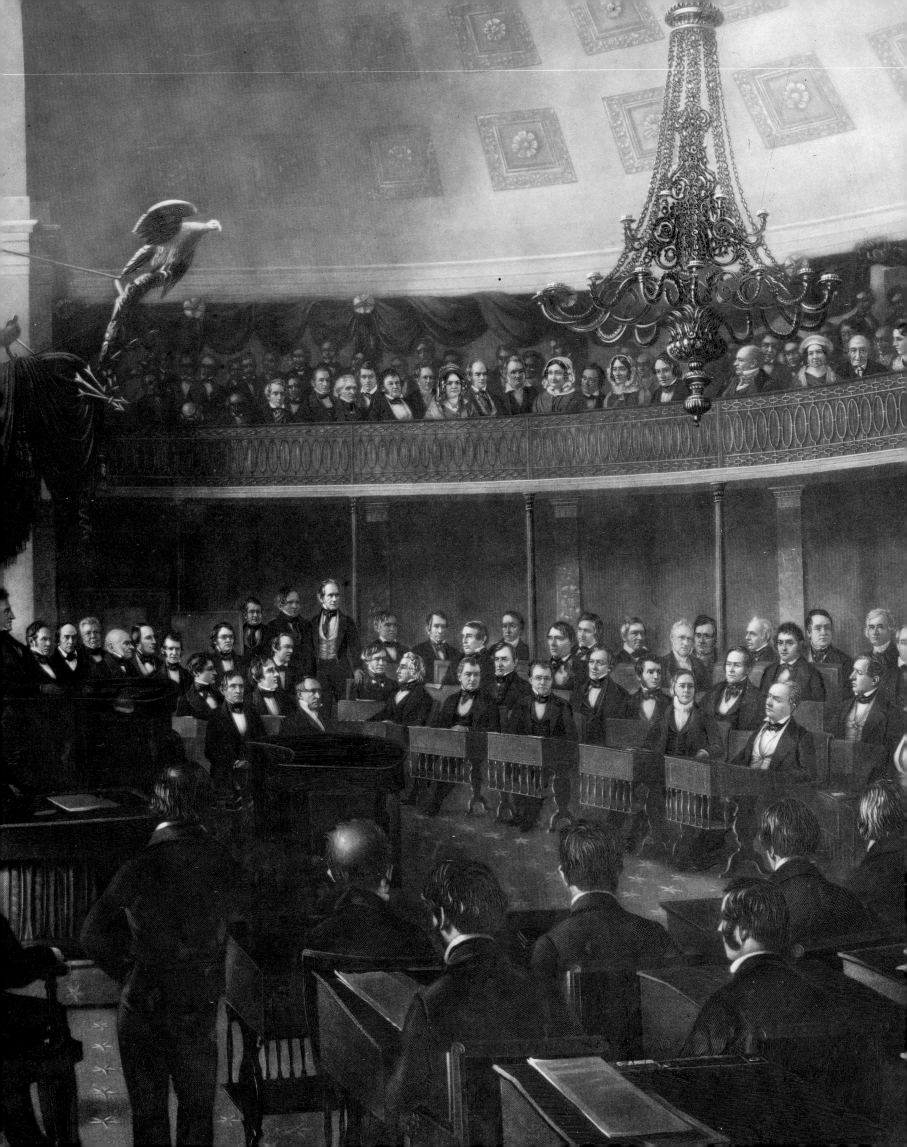

This engraving commemorates Henry Clay's farewell speech to the Senate on March 31, 1842, and is often considered the finest depiction of the United States Senate. Senator Clay of Kentucky appears in the left background, standing. The scene includes more than 100 likenesses that are based on individual daguerreotypes produced between 1843 and 1844 by the photographic studio of Edward Anthony. While the composite provides accurate portraits of scores of senators and distinguished Americans, the individuals depicted never appeared in the chamber at the same time. Despite such artistic license, the engraving was well received. One contemporary writer remarked, "there are persons introduced who were not there, and this is not only done with perfect propriety, but it gives the picture more the air of a historical composition, and renders it far more valuable than it would have been had the artists confined themselves to a merely slavish and mechanical accuracy."[1] The print was widely circulated and fed the public's growing appetite for inexpensive and faithful images of the country's most prominent citizens. ॐ

United States Senate Chamber.

Thomas Doney after James Whitehorn
Powell & Co., 1846
Mezzotint, black and white
28 x 36 inches (71.1 x 91.4 cm)
Cat. no. 38.00027.001

See appendix p. 478 for key

[1] "The United States Senate Chamber," *The American Review: A Whig Journal of Politics, Literature, Art and Science* 4, no. 4 (October 1846): 431–432.

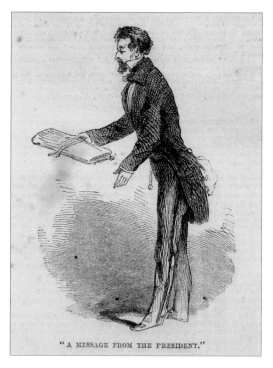

Senate Chamber

Deroy after Augustus Theodore Frederick Adam Köllner
Goupil, Vibert & Co., 1848
Lithograph, colored
7 ⅜ x 11 inches (18.7 x 27.9 cm)
Cat. no. 38.00964.001

"A Message from the President."

Unidentified
Frank Leslie's Illustrated Newspaper, 01/12/1856
Wood engraving, black and white
4 x 3 inches (10.2 x 7.6 cm)
Cat. no. 38.00334.001b

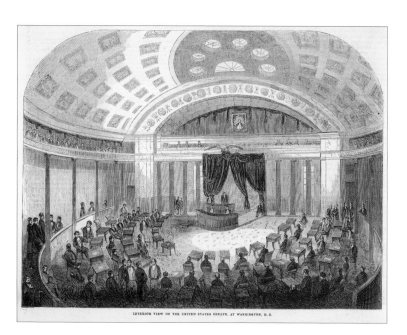

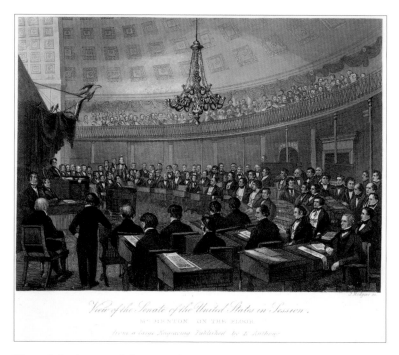

Interior View of the United States Senate, at Washington, D.C.

Unidentified after Augustus Theodore Frederick Adam Köllner
Gleason's Pictorial Drawing-Room Companion, ca. 1852
Wood engraving, hand-colored
7 ³⁄₁₆ x 9 ⅜ inches (18.3 x 23.8 cm)
Cat. no. 38.00051.004

View of the Senate of the United States in Session.

J. Rodgers
E. Anthony, ca. 1850
Engraving, hand-colored
5 ⅛ x 6 ¼ inches (13.0 x 15.9 cm)
Cat. no. 38.00911.001

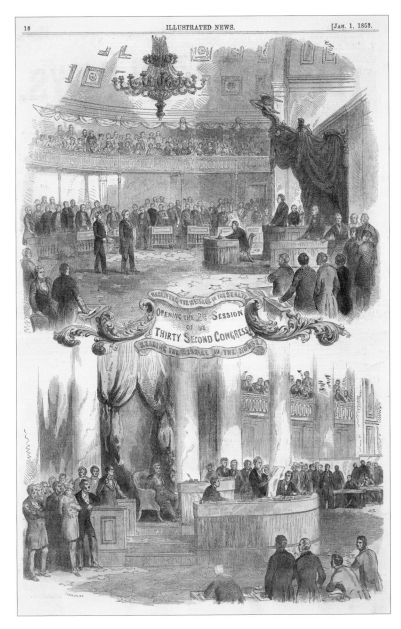

Opening the 2nd Session of [t]he Thirty Second Congress

Frank Leslie
The [New York] Illustrated News, 01/01/1853
Wood engraving, hand-colored
14 ½ x 9 ½ inches (36.8 x 24.1 cm)
Cat. no. 38.00311.003

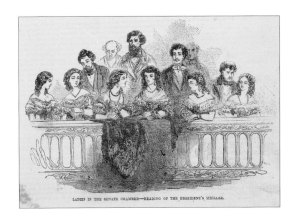

Ladies in the Senate Chamber—Reading of the President's Message.

Unidentified
Frank Leslie's Illustrated Newspaper, 01/12/1856
Wood engraving, black and white
4 ¼ x 6 ¼ inches (10.8 x 15.9 cm)
Cat. no. 38.00334.001a

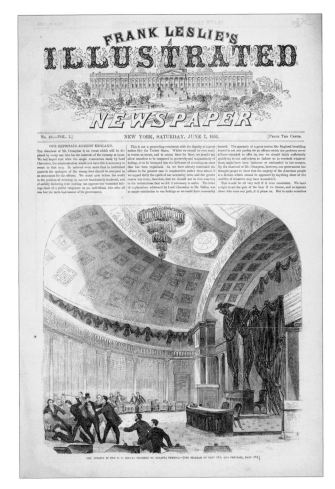

The Assault in the U.S. Senate Chamber on Senator Sumner.

Unidentified
Frank Leslie's Illustrated Newspaper, 06/07/1856
Wood engraving, black and white
8 ⅝ x 9 ⅛ inches (21.9 x 23.2 cm)
Cat. no. 38.00292.003

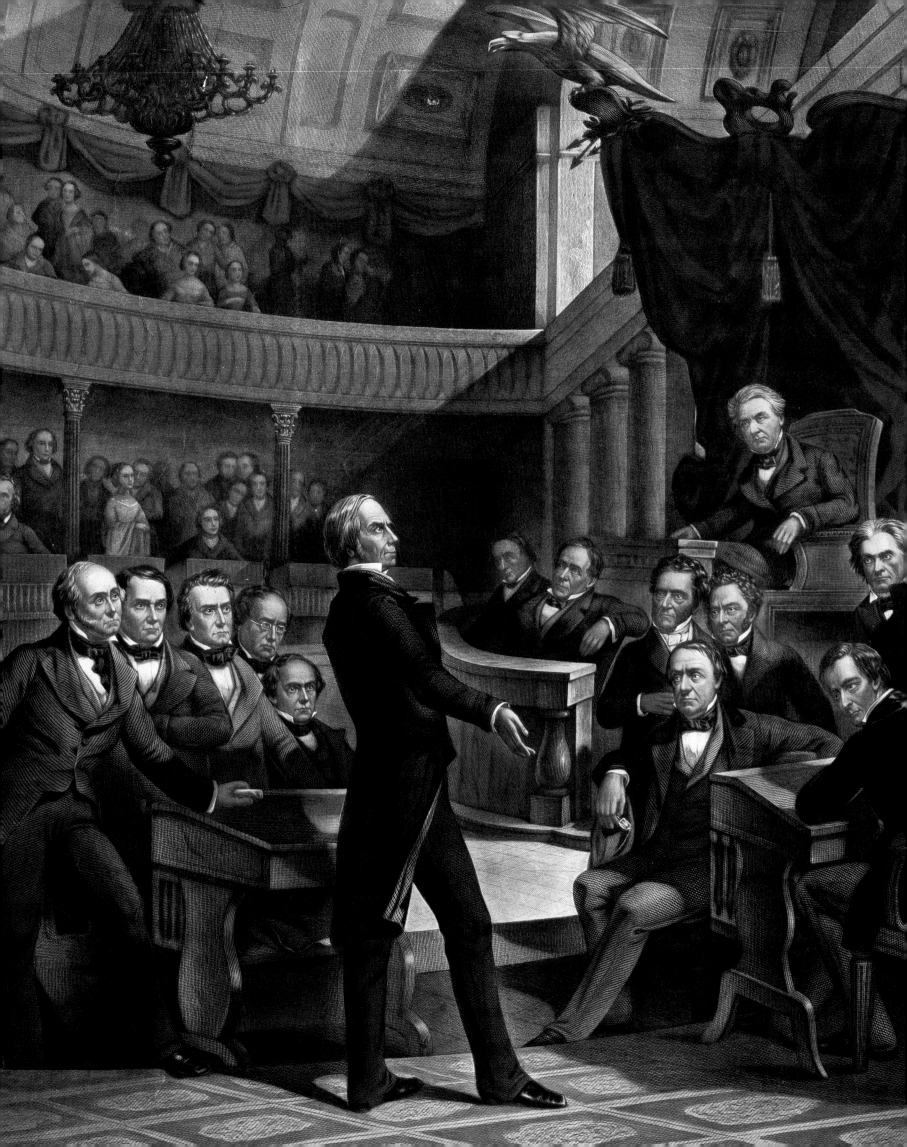

The United States Senate, A.D. 1850, depicts the Golden Era of the Senate in the Old Senate Chamber, site of many of the institution's most historic debates and deliberations. It was in this Chamber that Henry Clay of Kentucky, the "Great Compromiser," engaged in his last significant act as a senator by introducing the Compromise of 1850. In a desperate attempt to prevent war from erupting, the "Great Triumvirate" of Daniel Webster of Massachusetts, John C. Calhoun of South Carolina, and Clay struggled to balance the interests of the North, South, and West. This image shows all three men: Clay is at center stage presenting the compromise to the Senate, Calhoun stands third from the right, and Webster, head-in-hand, sits at the left. Peter F. Rothermel, who painted the work that served as the basis for Robert Whitechurch's engraving, used daguerreotypes to produce highly accurate portraits of the senators. By working from photographs, Rothermel produced an image with an immediacy almost as real as the event. Whitechurch attained the same quality in the engraving, which captures the spirit of the 19th-century Senate as no other print does. ☟

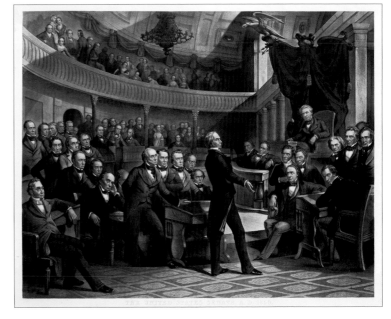

The United States Senate, A.D. 1850.

Robert Whitechurch after Peter Frederick Rothermel
William Smith, 1855
Engraving, hand-colored
28 ¼ x 33 ½ inches (71.8 x 85.1 cm)
Cat. no. 38.00029.001

See appendix p. 479 for key

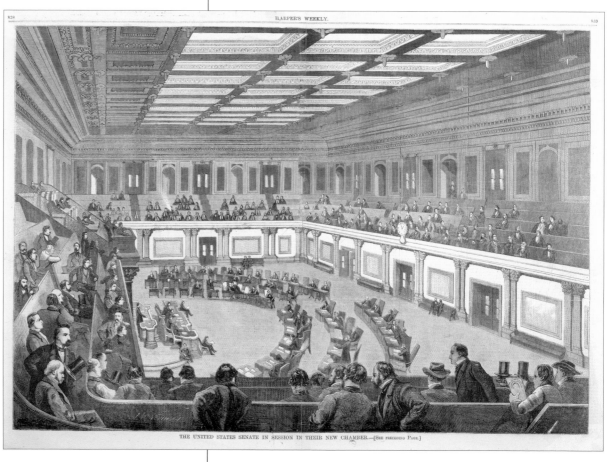

The United States Senate in Session in Their New Chamber.

Unidentified after John McNevin
Harper's Weekly, 12/31/1859
Wood engraving, black and white
14 x 20 ¼ inches (35.6 x 51.4 cm)
Cat. no. 38.00001.001

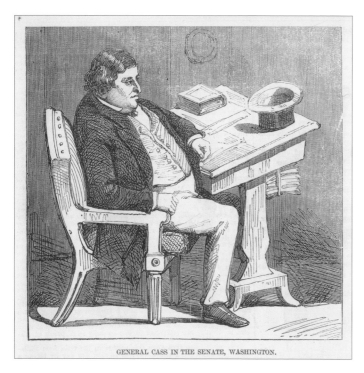

GENERAL CASS IN THE SENATE, WASHINGTON.

General Cass in the Senate, Washington.

Unidentified
The Illustrated London News, 09/27/1856
Wood engraving, black and white
4 ³⁄₁₆ x 4 ³⁄₁₆ inches (10.6 x 10.6 cm)
Cat. no. 38.00559.001

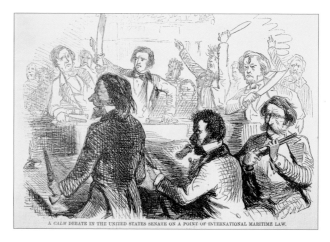

A CALM DEBATE IN THE UNITED STATES SENATE ON A POINT OF INTERNATIONAL MARITIME LAW.

A Calm Debate in the United States Senate on a Point of International Maritime Law.

Unidentified after J. M. L
Harper's Weekly, 06/12/1858
Wood engraving, black and white
15 ½ x 7 inches (39.4 x 17.8 cm)
Cat. no. 38.00526.001

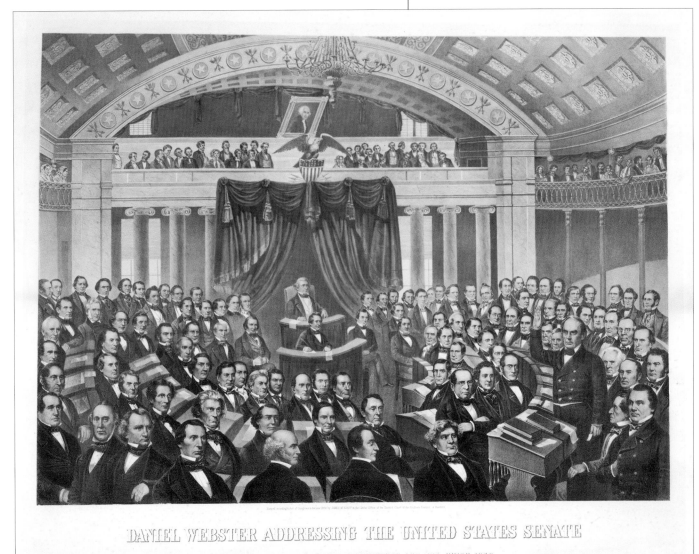

Daniel Webster Addressing the United States Senate / In the Great Debate on the Constitution and the Union 1850.

James M. Edney
Jones & Clark, 1860
Lithograph, hand-colored
25 ¼ x 29 ⅞ inches (64.1 x 75.9 cm)
Cat. no. 38.00016.003

See appendix p. 480 for key

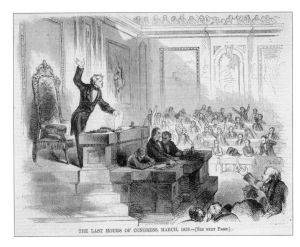

The Last Hours of Congress, March, 1859.

Unidentified
Harper's Weekly, 03/12/1859
Wood engraving, black and white
15 ⅝ x 7 ¼ inches (39.7 x 18.4 cm)
Cat. no. 38.00291.001

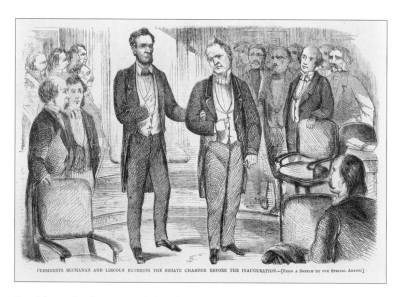

PRESIDENTS BUCHANAN AND LINCOLN ENTERING THE SENATE CHAMBER BEFORE THE INAUGURATION.—[From a Sketch by our Special Artist.]

Presidents Buchanan and Lincoln Entering the Senate Chamber before the Inauguration.

Unidentified
Harper's Weekly, 03/16/1861
Wood engraving, black and white
7 7/8 x 9 inches (20.0 x 22.9 cm)
Cat. no. 38.00180.001

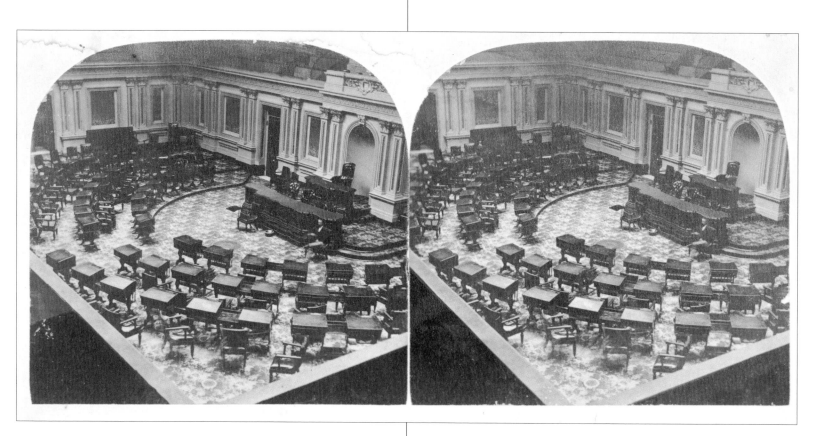

Senate Chamber, (in U.S. Capitol.)

Bell and Brothers
Bell and Brothers, 1867
Photograph, black and white
2 7/8 x 6 3/16 inches (7.3 x 15.7 cm)
Cat. no. 38.00129.001

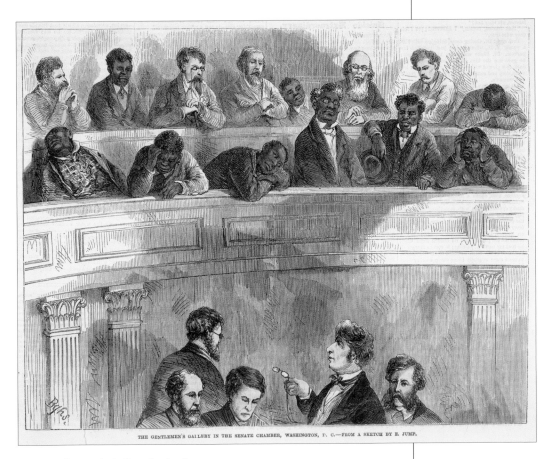

THE GENTLEMEN'S GALLERY IN THE SENATE CHAMBER, WASHINGTON, D. C.—FROM A SKETCH BY E. JUMP.

The Gentlemen's Gallery in the Senate Chamber, Washington, D.C.

Albert Berghaus after Edward Jump
Frank Leslie's Illustrated Newspaper, 02/01/1868
Wood engraving, hand-colored
6 $^{15}/_{16}$ x 9 $^1/_{16}$ inches (17.6 x 23.0 cm)
Cat. no. 38.00090.001b

312 FRANK LESLIE'S ILLUSTRATED NEWSPAPER. [FEB. 1, 1868.

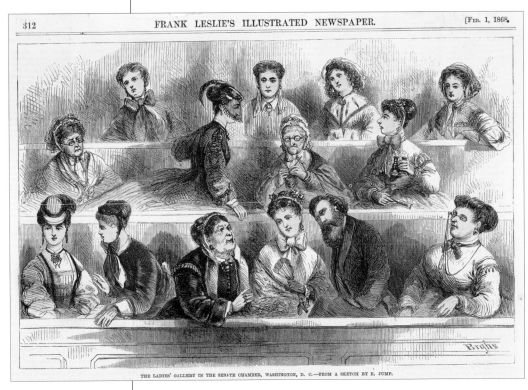

THE LADIES' GALLERY IN THE SENATE CHAMBER, WASHINGTON, D. C.—FROM A SKETCH BY E. JUMP.

The Ladies' Gallery in the Senate Chamber, Washington, D.C.

Albert Berghaus after Edward Jump
Frank Leslie's Illustrated Newspaper, 02/01/1868
Wood engraving, hand-colored
5 x 9 $^3/_8$ inches (12.7 x 23.8 cm)
Cat. no. 38.00090.001a

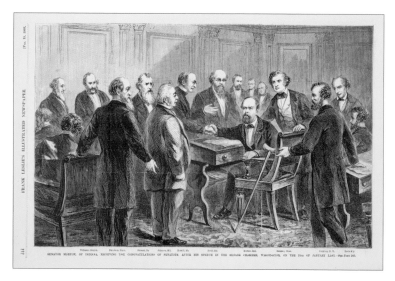

Senator Morton, of Indiana, Receiving the Congratulations of Senators, after His Speech in the Senate Chamber, Washington, on the 24th of January Last.

Unidentified
Frank Leslie's Illustrated Newspaper, 02/15/1868
Wood engraving, black and white
9 3/8 x 14 1/16 inches (23.8 x 35.7 cm)
Cat. no. 38.00338.001

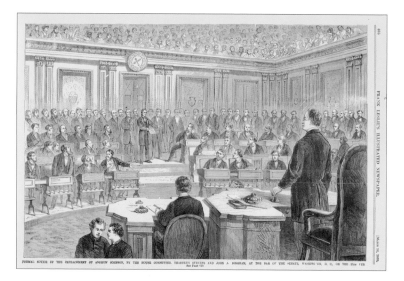

Formal Notice of the Impeachment of Andrew Johnson, by the House Committee, Thaddeus Stevens and John A. Bingham, at the Bar of the Senate, Washington, D.C. on the 25th Feb.

Unidentified
Frank Leslie's Illustrated Newspaper, 03/14/1868
Wood engraving, black and white
9 3/4 x 14 1/8 inches (24.8 x 35.9 cm)
Cat. no. 38.00156.002

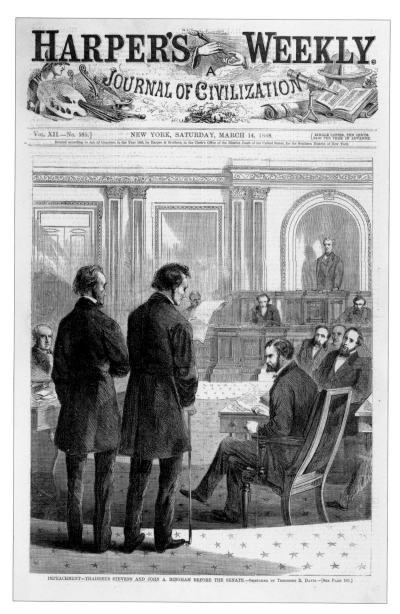

Impeachment—Thaddeus Stevens and John A. Bingham before the Senate.

Unidentified after Theodore R. Davis
Harper's Weekly, 03/14/1868
Wood engraving, black and white
11 3/8 x 9 1/8 inches (28.9 x 23.2 cm)
Cat. no. 38.00310.001

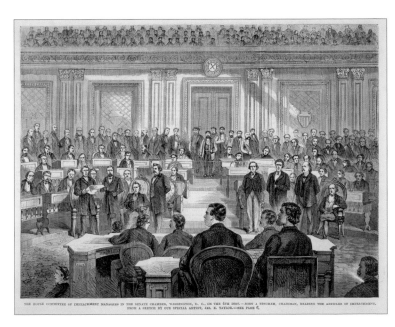

The House Committee of Impeachment Managers in the Senate Chamber, Washington, D.C., on the 4th Inst.—John A. Bingham, Chairman, Reading the Articles of Impeachment.

Unidentified after James E. Taylor
Frank Leslie's Illustrated Newspaper, 03/21/1868
Wood engraving, black and white
7 ½ x 9 ⅜ inches (19.1 x 23.8 cm)
Cat. no. 38.00339.001

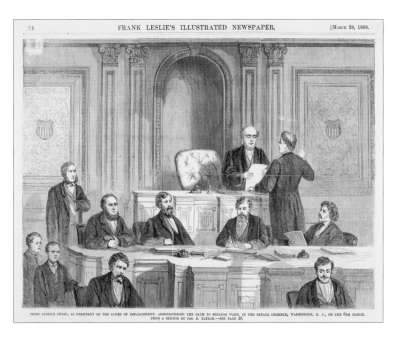

Chief Justice Chase, as President of the Court of Impeachment, Administering the Oath to Senator Wade, in the Senate Chamber, Washington, D.C., on the 6th March.

Unidentified after James E. Taylor
Frank Leslie's Illustrated Newspaper, 03/28/1868
Wood engraving, black and white
7 ⅜ x 9 ⁷⁄₁₆ inches (18.7 x 24.0 cm)
Cat. no. 38.00337.001a

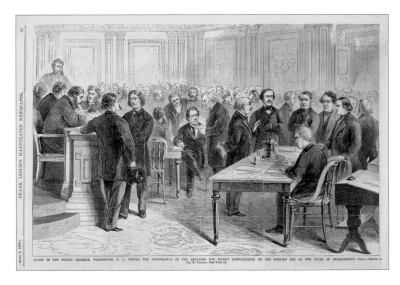

Scene in the Senate Chamber, Washington, D.C., during the Withdrawal of the Senators for Secret Consultation, on the Opening Day of the Court of Impeachment.

Unidentified after James E. Taylor
Frank Leslie's Illustrated Newspaper, 04/04/1868
Wood engraving, black and white
9 ½ x 14 inches (24.1 x 35.6 cm)
Cat. no. 38.00390.001

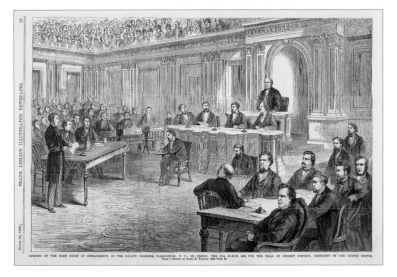

Opening of the High Court of Impeachment, in the Senate Chamber, Washington, D.C., on Friday, the 13th March, 1868, for the Trial of Andrew Johnson, President of the United States.

Unidentified after James E. Taylor
Frank Leslie's Illustrated Newspaper, 03/28/1868
Wood engraving, black and white
9 ¾ x 14 ⅛ inches (24.8 x 35.9 cm)
Cat. no. 38.00290.002

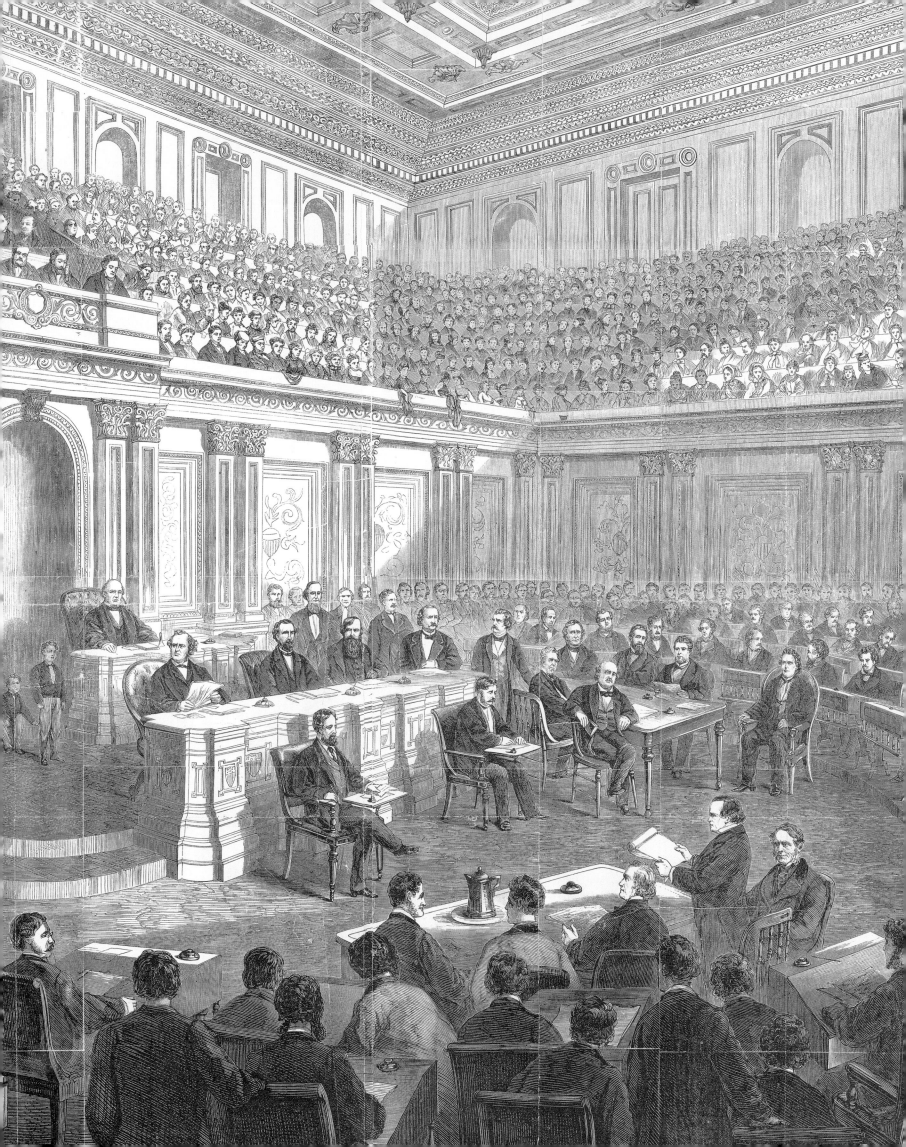

The dramatic impeachment trial of President Andrew Johnson captivated the nation for two months in 1868. With the chief justice of the United States presiding in the Senate Chamber, the debate focused on the legality of Johnson's actions in removing Secretary of War Edwin Stanton in defiance of the Tenure of Office Act. Although the Senate was largely opposed to the president—voting 35 to 19 on three of the articles of impeachment—it failed by one vote the two-thirds majority necessary for conviction. *Frank Leslie's Illustrated Newspaper* declared that this engraving of the Senate as the High Court of Impeachment "will be a most desirable acquisition to every household in the land, not only as a work of art, but as a memento of one of the most remarkable and important episodes in the history of the Republic. It should be framed and kept as an heirloom in every family that regards with interest the national destiny; for the time will come when, to future generations, this picture will tell, more eloquently than written words, its story of a crisis, the results of which none can now foresee in the experiment of republicanism, that is now passing, perhaps, its most trying ordeal."[1]

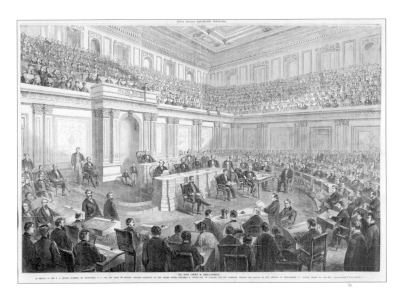

The High Court of Impeachment, in Session in the U.S. Senate Chamber, at Washington, D.C., for the Trial of Andrew Johnson, President of the United States—Benjamin R. Curtis, Esq., of Counsel for the President, Reading the Answer to the Articles of Impeachment, on Monday, March 23d, 1868.

Unidentified after James E. Taylor
Frank Leslie's Illustrated Newspaper, 04/11/1868
Wood engraving, black and white
21 x 30¼ inches (53.3 x 76.8 cm)
Cat. no. 38.00191.001

[1] "Our Picture of the High Court of Impeachment," *Frank Leslie's Illustrated Newspaper*, 11 April 1868, 1.

Judge Nelson Administering the Oath to Chief Justice Chase, as Presiding Officer of the Court of Impeachment, in the Senate Chamber, Washington, D.C., on the 5th March.

Unidentified after James E. Taylor
Frank Leslie's Illustrated Newspaper, 03/28/1868
Wood engraving, black and white
11 ¼ x 9 ⁷⁄₁₆ inches (28.6 x 24.0 cm)
Cat. no. 38.00379.001

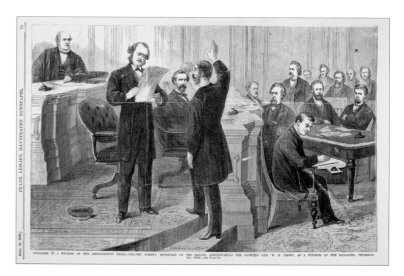

Swearing in a Witness at the Impeachment Trial—Colonel Forney, Secretary of the Senate, Administering the Oath to Gen. W. H. Emory, as a Witness of the Managers, Thursday, 2nd Inst.

Unidentified
Frank Leslie's Illustrated Newspaper, 04/18/1868
Wood engraving, black and white
7 ¼ x 14 ¼ inches (18.4 x 36.2 cm)
Cat. no. 38.00383.001

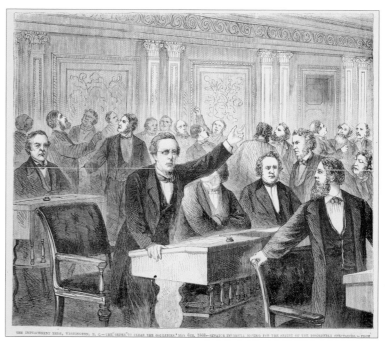

The Impeachment Trial, Washington, D.C.—The Order to Clear the Galleries, May 6th, 1868—Senator Trumbull Moving for the Arrest of the Disorderly Spectators.

Unidentified after James E. Taylor
Frank Leslie's Illustrated Newspaper, 05/23/1868
Wood engraving, black and white
8 ⁵⁄₁₆ x 9 ⅜ inches (21.1 x 23.8 cm)
Cat. no. 38.00529.001

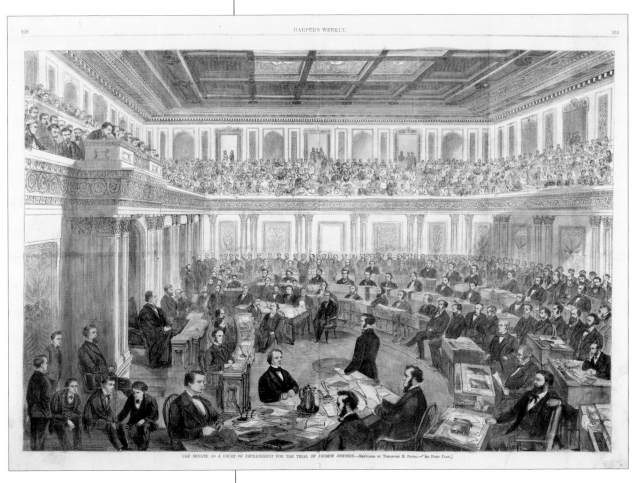

The Senate as a Court of Impeachment for the Trial of Andrew Johnson.

Unidentified after Theodore R. Davis
Harper's Weekly, 04/11/1868
Wood engraving, hand-colored
13 ¾ x 20 ½ inches (34.9 x 52.1 cm)
Cat. no. 38.00024.005

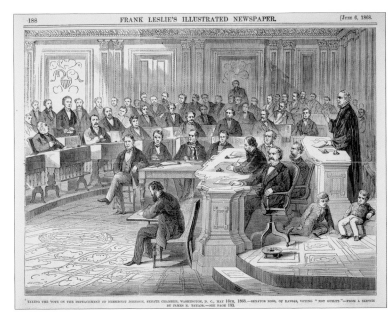

Taking the Vote on the Impeachment of President Johnson, Senate Chamber, Washington, D.C., May 16th, 1868.—Senator Ross, of Kansas, Voting "Not Guilty."

Unidentified after James E. Taylor
Frank Leslie's Illustrated Newspaper, 06/06/1868
Wood engraving, black and white
7 ⁵⁄₁₆ x 9 ⁷⁄₁₆ inches (18.6 x 24.0 cm)
Cat. no. 38.00378.001a

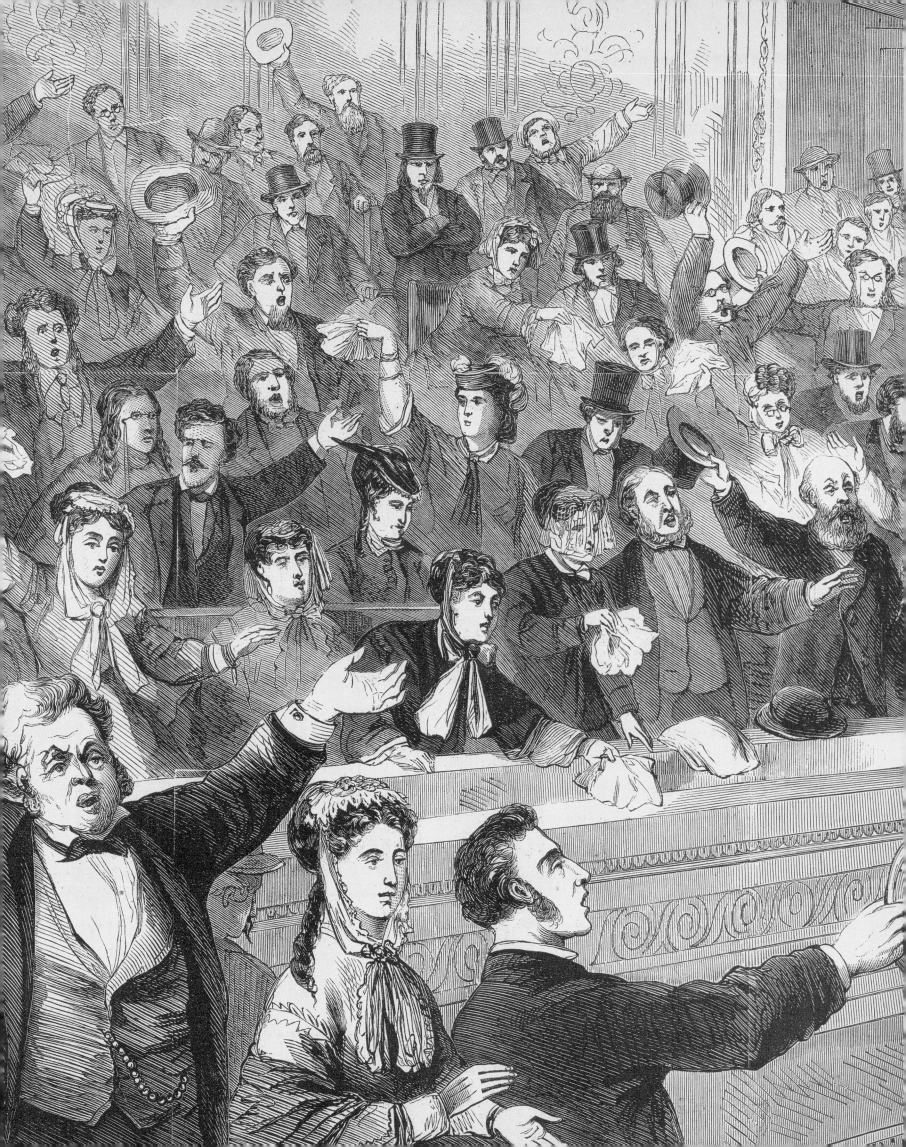

The Andrew Johnson impeachment trial began on March 30, 1868, and lasted almost two months. The illustrated papers sent scores of "special artists" to Washington, D.C., to keep the public informed of these historic proceedings. Aside from being one of the most dramatic events in Senate history, the trial was the focus of the city's social season. Only holders of numbered and dated tickets could enter the Senate galleries. *Harper's Weekly* reported that "the most lovely as well as the most distinguished ladies of Washington have been in daily attendance."[1] Police officers were stationed at the doors to hold back the crowd, which was "continually asking questions, making appeals, and muttering threats." On May 6, when Representative John Bingham finished summarizing the prosecution's case, spectators caused such an uproar that the sergeant at arms was forced to clear the galleries. As reported in *Frank Leslie's Illustrated Newspaper*, "the clapping of hands, the waving of handkerchiefs, the tumult of excited approbation, presented a scene not often associated with the history of parliamentary proceedings."[2] ☙

[1] "The Impeachment Trial," *Harper's Weekly*, 18 April 1868, 244.

[2] "The Impeachment Trial, Washington, D.C.—Remarkable Scene in the U.S. Senate, May 6th," *Frank Leslie's Illustrated Newspaper*, 23 May 1868, 151.

The Ladies' Gallery of the Senate during the Impeachment Trial.

William S. L. Jewett
Harper's Weekly, 04/18/1868
Wood engraving, black and white
9 1/16 x 13 11/16 inches (23.0 x 34.8 cm)
Cat. no. 38.00086.002

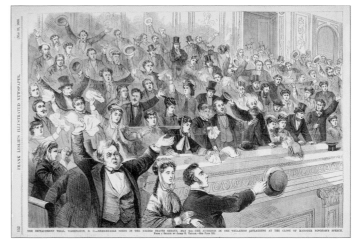

The Impeachment Trial, Washington, D.C.—Remarkable Scene in the United States Senate, May 6th —The Audience in the Galleries Applauding at the Close of Manager Bingham's Speech.

Unidentified after James E. Taylor
Frank Leslie's Illustrated Newspaper, 05/23/1868
Wood engraving, black and white
9 5/8 x 14 1/4 inches (24.4 x 36.2 cm)
Cat. no. 38.00365.001

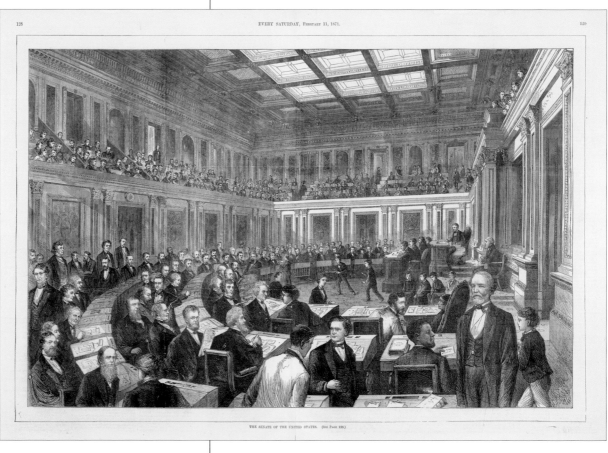

The Senate of the United States.

Unidentified
Every Saturday, 02/11/1871
Wood engraving, black and white
12 ½ x 18 ½ inches (31.8 x 47.0 cm)
Cat. no. 38.00003.002

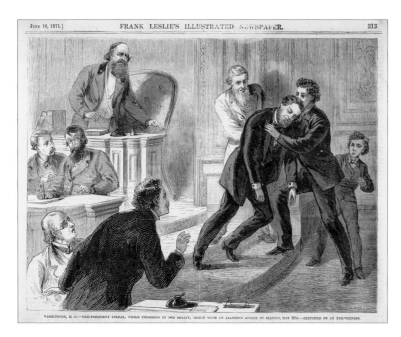

Washington, D.C.—Vice-President Colfax, While Presiding in the Senate, Seized with an Alarming Attack of Illness, May 22d.

Unidentified
Frank Leslie's Illustrated Newspaper, 06/10/1871
Wood engraving, black and white
7 ³⁄₁₆ x 9 ⅛ inches (18.3 x 23.2 cm)
Cat. no. 38.00381.001

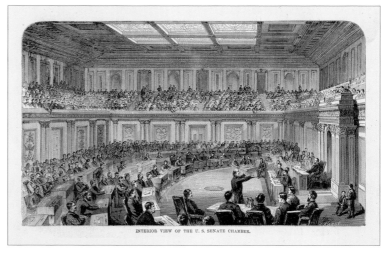

Interior View of the U.S. Senate Chamber.

Unidentified after John Karst
Unidentified, ca. 1872
Wood engraving, black and white
4 x 6 ¹¹⁄₁₆ inches (10.2 x 17.0 cm)
Cat. no. 38.00690.001

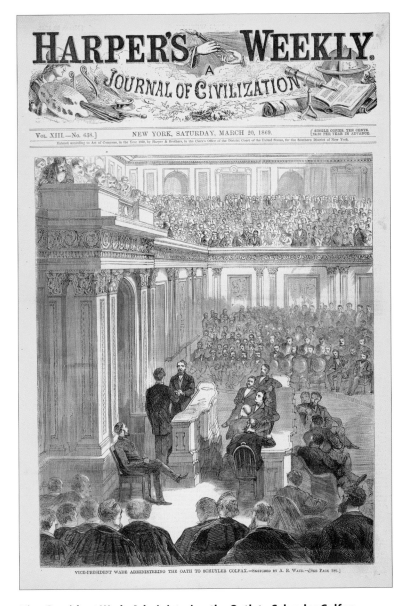

Vice-President Wade Administering the Oath to Schuyler Colfax.

Unidentified after Alfred R. Waud
Harper's Weekly, 03/20/1869
Wood engraving, black and white
11 ⅛ x 9 1/16 inches (28.3 x 23.0 cm)
Cat. no. 38.00394.002

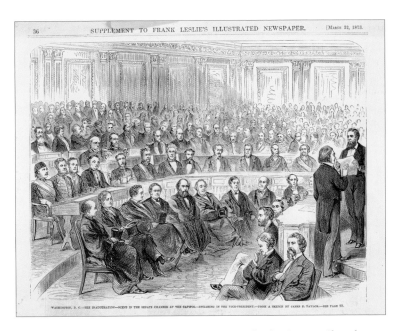

Washington, D.C.—The Inauguration—Scene in the Senate Chamber at the Capitol—Swearing in the Vice-President.

Unidentified after James E. Taylor
Supplement to Frank Leslie's Illustrated Newspaper, 03/22/1873
Wood engraving, black and white
7 ⅛ x 9 ¼ inches (18.1 x 23.5 cm)
Cat. no. 38.00850.001c

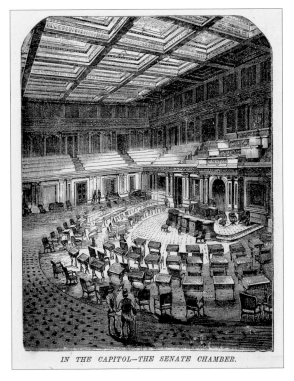

In the Capitol—The Senate Chamber.

Unidentified after Henri H. Lovie
Hearth and Home, 09/13/1873
Wood engraving, black and white
4 ½ x 3 5/16 inches (11.4 x 8.4 cm)
Cat. no. 38.00975.001a

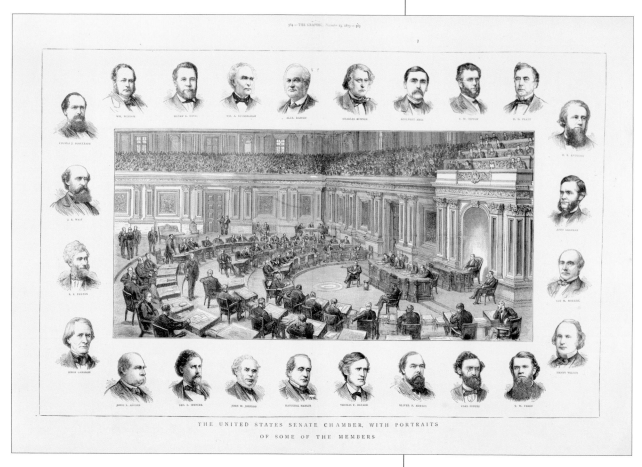

THE UNITED STATES SENATE CHAMBER, WITH PORTRAITS OF SOME OF THE MEMBERS

The United States Senate Chamber, with Portraits of Some of the Members

Unidentified
The Graphic, 12/13/1873
Wood engraving, black and white
13 ¼ x 19 ¾ inches (33.7 x 50.2 cm)
Cat. no. 38.00242.002

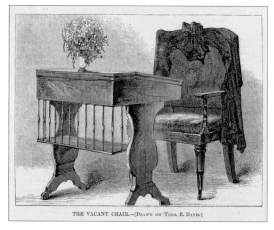

THE VACANT CHAIR.—[Drawn by Theo. R. Davis.]

The Vacant Chair.

Unidentified after Theodore R. Davis
Harper's Weekly, 04/04/1874
Wood engraving, black and white
3 ⅝ x 4 ⁹⁄₁₆ inches (9.2 x 11.6 cm)
Cat. no. 38.00225.001a

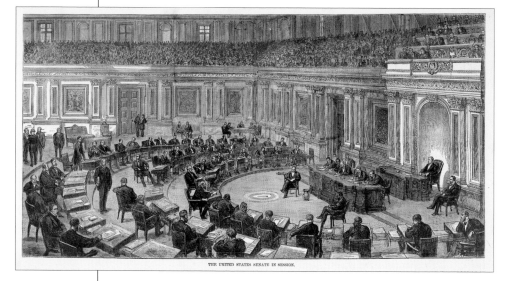

THE UNITED STATES SENATE IN SESSION.

The United States Senate in Session.

Unidentified
Harper's Weekly, 01/03/1874
Wood engraving, hand-colored
7 ⁷⁄₁₆ x 14 ¹⁄₁₆ inches (18.9 x 35.7 cm)
Cat. no. 38.00004.002

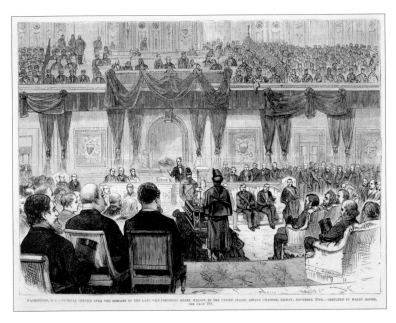

Washington, D.C.—Funeral Service over the Remains of the Late Vice-President Henry Wilson, in the United States Senate Chamber, Friday, November 26th.

Unidentified after Harry Ogden
Frank Leslie's Illustrated Newspaper, 12/11/1875
Wood engraving, black and white
7 1/16 x 9 1/4 inches (17.9 x 23.5 cm)
Cat. no. 38.00288.002b

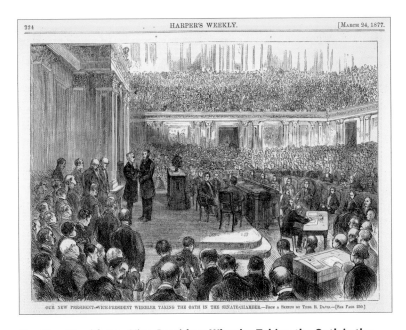

Our New President—Vice-President Wheeler Taking the Oath in the Senate-Chamber.

Unidentified after Theodore R. Davis
Harper's Weekly, 03/24/1877
Wood engraving, hand-colored
6 3/4 x 9 inches (17.1 x 22.9 cm)
Cat. no. 38.00036.002a

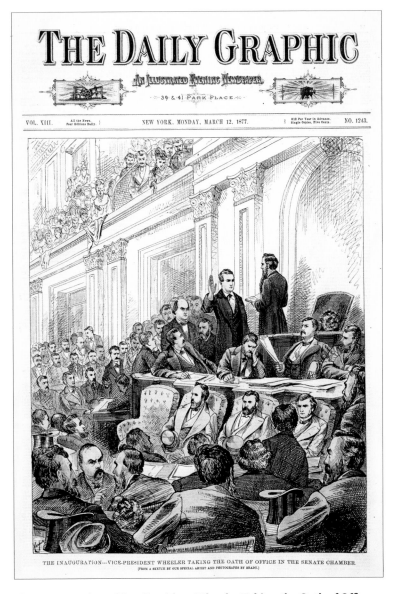

The Inauguration—Vice-President Wheeler Taking the Oath of Office in the Senate Chamber.

Unidentified after Harper after photographs by Mathew B. Brady
The Daily Graphic, 03/12/1877
Wood engraving, hand-colored
15 x 12 inches (38.1 x 30.5 cm)
Cat. no. 38.00969.001

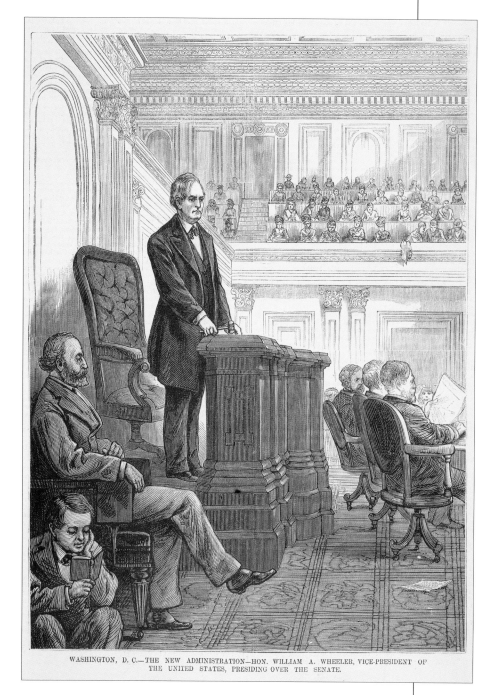

WASHINGTON, D. C.—THE NEW ADMINISTRATION—HON. WILLIAM A. WHEELER, VICE-PRESIDENT OF THE UNITED STATES, PRESIDING OVER THE SENATE.

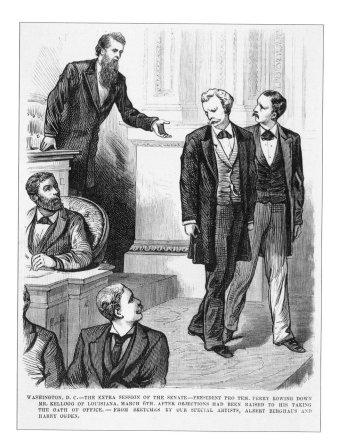

WASHINGTON, D. C.—THE EXTRA SESSION OF THE SENATE—PRESIDENT PRO TEM. FERRY BOWING DOWN MR. KELLOGG OF LOUISIANA, MARCH 6TH. AFTER OBJECTIONS HAD BEEN RAISED TO HIS TAKING THE OATH OF OFFICE. — FROM SKETCHES BY OUR SPECIAL ARTISTS, ALBERT BERGHAUS AND HARRY OGDEN.

Washington, D.C.—The Extra Session of the Senate—President Pro Tem. Ferry Bowing Down Mr. Kellogg of Louisiana, March 6th. After Objections Had Been Raised to His Taking the Oath of Office.

Unidentified after Albert Berghaus and Harry Ogden
Frank Leslie's Illustrated Newspaper, 03/24/1877
Wood engraving, black and white
6 x 4⅝ inches (15.2 x 11.7 cm)
Cat. no. 38.00397.001

Washington, D.C.—The New Administration—Hon. William A. Wheeler, Vice-President of the United States, Presiding over the Senate.

Unidentified
Frank Leslie's Illustrated Newspaper, 03/31/1877
Wood engraving, black and white
9 ¾ x 6 ¹³⁄₁₆ inches (24.8 x 17.3 cm)
Cat. no. 38.00558.002

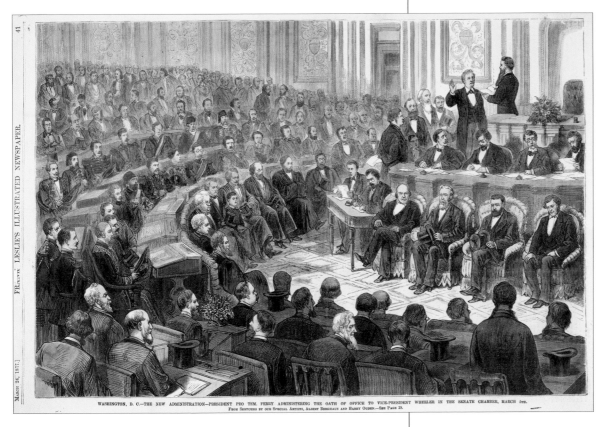

Washington, D.C.—The New Administration—President Pro Tem. Ferry Administering the Oath of Office to Vice-President Wheeler in the Senate Chamber, March 5th.

Unidentified after Albert Berghaus and Harry Ogden
Frank Leslie's Illustrated Newspaper, 03/24/1877
Wood engraving, hand-colored
9 ⅝ x 13 ⅞ inches (24.4 x 35.2 cm)
Cat. no. 38.00014.001

Senate Chamber, U.S. Capitol

Unidentified
John F. Jarvis, ca. 1880
Photograph, black and white
5 x 8 ⅛ inches (12.7 x 20.6 cm)
Cat. no. 38.00130.001

[U.S. Senate Chamber]

Unidentified after Thomas Doney
Unidentified, ca. 1880
Lithograph, black and white
6 ¹¹⁄₁₆ x 5 ⅞ inches (17.0 x 14.9 cm)
Cat. no. 38.00540.001

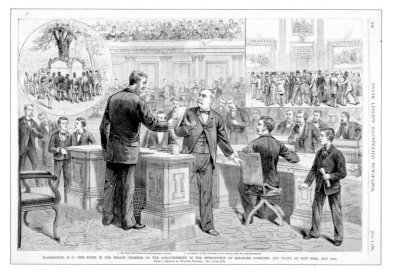

Washington, D.C.—The Scene in the Senate Chamber on the Announcement of the Resignation of Senators Conkling and Platt, of New York, May 16th.

Unidentified after Walter Goater
Frank Leslie's Illustrated Newspaper, 06/04/1881
Wood engraving, black and white
9 ⅞ x 14 ⅛ inches (25.1 x 35.9 cm)
Cat. no. 38.00218.002

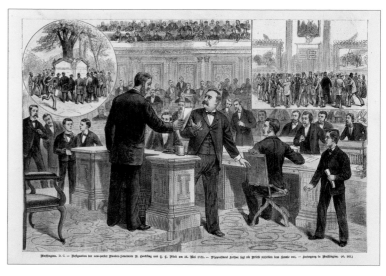

Washington. D.C.—Resignation der new-yorker Bundes-Senatoren R. Conkling und T. C. Platt am 16. Mei 1881.—Vizepräsident Arthur legt die Briefe derselben dem Senate vor.—Aufregung in Washington.

Unidentified [after Walter Goater]
Frank Leslie's Illustrirte Zeitung, 06/04/1881
Wood engraving, hand-colored
9 ¼ x 14 inches (23.5 x 35.6 cm)
Cat. no. 38.00970.001

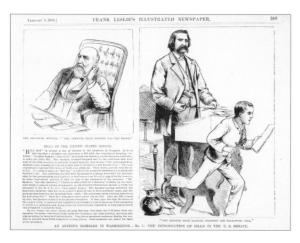

An Artist's Rambles in Washington.—No. 5: The Introduction of Bills in the U.S. Senate.

Unidentified
Frank Leslie's Illustrated Newspaper, 02/09/1884
Wood engraving, black and white
7 x 9 ¼ inches (17.8 x 23.5 cm)
Cat. no. 38.00874.001

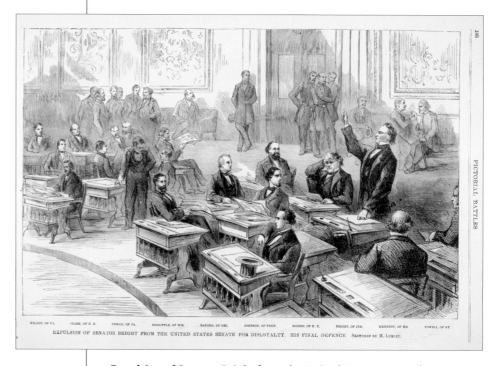

Expulsion of Senator Bright from the United States Senate for Disloyalty. His Final Defence [sic].

Unidentified after M. Lumley
Pictorial Battles of the Civil War, 1885
Wood engraving, black and white
9 ½ x 13 ¹⁵⁄₁₆ inches (24.1 x 35.4 cm)
Cat. no. 38.00252.001

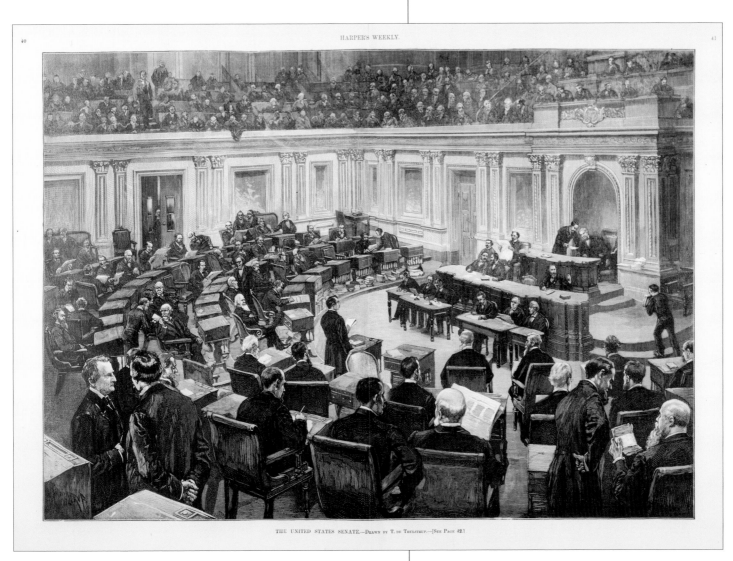

The United States Senate.

Unidentified after Thure de Thulstrup
Harper's Weekly, 01/16/1886
Wood engraving, black and white
14 ¼ x 19 ½ inches (36.2 x 49.5 cm)
Cat. no. 38.00025.002

[U.S. Senate Chamber]

Unidentified
Unidentified, ca. 1865-1885
Photograph, black and white
3 x 6 inches (7.6 x 15.2 cm)
Cat. no. 38.00707.001

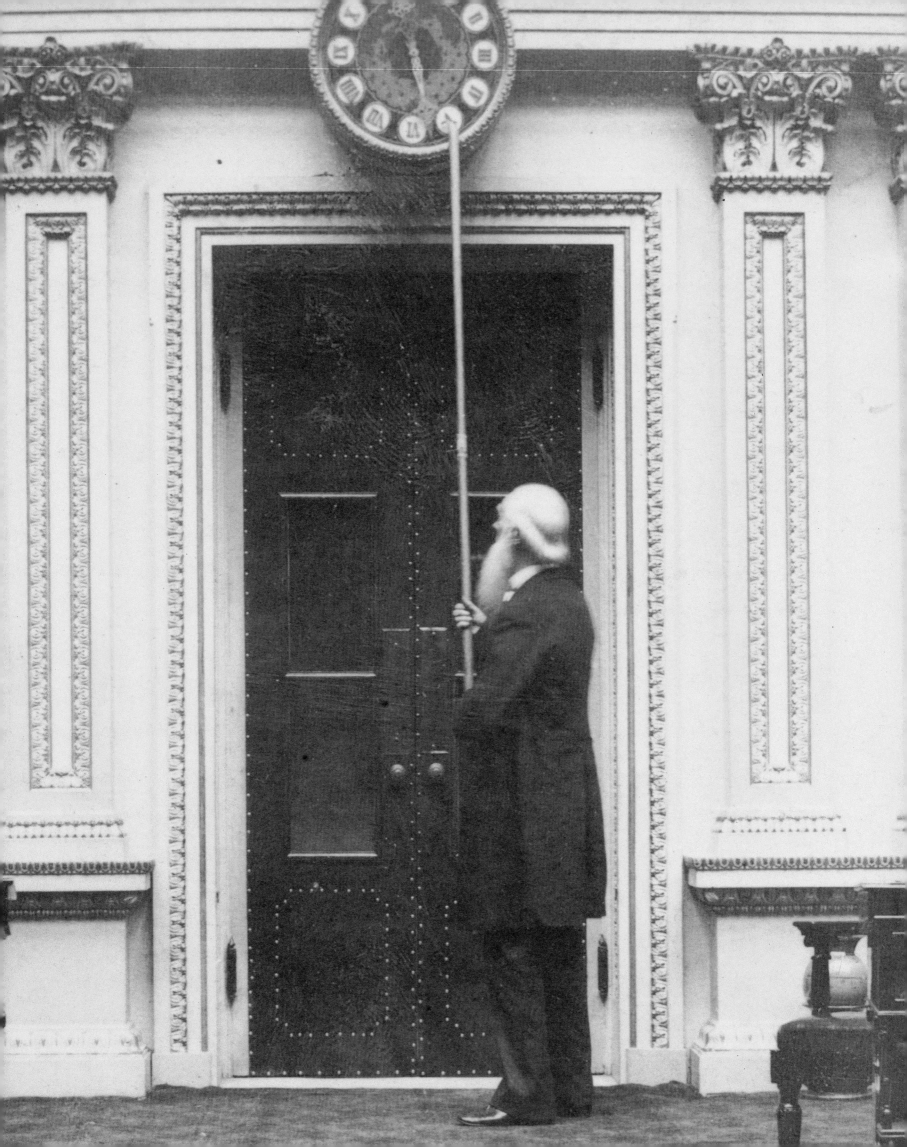

*I*saac Bassett worked in the Senate as a page, messenger, and assistant doorkeeper from 1831 to 1895. His most abiding legacy is a manuscript he wrote, recording some of the more dramatic incidents and personalities in the Senate's history, and providing an unparalleled chronicle of the institution in the 19th century. According to his account, his most celebrated and unusual duty began on March 4, 1845, the last day of the 28th Congress. President pro tempore Willie Mangum, fearing that an appropriations bill would not pass before the Senate was scheduled to adjourn, instructed Bassett to turn the hands of the Senate Chamber clock back 10 minutes. The senator stated, "I know of no one who could do it better than you."[1] While Bassett continued to carry out this task for over half a century, in his memoir he expressed dismay, particularly when senators—some jovial, others not—called into question the constitutionality of the action. Bassett recounted, "I have been called often by all of the presiding officers of the Senate since to move the clock back. There have been many instances when it was absolutely necessary to have it done. Many an extra ordinary [sic] session has been saved when I have moved the hands back."[2] ☙

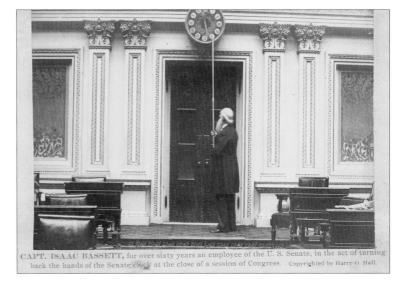

CAPT. ISAAC BASSETT, for over sixty years an employee of the U. S. Senate, in the act of turning back the hands of the Senate clock at the close of a session of Congress. Copyrighted by Harry O. Hall.

Capt. Isaac Bassett

Harry O. Hall
Unidentified, ca. 1890
Photograph, black and white
4 1/16 x 5 15/16 inches (10.3 x 15.1 cm)
Cat. no. 38.00502.001

[1] Papers of Isaac Bassett, Office of the Curator, U.S. Senate, 11 C 36–37.
[2] Ibid., 11 C 38.

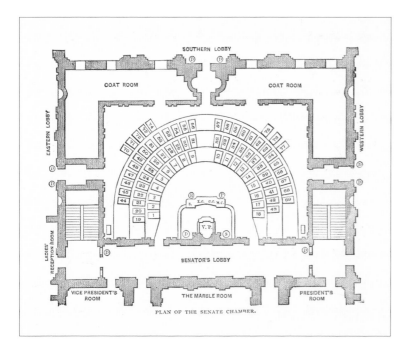

Plan of the Senate Chamber.

Unidentified
Picturesque Washington, 1888
Wood engraving, black and white
4 ⅝ x 5 ⅝ inches (11.7 x 14.3 cm)
Cat. no. 38.00556.001

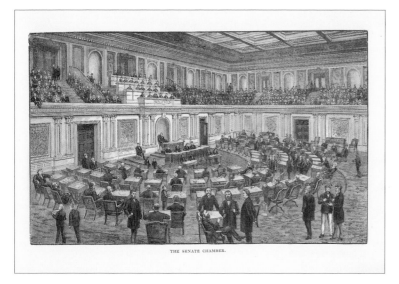

The Senate Chamber.

Unidentified after S. S. Kilburn
Picturesque Washington, ca. 1889
Wood engraving, hand-colored
5 x 7 ⅜ inches (12.7 x 18.7 cm)
Cat. no. 38.00645.001

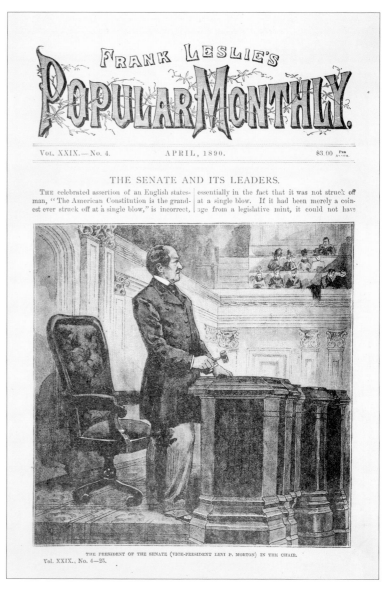

**The President of the Senate
(Vice-President Levi P. Morton) in the Chair.**

Unidentified
Frank Leslie's Popular Monthly, 04/1890
Halftone, black and white
6 ¼ x 6 inches (15.9 x 15.2 cm)
Cat. no. 38.00507.001

[U.S. Senate Chamber with Isaac Bassett and Pages]

Unidentified
Unidentified, ca. 1890
Photograph, black and white
7 9/16 x 9 5/8 inches (19.2 x 24.4 cm)
Cat. no. 38.00503.001

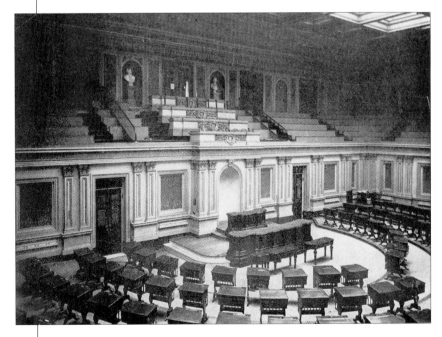

Washington . . . Senate Chamber.

Unidentified
Unidentified, ca. 1895
Halftone, black and white
3 3/4 x 5 inches (9.5 x 12.7 cm)
Cat. no. 38.00872.001

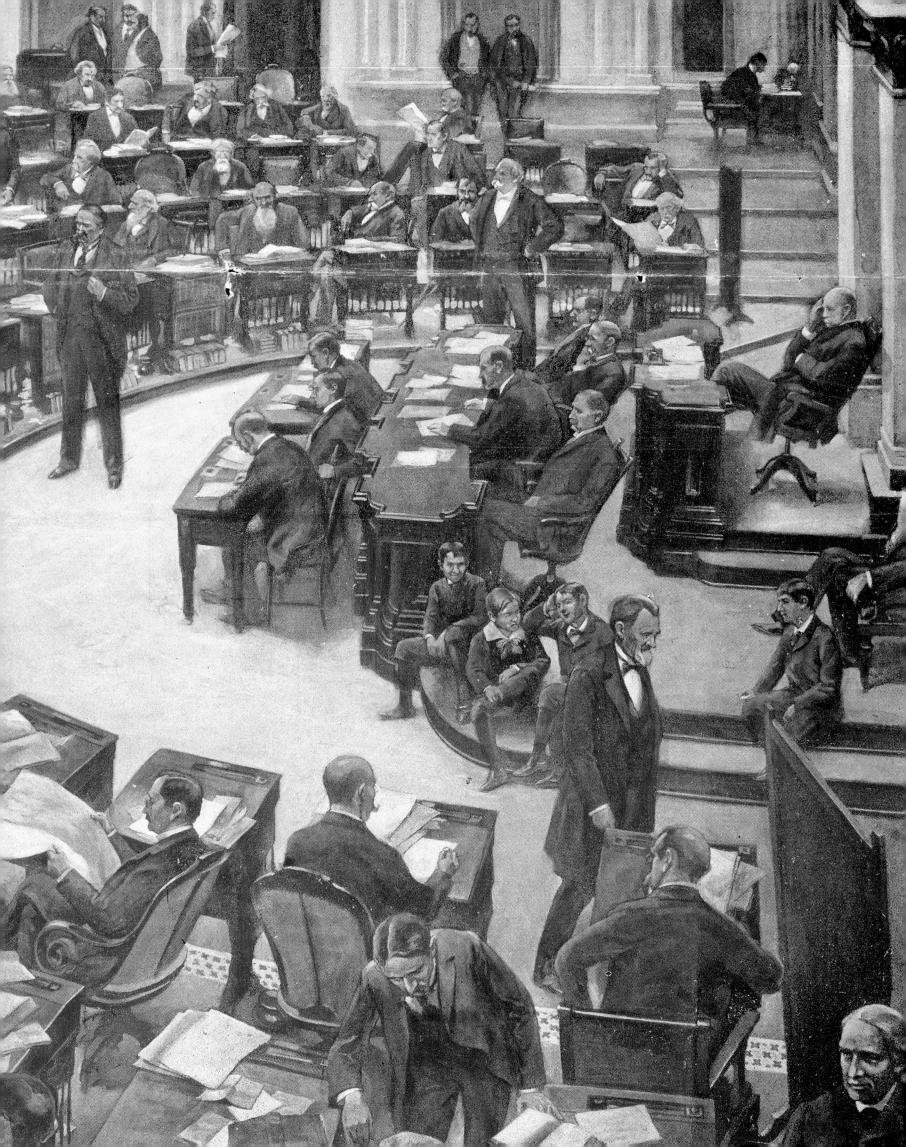

*T*his 1894 engraving shows the Senate Chamber during a typical session in the late 19th century. Senators occupy their desks, some listening to the proceedings, while others talk with one another or attend to business. During this time, only powerful committee chairmen had personal offices, and thus members spent much of their day at their desks doing work. Senate pages can be seen sitting at the rostrum awaiting a call from a member. The position of Senate page was first created in 1829. By the turn of the century, the Senate employed at least 17 young boys as pages. Dressed in knickers and jackets, they spent their days running errands for the senators, announcing impending votes, placing papers and pens on the senators' desks, and delivering messages throughout the city. Visitors watch the proceedings from the galleries, and three press reporters can be seen above the presiding officer's desk taking notes. The elaborate 19th-century Victorian interior shown in this image was significantly changed as part of a 1950s renovation. The original stained glass ceiling was found to be dangerously weak and had to be replaced; at the same time, the interior was altered to reflect a Federal-period look. ☙

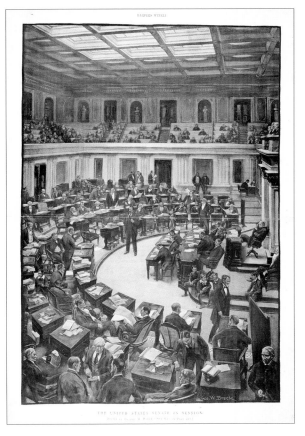

The United States Senate in Session.

Unidentified after George W. Breck after photograph by William Kurtz
Harper's Weekly, 09/22/1894
Halftone, colored
19 ½ x 13 ¾ inches (49.5 x 34.9 cm)
Cat. no. 38.00032.005

See appendix p. 481 for key

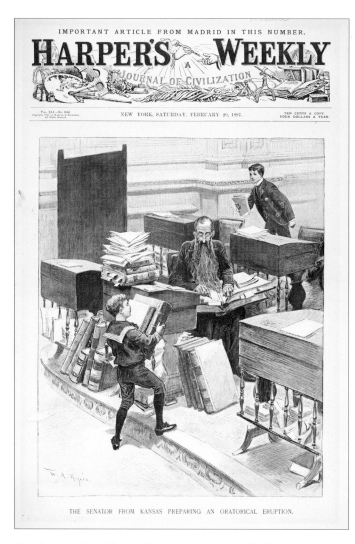

The Senator from Kansas Preparing an Oratorical Eruption.

Unidentified after William Allen Rogers
Harper's Weekly, 02/20/1897
Halftone, black and white
11 x 8 7/16 inches (27.9 x 21.4 cm)
Cat. no. 38.00140.001

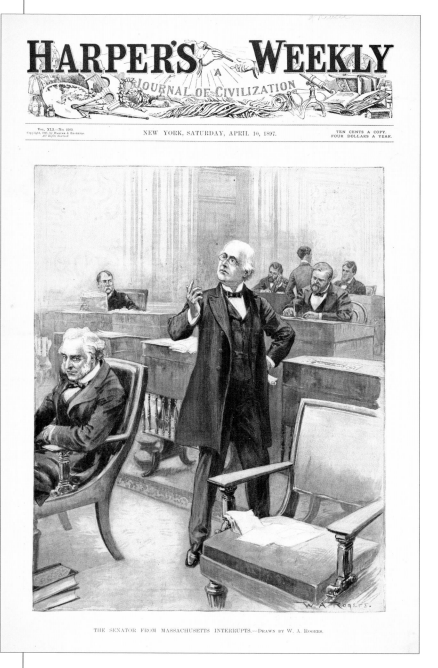

The Senator from Massachusetts Interrupts.

Unidentified after William Allen Rogers
Harper's Weekly, 04/10/1897
Halftone, black and white
11 1/8 x 8 1/2 inches (28.3 x 21.6 cm)
Cat. no. 38.00142.001

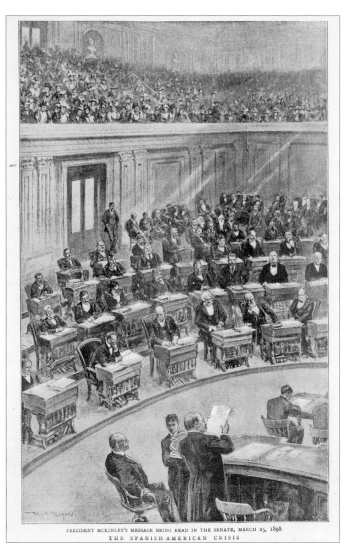

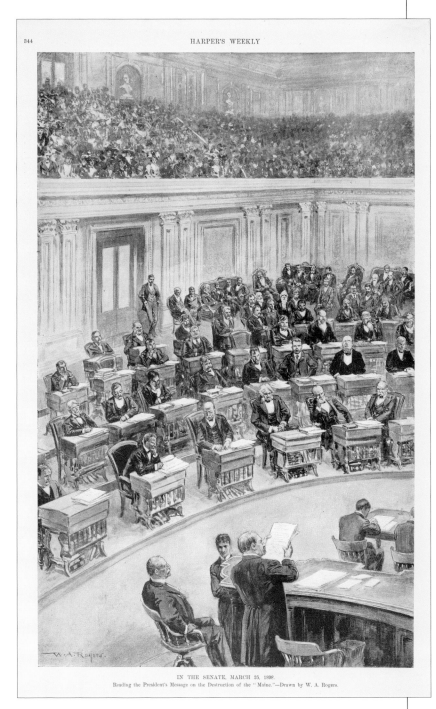

President McKinley's Message Being Read in the Senate, March 25, 1898 / The Spanish-American Crisis

Unidentified after William Allen Rogers
The Graphic, 04/23/1898
Halftone, black and white
9 ¼ x 5 ¹¹⁄₁₆ inches (23.5 x 14.4 cm)
Cat. no. 38.00385.001

In the Senate, March 25, 1898.

Unidentified after William Allen Rogers
Harper's Weekly, 04/09/1898
Halftone, black and white
14 x 8 ½ inches (35.6 x 21.6 cm)
Cat. no. 38.00212.001

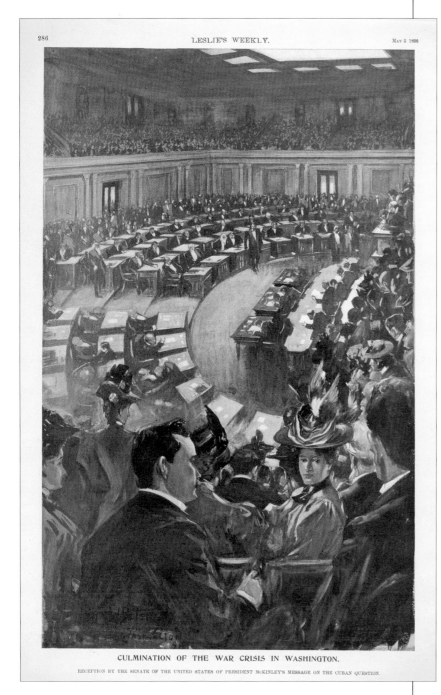

Culmination of the War Crisis in Washington.

Unidentified after G. W. Peters
Leslie's Weekly, 05/05/1898
Lithograph, black and white
14 ¾ x 9 inches (37.5 x 22.9 cm)
Cat. no. 38.00234.001

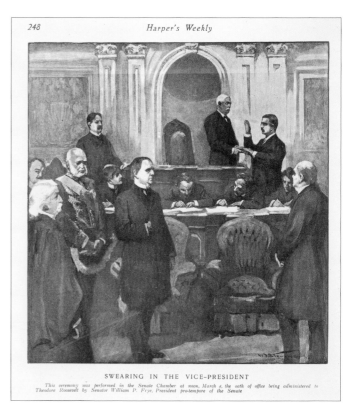

Swearing in the Vice-President

Unidentified after William D. Stevens
Harper's Weekly, 03/09/1901
Halftone, blue and white
10 ¼ x 9 inches (26.0 x 22.9 cm)
Cat. no. 38.00591.001

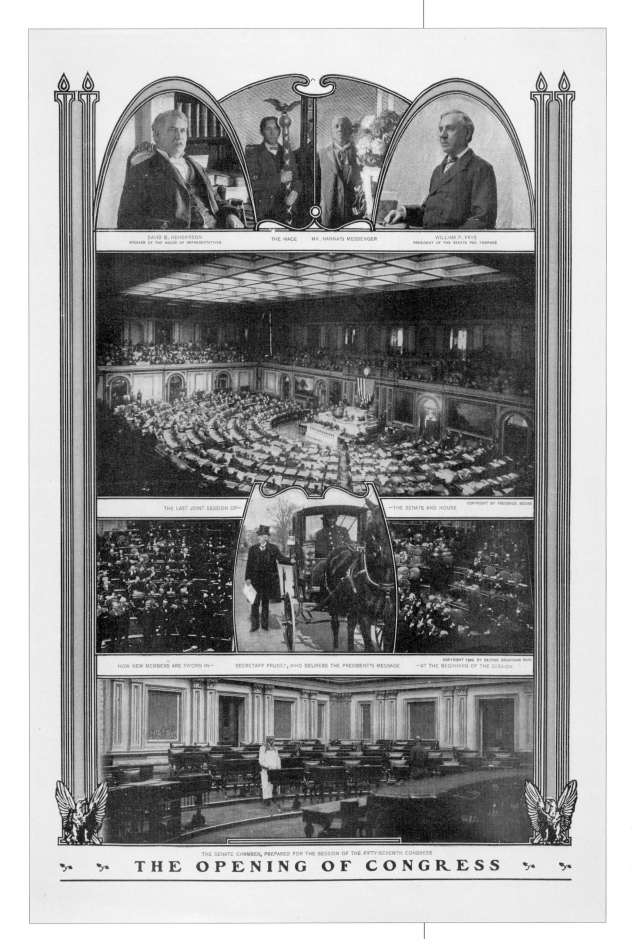

The Opening of Congress

Unidentified
Collier's, 11/30/1901
Halftone, colored
14 ¼ x 9 ¼ inches (36.2 x 23.5 cm)
Cat. no. 38.00650.001

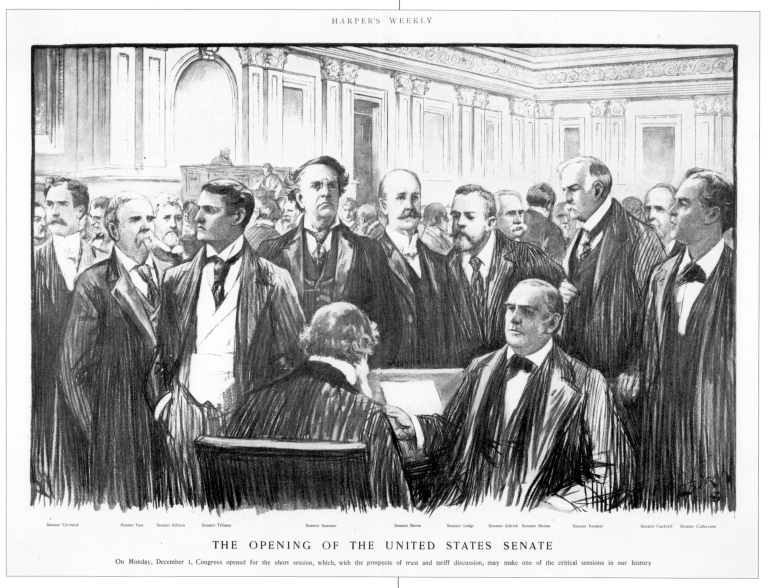

The Opening of the United States Senate

Unidentified after Birch
Harper's Weekly, 12/13/1902
Halftone, black and white
11 ⅜ x 15 ⅞ inches (28.9 x 40.3 cm)
Cat. no. 38.00135.001

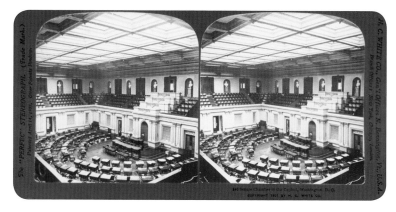

Senate Chamber in the Capitol, Washington, D.C.

Unidentified
H.C. White Co., 1901
Photograph, black and white
3 ⅜ x 6 ⅛ inches (8.6 x 15.6 cm)
Cat. no. 38.00711.001

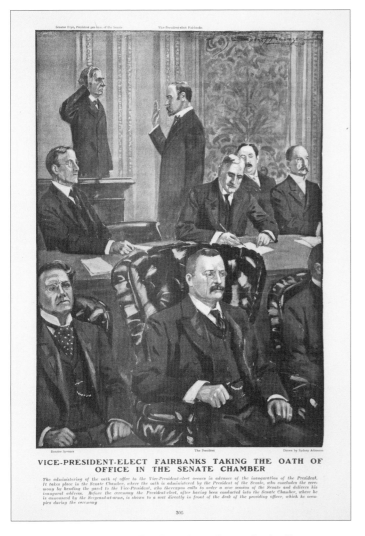

Vice-President-Elect Fairbanks Taking the Oath of Office in the Senate Chamber

Unidentified after Sydney Adamson
Harper's Weekly, 03/04/1905
Halftone, blue and white
11 x 7 ¼ inches (27.9 x 18.4 cm)
Cat. no. 38.00590.001

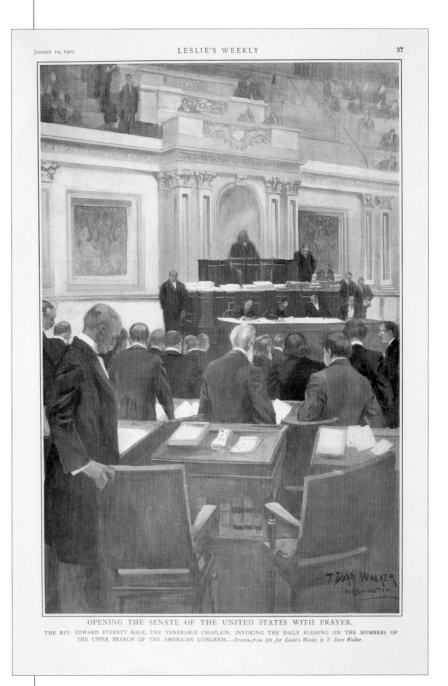

Opening the Senate of the United States with Prayer. The Rev. Edward Everett Hale, the Venerable Chaplain, Invoking the Daily Blessing on the Members of the Upper Branch of the American Congress.

Unidentified after T. Dart Walker
Leslie's Weekly, 01/12/1905
Halftone, colored
13 ½ x 9 inches (34.3 x 22.9 cm)
Cat. no. 38.00972.001

CAPITOL INTERIOR

Interior View of the United States House of Representatives, at Washington, D.C.

Unidentified
Gleason's Pictorial Drawing-Room Companion, 1851
Wood engraving, hand-colored
7 1/16 x 9 5/16 inches (17.9 x 23.7 cm)
Cat. no. 38.00052.001b

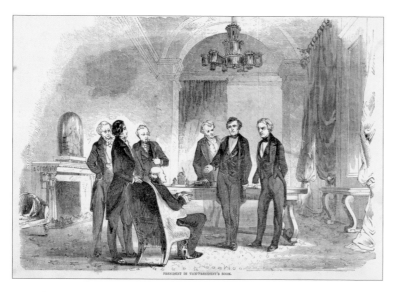

President in Vice-President's Room.

Unidentified
The [New York] Illustrated News, 03/12/1853
Wood engraving, black and white
6 3/4 x 9 5/8 inches (17.1 x 24.4 cm)
Cat. no. 38.00241.001

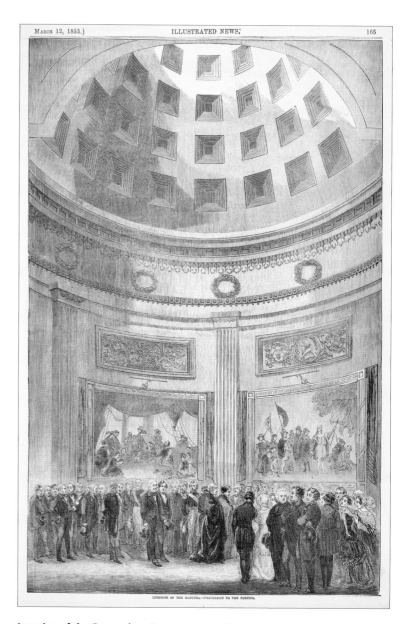

Interior of the Rotunda—Procession to the Portico.

Unidentified
The [New York] Illustrated News, 03/12/1853
Wood engraving, hand-colored
14 3/8 x 9 5/16 inches (36.5 x 23.7 cm)
Cat. no. 38.00062.001

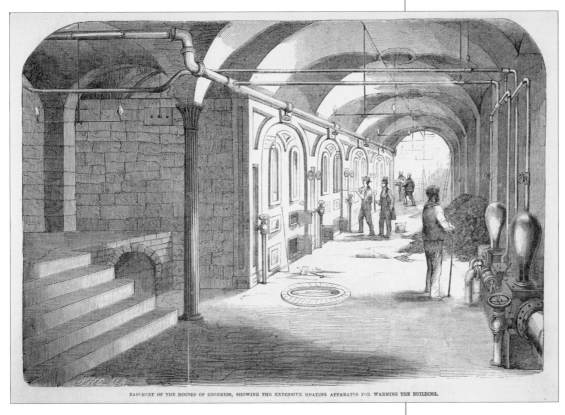

Basement of the Houses of Congress, Showing the Extensive Heating Apparatus for Warming the Building.

W.H.C.
Frank Leslie's Illustrated Newspaper, 06/05/1858
Wood engraving, black and white
6 ⁵⁄₁₆ x 9 inches (16.0 x 22.9 cm)
Cat. no. 38.00423.001a

Balustrade of the Staircase in the New Extension Building of the Capitol, Washington. / Ornamented Railing in the New Extension Building of the Capitol, Washington.

Unidentified
Frank Leslie's Illustrated Newspaper, 06/05/1858
Wood engraving, black and white
3 ½ x 5 ⅝ inches (8.9 x 14.3 cm)
Cat. no. 38.00423.001b

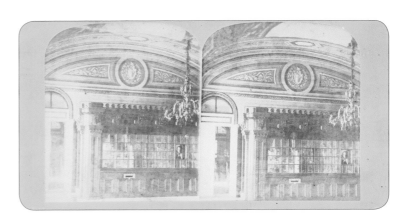

Senate Post Office—Washington.

Unidentified
Unidentified, ca. 1859-1866
Photograph, black and white
3 ³⁄₁₆ x 5 ¾ inches (8.1 x 14.6 cm)
Cat. no. 38.00910.001

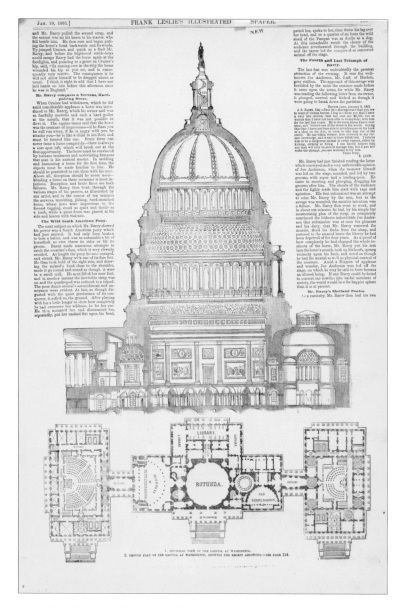

1. Sectional View of the Capitol at Washington. 2. Ground Plan of the Capitol at Washington, Showing the Recent Additions.

Unidentified
Frank Leslie's Illustrated Newspaper, 01/19/1861
Wood engraving, black and white
14 x 9 ¼ inches (35.6 x 23.5 cm)
Cat. no. 38.00166.001

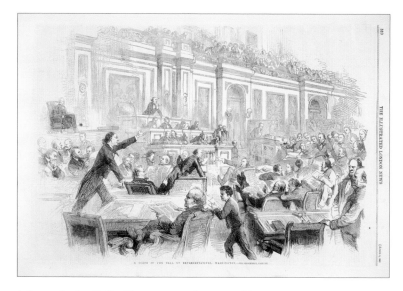

A Scene in the Hall of Representatives, Washington.

Unidentified after Thomas Nast
The Illustrated London News, 04/06/1861
Wood engraving, black and white
9 ⅝ x 13 ¾ inches (24.4 x 34.9 cm)
Cat. no. 38.00247.001

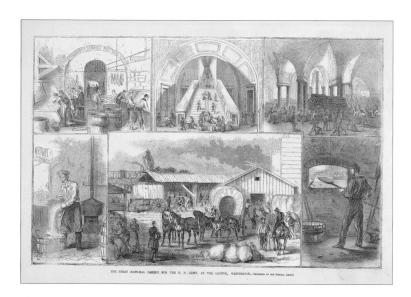

The Great National Bakery for the U.S. Army, at the Capitol, Washington.

Unidentified
Frank Leslie's Illustrated Newspaper, 09/20/1862
Wood engraving, black and white
9 ¼ x 13 ⅝ inches (23.5 x 34.6 cm)
Cat. no. 38.00229.002

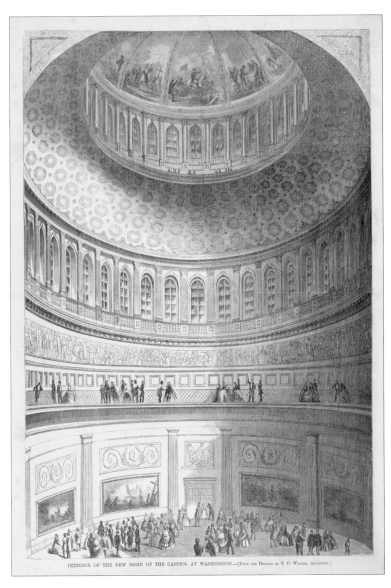

Interior of the New Dome of the Capitol at Washington.

Unidentified after Thomas U. Walter
Harper's Weekly, 03/09/1861
Wood engraving, black and white
20½ x 13¾ inches (52.1 x 34.9 cm)
Cat. no. 38.00033.001

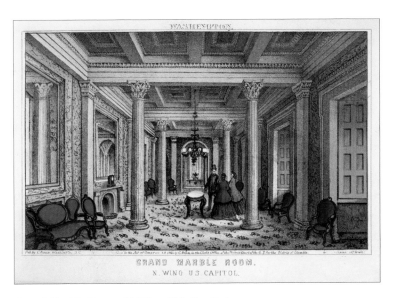

Grand Marble Room. N. Wing U.S. Capitol.

Edward Sachse & Co. after Casimir Bohn
Casimir Bohn, 1865
Lithograph, hand-colored
5 x 7 inches (12.7 x 17.8 cm)
Cat. no. 38.00021.001

Interior of the Dome of the Capitol at Washington.

Unidentified after photograph by Lewis E. Walker
Harper's Weekly, 12/15/1866
Wood engraving, black and white
11 5/16 x 9¼ inches (28.7 x 23.5 cm)
Cat. no. 38.00026.002

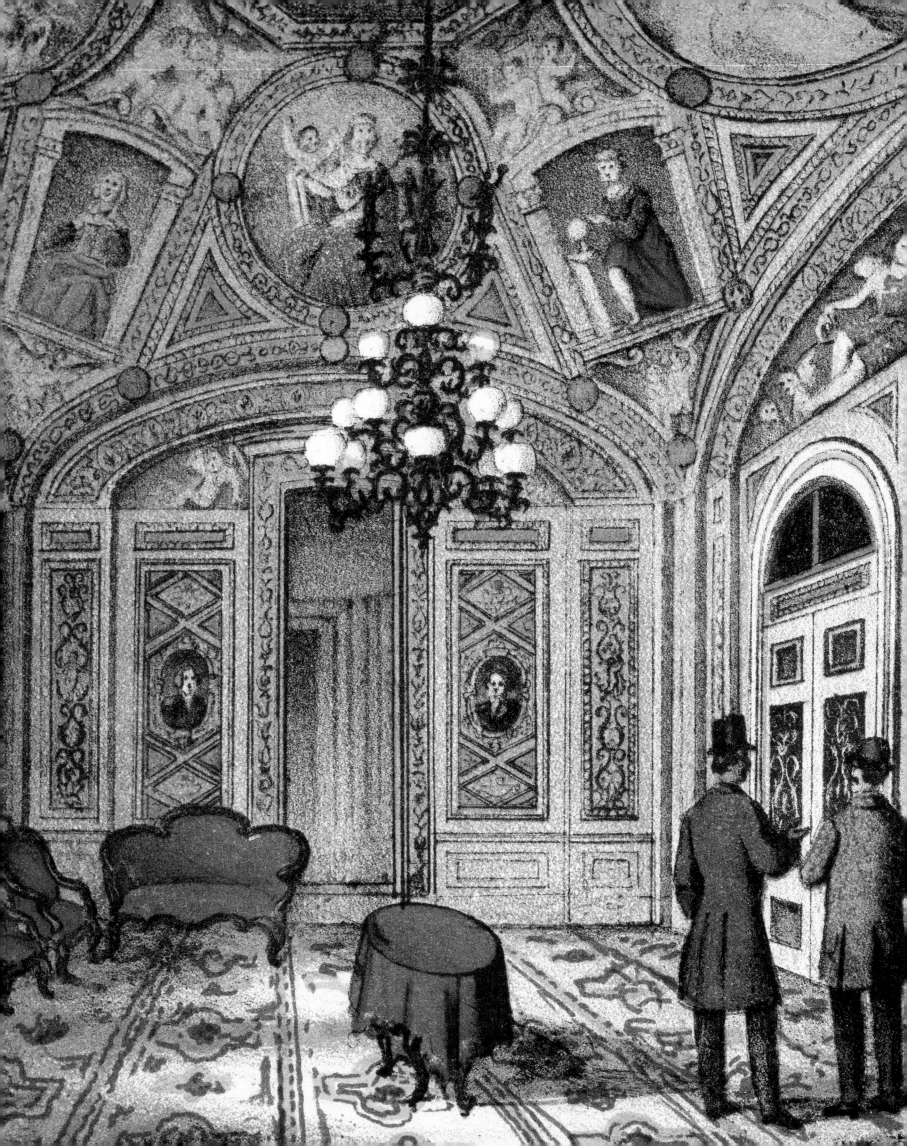

The President's Room, which was built as part of the 1850s extension of the Capitol, is one of the most highly decorated spaces in the building. It was planned to fulfill an important function. Originally, the terms of office for the president and Congress began at the same time—March 4 at noon. Consequently, outgoing presidents often visited the Capitol, and the President's Room, during a session's final hours to sign last-minute legislation hurriedly passed by outgoing Congresses. The 20th Amendment in 1933 eliminated the need for the room by separating the ends of congressional and presidential terms.

The room is decorated with painted wall and ceiling murals completed in 1860 by Italian artist Constantino Brumidi. Portraits of President Washington and his first cabinet adorn the walls, elegantly framed with floral motifs; on the ceiling are allegorical figures personifying the foundations of government, along with historical portraits representing fundamental aspects of the development of the nation. This 1865 engraving of the President's Room appeared in period guidebooks, where the room was described as "one of the gems of the Capitol."[1] ∾

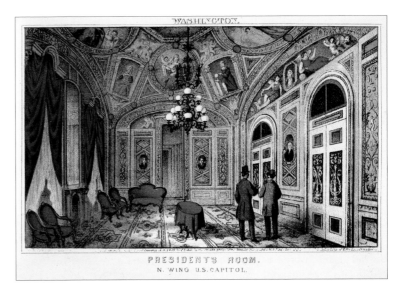

Presidents Room. N. Wing U.S. Capitol.

Edward Sachse & Co. after Casimir Bohn
Casimir Bohn, 1865
Lithograph, hand-colored
4⅞ x 7 1/16 inches (12.4 x 17.9 cm)
Cat. no. 38.00020.001

[1] John B. Ellis, *The Sights and Secrets of the National Capital* (Chicago: Jones, Junkin, 1869), 89.

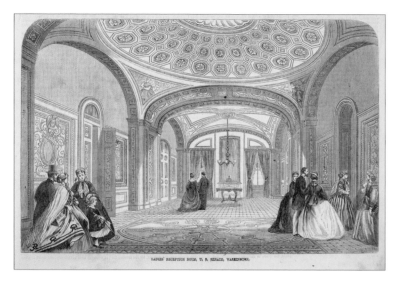

Ladies' Reception Room, U.S. Senate, Washington.

Unidentified
Frank Leslie's Illustrated Newspaper, 03/09/1867
Wood engraving, black and white
6 ¼ x 9 ⅜ inches (15.9 x 23.8 cm)
Cat. no. 38.00424.001

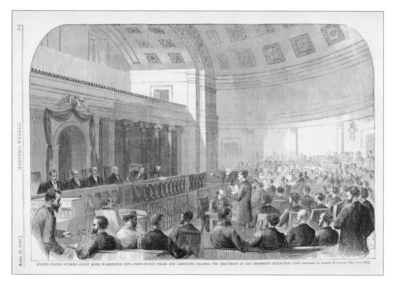

United States Supreme Court Room, Washington City—Chief-Justice Chase and Associates Hearing the Arguments in the Mississippi Injunction Case.

Unidentified after Andrew M'Callum
Harper's Weekly, 04/27/1867
Wood engraving, black and white
9 ½ x 13 ¾ inches (24.1 x 34.9 cm)
Cat. no. 38.00213.002

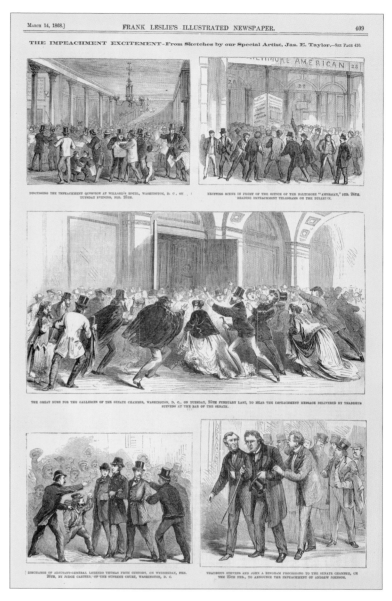

The Impeachment Excitement

Unidentified after James E. Taylor
Frank Leslie's Illustrated Newspaper, 03/14/1868
Wood engraving, black and white
14 ½ x 9 ⅜ inches (36.8 x 23.8 cm)
Cat. no. 38.00155.002

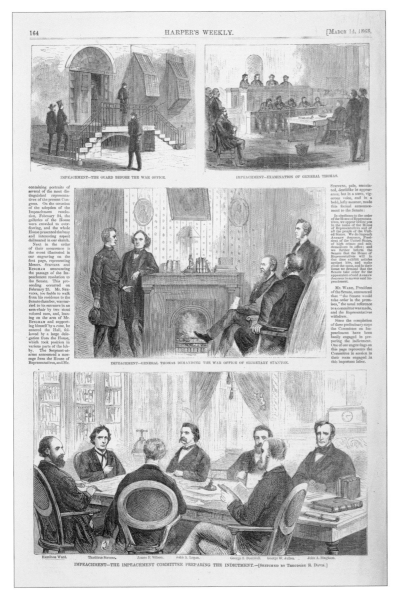

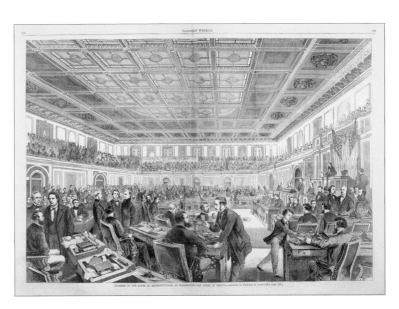

Impeachment—The Impeachment Committee Preparing the Indictment.

Unidentified after Theodore R. Davis
Harper's Weekly, 03/14/1868
Wood engraving, black and white
14 ⅛ x 9 ½ inches (35.9 x 24.1 cm)
Cat. no. 38.00443.001

Interior of the House of Representatives at Washington— The House in Session.

Unidentified after Theodore R. Davis
Harper's Weekly, 03/14/1868
Wood engraving, black and white
13 ⅞ x 4 ½ inches (35.2 x 11.4 cm)
Cat. no. 38.00444.001

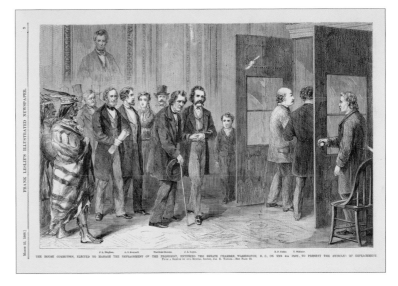

The House Committee, Elected to Manage the Impeachment of the President, Entering the Senate Chamber, Washington, D.C., on the 4th Inst., to Present the Articles of Impeachment.

Unidentified after James E. Taylor
Frank Leslie's Illustrated Newspaper, 03/21/1868
Wood engraving, black and white
9 ½ x 13 ¾ inches (24.1 x 34.9 cm)
Cat. no. 38.00154.002

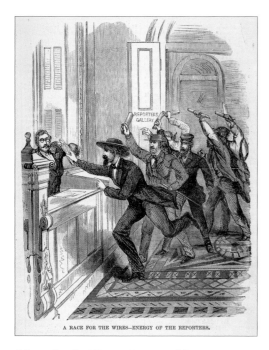

A Race for the Wires—Energy of the Reporters.

Unidentified after Theodore R. Davis
Harper's Weekly, 03/21/1868
Wood engraving, black and white
6⅛ x 4½ inches (15.6 x 11.4 cm)
Cat. no. 38.00446.001

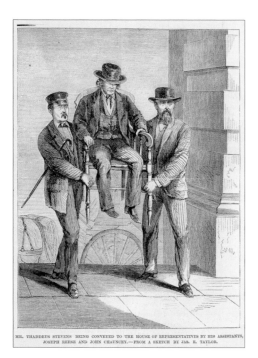

Mr. Thaddeus Stevens Being Conveyed to the House of Representatives by His Assistants, Joseph Reese and John Chauncey.

Unidentified after James E. Taylor
Frank Leslie's Illustrated Newspaper, 03/28/1868
Wood engraving, black and white
6 x 4⁹⁄₁₆ inches (15.2 x 11.6 cm)
Cat. no. 38.00527.001b

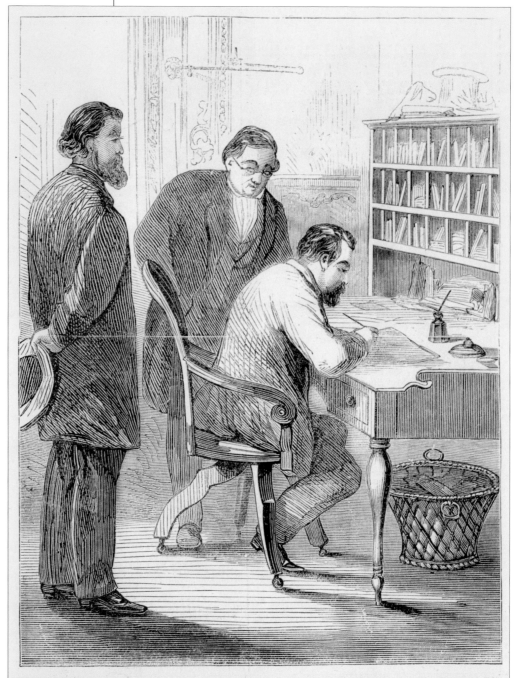

Office of the Secretary of the Senate, Washington, DC. [sic]—Preparing the Summons for President Johnson to Appear before the Court of Impeachment.

Unidentified after James E. Taylor
Frank Leslie's Illustrated Newspaper, 03/28/1868
Wood engraving, black and white
6 x 4⅝ inches (15.2 x 11.7 cm)
Cat. no. 38.00527.001a

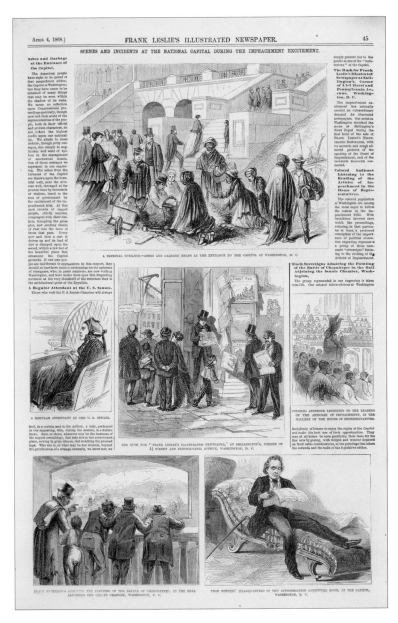

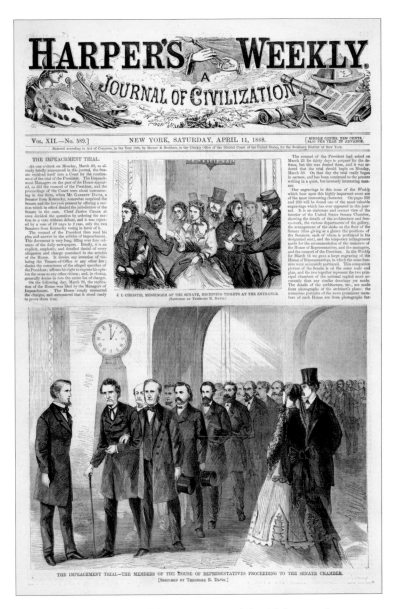

Scenes and Incidents at the National Capital during the Impeachment Excitement.

Unidentified
Frank Leslie's Illustrated Newspaper, 04/04/1868
Wood engraving, black and white
14 ¾ x 9 ½ inches (37.5 x 24.1 cm)
Cat. no. 38.00422.001

J. I. Christie, Messenger of the Senate, Receiving Tickets at the Entrance. / The Impeachment Trial—The Members of the House of Representatives Proceeding to the Senate Chamber.

Unidentified after Theodore R. Davis
Harper's Weekly, 04/11/1868
Wood engraving, black and white
11 ⅛ x 9 ¼ inches (28.3 x 23.5 cm)
Cat. no. 38.00230.002

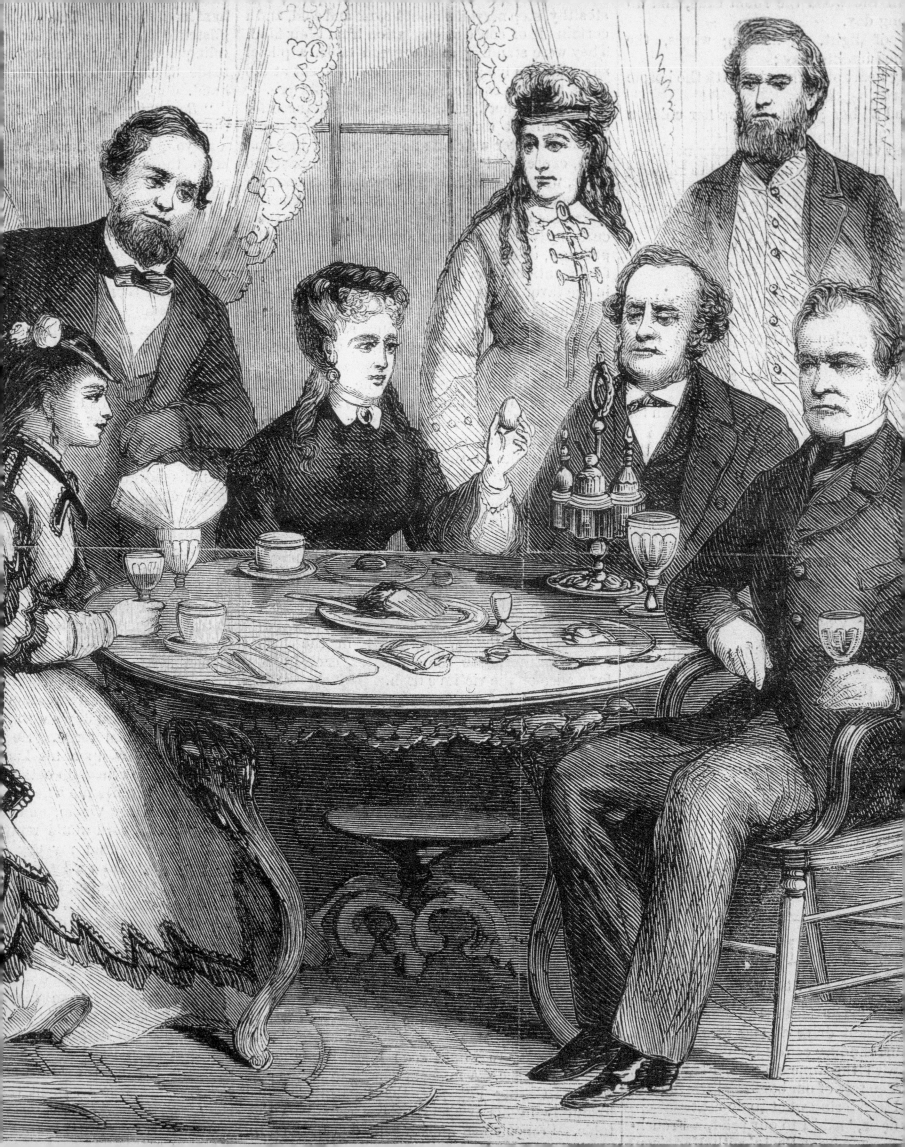

The first restaurant in the Capitol, known as the "Hole in the Wall," was provided for the exclusive use of the members of Congress. In this tiny, circular room, measuring only 10 feet in diameter, Senators Webster, Clay, and Calhoun, as well as others, continued their debates over "ham and bread and . . . simple eatables."[1] Oysters—raw, fried, steamed, or baked—were a speciality. By the late 1850s, when the current Senate and House wings were occupied, senators could dine at several restaurants in the Capitol, in various committee rooms, "where they kept such refreshments as they desired," and at counters provided for them near the Senate Chamber.[2] In the 1860s, Downing's Restaurant, located on the first floor and occupying two rooms, served the members, their guests, and visitors. Managed by George T. Downing, the restaurant prepared dishes "in a style which would not shame Delmonico himself."[3] This engraving appeared during the Andrew Johnson impeachment trial, to add a human-interest story to the proceedings. The publication noted that "the grave and reverend Senators are not so much engrossed with their Impeachment responsibilities as to neglect the material comforts of the inner man."[4]

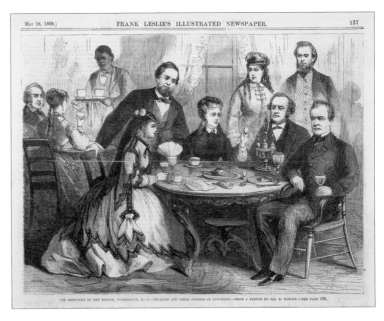

The Refectory of the Senate, Washington, D.C.—Senators and Their Friends at Luncheon.

Unidentified after James E. Taylor
Frank Leslie's Illustrated Newspaper, 05/16/1868
Wood engraving, black and white
7 1/8 x 9 3/8 inches (18.1 x 23.8 cm)
Cat. no. 38.00725.001

[1] Papers of Isaac Bassett, Office of the Curator, U.S. Senate, 20 F 158.

[2] Ibid.

[3] John B. Ellis, *The Sights and Secrets of the National Capital* (Chicago: Jones, Junkin, 1869), 112.

[4] "The Refectory of the Senate, Washington, D.C.—Senators and Their Friends at Luncheon," *Frank Leslie's Illustrated Newspaper*, 16 May 1868, 139.

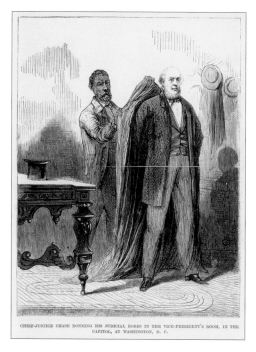

CHIEF-JUSTICE CHASE DONNING HIS JUDICIAL ROBES IN THE VICE-PRESIDENT'S ROOM, IN THE CAPITOL, AT WASHINGTON, D. C.

Chief-Justice Chase Donning His Judicial Robes in the Vice-President's Room, in the Capitol, at Washington, D.C.

Unidentified after James E. Taylor
Frank Leslie's Illustrated Newspaper, 04/18/1868
Wood engraving, black and white
6 ¼ x 4 ½ inches (15.9 x 11.4 cm)
Cat. no. 38.00429.001a

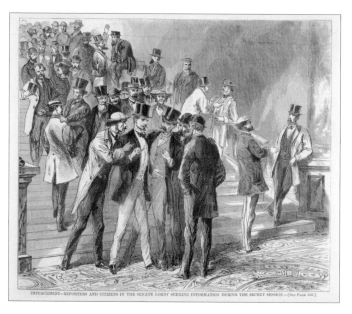

IMPEACHMENT—REPORTERS AND CITIZENS IN THE SENATE LOBBY SEEKING INFORMATION DURING THE SECRET SESSION.—[SEE PAGE 338.]

Impeachment—Reporters and Citizens in the Senate Lobby Seeking Information during the Secret Session.

Unidentified after Theodore R. Davis
Harper's Weekly, 05/30/1868
Wood engraving, black and white
7 ¹⁵⁄₁₆ x 9 ⅛ inches (20.2 x 23.2 cm)
Cat. no. 38.00426.001b

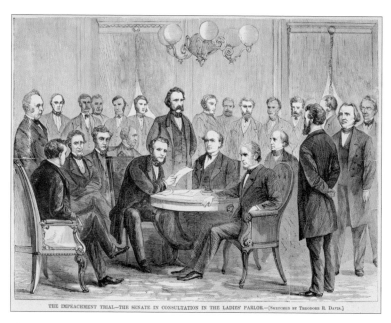

THE IMPEACHMENT TRIAL—THE SENATE IN CONSULTATION IN THE LADIES' PARLOR.—[SKETCHED BY THEODORE R. DAVIS.]

The Impeachment Trial—The Senate in Consultation in the Ladies' Parlor.

Unidentified after Theodore R. Davis
Harper's Weekly, 04/18/1868
Wood engraving, black and white
7 ⅛ x 9 ⅛ inches (18.1 x 23.2 cm)
Cat. no. 38.00309.001b

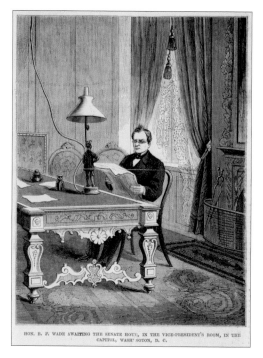

HON. B. F. WADE AWAITING THE SENATE HOUR, IN THE VICE-PRESIDENT'S ROOM, IN THE CAPITOL, WASH'GTON, D. C.

Hon. B. F. Wade Awaiting the Senate Hour, in the Vice-President's Room, in the Capitol, Washington, D.C.

Unidentified after James E. Taylor
Frank Leslie's Illustrated Newspaper, 04/18/1868
Wood engraving, black and white
6 ¼ x 4 ½ inches (15.9 x 11.4 cm)
Cat. no. 38.00429.001b

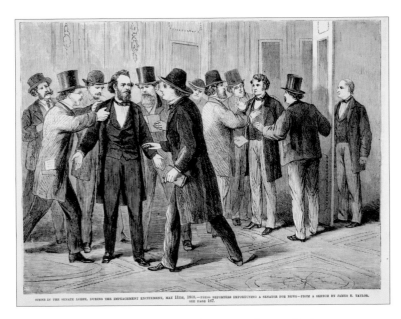

Scene in the Senate Lobby, during the Impeachment Excitement, May 11th, 1868.—Press Reporters Importuning a Senator for News

Unidentified after James E. Taylor
Frank Leslie's Illustrated Newspaper, 05/30/1868
Wood engraving, black and white
7 ¼ x 9 ⁷⁄₁₆ inches (18.4 x 24.0 cm)
Cat. no. 38.00374.001b

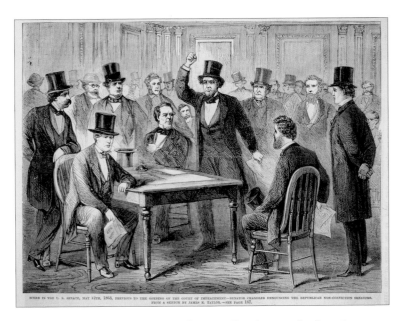

Scene in the U.S. Senate, May 12th, 1868, Previous to the Opening of the Court of Impeachment—Senator Chandler Denouncing the Republican Non-Conviction Senators.

Unidentified after James E. Taylor
Frank Leslie's Illustrated Newspaper, 05/30/1868
Wood engraving, black and white
7 ¼ x 9 ⅜ inches (18.4 x 23.8 cm)
Cat. no. 38.00374.001a

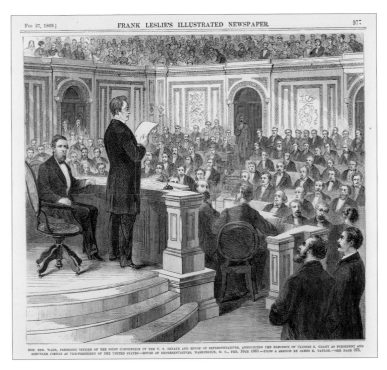

Hon. Ben. Wade, Presiding Officer of the Joint Convention of the U.S. Senate and House of Representatives, Announcing the Election of Ulysses S. Grant as President and Schuyler Colfax as Vice-President of the United States—House of Representatives, Washington, D.C., Feb. 10th 1869.

Unidentified after James E. Taylor
Frank Leslie's Illustrated Newspaper, 02/27/1869
Wood engraving, hand-colored
8 ¼ x 9 ¼ inches (21.0 x 23.5 cm)
Cat. no. 38.00331.002

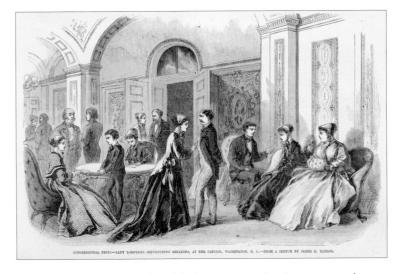

Congressional Pests—Lady Lobbyists Importuning Senators, at the Capitol, Washington, D.C.

Unidentified after James E. Taylor
Frank Leslie's Illustrated Newspaper, 03/06/1869
Wood engraving, black and white
6 ⅛ x 9 ½ inches (15.6 x 24.1 cm)
Cat. no. 38.00289.001

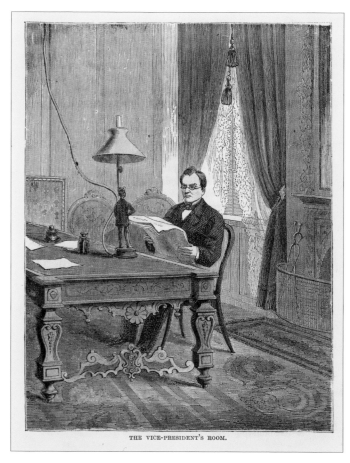

THE VICE-PRESIDENT'S ROOM.

The Vice-President's Room.

Unidentified [after James E. Taylor]
Jones, Junkin & Co., ca. 1869
Wood engraving, hand-colored
6 ⅛ x 4 ⁹⁄₁₆ inches (15.6 x 11.6 cm)
Cat. no. 38.00103.001

[Vice President's Room, U.S. Capitol]

Unidentified
Unidentified, ca. 1870
Photograph, black and white
3 ¾ x 6 ⅜ inches (9.5 x 16.2 cm)
Cat. no. 38.00193.001

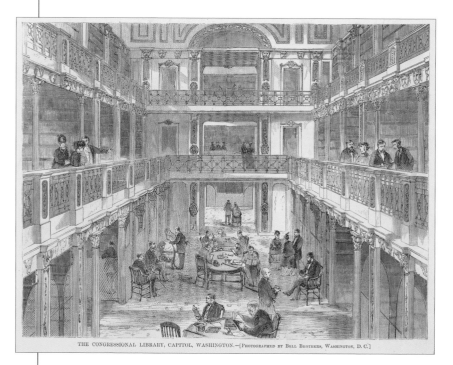

THE CONGRESSIONAL LIBRARY, CAPITOL, WASHINGTON.—[PHOTOGRAPHED BY BELL BROTHERS, WASHINGTON, D. C.]

The Congressional Library, Capitol, Washington.

Unidentified after photograph by Bell and Brothers
Harper's Weekly, 01/21/1871
Wood engraving, hand-colored
7 ⅛ x 9 ⅛ inches (18.1 x 23.2 cm)
Cat. no. 38.00541.001

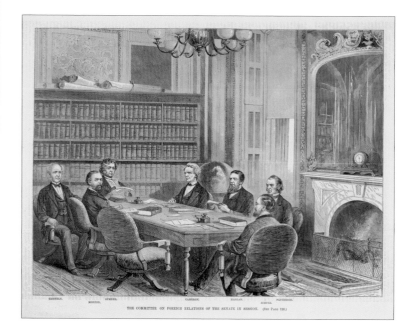

THE COMMITTEE ON FOREIGN RELATIONS OF THE SENATE IN SESSION. (See Page 126.)

The Committee on Foreign Relations of the Senate in Session.

Unidentified
Every Saturday, 02/11/1871
Wood engraving, black and white
9 ¼ x 11 ¾ inches (23.5 x 29.8 cm)
Cat. no. 38.00216.001

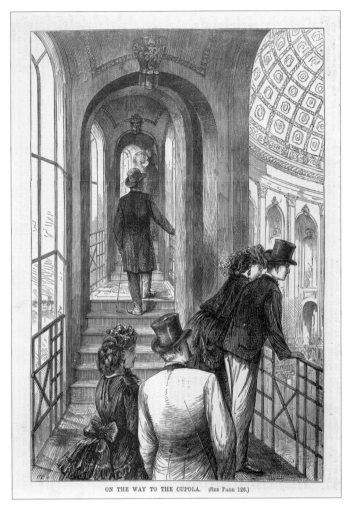

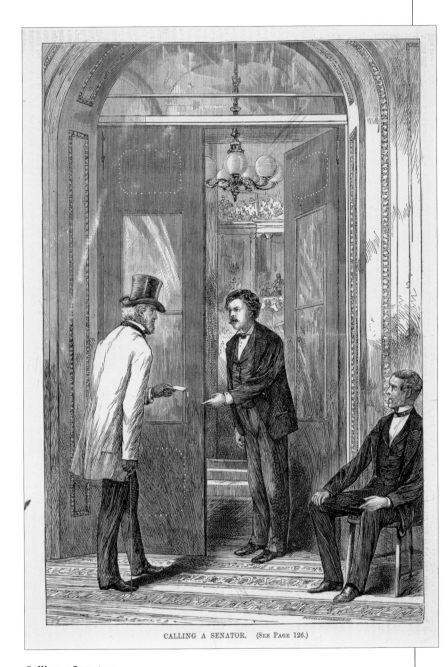

Calling a Senator.

Russell C. Richardson after H.
Every Saturday, 02/11/1871
Wood engraving, black and white
9 x 5 ¹⁵⁄₁₆ inches (22.9 x 15.1 cm)
Cat. no. 38.00266.002a

On the Way to the Cupola.

John Andrew and Son after H.
Every Saturday, 02/11/1871
Wood engraving, black and white
8 ¹⁵⁄₁₆ x 5 ¹³⁄₁₆ inches (22.7 x 14.8 cm)
Cat. no. 38.00266.002b

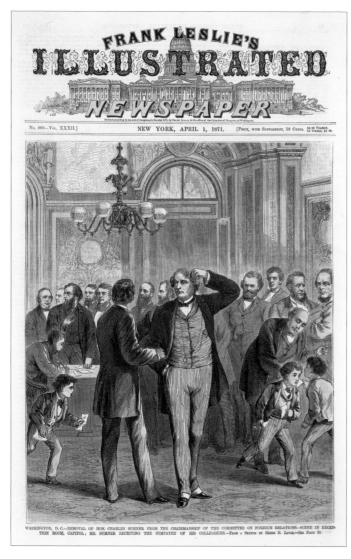

Washington, D.C.—Removal of Hon. Charles Sumner from the Chairmanship of the Committee on Foreign Relations—Scene in Reception Room, Capitol; Mr. Sumner Receiving the Sympathy of His Colleagues.

Unidentified after Henri H. Lovie
Frank Leslie's Illustrated Newspaper, 04/01/1871
Wood engraving, hand-colored
11 ½ x 9 ¼ inches (29.2 x 23.5 cm)
Cat. no. 38.00968.001

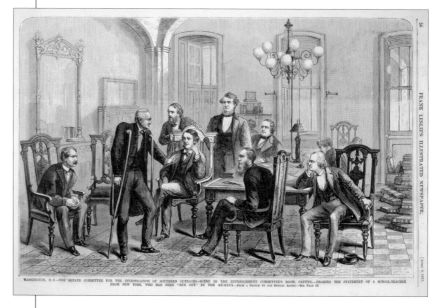

Washington, D.C.—The Senate Committee for the Investigation of Southern Outrages—Scene in the Retrenchment Committee's Room, Capitol.—Hearing the Statement of a School-Teacher from New York, Who Had Been "Run Out" by the Ku-Klux.

Unidentified
Frank Leslie's Illustrated Newspaper, 04/08/1871
Wood engraving, black and white
9 ½ x 14 ⁵⁄₁₆ inches (24.1 x 36.4 cm)
Cat. no. 38.00382.001

[U.S. Capitol Interiors]

Unidentified
Unidentified, ca. 1871
Engraving, black and white
8 ¼ x 5 ⅜ inches (21.0 x 13.7 cm)
Cat. no. 38.00834.001

"I Am Completely Floored!" [—Chief Justice John Marshall]

Unidentified after Charles S. Reinhart
Harper's New Monthly Magazine, 12/1872
Wood engraving, black and white
3 ¹⁄₁₆ x 4 ½ inches (7.8 x 11.4 cm)
Cat. no. 38.00017.001

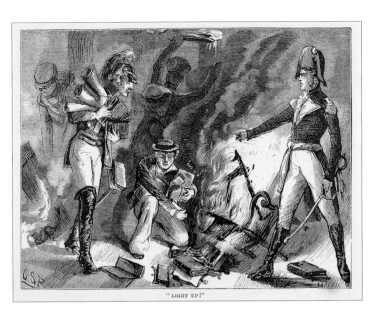

"Light Up!" [The British Burn the U.S. Capitol]

Unidentified after Charles S. Reinhart
Harper's New Monthly Magazine, 12/1872
Wood engraving, black and white
3 ⅝ x 4 ½ inches (9.2 x 11.4 cm)
Cat. no. 38.00028.001

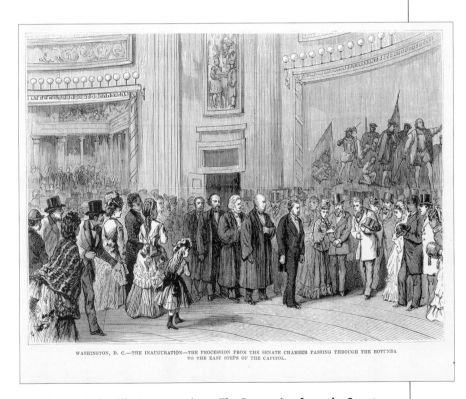

Washington D.C.—The Inauguration—The Procession from the Senate Chamber Passing through the Rotunda to the East Steps of the Capitol.

Unidentified
Frank Leslie's Illustrated Newspaper, 03/15/1873
Wood engraving, black and white
5 ¼ x 6 ⅞ inches (13.3 x 17.5 cm)
Cat. no. 38.00979.001

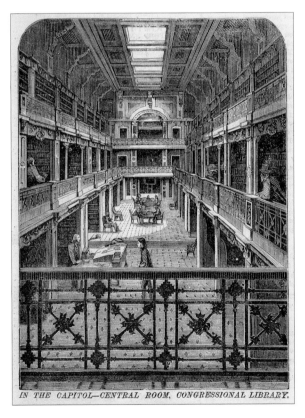

In the Capitol—Central Room, Congressional Library.

Unidentified
Hearth and Home, 09/13/1873
Wood engraving, black and white
4 ⁹⁄₁₆ x 3 ⁵⁄₁₆ inches (11.6 x 8.4 cm)
Cat. no. 38.00649.001b

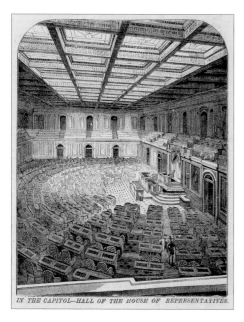

In the Capitol—Hall of the House of Representatives.

Unidentified after Henri H. Lovie
Hearth and Home, 09/13/1873
Wood engraving, black and white
4 ½ x 3 ⅜ inches (11.4 x 8.6 cm)
Cat. no. 38.00975.001c

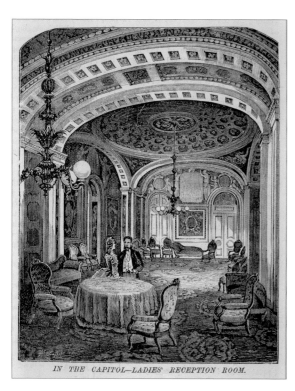

In the Capitol—Ladies' Reception Room.

Unidentified after Henri H. Lovie
Hearth and Home, 09/13/1873
Wood engraving, black and white
4 ½ x 3 ⁷⁄₁₆ inches (11.4 x 8.7 cm)
Cat. no. 38.00975.001b

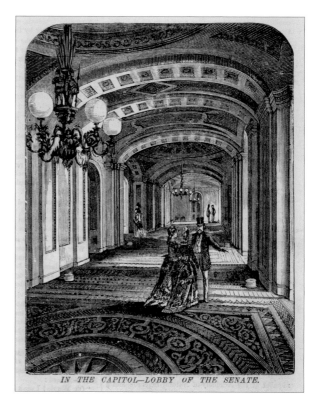

In the Capitol—Lobby of the Senate.

Unidentified
Hearth and Home, 09/13/1873
Wood engraving, black and white
4 ⁹⁄₁₆ x 3 ⁵⁄₁₆ inches (11.6 x 8.4 cm)
Cat. no. 38.00649.001c

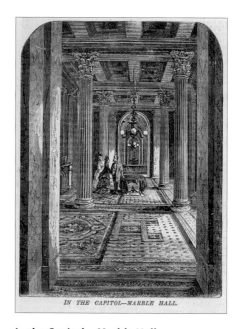

In the Capitol—Marble Hall.

Unidentified after Henri H. Lovie
Hearth and Home, 09/13/1873
Wood engraving, black and white
4 ⁹⁄₁₆ x 3 ⁵⁄₁₆ inches (11.6 x 8.4 cm)
Cat. no. 38.00649.001a

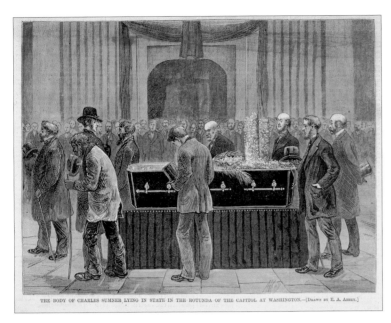

The Body of Charles Sumner Lying in State in the Rotunda of the Capitol at Washington.

Unidentified after Edwin A. Abbey
Harper's Weekly, 04/04/1874
Wood engraving, black and white
7 x 9½ inches (17.8 x 24.1 cm)
Cat. no. 38.00225.001b

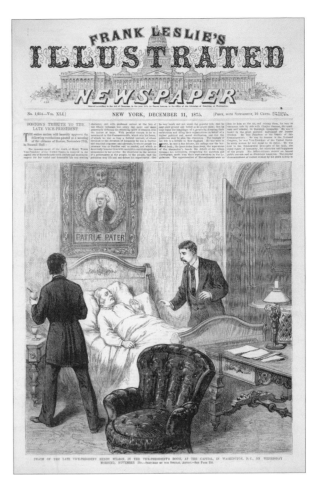

Death of the Late Vice-President Henry Wilson, in the Vice-President's Room, at the Capitol, in Washington, D.C., on Wednesday Morning, November 22d.

Unidentified
Frank Leslie's Illustrated Newspaper, 12/11/1875
Wood engraving, black and white
10¼ x 9¼ inches (26.0 x 23.5 cm)
Cat. no. 38.00411.001

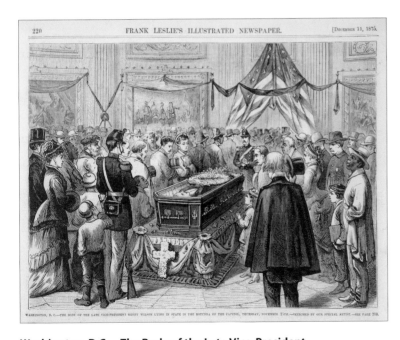

Washington, D.C.—The Body of the Late Vice-President Henry Wilson Lying in State in the Rotunda of the Capitol, Thursday, November 25th.

Unidentified
Frank Leslie's Illustrated Newspaper, 12/11/1875
Wood engraving, black and white
7 x 9⅜ inches (17.8 x 23.8 cm)
Cat. no. 38.00288.002a

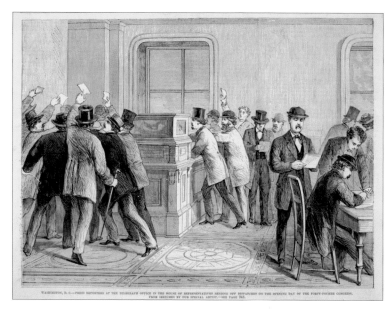

Washington, D.C.—Press Reporters at the Telegraph Office in the House of Representatives Sending Off Dispatches on the Opening Day of the Forty-Fourth Congress.

Unidentified
Frank Leslie's Illustrated Newspaper, 12/18/1875
Wood engraving, black and white
7 ¼ x 9 ¼ inches (18.4 x 23.5 cm)
Cat. no. 38.00409.001

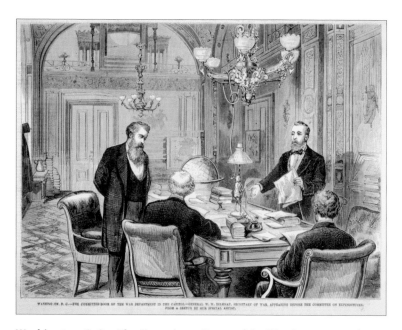

Washington, D.C.—The Committee-Room of the War Department in the Capitol—General W. W. Belknap, Secretary of War, Appearing before the Committee on Expenditures.

Unidentified
Frank Leslie's Illustrated Newspaper, 03/18/1876
Wood engraving, black and white
6 ⅞ x 9 ¼ inches (17.5 x 23.5 cm)
Cat. no. 38.00405.001

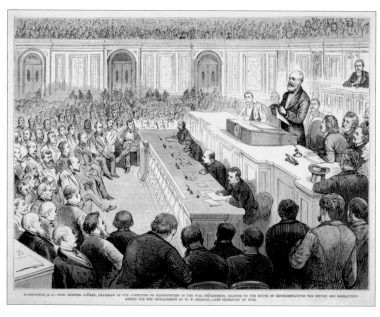

Washington, D.C.—Hon. Hiester Clymer, Chairman of the Committee on Expenditures in the War Department, Reading to the House of Representatives the Report and Resolutions Asking for the Impeachment of W. W. Belknap, Late Secretary of War.

Unidentified
Frank Leslie's Illustrated Newspaper, 03/18/1876
Wood engraving, black and white
7 ³⁄₁₆ x 9 ¼ inches (18.3 x 23.5 cm)
Cat. no. 38.00403.001a

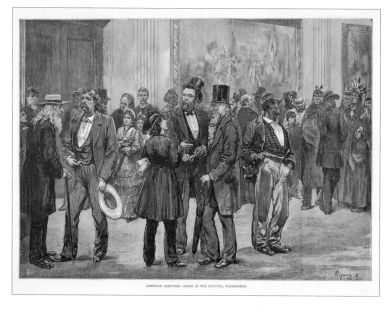

American Sketches: Scene in the Rotunda, Washington.

J. B. after Felix Elie Regamey
The Illustrated London News, 04/15/1876
Wood engraving, hand-colored
8 ¾ x 11 ¾ inches (22.2 x 29.8 cm)
Cat. no. 38.00238.002

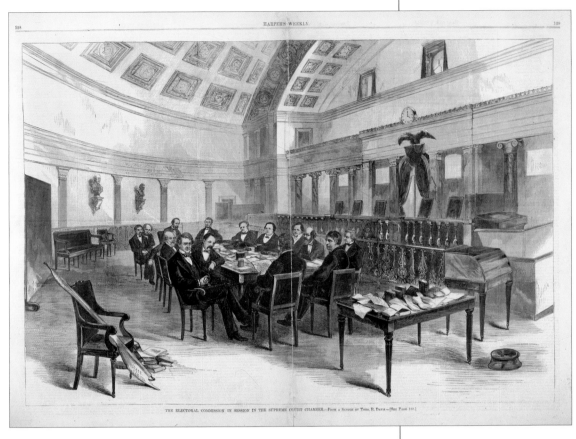

The Electoral Commission in Session in the Supreme Court Chamber.

Unidentified after Theodore R. Davis
Harper's Weekly, 02/17/1877
Wood engraving, hand-colored
13 ¾ x 20 ¼ inches (34.9 x 51.4 cm)
Cat. no. 38.00271.002

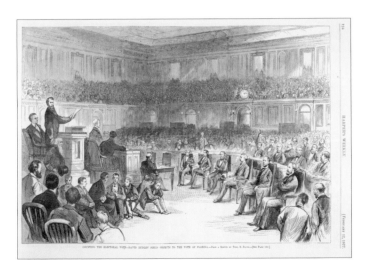

Counting the Electoral Vote—David Dudley Field Objects to the Vote of Florida.

Unidentified after Theodore R. Davis
Harper's Weekly, 02/17/1877
Wood engraving, black and white
9 5⁄16 x 13 ½ inches (23.7 x 34.3 cm)
Cat. no. 38.00435.001

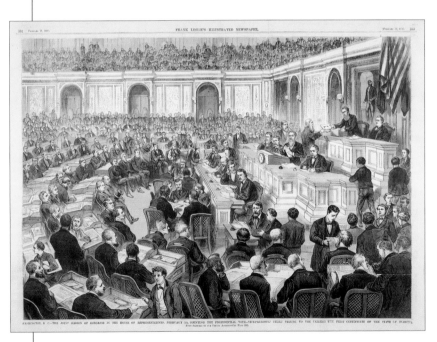

Washington, D.C.—The Joint Session of Congress in the House of Representatives, February 1st, Counting the Presidential Vote— Vice-President Ferry Passing to the Tellers the First Certificate of the State of Florida.

Unidentified
Frank Leslie's Illustrated Newspaper, 02/17/1877
Wood engraving, black and white
14 ⅛ x 20 inches (35.9 x 50.8 cm)
Cat. no. 38.00412.001

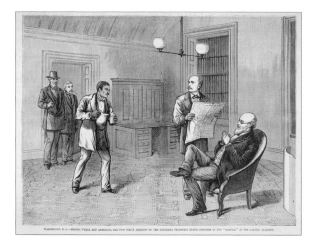

Washington, D.C.—Messrs. Wells and Anderson, the Two White Members of the Louisiana Returning Board, Confined in the "Bastile" in the Capitol Building.

Unidentified
Frank Leslie's Illustrated Newspaper, 02/17/1877
Wood engraving, black and white
7 ⅛ x 9 ¼ inches (18.1 x 23.5 cm)
Cat. no. 38.00396.001b

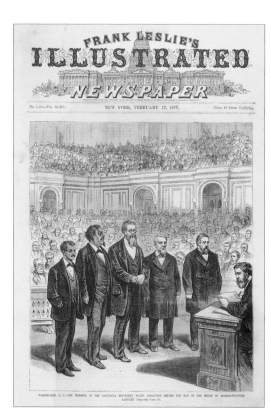

Washington, D.C.—The Members of the Louisiana Returning Board Arraigned before the Bar of the House of Representatives, January 27th.

Unidentified
Frank Leslie's Illustrated Newspaper, 02/17/1877
Wood engraving, black and white
11 ¹⁄₁₆ x 9 ⅛ inches (28.1 x 23.2 cm)
Cat. no. 38.00557.001

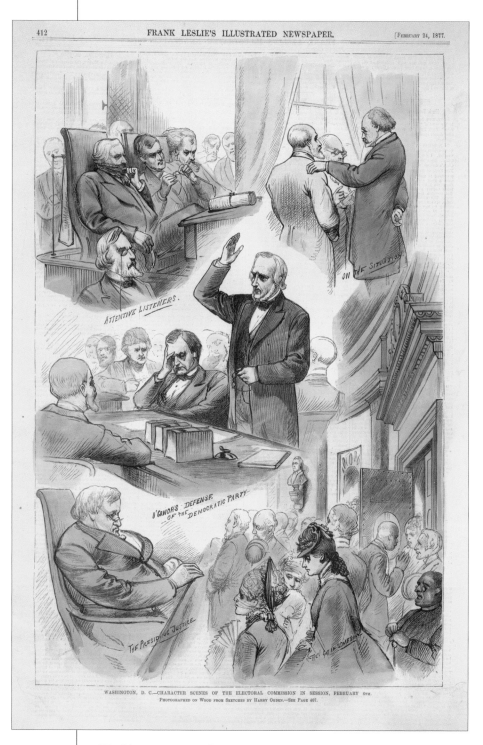

Washington, D.C.—Character Scenes of the Electoral Commission in Session, February 6th

Unidentified after Harry Ogden
Frank Leslie's Illustrated Newspaper, 02/24/1877
Wood engraving, hand-colored
14 x 9 ⅛ inches (35.6 x 23.2 cm)
Cat. no. 38.00876.002

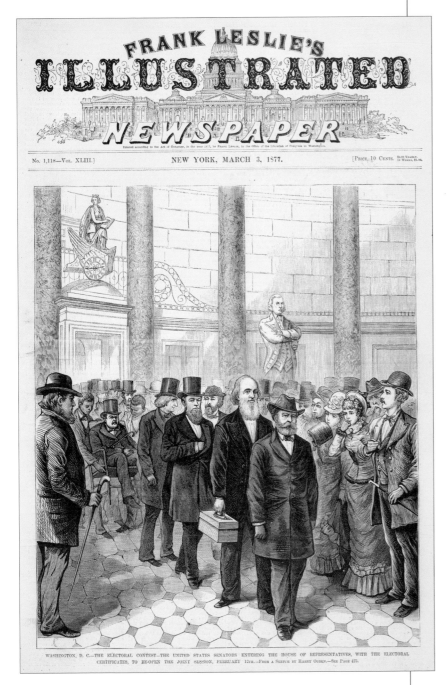

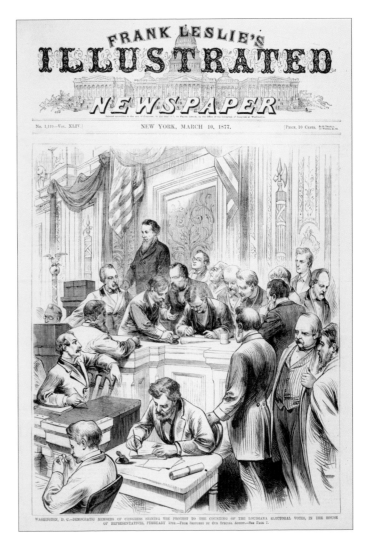

Washington, D.C.—The Electoral Contest—The United States Senators Entering the House of Representatives, with the Electoral Certificates, to Re-Open the Joint Session, February 12th.

Unidentified after Harry Ogden
Frank Leslie's Illustrated Newspaper, 03/03/1877
Wood engraving, black and white
11 x 9 1/16 inches (27.9 x 23.0 cm)
Cat. no. 38.00245.002

Washington, D.C.—Democratic Members of Congress Signing the Protest to the Counting of the Louisiana Electoral Votes, in the House of Representatives, February 19th.

Unidentified
Frank Leslie's Illustrated Newspaper, 03/10/1877
Wood engraving, black and white
11 1/4 x 9 3/8 inches (28.6 x 23.8 cm)
Cat. no. 38.00399.001

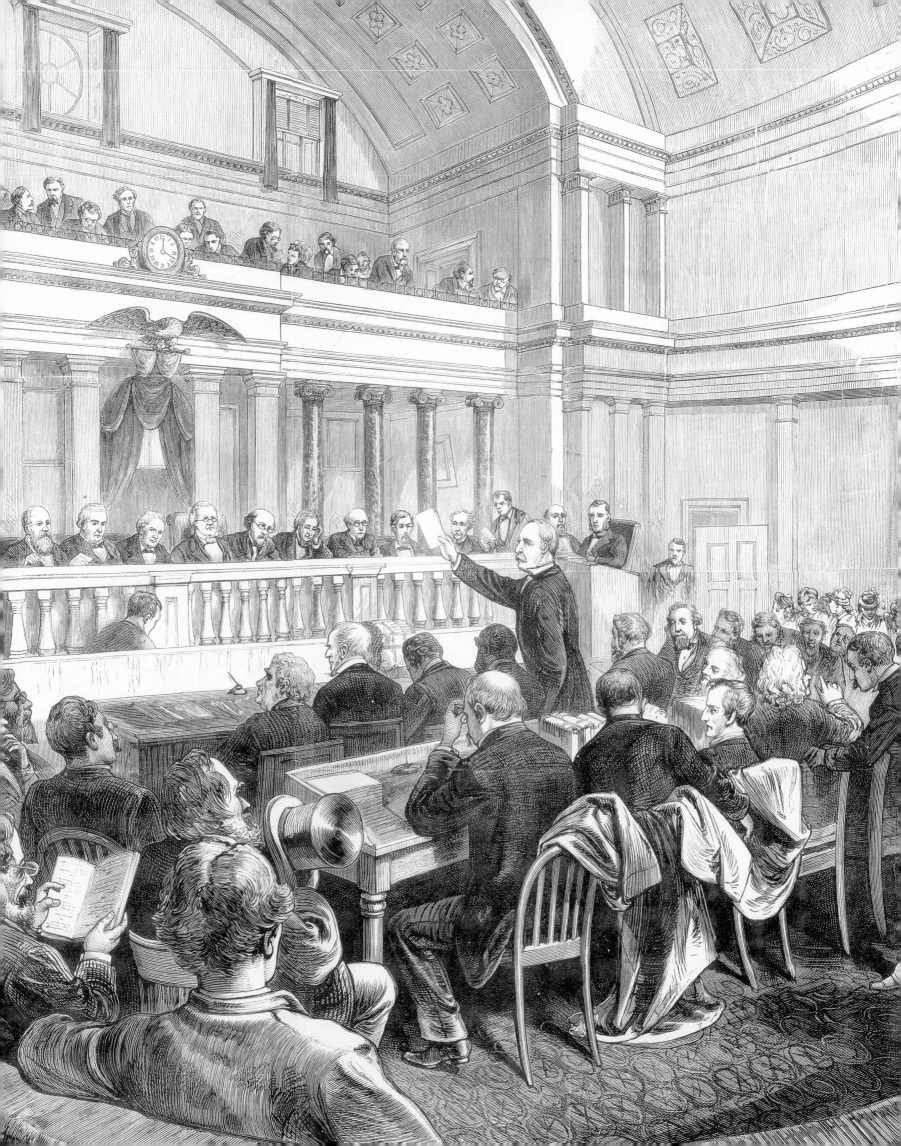

The country faced a major electoral challenge with the disputed Hayes-Tilden presidential election of 1876. While Democratic candidate Samuel J. Tilden won the popular vote by a margin of 250,000, the Electoral College ballots of four states were called into question. To resolve the dispute, Congress created a special electoral commission to review the ballots and determine the outcome of the election. The 15-member commission held its first public hearing on February 1, 1877, in the Capitol's Old Senate Chamber (then serving as the Supreme Court's meeting place). Throughout the month-long hearings, the room was packed with spectators expecting high drama and great oratory. The press followed the proceedings closely, providing up-to-the-minute coverage for the anxious nation. *Frank Leslie's Illustrated Newspaper* and *Harper's Weekly* both covered the event in depth and included numerous engravings in their publications, such as the one shown here. According to the findings of the commission, Rutherford B. Hayes received all of the disputed electoral votes, and Congress declared him the victor on March 2, 1877, just two days before his term began. ☻

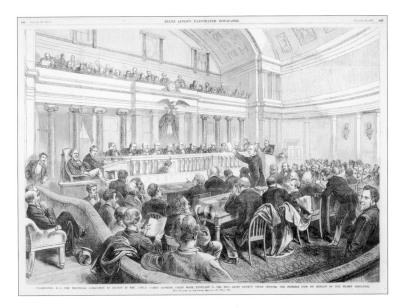

Washington. D.C.—The Electoral Commission in Session in the United States Supreme Court Room, February 2d—The Hon. David Dudley Field Opening the Florida Case on Behalf of the Tilden Objectors.

Unidentified
Frank Leslie's Illustrated Newspaper, 02/24/1877
Wood engraving, black and white
14 ½ x 20 ⅛ inches (36.8 x 51.1 cm)
Cat. no. 38.00022.002

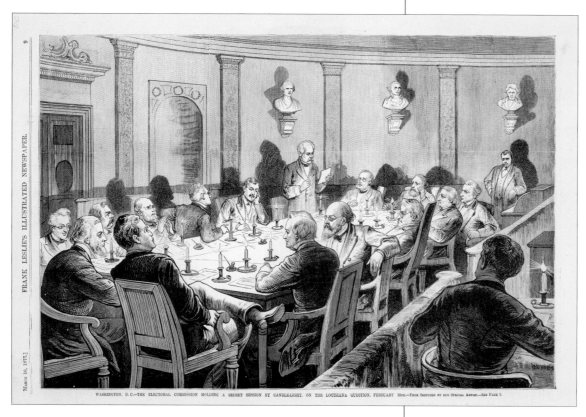

Washington, D.C.—The Electoral Commission Holding a Secret Session by Candlelight, on the Louisiana Question, February 16th.

Unidentified
Frank Leslie's Illustrated Newspaper, 03/10/1877
Wood engraving, black and white
9 ½ x 14 inches (24.1 x 35.6 cm)
Cat. no. 38.00880.001

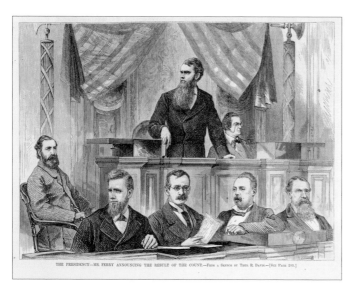

The Presidency—Mr. Ferry Announcing the Result of the Count.

Unidentified after Theodore R. Davis
Harper's Weekly, 03/17/1877
Wood engraving, hand-colored
6 ¾ x 9 inches (17.1 x 22.9 cm)
Cat. no. 38.00542.001

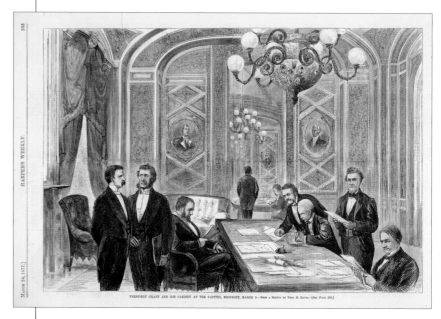

President Grant and His Cabinet at the Capitol, Midnight, March 3.

Unidentified after Theodore R. Davis
Harper's Weekly, 03/24/1877
Wood engraving, hand-colored
9 ¼ x 13 ⁵⁄₁₆ inches (23.5 x 33.8 cm)
Cat. no. 38.00082.001

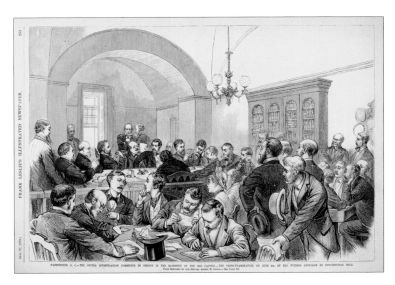

Washington, D.C.—The Potter Investigation Committee in Session in the Basement of the Old Capitol—The Cross-Examination, on June 4th, of the Witness Anderson by Congressman Reed.

Unidentified after Harry Ogden
Frank Leslie's Illustrated Newspaper, 06/22/1878
Wood engraving, black and white
9 ½ x 14 ⅜ inches (24.1 x 36.5 cm)
Cat. no. 38.00268.002

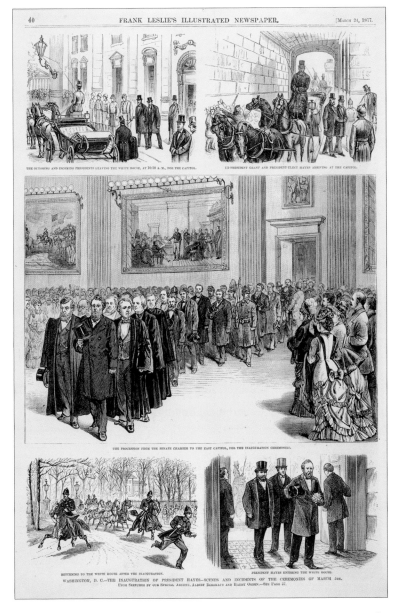

Washington, D.C.—The Inauguration of President Hayes—Scenes and Incidents of the Ceremonies of March 5th.

Unidentified after Albert Berghaus and Harry Ogden
Frank Leslie's Illustrated Newspaper, 03/24/1877
Wood engraving, black and white
14 ½ x 9 ⅜ inches (36.8 x 23.8 cm)
Cat. no. 38.00401.002

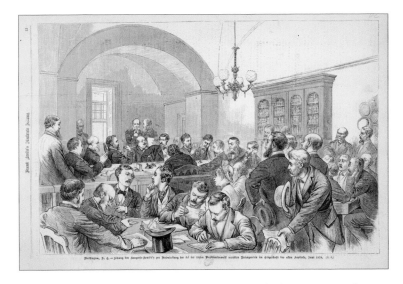

Washington, D.C.—Sitzung des Krongress-Komite's zur untersuchung der bei der letzen Präsidentenwahl verübten Betrügereien im Erdgesschosse des alten Kapitols, Juni 1878.

Unidentified [after Harry Ogden]
Frank Leslie's Illustrirte Zeitung, 07/01/1878
Wood engraving, black and white
9 ½ x 14 ¼ inches (24.1 x 36.2 cm)
Cat. no. 38.00585.001

Scenes in the National Capitol.

Unidentified after C. A. Northam
Harper's Weekly, 07/26/1879
Wood engraving, black and white
16 x 11 ¼ inches (40.6 x 28.6 cm)
Cat. no. 38.00105.001

[U.S. Capitol and Other Government Building Interiors]

Unidentified
Unidentified, ca. 1880
Lithograph, black and white
8 x 10 ¾ inches (20.3 x 27.3 cm)
Cat. no. 38.00694.001

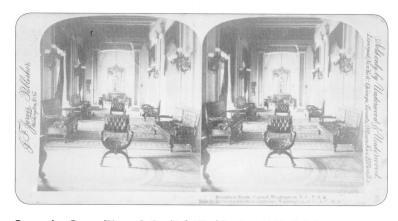

Reception Room [House], Capitol, Washington, D.C., U.S.A.

Unidentified after Underwood & Underwood
John F. Jarvis, ca. 1880
Photograph, black and white
3 ⅜ x 6 inches (8.6 x 15.2 cm)
Cat. no. 38.00704.001

A Pictorial History of the Geneva Award.

Unidentified
The Daily Graphic, 05/14/1880
Wood engraving, black and white
14 ¾ x 12 ¼ inches (37.5 x 31.1 cm)
Cat. no. 38.00691.001

Washington, D.C.—Character Sketches at the National Capital during the Session of Congress.

Unidentified after Joseph Becker
Frank Leslie's Illustrated Newspaper, 02/26/1881
Wood engraving, black and white
14 ⅝ x 9 ⅜ inches (37.1 x 23.8 cm)
Cat. no. 38.00844.001

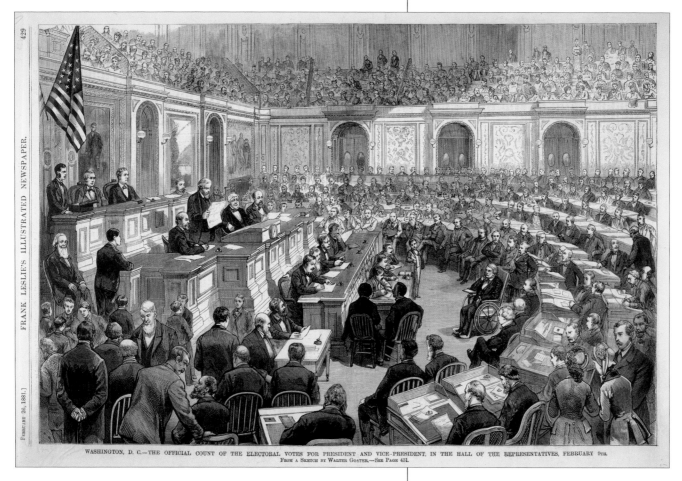

Washington, D.C.—The Official Count of the Electoral Votes for President and Vice-President, in the Hall of the Representatives, February 9th.

Unidentified after Walter Goater
Frank Leslie's Illustrated Newspaper, 02/26/1881
Wood engraving, black and white
9 ¾ x 14 ¼ inches (24.8 x 36.2 cm)
Cat. no. 38.00408.001

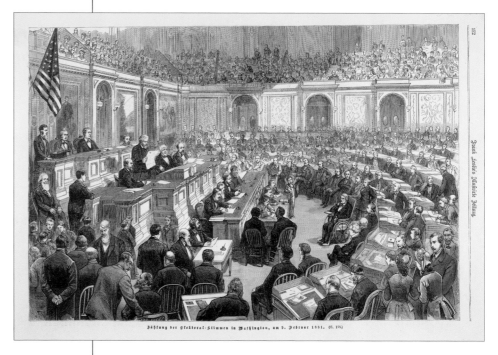

Bählung der Elektoral-Stimmen in Washington, am 9. Februar 1881.

Unidentified [after Walter Goater]
Frank Leslie's Illustrirte Zeitung, 02/26/1881
Wood engraving, black and white
9 ⅝ x 14 ¼ inches (24.4 x 36.2 cm)
Cat. no. 38.00534.001

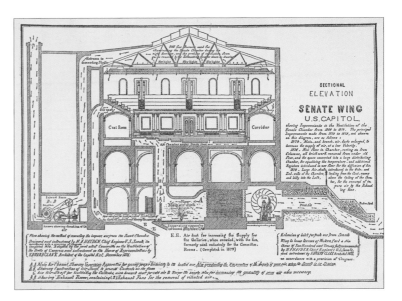

Sectional Elevation Senate Wing U.S. Capitol.

Unidentified
Frank Leslie's Illustrated Newspaper, 12/31/1881
Wood engraving, black and white
4 ⅞ x 7 inches (12.4 x 17.8 cm)
Cat. no. 38.00406.001

Southern Senators in the Cloak-Room.

Unidentified
Harper's New Monthly Magazine, 03/1881
Wood engraving, black and white
4 ¾ x 4 inches (12.1 x 11.9 cm)
Cat. no. 38.00858.001a

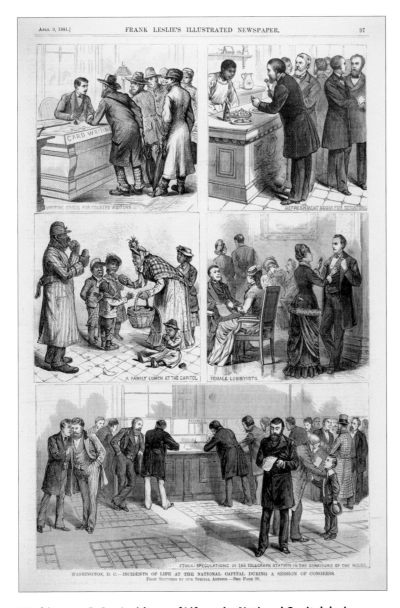

Washington, D.C.—Incidents of Life at the National Capital during a Session of Congress.

Unidentified
Frank Leslie's Illustrated Newspaper, 04/09/1881
Wood engraving, black and white
14 ½ x 9 ¼ inches (36.8 x 23.5 cm)
Cat. no. 38.00384.002

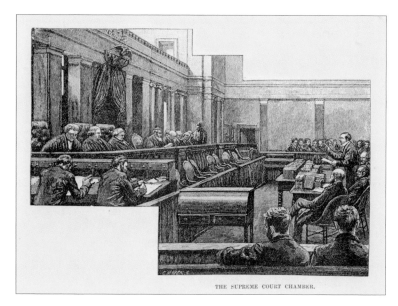

The Supreme Court Chamber.

H. Y. Mayer
Harper's New Monthly Magazine, 03/1881
Wood engraving, black and white
3 ½ x 4 inches (8.9 x 11.9 cm)
Cat. no. 38.00858.001b

The Garfield Monument Fair, Washington, D.C.—In the Rotunda.

Unidentified after photograph by Charles M. Bell
Harper's Weekly, 12/09/1882
Wood engraving, black and white
7 ³⁄₁₆ x 9 ¼ inches (18.3 x 23.5 cm)
Cat. no. 38.00093.001

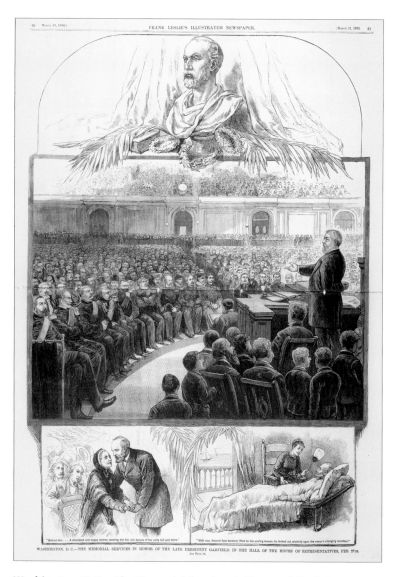

Washington, D.C.—The Memorial Services in Honor of the Late President Garfield, in the Hall of the House of Representatives, Feb. 27th.

Unidentified
Frank Leslie's Illustrated Newspaper, 03/11/1882
Wood engraving, black and white
20 x 14 inches (51.4 x 35.6 cm)
Cat. no. 38.00400.001

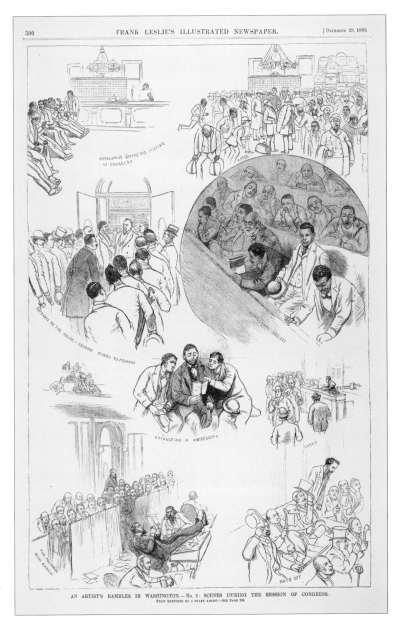

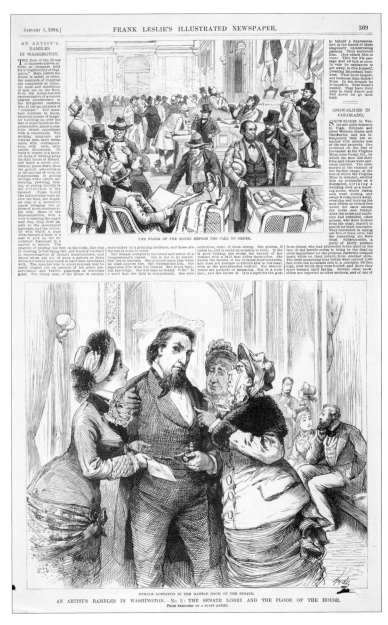

**An Artist's Rambles in Washington.—No. 2:
Scenes during the Session of Congress.**

Unidentified
Frank Leslie's Illustrated Newspaper, 12/29/1883
Wood engraving, black and white
14 1/2 x 9 1/16 inches (36.8 x 23.0 cm)
Cat. no. 38.00367.002

**An Artist's Rambles in Washington.—No. 3:
The Senate Lobby and the Floor of the House.**

Unidentified after J. N. Hyde
Frank Leslie's Illustrated Newspaper, 01/05/1884
Wood engraving, black and white
14 1/2 x 9 1/4 inches (36.8 x 23.5 cm)
Cat. no. 38.00875.001

Washington, D.C.—Character Sketches in and about the Capitol.

Unidentified after J. N. Hyde
Frank Leslie's Illustrated Newspaper, 03/14/1885
Wood engraving, black and white
13 ½ x 9 inches (34.3 x 22.9 cm)
Cat. no. 38.00228.002

The Funeral of General Logan—Lying in State in the Rotunda of the Capitol.

Unidentified after Charles Graham and William P. Snyder
Harper's Weekly, 01/08/1887
Wood engraving, black and white
14 x 9 ³⁄₁₆ inches (35.6 x 23.3 cm)
Cat. no. 38.00387.001

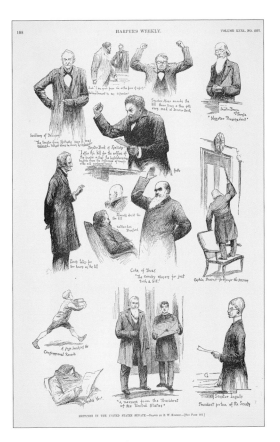

Sketches in the United States Senate.

Unidentified after Edward W. Kemble
Harper's Weekly, 03/12/1887
Wood engraving, black and white
14 ⅛ x 8 ⅞ inches (35.9 x 22.5 cm)
Cat. no. 38.00132.004

Sketches in Washington—In and about the Capitol.

Unidentified after Edward W. Kemble
Harper's Weekly, 02/26/1887
Wood engraving, hand-colored
13 ½ x 9 ¼ inches (34.3 x 23.5 cm)
Cat. no. 38.00133.002

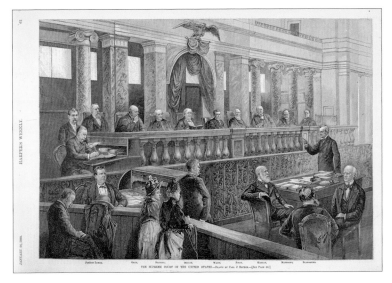

The Supreme Court of the United States.

Unidentified after Carl J. Becker
Harper's Weekly, 01/28/1888
Wood engraving, black and white
9 ¹¹⁄₁₆ x 13 ¼ inches (24.6 x 33.7 cm)
Cat. no. 38.00203.002

A Stormy Sitting. [Official Reporter of the House of Representatives]

Unidentified after Paul Renouard
Harper's Weekly, 09/15/1888
Lithograph, black and white
14 ¹⁄₁₆ x 9 ¼ inches (35.7 x 23.5 cm)
Cat. no. 38.00219.001

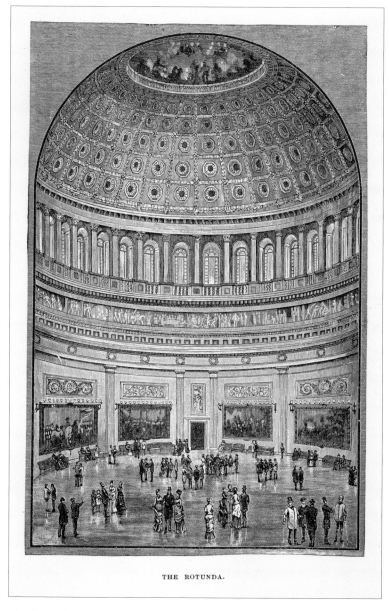

THE ROTUNDA.

The Rotunda.

Unidentified
Picturesque Washington, 1888
Wood engraving, hand-colored
6 ½ x 4 inches (16.5 x 10.2 cm)
Cat. no. 38.00081.001

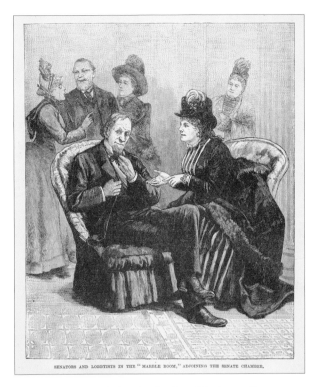

Senators and Lobbyists in the "Marble Room," Adjoining the Senate Chamber.

FEMALE LOBBYISTS AT WASHINGTON. D. C.—A SCENE IN THE MARBLE ROOM OF THE CAPITOL.

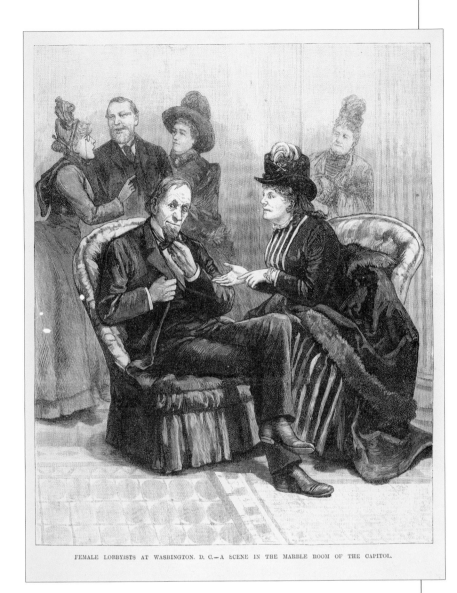

Senators and Lobbyists in the "Marble Room," Adjoining the Senate Chamber.

Unidentified
Frank Leslie's Popular Monthly, 04/1890
Wood engraving, black and white
6 ¾ x 5 ⅜ inches (17.1 x 13.7 cm)
Cat. no. 38.00510.001

Female Lobbyists at Washington. D.C.—A Scene in the Marble Room of the Capitol.

Unidentified
Frank Leslie's Illustrated Newspaper, 03/09/1889
Wood engraving, black and white
11 ¼ x 8 ⅞ inches (28.6 x 22.5 cm)
Cat. no. 38.00131.002

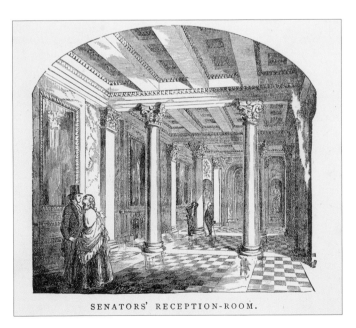

SENATORS' RECEPTION-ROOM.

Senators' Reception-Room. [Marble Room]

Unidentified after J. W. Orr
Unidentified, 1889
Wood engraving, black and white
3 ¾ x 4 ¼ inches (9.5 x 10.8 cm)
Cat. no. 38.00974.001b

y the late 19th century, the majority of visitors traveling to the nation's capital came for patriotic reasons—with a tour of the U.S. Capitol a highlight of their trip. Following the Civil War, the building became a symbol of freedom and democracy; it was the people's house, where everyone was equal. Civic improvements in Washington, D.C., and progress in transportation throughout the nation made the city an attractive destination. In addition, the proliferation of illustrated newspapers and magazines encouraged Washington tourism by providing images like this 1890 view of a newlywed couple in the Capitol Rotunda. The city was surpassing Niagara as a popular destination for honeymooners. One contemporary writer commented, "And so many people seem to have come under the great dome to rest. . . . Nearly all are people from the country, the greater proportion brides and grooms. . . . Early summer always brings a great influx of bridal pairs to Washington."[1]

[1] Mary Clemmer Ames, *Ten Years in Washington. Life and Scenes in the National Capital, as a Woman Sees Them* (Cincinnati, OH: Queen City Publishing, 1874), 154–155.

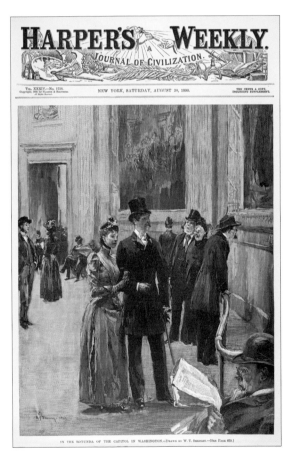

In the Rotunda of the Capitol in Washington.

Unidentified after William T. Smedley
Harper's Weekly, 08/30/1890
Wood engraving, black and white
12 x 9¼ inches (30.5 x 23.5 cm)
Cat. no. 38.00270.002

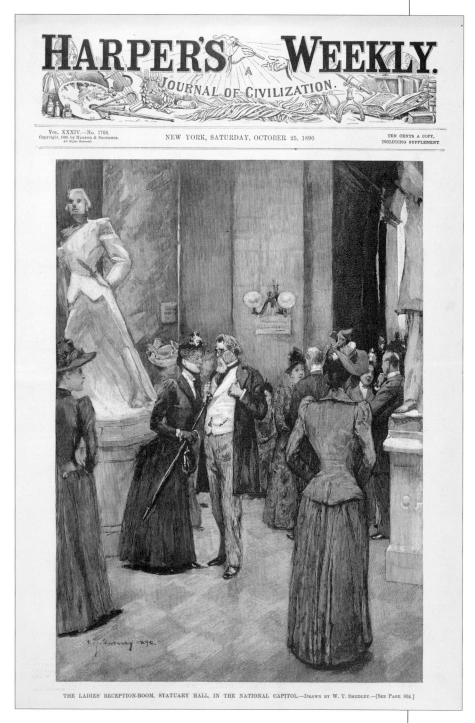

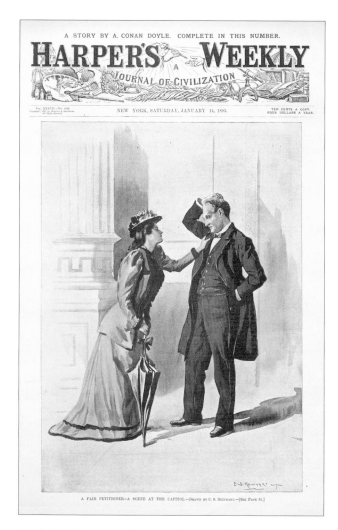

A Fair Petitioner—A Scene at the Capitol.

Unidentified after Charles S. Reinhart
Harper's Weekly, 01/14/1893
Halftone, black and white
11 ¼ x 8 ⅜ inches (29.8 x 21.3 cm)
Cat. no. 38.00246.001

The Ladies' Reception-Room, Statuary Hall, in the National Capitol.

Unidentified after William T. Smedley
Harper's Weekly, 10/25/1890
Wood engraving, black and white
12 x 8 ¼ inches (30.5 x 21.0 cm)
Cat. no. 38.00335.001

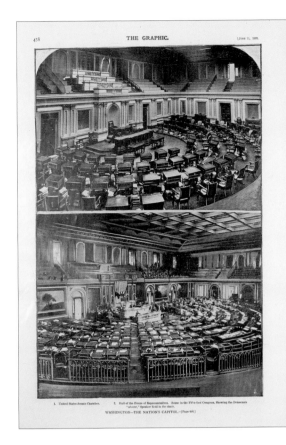

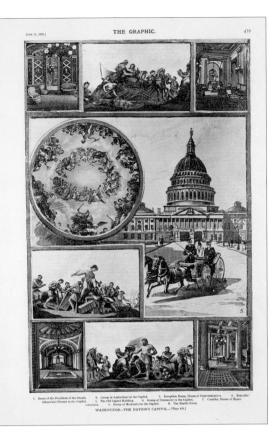

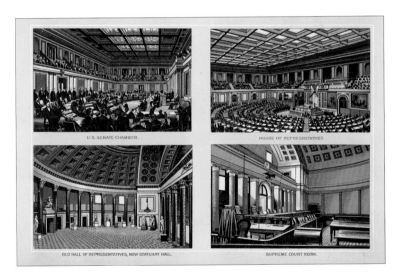

[U.S. Capitol Interiors]

Unidentified
Unidentified, ca. 1870–1890
Engraving, black and white
5 ⅜ x 8 ¼ inches (13.7 x 21.0 cm)
Cat. no. 38.00835.001

Washington—The Nation's Capitol.

Unidentified
The Graphic, 06/11/1892
Halftone, black and white
13 x 19 inches (33.0 x 48.3 cm)
Cat. no. 38.00958.001

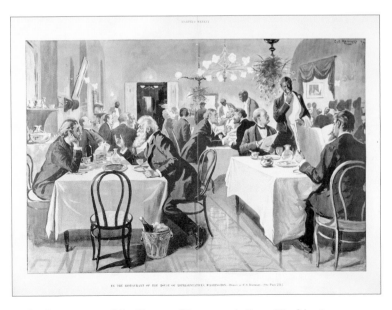

In the Restaurant of the House of Representatives, Washington.

Unidentified after Charles S. Reinhart after photograph by William Kurtz
Harper's Weekly, 08/12/1893
Halftone, black and white
13 ⅜ x 19 inches (34.0 x 48.3 cm)
Cat. no. 38.00147.001

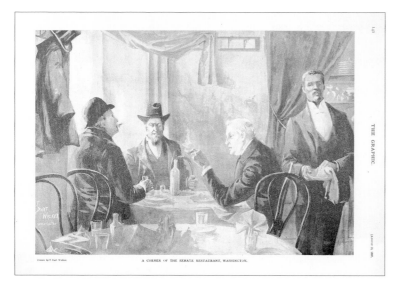

A Corner of the Senate Restaurant, Washington.

Unidentified after T. Dart Walker
The Graphic, 08/19/1893
Halftone, black and white
8 5/16 x 12 1/4 inches (21.1 x 31.1 cm)
Cat. no. 38.00954.001

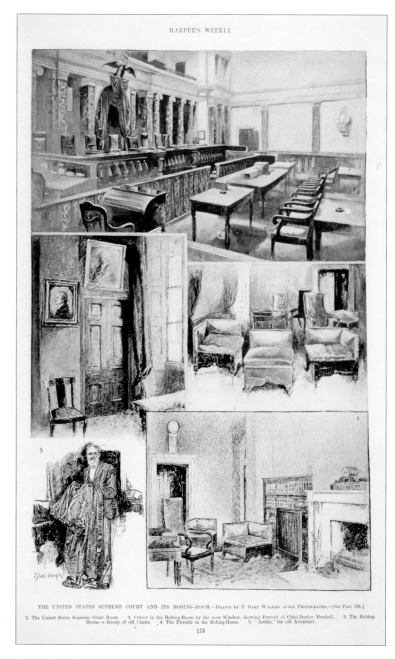

The United States Supreme Court and Its Robing-Room.

Unidentified after T. Dart Walker
Harper's Weekly, 02/24/1894
Lithograph and halftone, black and white
13 7/8 x 8 1/2 inches (35.2 x 21.6 cm)
Cat. no. 38.00227.001

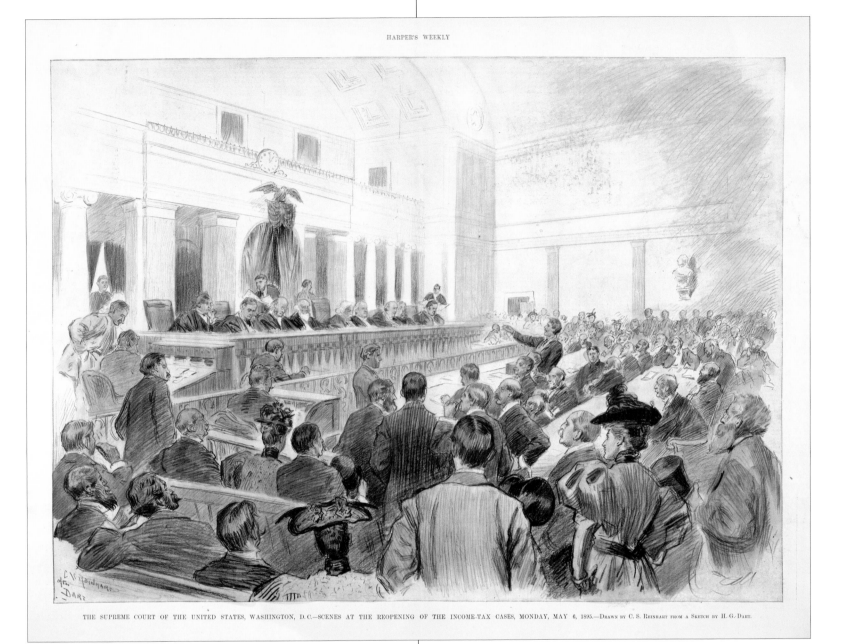

THE SUPREME COURT OF THE UNITED STATES, WASHINGTON, D.C.—SCENES AT THE REOPENING OF THE INCOME-TAX CASES, MONDAY, MAY 6, 1895.—DRAWN BY C. S. REINHART FROM A SKETCH BY H. G. DART.

The Supreme Court of the United States, Washington, D.C.—Scenes at the Reopening of the Income-Tax Cases, Monday, May 6, 1895.

Unidentified after Charles S. Reinhart after Harry G. Dart
Harper's Weekly, 06/01/1895
Halftone, colored
13 ¾ x 18 ½ inches (34.9 x 47.0 cm)
Cat. no. 38.00240.002

Mark A. Hanna, Senator from Ohio.

Unidentified after William Allen Rogers
Harper's Weekly, 03/13/1897
Halftone, black and white
13 $\frac{7}{16}$ x 8 $\frac{1}{2}$ inches (34.1 x 21.6 cm)
Cat. no. 38.00011.002

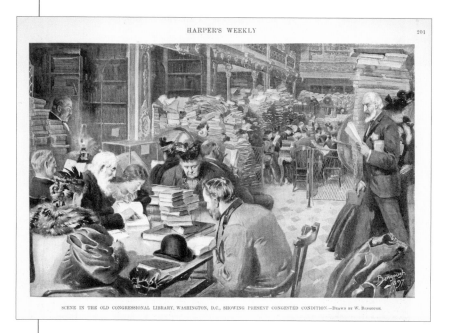

Scene in the Old Congressional Library, Washington, D.C., Showing Present Congested Condition.

Unidentified after William Bengough
Harper's Weekly, 02/27/1897
Halftone, black and white
5 $\frac{3}{4}$ x 8 $\frac{1}{2}$ inches (14.6 x 21.6 cm)
Cat. no. 38.00144.001

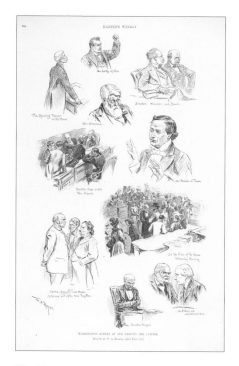

Washington—Scenes in and around the Capitol.

Unidentified after William Allen Rogers
Harper's Weekly, 04/16/1898
Lithograph and halftone, black and white
13 $\frac{3}{4}$ x 8 $\frac{1}{2}$ inches (34.9 x 21.6 cm)
Cat. no. 38.00233.002

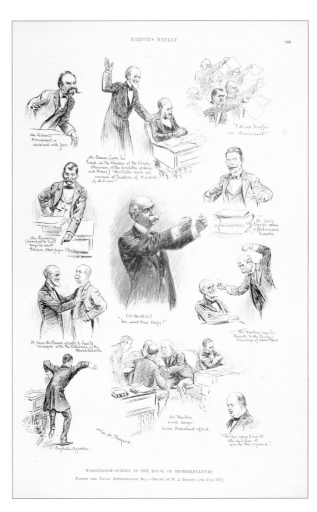

Washington—Scenes in the House of Representatives.

Unidentified after William Allen Rogers
Harper's Weekly, 04/16/1898
Lithograph and halftone, black and white
13 ¾ x 8 ⅝ inches (34.9 x 21.9 cm)
Cat. no. 38.00232.001

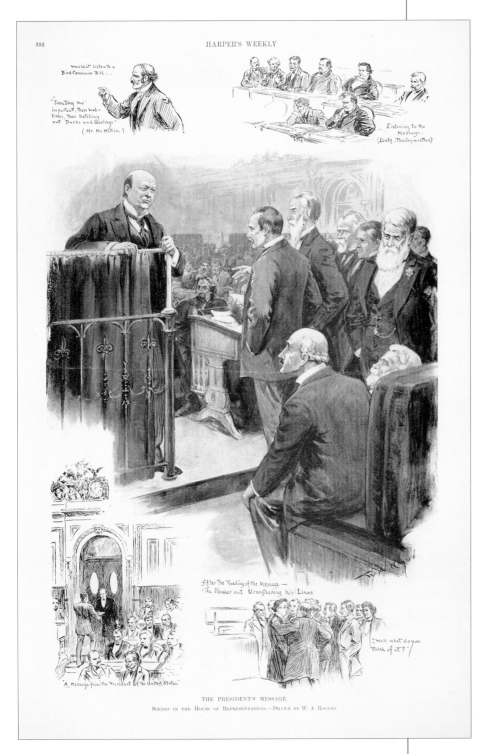

The President's Message. Scenes in the House of Representatives.

Unidentified after William Allen Rogers
Harper's Weekly, 04/23/1898
Lithograph and halftone, black and white
14 x 8 ⁹⁄₁₆ inches (35.6 x 21.7 cm)
Cat. no. 38.00235.001

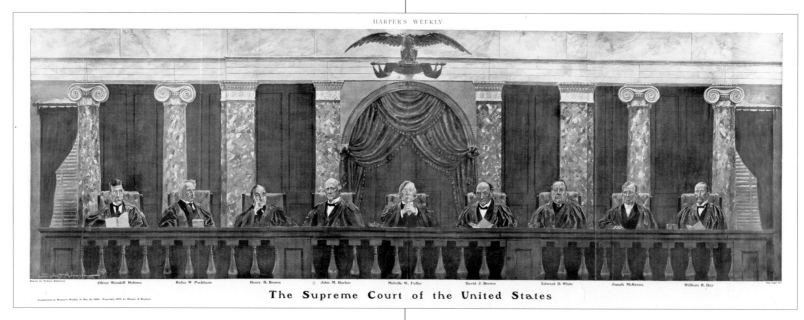

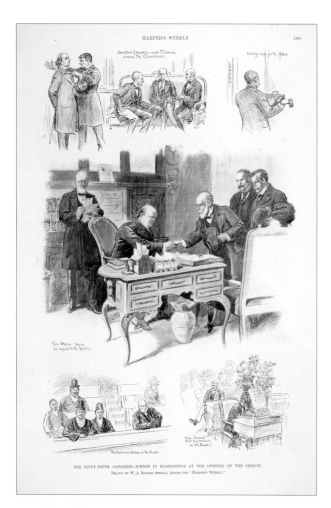

The Fifty-Fifth Congress—Scenes in Washington at the Opening of the Session.

Unidentified after William Allen Rogers
Harper's Weekly, 12/24/1898
Lithograph and halftone, black and white
13 ¾ x 8 ¾ inches (34.9 x 22.2 cm)
Cat. no. 38.00284.003

The Supreme Court of the United States

Sydney Adamson
Harper's Weekly, 05/16/1903
Lithograph, colored
11 ¾ x 34 inches (29.8 x 86.4 cm)
Cat. no. 38.00215.001

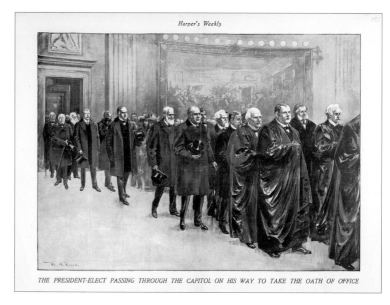

The President-Elect Passing through the Capitol on His Way to Take the Oath of Office

Unidentified after William Allen Rogers
Harper's Weekly, 03/09/1901
Halftone, blue and white
13 ¾ x 18 ¼ inches (34.9 x 46.4 cm)
Cat. no. 38.00803.001

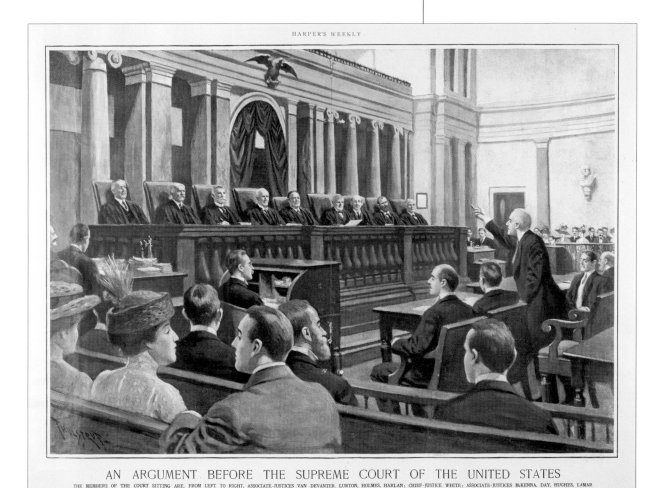

AN ARGUMENT BEFORE THE SUPREME COURT OF THE UNITED STATES

THE MEMBERS OF THE COURT SITTING ARE, FROM LEFT TO RIGHT, ASSOCIATE-JUSTICES VAN DEVANTER, LURTON, HOLMES, HARLAN ; CHIEF-JUSTICE WHITE ; ASSOCIATE-JUSTICES McKENNA, DAY, HUGHES, LAMAR.
DRAWN BY T DE THULSTRUP

An Argument before the Supreme Court of the United States

Unidentified after Thure de Thulstrup
Harper's Weekly, 05/27/1911
Halftone, hand-colored
14 ⅛ x 18 ½ inches (35.9 x 47.0 cm)
Cat. no. 38.00107.001

Supreme Court Room in the Capitol, Washington, D.C.

Unidentified
Keystone View Company, ca. 1920
Photograph, black and white
3 ¼ x 6 inches (8.3 x 15.2 cm)
Cat. no. 38.00710.001

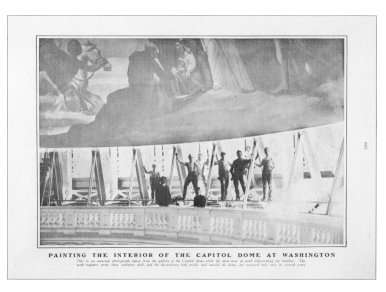

PAINTING THE INTERIOR OF THE CAPITOL DOME AT WASHINGTON

Painting the Interior of the Capitol Dome at Washington

Unidentified
Unidentified, ca. 1903
Halftone, black and white
7 ½ x 10 ½ inches (19.1 x 26.7 cm)
Cat. no. 38.00838.001

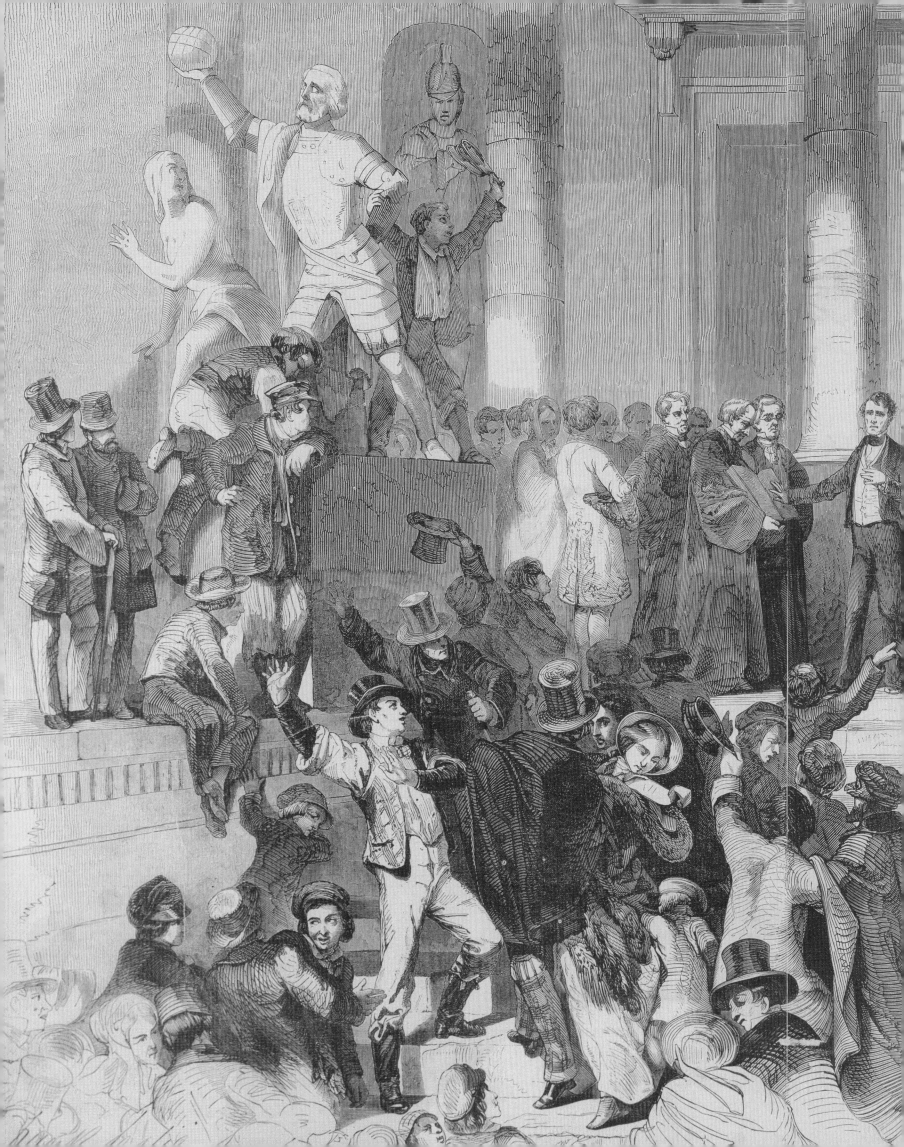

CAPITOL EXTERIOR & GROUNDS

Le Capitol à Washington

Eoban Grünewald after H. Brown
Unidentified, ca. 1830
Steel engraving, hand-colored
4 ⁵⁄₁₆ x 6 ³⁄₁₆ inches (11.0 x 15.7 cm)
Cat. no. 38.00042.001

Front View of the Capitol at Washington.

Unidentified
The History and Topography of the United States of North America, from the Earliest Period to the Present Time, 1834
Wood engraving, black and white
5 ³⁄₁₆ x 7 ¾ inches (13.2 x 19.7 cm)
Cat. no. 38.00561.001

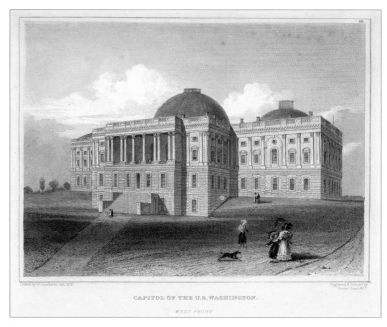

Capitol of the U.S. Washington.

Fenner, Sears & Co. after W. Goodacre
I. T. Hinton & Simpkin & Marshall, 10/01/1831
Steel engraving, hand-colored
5 x 5 ⅞ inches (12.7 x 14.9 cm)
Cat. no. 38.00046.001

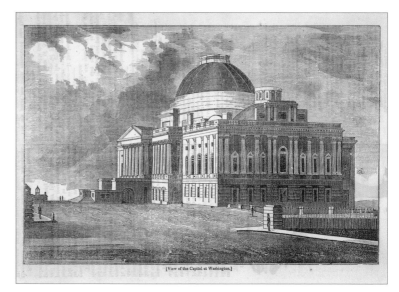

View of the Capitol at Washington

Unidentified
Unidentified, ca. 1830
Wood engraving, black and white
5 ⅝ x 8 ⅜ inches (14.3 x 21.3 cm)
Cat. no. 38.00836.001

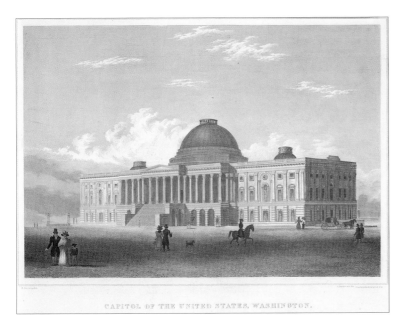

Capitol of the United States, Washington.

Joseph Andrews after H. Brown
Carter, Andrews, & Co., ca. 1834
Steel engraving, hand-colored
6 ½ x 8 ¼ inches (16.5 x 21.0 cm)
Cat. no. 38.00199.002

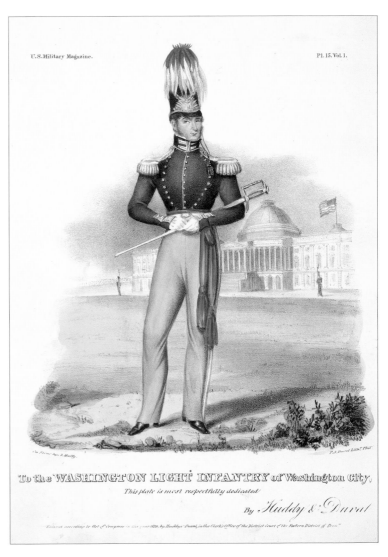

To the Washington Light Infantry of Washington City

P. S. Duval after Alfred Hoffy
U.S. Military Magazine, 1839
Lithograph, hand-colored
10 ⁵⁄₁₆ x 7 ⅞ inches (26.2 x 20.0 cm)
Cat. no. 38.00063.001

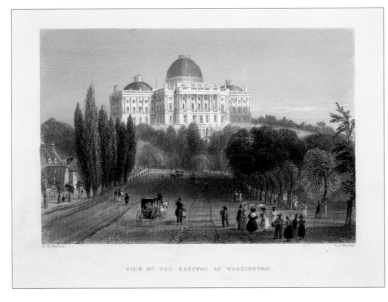

View of the Capitol at Washington.

C. J. Bentley after William Henry Bartlett
American Scenery, 1837
Steel engraving, hand-colored
5 ½ x 7 ⅛ inches (14.0 x 18.1 cm)
Cat. no. 38.00210.002

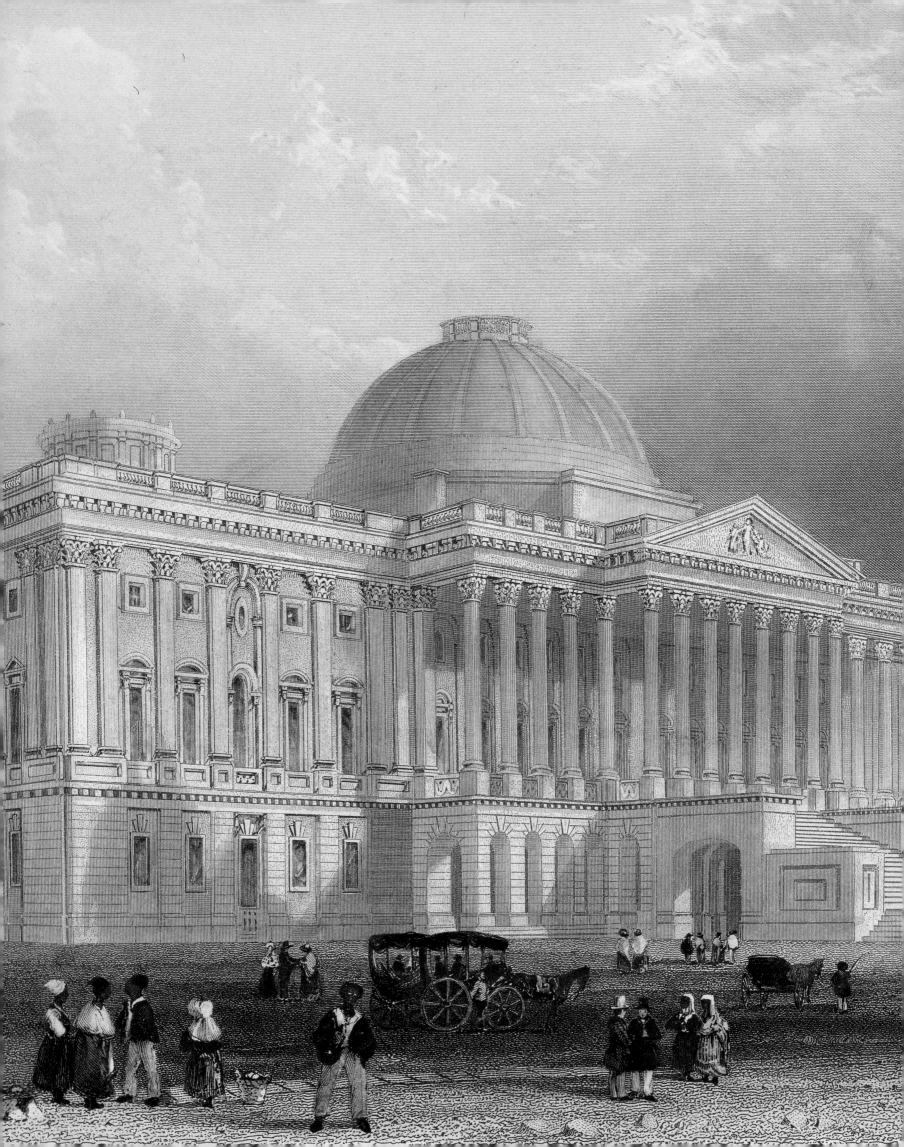

English artist William Henry Bartlett (1809-1854) traveled extensively throughout this country between 1836 and 1838, producing numerous watercolors of locations along the eastern United States. In all, Bartlett made 115 sketches from nature—primarily romantic scenes that emphasized the untamed American landscape, with some notable buildings also depicted. These images were published as engravings in 1839, in a volume titled *American Scenery*. The publication was an immediate success, both in this country and in Europe, as it provided some of the earliest and most accurate views of the American countryside. Numerous printmakers later copied Bartlett's views, while other artists reproduced the images in oil for sale to the public. This Bartlett print, engraved by fellow Englishman Robert Brandard, depicts the Capitol as completed in 1826. Bartlett's original watercolor of the scene is in the collection of the Museum of Fine Arts, Boston; the Senate owns several other engravings after Bartlett images. ☙

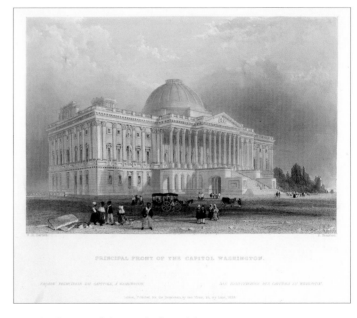

Principal Front of the Capitol Washington.

Robert Brandard after William Henry Bartlett
American Scenery, 1839
Steel engraving, hand-colored
6 ⁹⁄₁₆ x 7 ¼ inches (16.7 x 18.4 cm)
Cat. no. 38.00045.002

Washington, from the Presidents House.

Henry Wallis after William Henry Bartlett
American Scenery, 1839
Steel engraving, hand-colored
6 ⁹⁄₁₆ x 7 ³⁄₁₆ inches (16.7 x 18.3 cm)
Cat. no. 38.00047.001

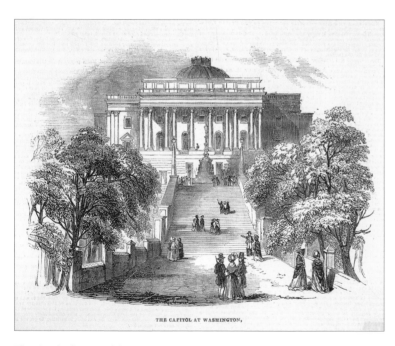

The Capitol at Washington

Unidentified after William Henry Bartlett
The Illustrated London News, 12/31/1842
Wood engraving, black and white
5 x 6 ¼ inches (12.7 x 15.9 cm)
Cat. no. 38.00364.001

The Ascent to the Capitol Washington.

Robert Wallis after William Henry Bartlett
American Scenery, 1840
Steel engraving, hand-colored
5 ½ x 5 ½ inches (14.0 x 14.0 cm)
Cat. no. 38.00525.002

The Capitol at Washington.

Unidentified
Unidentified, ca. 1846
Wood engraving, black and white
2 ⅛ x 4 ⅛ inches (5.4 x 10.5 cm)
Cat. no. 38.00845.001

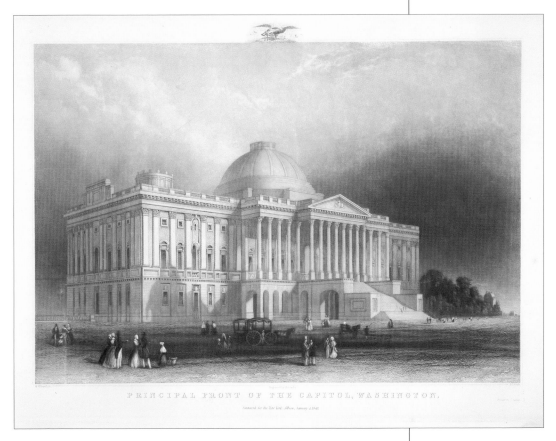

Principal Front of the Capitol, Washington.

Henry S. Sadd and Alexander L. Dick after William Henry Bartlett
New York Albion, 01/01/1848
Mezzotint, black and white
12 ½ x 16 ¼ inches (31.8 x 41.3 cm)
Cat. no. 38.00050.001

Washington, As It Is Seen from the Presidents House Looking down Pennsylvania Avenue towards the Capitol in the Distance.

Unidentified after William Henry Bartlett
Unidentified, 1848
Wood engraving, black and white
3 ⅞ x 6 ¹¹/₁₆ inches (9.8 x 17.0 cm)
Cat. no. 38.00539.001

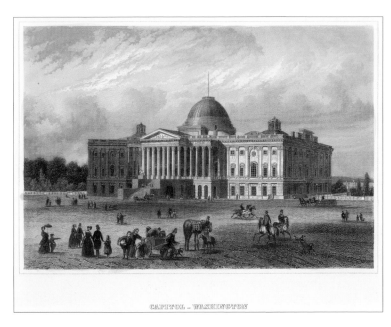

Capitol—Washington

Unidentified
Herrmann J. Meyer, ca. 1849
Metal engraving, hand-colored
5 x 6 ½ inches (12.7 x 16.5 cm)
Cat. no. 38.00908.001

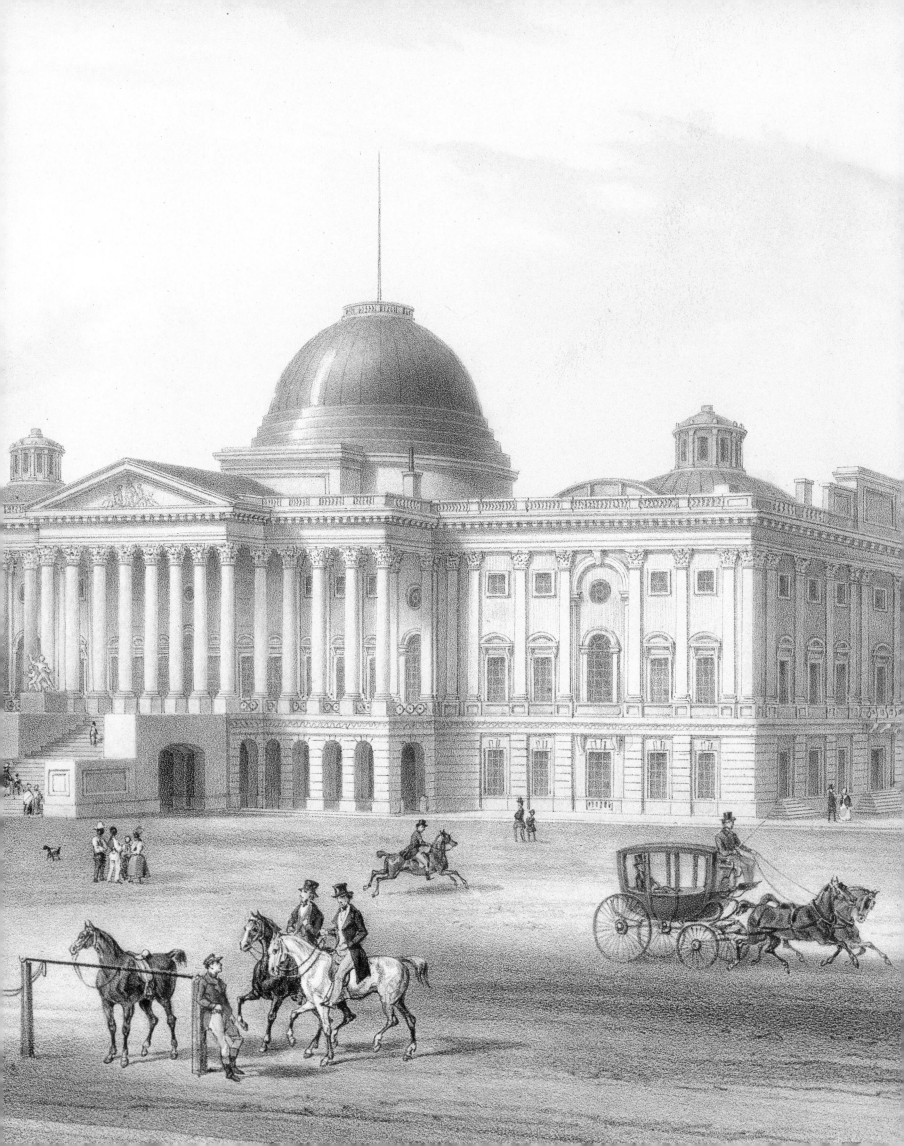

This carefully drawn view of the Capitol shows the building as completed by architects Benjamin Henry Latrobe and Charles Bulfinch. The image is by Augustus Köllner, a German-born lithographer and painter who immigrated to America around 1839. Köllner was considered one of the premier artists working in Philadelphia during the city's commercial lithography boom. During that time, he traveled throughout much of the country, producing watercolor images that he later translated into attractive hand-colored lithographs. This print of the Capitol is from *Views of American Cities*, a series of 54 engravings produced by Köllner and published between 1848 and 1851. The series also included images of the original Senate Chamber (38.00964.001, p. 16) and the Old Hall of the House of Representatives. The views were expertly rendered and highly accurate, and thus are important historical documents of 19th-century America. The artist also was known for his military figures, drawings of horses and cattle, and illustrations for children's books. ☙

Washington / Capitol (East View.)

Deroy after Augustus Theodore Frederick Adam Köllner
Goupil, Vibert & Co., 1848
Lithograph, hand-colored
18 ½ x 18 ⅜ inches (47.0 x 46.7 cm)
Cat. no. 38.00951.001

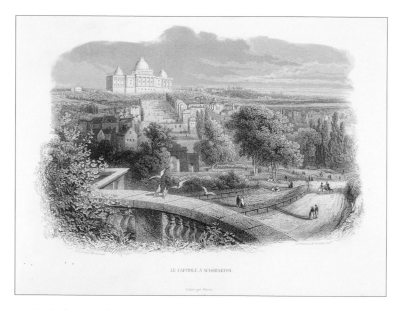

Le Capitole a Washington.

E. Lechard
Delamain, ca. 1850
Steel engraving, black and white
6 ¹⁄₁₆ x 8 inches (15.4 x 20.3 cm)
Cat. no. 38.00469.001

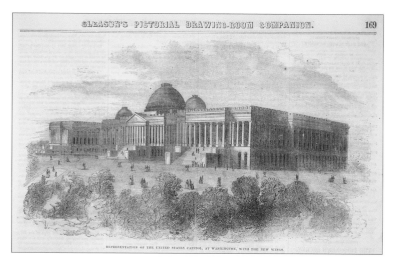

**Representation of the United States Capitol,
at Washington, with the New Wings.**

Unidentified
Gleason's Pictorial Drawing-Room Companion, 1851
Wood engraving, hand-colored
5 ¾ x 9 ³⁄₁₆ inches (14.6 x 23.3 cm)
Cat. no. 38.00052.001a

A View of the City of Washington, D.C, [sic] from the Capitol.

Schenck after John R. Chapin
Gleason's Pictorial Drawing-Room Companion, 1851
Wood engraving, hand-colored
6 ¼ x 9 ⅜ inches (15.9 x 23.8 cm)
Cat. no. 38.00083.002

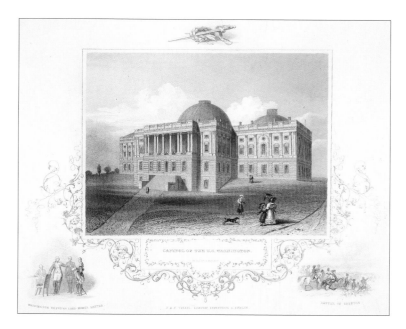

Capitol of the U.S. Washington.

Unidentified
J. & F. Tallis, ca. 1851
Steel engraving, black and white
6 ¹⁵⁄₁₆ x 8 ½ inches (17.6 x 21.6 cm)
Cat. no. 38.00048.002

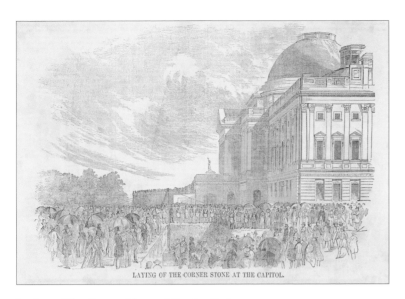

Laying of the Corner Stone at the Capitol.

Unidentified
Gleason's Pictorial Drawing Room Companion, 08/02/1851
Wood engraving, black and white
6 ½ x 9 ¾ inches (16.5 x 24.8 cm)
Cat. no. 38.00427.001b

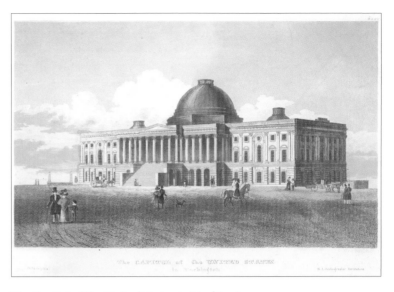

The Capitol of the United States in Washington

Eoban Grünewald after H. Brown
North American Bibliographic Institution, ca. 1852
Steel engraving, black and white
4 ⅛ x 6 ³⁄₁₆ inches (10.5 x 15.7 cm)
Cat. no. 38.00467.001

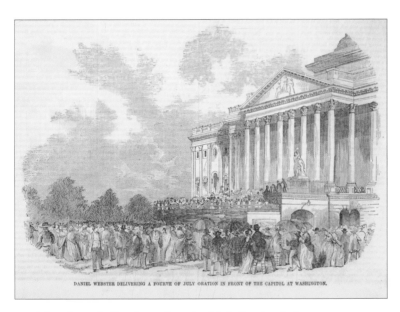

Daniel Webster Delivering a Fourth of July Oration in Front of the Capitol at Washington.

Unidentified
Gleason's Pictorial Drawing Room Companion, 08/02/1851
Wood engraving, hand-colored
6 ⅛ x 8 ⁹⁄₁₆ inches (15.6 x 21.7 cm)
Cat. no. 38.00053.001

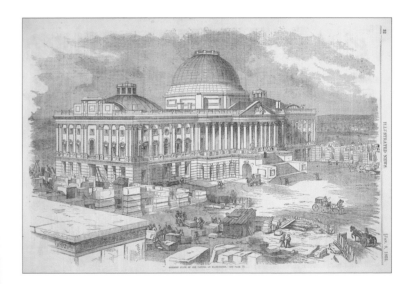

Present State of the Capitol at Washington.

Unidentified after Carl E. Doepler
The [New York] Illustrated News, 01/08/1853
Wood engraving, black and white
9 ⅞ x 14 ⅛ inches (25.1 x 35.9 cm)
Cat. no. 38.00137.002

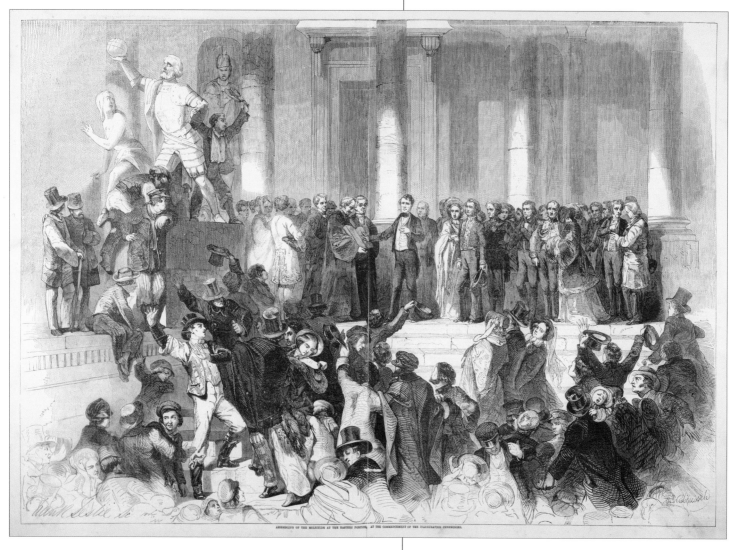

Assembling of the Multitude at the Eastern Portico, at the Commencement of the Inaugural Ceremonies.

Frank Leslie after Christian Schussele
[Frank Leslie's] Illustrated News, 03/12/1853
Wood engraving, black and white
14 ½ x 20 ½ inches (36.8 x 52.1 cm)
Cat. no. 38.00248.001

Bird's-Eye View oe [sic] Washington, from the Capitol.

Frank Leslie after William R. Miller
The [New York] Illustrated News, 03/12/1853
Wood engraving, hand-colored
9 ½ x 14 ¼ inches (24.1 x 36.2 cm)
Cat. no. 38.00008.001

Principal Public Buildings at Washington, D.C.

Principal Public Buildings at Washington, D.C.

E. B. after William Wade
Gleason's Pictorial Drawing-Room Companion, 03/11/1854
Wood engraving, black and white
15 x 21 ⅞ inches (38.1 x 55.6 cm)
Cat. no. 38.00108.002

Das Neue Capitol (Washington)

Unidentified
Kunstanst. d. Bibli. Instit. in Hildbhsn, ca. 1855
Steel engraving, black and white
5 x 6 5/16 inches (12.7 x 16.0 cm)
Cat. no. 38.00468.001

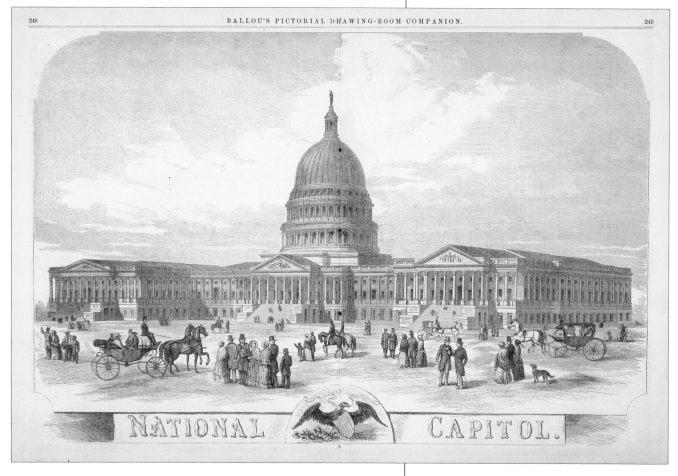

National Capitol.

Unidentified after John Andrew
Ballou's Pictorial Drawing-Room Companion, ca. 1855
Wood engraving, hand-colored
13 ½ x 21 ¾ inches (34.3 x 55.2 cm)
Cat. no. 38.00015.001

Inauguration of Mr. Buchanan, as President of the United States, at Washington.

Unidentified after photograph by Whitchurch
The Illustrated London News, 03/28/1857
Wood engraving, black and white
7 ⅛ x 9 ½ inches (18.1 x 24.1 cm)
Cat. no. 38.00096.001

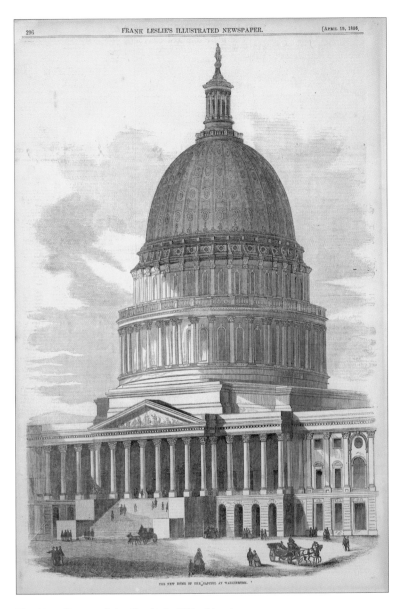

The New Dome of the Capitol at Washington.

Unidentified after Bunkle
Frank Leslie's Illustrated Newspaper, 04/19/1856
Wood engraving, hand-colored
15 x 10 inches (38.1 x 25.4 cm)
Cat. no. 38.00041.001

The Capitol at Washington, with the New Extensions.

Unidentified after Charles S. Reinhart
Harper's Weekly, 02/06/1858
Wood engraving, black and white
9 ³⁄₁₆ x 13 ¾ inches (23.3 x 34.9 cm)
Cat. no. 38.00088.001

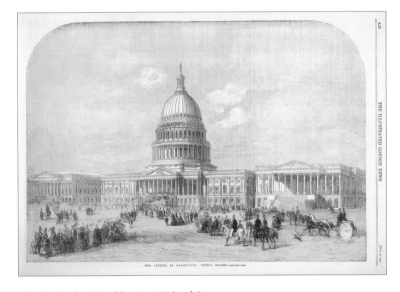

The Capitol at Washington United States.

Unidentified
The Illustrated London News, 10/29/1859
Wood engraving, black and white
9 ⅜ x 13 ½ inches (23.8 x 34.3 cm)
Cat. no. 38.00136.001

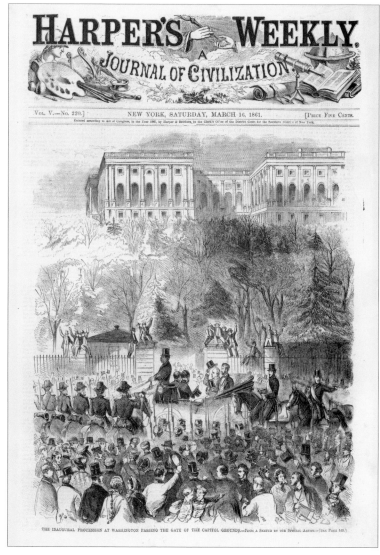

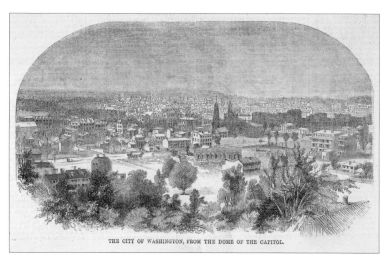

The City of Washington, from the Dome of the Capitol.

Unidentified
Harper's Weekly, 12/15/1860
Wood engraving, hand-colored
4 ¾ x 7 ⅝ inches (12.1 x 19.4 cm)
Cat. no. 38.00035.001b

The Inaugural Procession at Washington Passing the Gate of the Capitol Grounds.

Unidentified after Winslow Homer
Harper's Weekly, 03/16/1861
Wood engraving, black and white
11 ¼ x 9 ¼ inches (28.6 x 23.5 cm)
Cat. no. 38.00159.001

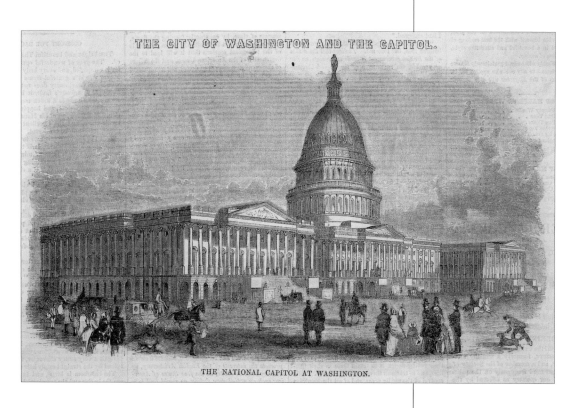

The National Capitol at Washington.

Unidentified [after Charles S. Reinhart]
Harper's Weekly, 12/15/1860
Wood engraving, hand-colored
5 x 7 ⅝ inches (12.7 x 19.4 cm)
Cat. no. 38.00035.001a

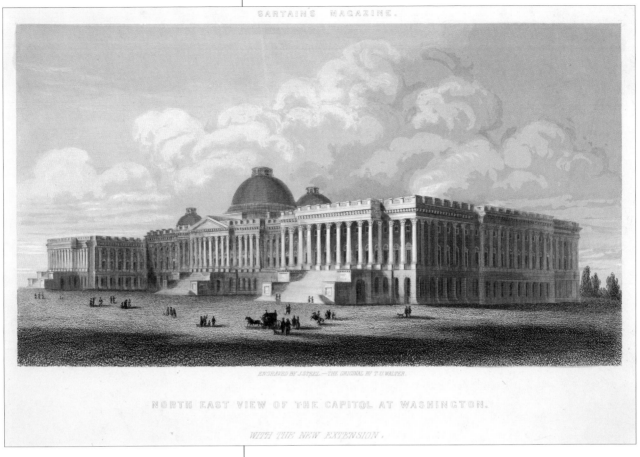

North East View of the Capitol at Washington.

J. Steel after Thomas U. Walter
Sartain's Magazine, ca. 1860
Metal engraving, hand-colored
4 ½ x 7 ¼ inches (11.4 x 18.4 cm)
Cat. no. 38.00952.001

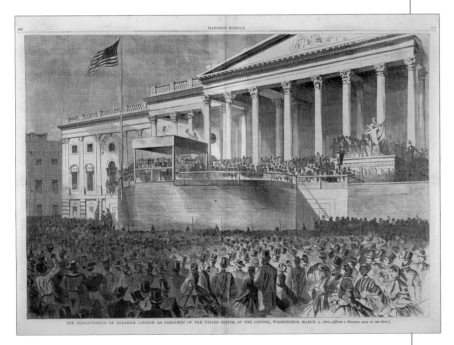

The Inauguration of Abraham Lincoln as President of the United States, at the Capitol, Washington, March 4, 1861.

Unidentified after Winslow Homer
Harper's Weekly, 03/16/1861
Wood engraving, black and white
14 x 21 ¼ inches (35.6 x 54.0 cm)
Cat. no. 38.00039.002

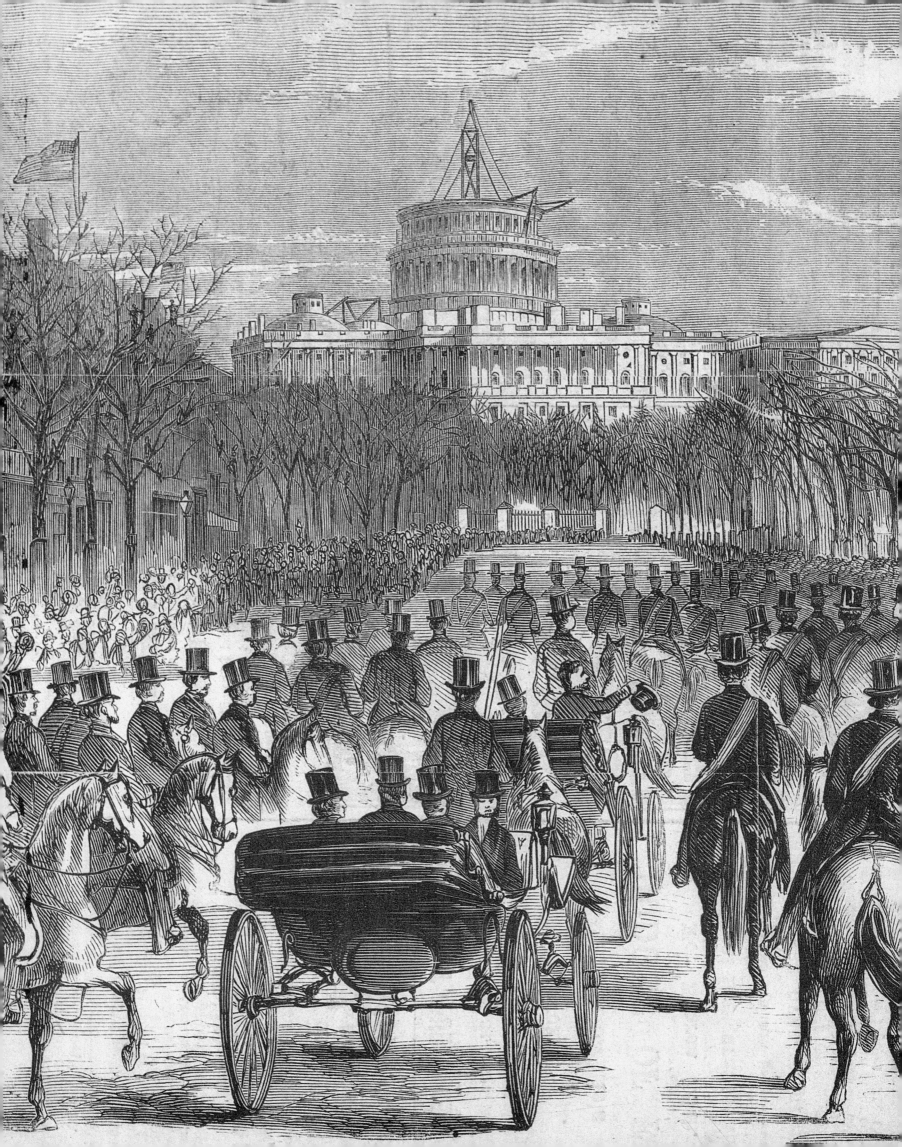

*S*ince March 4, 1801, when Thomas Jefferson walked the short distance from his boardinghouse to the nearby Capitol to take his oath of office as president of the United States, the building has served as the grand stage for almost all presidential inaugurations. While early inaugurations were small, local affairs, by Abraham Lincoln's first inauguration the crowds had swelled from thousands to tens of thousands, lining the parade route and packing the Capitol grounds. The entire nation shared in the excitement thanks to illustrated weekly newspapers, which delivered images within days of the event to homes across the country. With the nation on the brink of civil war, Abraham Lincoln feared that violence would mar his inauguration day. For the first time during an American presidential inauguration, the primary duty of the military units escorting the president was to protect him rather than to serve a ceremonial role. The inauguration was held on the east front of the Capitol, with the unfinished dome providing a symbolic image of the fragmented nation. ᴐ》

View on Pennsylvania Avenue, Washington, Monday, March 4th, 1861—Mr. Lincoln, Accompanied by President Buchanan, on His Way to the Capitol to Be Inaugurated.

Unidentified
Frank Leslie's Illustrated Newspaper, 03/16/1861
Wood engraving, black and white
9 ¼ x 14 inches (23.5 x 35.6 cm)
Cat. no. 38.00006.004

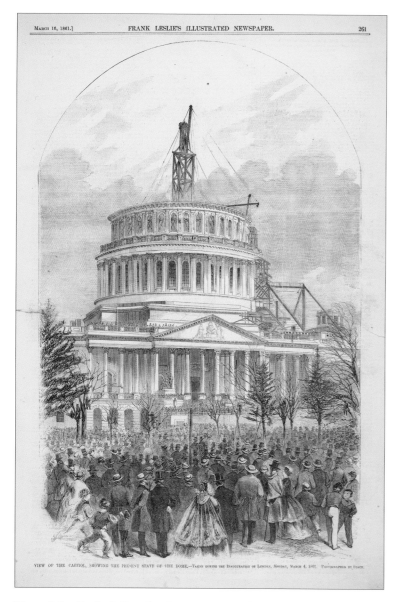

**View of the Capitol, Showing Present State of the Dome.—
Taken during the Inauguration of Lincoln, Monday, March 4, 1861.**

Unidentified after photograph by George Stacy
Frank Leslie's Illustrated Newspaper, 03/16/1861
Wood engraving, black and white
14 3/16 x 8 15/16 inches (36.0 x 22.7 cm)
Cat. no. 38.00009.004

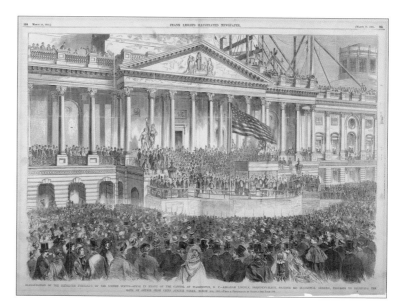

**Inauguration of the Sixteenth President of the United States—
Scene in Front of the Capitol at Washington, D.C.—Abraham Lincoln,
President-Elect, Reading His Inaugural Address, Previous to Receiving
the Oath of Office from Chief Justice Taney, March 4th, 1861.**

Unidentified after photograph by George Stacy
Frank Leslie's Illustrated Newspaper, 03/16/1861
Wood engraving, black and white
14 1/4 x 19 3/4 inches (36.2 x 50.2 cm)
Cat. no. 38.00134.001

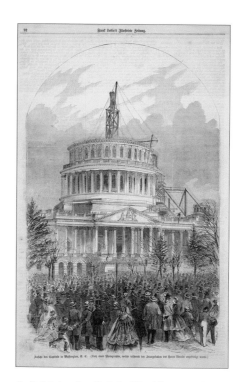

Anficht des Capitols in Washington, D.C.

Unidentified [after photograph by George Stacy]
Frank Leslie's Illustrirte Zeitung, ca. 1861
Wood engraving, black and white
10 1/4 x 8 7/8 inches (26.0 x 22.5 cm)
Cat. no. 38.00414.001

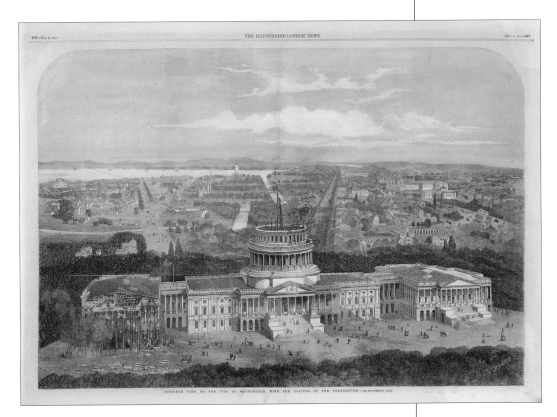

Birds Eye View of the City of Washington, with the Capitol in the Foreground

Unidentified after George Henry Andrews
The Illustrated London News, 05/25/1861
Wood engraving, hand-colored
13 ¾ x 20 inches (34.9 x 50.8 cm)
Cat. no. 38.00012.001

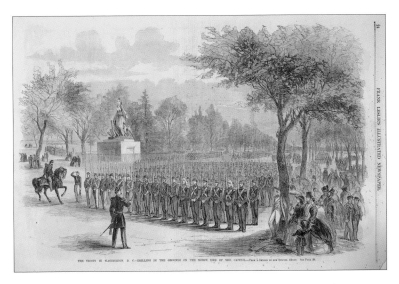

The Troops in Washington, D.C.—Drilling in the Grounds on the North Side of the Capitol.

Unidentified
Frank Leslie's Illustrated Newspaper, 05/25/1861
Wood engraving, black and white
9 ⅜ x 14 inches (23.8 x 35.6 cm)
Cat. no. 38.00260.001

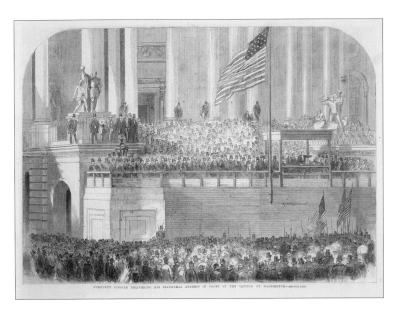

President Lincoln Delivering His Inaugural Address in Front of the Capitol at Washington.

Unidentified
The Illustrated London News, 03/30/1861
Wood engraving, black and white
9 ⁹⁄₁₆ x 13 ½ inches (24.3 x 34.3 cm)
Cat. no. 38.00434.001

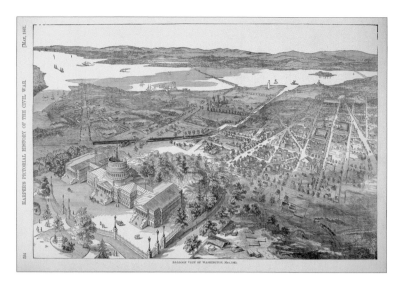

Balloon View of Washington, May, 1861.

Unidentified after Jacob Wells
Harper's Pictorial History of the Civil War, 05/1861
Wood engraving, black and white
9 ½ x 14 inches (24.1 x 35.6 cm)
Cat. no. 38.00253.001

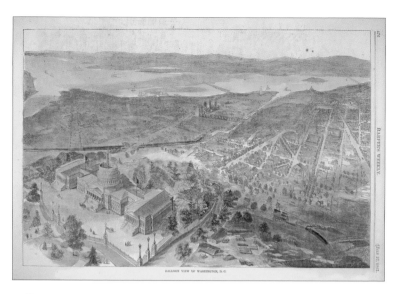

Balloon View of Washington, D.C.

Unidentified after Jacob Wells
Harper's Weekly, 07/27/1861
Wood engraving, hand-colored
9 ³⁄₁₆ x 13 ⅞ inches (23.3 x 35.2 cm)
Cat. no. 38.00002.003

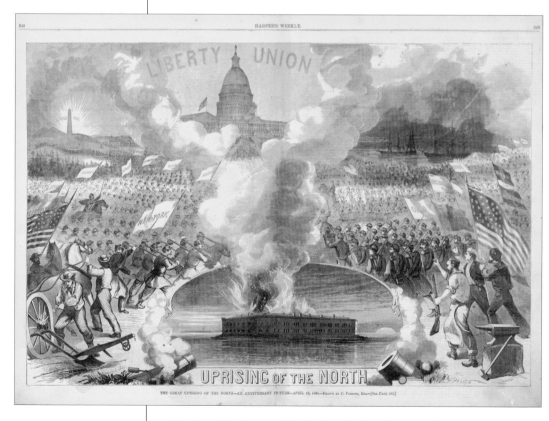

**The Great Uprising of the North—An Anniversary Picture—
April 12, 1862.**

Unidentified after C. Parsons
Harper's Weekly, 04/19/1862
Wood engraving, black and white
13 ⅝ x 20 ⅛ inches (34.6 x 51.1 cm)
Cat. no. 38.00264.001

Capitol at Washington.

Unidentified
Unidentified, ca. 1864
Photograph, black and white
3 3/16 x 5 11/16 inches (8.1 x 14.4 cm)
Cat. no. 38.00466.001

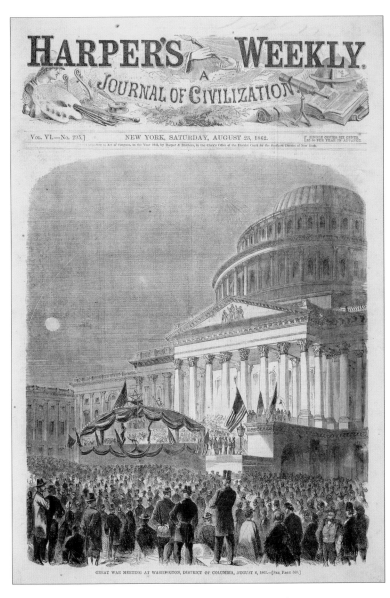

Great War Meeting at Washington, District of Columbia, August 6, 1862.

Unidentified
Harper's Weekly, 08/23/1862
Wood engraving, hand-colored
10 15/16 x 9 5/16 inches (27.8 x 23.7 cm)
Cat. no. 38.00064.001

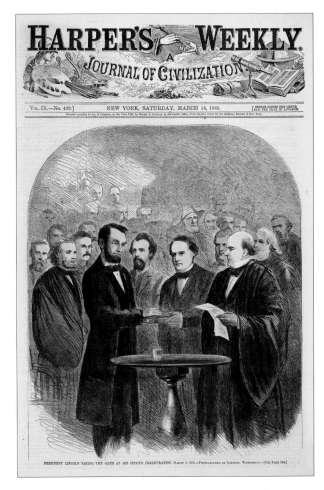

President Lincoln Taking the Oath at His Second Inauguration, March 4, 1865.

Unidentified after photograph by Alexander Gardner
Harper's Weekly, 03/18/1865
Wood engraving, hand-colored
11 x 9 3/16 inches (27.9 x 23.3 cm)
Cat. no. 38.00085.001

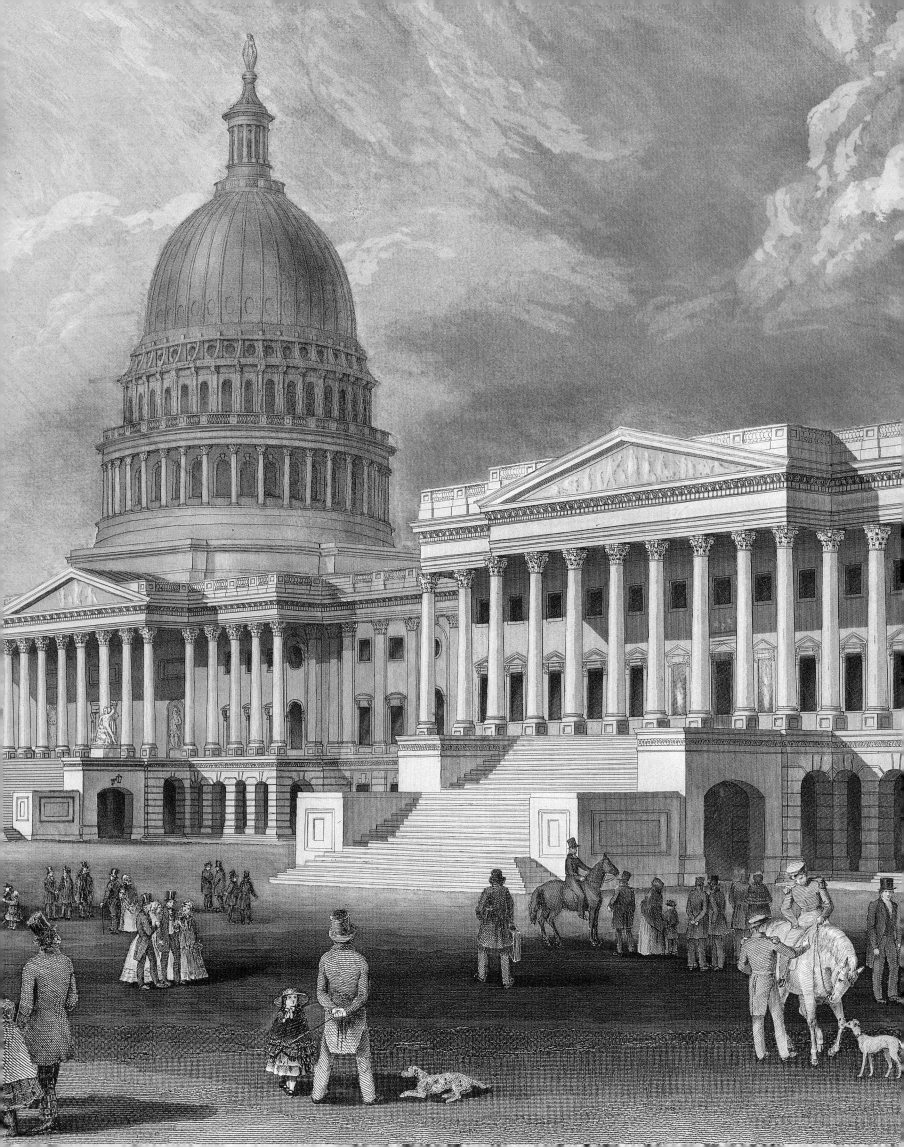

By 1850 so many new states had joined the Union that the U.S. Senate and House of Representatives had outgrown their chambers. Congress addressed the problem by authorizing the addition of grand wings to the north and south ends of the Capitol, and replacing the old copper dome with a much larger, magnificent cast-iron one. Philadelphia architect Thomas U. Walter designed the additions and, along with engineer Montgomery C. Meigs, supervised construction. On December 2, 1863, the last section of the Statue of Freedom was placed on top of the dome, although work still continued on the interior of the Capitol. This 1863 engraving by Henry Sartain anticipated the completion of the building and also envisioned the end of the Civil War by depicting an idyllic setting. The son of John Sartain—a preeminent portrait engraver who is considered the father of mezzotint engraving in America—Henry Sartain engraved only a few images before establishing a printing business devoted to producing engravings by his father and others. It is believed his father assisted him in completing this Capitol view. ◐

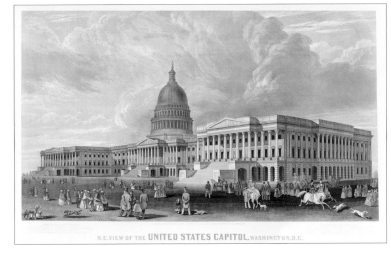

N.E. View of the United States Capitol, Washington. D.C.

Henry Sartain
James Irwin, 1863
Steel engraving, black and white
18 x 27 inches (45.7 x 68.6 cm)
Cat. no. 38.00089.001

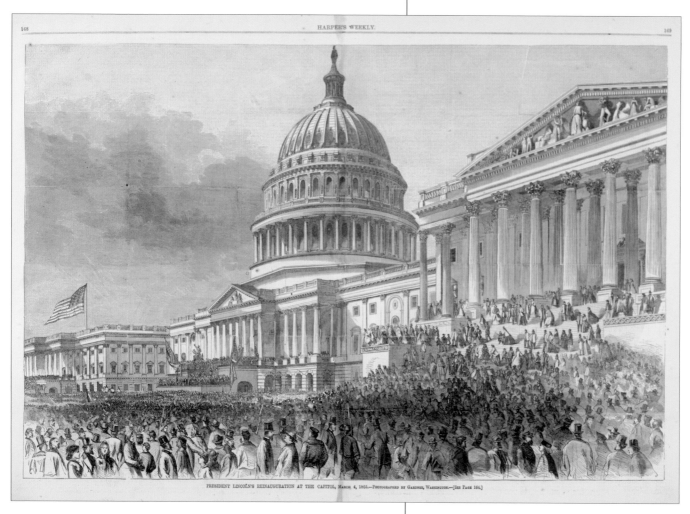

President Lincoln's Reinauguration at the Capitol, March 4, 1865.

Unidentified after photograph by Alexander Gardner
Harper's Weekly, 03/18/1865
Wood engraving, black and white
13 ¾ x 20 ½ inches (34.9 x 52.1 cm)
Cat. no. 38.00087.004

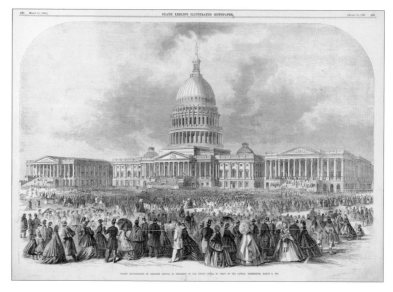

Second Inauguration of Abraham Lincoln as President of the United States, in Front of the Capitol, Washington, March 4, 1865.

Unidentified
Frank Leslie's Illustrated Newspaper, 03/18/1865
Wood engraving, black and white
14 ¼ x 20 ½ inches (36.2 x 52.1 cm)
Cat. no. 38.00146.002

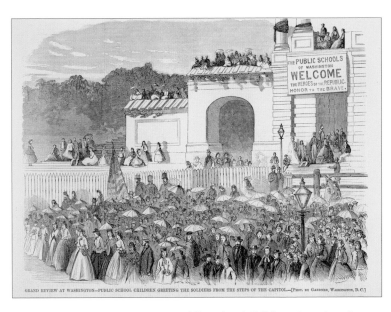

Grand Review at Washington—Public School Children Greeting the Soldiers from the Steps of the Capitol.

Unidentified after photograph by Alexander Gardner
Harper's Weekly, 06/10/1865
Wood engraving, black and white
7 ⅛ x 9 ³⁄₁₆ inches (18.1 x 23.3 cm)
Cat. no. 38.00127.002a

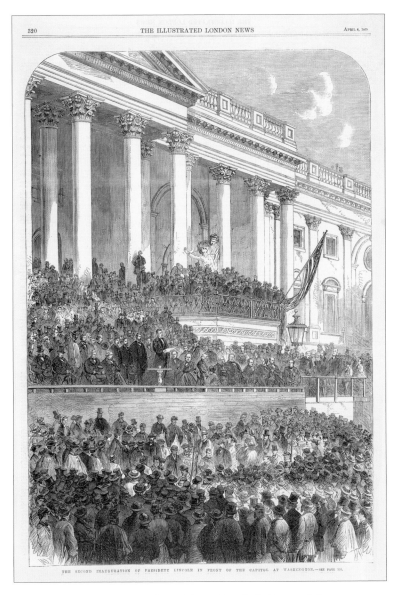

The Second Inauguration of President Lincoln in Front of the Capitol at Washington.

Unidentified
The Illustrated London News, 04/08/1865
Wood engraving, black and white
13 ⁹⁄₁₆ x 9 ⅜ inches (34.4 x 23.8 cm)
Cat. no. 38.00336.001

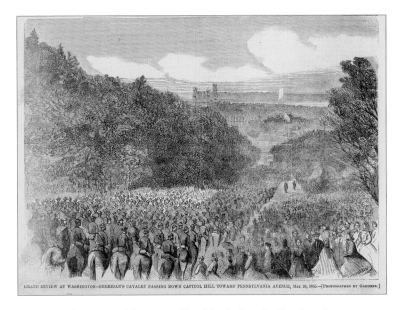

Grand Review at Washington—Sheridan's Cavalry Passing down Capitol Hill toward Pennsylvania Avenue, May 23, 1865.

Unidentified after photograph by Alexander Gardner
Harper's Weekly, 06/10/1865
Wood engraving, black and white
6 ¹³⁄₁₆ x 9 ³⁄₁₆ inches (17.3 x 23.3 cm)
Cat. no. 38.00127.002b

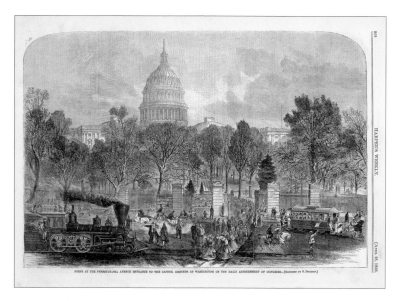

Scene at the Pennsylvania Avenue Entrance to the Capitol Grounds at Washington on the Daily Adjournment of Congress.

Unidentified after Frederick Dielman
Harper's Weekly, 04/28/1866
Wood engraving, hand-colored
9 ⅜ x 13 ¾ inches (23.8 x 34.9 cm)
Cat. no. 38.00059.002

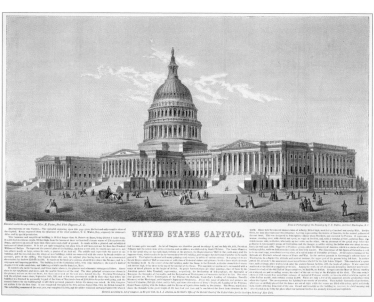

United States Capitol.

George E. Perine after photograph of drawings by Thomas U. Walter
Johnson's Atlas, 1866
Steel engraving, hand-colored
11 x 15 inches (27.9 x 38.1 cm)
Cat. no. 38.00013.002

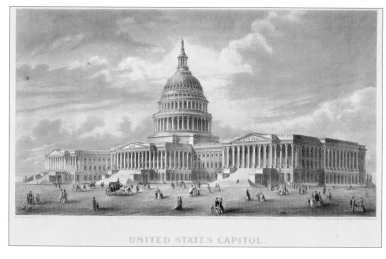

United States Capitol.

C. E. Loven after photograph of drawing by Thomas U. Walter
A. J. Johnson, 1866
Steel engraving, hand-colored
9 ¾ x 15 ¼ inches (24.8 x 38.7 cm)
Cat. no. 38.00110.003

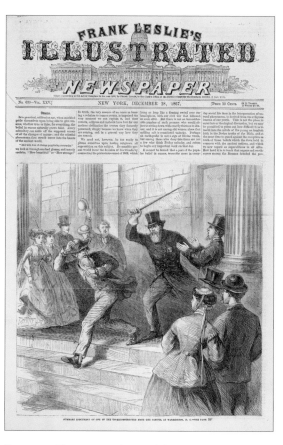

Summary Ejectment of One of the Un-Reconstructed from the Capitol at Washington, D.C.

Unidentified
Frank Leslie's Illustrated Newspaper, 12/28/1867
Wood engraving, black and white
9 ½ x 9 ¼ inches (24.1 x 23.5 cm)
Cat. no. 38.00363.001

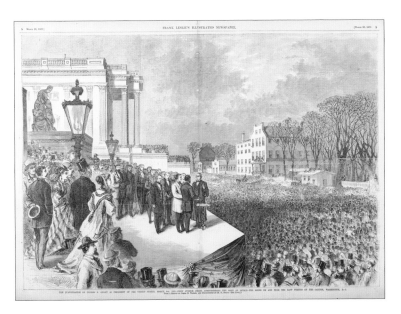

The Inauguration of Ulysses S. Grant as President of the United States, March 4th, 1869—Chief Justice Chase Administering the Oath of Office—The Scene on and near the East Portico of the Capitol, Washington, D.C.

Unidentified after James E. Taylor and photograph by Mathew B. Brady
Frank Leslie's Illustrated Newspaper, 03/20/1869
Wood engraving, black and white
14 ¼ x 20 ⅜ inches (36.2 x 51.8 cm)
Cat. no. 38.00152.001

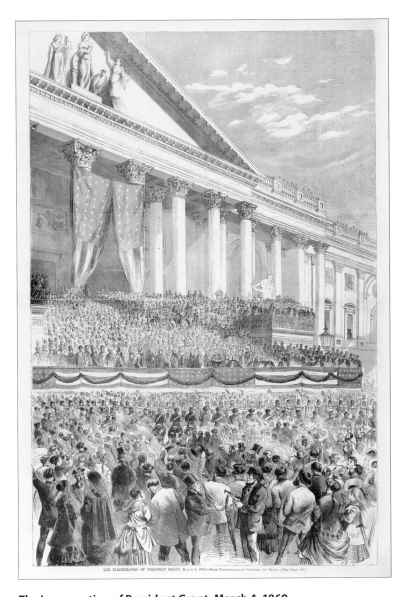

The Inauguration of President Grant, March 4, 1869.

Unidentified after photographs by Alexander Gardner and
Mathew B. Brady
Harper's Weekly, 03/20/1869
Wood engraving, black and white
20 ¾ x 13 ½ inches (52.7 x 34.3 cm)
Cat. no. 38.00010.002

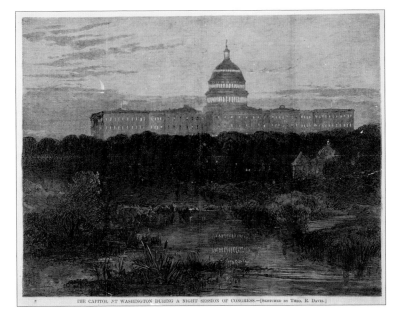

The Capitol at Washington during a Night Session of Congress.

Unidentified after Theodore R. Davis
Harper's Weekly, 05/08/1869
Wood engraving, hand-colored
7 ⅛ x 9 ¹⁄₁₆ inches (18.1 x 23.0 cm)
Cat. no. 38.00040.001

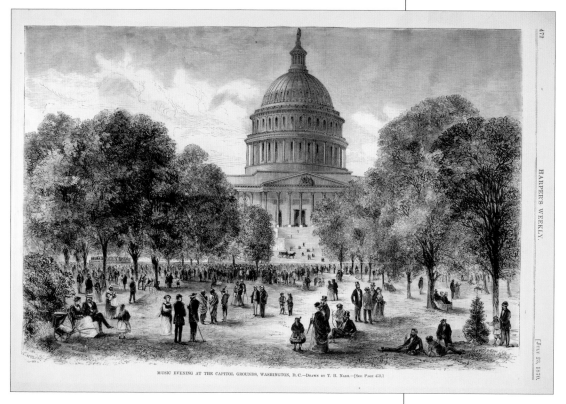

Music Evening at the Capitol Grounds, Washington, D.C.

Unidentified after T. H. Nash
Harper's Weekly, 07/23/1870
Wood engraving, hand-colored
9 ½ x 13 ¾ inches (24.1 x 34.9 cm)
Cat. no. 38.00007.004

Public Buildings in Washington.

John Filmer after William Hamilton Gibson
Picturesque America, 1872
Steel engraving, hand-colored
6 ¾ x 9 inches (17.1 x 22.9 cm)
Cat. no. 38.00049.004

[U.S. Capitol]

Unidentified after Harry Fenn
Picturesque America, 1872
Steel engraving, black and white
9 ⅛ x 7 ½ inches (23.2 x 19.1 cm)
Cat. no. 38.00533.001

Washington from Arlington Heights

Washington from Arlington Heights.

Robert Hinshelwood after William L. Sheppard
Picturesque America, 1872
Steel engraving, hand-colored
6 ½ x 8 ⅝ inches (16.5 x 21.9 cm)
Cat. no. 38.00202.002

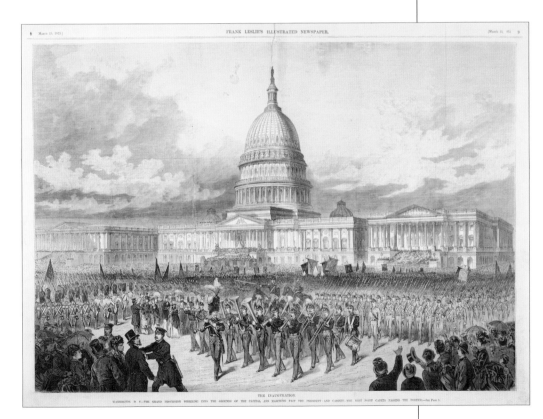

The Inauguration. Washington, D.C.—The Grand Procession Wheeling into the Grounds of the Capitol and Marching Past the President and Cabinet—The West Point Cadets Passing the Portico.

Unidentified
Frank Leslie's Illustrated Newspaper, 03/15/1873
Wood engraving, black and white
14 ½ x 20 inches (36.8 x 50.8 cm)
Cat. no. 38.00104.001

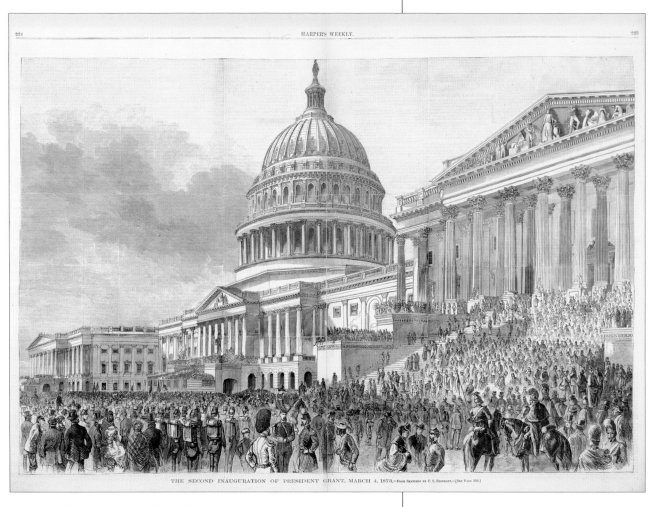

The Second Inauguration of President Grant, March 4, 1873.

Unidentified after Charles S. Reinhart
Harper's Weekly, 03/22/1873
Wood engraving, black and white
13 ¾ x 20 ¼ inches (34.9 x 51.4 cm)
Cat. no. 38.00031.001

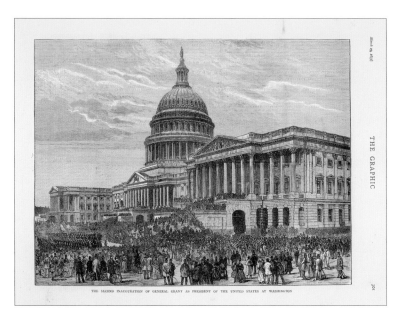

The Second Inauguration of General Grant as President of the United States at Washington

Unidentified
The Graphic, 03/29/1873
Wood engraving, black and white
9 ¼ x 11 ⅞ inches (23.5 x 30.2 cm)
Cat. no. 38.00153.001

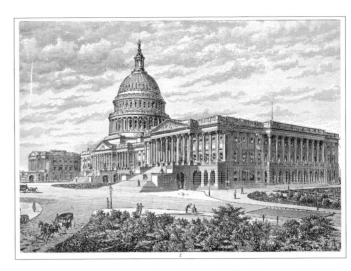

American Architecture. National Capitol, Washington, D.C.

Unidentified
Unidentified, ca. 1876
Wood engraving, black and white
4 ⅜ x 5 ⅞ inches (11.1 x 14.9 cm)
Cat. no. 38.00839.001

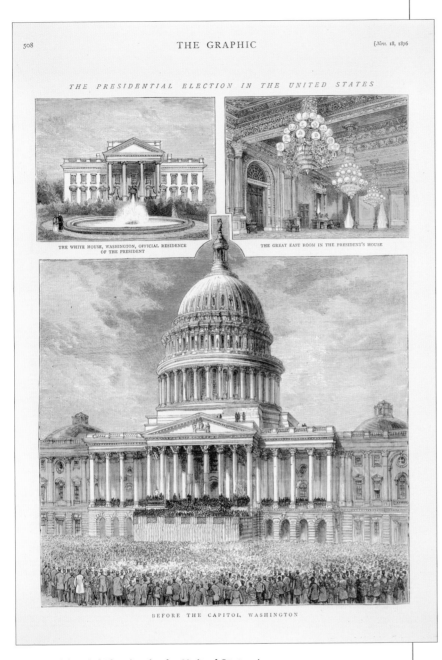

**The Presidential Election in the United States /
Before the Capitol, Washington**

Unidentified
The Graphic, 11/18/1876
Wood engraving, black and white
12 ½ x 8 ¾ inches (31.8 x 22.2 cm)
Cat. no. 38.00243.001

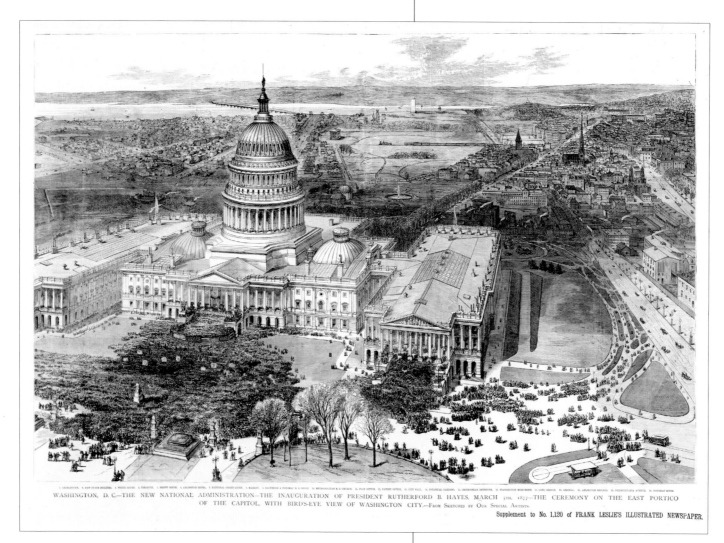

WASHINGTON, D. C.—THE NEW NATIONAL ADMINISTRATION—THE INAUGURATION OF PRESIDENT RUTHERFORD B. HAYES, MARCH 5TH, 1877—THE CEREMONY ON THE EAST PORTICO OF THE CAPITOL, WITH BIRDS-EYE VIEW OF WASHINGTON CITY.—FROM SKETCHES BY OUR SPECIAL ARTISTS.

Supplement to No. 1,120 of FRANK LESLIE'S ILLUSTRATED NEWSPAPER.

**Washington, D.C.—The New National Administration—
The Inauguration of President Rutherford B. Hayes, March 5th, 1877—
The Ceremony on the East Portico of the Capitol, with Bird's-Eye View
of Washington City.**

Unidentified
Frank Leslie's Illustrated Newspaper, 03/17/1877
Wood engraving, black and white
20 ½ x 28 ½ inches (52.1 x 72.4 cm)
Cat. no. 38.00097.001

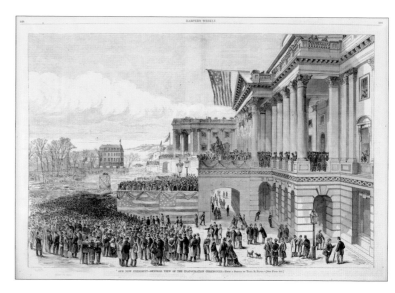

Our New President—General View of the Inauguration Ceremonies.

Unidentified after Theodore R. Davis
Harper's Weekly, 03/24/1877
Wood engraving, black and white
13 ⅜ x 20 inches (34.0 x 50.8 cm)
Cat. no. 38.00106.003

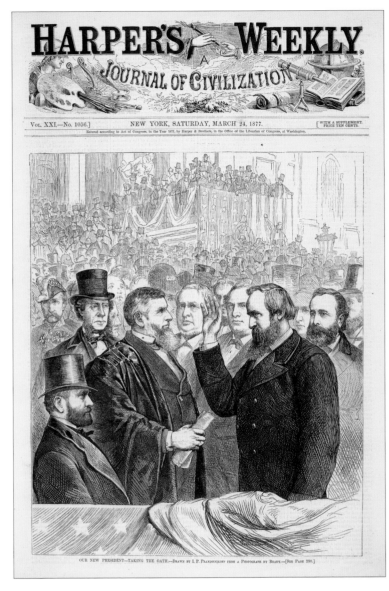

Our New President—Taking the Oath.

Unidentified after I. P. Pranishnikoff after
photograph by Mathew B. Brady
Harper's Weekly, 03/24/1877
Wood engraving, black and white
11 x 9 inches (27.9 x 22.9 cm)
Cat. no. 38.00092.001

The Inauguration of President Garfield.

Unidentified after Arthur B. Frost
Harper's Weekly, 03/18/1881
Wood engraving, black and white
20 ¼ x 13 ⅜ inches (51.4 x 34.0 cm)
Cat. no. 38.00099.001

Washington. D.C.—General J. A. Garfield legt vor dem Oberbundesrichter Waite den Amtseid ab. 4. März 1881.

Unidentified
Frank Leslie's Illustrirte Zeitung, 03/19/1881
Wood engraving, black and white
11 ⅛ x 9 ¼ inches (28.3 x 23.5 cm)
Cat. no. 38.00843.001

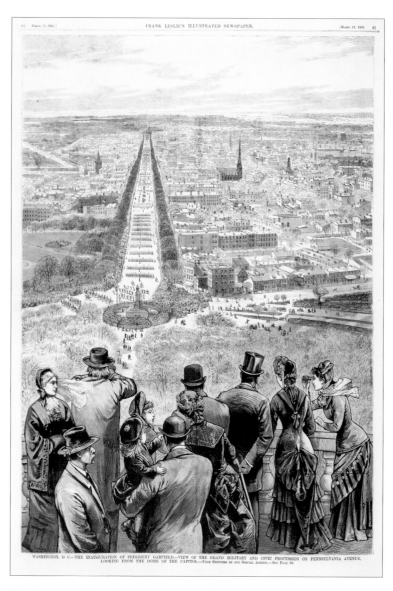

Washington, D.C.—The Inauguration of President Garfield.—View of the Grand Military and Civic Procession on Pennsylvania Avenue, Looking from the Dome of the Capitol.

Unidentified
Frank Leslie's Illustrated Newspaper, 03/19/1881
Wood engraving, black and white
20 ½ x 14 inches (52.1 x 35.6 cm)
Cat. no. 38.00101.002

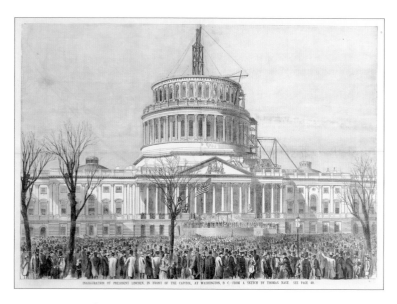

Inauguration of President Lincoln, in Front of the Capitol, at Washington, D.C.

Unidentified after Thomas Nast
Pictorial War Record, 10/01/1881
Wood engraving, black and white
21 x 29 ¾ inches (53.3 x 75.6 cm)
Cat. no. 38.00151.001

Washington, D.C.—The Dome of the Capitol Illuminated during a Session of Congress.

Unidentified
Frank Leslie's Illustrated Newspaper, 12/31/1881
Wood engraving, black and white
9 ½ x 5 ⅞ inches (24.1 x 14.9 cm)
Cat. no. 38.00410.001

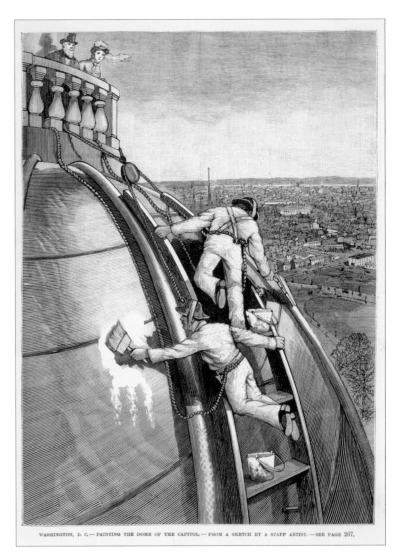

Washington, D.C.—Painting the Dome of the Capitol.

Unidentified
Frank Leslie's Illustrated Newspaper, 12/16/1882
Wood engraving, black and white
9 ½ x 6 ⅞ inches (24.1 x 17.5 cm)
Cat. no. 38.00846.001

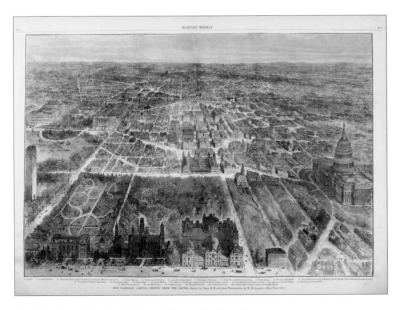

Our National Capitol, Viewed from the South.

Unidentified after Theodore R. Davis after photograph
by William Henry Jackson
Harper's Weekly, 05/20/1882
Wood engraving, hand-colored
14 ¼ x 20 inches (36.2 x 50.8 cm)
Cat. no. 38.00037.001

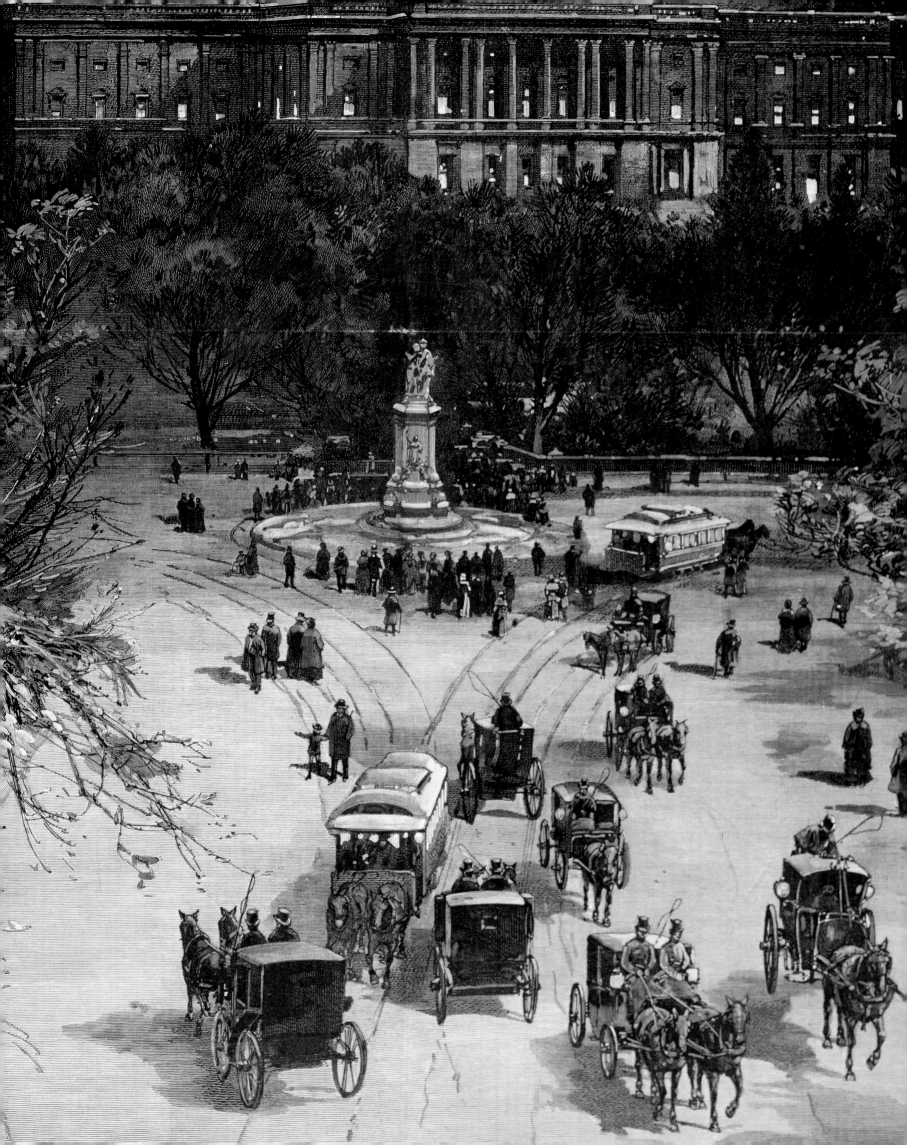

The late 1880s and 1890s are considered watershed years in the history of the Senate and the nation. Old systems and philosophies were being supplanted by a new America—predominantly urban and industrial—energized to take a leading role on the world stage. As the Civil War became a distant memory, a new generation looked to the future with enthusiasm, optimism, and increasing national harmony. This engraving was published in March 1885, four days after Grover Cleveland was sworn in as president—the first Democrat to lead the nation in a quarter century. The next 15 years were marked by major legislation and reform, including efforts to improve the conditions of Native Americans, regulate interstate commerce, and resolve the tariff issues that had plagued the country for decades. The idyllic scene depicted in this print reflects the peaceful optimism felt throughout the nation. Washington, D.C., is blanketed in snow and the Capitol is ablaze as Congress works late into the night attending to the country's needs. ❧

Winter at the National Capital—A Night Session.

William H. Redding after Charles Graham
Harper's Weekly, 03/07/1885
Wood engraving, hand-colored
20 ½ x 13 ½ inches (52.1 x 34.3 cm)
Cat. no. 38.00023.002

Washington, D.C.—Arrival of Military and Other Organizations to Participate in the Inauguration of the President-Elect—Passing the Peace Monument, near the West Front of the Capitol.

Unidentified
Frank Leslie's Illustrated Newspaper, 03/07/1885
Wood engraving, black and white
9 ⅛ x 13 ¾ inches (23.2 x 34.9 cm)
Cat. no. 38.00330.001

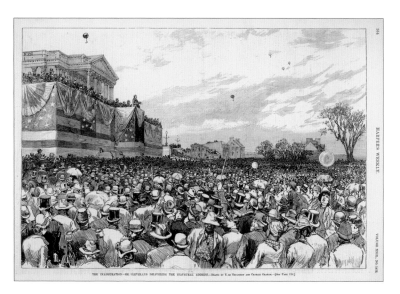

The Inauguration—Mr. Cleveland Delivering the Inaugural Address.

Unidentified after Thure de Thulstrup and Charles Graham
Harper's Weekly, 03/14/1885
Wood engraving, black and white
9 ½ x 13 ⅛ inches (24.1 x 33.3 cm)
Cat. no. 38.00060.002

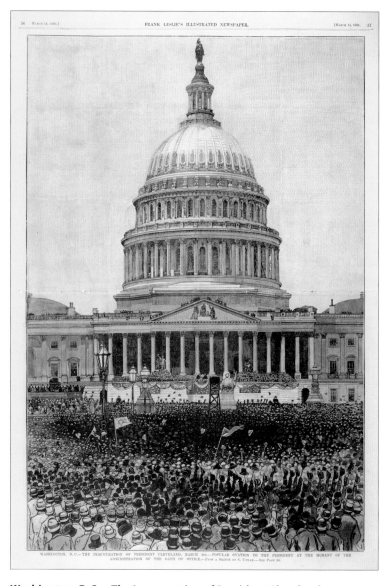

Washington, D.C.—The Inauguration of President Cleveland, March 4th.—Popular Ovation to the President at the Moment of the Administration of the Oath of Office.

Unidentified after Charles E. Upham
Frank Leslie's Illustrated Newspaper, 03/14/1885
Wood engraving, black and white
20 ½ x 13 ¾ inches (52.1 x 34.9 cm)
Cat. no. 38.00034.002

The Garfield Monument Unveiled at Washington, D.C., on May 12, 1887.

Unidentified
Harper's Weekly, 05/14/1887
Wood engraving, black and white
12 x 9 ¼ inches (30.5 x 23.5 cm)
Cat. no. 38.00091.002

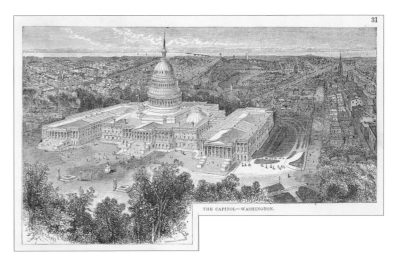

The Capitol—Washington.

Unidentified
Unidentified, ca. 1887
Wood engraving, black and white
3 ½ x 6 inches (8.9 x 15.2 cm)
Cat. no. 38.00658.001

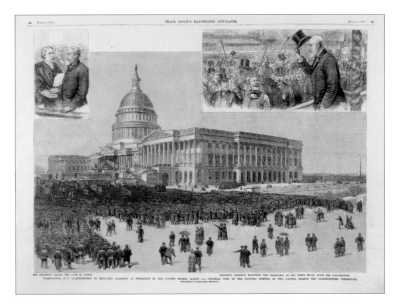

Washington, D.C.—Inauguration of Benjamin Harrison as President of the United States, March 4th—General View of the Eastern Portico of the Capitol during the Inauguration Ceremonies. / The President Taking the Oath of Office. / President Harrison Reviewing the Procession at the White House, after the Inauguration.

Unidentified
Frank Leslie's Illustrated Newspaper, 03/09/1889
Wood engraving, hand-colored
14 ¾ x 19 ¾ inches (37.5 x 50.2 cm)
Cat. no. 38.00912.001

The Capitol—West Front.

Unidentified after S. S. Kilburn
Picturesque Washington, 1888
Wood engraving, hand-colored
4 ¹³⁄₁₆ x 7 ½ inches (12.2 x 19.1 cm)
Cat. no. 38.00425.001

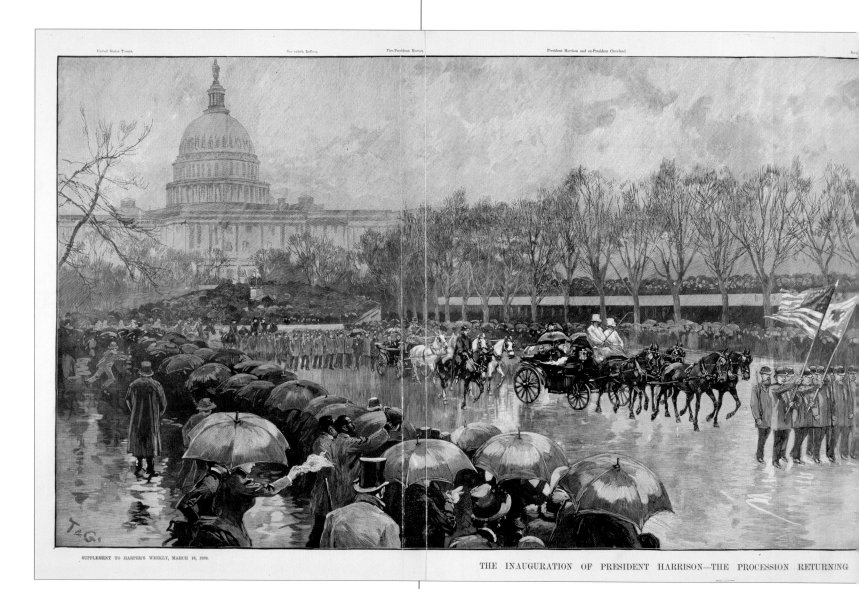

United States Troops. See wrisch Indians. Vice-President Morton. President Harrison and ex-President Cleveland. Sen

SUPPLEMENT TO HARPER'S WEEKLY, MARCH 16, 1889.

THE INAUGURATION OF PRESIDENT HARRISON—THE PROCESSION RETURNING

The Inauguration of President Harrison—The Procession Returning from the Capitol.

Unidentified after Thure de Thulstrup and Charles Graham
Harper's Weekly, 03/16/1889
Wood engraving, black and white
14 ¾ x 43 ⅝ inches (37.5 x 110.8 cm)
Cat. no. 38.00038.003

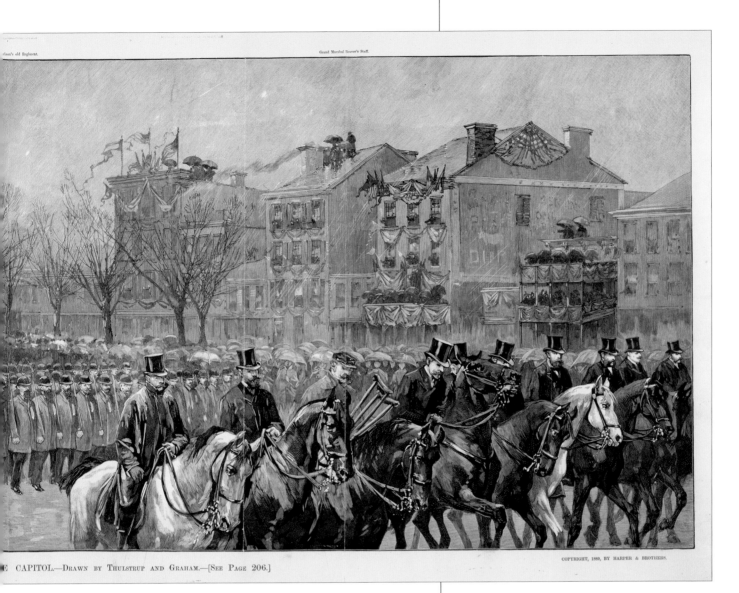

CAPITOL.—Drawn by Thulstrup and Graham.—[See Page 206.]

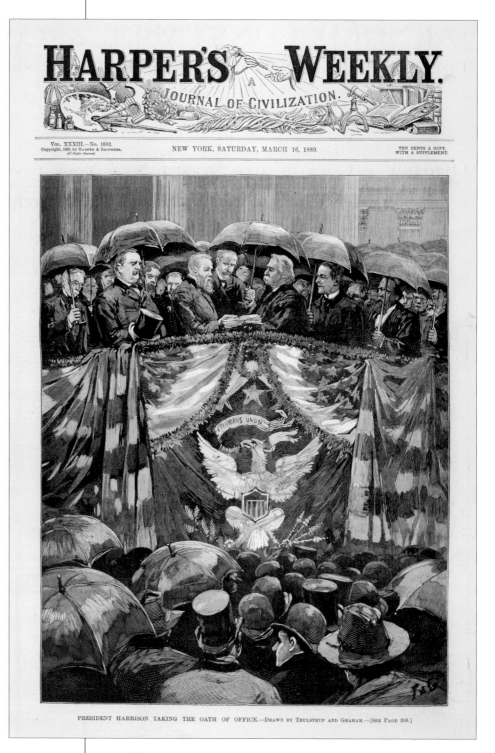

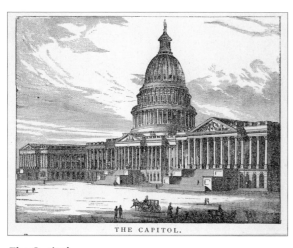

The Capitol.

Unidentified
Unidentified, 1889
Wood engraving, black and white
3 ½ x 4 ¾ inches (8.9 x 12.1 cm)
Cat. no. 38.00974.001a

President Harrison Taking the Oath of Office.

Unidentified after Thure de Thulstrup and Charles Graham
Harper's Weekly, 03/16/1889
Wood engraving, black and white
11 ¼ x 9 ⅛ inches (28.6 x 23.2 cm)
Cat. no. 38.00463.001

Illumination of the Capitol during a Night Session of Congress.

Unidentified
Frank Leslie's Popular Monthly, 04/1890
Wood engraving, black and white
9 ⅛ x 5 ⅞ inches (23.2 x 14.9 cm)
Cat. no. 38.00509.001

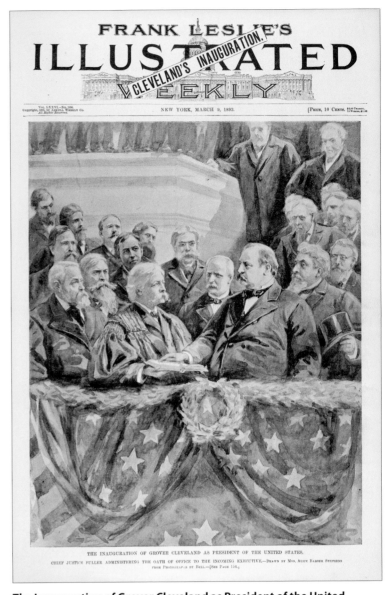

The Inauguration of Grover Cleveland as President of the United States. Chief Justice Fuller Administering the Oath of Office to the Incoming Executive.

Unidentified after Alice Barber Stephens after photographs by Charles M. Bell
Frank Leslie's Illustrated Weekly, 03/09/1893
Halftone, black and white
11 ¹³⁄₁₆ x 9 inches (30.0 x 22.9 cm)
Cat. no. 38.00126.001

Washington—Visitors on the Terrace of the Capitol.

Unidentified after Charles S. Reinhart
Harper's Weekly, 02/25/1893
Halftone, black and white
9 ⁵⁄₁₆ x 13 ¾ inches (23.7 x 34.9 cm)
Cat. no. 38.00532.001

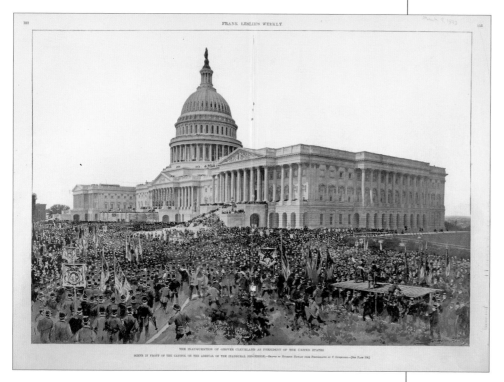

The Inauguration of Grover Cleveland as President of the United States / Scene in Front of the Capitol on the Arrival of the Inaugural Procession

Unidentified after Hughson Hawley after photographs by Frederick Gutekunst
Frank Leslie's Weekly, 03/09/1893
Halftone, black and white
14 ½ x 19 ⅞ inches (36.8 x 50.5 cm)
Cat. no. 38.00957.001

West View of the Capitol, Showing Grand Staircase.

Unidentified
Unidentified, ca. 1895
Photomechanical process, black and white
5 ¼ x 8 inches (13.3 x 20.3 cm)
Cat. no. 38.00833.001

The Inauguration of President McKinley—At the Capitol and on the Line of March.

Unidentified after photographs by Charles M. Bell
Harper's Weekly, 03/13/1897
Halftone, black and white
13 ⅞ x 8 ½ inches (35.2 x 21.6 cm)
Cat. no. 38.00393.001

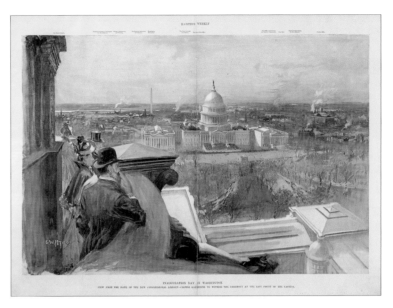

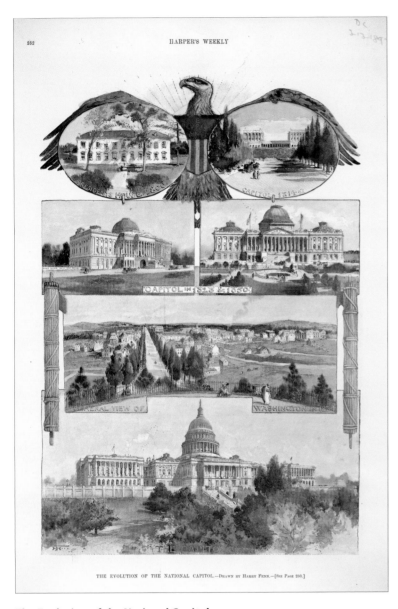

The Evolution of the National Capitol.

Unidentified after Harry Fenn
Harper's Weekly, 03/13/1897
Halftone, colored
13 ¼ x 8 ⅜ inches (33.7 x 21.3 cm)
Cat. no. 38.00254.003

Inauguration Day in Washington. View from the Dome of the New Congressional Library—Crowds Gathering to Witness the Ceremony at the East Front of the Capitol.

Unidentified after G. W. Peters
Harper's Weekly, 03/13/1897
Halftone, black and white
13 ¾ x 19 inches (34.9 x 48.3 cm)
Cat. no. 38.00095.002

The Inauguration of President McKinley. Chief-Justice Fuller Administering the Oath of Office in Front of the Senate Wing of the Capitol.

Unidentified after Thure de Thulstrup
Harper's Weekly, 03/13/1897
Halftone, black and white
11 ¼ x 8 ¼ inches (28.6 x 21.0 cm)
Cat. no. 38.00100.001

The National Capitols of the United States.

Unidentified after Charles E. Upham
Harper's Weekly, 12/15/1900
Halftone, black and white
14 x 9 inches (35.6 x 22.9 cm)
Cat. no. 38.00413.001

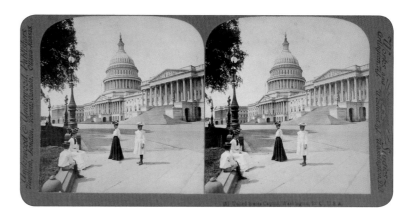

United States Capitol, Washington, D.C., U.S.A.

Unidentified
Underwood & Underwood, ca. 1900
Photograph, black and white
3 ⁷⁄₁₆ x 6 ⅛ inches (8.7 x 15.6 cm)
Cat. no. 38.00703.001

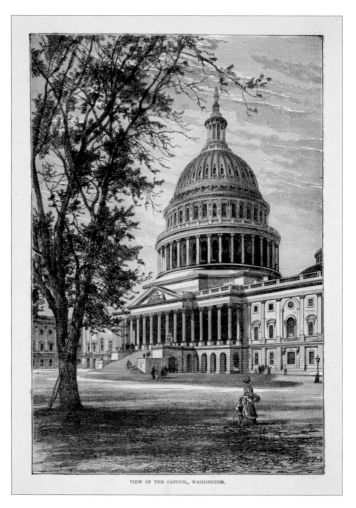

View of the Capitol, Washington.

Unidentified
Unidentified, ca. 1900
Wood engraving, hand-colored
6 ¾ x 5 ⅝ inches (17.1 x 14.3 cm)
Cat. no. 38.00727.001

THE FUTURE OFFICES OF OUR CONGRESSMEN

For years, owing to lack of space, only committees have had rooms in the Capitol at Washington. The fact that the Congressmen have not had private offices near the Capitol building has been a serious detriment. It is now proposed to build a large building having underground connections with the Capitol, where each Congressman may have his own private office

The Future Offices of Our Congressmen

Unidentified after Vernon H. Bailey
Harper's Weekly, 01/17/1903
Halftone, black and white
7 ½ x 10 ⅛ inches (19.1 x 25.7 cm)
Cat. no. 38.00293.002

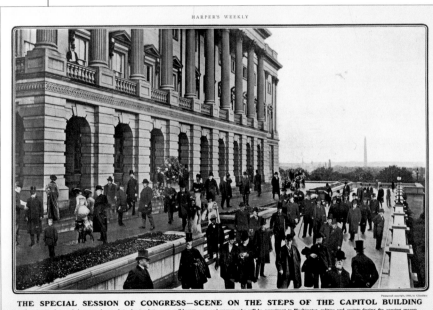

THE SPECIAL SESSION OF CONGRESS—SCENE ON THE STEPS OF THE CAPITOL BUILDING

A composite photograph from actual snap shots, showing forty-seven well-known men and women who will be prominent in Washington politics and society during the coming season

The Special Session of Congress—Scene on the Steps of the Capitol Building

Unidentified after Benjamin West Clinedinst
Harper's Weekly, 11/14/1903
Halftone, black and white
11 ⅝ x 16 ¾ inches (29.5 x 42.5 cm)
Cat. no. 38.00111.001

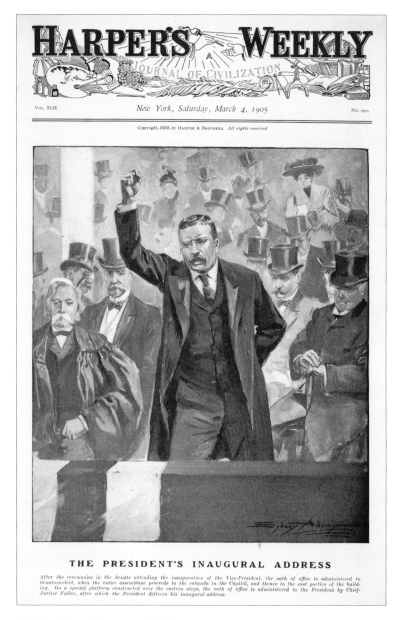

The President's Inaugural Address

Unidentified after Sydney Adamson
Harper's Weekly, 03/04/1905
Halftone, blue and white
9 ⅜ x 7 ¼ inches (23.8 x 18.4 cm)
Cat. no. 38.00098.001

Opening Address of Inauguration Ceremonies.

Unidentified
Unidentified, 1905
Photomechanical process, colored
3 ³⁄₁₆ x 6 inches (8.1 x 15.2 cm)
Cat. no. 38.00702.001

[Dirigible, U.S. Capitol]

Unidentified
Unidentified, 06/14/1906
Photograph, black and white
4 ¾ x 3 ¾ inches (12.1 x 9.5 cm)
Cat. no. 38.00731.001

President Roosevelt Taking the Oath.

Unidentified
Unidentified, 1905
Photomechanical process, colored
3 ³⁄₁₆ x 5 ¹⁵⁄₁₆ inches (8.1 x 15.1 cm)
Cat. no. 38.00709.001

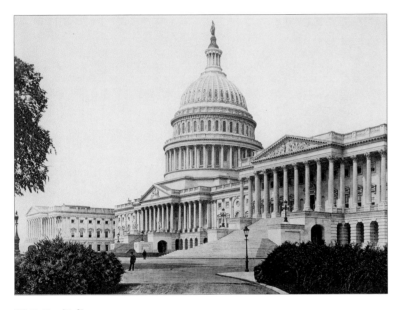

[U.S. Capitol]

Unidentified
Unidentified, ca. 1913
Photomechanical process, black and white
6 ½ x 9 inches (16.5 x 22.9 cm)
Cat. no. 38.00962.001

What the Nation Hopes of Taft / For "President Taft's Opportunity"

Unidentified after photograph from Baker Art Gallery
Christian Herald, 03/03/1909
Halftone, colored
10 ½ x 9 inches (26.7 x 22.9 cm)
Cat. no. 38.00451.001

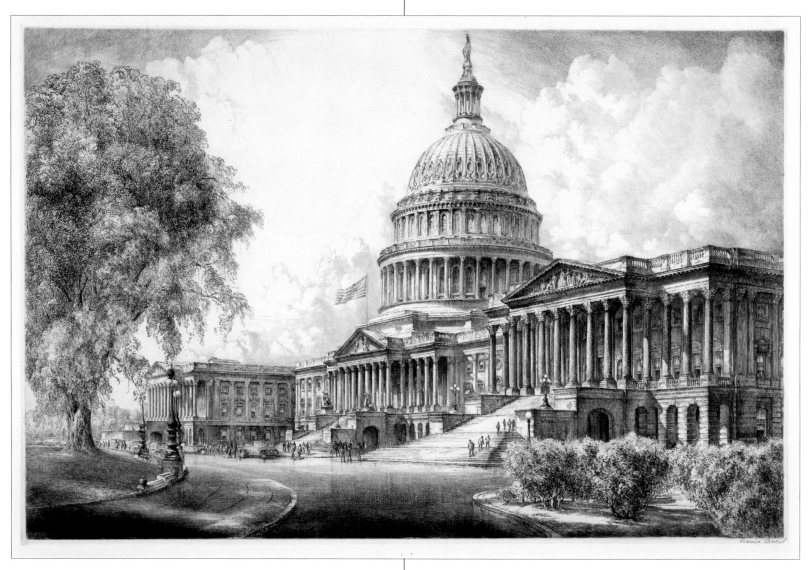

[U.S. Capitol]

Louis Orr
Unidentified, 1920
Etching, black and white
15 x 23 inches (38.1 x 58.4 cm)
Cat. no. 38.00563.001

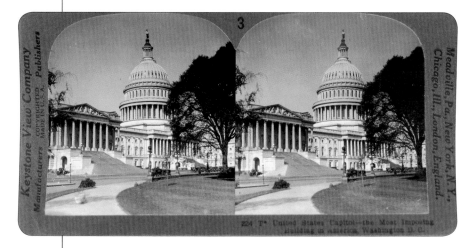

United States Capitol—The Most Imposing Building in America, Washington D.C.

Unidentified
Keystone View Company, date unknown
Photograph, black and white
3 ⁷⁄₁₆ x 6 inches (8.7 x 15.2 cm)
Cat. no. 38.00706.001

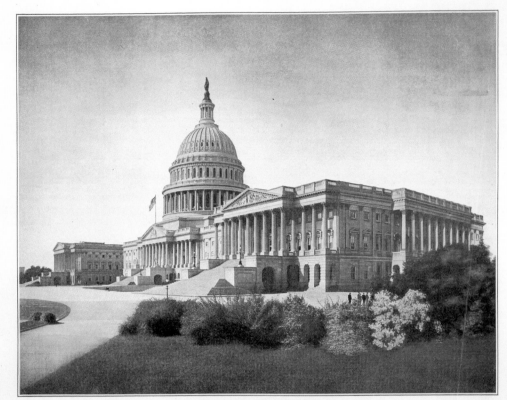

THE CAPITOL, WASHINGTON, D. C.

Corner Stone laid by Washington, September 18, 1793.—Corner Stone of Extensions laid by Fillmore, July 4, 1851.
751 ft. 4 in. long—350 ft. greatest width—Dome 287 ft. 5 in. high. Statue on dome 19 ft. 6 in. Building and grounds cost $26,000,000.

Daniel Webster, in his oration at the laying of the corner stone, July 4, 1851, ably and eloquently expressed the true sentiment deep in the hearts of every loyal and patriotic American citizen, when he said: "With hearts devoutly thankful to Almighty God for the preservation of the liberty and happiness of the country, all here unite in sincere and fervent prayers that this deposit, and the walls and arches, the domes and towers, the columns and entablatures now to be erected over it, may endure forever. God save the United States of America."

The Capitol, Washington, D.C.

Unidentified
Unidentified, ca. 1921
Photomechanical process, colored
8 ¼ x 9 inches (21.0 x 22.9 cm)
Cat. no. 38.00847.001

The Nation's Pride—Washington, Capitol City of the United States, from an Airplane.

Unidentified
Keystone View Company, ca. 1923
Photograph, black and white
3 ⅜ x 6 inches (8.6 x 15.2 cm)
Cat. no. 38.00708.001

The Dazzling Dome of the Capitol on a Rainy Night, Washington, D.C.

Unidentified
Keystone View Company, date unknown
Photograph, black and white
3 ½ x 6 inches (8.9 x 15.2 cm)
Cat. no. 38.00705.001

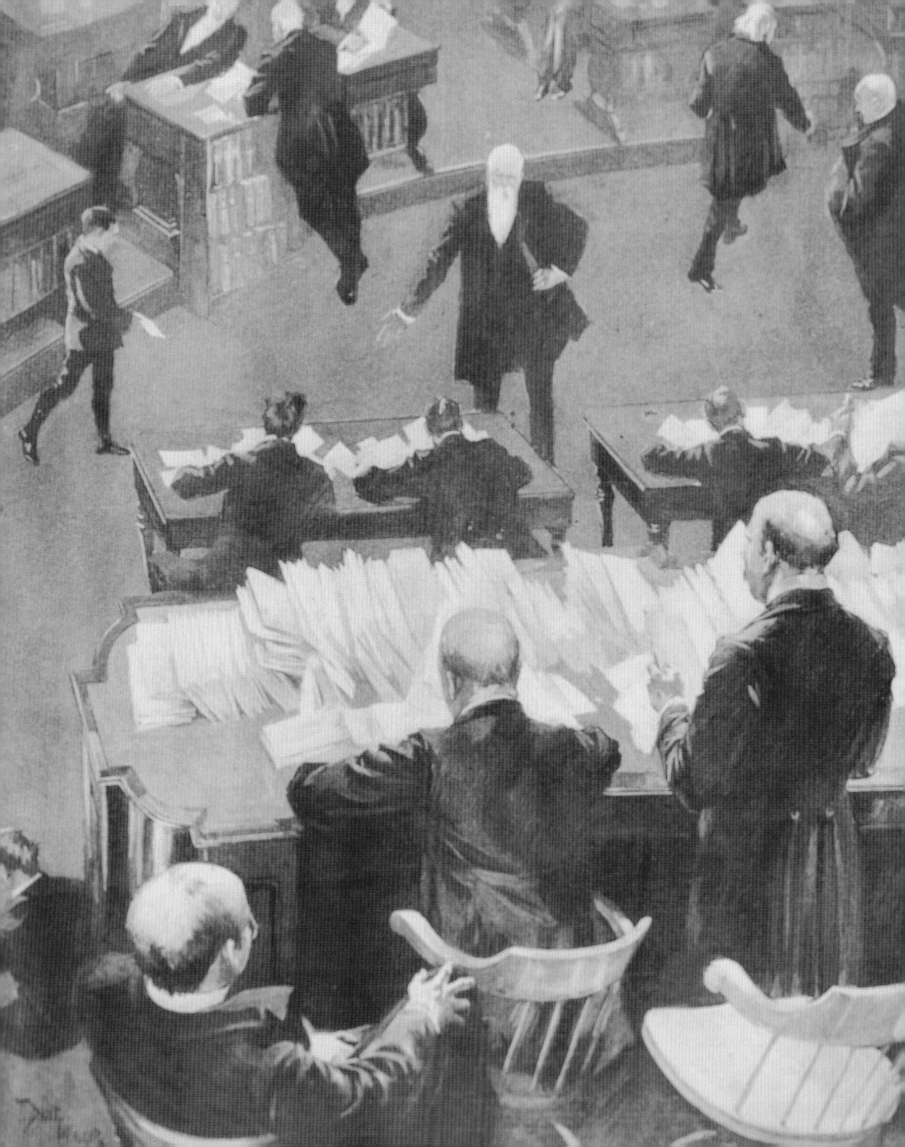

SENATE ART

On display in the Old Senate Chamber in the U.S. Capitol is Rembrandt Peale's striking painting of George Washington, subtitled *Patriæ Pater* (Father of His Country). Also known as the "porthole portrait," the painting incorporates classical elements to create a heroic image of Washington, which Peale hoped would become the "Standard likeness" of the first president.[1] To promote the portrait and provide additional income, Peale exhibited the painting in Europe, made numerous oil replicas (more than 75), and created a print for sale to the

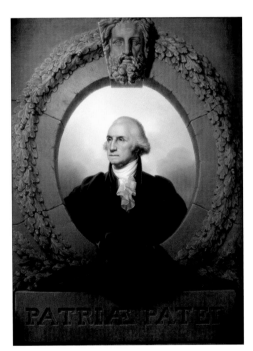

George Washington (Patriæ Pater)
by Rembrandt Peale, 1823, oil on canvas.
(U. S. Senate Collection)

public (38.00982.001). He drew the lithograph in the spring of 1827 in the Boston studio of William and John Pendleton, whose state-of-the-art printing press was highly regarded. Peale was one of the first American artists to become skilled in the lithographic process, and he personally redrew his composition on stone to create this popular image. Contemporary critics considered it the finest print produced in America, and it won a silver medal, the highest award, at the 1827 exhibition at the Franklin Institute in Philadelphia. The popularity of the print helped Peale publicize his work and increase his reputation. ☙

[1] Lillian B. Miller and Carol Eaton Hevner, *In Pursuit of Fame: Rembrandt Peale, 1778–1860,* (Washington, D.C.: National Portrait Gallery; Seattle: University of Washington Press, 1992), 144.

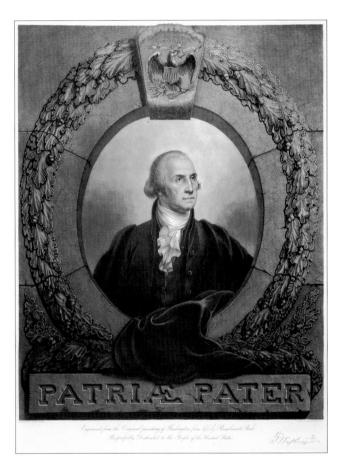

[George Washington]

Adam B. Walter after painting by Rembrandt Peale
Unidentified, ca. 1865
Engraving, black and white
20 ¼ x 15 ⅛ inches (51.4 x 38.4 cm)
Cat. no. 38.00473.001

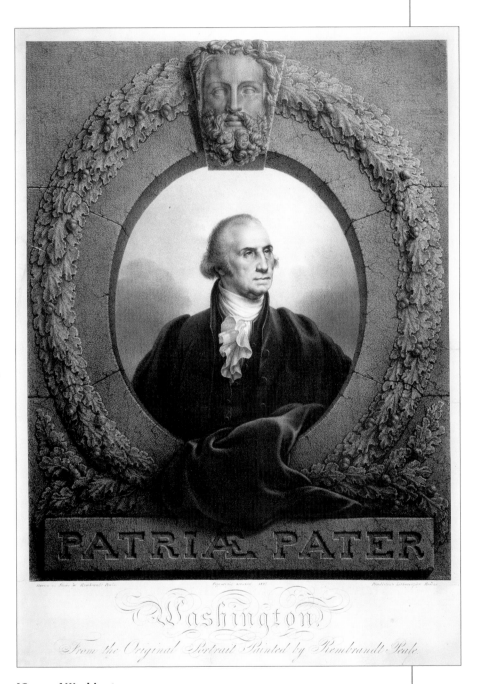

[George] Washington.

Rembrandt Peale
Pendleton's Lithography, 1827
Lithograph, black and white
18 ¾ x 15 ⅛ inches (47.6 x 38.4 cm)
Cat. no. 38.00982.001

*I*n 1840 noted Philadelphia engraver John Sartain copied John Blake White's painting of *General Marion Inviting a British Officer to Share His Meal*, now owned by the U.S. Senate. The mezzotint was made for the Apollo Association for the Promotion of the Fine Arts in the United States, a group that showcased American painters by making their work available to a wider audience. Sartain's print was the first in a series of engravings made from American paintings and distributed to the association's members. He received numerous commissions throughout his career to create prints based on paintings by such noted artists as Thomas Sully and Benjamin West. Sartain is credited with introducing illustrations into American periodicals and pioneering mezzotint engraving. This image depicts one of the many legendary exploits of Revolutionary War General Francis Marion. According to the tale, while camped on Snow's Island, South Carolina, around 1781, the general received a British officer who had been sent to arrange an exchange of prisoners. After completing their business, General Marion (right center with plumed shako) asked the visiting officer to stay for a meal. The officer was surprised by the modest fare and the dedication of the American soldiers. ❧

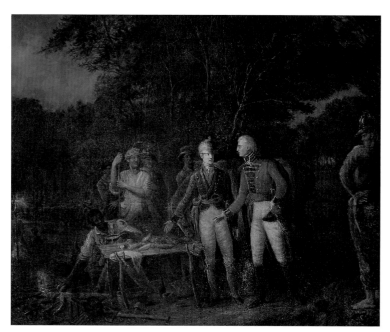

General Marion Inviting a British Officer to Share His Meal
by John Blake White, date unknown, oil on canvas.
(U.S. Senate Collection)

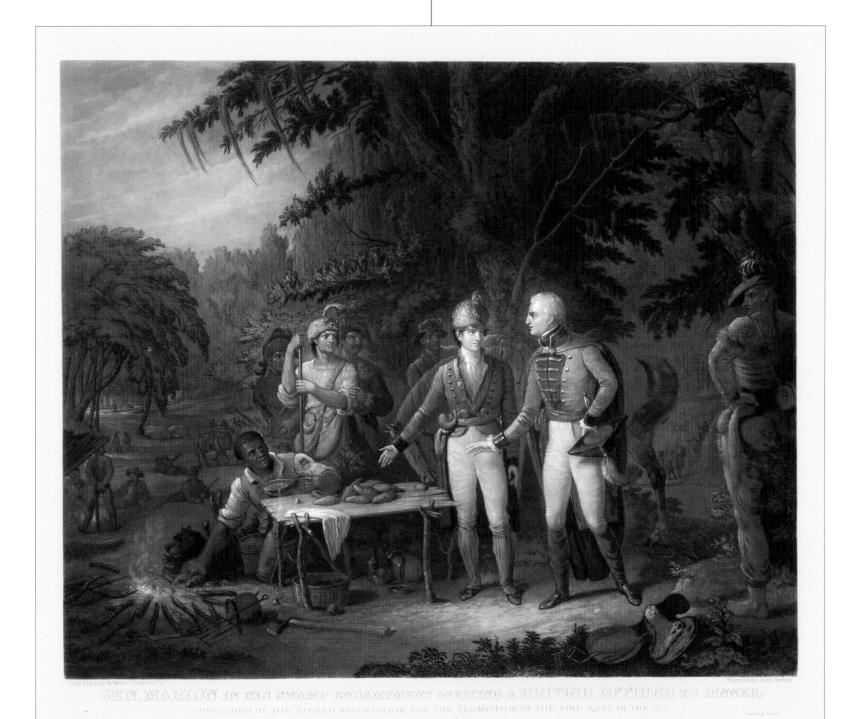

Gen. Marion in His Swamp Encampment Inviting a British Officer to Dinner.

John Sartain after painting by John Blake White
The Apollo Association for the Promotion of the Fine Arts
in the United States, 1840
Mezzotint, black and white
18 ¼ x 20 ⅜ inches (46.4 x 51.8 cm)
Cat. no. 38.00961.001

homas Sully first painted Andrew Jackson in 1824. The hero of the Battle of New Orleans was by then a U.S. senator from Tennessee and a Democratic nominee for president. Sully painted a total of 11 portraits of Jackson, from a head-only likeness to a full-length, life-size image. One of the half-length portraits came into the possession of Francis Preston Blair, Jr., a lawyer, politician, and later U.S. representative and senator from Missouri. Blair was reported to have loaned his Sully painting to Philadelphia publisher George W. Childs, who had Thomas Welch engrave the Jackson portrait. Childs sent complimentary copies of the engraving to prominent individuals, hoping for testimonials that could be published in newspapers to increase sales of the print. Sully's half-length image of Jackson is the most widely recognized portrait of the president; it was the basis for the likeness that appears on the $20 bill.

Andrew Jackson
attributed to Thomas Sully, ca. 1857,
oil on canvas. (U.S. Senate Collection)

The Senate owns an oil on canvas painting attributed to Thomas Sully that shares many stylistic similarities to the 1852 Welch engraving, especially in the hair, eyebrows, chin, and facial lines, but differs from Sully's other Jackson portraits. Although Sully may have replicated it from an engraving of his own painting, it is also possible that the Senate's oil portrait was copied from Welch's engraving by another, unidentified artist. ☙

[Andrew] Jackson.

Thomas B. Welch after painting by Thomas Sully
George W. Childs, 1852
Engraving, black and white
22 ½ x 17 ½ inches (57.2 x 44.5 cm)
Cat. no. 38.00963.001

"We have met the enemy and they are ours—two ships, two brigs, one schooner and a sloop." With this simple victory message to General William Henry Harrison, commander of the U.S. forces in the Northwest Territory, Commodore Oliver Hazard Perry announced his victory over the British fleet at the Battle of Lake Erie. The battle ensured American control of the Great Lakes during the War of 1812, and secured the country's tenuous hold on the Northwest. Artist William Henry Powell captured this historic event in a monumental painting that dominates the east grand stairway in the Senate wing of the U.S. Capitol. A stereoview (38.00476.001), by Washington, D.C., publisher John F. Jarvis, shows a detail from Powell's painting—it depicts the moment when Perry made his way in a rowboat, through enemy fire, from his severely damaged flagship, the *Lawrence*, to another ship, the *Niagara*, where he took command and soundly defeated the British. Stereoviews were popular with the public by the 1860s, and viewing stereo cards became a common pastime for middle and upper class America. Jarvis's photograph may have been bought as a souvenir from a Capitol visit, or purchased by someone who would never have the opportunity to see the building, but wanted a collectible symbol representing the nation's Capitol. ॐ

Battle of Lake Erie
by William Henry Powell, 1873, oil on canvas.
(U.S. Senate Collection)

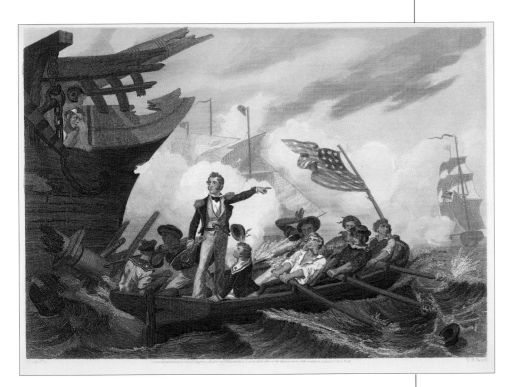

Battle of Lake Erie.

Unidentified after an 1865 painting by William Henry Powell
Johnson, Fry & Co., 1866
Metal engraving, black and white
7 5/16 x 10 3/4 inches (18.6 x 27.3 cm)
Cat. no. 38.00953.001

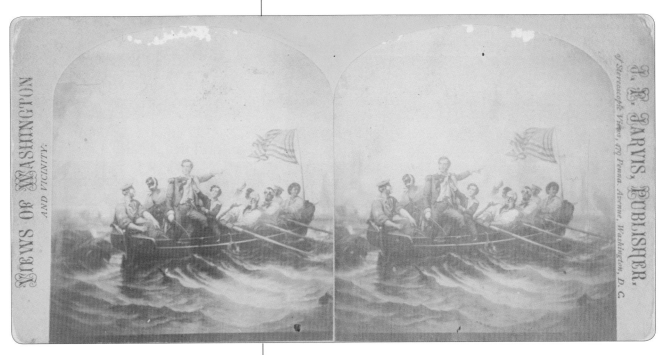

Perries [sic] Victory on Lake Erie.

Unidentified after painting by William Henry Powell
John F. Jarvis, date unknown
Photograph, black and white
3 1/4 x 6 1/16 inches (8.3 x 15.4 cm)
Cat. no. 38.00476.001

*I*t took Francis Bicknell Carpenter only six months to paint his 15-foot-wide canvas of the *First Reading of the Emancipation Proclamation by President Lincoln.* As the title suggests, the scene shows members of Abraham Lincoln's cabinet gathered at the White House on July 22, 1862, to hear the president read his draft of the Emancipation Proclamation. Depicted in the painting are, from left to right: Edwin M. Stanton, secretary of war; Salmon P. Chase, secretary of the treasury; President Lincoln; Gideon Welles, secretary of the navy; Caleb B. Smith, secretary of the interior (standing); William H. Seward, secretary of state (seated); Montgomery Blair, postmaster general; and Edward Bates, attorney general. Soon after completing his masterpiece, Carpenter commissioned Alexander Hay Ritchie to create an engraving of the painting in hopes of advancing its popularity. Ritchie, who emigrated from Scotland in 1841, was a successful and accomplished painter and engraver of historical and allegorical subjects, and also created superb mezzotint portraits. The *New York Evening Post* predicted that the engraving would "take its place among the pictures which the people hang upon their walls to commemorate one of the great and most notable acts in the nation's history."[1] President Lincoln himself signed on as the first subscriber, requesting an artist's proof. ⌘

First Reading of the Emancipation Proclamation by President Lincoln
by Francis Bicknell Carpenter, 1864, oil on canvas.
(U.S. Senate Collection)

[1] Francis B. Carpenter, *Six Months at the White House with Abraham Lincoln. The Story of A Picture.* New York: Hurd and Houghton, 1867, appendix.

The First Reading of the Emancipation Proclamation before the Cabinet.

Alexander Hay Ritchie after painting by Francis Bicknell Carpenter
Derby and Miller, 1866
Metal engraving, black and white
23 ½ x 33 ½ inches (59.7 x 85.1 cm)
Cat. no. 38.00450.001

See appendix p. 482 for key

*I*n the summers of 1877 and 1878, artist Cornelia Adèle Fassett set up a temporary studio in the U.S. Capitol's Supreme Court Chamber (now the Old Senate Chamber) to paint her monumental group portrait of the Electoral Commission meeting in the room over the disputed Hayes-Tilden election of 1876. The federal government did not commission the painting; Fassett created it independently, but was granted special access to record the historic event. While the architectural features are correct, Fassett took some artistic license—not all of the individuals depicted attended the hearings. She also interjected her own political concerns into the scene, such as including abolitionist Frederick Douglass (far right side, below center), champion of African American equality, and writer Mary Clemmer Ames (lower right corner), a vigorous advocate for women suffrage and equality. The artist depicted herself (bottom foreground, right of center) holding her sketchbook and drawing the head of William M. Evarts, counsel for Hayes. This detailed key was produced by the firm of J. F. Gedney the same year Fassett completed her group portrait. The painting was purchased by Congress in 1886. ☙

The Florida Case before the Electoral Commission
by Cornelia Adèle Strong Fassett, 1879, oil on canvas.
(U.S. Senate Collection)

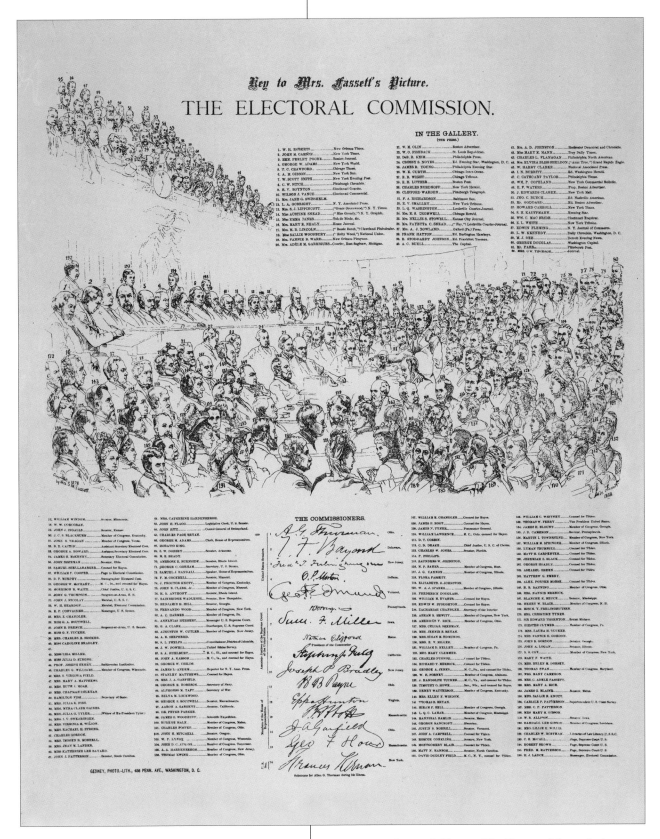

Key to Mrs. Fassett's Picture. The Electoral Commission.

Gedney, Photo.-Lith. after painting by Cornelia Adèle
Strong Fassett
Unidentified, 1879
Wood engraving, black and white
14 ⅝ x 11 ¼ inches (37.1 x 28.6 cm)
Cat. no. 38.00373.001

For many, the quintessential image of Revolutionary War hero Patrick Henry is Thomas Sully's half-length portrait, now owned by the Virginia Historical Society in Richmond. The Senate has an oil on canvas copy of Sully's portrait by George Matthews. In 1896 John C. Yorsten & Co. also copied Thomas Sully's painting as a metal engraving. Yorsten included below the portrait an image of the old Virginia Capitol in Williamsburg, site of many of

Patrick Henry
by George Bagby Matthews after Thomas Sully,
ca. 1891, oil on canvas. (U.S. Senate Collection)

Henry's famous speeches. Henry will forever be remembered by Americans for his courageous patriotism and for his stirring words, "Give me liberty or give me death!" His eloquent call to arms, reported to be from a speech he delivered in 1775 at the second Virginia Convention, galvanized his fellow colonists to action. As the movement for independence grew, Henry served as a delegate to both the first and second Continental Congresses, and was largely responsible for the establishment of a colonial militia. He helped draft a constitution for the new state of Virginia, served as its first governor, and was among those most responsible for adding a bill of rights to the Constitution. ☙

P[atrick]. Henry

Unidentified after Bather after painting by
Thomas Sully
John C. Yorsten & Co., 1896
Metal engraving, black and white
9 ¹¹⁄₁₆ x 6 inches (24.6 x 15.2 cm)
Cat. no. 38.00487.001

ew York illustrator T. Dart Walker produced this image for the front cover of the December 23, 1899, issue of *Leslie's Weekly*. The Senate now owns the original painting. *Leslie's* technicians transferred the watercolor into a halftone image, a process that gained popularity among illustrated newspapers in the late 19th century. In the scene, Walker depicts the Senate Chamber as it appeared at the opening of a session of Congress. Senators have just introduced bills for consideration during the session, and the large number of papers suggests a heavy workload lies before them. The artist captured the view from the press gallery on the north side of the Chamber. In the lower half of the print, three Senate staff members sit in front of the presiding officer's desk (not shown). Most likely these men are, from left to right, the secretary of the Senate, the legislative clerk, and the reading clerk. Senators discuss the business at hand, and two Senate pages can be seen— these young boys ran errands for the members and handled other minor tasks as assigned. ❧

Spending Uncle Sam's Money
by T. Dart Walker, ca. 1899, watercolor on board.
(U.S. Senate Collection)

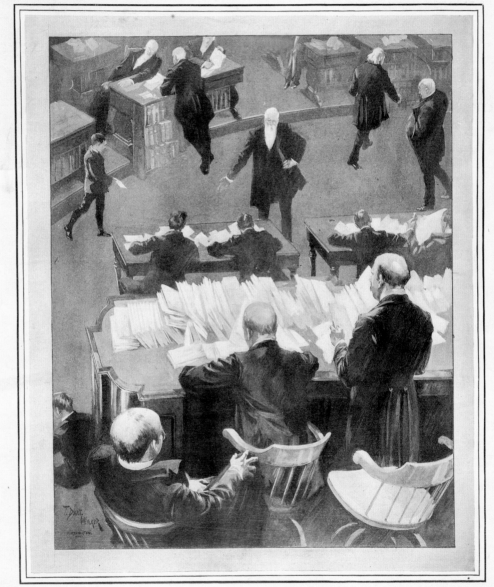

ILLUSTRATED REVIEW OF THE COLLEGE FOOT-BALL SEASON, BY CHARLES E. PATTERSON.

LESLIE'S WEEKLY
ILLUSTRATED

Vol. LXXXIX.—No. 2311.
Copyright, 1899, by JUDGE COMPANY, No. 110 Fifth Avenue.
Title Registered as a Trade-mark. All Rights Reserved.

NEW YORK, DECEMBER 23, 1899.

PRICE, 10 CENTS. $4.00 YEARLY
13 WEEKS $1.00.
Entered as second-class matter at the New York Post-office.

SPENDING UNCLE SAM'S MONEY.

SENATORS INTRODUCING THE CUSTOMARY BATCH OF MISCELLANEOUS BILLS AT THE OPENING OF THE SESSION OF CONGRESS.—SKETCHED FROM THE PRESS GALLERY, DIRECTLY OVER THE CLERK'S DESK, BY OUR SPECIAL ARTIST, T. DART WALKER.

Spending Uncle Sam's Money.

Unidentified after painting by T. Dart Walker
Leslie's Weekly, 12/23/1899
Halftone, black and white
11 ½ x 9 inches (29.2 x 22.9 cm)
Cat. no. 38.00588.001

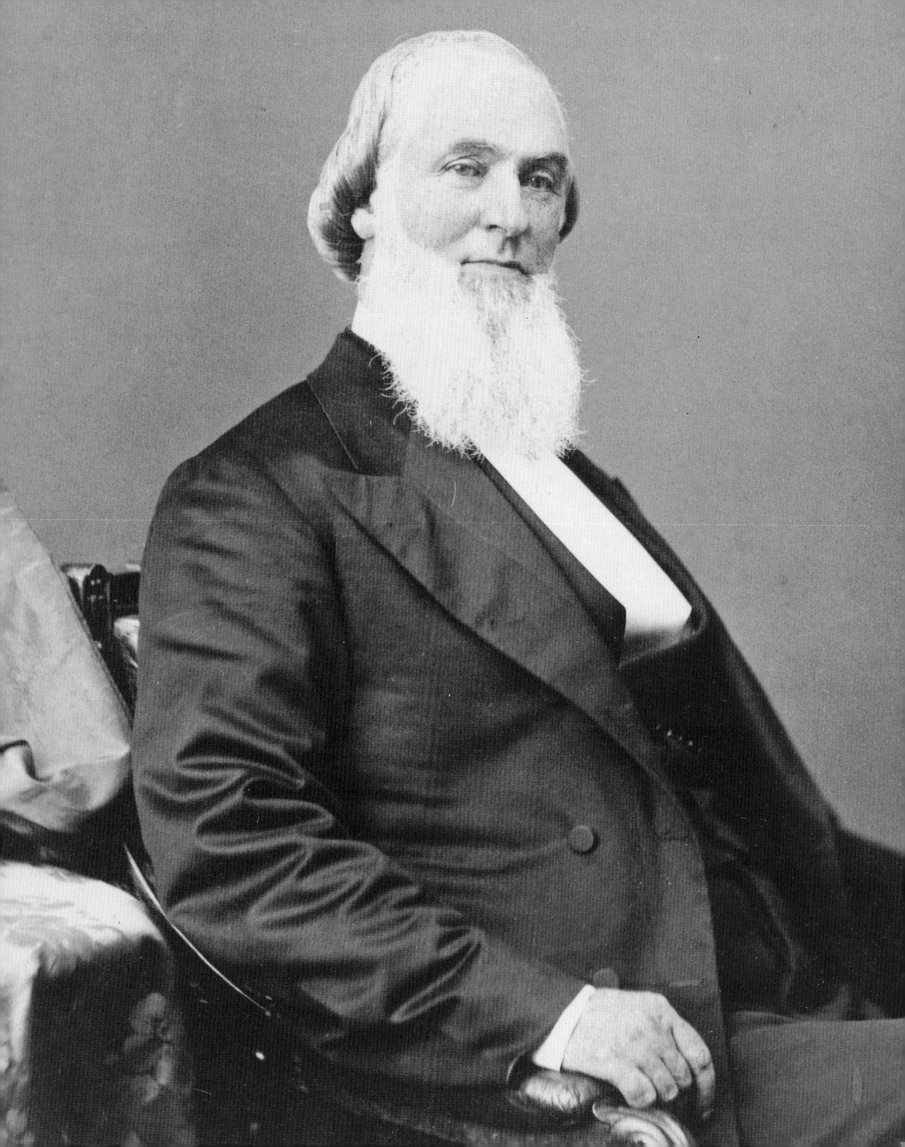

PORTRAITS

John Quincy Adams.

Edmund Burke Kellogg and Elijah Chapman Kellogg
after William Henry Brown
Portrait Gallery of Distinguished American Citizens, 1845
Lithograph, colored
14 ½ x 9 ¾ inches (36.8 x 24.8 cm)
Cat. no. 38.00065.001

Senator William B. Allison, of Iowa.

R. Staudenbaur
Harper's Weekly, 03/17/1888
Wood engraving, black and white
12 x 8 ½ inches (30.5 x 21.6 cm)
Cat. no. 38.00806.001

[Mrs. Isaac Bassett]

Unidentified
Unidentified, ca. 1861
Photograph, black and white
3 9/16 x 2 1/8 inches (9.0 x 5.4 cm)
Cat. no. 38.00913.001

[Isaac Bassett]

Unidentified
Unidentified, ca. 1861
Photograph, black and white
3 9/16 x 2 5/16 inches (9.0 x 5.9 cm)
Cat. no. 38.00914.001

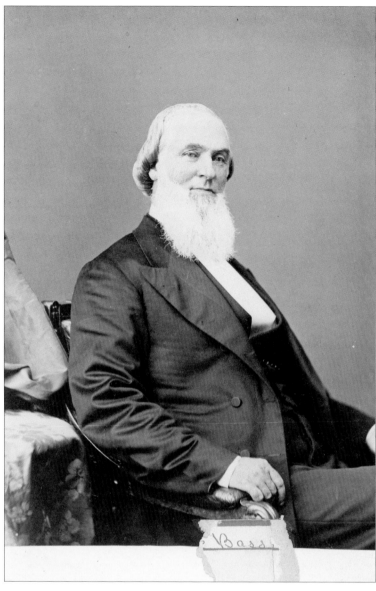

[Isaac Bassett]

Mathew B. Brady
Brady's National Photographic Portrait Galleries, ca. 1865
Photograph, black and white
5 ¾ x 4 inches (14.6 x 10.2 cm)
Cat. no. 38.00960.001

[Isaac Bassett]

Charles Parker
Unidentified, ca. 1890
Photograph, black and white
5 ⅝ x 3 ⅞ inches (14.3 x 9.8 cm)
Cat. no. 38.00801.001

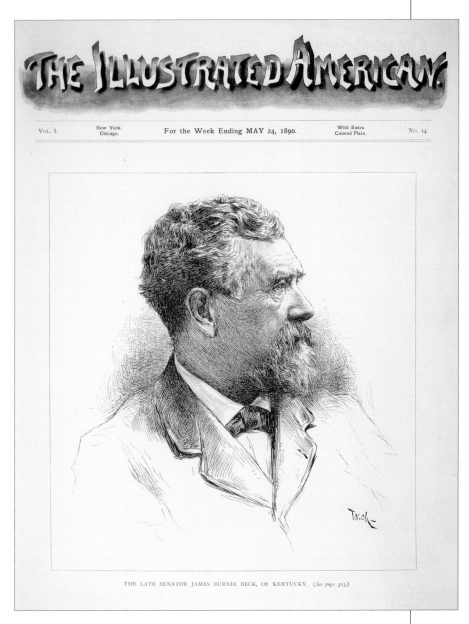

Gallery of Possible Presidential Candidates. No. 7—Hon. Thomas F. Bayard, United States Senator from Delaware.

Unidentified
Frank Leslie's Illustrated Newspaper, 05/29/1880
Wood engraving, black and white
11 ¼ x 9 ¼ inches (28.6 x 23.5 cm)
Cat. no. 38.00860.001

The Late Senator James Burnie Beck, of Kentucky.

Unidentified after W. Ch
The Illustrated American, 05/24/1890
Lithograph, black and white
10 ⅛ x 9 ⅛ inches (25.7 x 23.2 cm)
Cat. no. 38.00808.001

Gallery of Possible Presidential Candidates. No. 3.—Hon. James G. Blaine, United States Senator from Maine.

Unidentified after Thure de Thulstrup
Frank Leslie's Illustrated Newspaper, 05/01/1880
Wood engraving, black and white
11 ¼ x 9 inches (28.6 x 22.9 cm)
Cat. no. 38.00861.001

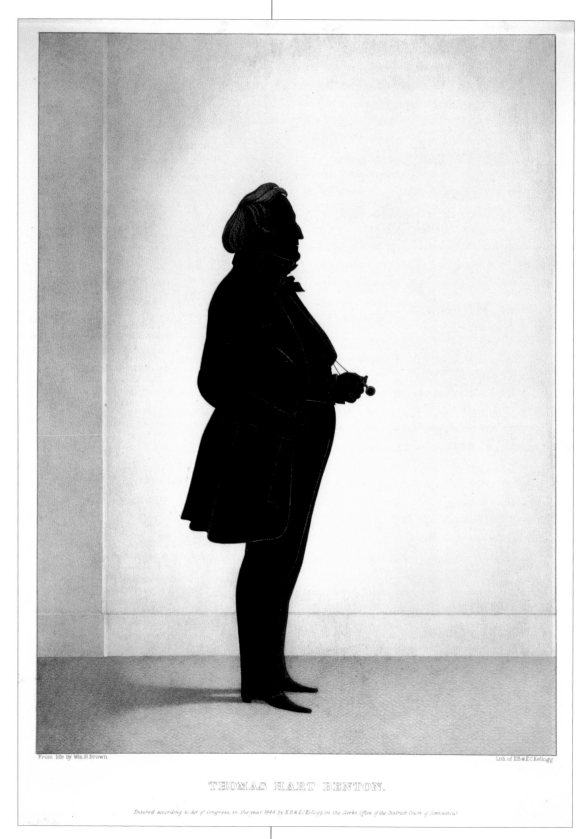

THOMAS HART BENTON.

From life by Wm.H.Brown.

Lith. of E.B.& E.C.Kellogg

Entered according to Act of Congress, in the year 1844 by E.B.& E.C.Kellogg, in the Clerks Office of the District Court of Connecticut.

Thomas Hart Benton.

Edmund Burke Kellogg and Elijah Chapman Kellogg
after William Henry Brown
Portrait Gallery of Distinguished American Citizens, 1845
Lithograph, colored
14 ½ x 10 inches (36.8 x 25.4 cm)
Cat. no. 38.00066.001

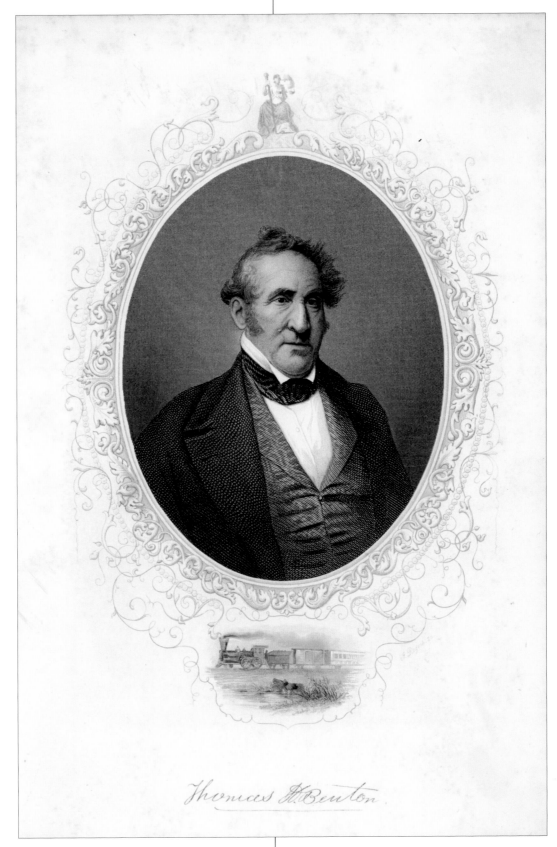

Thomas H. Benton

Thomas H. Benton

John Rogers
Unidentified, 1865
Steel engraving, hand-colored
8 ⅛ x 5 ⅜ inches (20.6 x 13.7 cm)
Cat. no. 38.00249.001

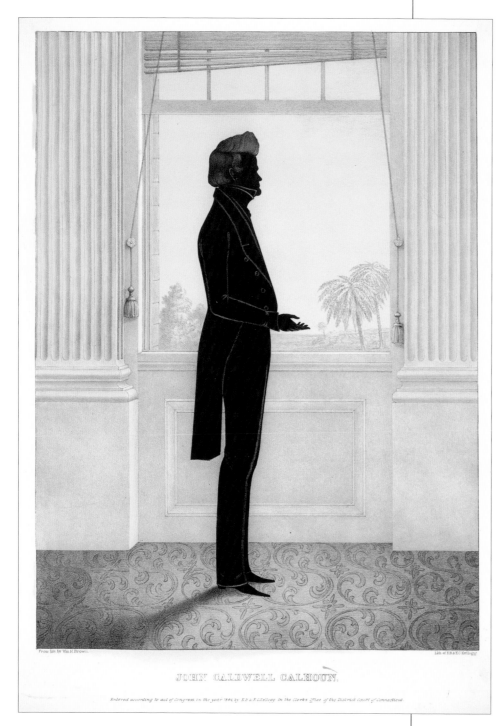

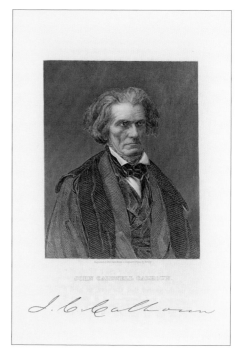

John Caldwell Calhoun.

Henry B. Hall after daguerreotype by
Mathew B. Brady
Bancroft's, ca. 1850
Steel engraving, black and white
5 ¾ x 4 ½ inches (14.6 x 11.4 cm)
Cat. no. 38.00700.001

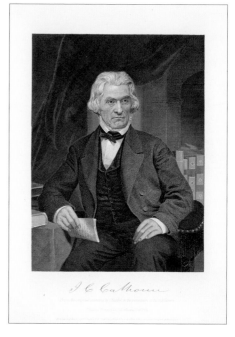

J[ohn] C[aldwell] Calhoun

Unidentified after Alonzo Chappel
Johnson, Wilson & Co., 1873
Metal engraving, black and white
8 ⅞ x 5 ⅜ inches (22.5 x 13.7 cm)
Cat. no. 38.00735.001

John Caldwell Calhoun.

Edmund Burke Kellogg and Elijah Chapman Kellogg
after William Henry Brown
Portrait Gallery of Distinguished American Citizens, 1845
Lithograph, colored
14 ¼ x 10 inches (36.2 x 25.4 cm)
Cat. no. 38.00207.001

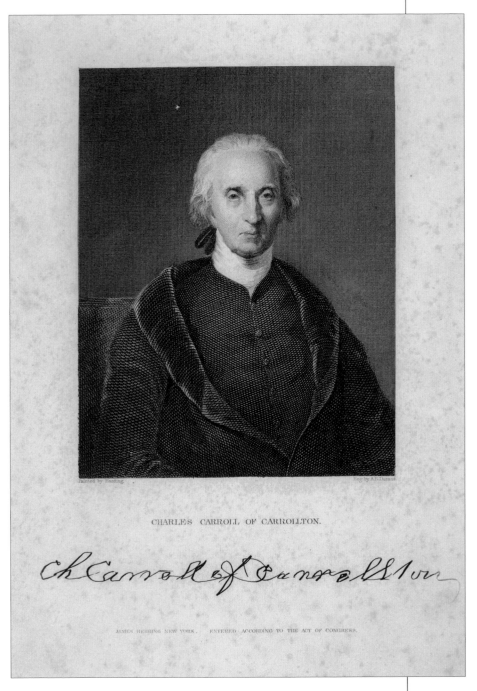

Judge [John] Catron

Mathew B. Brady
Edward and Henry T. Anthony, ca. 1865
Photograph, black and white
3 ³⁄₁₆ x 2 ³⁄₁₆ inches (8.1 x 5.6 cm)
Cat. no. 38.00717.001

Charles Carroll of Carrollton.

Ashur B. Durand after Chester Harding
James Herring, ca. 1830
Steel engraving, black and white
6 ⅛ x 4 ¾ inches (15.6 x 12.1 cm)
Cat. no. 38.00477.001

S[almon]. P. Chase

Unidentified after Alonzo Chappel after photograph
Johnson, Fry & Co., 1863
Steel engraving, black and white
8 ⅞ x 5 ⅝ inches (22.5 x 14.3 cm)
Cat. no. 38.00478.001

[Salmon P. Chase]

Mathew B. Brady
Edward Anthony, ca. 1863
Photograph, black and white
3 ⅜ x 2 ⅛ inches (8.6 x 5.4 cm)
Cat. no. 38.00274.001

The Late Chief Justice [Salmon P.] Chase.

Unidentified after photograph
by Bendann Brothers
Harper's Weekly, 05/24/1873
Wood engraving, black and white
13 ½ x 9 ⅛ inches (34.3 x 23.2 cm)
Cat. no. 38.00816.001

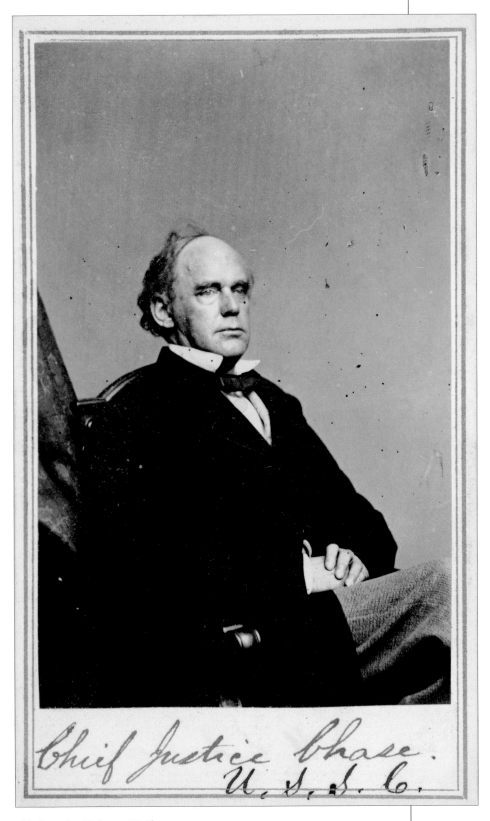

Chief Justice [Salmon P.] Chase

Mathew B. Brady
Edward and Henry T. Anthony, ca. 1865
Photograph, black and white
3 ³⁄₁₆ x 2 ³⁄₁₆ inches (8.1 x 5.6 cm)
Cat. no. 38.00718.001

Rufus Choate

Unidentified after painting by Alonzo Chappel
Johnson, Fry & Co., 1861
Metal engraving, black and white
9 ¹⁄₁₆ x 5 ⁷⁄₁₆ inches (23.0 x 13.8 cm)
Cat. no. 38.00479.001

Known as the "Great Compromiser," Henry Clay of Kentucky served in both the U.S. House of Representatives and the U.S. Senate. He was Speaker of the House, secretary of state, and a perennial Whig presidential candidate. During an illustrious political career that spanned almost half a century, Clay crafted three major legislative compromises in an attempt to resolve the sectional struggle threatening the Union.

Despite the attribution to "T. Nagle" noted at the bottom of the engraving, this portrait is clearly based on a painting from life by artist John Neagle. That painting was commissioned in 1842 by the Philadelphia Whigs in anticipation of the 1844 presidential campaign. Neagle initially painted a bust portrait, then completed a full-length figure (a second version of the latter is in the U.S. Capitol). Clay complimented Neagle: "I think you have happily delineated the character, as well as the physical appearance, of your subject."[1] William Warner's engraving differs from the original painting by placing Clay in an oval porthole. This is no doubt a reference to Rembrandt Peale's famous portrait of George Washington (see 38.00982.001, p. 159) and an attempt to associate the two great statesmen. ৩

[1]Henry Clay, *Papers of Henry Clay*, vol. 9, edited by Robert Seager, et al. (Lexington: University of Kentucky Press, 1991), 822.

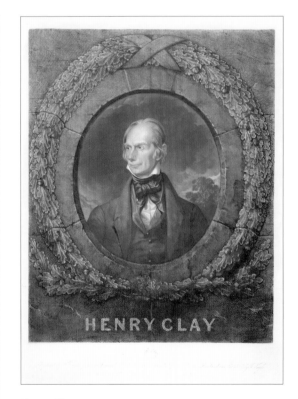

Henry Clay

William Warner, Jr. after John Neagle
William B. Lane, 04/02/1844
Mezzotint, hand-colored
22 x 17 ¹¹⁄₁₆ inches (57.2 x 44.9 cm)
Cat. no. 38.00956.001

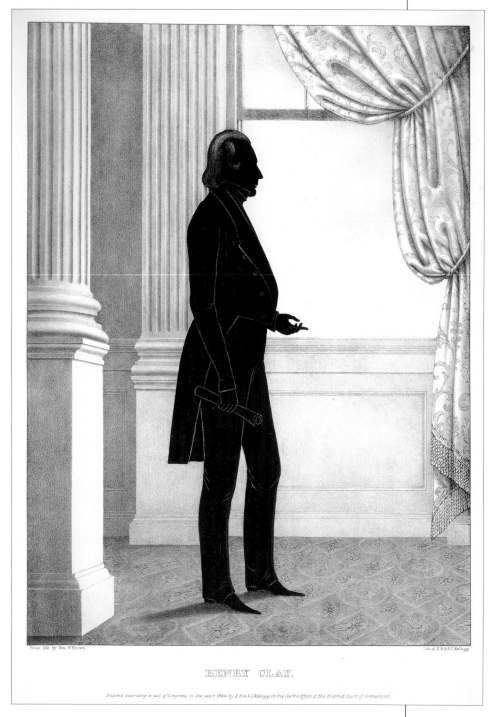

Henry Clay.

Edmund Burke Kellogg and Elijah Chapman Kellogg
after William Henry Brown
Portrait Gallery of Distinguished American Citizens, 1845
Lithograph, colored
14 9/16 x 9 7/8 inches (37.0 x 25.1 cm)
Cat. no. 38.00067.001

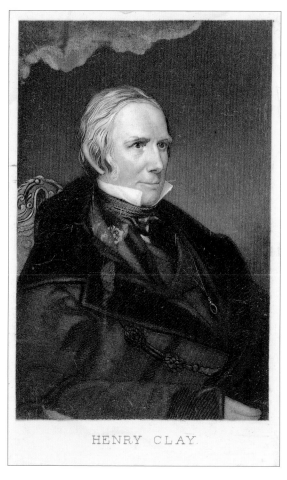

Henry Clay.

Unidentified after daguerreotype by Marcus A. Root
Unidentified, ca. 1850
Mezzotint, black and white
3 5/16 x 2 1/8 inches (8.4 x 5.4 cm)
Cat. no. 38.00280.001

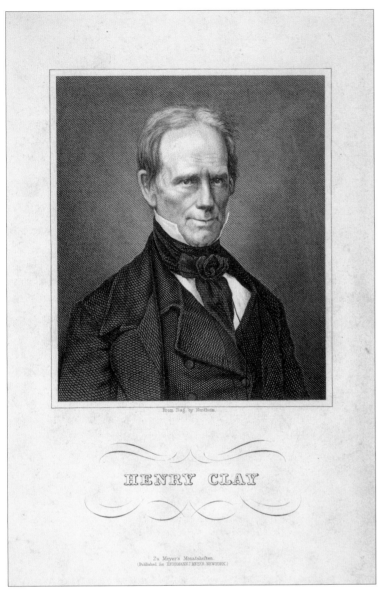

From Dag. by Nordheim.

HENRY CLAY

Zu Meyer's Monatsheften.
(Published for EGGMANN J MEYER, NEW YORK.)

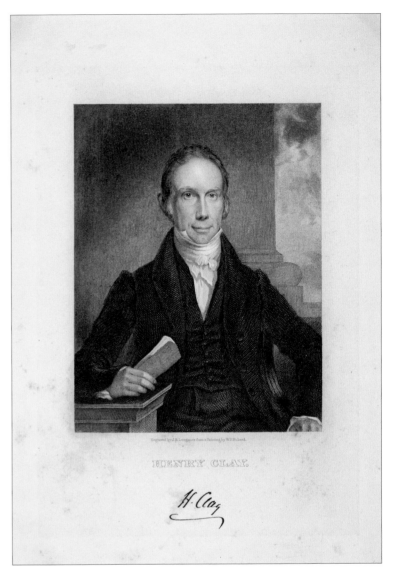

Engraved by J. B. Longacre from a Painting by W.J. Hubard.

HENRY CLAY

H. Clay

Henry Clay.

James B. Longacre after painting by William J. Hubard
Bancroft's, ca. 1850
Copper engraving, black and white
6 x 3 ½ inches (15.2 x 8.9 cm)
Cat. no. 38.00698.001

Henry Clay

Unidentified after daguerreotype by Nordheim
Herrmann J. Meyer, ca. 1850
Metal engraving, black and white
6 ⅜ x 3 ¾ inches (16.2 x 9.5 cm)
Cat. no. 38.00481.001

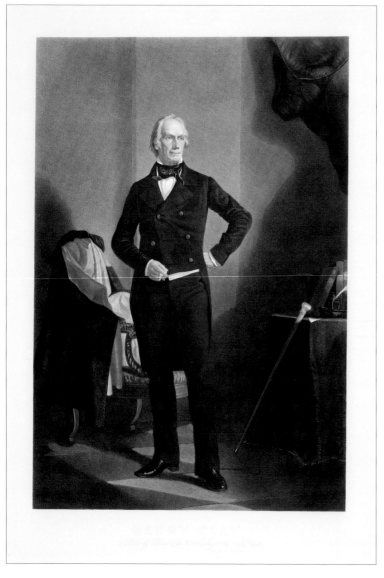

Henry Clay.

Unidentified
William Pate, 1852
Lithograph, colored
27 ¼ x 17 inches (69.2 x 43.2 cm)
Cat. no. 38.00565.001

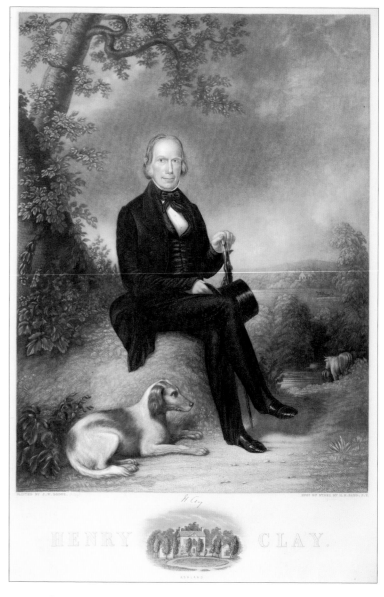

Henry Clay.

Henry S. Sadd after painting by John Wood Dodge
Coats and Cosine, ca. 1860
Mezzotint, black and white
30 x 24 inches (76.2 x 61.0 cm)
Cat. no. 38.00950.001

[Henry] Clay.

Unidentified
Unidentified, ca. 1855
Metal engraving, black and white
9 ⁵⁄₈ x 7 ⅛ inches (24.4 x 18.1 cm)
Cat. no. 38.00482.001

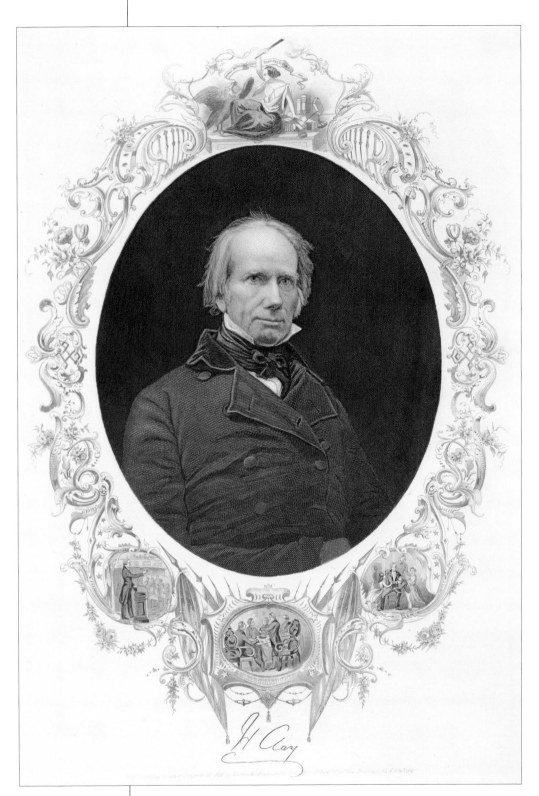

H[enry] Clay

Unidentified
Martin & Johnson, 1856
Steel engraving, black and white
10 x 7 inches (25.4 x 17.8 cm)
Cat. no. 38.00712.001

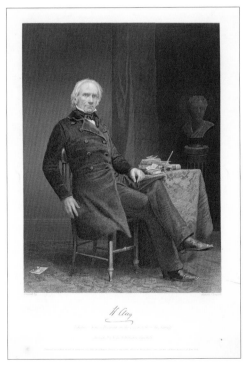

H[enry] Clay

Unidentified after painting by Alonzo Chappel
Johnson, Fry & Co., 1861
Metal engraving, black and white
8 ⅞ x 5 ½ inches (22.5 x 14.0 cm)
Cat. no. 38.00480.001

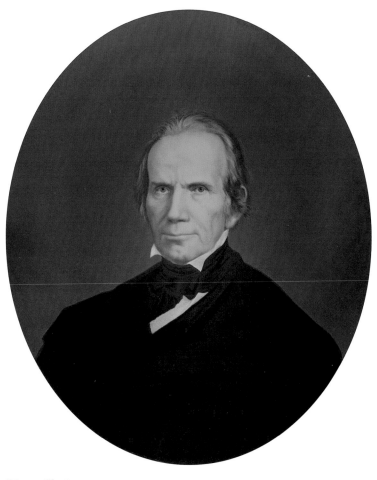

[Henry Clay]

Unidentified
Middleton, Strobridge & Co., 1863
Lithograph, colored
17 x 14 inches (43.2 x 35.6 cm)
Cat. no. 38.00223.001

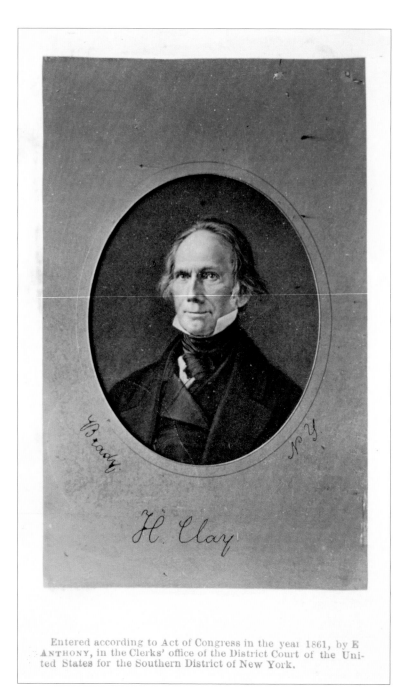

Entered according to Act of Congress in the year 1861, by E ANTHONY, in the Clerks' office of the District Court of the United States for the Southern District of New York.

H[enry]. Clay

Mathew B. Brady
Edward Anthony, 1861
Photograph, black and white
3 ⅜ x 2 ⅛ inches (8.6 x 5.4 cm)
Cat. no. 38.00357.001

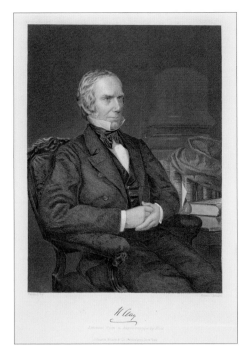

H[enry] Clay

Unidentified after painting by Alonzo Chappel
after daguerreotype by Marcus A. Root
Johnson, Wilson & Co., 1873
Steel engraving, black and white
9 ⅛ x 5 ⁹⁄₁₆ inches (23.2 x 14.1 cm)
Cat. no. 38.00475.001

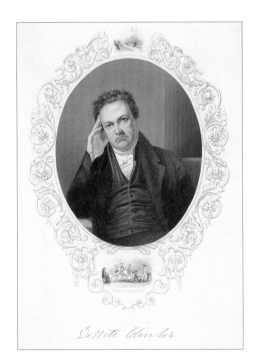

De Witt Clinton

John Rogers
Unidentified, ca. 1870
Metal engraving, black and white
8 x 5 ⅜ inches (20.3 x 13.7 cm)
Cat. no. 38.00483.001

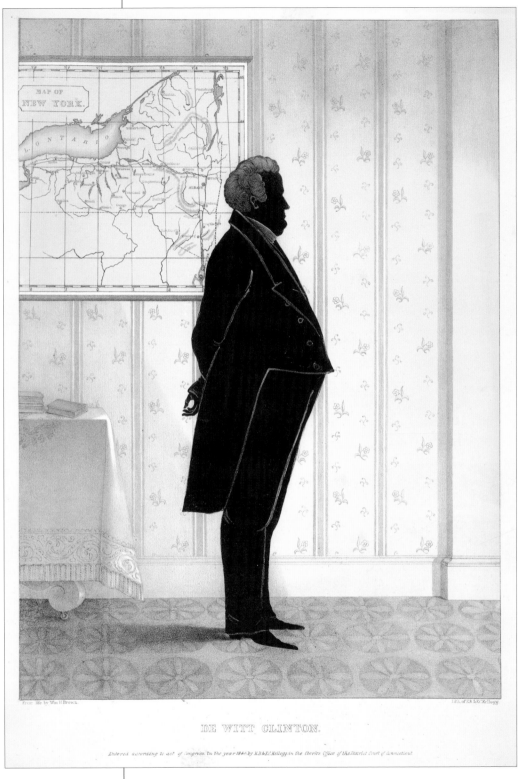

De Witt Clinton.

Edmund Burke Kellogg and Elijah Chapman Kellogg
after William Henry Brown
Portrait Gallery of Distinguished American Citizens, 1845
Lithograph, colored
14 ⅝ x 9 ¹³⁄₁₆ inches (37.1 x 24.9 cm)
Cat. no. 38.00068.001

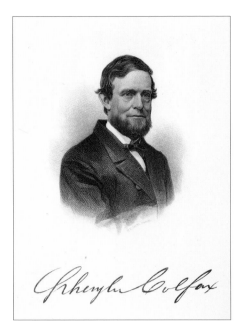

Schuyler Colfax

Hezekiah W. Smith
Men of Our Times, 1868
Steel engraving, black and white
5 ½ x 4 inches (14.0 x 10.2 cm)
Cat. no. 38.00701.001

Hon. Jacob Collamer, United States Senator from Vermont.

Unidentified after photograph by
Mathew B. Brady
Harper's Weekly, 05/15/1858
Wood engraving, black and white
9 ¼ x 6 inches (23.5 x 15.2 cm)
Cat. no. 38.00815.001

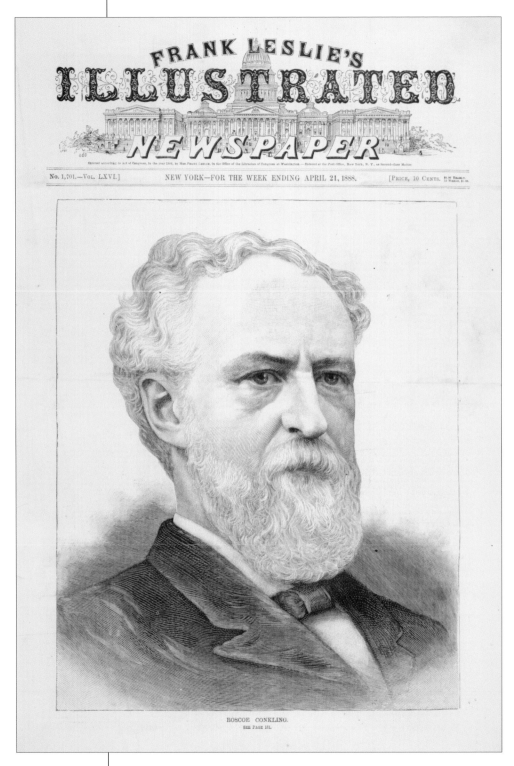

Roscoe Conkling.

Unidentified
Frank Leslie's Illustrated Newspaper, 04/21/1888
Wood engraving, black and white
11 ⅜ x 8 ¹⁵⁄₁₆ inches (28.9 x 22.7 cm)
Cat. no. 38.00431.001

Judge P[eter]. V. Daniel

Mathew B. Brady
Edward and Henry T. Anthony, ca. 1865
Photograph, black and white
3 3/16 x 2 3/16 inches (8.1 x 5.6 cm)
Cat. no. 38.00719.001

Engraved for the Eclectic, by Geo. E. Perine, New York.

GEORGE WILLIAM CURTIS.

George William Curtis.

George E. Perine
Eclectic, 1870
Metal engraving, black and white
7 1/8 x 4 5/8 inches (18.1 x 11.7 cm)
Cat. no. 38.00484.001

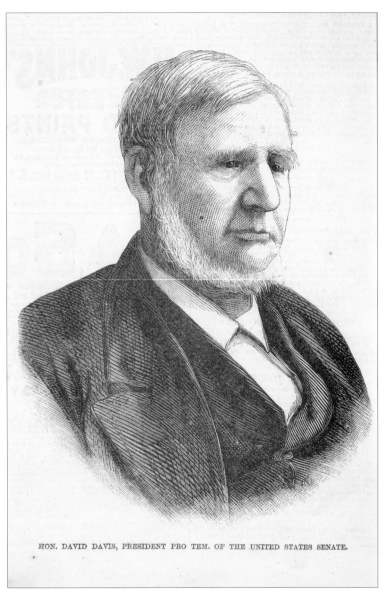

HON. DAVID DAVIS, PRESIDENT PRO TEM. OF THE UNITED STATES SENATE.

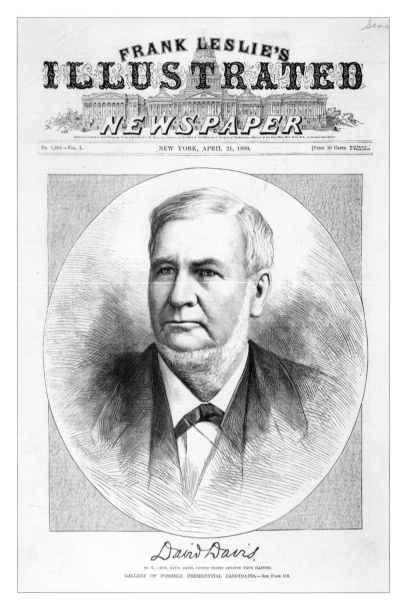

Hon. David Davis, President Pro Tem. of the United States Senate.

Unidentified
Frank Leslie's Illustrated Newspaper, 10/29/1881
Wood engraving, black and white
6 x 4 ¾ inches (15.2 x 12.1 cm)
Cat. no. 38.00900.001

**Gallery of Possible Presidential Candidates. No. 2.—
Hon. David Davis, United States Senator from Illinois.**

Unidentified after Thure de Thulstrup
Frank Leslie's Illustrated Newspaper, 04/24/1880
Wood engraving, black and white
11 ¼ x 9 inches (28.6 x 22.9 cm)
Cat. no. 38.00862.001

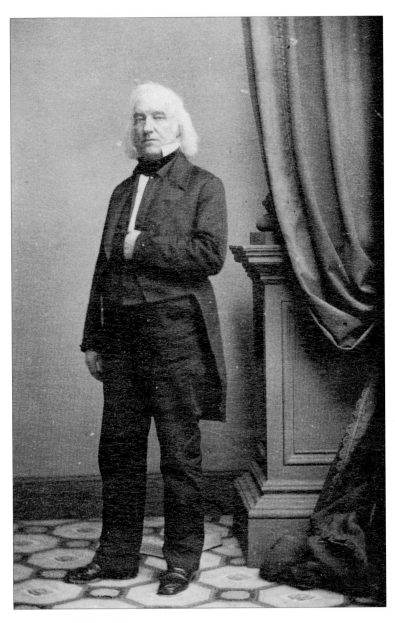

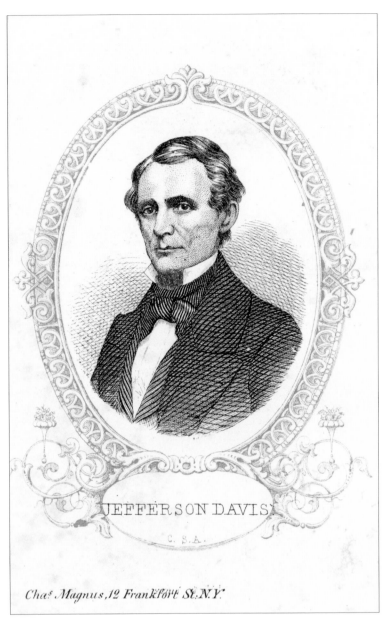

[Daniel S. Dickinson]

Mathew B. Brady
Unidentified, ca. 1860
Photograph, black and white
3 ¼ x 2 ¹⁄₁₆ inches (8.3 x 5.2 cm)
Cat. no. 38.00279.001

Jefferson Davis

Unidentified
Charles Magnus, ca. 1861
Wood engraving, black and white
3 x 2 ⅝ inches (7.6 x 6.7 cm)
Cat. no. 38.00273.001

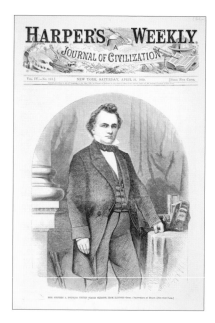

Hon. Stephen A. Douglas, United States Senator from Illinois.

Unidentified after photograph
by Mathew B. Brady
Harper's Weekly, 04/21/1860
Wood engraving, black and white
11 x 8 ⅝ inches (27.9 x 21.9 cm)
Cat. no. 38.00817.001

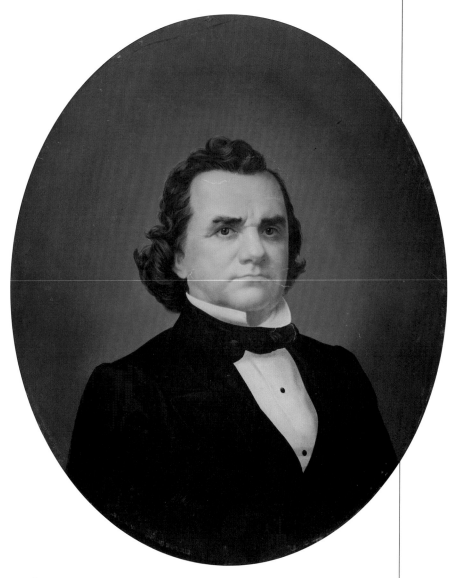

[Stephen A. Douglas]

Unidentified
Middleton, Strobridge & Co., 1864
Lithograph, colored
17 x 14 inches (43.2 x 35.6 cm)
Cat. no. 38.00224.001

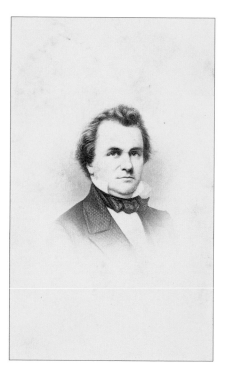

[Stephen A. Douglas]

Unidentified
A. Winch, ca. 1865
Steel engraving, black and white
3 ⁹⁄₁₆ x 2 ¼ inches (9.0 x 5.7 cm)
Cat. no. 38.00272.001

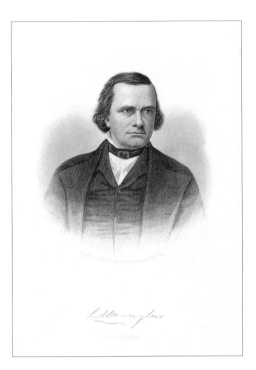

S[tephen]. A. Douglas

John C. McRae
Abbott's Civil War, ca. 1875
Steel engraving, black and white
6 ½ x 4 ⅜ inches (16.5 x 11.1 cm)
Cat. no. 38.00560.002

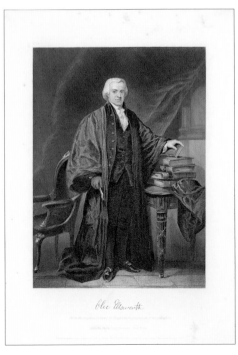

Olie [Oliver] Ellsworth

Unidentified after painting by Alonzo Chappel
Johnson, Fry & Co., 1863
Metal engraving, black and white
8 x 5 ½ inches (20.3 x 14.0 cm)
Cat. no. 38.00831.001

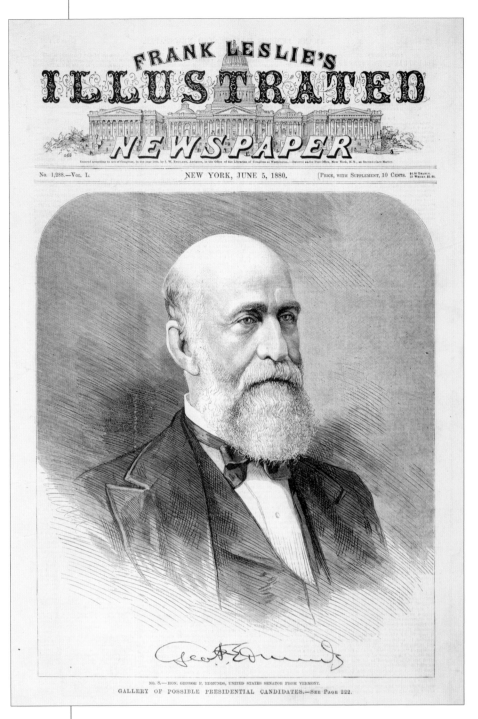

**Gallery of Possible Presidential Candidates. No. 8.—
Hon. George F. Edmunds, United States Senator from Vermont.**

Unidentified
Frank Leslie's Illustrated Newspaper, 06/05/1880
Wood engraving, black and white
11 ⅜ x 9 ¼ inches (28.9 x 23.5 cm)
Cat. no. 38.00863.001

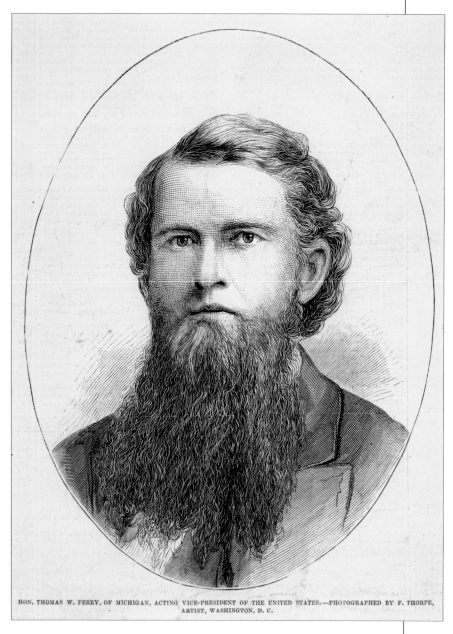

HON. THOMAS W. FERRY, OF MICHIGAN, ACTING VICE-PRESIDENT OF THE UNITED STATES.—PHOTOGRAPHED BY F. THORPE, ARTIST, WASHINGTON, D. C.

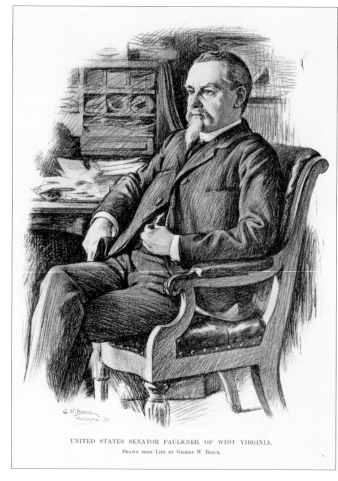

UNITED STATES SENATOR FAULKNER, OF WEST VIRGINIA.
DRAWN FROM LIFE BY GEORGE W. BRECK.

United States Senator Faulkner, of West Virginia.

Unidentified after George W. Breck
Harper's Weekly, 11/03/1894
Halftone, black and white
8 ⅜ x 6 inches (21.3 x 15.2 cm)
Cat. no. 38.00810.001

**Hon. Thomas W. Ferry, of Michigan,
Acting Vice-President of the United States.**

Unidentified after photograph by Freeman Thorpe
Frank Leslie's Illustrated Newspaper, 12/11/1875
Wood engraving, black and white
7 ½ x 5 ¾ inches (19.1 x 14.6 cm)
Cat. no. 38.00404.001

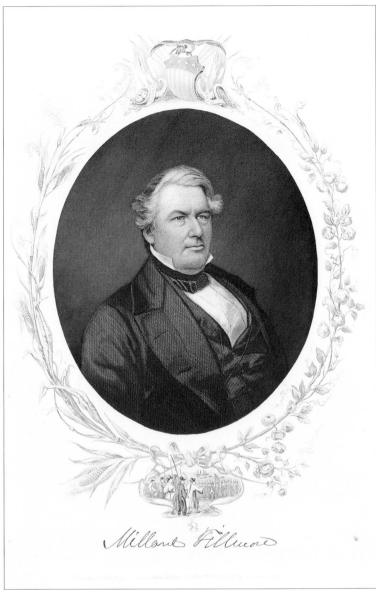

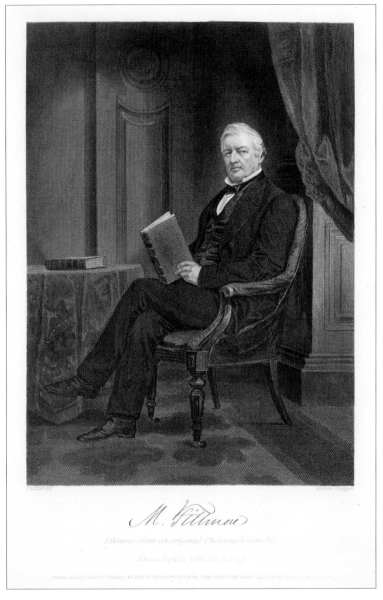

Millard Fillmore

Unidentified
Johnson, Fry & Co., 1859
Metal engraving, black and white
9 ½ x 6 ¾ inches (24.1 x 17.1 cm)
Cat. no. 38.00486.002

M[illard]. Fillmore

Unidentified after Alonzo Chappel after photograph
Johnson, Fry & Co., 1862
Metal engraving, black and white
9 1/16 x 5 ½ inches (23.0 x 14.0 cm)
Cat. no. 38.00485.001

John Forsyth.

Edmund Burke Kellogg and Elijah Chapman
Kellogg after William Henry Brown
*Portrait Gallery of Distinguished American
Citizens*, 1845
Lithograph, colored
14 ½ x 9 ¹⁵⁄₁₆ inches (36.8 x 25.2 cm)
Cat. no. 38.00069.001

The Late Chief Justice [Melville W.] Fuller

Unidentified
Harper's Weekly, 07/16/1910
Halftone, black and white
10 ¼ x 7 ⅝ inches (26.0 x 19.4 cm)
Cat. no. 38.00812.001

Judge [Stephen J.] Field

Mathew B. Brady
Edward and Henry T. Anthony, ca. 1865
Photograph, black and white
3 ³⁄₁₆ x 2 ⅛ inches (8.1 x 5.4 cm)
Cat. no. 38.00720.001

[Benjamin Franklin]

Henri Lefort after Joseph S. Duplessis
Grolier Club, 1898
Etching, black and white
18 ¾ x 12 ¼ inches (47.6 x 31.1 cm)
Cat. no. 38.00057.001

Albert Gallatin

Unidentified after painting by Alonzo Chappel
Johnson, Fry & Co., 1862
Metal engraving, black and white
9 ⅛ x 5 ½ inches (23.2 x 14.0 cm)
Cat. no. 38.00488.001

Hon. William M. Gwin, United States Senator from California.

Unidentified after photograph by
Mathew B. Brady
Harper's Weekly, 05/29/1858
Wood engraving, black and white
9 x 6 ⅛ inches (23.6 x 15.6 cm)
Cat. no. 38.00826.001

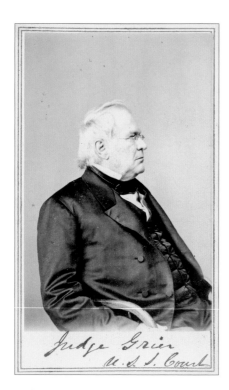

Judge [Robert C.] Grier

Mathew B. Brady
Edward and Henry T. Anthony, ca. 1865
Photograph, black and white
3 ³⁄₁₆ x 2 ³⁄₁₆ inches (8.1 x 5.6 cm)
Cat. no. 38.00721.001

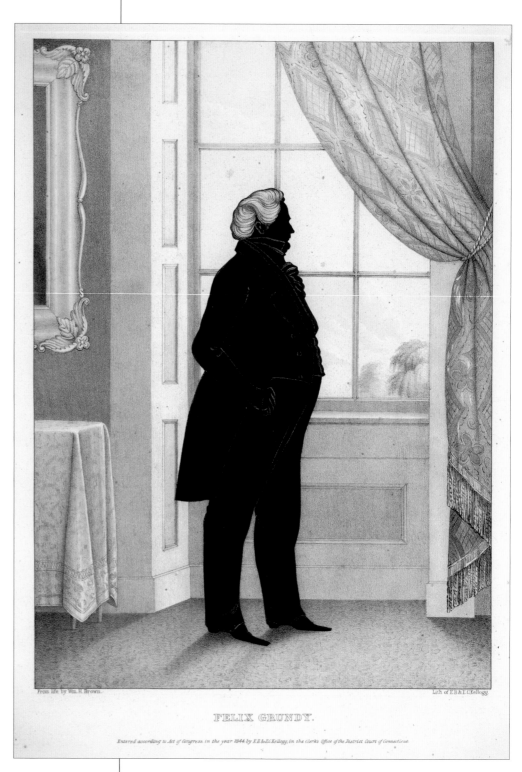

Felix Grundy.

Edmund Burke Kellogg and Elijah Chapman Kellogg
after William Henry Brown
Portrait Gallery of Distinguished American Citizens, 1845
Lithograph, colored
14 ½ x 9 ¹¹⁄₁₆ inches (36.8 x 24.6 cm)
Cat. no. 38.00070.001

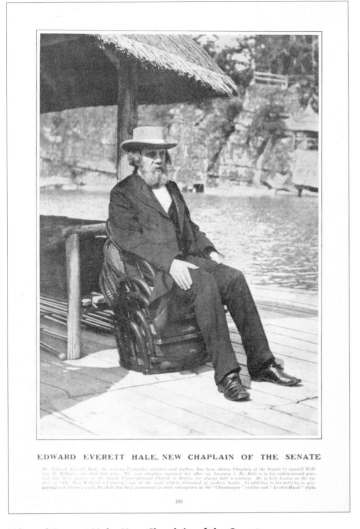

EDWARD EVERETT HALE, NEW CHAPLAIN OF THE SENATE

Dr. Edward Everett Hale, the veteran Unitarian minister and author, has been chosen Chaplain of the Senate to succeed William H. Milburn, who died last year. The new chaplain assumed his office on January 1. Dr. Hale is in his eighty-second year, and has been pastor of the South Congregational Church in Boston for almost half a century. He is best known as the author of "The Man Without a Country," one of the most widely discussed of modern books. In addition to his activity in ministerial and literary work, Dr. Hale has been prominent in such enterprises as the "Chautauqua" circles and "Lend-a-Hand" clubs

195

Edward Everett Hale, New Chaplain of the Senate

Unidentified
Unidentified, 1904
Halftone, black and white
10 x 7 inches (25.4 x 17.8 cm)
Cat. no. 38.00973.001

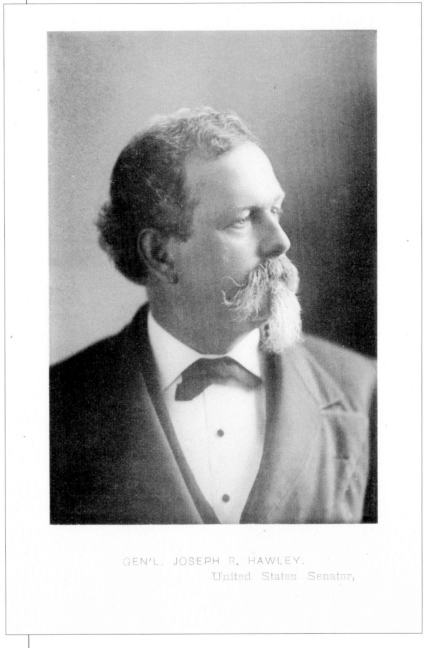

GEN'L. JOSEPH R. HAWLEY.
United States Senator,

Gen'l. Joseph R. Hawley. United States Senator

Unidentified
Unidentified, ca. 1880
Photograph, black and white
4 ⅝ x 2 ¹³⁄₁₆ inches (11.7 x 7.1 cm)
Cat. no. 38.00805.001

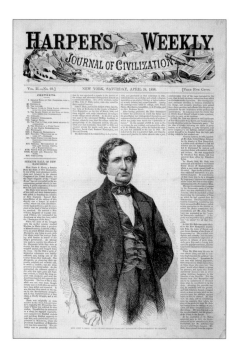

Hon. John P. Hale, United States Senator from New Hampshire.

Unidentified after S. W. after photograph by Mathew B. Brady
Harper's Weekly, 04/24/1858
Wood engraving, black and white
9 ¾ x 6 ⅛ inches (24.8 x 15.6 cm)
Cat. no. 38.00825.001

William Henry Harrison.

Edmund Burke Kellogg and Elijah Chapman Kellogg
after William Henry Brown
Portrait Gallery of Distinguished American Citizens, 1845
Lithograph, colored
14 ¼ x 10 inches (36.2 x 25.4 cm)
Cat. no. 38.00206.001

Samuel Houston

W. J. Edwards after daguerreotype
Unidentified, 1856
Steel engraving, hand-colored
9 x 6 ¹⁄₁₆ inches (22.9 x 15.4 cm)
Cat. no. 38.00250.001

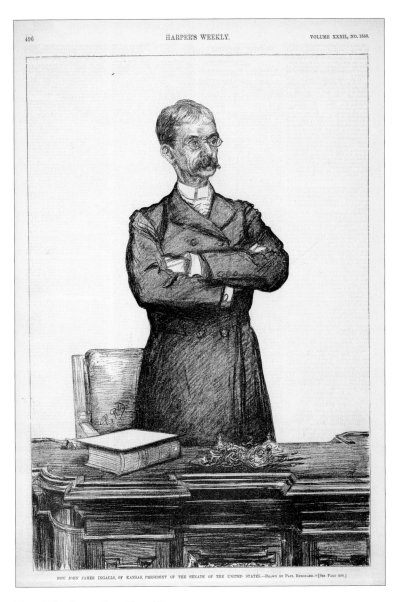

Hon. Robert M. T. Hunter, United States Senator from Virginia.

Unidentified after A. F. after photograph by Mathew B. Brady
Harper's Weekly, 03/10/1860
Wood engraving, black and white
9 1/16 x 5 7/8 inches (23.0 x 14.9 cm)
Cat. no. 38.00538.001

Hon. John James Ingalls, of Kansas,
President of the Senate of the United States.

Unidentified after Paul Renouard
Harper's Weekly, 07/07/1888
Lithograph, black and white
14 x 9 5/16 inches (35.6 x 23.7 cm)
Cat. no. 38.00217.001

Andrew Jackson.

Edmund Burke Kellogg and Elijah Chapman Kellogg
after William Henry Brown
Portrait Gallery of Distinguished American Citizens, 1845
Lithograph, colored
14 ¾ x 9 ⅞ inches (37.5 x 25.1 cm)
Cat. no. 38.00071.001

[Andrew Jackson]

Unidentified
Middleton, Strobridge & Co., 1864
Lithograph, colored
17 x 14 inches (43.2 x 35.6 cm)
Cat. no. 38.00222.001

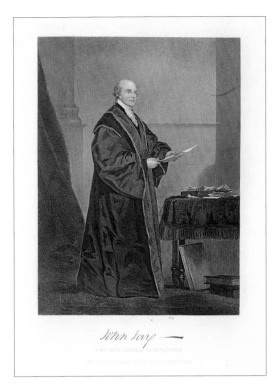

John Jay—First Chief Justice of the United States.

Unidentified after Alonzo Chappel
Johnson, Fry & Co., 1862
Metal engraving, black and white
9 x 5 ⅜ inches (22.9 x 13.7 cm)
Cat. no. 38.00800.001

Richard Mentor Johnson.

Edmund Burke Kellogg and Elijah Chapman Kellogg
after William Henry Brown
Portrait Gallery of Distinguished American Citizens, 1845
Lithograph, black and white
14 ¾ x 9 ¹³⁄₁₆ inches (37.5 x 24.9 cm)
Cat. no. 38.00072.001

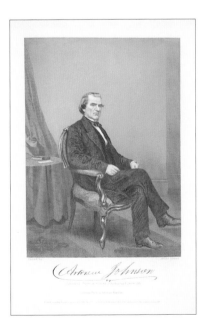

Andrew Johnson

Unidentified after Alonzo Chappel
after photograph
Johnson, Fry & Co., 1864
Metal engraving, black and white
9 ³⁄₁₆ x 5 ½ inches (23.3 x 14.0 cm)
Cat. no. 38.00489.001

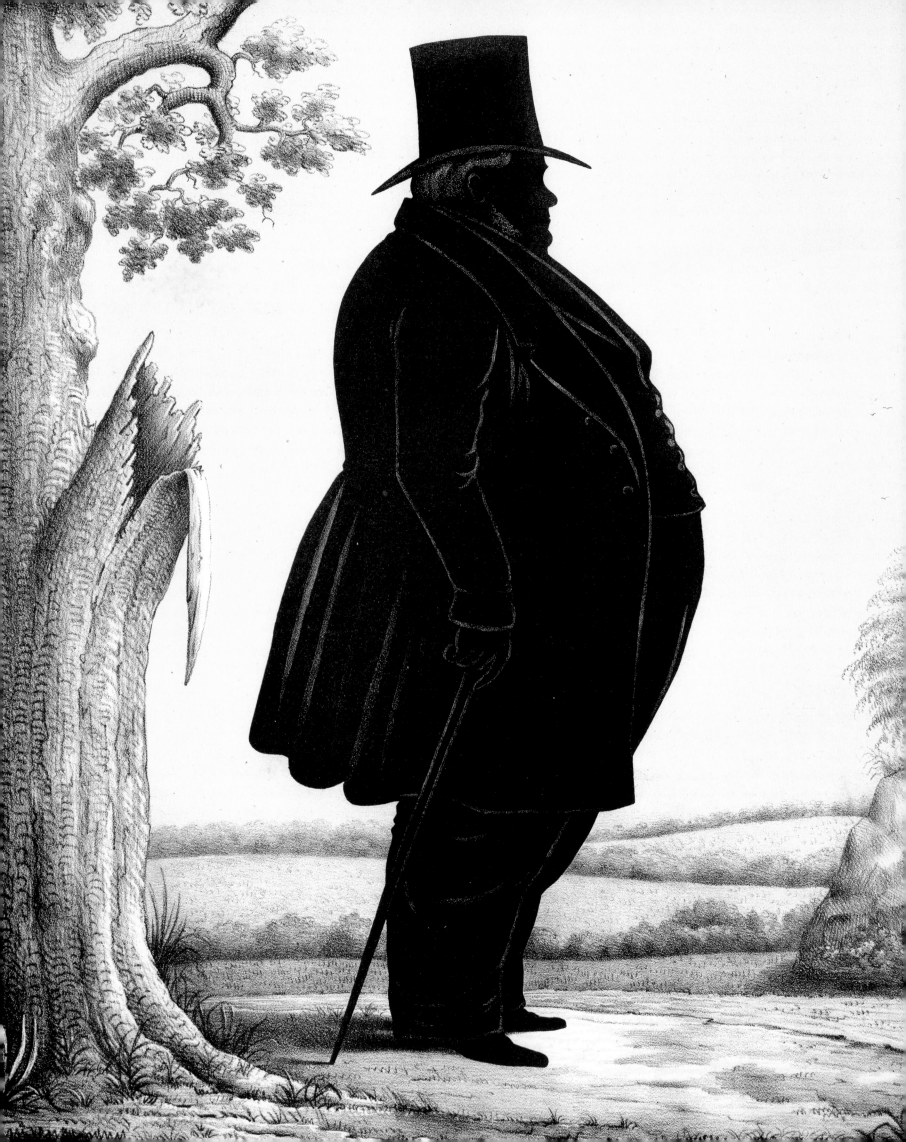

This lithograph is part of a series produced in 1845 by E. B. and E. C. Kellogg entitled *Portrait Gallery of Distinguished American Citizens*. The folio consisted of 26 images of notable statesmen (20 of which are in the Senate collection). The Kellogg brothers were considered rivals of Currier and Ives, producing popular, low-priced prints for direct sale to the public. The silhouette accurately depicts the 430-pound, rotund figure of Senator Dixon Hall Lewis (1802–1848) of Alabama. A strong states' rights proponent, Lewis opposed the national bank and protective tariffs and allied with John Calhoun on nullification. His excessive weight required special accommodation for his safety and comfort. He sat in a custom built chair in the Senate Chamber and, during hot summer months, Senate pages fanned Lewis for hours to keep him cool. Senate Assistant Doorkeeper Isaac Bassett wrote: "Mr. Lewis was the terror of hackmen. . . . On one occasion in town getting into a hack he broke through its floor and fell into the ground beneath it. The accident placed him in considerable peril. Had the horses been wild or scared, he might have been killed or greatly infirmed."[1] 𝕯

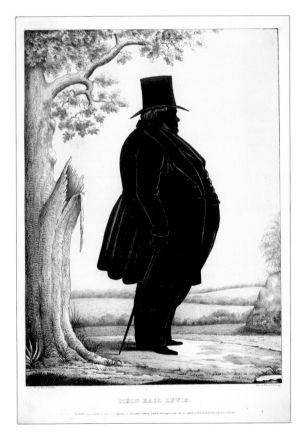

Dixon Hall Lewis.

Edmund Burke Kellogg and Elijah Chapman Kellogg after William Henry Brown
Portrait Gallery of Distinguished American Citizens, 1845
Lithograph, colored
14 ⅛ x 10 inches (35.9 x 25.4 cm)
Cat. no. 38.00209.001

[1] Papers of Isaac Bassett, Office of the Curator, U.S. Senate, 20 C 73–74.

Geo[rge] W. Jones

Alexander Gardner
Philp and Solomons, ca. 1860
Photograph, black and white
3 ¾ x 2 ³⁄₁₆ inches (9.5 x 5.6 cm)
Cat. no. 38.00792.001

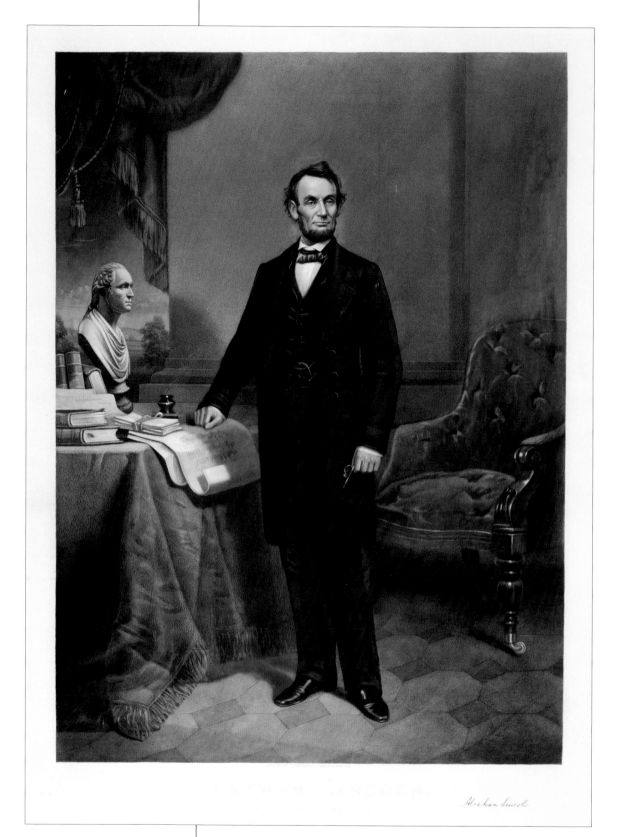

Abraham Lincoln.

Unidentified
J.C. Buttre, ca. 1870
Engraving, black and white
28 x 19 ⅜ inches (71.1 x 49.2 cm)
Cat. no. 38.00796.001

**The Hon. John R. M'Pherson [sic],
United States Senator-Elect from New Jersey.**

Unidentified after photograph by Henry C. Lovejoy
Frank Leslie's Illustrated Newspaper, 02/17/1877
Wood engraving, black and white
6 ½ x 4 ¹⁵⁄₁₆ inches (16.5 x 12.5 cm)
Cat. no. 38.00396.001a

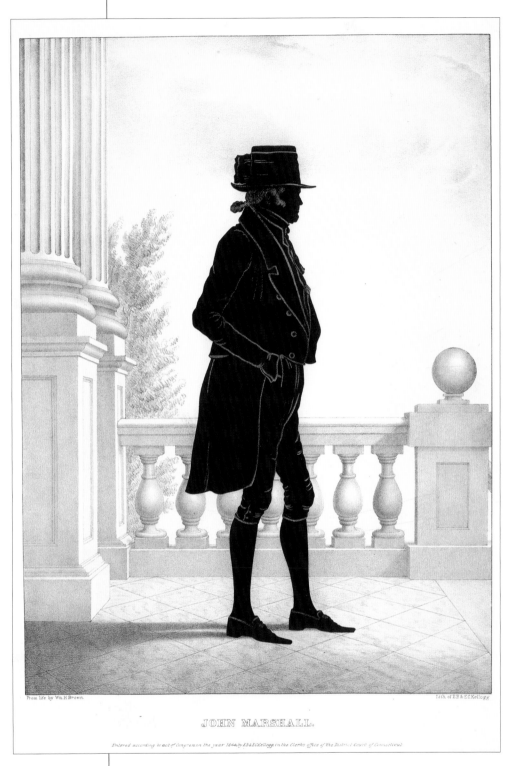

John Marshall.

Edmund Burke Kellogg and Elijah Chapman Kellogg
after William Henry Brown
Portrait Gallery of Distinguished American Citizens, 1845
Lithograph, colored
14 ⅝ x 9 ⅞ inches (37.1 x 25.1 cm)
Cat. no. 38.00073.001

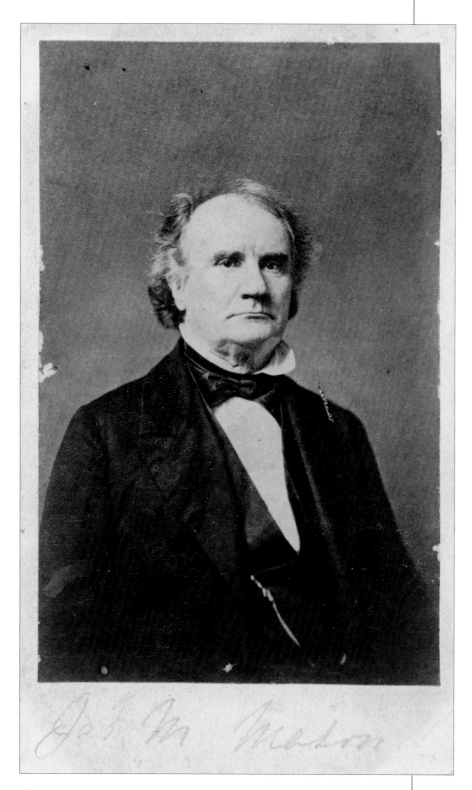

J[ames] M[urray] Mason

Unidentified
Silsbee, Case & Co., ca. 1860
Photograph, black and white
3 ⅜ x 2 ³⁄₁₆ inches (8.6 x 5.6 cm)
Cat. no. 38.00276.001

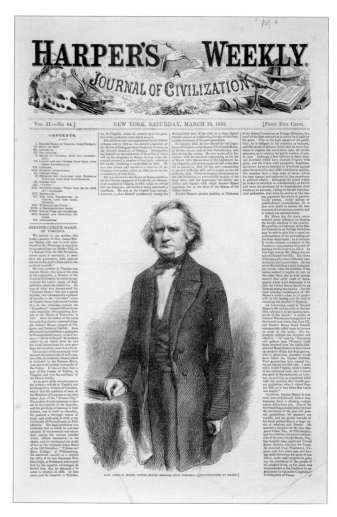

Hon. James M. Mason, United States Senator from Virginia.

Unidentified after S. W. after photograph by Mathew B. Brady
Harper's Weekly, 03/20/1858
Wood engraving, black and white
9 ¼ x 6 inches (23.5 x 15.2 cm)
Cat. no. 38.00818.001

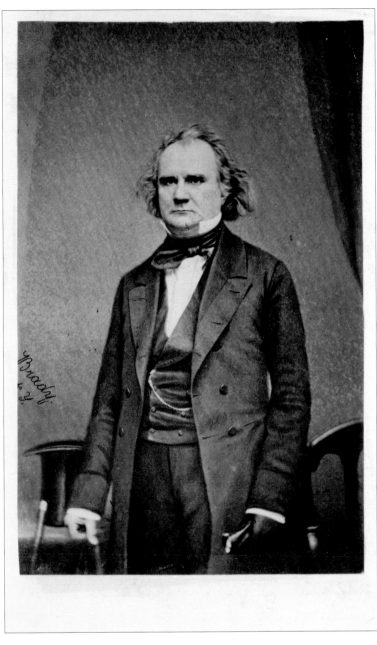

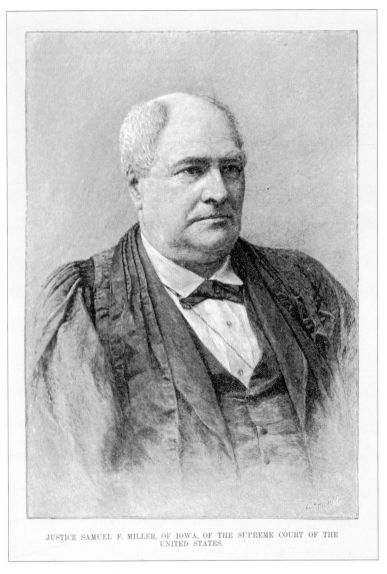

JUSTICE SAMUEL F. MILLER, OF IOWA, OF THE SUPREME COURT OF THE UNITED STATES.

Justice Samuel F. Miller, of Iowa, of the Supreme Court of the United States.

Unidentified after G. Kruell
Harper's Weekly, 10/18/1890
Wood engraving, black and white
7 ¼ x 4 ¹³⁄₁₆ inches (18.4 x 12.2 cm)
Cat. no. 38.00802.001

[James M. Mason]

Mathew B. Brady
Edward Anthony, ca. 1861
Photograph, black and white
3 ⁵⁄₁₆ x 2 ⅛ inches (8.4 x 5.4 cm)
Cat. no. 38.00359.001

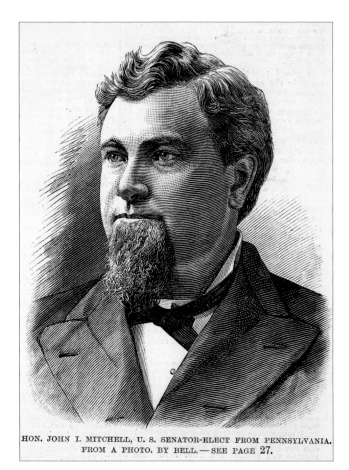

Hon. John I. Mitchell, U.S. Senator-Elect from Pennsylvania.

Unidentified after photograph by Charles M. Bell
Frank Leslie's Illustrated Newspaper, 03/12/1881
Wood engraving, black and white
5 x 4 inches (12.7 x 10.2 cm)
Cat. no. 38.00869.001

Senator [Lot M.] Morrill

Alexander Gardner
Philp and Solomons, ca. 1860
Photograph, black and white
3 7/16 x 2 1/8 inches (8.7 x 5.4 cm)
Cat. no. 38.00795.001

Gouv[erneur] Morris

Unidentified after painting by Alonzo Chappel
Johnson, Fry & Co., 1863
Metal engraving, black and white
9 x 5 inches (22.9 x 12.7 cm)
Cat. no. 38.00490.001

Rob[ert] Morris.

Thomas Phillibrown after painting by Alonzo Chappel
Johnson, Fry & Co., 1862
Metal engraving, black and white
9 x 5 ½ inches (22.9 x 14.0 cm)
Cat. no. 38.00491.001

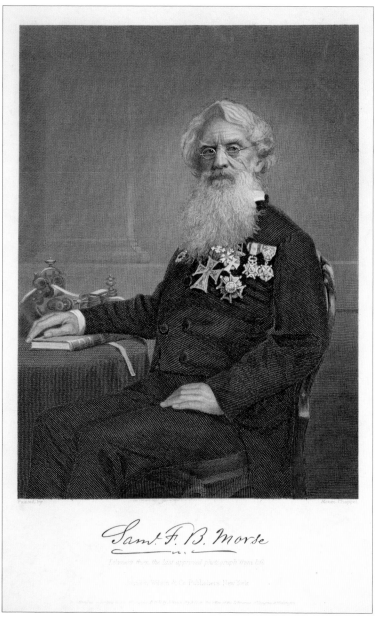

Sam[ue]l F. B. Morse

Unidentified after Alonzo Chappel after photograph
Johnson, Wilson & Co., 1872
Metal engraving, black and white
9 x 5 ½ inches (22.9 x 14.0 cm)
Cat. no. 38.00492.001

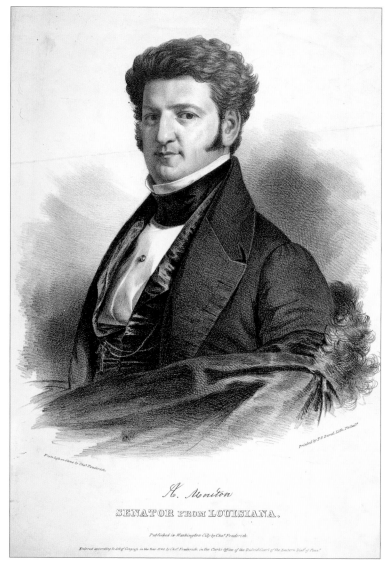

A[lexander]. Mouton / Senator from Louisiana.

Charles Fenderich
P. S. Duval, 1840
Lithograph, black and white
13 ¼ x 10 ¼ inches (33.7 x 26.0 cm)
Cat. no. 38.00187.001

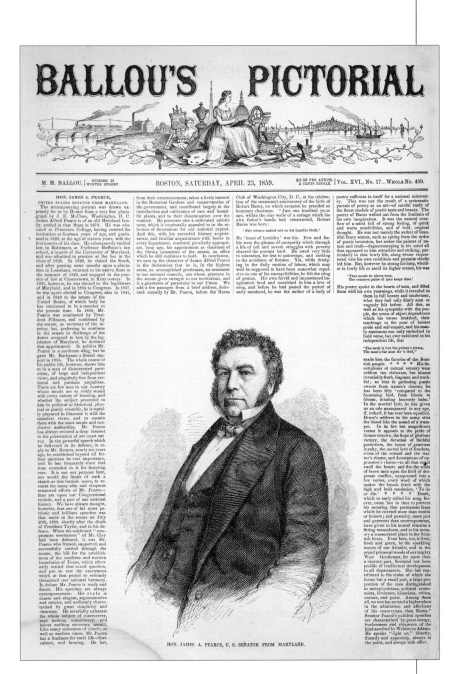

Hon. James A. Pearce, U.S. Senator from Maryland.

Unidentified
Ballou's Pictorial, 04/23/1859
Wood engraving, black and white
8 ½ x 6 ¼ inches (21.6 x 15.9 cm)
Cat. no. 38.00824.001

The Hon. Bishop W. Perkins,
Appointed United States Senator from Kansas.

W. K.
Harper's Weekly, 01/09/1892
Wood engraving, black and white
4 ⅝ x 4 ¼ inches (11.7 x 10.8 cm)
Cat. no. 38.00819.001

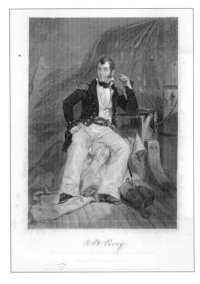

O[liver]. H. Perry

Unidentified after Alonzo Chappel
Johnson, Fry & Co., 1862
Metal engraving, black and white
9 x 5 ½ inches (22.9 x 14.0 cm)
Cat. no. 38.00736.001

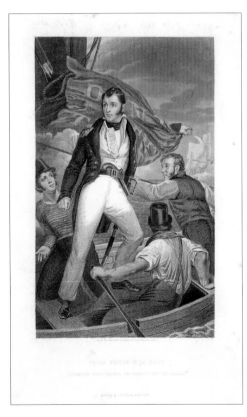

**"I'll Fetch Him Up!" Commodore [Oliver H.]
Perry Leaving the Lawrence for the Niagara.**

Unidentified after painting by John Wesley Jarvis
Virtue & Yorston, date unknown
Metal engraving, black and white
9 x 4 ⅝ inches (22.9 x 11.7 cm)
Cat. no. 38.00732.001

S[amuel] C. Pomeroy

Alexander Gardner
Philp and Solomons, ca. 1860
Photograph, black and white
3 ¼ x 2 ³⁄₁₆ inches (8.3 x 5.6 cm)
Cat. no. 38.00793.001

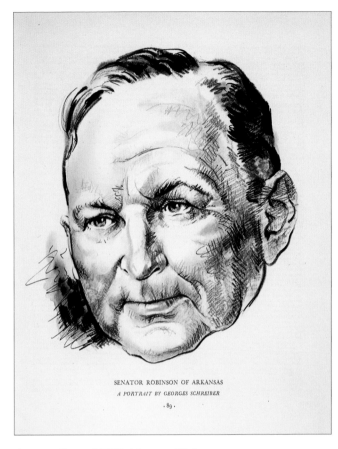

Senator [Joseph T.] Robinson of Arkansas

Unidentified after Georges Schreiber
Fortune Magazine, 01/1937
Photomechanical process, colored
11 ⅛ x 9 inches (28.3 x 22.9 cm)
Cat. no. 38.00715.001

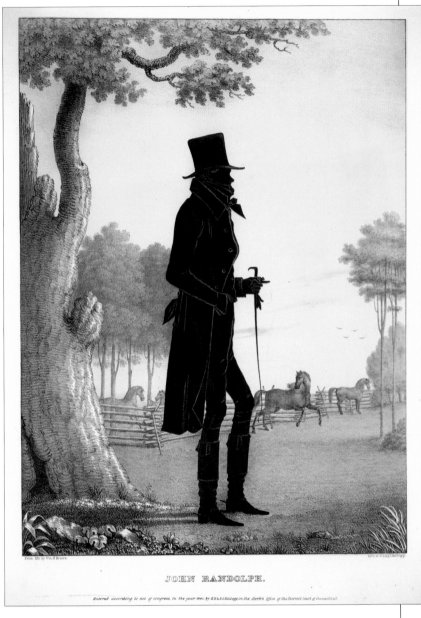

John Randolph.

Edmund Burke Kellogg and Elijah Chapman Kellogg
after William Henry Brown
Portrait Gallery of Distinguished American Citizens, 1845
Lithograph, colored
14 ½ x 9 ¾ inches (36.8 x 24.8 cm)
Cat. no. 38.00074.001

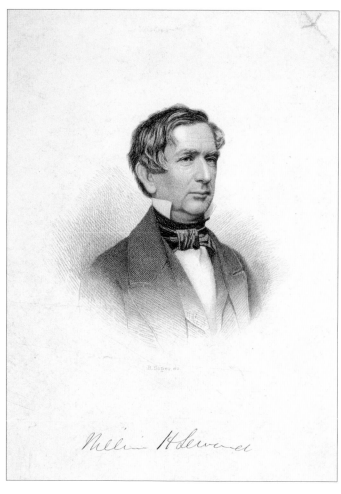

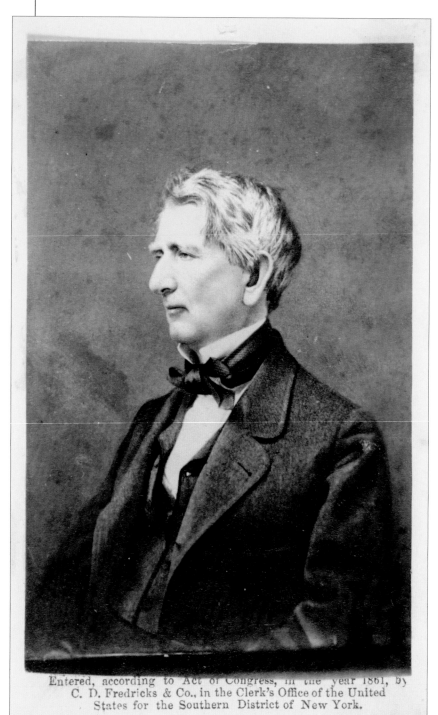

William H. Seward

Richard F. Soper
Unidentified, ca. 1861
Metal engraving, black and white
5 x 3 ½ inches (12.7 x 8.9 cm)
Cat. no. 38.00494.001

[William H. Seward]

Unidentified
Charles D. Fredricks & Co., 1861
Photograph, black and white
3 ½ x 2 ¼ inches (8.9 x 5.7 cm)
Cat. no. 38.00275.001

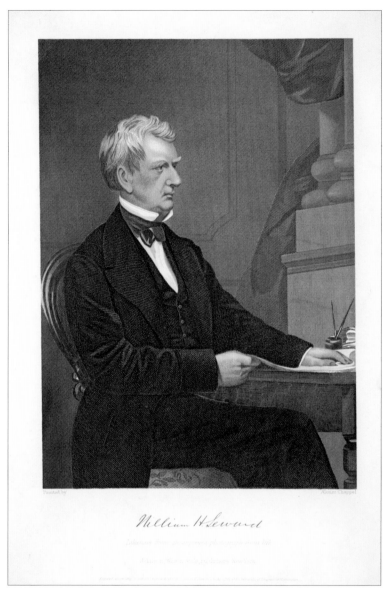

William H. Seward

Unidentified after Alonzo Chappel after photograph
Johnson, Wilson & Co., 1873
Metal engraving, black and white
9 3/16 x 5 7/16 inches (23.3 x 13.8 cm)
Cat. no. 38.00493.001

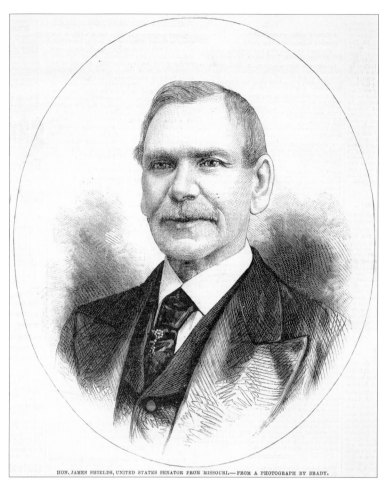

HON. JAMES SHIELDS, UNITED STATES SENATOR FROM MISSOURI.— FROM A PHOTOGRAPH BY BRADY.

Hon. James Shields, United States Senator from Missouri.

Unidentified after photograph by Mathew B. Brady
Frank Leslie's Illustrated Newspaper, 03/15/1879
Wood engraving, black and white
7 x 5 3/4 inches (17.8 x 14.6 cm)
Cat. no. 38.00865.001

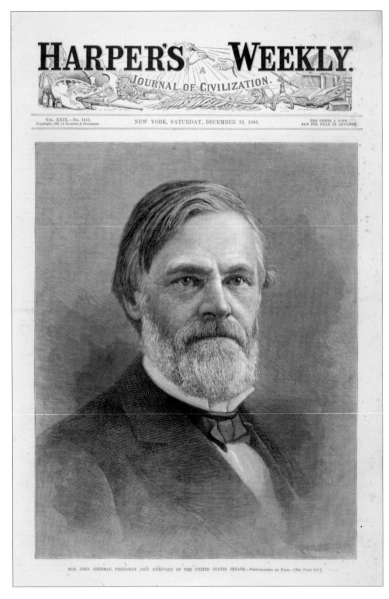

Hon. John Sherman, President Pro Tempore of the United States Senate.

R. Staudenbaur after photograph by Pach Brothers
Harper's Weekly, 12/19/1885
Wood engraving, black and white
11 ¹³⁄₁₆ x 9 ⅛ inches (30.0 x 23.2 cm)
Cat. no. 38.00555.001

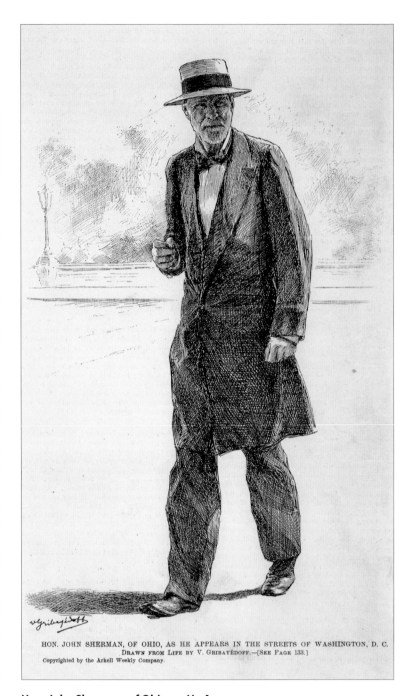

Hon. John Sherman, of Ohio, as He Appears in the Streets of Washington, D.C.

Unidentified after Valerian Gribayédoff
Leslie's Weekly, 08/30/1894
Lithograph, black and white
10 x 6 inches (25.4 x 15.2 cm)
Cat. no. 38.00807.001

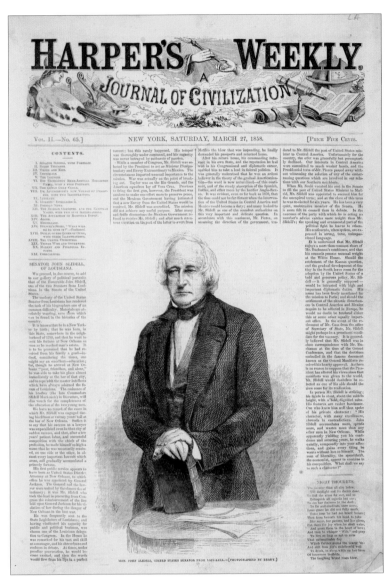

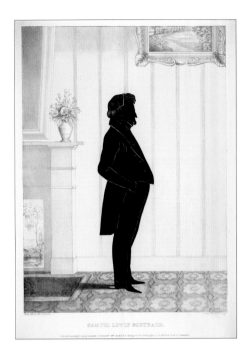

Hon. John Slidell, United States Senator from Louisiana.

Unidentified after S. W. after photograph by Mathew B. Brady
Harper's Weekly, 03/27/1858
Wood engraving, black and white
9 ¼ x 6 ⅛ inches (23.5 x 15.6 cm)
Cat. no. 38.00821.001

Samuel Lewis Southard.

Edmund Burke Kellogg and Elijah Chapman
Kellogg after William Henry Brown
*Portrait Gallery of Distinguished American
Citizens*, 1845
Lithograph, colored
14 ½ x 9 ¾ inches (36.8 x 24.8 cm)
Cat. no. 38.00075.001

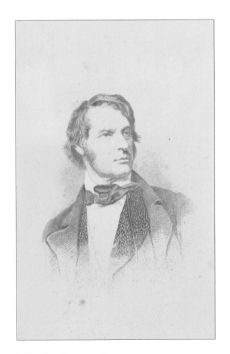

[Charles Sumner]

Unidentified
Unidentified, ca. 1860
Steel engraving, black and white
3 ¹¹⁄₁₆ x 2 ⁷⁄₁₆ inches (9.4 x 6.2 cm)
Cat. no. 38.00278.001

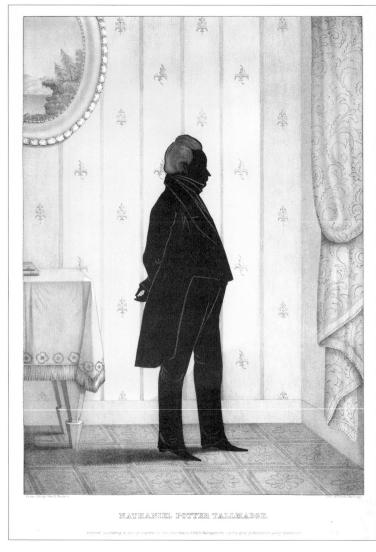

Nathaniel Potter [sic] Tallmadge.

Edmund Burke Kellogg and Elijah Chapman Kellogg
after William Henry Brown
Portrait Gallery of Distinguished American Citizens, 1845
Lithograph, colored
14 ¼ x 10 inches (36.2 x 25.4 cm)
Cat. no. 38.00208.001

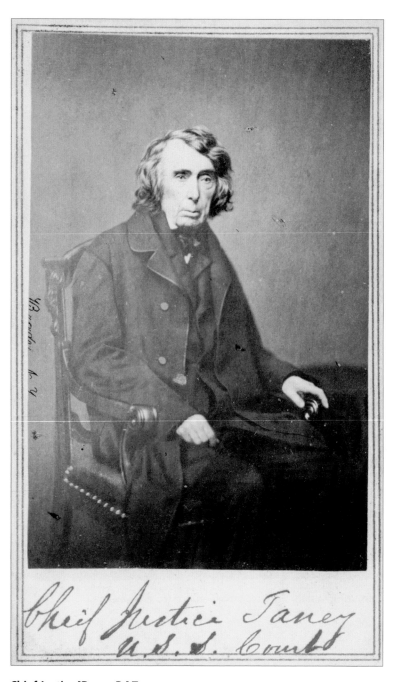

Chief Justice [Roger B.] Taney

Mathew B. Brady
Edward and Henry T. Anthony, ca. 1865
Photograph, black and white
2 ⅜ x 2 ⅛ inches (6.0 x 5.4 cm)
Cat. no. 38.00722.001

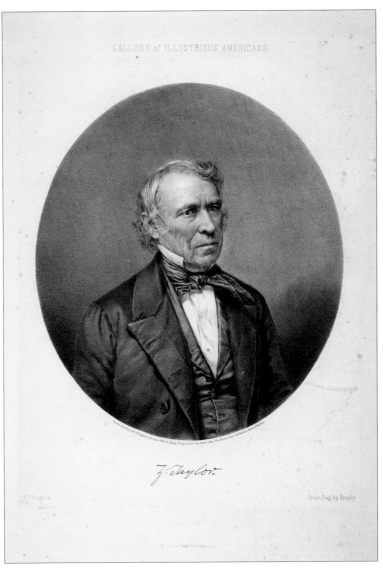

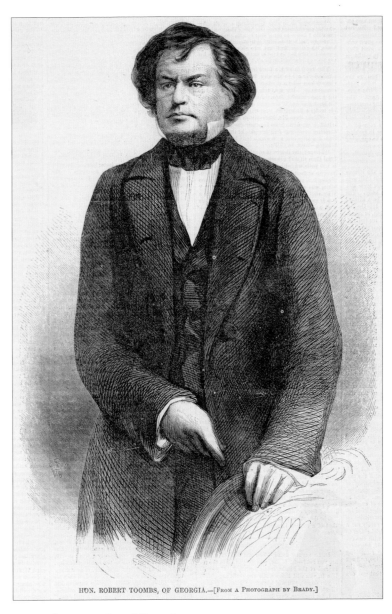

Z[achery]. Taylor.

Francis D'Avignon after photograph by Mathew B. Brady
Gallery of Illustrious Americans, 1850
Lithograph, black and white
14 x 10⅞ inches (35.6 x 27.6 cm)
Cat. no. 38.00189.001

Hon. Robert Toombs, of Georgia.

Unidentified after S. W. after photograph by Mathew B. Brady
Harper's Weekly, 03/24/1860
Wood engraving, black and white
9¼ x 6 inches (23.5 x 15.2 cm)
Cat. no. 38.00813.001

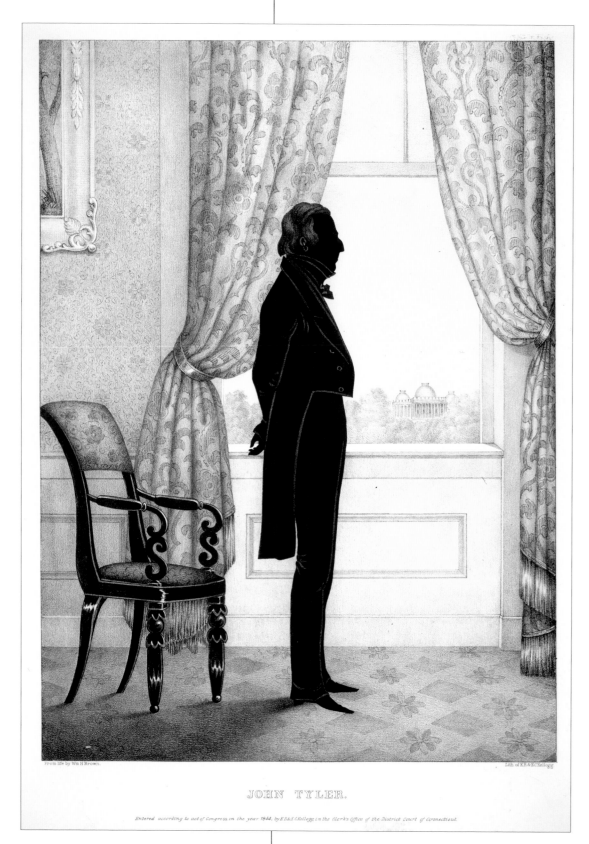

From life by Wm H Brown. Lith of E.B.& E.C.Kellogg

JOHN TYLER.

Entered according to act of Congress, in the year 1844, by E.B.& E.C.Kellogg in the Clerk's Office of the District Court of Connecticut.

John Tyler.

Edmund Burke Kellogg and Elijah Chapman Kellogg
after William Henry Brown
Portrait Gallery of Distinguished American Citizens, 1845
Lithograph, colored
14 $\frac{11}{16}$ x 9 ¾ inches (37.3 x 24.8 cm)
Cat. no. 38.00076.001

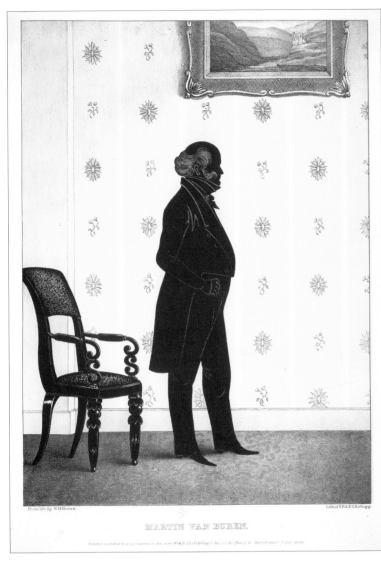

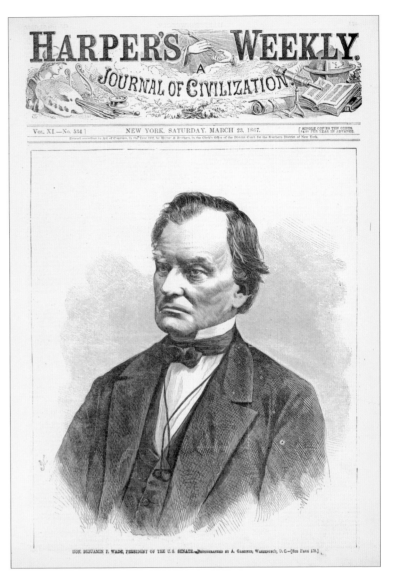

Martin Van Buren.

Edmund Burke Kellogg and Elijah Chapman Kellogg
after William Henry Brown
Portrait Gallery of Distinguished American Citizens, 1845
Lithograph, colored
14 ⅝ x 9 ⅞ inches (37.1 x 25.1 cm)
Cat. no. 38.00077.001

Hon. Benjamin F. Wade, President of the U.S. Senate.

Unidentified after photograph by Alexander Gardner
Harper's Weekly, 03/23/1867
Wood engraving, black and white
11 ⅛ x 9 ³⁄₁₆ inches (28.3 x 23.3 cm)
Cat. no. 38.00380.001

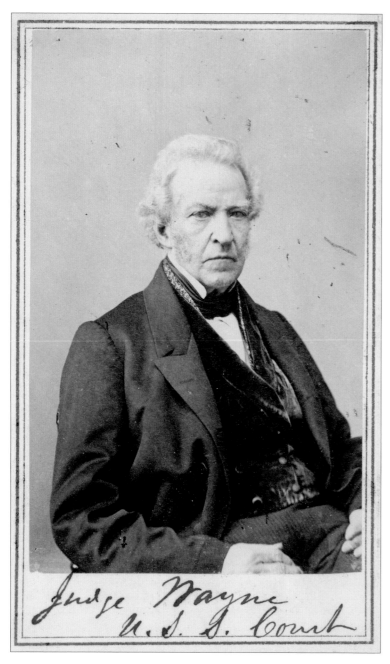

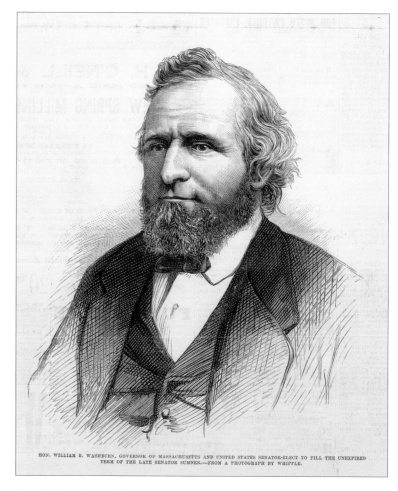

Hon. William B. Washburn, Governor of Massachusetts and United States Senator-Elect to Fill the Unexpired Term of the Late Senator Sumner.

Unidentified after photograph by John A. Whipple
Frank Leslie's Illustrated Newspaper, 05/09/1874
Wood engraving, black and white
7 x 6 inches (17.8 x 15.2 cm)
Cat. no. 38.00897.001

Judge [James M.] Wayne

Mathew B. Brady
Mathew B. Brady, ca. 1865
Photograph, black and white
2 7/16 x 2 1/8 inches (6.2 x 5.4 cm)
Cat. no. 38.00723.001

**[George] Washington's Farewell Address
to the People of the United States**

Gideon Fairman [portrait of Washington
after Gilbert Stuart]
Atlas Folio, ca. 1820
Engraving, black and white
39 9/16 x 28 7/8 inches (100.5 x 73.4 cm)
Cat. no. 38.00005.001

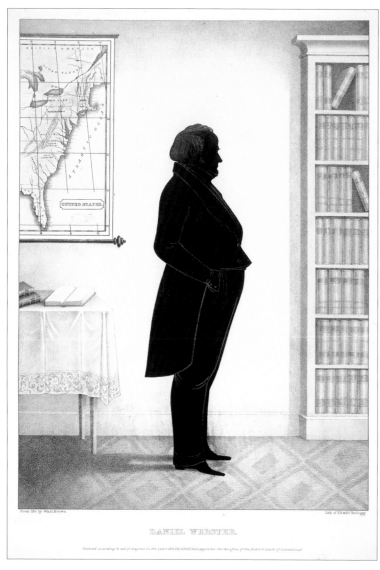

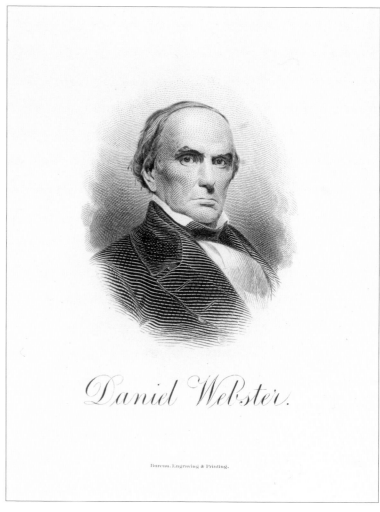

Daniel Webster.

Edmund Burke Kellogg and Elijah Chapman Kellogg
after William Henry Brown
Portrait Gallery of Distinguished American Citizens, 1845
Lithograph, colored
14 ⅝ x 9 ¹⁵⁄₁₆ inches (37.1 x 25.2 cm)
Cat. no. 38.00078.001

Daniel Webster.

Alfred Sealey
Bureau of Engraving and Printing, date unknown
Metal engraving, black and white
3 x 2 inches (7.6 x 5.1 cm)
Cat. no. 38.00852.001

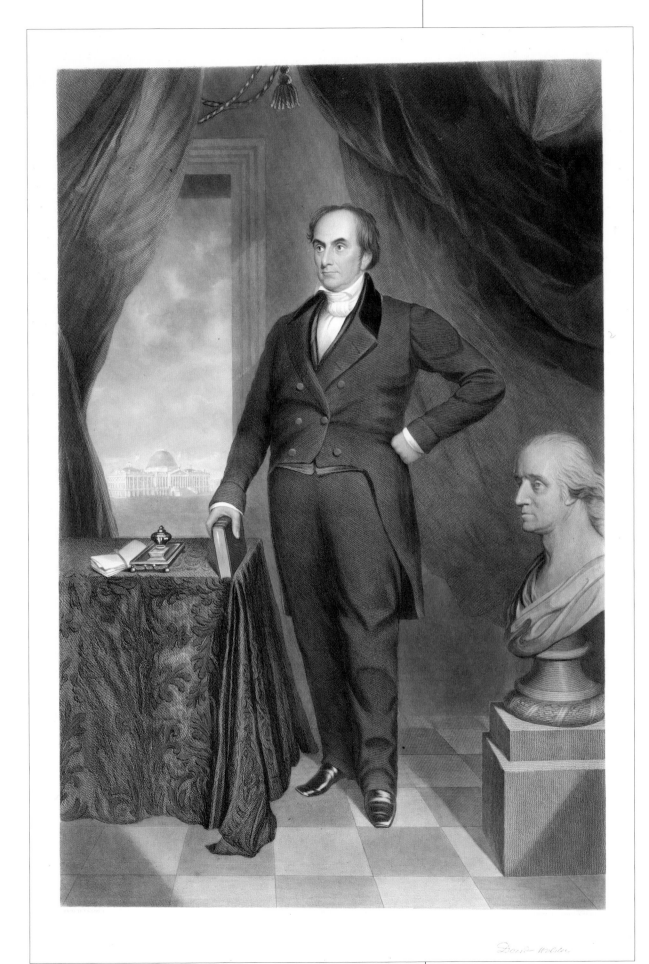

Dan[ie]l Webster

Charles Edward Wagstaff
and Joseph Andrews
after Thomas Bayley Lawson
Henry Williams & Sons, 1852
Engraving, hand-colored
28 x 17 ½ inches (71.1 x 44.5 cm)
Cat. no. 38.00564.001

Hon. Daniel Webster.

Unidentified
Gleason's Pictorial Drawing Room Companion,
ca. 1851
Wood engraving, black and white
14 ¼ x 9 ¾ inches (36.2 x 24.8 cm)
Cat. no. 38.00857.001

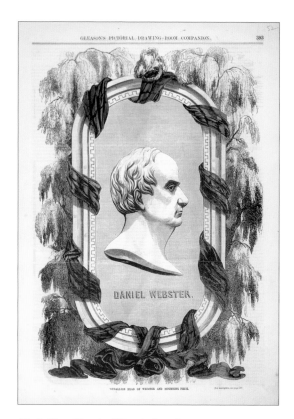

**Medallion Head of [Daniel] Webster
and Mourning Piece.**

Unidentified
Gleason's Pictorial Drawing-Room Companion, ca. 1852
Wood engraving, black and white
13 ⅝ x 9 ½ inches (34.6 x 24.1 cm)
Cat. no. 38.00799.001

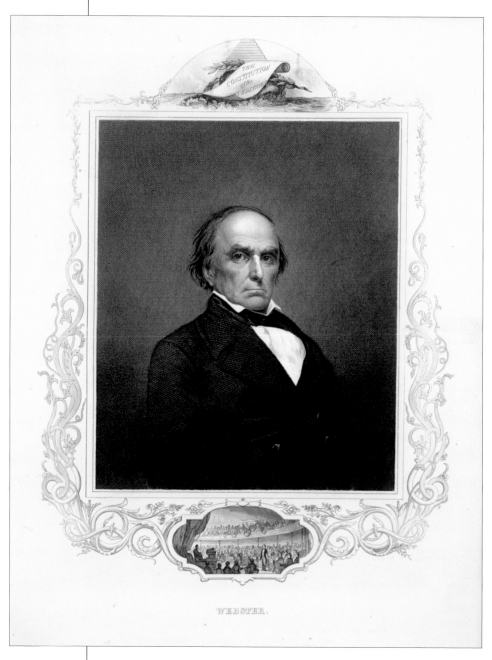

[Daniel] Webster.

Unidentified
Unidentified, ca. 1854
Metal engraving, black and white
10 x 7 ⅜ inches (25.4 x 18.7 cm)
Cat. no. 38.00761.001

[Daniel Webster]

Unidentified
Unidentified, ca. 1860
Photograph, black and white
2 ½ x 1 ¹⁵⁄₁₆ inches (6.4 x 4.9 cm)
Cat. no. 38.00282.001

Dan[ie]l Webster

Mathew B. Brady
Edward Anthony, 1861
Photograph, black and white
3 ⅜ x 2 ⅛ inches (8.6 x 5.4 cm)
Cat. no. 38.00358.001

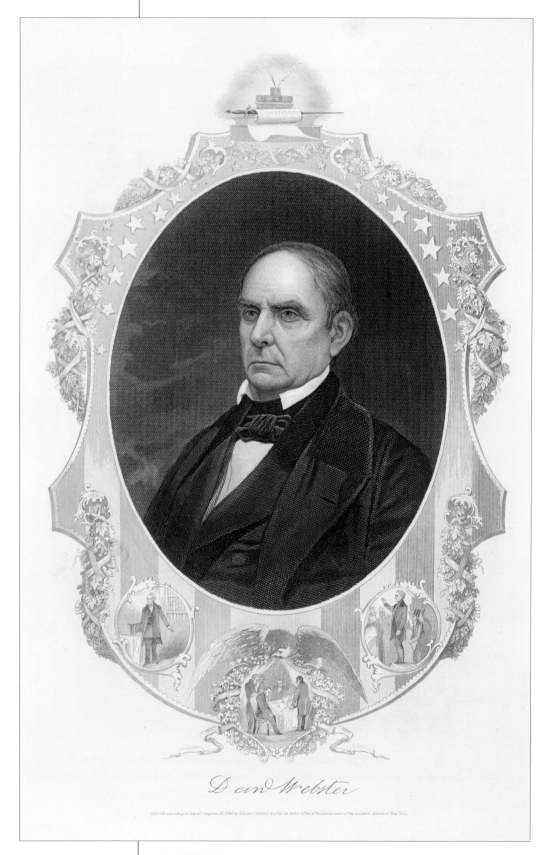

Dan[ie]l Webster

Unidentified
Martin & Johnson, 1856
Steel engraving, black and white
10 x 6 ½ inches (25.4 x 16.5 cm)
Cat. no. 38.00713.001

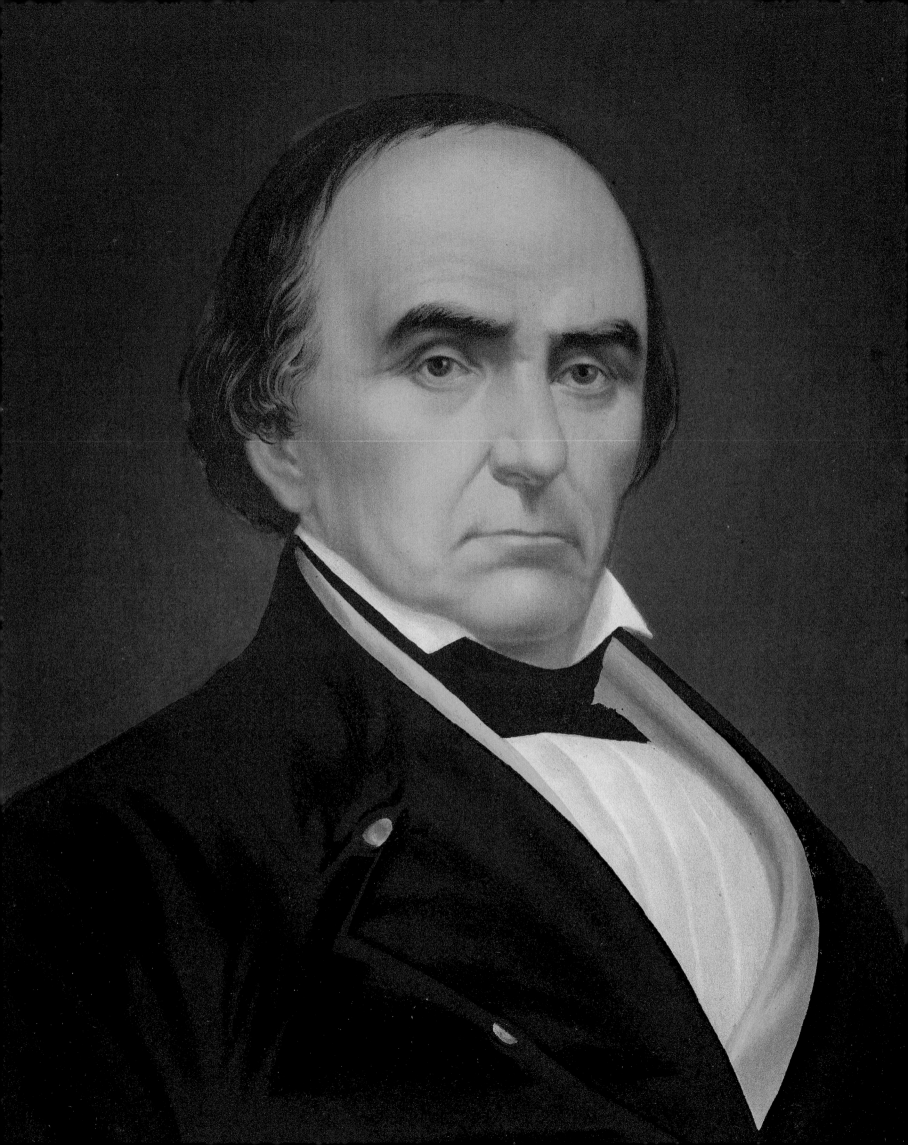

This portrait of Daniel Webster is expertly rendered, yet somehow fails to capture the power and intensity of the Massachusetts senator. Webster's impassioned oratory was legendary, and it was intensified by his unforgettable physical presence. Dark in complexion, with penetrating eyes—often likened to glowing coals—he had an electrifying effect on anyone who saw him. One 19th-century journalist wrote, "The God-like Daniel. . .had broad shoulders, a deep chest, and a large frame. . . . The head, the face, the whole presence of Webster, was kingly, majestic, godlike."[1]

This Webster image is part of a lithographic series of famous individuals produced by Elijah C. Middleton, of the renowned 19th-century Cincinnati lithographic firm Middleton, Strobridge and Company. The portraits were printed on embossed canvas-like paper and varnished in order to simulate an oil painting. This process was enormously popular until the early 1880s; Middleton's oil-portrait prints of Henry Clay (38.00223.001, p. 192), Stephen A. Douglas (38.00224.001, p. 198), and Andrew Jackson (38.00222.001, p. 208) are also in the Senate collection. ꙮ

[1] Oliver Dyer, *Great Senators of the United States Forty Years Ago (1848 and 1849)*, (1889; reprint, Freeport, NY: Books for Libraries Press, 1972), 251–253.

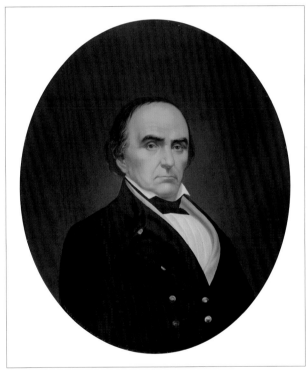

[Daniel Webster]

Unidentified
Middleton, Strobridge & Co., 1863
Lithograph, colored
17 x 14 inches (43.2 x 35.6 cm)
Cat. no. 38.00221.001

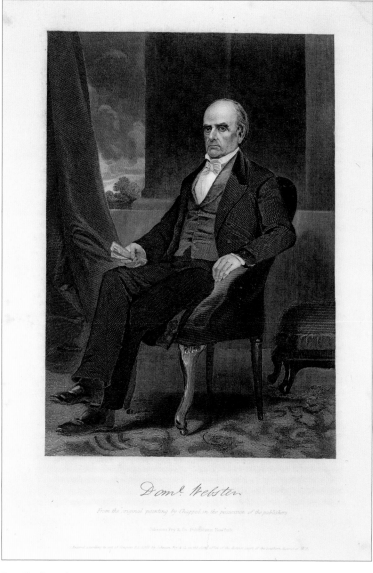

Dan[ie]l. Webster

Unidentified after painting by Alonzo Chappel
Johnson, Fry & Co., ca. 1861
Metal engraving, black and white
8 x 5 ¼ inches (20.3 x 13.3 cm)
Cat. no. 38.00853.001

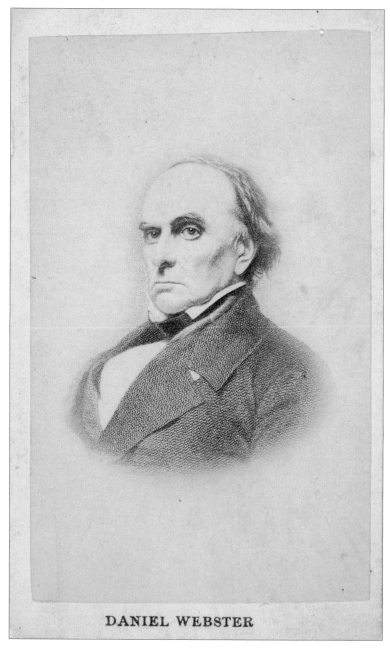

DANIEL WEBSTER

Daniel Webster

Unidentified after engraving by Alexander Hay Ritchie
after photograph by John A. Whipple Studio
Unidentified, ca. 1865
Steel engraving, black and white
3 ½ x 2 ³⁄₁₆ inches (8.9 x 5.6 cm)
Cat. no. 38.00277.001

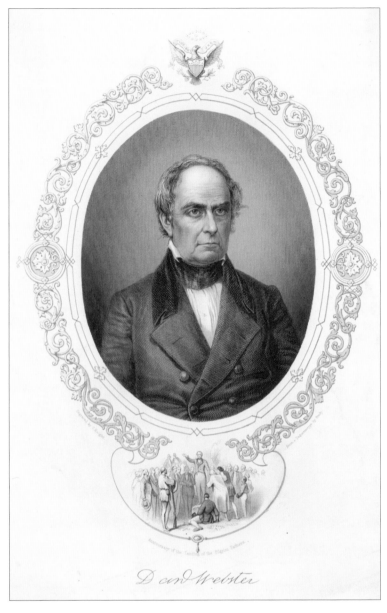

Dan[ie]l Webster

T. Knight after daguerreotype by Mathew B. Brady
Unidentified, ca. 1865
Metal engraving, black and white
9 x 5 ⅞ inches (22.9 x 14.9 cm)
Cat. no. 38.00495.001

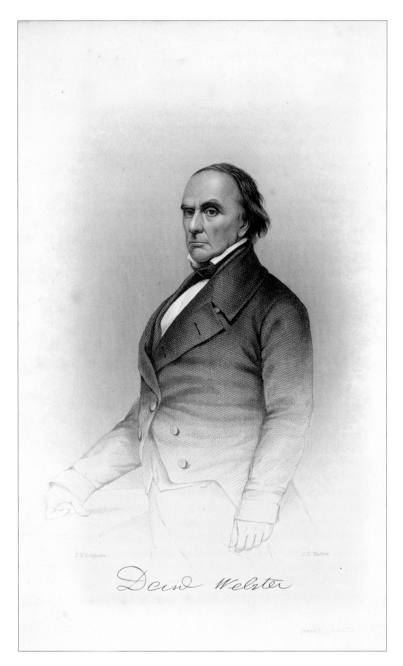

Dan[ie]l Webster

J.C. Buttre after Francis D'Avignon
Unidentified, ca. 1870
Metal engraving, black and white
6 ½ x 4 ¼ inches (16.5 x 10.8 cm)
Cat. no. 38.00851.001

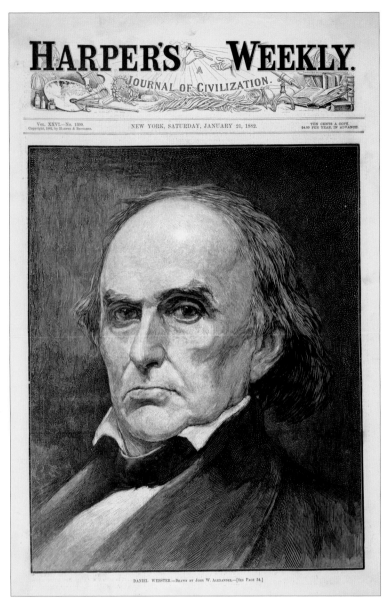

Daniel Webster.

Unidentified after John W. Alexander
Harper's Weekly, 01/21/1882
Wood engraving, black and white
11 ⅝ x 9 ¼ inches (29.5 x 23.5 cm)
Cat. no. 38.00856.001

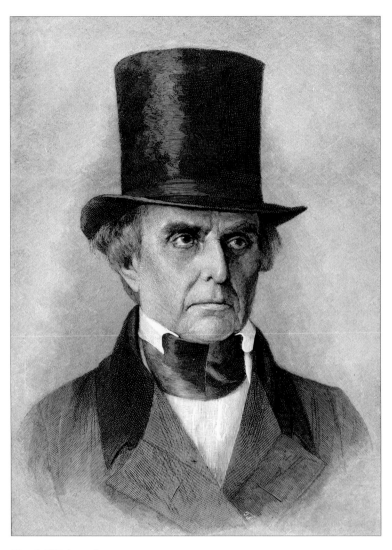

[Daniel Webster]

Unidentified
Unidentified, ca. 1885
Metal engraving, black and white
7 ¹³⁄₁₆ x 5 ¾ inches (19.8 x 14.6 cm)
Cat. no. 38.00757.002

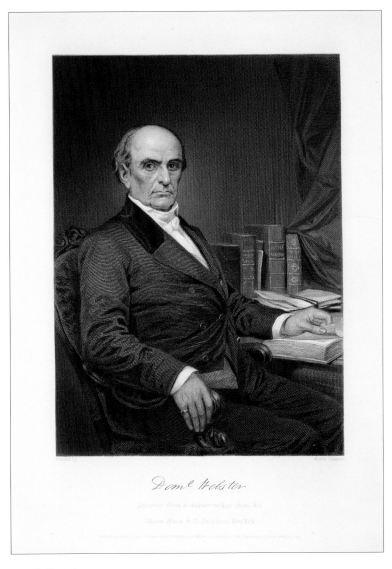

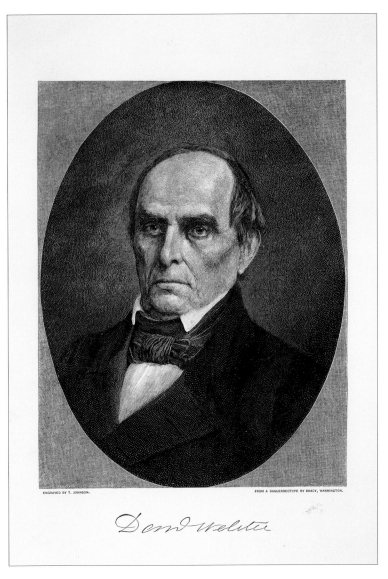

Dan[ie]l Webster

Unidentified after Alonzo Chappel after daguerreotype
Johnson, Wilson & Co., 1873
Steel engraving, black and white
9 x 5 7/16 inches (22.9 x 13.8 cm)
Cat. no. 38.00714.001

Dan[ie]l Webster

T. Johnson after daguerreotype by Mathew B. Brady
Unidentified, ca. 1893
Metal engraving, black and white
7 1/2 x 5 3/16 inches (18.4 x 13.2 cm)
Cat. no. 38.00764.001

[Henry Wilson]

Alexander Gardner
Philp and Solomons, ca. 1860
Photograph, black and white
3 ⁷⁄₁₆ x 2 ⅛ inches (8.7 x 5.4 cm)
Cat. no. 38.00794.001

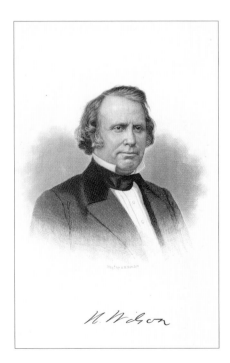

H[enry] Wilson

Alexander Hay Ritchie
Men of Our Times, 1868
Steel engraving, black and white
4 ¾ x 4 inches (12.1 x 10.2 cm)
Cat. no. 38.00699.001

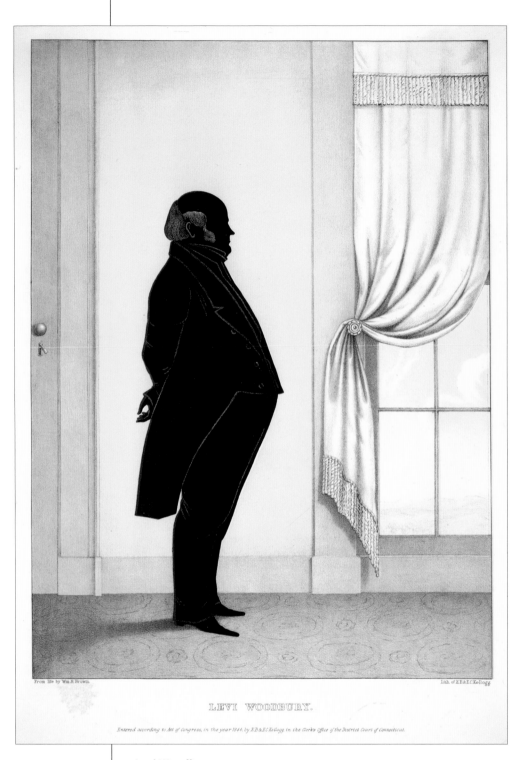

LEVI WOODBURY.

Levi Woodbury.

Edmund Burke Kellogg and Elijah Chapman Kellogg
after William Henry Brown
Portrait Gallery of Distinguished American Citizens, 1845
Lithograph, colored
14 ½ x 9 ¹⁵⁄₁₆ inches (36.8 x 25.2 cm)
Cat. no. 38.00079.001

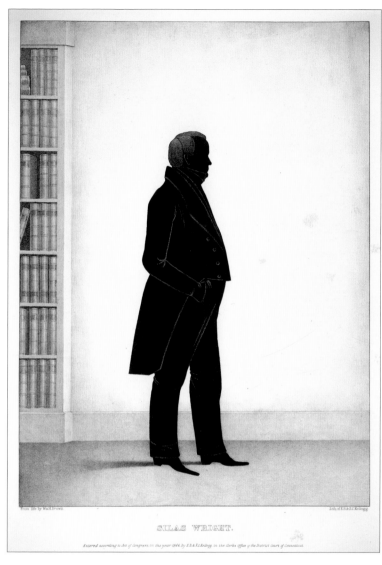

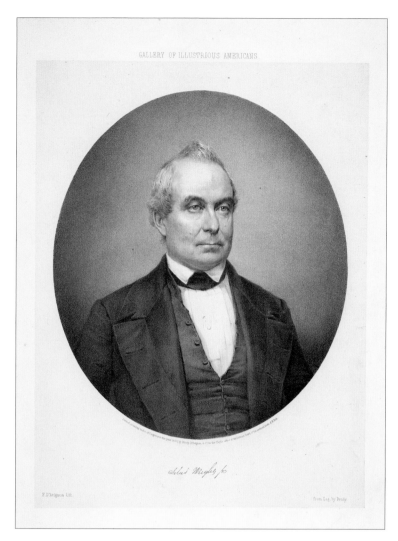

Silas Wright[, Jr].

Edmund Burke Kellogg and Elijah Chapman
Kellogg after William Henry Brown
Portrait Gallery of Distinguished American Citizens, 1845
Lithograph, black and white
14 ½ x 9 ⅞ inches (36.8 x 25.1 cm)
Cat. no. 38.00080.001

Silas Wright, Jr.

Francis D'Avignon after photograph by Mathew B. Brady
Gallery of Illustrious Americans, 1850
Lithograph, black and white
14 x 10 ⅞ inches (35.6 x 27.6 cm)
Cat. no. 38.00188.001

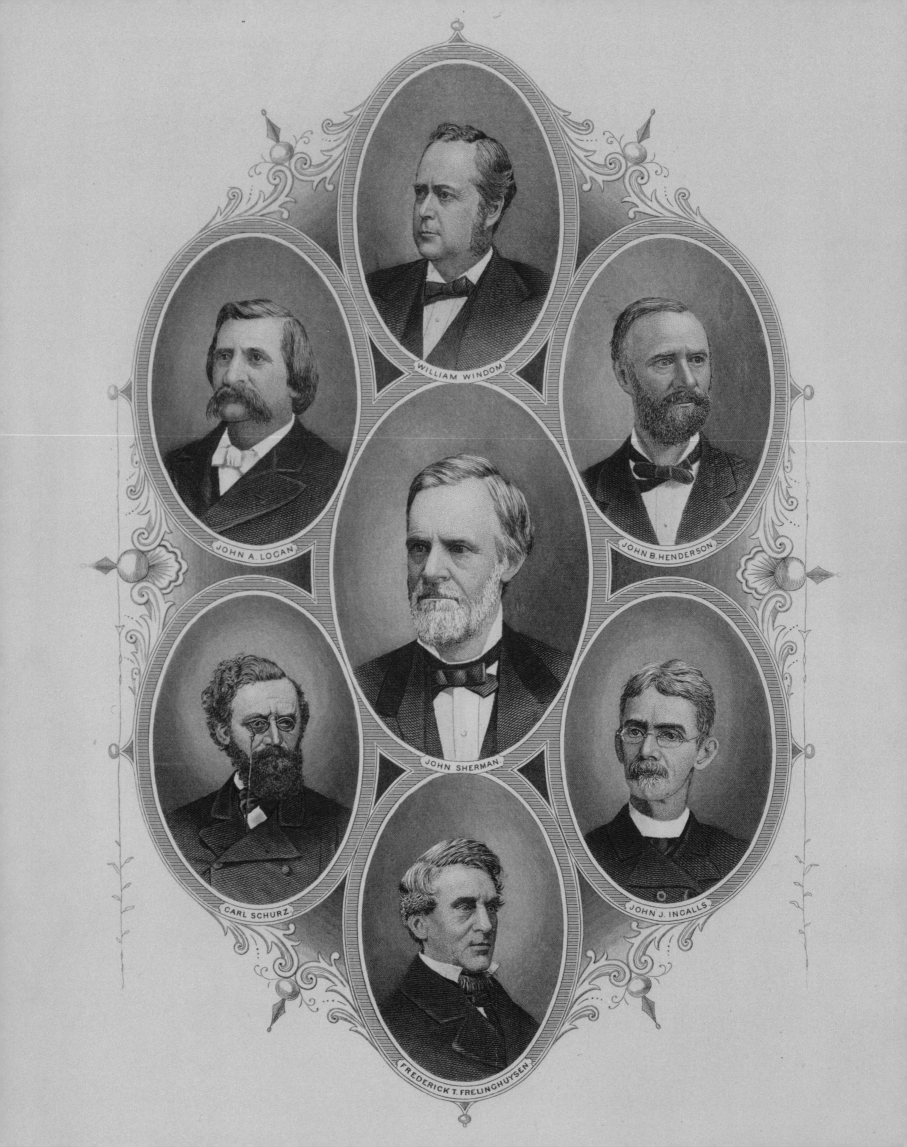

WILLIAM WINDOM

JOHN A. LOGAN

JOHN B. HENDERSON

JOHN SHERMAN

CARL SCHURZ

JOHN J. INGALLS

FREDERICK T. FRELINGHUYSEN

GROUP PORTRAITS

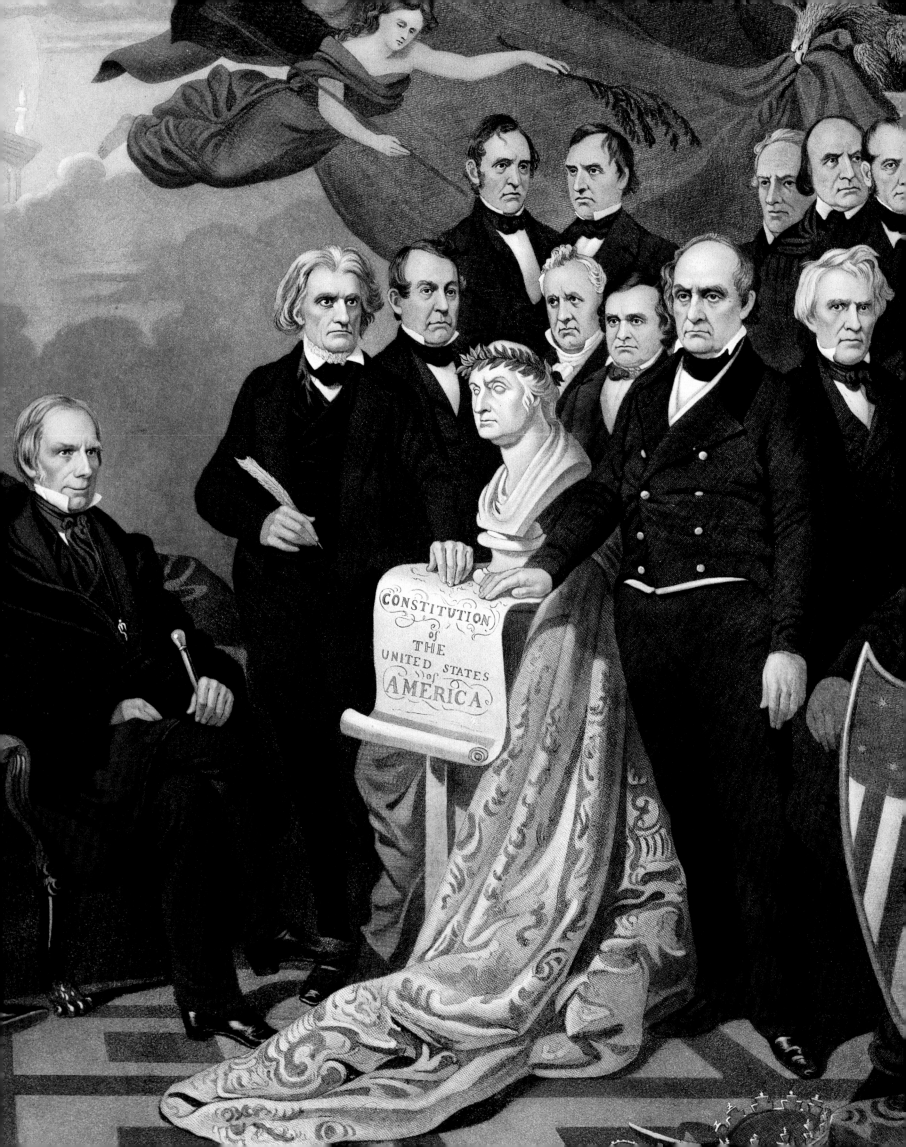

CONSTITUTION
OF
THE
UNITED STATES
OF
AMERICA

This symbolic group portrait—which unites Senators Henry Clay, Daniel Webster, and John C. Calhoun—celebrates the legislative efforts to preserve the Union, most notably the Compromise of 1850. Webster stands with his hand resting on the "Constitution of the United States of America." Senator Calhoun, holding a quill, looks on near the center; seated next to him is Henry Clay. Other prominent politicians and military leaders of the day also appear. The print reflects the hopeful sentiments of a nation that recently averted war and also draws on patriotic themes: a winged goddess Liberty flies down from an Olympian temple inscribed "America" to crown the gathering with an olive branch; while a laurel-crowned bust of George Washington holds a copy of the Constitution in place. The print was published two years after the 1850 Compromise, no doubt to take advantage of this legislative achievement and to celebrate the life of the three principals (all were deceased by the end of 1852; Webster died last, on October 24, 1852). Nearly a decade after the print was published, it was reissued with alterations reflecting the changing political environment (38.00018.001, p. 254). Several of the faces were removed and replaced with more pro-Union public figures. Most notably, the head of Calhoun was supplanted with a portrait of Abraham Lincoln. ☙

Union.

Henry S. Sadd after painting by Tompkins H. Matteson
William Pate, 1852
Mezzotint, hand-colored
19 ½ x 26 ½ inches (49.5 x 67.3 cm)
Cat. no. 38.00019.001

See appendix p. 483 for key

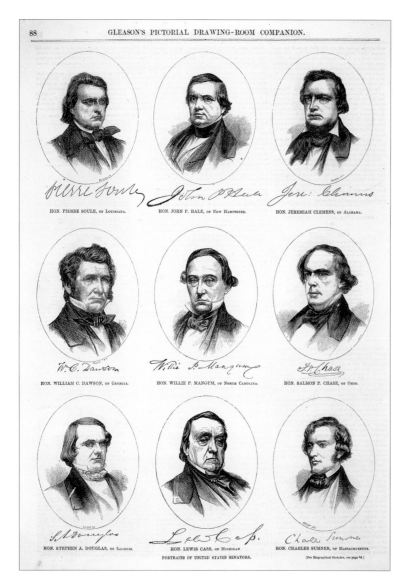

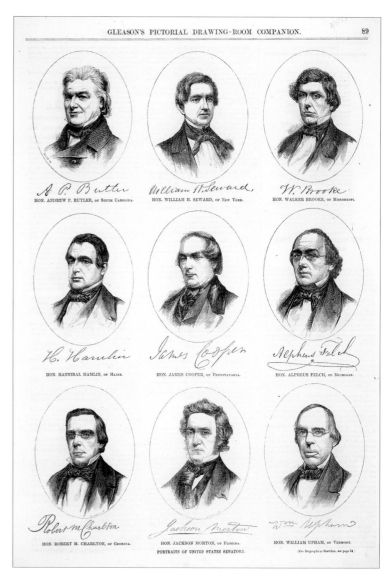

Portraits of United States Senators.

Gulick, Pierson, and Wright
Gleason's Pictorial Drawing-Room Companion, 02/05/1853
Wood engraving, black and white
13 ⅝ x 9 ½ inches (34.9 x 24.8 cm)
Cat. no. 38.00370.001a

(left to right, top) Soule, Pierre
Hale, John P.
Clemens, Jeremiah
(center) Dawson, William C.
Mangum, Willie P.
Chase, Salmon P.
(bottom) Douglas, Stephen A.
Cass, Lewis
Sumner, Charles

Portraits of United States Senators.

Gulick, Pierson, and Wright
Gleason's Pictorial Drawing-Room Companion, 02/05/1853
Wood engraving, black and white
13 ⅝ x 9 ½ inches (34.6 x 24.4 cm)
Cat. no. 38.00370.001b

(left to right, top) Butler, Andrew P.
Seward, William H.
Brooke, Walker
(center) Hamlin, Hannibal
Cooper, James
Felch, Alpheus
(bottom) Charlton, Robert M.
Morton, Jackson
Upham, William

Portraits of United States Senators.

Pierson

Gleason's Pictorial Drawing-Room Companion, 02/19/1853

Wood engraving, black and white

13 ½ x 9 ⅜ inches (34.3 x 23.8 cm)

Cat. no. 38.00283.002a

(left to right, top) Houston, Samuel
Weller, John B.
Cathcart, Charles W.
(center) Clarke, John H.
Shields, James
James, Charles T.
(bottom) Foot, Solomon
Norris, Moses, Jr.
Davis, John

Portraits of United States Senators.

Pierson

Gleason's Pictorial Drawing-Room Companion, 02/19/1853

Wood engraving, black and white

13 ½ x 9 ⅜ inches (34.3 x 23.8 cm)

Cat. no. 38.00283.002b

(left to right, top) Miller, Jacob W.
Wade, Benjamin F.
Spruance, Presley
(center) Dixon, Archibald
Rusk, Thomas J.
Pearce, James A.
(bottom) Underwood, Joseph R.
Smith, Truman
Bradbury, James W.

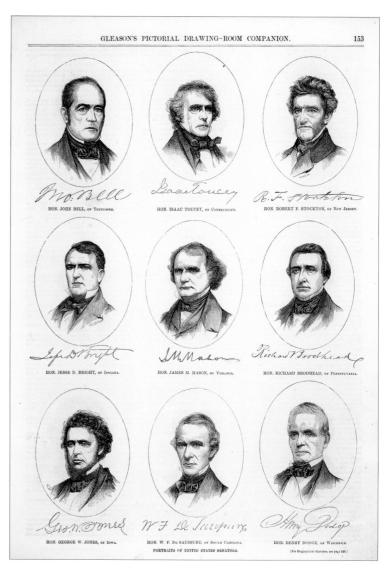

Portraits of United States Senators.

William J. Peirce
Gleason's Pictorial Drawing-Room Companion, ca. 1853
Wood engraving, black and white
13 ¾ x 9 ½ inches (34.9 x 24.1 cm)
Cat. no. 38.00308.002a

(left to right, top) Dodge, Augustus C.
Borland, Solon
Adams, Stephen
(center) Fish, Hamilton
Jones, James C.
Downs, Solomon W.
(bottom) Mallory, Stephen R.
Gwin, William M.
Bayard, James A., Jr.

Portraits of United States Senators.

William J. Peirce
Gleason's Pictorial Drawing-Room Companion, ca. 1853
Wood engraving, black and white
13 ¾ x 9 ½ inches (34.9 x 24.1 cm)
Cat. no. 38.00308.002b

(left to right, top) Bell, John
Toucey, Isaac
Stockton, Robert F.
(center) Bright, Jesse D.
Mason, James M.
Brodhead, Richard
(bottom) Jones, George W.
De Saussure, William F.
Dodge, Henry

[Dred Scott and His Family]

Holcomb and Joseph H. Brightly after S. W. after photographs by Fitzgibbon
Frank Leslie's Illustrated Newspaper, 06/27/1857
Wood engraving, black and white
10 ⅛ x 9 ⅝ inches (27.6 x 24.4 cm)
Cat. no. 38.00372.001

(left to right, top) Scott, Eliza
Scott, Lizzie
(bottom) Scott, Dred
Scott, Harriet

[U.S. Senators and Representatives]

W. Wellstood & Co.
Unidentified, ca. 1860
Metal engraving, black and white
8 ¼ x 5 ¾ inches (21.0 x 14.6 cm)
Cat. no. 38.00842.001

(clockwise from top) Douglas, Stephen A.
Fessenden, William P.
Breckinridge, John C.
Davis, Henry W.
Stevens, Thaddeus
Wade, Benjamin F.
(center) Sumner, Charles

PRESIDENTIAL CAMPAIGN.

REPUBLICAN CANDIDATES FOR PRESIDENT AND VICE-PRESIDENT, Nominated by the National Republican Convention, at Chicago, May 18th, 1860.

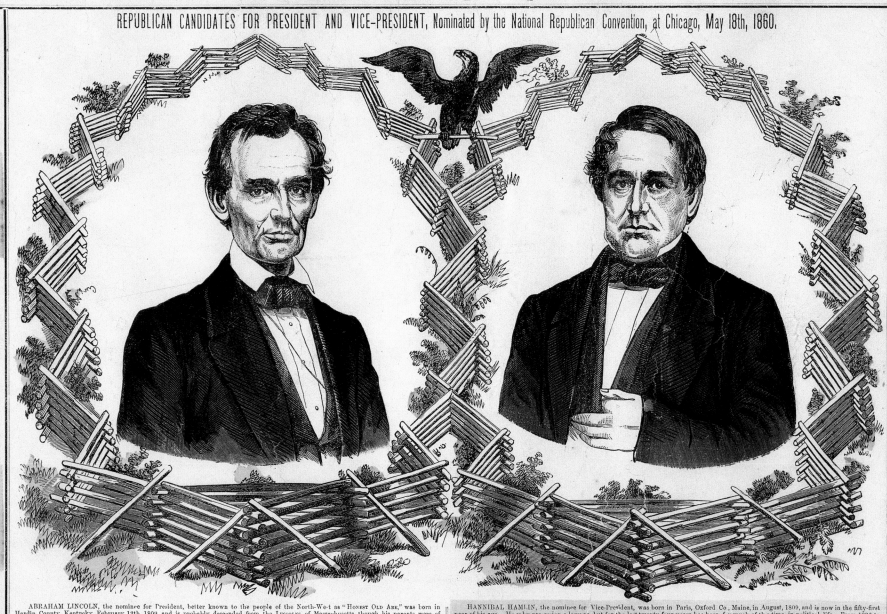

ABRAHAM LINCOLN, the nominee for President, better known to the people of the North-West as "HONEST OLD ABE," was born in Hardin County, Kentucky, February 12th, 1809, and is probably descended from the LINCOLNS of Massachusetts, though his parents were of Quaker stock, that migrated from Pennsylvania to Virginia, whence his grandfather removed in 1781–2 to Kentucky, and was there surprised and killed by Indians while at work on his clearing. Like most pioneers, he left his family poor; and his son also died prematurely, leaving a widow and several children, including Abraham, then six years old. The family removed soon after to Southern Indiana, where Abraham grew to the stature of six feet and some inches, but enjoyed scarcely better opportunities for instruction than in Kentucky. At the age of twenty-one, he pushed further West, into Illinois, which has for the last thirty years been his home, living always near and for some years past in Springfield, the State Capital. He worked on a farm as hired man his first year in Illinois; the next year he was clerk in a store; then volunteered for the Black Hawk war, and was chosen a captain by his company. He subsequently served in the Legislature four sessions, with eminent usefulness and steadily increasing reputation; studied law meantime, and took his place at the bar, where his success was highly flattering. In 1846 he was chosen to represent the Central District of Illinois in the Thirtieth Congress, and served to its close, but was not a candidate for re-election; and in 1849 measurably withdrew from politics, and devoted himself to the practice of his profession, until the *Nebraska Iniquity* of 1854 called him again into the political arena. In 1858 he was nominated to succeed Mr. Douglas in the Senate, and, although defeated in the Legislature, yet, by his logic, eloquence, and truth, he secured the popular vote.

HANNIBAL HAMLIN, the nominee for Vice-President, was born in Paris, Oxford Co., Maine, in August, 1809, and is now in the fifty-first year of his age. He is by profession a lawyer, but for the last twenty-four years has been, for much of the time, in political life. From 1836 to 1840 he was a member of the Legislature of Maine, and for three of those years was Speaker of its House of Representatives. In 1843 he was elected a member of Congress, and re-elected for the following term. In 1847 he was again a member of the State Legislature, and the next year was chosen to fill a vacancy, occasioned by the death of John Fairfield, in the United States Senate. In 1851 he was re-elected for the full term in the same body, but resigned on being chosen Governor of Maine in 1857. In the same month he was again elected to the United States Senate for six years, which office he accepted, resigning the Governorship. He is still a member of the Senate. This record is an evidence of the confidence with which he has always been regarded by his fellow-citizens in Maine. Up to the time of the passage of the Kansas-Nebraska bill, in 1854, Mr. HAMLIN was a member of the Democratic party. That act he regarded as a proof that the party with which he had been all his life connected no longer deserved the name of *Democratic*, and was treacherous to the principles he had so long cherished. Thenceforward he gave his support to the Republican party, of which he has ever since continued a faithful and distinguished leader.

Mr. HAMLIN is a man of dignified presence, of solid abilities, of unflinching integrity, and great executive talent. Familiar with the business of legislation, he is peculiarly adapted, by the possession of all these qualities, to fill beneficially for the country, and to his own and his party's honor, the high post to which he has been nominated.

This elaborate campaign poster was issued sometime after May 18, 1860, when Abraham Lincoln won the Republican presidential nomination. The broadside features portraits of Lincoln and his vice-presidential running mate Hannibal Hamlin, a summary of the Republican platform adopted at the Chicago Convention that year, biographies of the two candidates, a large map of the United States delineating the slave states, and various statistical information. In the border are images of the first 15 presidents. Washington is engraved at the top—the image is based on Gilbert Stuart's famous Athenaeum portrait—thus suggesting that the first president is blessing both the Lincoln-Hamlin ticket and the Republican platform. Published by the prolific New York cartographic firm of H. H. Lloyd & Company, the broadside was probably a commercial venture rather than strictly a political product, as the printer produced other similar charts, including one for the Democratic party and one listing all the parties and candidates. The 1860 presidential election was historic in fielding four major presidential candidates. ☟

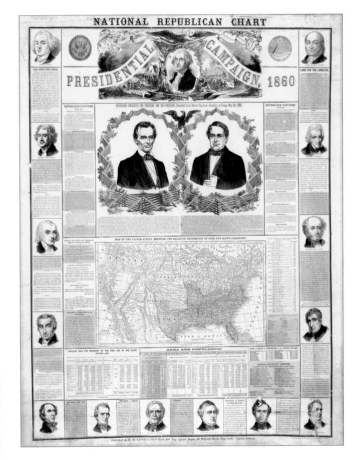

National Republican Chart—Presidential Campaign 1860

Unidentified
H. H. Lloyd & Co., 1860
Wood engraving, hand-colored
35 ¾ x 27 ⅞ inches (90.8 x 70.8 cm)
Cat. no. 38.00150.001

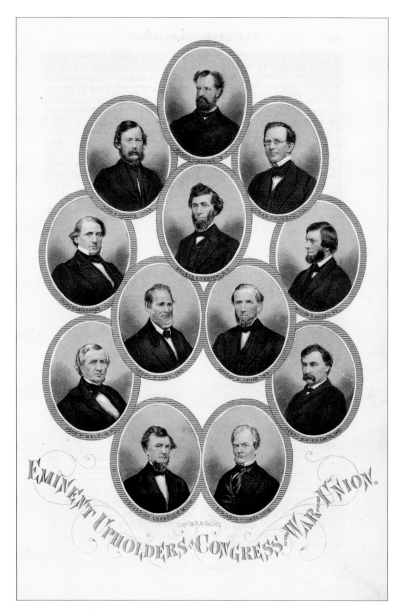

Eminent Upholders in Congress of the War for the Union.

Henry B. Hall
Unidentified, ca. 1861
Steel engraving, hand-colored
8 ⅛ x 6 ⅛ inches (20.6 x 15.6 cm)
Cat. no. 38.00251.001

(clockwise from top) Conkling, Roscoe
Trumbull, Lyman
Kelley, William D.
Davis, Henry W.
Wade, Benjamin F.
Chandler, Zachariah
Hale, John P.
Washburne, Elihu B.
Kasson, John A.
(center, clockwise from top) Fenton, Reuben E.
Julian, George W.
Lane, Henry S.

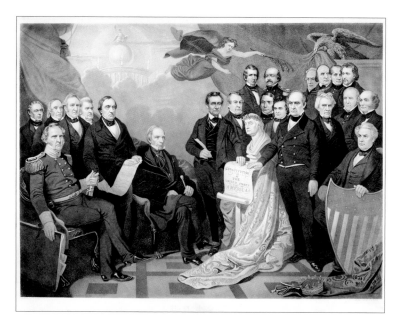

Union.

Henry S. Sadd after painting by Tompkins H. Matteson
William Pate and L. A. Elliot & Co., ca. 1861
Mezzotint, black and white
19 ½ x 26 ½ inches (49.5 x 67.3 cm)
Cat. no. 38.00018.001

(seated, left) Scott, Winfield
(seated, left center) Clay, Henry
(standing, center) Lincoln, Abraham
(standing, front right) Webster, Daniel
(seated, far right) Fillmore, Millard

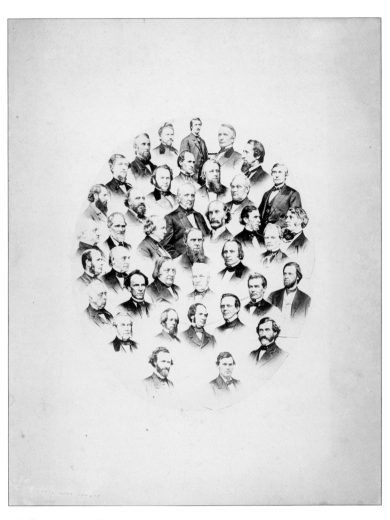

[Civil War Senate]

Unidentified
Unidentified, ca. 1863
Photograph, black and white
10 ⅛ x 8 ¾ inches (25.7 x 22.2 cm)
Cat. no. 38.00724.001

See appendix p. 484 for key

The Chief Justices of the United States.

Unidentified
Harper's Weekly, 12/24/1864
Wood engraving, black and white
11 x 9 ⅛ inches (27.9 x 23.2 cm)
Cat. no. 38.00214.001

(clockwise from top left) Jay, John
Ellsworth, Oliver
Taney, Roger B.
Marshall, John
(center) Chase, Salmon P.

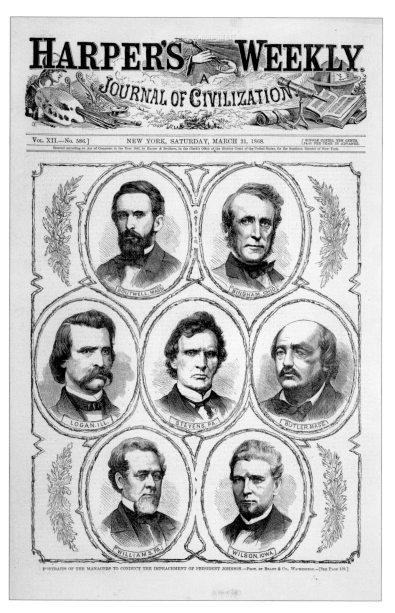

[U.S. Senators]

W. Wellstood & Co.
Unidentified, ca. 1865
Metal engraving, black and white
8 ¼ x 5 ¾ inches (21.0 x 14.6 cm)
Cat. no. 38.00971.001

(clockwise from top) Chandler, Zachariah
Anthony, Henry B.
Hendricks, Thomas A.
Cameron, Simon
Grimes, James W.
Hale, John P.
(center) Morton, Oliver P.

Portraits of the Managers to Conduct the Impeachment of President Johnson.

Unidentified after photographs by Mathew B. Brady & Co.
Harper's Weekly, 03/21/1868
Wood engraving, black and white
11 ¼ x 9 ¼ inches (28.6 x 23.5 cm)
Cat. no. 38.00369.001

(clockwise from top left) Boutwell, George S.
Bingham, John A.
Butler, Benjamin F.
Wilson, James F.
Williams, Thomas
Logan, John A.
(center) Stevens, Thaddeus

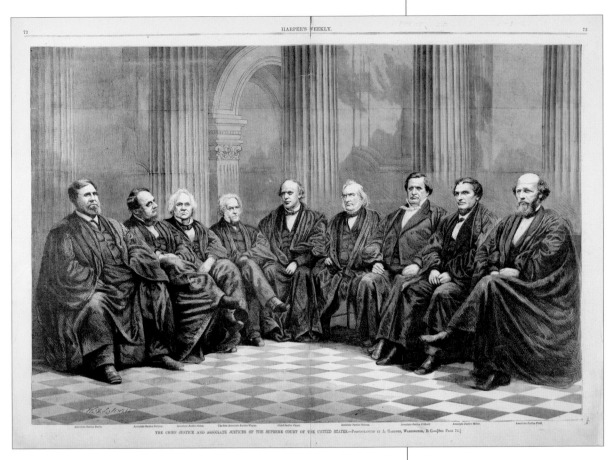

The Chief Justice and Associate Justices of the Supreme Court of the United States.

William S. L. Jewett after photograph by Alexander Gardner
Harper's Weekly, 02/01/1868
Wood engraving, black and white
13¾ x 20¼ inches (34.9 x 51.4 cm)
Cat. no. 38.00239.001

(left to right) Davis, David
Swayne, Noah H.
Grier, Robert C.
Wayne, James M.
Chase, Salmon P.
Nelson, Samuel
Clifford, Nathan
Miller, Samuel F.
Field, Stephen J.

[U.S. Senators]

Unidentified after photographs by Rockwood, Mathew B. Brady & Co., and John A. Whipple
Harper's Weekly, 04/18/1868
Wood engraving, black and white
5 x 9¼ inches (12.7 x 23.5 cm)
Cat. no. 38.00309.001a

(left to right) Evarts, William M.
Stanbery, Henry
Curtis, Benjamin R.

[U.S. Senators]

W. Wellstood & Co.
Unidentified, ca. 1870
Metal engraving, black and white
8 x 6 inches (20.3 x 15.2 cm)
Cat. no. 38.00840.001

(clockwise from top) Windom, William
Henderson, John B.
Ingalls, John J.
Frelinghuysen, Frederick T.
Schurz, Carl
Logan, John A.
(center) Sherman, John

[U.S. Representatives]

W. Wellstood & Co.
Unidentified, ca. 1870
Metal engraving, black and white
8 x 5 ⅞ inches (20.3 x 14.9 cm)
Cat. no. 38.00841.001

(clockwise from top) Schenck, Robert C.
Shellabarger, Samuel
Boutwell, George S.
Fenton, Reuben E.
Morrill, Justin S.
Kelley, William D.
(center) Washburne, Elihu B.

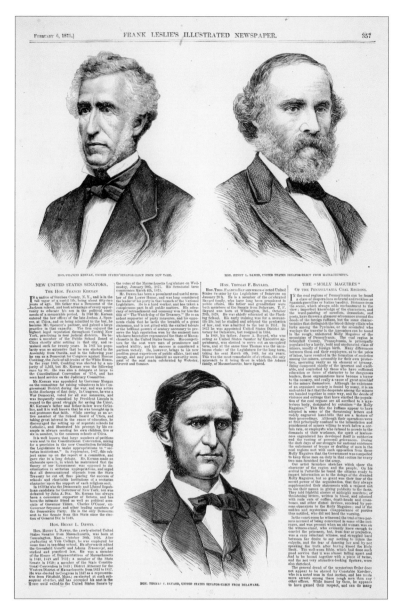

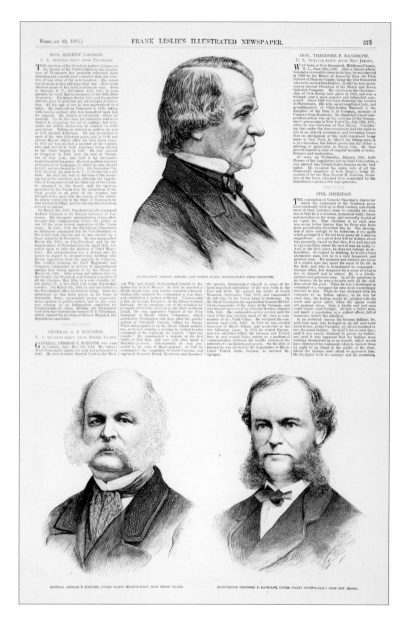

New United States Senators.

Unidentified
Frank Leslie's Illustrated Newspaper, 02/06/1875
Wood engraving, black and white
14 ½ x 9 ⁷⁄₁₆ inches (36.8 x 24.0 cm)
Cat. no. 38.00695.001

(left to right, top) Kernan, Francis
Dawes, Henry L.
(bottom) Bayard, Thomas F.

[U.S. Senators-Elect.]

Unidentified
Frank Leslie's Illustrated Newspaper, 02/13/1875
Wood engraving, black and white
14 ½ x 9 ⁷⁄₁₆ inches (36.8 x 24.0 cm)
Cat. no. 38.00696.001

(left to right, top) Johnson, Andrew
(bottom) Burnside, Ambrose E.
Randolph, Theodore F.

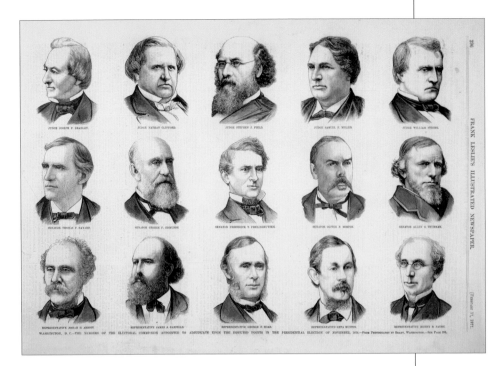

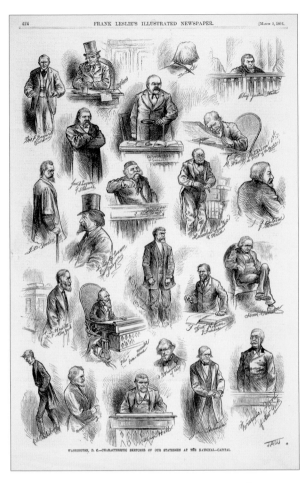

Washington, D.C.—The Members of the Electoral Commission Appointed to Adjudicate upon the Disputed Points in the Presidential Election of November, 1876.

Unidentified after photographs by Mathew B. Brady
Frank Leslie's Illustrated Newspaper, 02/17/1877
Wood engraving, black and white
9 ½ x 14 ½ inches (24.1 x 36.8 cm)
Cat. no. 38.00762.001

(left to right, top) Bradley, Joseph P.
Clifford, Nathan
Field, Stephen J.
Miller, Samuel F.
Strong, William
(center) Bayard, Thomas F.
Edmunds, George
Frelinghuysen, Frederick T.
Morton, Oliver P.
Thurman, Allen G.
(bottom) Abbott, Josiah G.
Garfield, James A.
Hoar, George F.
Hunton, Eppa
Payne, Henry B.

Washington, D.C.—Characteristic Sketches of Our Statesmen at the National—Capital

Unidentified after James A. Wales
Frank Leslie's Illustrated Newspaper, 03/03/1877
Wood engraving, black and white
14 ¾ x 9 ⅜ inches (37.5 x 23.8 cm)
Cat. no. 38.00244.002

(left to right, top row) Bayard, Thomas F.
Stephens, Alexander H.
Boutwell, George S.
Waite, Morrison R.
(second row) Logan, John A.
Morton, Oliver H.P.T.
Watterson, Henry
(third row) Gordon, John B.
Lamar, Lucius Q.C.
Burnside, Ambrose E.
Hamlin, Hannibal
Blaine, James G.
(fourth row) Hewitt, Abram S.
Kelley, William D.
Holman, William S.
Cameron, Simon
(bottom row) Saulsbury, Eli
Conkling, Roscoe
Hill, Benjamin H.
Thurman, Allen G.
Sherman, John
Wood, Fernando

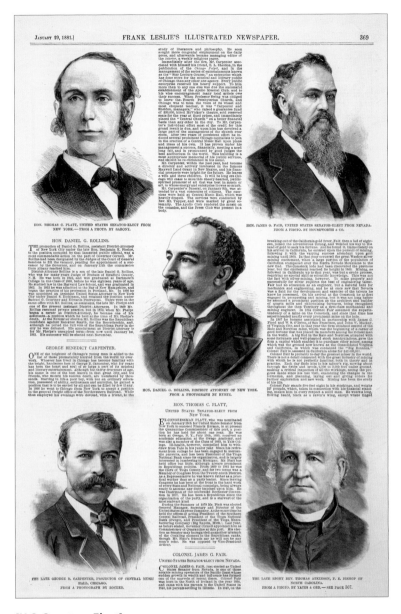

[U.S. Senators-Elect]

Unidentified after photographs by Sarony and Houseworth & Co.
Frank Leslie's Illustrated Newspaper, 01/29/1881
Wood engraving, black and white
5 x 3 ⅜ inches (12.7 x 8.6 cm)
Cat. no. 38.00864.001

(left to right, top) Platt, Thomas C.
Fair, James G.

The New Senate of the United States.

Unidentified after photographs by Charles M. Bell, Dillon, Samuel M. Fassett, Thomas Houseworth, William Notman, Pach Brothers, Taber, and Warren
Harper's Weekly, 02/05/1881
Wood engraving, black and white
14 ½ x 9 ½ inches (36.8 x 24.1 cm)
Cat. no. 38.00313.001

(left to right, top) Platt, Thomas C.
Dawes, Henry L.
Hale, Eugene
(center) Bayard, Thomas F.
Conger, Omar D.
Pugh, James L.
(bottom) Fair, James G.
Miller, John F.
Cockrell, Francis M.

The New Senate of the United States.

Unidentified after photographs by Mathew B. Brady,
White, and William Notman
Harper's Weekly, 02/05/1881
Wood engraving, black and white
6 ¼ x 4 ½ inches (15.9 x 11.4 cm)
Cat. no. 38.00332.001

(left to right, top) Edmunds, George F.
Hawley, Joseph R.
(bottom) Sherman, John
Harrison, Benjamin

The New Senate.

Unidentified after photographs by Anderson, Charles M. Bell,
D. Bendann, Broadbent and Phillips, Mora, and Zimmerman
Harper's Weekly, 02/12/1881
Wood engraving, black and white
14 ½ x 9 ½ inches (36.8 x 24.1 cm)
Cat. no. 38.00312.001

(left to right, top) Camden, Johnson N.
Sawyer, Philetus
McMillan, Samuel J.R.
(center) Gorman, Arthur P.
Burnside, Ambrose E.
Jones, Charles W.
(bottom) Mahone, William
Sewell, William J.
Brown, Joseph E.

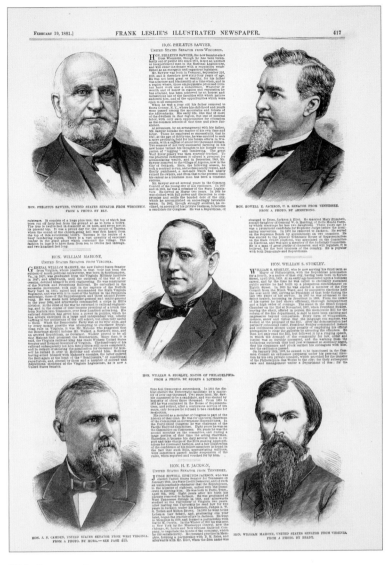

[U.S. Senators]

Unidentified after photographs by Ely, Armstrong, Stokes & Lothrop, Mora, and Mathew B. Brady
Frank Leslie's Illustrated Newspaper, 02/19/1881
Wood engraving, black and white
14 ½ x 9 ½ inches (36.8 x 24.1 cm)
Cat. no. 38.00896.001

(left to right, top) Sawyer, Philetus
Jackson, Howell E.
(center) Stokley, William S.
(bottom) Camden, Johnson N.
Mahone, William

Sketches in the Capitol, Washington.

Unidentified after John W. Alexander
Harper's Weekly, 04/08/1882
Lithograph, black and white
13 ⅝ x 9 ⁷⁄₁₆ inches (34.6 x 24.0 cm)
Cat. no. 38.00226.001

(clockwise from top) Logan, John A.
Sherman, John
McPherson, John R.
Saulsbury, Eli
Robeson, George M.
Hoar, George F.
Miller, John F.
Conger, Omar D.
(left center) Hale, Eugene
(right center) Hampton, Wade

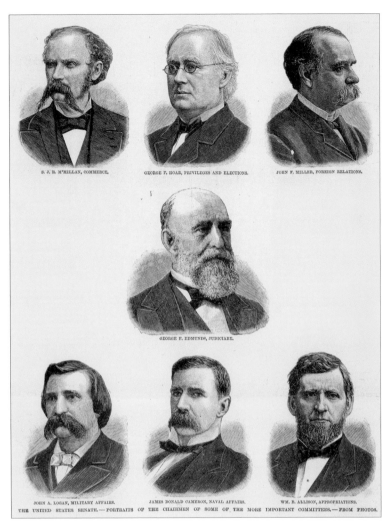

The United States Senate.—Portraits of the Chairmen of Some of the
More Important Committees.

Unidentified after photographs
Frank Leslie's Illustrated Newspaper, 01/26/1884
Wood engraving, black and white
9 ½ x 7 ⁵⁄₁₆ inches (24.1 x 18.6 cm)
Cat. no. 38.00430.001

(left to right, top) McMillan, Samuel J.R.
Hoar, George F.
Miller, John F.
(center) Edmunds, George F.
(bottom) Logan, John A.
Cameron, James Donald
Allison, William B.

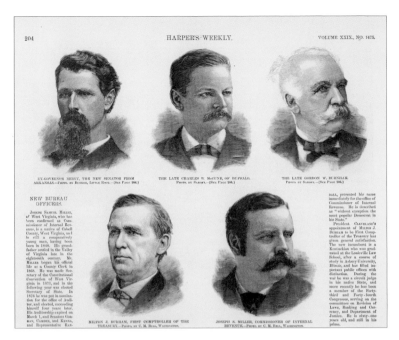

New Bureau Officers.

Unidentified after photograph by Bunker
Harper's Weekly, 03/28/1885
Wood engraving, hand-colored
7 ⁵⁄₁₆ x 9 inches (18.6 x 22.9 cm)
Cat. no. 38.00811.001

(left, top) Berry, James H

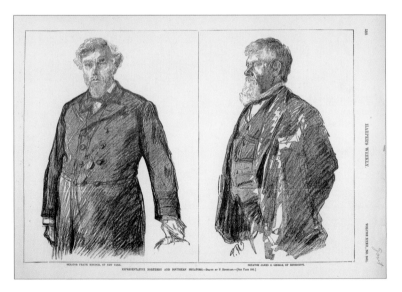

Representative Northern and Southern Senators.

Unidentified after Paul Renouard
Harper's Weekly, 08/11/1888
Lithograph, black and white
9 ¾ x 7 ¼ inches (24.8 x 18.4 cm)
Cat. no. 38.00545.001

(left) Hiscock, Frank
(right) George, James Z.

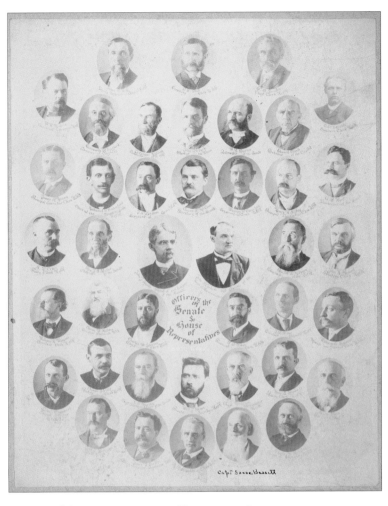

Officers of the Senate & House of Representatives

Unidentified
Unidentified, ca. 1888
Photograph, black and white
9 ½ x 7 ⁹⁄₁₆ inches (24.1 x 19.2 cm)
Cat. no. 38.00505.001

(top row, center) Platt, R.S.
(second row, third from right) Rigelow, W.H.
(third row, far left) Young, James R.
(third row, center) McCook, Anson G.
(third row, third from right) Canaday, William P.
(third row, second from left) Butler, Reverend T.G.
(fourth row, third from left) Ingalls, John J.
(fifth row, second from left) Kellogg, Caron W.
(fifth row, third from left) Johnson, Charles W.
(fifth row, third from right) Nixon, P.B.
(fifth row, far right) Spencer, William E.
(sixth row, third from left) Murphy, D.F.
(bottom row, second from left) Christie, James T.
(bottom row, center) Shankland, M.R.
(bottom row, second from right) Bassett, Isaac
(bottom row, far right) Richards, Charles K.

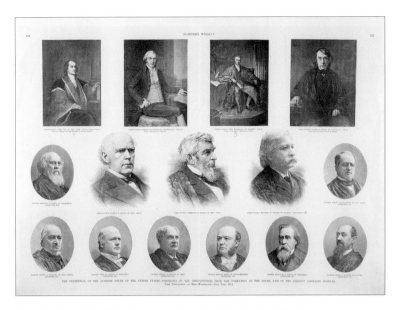

**The Centennial of the Supreme Court of the United States—
Portraits of the Chief-Justices from the Formation of the Court,
and of the Present Associate Justices.**

Gray after painting by Gilbert Stuart, and Unidentified after paintings
by Wheeler, Rembrandt Peale, G.P.A. Healey and after photographs by
Charles M. Bell
Harper's Weekly, 02/08/1890
Wood engraving, black and white
14 ½ x 20 ½ inches (36.8 x 52.1 cm)
Cat. no. 38.00205.001

(left to right, top) Jay, John
Ellsworth, Oliver
Marshall, John
Taney, Roger B.
(center) Field, Stephen J.
Chase, Salmon P.
Waite, Morrisson R.
Fuller, Melville W.
Blatchford, Samuel
(bottom) Bradley, Joseph P.
Harlan, John M.
Miller, Samuel F.
Gray, Horace
Lamar, Lucius Q.C.
Brewer, David J.

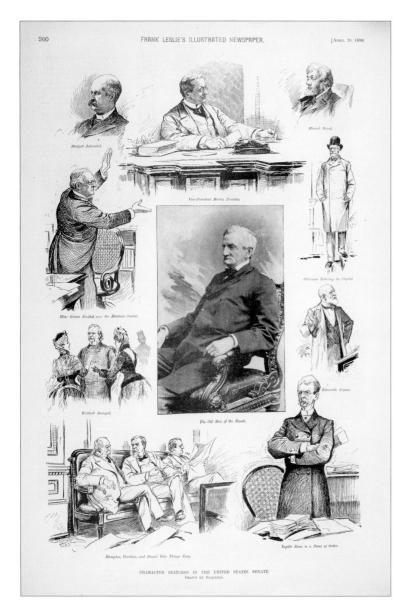

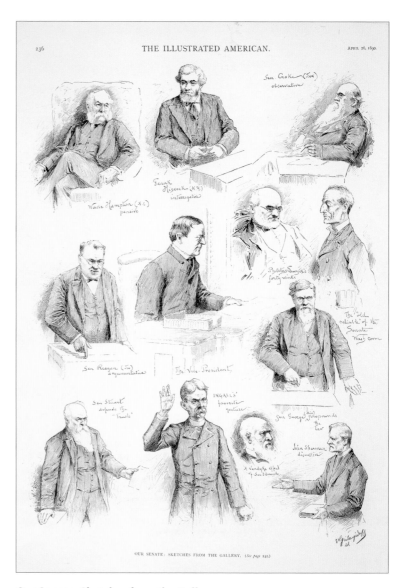

Character Sketches in the United States Senate.

Unidentified after Grant E. Hamilton
Frank Leslie's Illustrated Newspaper, 04/26/1890
Lithograph and halftone, black and white
13 7/8 x 8 1/2 inches (35.2 x 21.6 cm)
Cat. no. 38.00286.001

(clockwise from top left) Blodgett, Rufus
Morton, Levi P.
Hiscock, Frank
Sherman, John
Edmunds, George F.
Ingalls, John J.
Hampton, Wade
Voorhees, Daniel W.
Daniel, John W.
Walthall, Edward C.
Hoar, George F.
(center) Evarts, William M.

Our Senate: Sketches from the Gallery.

Unidentified after Valerian Gribayédoff
The Illustrated American, 04/26/1890
Lithograph, black and white
14 1/8 x 10 1/2 inches (35.9 x 26.7 cm)
Cat. no. 38.00870.001

(left to right, top) Hampton, Wade
Hiscock, Frank
Coke, Richard
(center) Reagan, John H.
Morton, Levi P.
Sawyer, Philetus
George, James Z.
(bottom) Stewart, William M.
Ingalls, John J.
Edmunds, George F.
Sherman, John

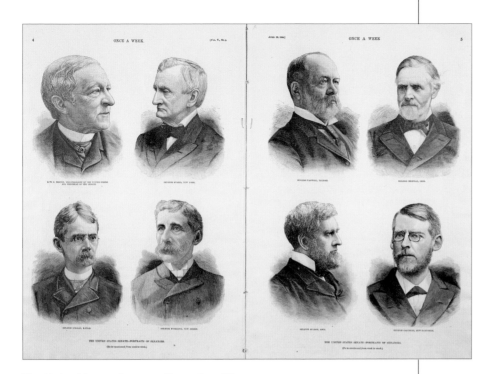

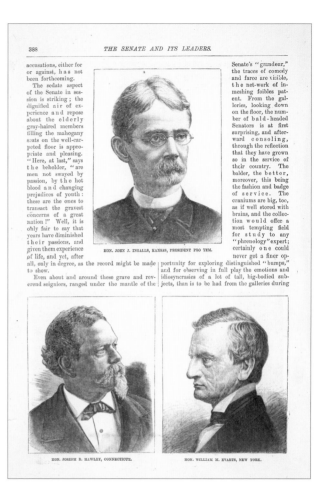

The United States Senate—Portraits of Senators.

Unidentified
Once a Week, 04/29/1890
Wood engraving, black and white
14 ¼ x 21 inches (36.2 x 53.3 cm)
Cat. no. 38.00456.001

(left to right, top) Morton, Levi P.
Evarts, William M.
Farwell, Charles B.
Sherman, John
(bottom) Ingalls, John J.
McPherson, John R.
Allison, William B.
Chandler, William E.

The Senate and Its Leaders.

Unidentified
Frank Leslie's Popular Monthly, 04/1890
Wood engraving, black and white
9 ½ x 6 ¼ inches (24.1 x 15.9 cm)
Cat. no. 38.00508.001

(left to right, top) Ingalls, John J.
(bottom) Hawley, Joseph R.
Evarts, William M.

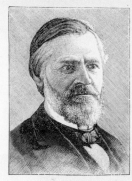

HON. G. F. EDMUNDS, VERMONT.

HON. JOHN SHERMAN, OHIO.

hobby, the "Blair Bill," which he rides in the Senate, though he runs, in addition, a large assortment outside. In his eyes the Senate means only the Blair Bill, and he is its father recognized all over the land. The Bill has passed several times, has never become a law, however, and so always remains to be repassed. Meanwhile Mr. Blair prepares fresh and additional budgets of vouchers in its behalf. His desk is the most crowded in the Senate, with books, certificates, letters and reports bearing on the famous Bill. He takes occasion, in and out of season, early and often, to allude to it; gets snubbed by the presiding officer, or some member, for doing so, and

only sits down to spring up again at the next favorable chance. The hobby does not tire him in the least, notwithstanding all the fretting it causes in others, and the more unmanageable it proves to be, the closer he sticks to it. Truly his care is fatherly, and a very fatherly-looking Senator he is, too, as he glides about or spreads himself to make a speech. He is a good speaker, and only the monotony of his theme causes an evacuation of the Senate whenever he secures the floor, for a big effort, behind a huge pile of leather-covered books, a glass of water and a bouquet of flowers. His colleague, Mr. Chandler, is beside him, a silent partner, although he excels as an

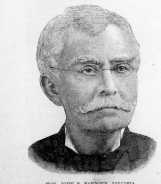

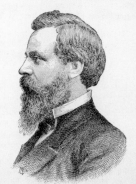

HON. JOHN S. BARBOUR, VIRGINIA.

HON. HENRY W. BLAIR, NEW HAMPSHIRE.

The Senate and Its Leaders.

Unidentified
Frank Leslie's Popular Monthly, 04/1890
Wood engraving, black and white
9 ½ x 6 ¼ inches (24.1 x 15.9 cm)
Cat. no. 38.00511.001

(left to right, top) Edmunds, George F.
Sherman, John
(bottom) Barbour, John S., Jr.
Blair, Henry W.

Britain and the United States, there is little or no demand for the comedietta or for the two-act comedy; a play must be long enough and strong enough to furnish forth the whole evening's entertainment. The dramatist may divide his piece into three, four, or five acts, as he prefers, but, except from some good reason, there must be but a single scene to each act. The characters must be so many in number that no one shall seem obtrusive; they must be sharply contrasted; most of them must be sympathetic to the spectators, for the audience in a theatre, however pessimistic it may be individually, is always optimistic as a whole. There must be an infusion of humor at recurrent intervals, and a slowly increasing intensity of emotional stress. In short, the fetters of the dramatist are as obvious as the freedom of the novelist.

Perhaps the chief disadvantage under which the dramatist labors is that it is almost impossible for him to show adequately the contrasting and well-nigh imperceptible disintegration of character under the attrition of recurring circumstances. Time and space are both beyond the control of the maker of plays, while the storyteller may take his hero by slow stages to the world's end. The drama has but five acts at most,

possible on the stage; and there are many who love certain novels—Thackeray's, for example—chiefly because they feel therein the personal presence of the author. It is at once the merit

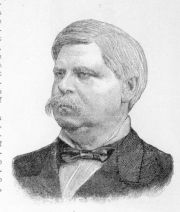

HON. ZEBULON B. VANCE, NORTH CAROLINA.

and the difficulty of dramatic art that the characters must reveal themselves; they must be illuminated from within, not from without; they must speak for themselves in unmistakable terms; and the author cannot dissect them for us or lay bare their innermost thoughts with his pen as with a scalpel.

The drama must needs be sympathetic, while now the novel, more often than not, is an analytic. The vocabulary of the playwright must be clear, succinct, precise and picturesque, while that of the novelist may be archaic, fantastic, subtle, or illusive. Simplicity and directness are the ear-marks of a good play; but we all know good novels which are complex, involute, tortuous. A French critic has declared that the laws of the drama are logic and movement, by which he means that in a good play the subject clearly exposed at first moves forward by regular steps, artfully prepared, straight to its inevitable end. The finer the novel, the more delicate and delightful its workmanship, the more subtle its psychology, the greater is the difficulty in dramatizing it, and the greater the ensuing disappointment. The frequent attempts to turn into a play "Vanity Fair" and the "Scarlet Letter" were all doomed to the certainty of failure, because the development of the central character and leading

THE SENATE AND ITS LEADERS.—HON. WADE HAMPTON, SOUTH CAROLINA.—SEE PAGE 385.

and the theatre is but a few yards wide. Description is scarcely permissible in a play; and it may be the most beautiful and valuable part of a novel. Comment by the author is absolutely im-

The Senate and Its Leaders.

Unidentified
Frank Leslie's Popular Monthly, 04/1890
Wood engraving, black and white
7 ½ x 6 ¼ inches (19.1 x 15.9 cm)
Cat. no. 38.00512.001

(top) Vance, Zebulon B.
(bottom) Hampton, Wade

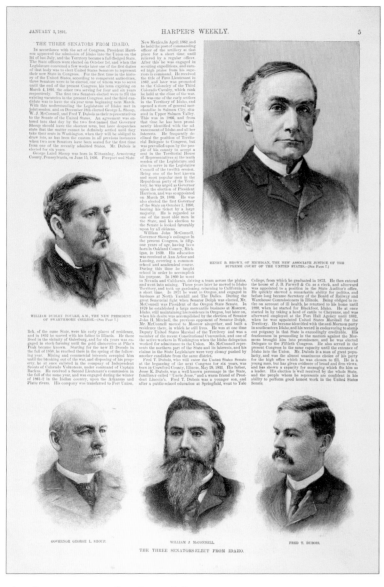

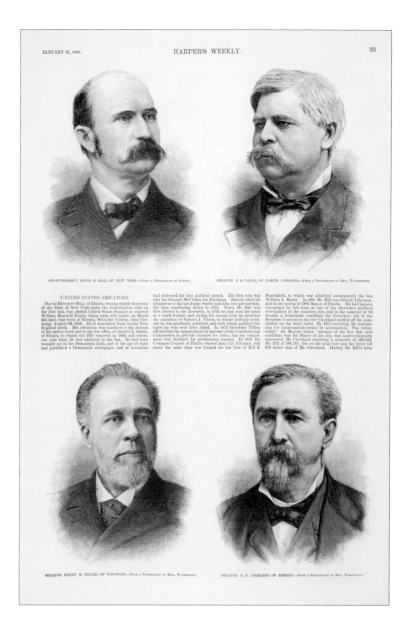

The Three Senators Elect from Idaho.

Unidentified
Harper's Weekly, 01/03/1891
Wood engraving, black and white
4 ½ x 9 ½ inches (11.4 x 24.1 cm)
Cat. no. 38.00814.001

(right, top) Brown, Henry B.
(left to right bottom) Shoup, George L.
McConnell, William J.
Dubois, Fred T.

United States Senators.

Unidentified after photographs by Sarony and Charles M. Bell
Harper's Weekly, 01/31/1891
Wood engraving, black and white
14 x 9 ¼ inches (35.6 x 23.5 cm)
Cat. no. 38.00586.001

(left to right, top) Hill, David B.
Vance, Zebulon B.
(bottom) Teller, Henry M.
Voorhees, Daniel W.

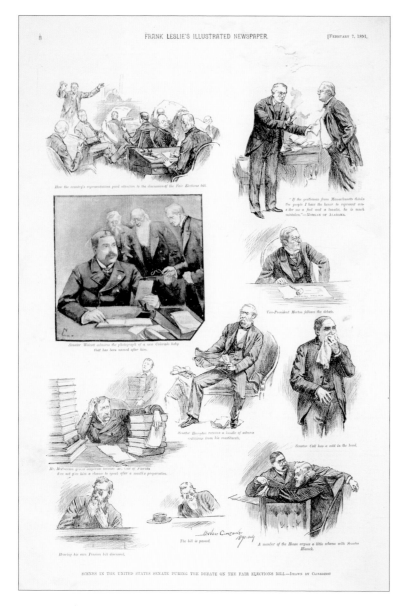

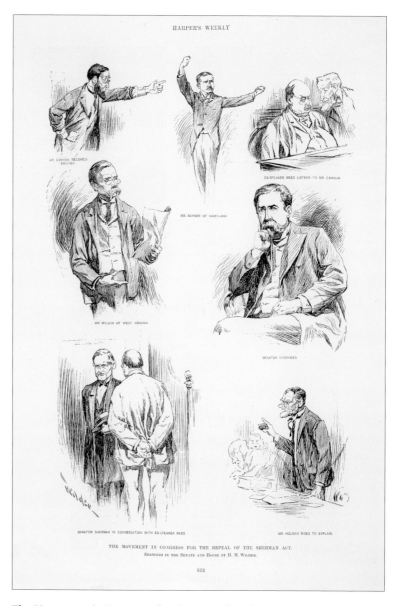

Scenes in the United States Senate during the Debate on the Fair Elections Bill.

Unidentified after Benjamin West Clinedinst
Frank Leslie's Illustrated Newspaper, 02/07/1891
Lithograph and halftone, black and white
14 x 9 ¼ inches (35.6 x 23.5 cm)
Cat. no. 38.00765.001

(left to right, top row) Morgan, John T.
(second row) Wolcott, Edward O.
Morton, Levi P.
(third row) McPherson, John R.
Hampton, Wade
Call, Wilkinson
(bottom row) Hiscock, Frank

The Movement in Congress for the Repeal of the Sherman Act.

Unidentified after H. M. Wilder
Harper's Weekly, 09/02/1893
Lithograph, black and white
13 ½ x 8 ¼ inches (34.3 x 21.0 cm)
Cat. no. 38.00589.002

(left to right, top) Cannon, Joseph G.
Rayner, Isidor
Reed, Thomas B.
(center) Wilson, William L.
Voorhees, Daniel W.
(bottom) Sherman, John
Holman, William S.

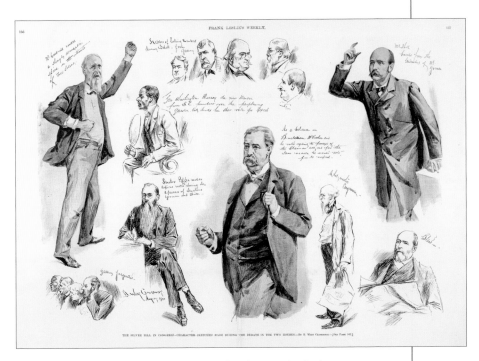

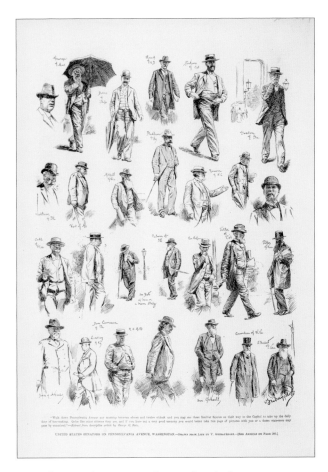

The Silver Bill in Congress—Character-Sketches Made during the Debate in the Two Houses.

Unidentified after Benjamin West Clinedinst
Frank Leslie's Weekly, 09/07/1893
Lithograph and halftone, black and white
14 x 19½ inches (35.6 x 49.5 cm)
Cat. no. 38.00220.001

(left to right, top) Cockrell, Francis M.
Murray, George W.
Hill, David B.
(bottom) Peffer, William A.
Voorhees, Daniel W.
Bland, Richard P.

United States Senators on Pennsylvania Avenue, Washington.

Unidentified after Valerian Gribayédoff
Leslie's Weekly, 03/29/1894
Lithograph, black and white
13½ x 10 inches (34.3 x 25.4 cm)
Cat. no. 38.00763.001

(left to right, top row) George, James Z.
DuBois, Fred T.
Roach, William N.
Perkins, George C.
Gordon, John B.
(second row) Washburne, William D.
Vest, George G.
Mitchell, John L.
Blackburn, Joseph C.S.
Ransom, Matt W.
(third row) Call, Wilkinson
Cameron, James D.
Bate, William B.
Palmer, John M.
Cullom, Shelby M.
Teller, Henry M.
Peffer, William A.
(bottom row) Jones, James K.
Lindsay, William
Mills, Roger Q.
Cockrell, Francis M.
Camden, Johnson N.
Stewart, William M.

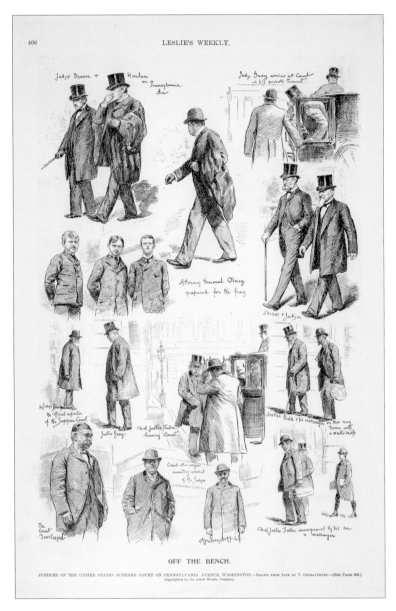

Off the Bench. Justices of the United States Supreme Court on Pennsylvania Avenue, Washington.

Unidentified after Valerian Gribayédoff
Leslie's Weekly, 06/14/1894
Lithograph, black and white
14 x 9 inches (35.6 x 22.9 cm)
Cat. no. 38.00878.001

(left to right, top row) Brewer, David J.
Harlan, John M.
Gray, Horace
(second row) Olney, Richard
Shiras, George, Jr.
Jackson, Howell E.
(third row) Davis, David
Gray, Horace
Fuller, Melville W.
Field, Stephen J.
(bottom row) Fuller, Melville W.

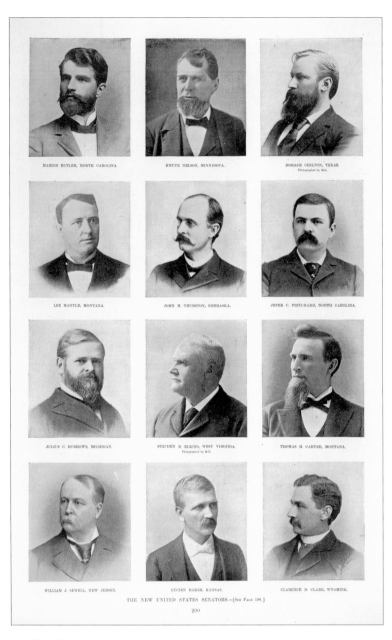

The New United States Senators.

Unidentified after photographs by Charles M. Bell and others
Harper's Weekly, 03/02/1895
Halftone, black and white
14 1/16 x 8 9/16 inches (35.7 x 21.7 cm)
Cat. no. 38.00340.001

(left to right, top row) Butler, Marion
Nelson, Knute
Chilton, Horace
(second row) Mantle, Lee
Thurston, John M.
Pritchard, Jeter C.
(third row) Burrows, Julius C.
Elkins, Stephen B.
Carter, Thomas H.
(bottom row) Sewell, William J.
Baker, Lucien
Clark, Clarence D.

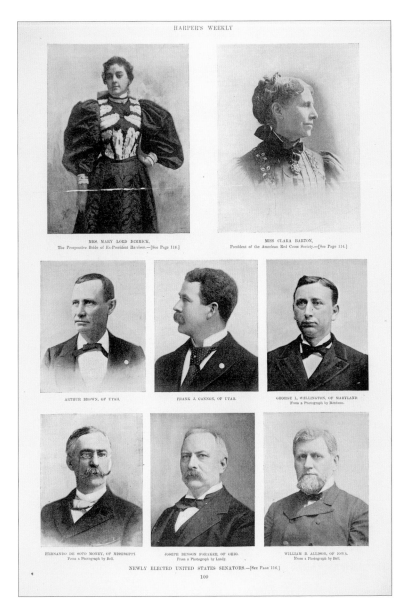

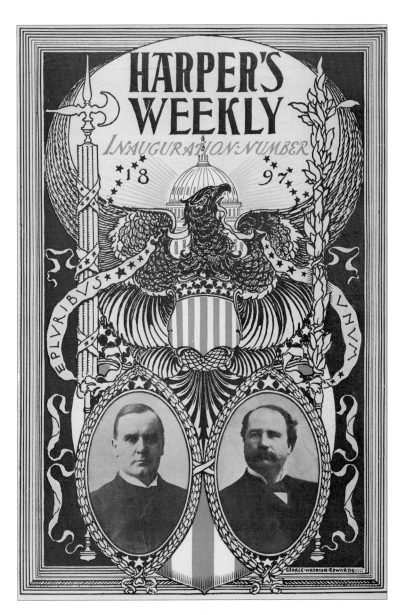

Newly Elected United States Senators.

Unidentified after photographs by Charles M. Bell, D. Bendann, James M. Landy, and others
Harper's Weekly, 02/01/1896
Halftone, black and white
14 x 8 11/16 inches (35.6 x 22.1 cm)
Cat. no. 38.00341.001

(left to right, center) Brown, Arthur
Cannon, Frank J.
Wellington, George L.
(bottom) Money, Hernando De Soto
Foraker, Joseph B.
Allison, William B.

Harper's Weekly Inauguration Number 1897

George Wharton Edwards
Harper's Weekly, 03/13/1897
Halftone, colored
15 5/8 x 10 13/16 inches (39.7 x 27.5 cm)
Cat. no. 38.00145.001

(left) McKinley, William
(right) Hobart, Garret A.

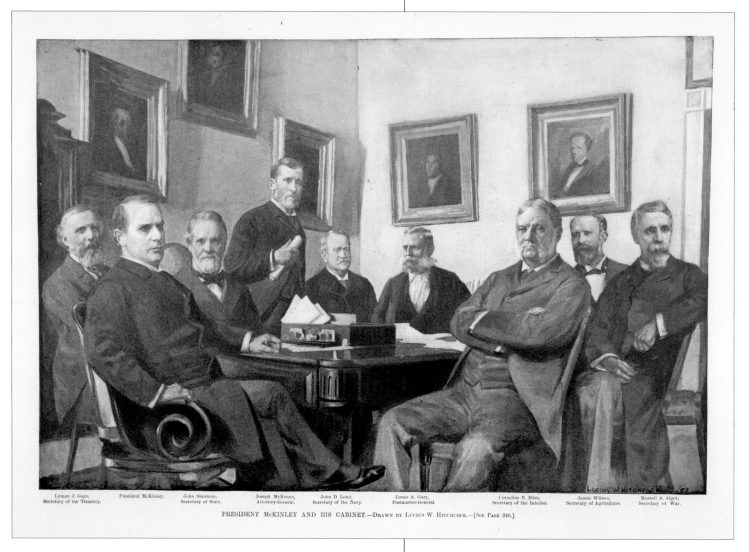

Lyman J. Gage, Secretary of the Treasury. · President McKinley. · John Sherman, Secretary of State. · Joseph McKenna, Attorney-General. · John D. Long, Secretary of the Navy. · James A. Gary, Postmaster-General. · Cornelius N. Bliss, Secretary of the Interior. · James Wilson, Secretary of Agriculture. · Russell A. Alger, Secretary of War.

PRESIDENT McKINLEY AND HIS CABINET.—DRAWN BY LUCIUS W. HITCHCOCK.—[SEE PAGE 246.]

President McKinley and His Cabinet.

Unidentified after Lucius W. Hitchcock
Harper's Weekly, 03/13/1897
Halftone, black and white
9 x 13 inches (22.9 x 33.0 cm)
Cat. no. 38.00261.001

(left to right) Gage, Lyman J.
McKinley, William
Sherman, John
McKenna, Joseph
Long, John D.
Gary, James A.
Bliss, Cornelius N.
Wilson, James
Alger, Russell A.

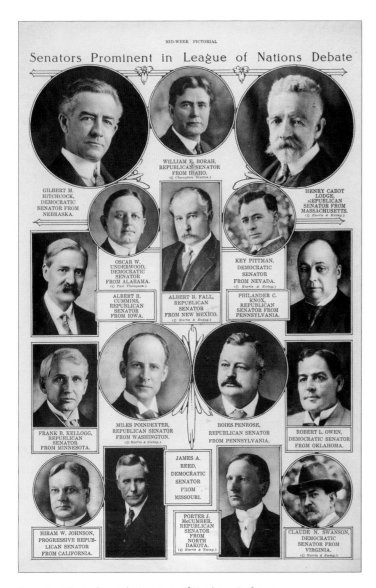

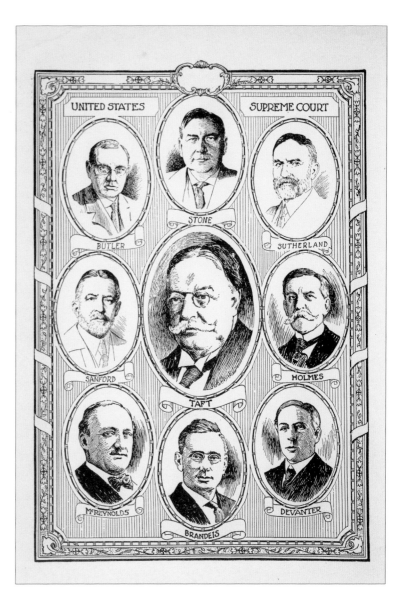

Senators Prominent in League of Nations Debate

Unidentified after photographs by Harris & Ewing,
Paul Thompson, and Champlain Studios
Mid-Week Pictorial, 07/03/1919
Photomechanical process, black and white
14 ⅝ x 9 ½ inches (37.1 x 24.1 cm)
Cat. no. 38.00828.001

(left to right, top row) Hitchcock, Gilbert M.
Borah, William E.
Lodge, Henry C.
(second row) Cummins, Albert B.
Underwood, Oscar W.
Fall, Albert B.
Pittman, Key
Knox, Philander C.
(third row) Kellogg, Frank B.
Poindexter, Miles
Penrose, Boies
Owen, Robert L.
(bottom row) Johnson, Hiram W.
Reed, James A.
McCumber, Porter J.
Swanson, Claude N. [sic]

United States Supreme Court

Unidentified after W. A. Bailey
Unidentified, ca. 1919
Lithograph, black and white
9 ¼ x 6 ⅜ inches (23.5 x 16.2 cm)
Cat. no. 38.00804.001

(clockwise from top left) Butler, Pierce
Stone, Harlan Fiske
Sutherland, George
Holmes, Oliver W., Jr.
Van Devanter, Willis
Brandeis, Louis D.
McReynolds, James C.
Sanford, Edward T.
(center) Taft, William Howard

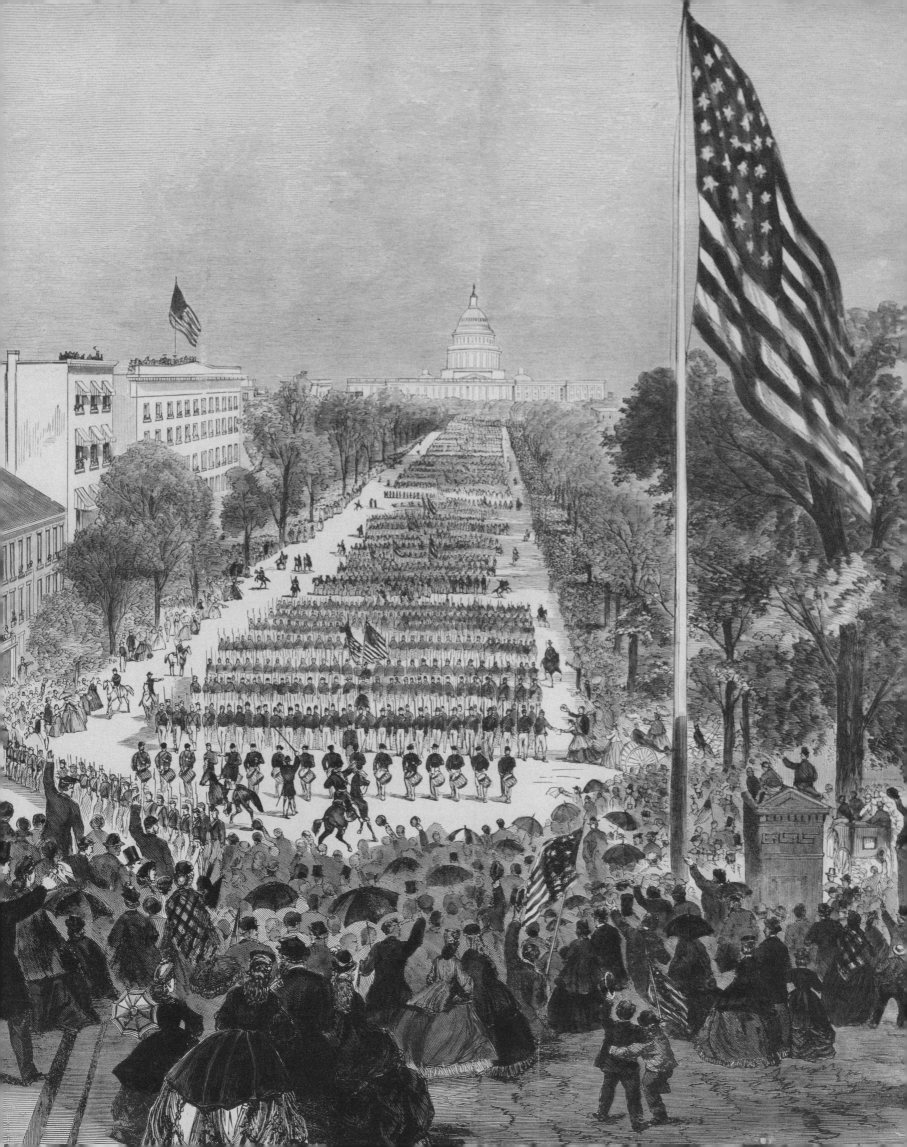

BEYOND CAPITOL HILL

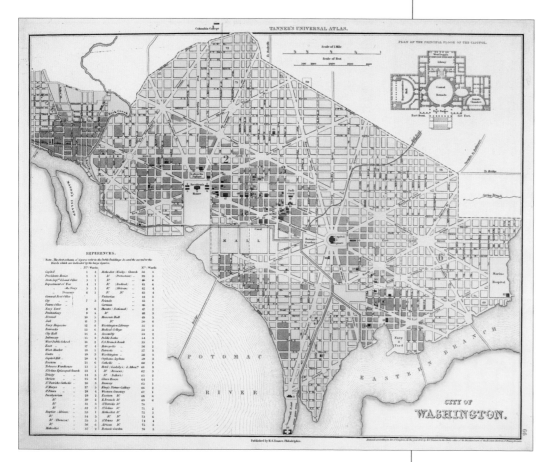

City of Washington.

Unidentified
Tanner's Universal Atlas, 1836
Engraving, hand-colored
11 ½ x 14 ½ inches (29.2 x 36.8 cm)
Cat. no. 38.00237.001

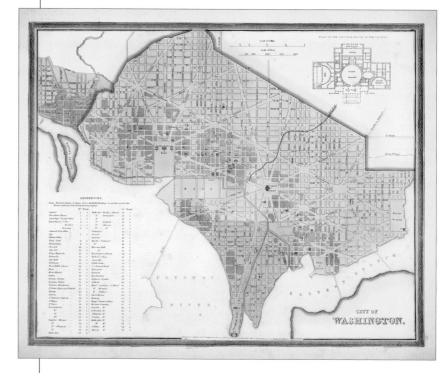

City of Washington.

Unidentified
H.S. Tanner, 1836
Engraving, hand-colored
12 x 15 ¼ inches (30.5 x 38.7 cm)
Cat. no. 38.00030.001

A New Map for Travelers through the United States of America Showing the Railroads, Canals & Stage Roads.

J. Calvin Smith
Sherman and Smith, 1847
Lithograph, colored
22 x 26 inches (55.9 x 66.0 cm)
Cat. no. 38.00056.001

New Map of the United States, Mexico, South America, Central America[,] West Indies and Part of Canada

Unidentified
Ensign, Bridgman and Fanning, ca. 1850
Engraving, hand-colored
23 x 25 inches (58.4 x 63.5 cm)
Cat. no. 38.00054.001

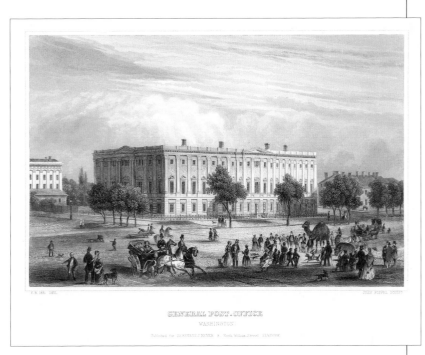

General Post-Office

John Poppel after C.R.
Herrmann J. Meyer, 1851
Metal engraving, hand-colored
4 ¾ x 6 ¼ inches (12.1 x 15.9 cm)
Cat. no. 38.00584.001

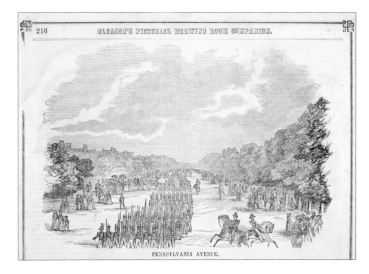

Pennsylvania Avenue.

Unidentified
Gleason's Pictorial Drawing Room Companion, 07/1852
Wood engraving, black and white
6 ⅜ x 9 ¾ inches (16.2 x 24.8 cm)
Cat. no. 38.00427.001a

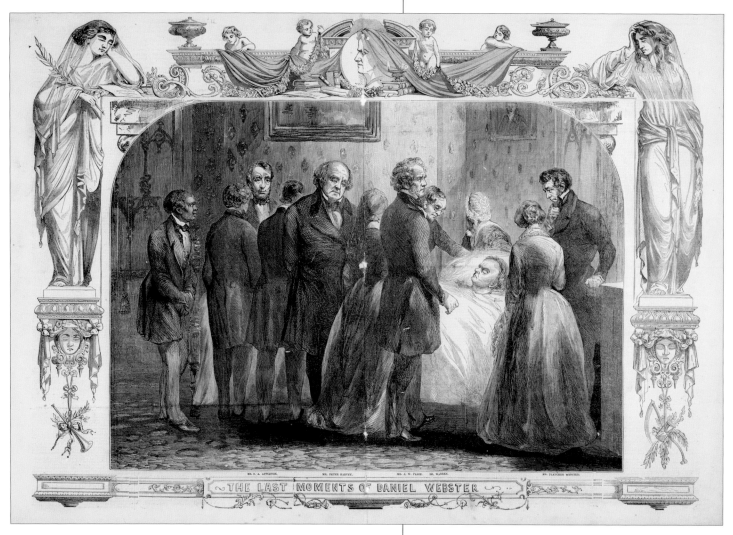

The Last Moments of Daniel Webster

Unidentified
Illustrated News, 01/01/1853
Wood engraving, black and white
14 ¾ x 20 ½ inches (37.5 x 52.1 cm)
Cat. no. 38.00820.001

Webster Funeral Procession of the Citizens of Boston and Vicinity.

Unidentified
Gleason's Pictorial Drawing-Room Companion, ca. 1852
Wood engraving, black and white
9 ½ x 13 ½ inches (24.1 x 34.3 cm)
Cat. no. 38.00798.001

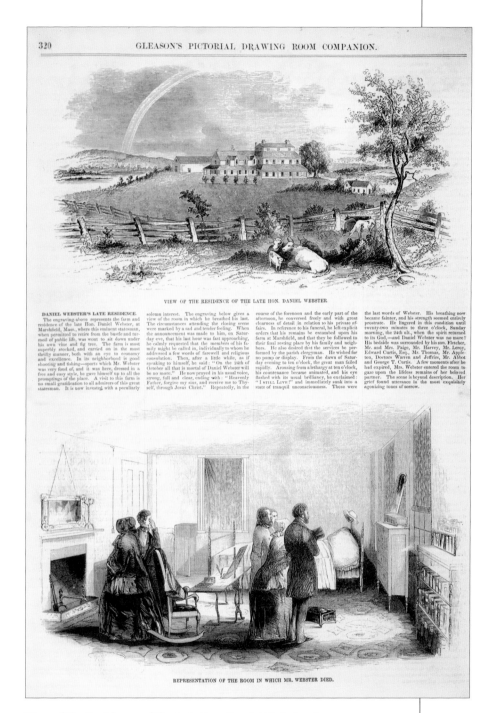

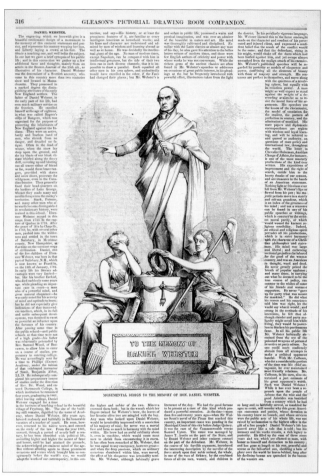

**View of the Residence of the Late Hon. Daniel Webster. /
Representation of the Room in Which Mr. Webster Died.**

Unidentified
Gleason's Pictorial Drawing Room Companion, 11/13/1852
Wood engraving, black and white
13 ½ x 9 ½ inches (34.3 x 24.1 cm)
Cat. no. 38.00760.001

Monumental Design to the Memory of Hon. Daniel Webster.

Unidentified
Gleason's Pictorial Drawing Room Companion, 11/13/1852
Wood engraving, black and white
10 x 6 ¾ inches (25.4 x 17.1 cm)
Cat. no. 38.00758.001

Statue of Daniel Webster, on Exhibition at the Crystal Palace, New York.

Gulick after John R. Chapin
Gleason's Pictorial Drawing-Room Companion, 08/27/1853
Wood engraving, black and white
10 x 7 ¼ inches (25.4 x 18.4 cm)
Cat. no. 38.00854.001

Mr. Webster's Library.

W. Roberts after D. C. H.
Illustrated News, 01/01/1853
Wood engraving, black and white
9 ⅞ x 10 ⅞ inches (25.1 x 27.6 cm)
Cat. no. 38.00759.001

Georgetown and the City of Washington[,] the Capital of the United States of America.

Unidentified
J. H. Colton & Co., 1855
Engraving, hand-colored
12 ⅞ x 15 ¾ inches (32.7 x 40.0 cm)
Cat. no. 38.00295.001

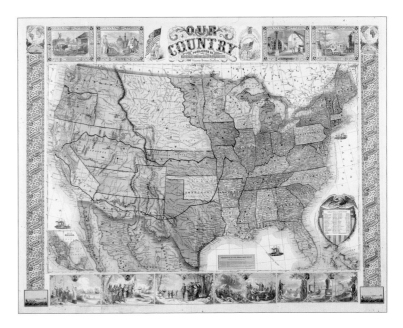

Our Country

Unidentified
Ensign, Bridgman and Fanning, 1855
Lithograph, colored
25 x 33 ½ inches (63.5 x 85.1 cm)
Cat. no. 38.00055.001

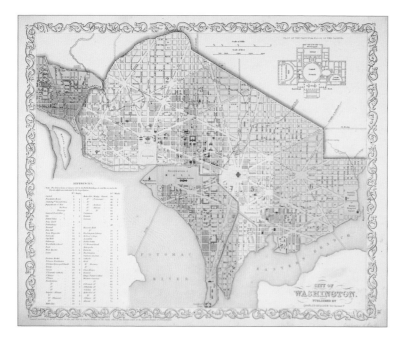

City of Washington.

Unidentified
Charlies Desilver, 1856
Lithograph, hand-colored
12 ¾ x 15 ½ inches (32.4 x 39.4 cm)
Cat. no. 38.00211.001

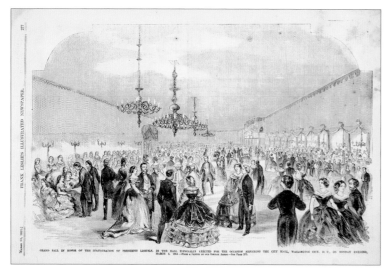

Grand Ball in Honor of the Inauguration of President Lincoln, in the Hall Especially Erected for the Occasion Adjoining the City Hall, Washington City, D.C., on Monday Evening, March 4, 1861

Unidentified
Frank Leslie's Illustrated Newspaper, 03/23/1861
Wood engraving, black and white
9 ³⁄₁₆ x 14 inches (23.3 x 35.6 cm)
Cat. no. 38.00148.001

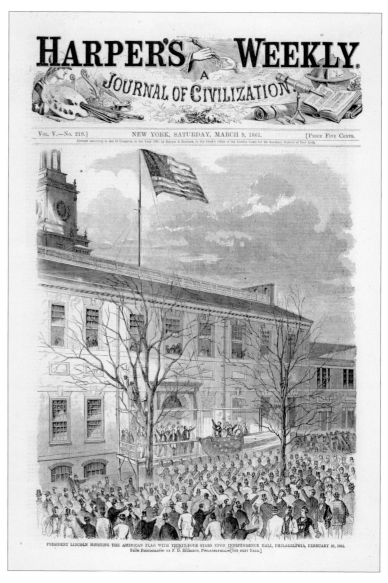

President Lincoln Hoisting the American Flag with Thirty-Four Stars upon Independence Hall, Philadelphia, February 22, 1861.

Unidentified after photographs by Frederick D. Richards
Harper's Weekly, 03/09/1861
Wood engraving, black and white
11 ⁵⁄₁₆ x 9 ¼ inches (28.7 x 23.5 cm)
Cat. no. 38.00165.001

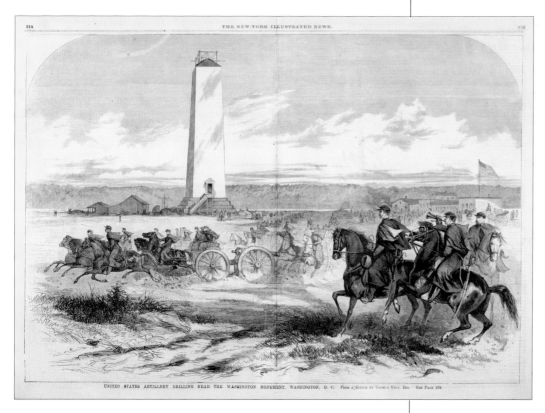

United States Artillery Drilling near the Washington Monument, Washington, D.C.

Unidentified after Thomas Nast
The New-York Illustrated News, 03/23/1861
Wood engraving, black and white
14 ⅛ x 20 ¼ inches (35.9 x 51.4 cm)
Cat. no. 38.00143.001

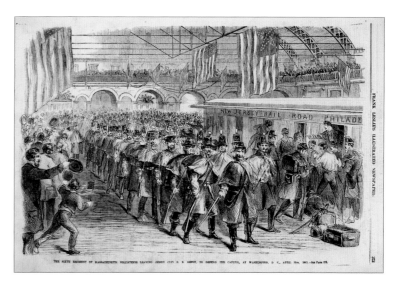

The Sixth Regiment of Massachusetts Volunteers Leaving Jersey City R. R. Depot, to Defend the Capitol, at Washington, D C. [sic], April 18th, 1861.

Unidentified
Frank Leslie's Illustrated Newspaper, 04/30/1861
Wood engraving, black and white
9 ⅜ x 14 inches (23.8 x 35.6 cm)
Cat. no. 38.00258.001

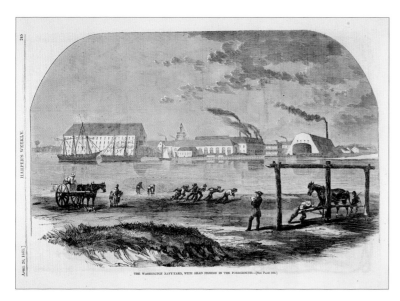

The Washington Navy-Yard, with Shad Fishers in the Foreground.

Unidentified
Harper's Weekly, 04/20/1861
Wood engraving, black and white
9 ½ x 13 ¹³⁄₁₆ inches (24.1 x 35.1 cm)
Cat. no. 38.00179.001

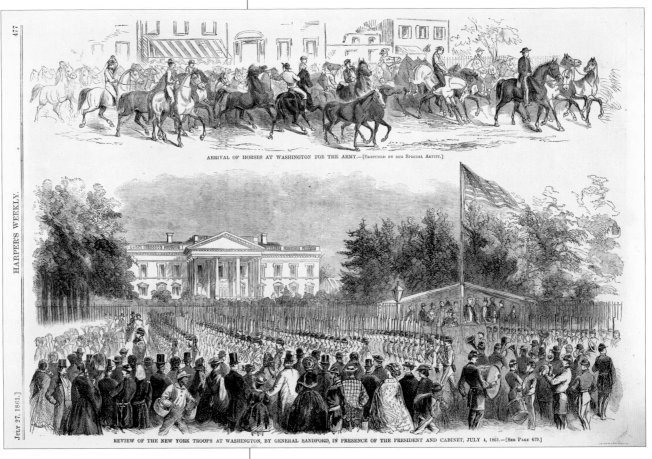

Arrival of Horses at Washington for the Army. / Review of the New York Troops at Washington, by General Sandford, in Presence of the President and Cabinet, July 4, 1861.

Unidentified
Harper's Weekly, 07/27/1861
Wood engraving, black and white
9 ½ x 14 inches (24.1 x 35.6 cm)
Cat. no. 38.00263.001

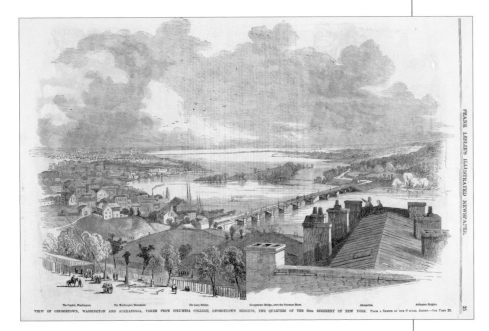

View of Georgetown, Washington and Alexandria, Taken from Columbia College, Georgetown Heights, the Quarters of the 69th Regiment of New York.

Unidentified
Frank Leslie's Illustrated Newspaper, 05/25/1861
Wood engraving, black and white
9 ⁹⁄₁₆ x 14 ¼ inches (24.3 x 36.2 cm)
Cat. no. 38.00198.001

Death of Colonel E[dward]. D. Baker, U.S. Senator for Oregon, at the Head of the California Regiment, Battle of Ball's Heights, October 21.

Unidentified
Frank Leslie's Illustrated Newspaper, 11/09/1861
Wood engraving, black and white
9 ¾ x 9 ½ inches (24.8 x 24.1 cm)
Cat. no. 38.00609.001

Convalescent Soldiers Passing through Washington to Join Their Regiments.

Unidentified after Johannes A. Oertel
Harper's Weekly, 11/15/1862
Wood engraving, black and white
11 x 9 ⅛ inches (27.9 x 23.2 cm)
Cat. no. 38.00109.001

Grand Review at Washington—Sheridan's Cavalry Passing through Pennsylvania Avenue, May 23, 1865.

Unidentified after photograph by Alexander Gardner
Harper's Weekly, 06/10/1865
Wood engraving, black and white
9 ½ x 13 ¹³⁄₁₆ inches (24.1 x 35.1 cm)
Cat. no. 38.00265.001

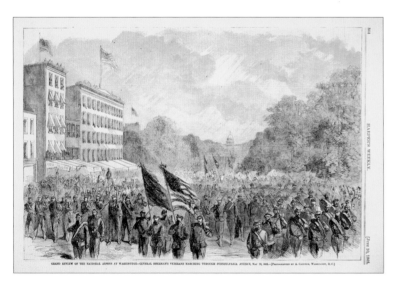

Grand Review of the National Armies at Washington—General Sherman's Veterans Marching through Pennsylvania Avenue, May 24, 1865.

Unidentified after photograph by Alexander Gardner
Harper's Weekly, 06/10/1865
Wood engraving, black and white
9 ½ x 14 inches (24.1 x 35.6 cm)
Cat. no. 38.00262.001

Ashland – Homestead of Henry Clay.

Ashland—Homestead of Henry Clay.

Unidentified
Unidentified, ca. 1865
Engraving, black and white
2 ⁵⁄₁₆ x 3 ¹³⁄₁₆ inches (5.9 x 9.4 cm)
Cat. no. 38.00281.001

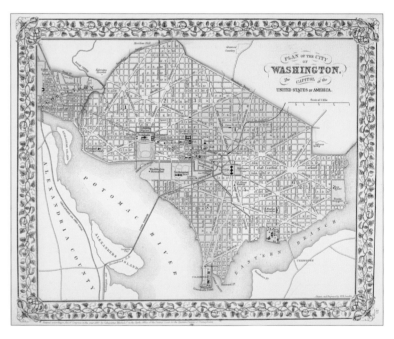

Plan of the City of Washington. The Capitol of the United States of America.

W. H. Gamble
S. Augustus Mitchell, Jr., 1867
Engraving, hand-colored
11 x 13 ½ inches (27.9 x 34.3 cm)
Cat. no. 38.00201.001

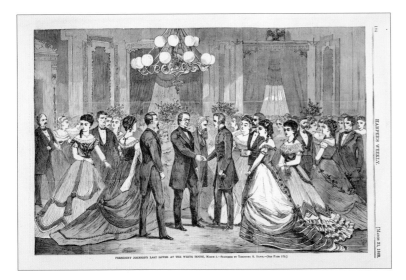

President Johnson's Last Levee at the White House, March 2.

Unidentified after Theodore R. Davis
Harper's Weekly, 03/21/1868
Wood engraving, black and white
9 ⅜ x 13 ⅜ inches (23.8 x 34.0 cm)
Cat. no. 38.00368.001

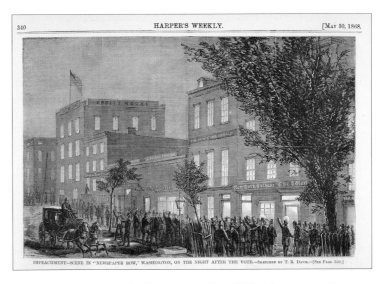

Impeachment—Scene in "Newspaper Row," Washington, on the Night after the Vote.

Unidentified after Theodore R. Davis
Harper's Weekly, 05/30/1868
Wood engraving, black and white
6 x 9 1/16 inches (15.2 x 23.0 cm)
Cat. no. 38.00426.001a

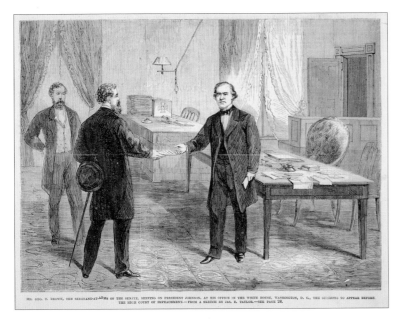

Mr. Geo. T. Brown, the Sergeant-at-Arms of the Senate, Serving on President Johnson, at His Office in the White House, Washington, D.C., the Summons to Appear before the High Court of Impeachment.

Unidentified after James E. Taylor
Frank Leslie's Illustrated Newspaper, 03/28/1868
Wood engraving, black and white
7 ⅜ x 9 7/16 inches (18.7 x 24.0 cm)
Cat. no. 38.00337.001b

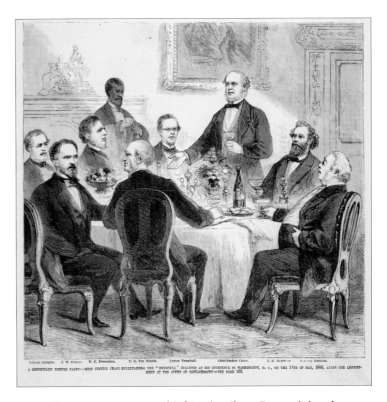

A Significant Dinner Party—Chief Justice Chase Entertaining the "Doubtful" Senators at His Residence in Washington, D.C., on the 11th of May, 1868, after the Adjournment of the Court of Impeachment.

Unidentified
Frank Leslie's Illustrated Newspaper, 05/30/1868
Wood engraving, black and white
9 ⅜ x 9 ⅜ inches (23.8 x 23.8 cm)
Cat. no. 38.00375.001

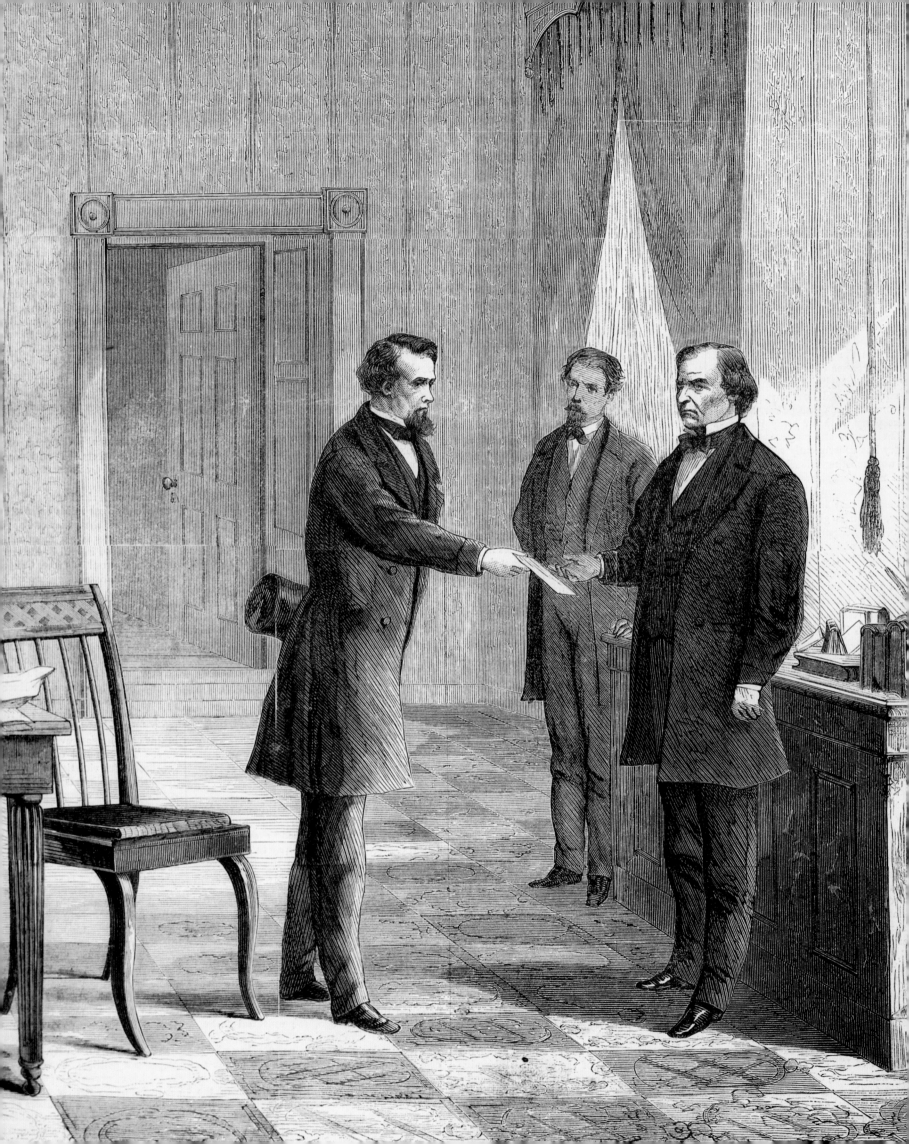

On the afternoon of Saturday, March 7, 1868, Senate Sergeant at Arms George T. Brown traveled from the Capitol to the White House to serve President Andrew Johnson with a summons to his Senate impeachment trial. The "Writ of Summons," signed by Chief Justice Salmon P. Chase, was the formal notification by the Senate that impeachment proceedings had begun. It is reported that the president read the statement and returned it to Brown, announcing that he "would attend to the matter."[1] The historic encounter, captured in this engraving by artist Theodore R. Davis, is one of the only existing images of Brown. As Senate sergeant at arms from 1861 to 1869, Brown served as chief protocol and law enforcement officer for the Senate. In that capacity he controlled access to the chamber and galleries, ensured that Senate rules were followed, handled special events such as inaugurations and funerals, and, when necessary, compelled attendance of absent members. ❧

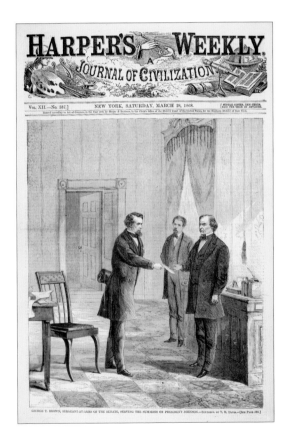

George T. Brown, Sergeant-at-Arms of the Senate, Serving the Summons on President Johnson.

Unidentified after Theodore R. Davis
Harper's Weekly, 03/28/1868
Wood engraving, black and white
11 ⅛ x 9 ⅛ inches (28.3 x 23.2 cm)
Cat. no. 38.00333.001

[1] "The Impeachment Trial," *Harper's Weekly*, 28 March 1868, 198.

Washington, D.C.—Hon. Charles Sumner in His Study, at His Residence, Corner of H and Fifteenth Streets.

Unidentified after Bghs
Frank Leslie's Illustrated Newspaper, 04/22/1871
Wood engraving, black and white
9 ½ x 14 ¼ inches (24.1 x 36.2 cm)
Cat. no. 38.00965.001

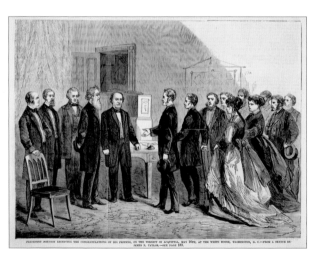

President Johnson Receiving the Congratulations of His Friends, on the Verdict of Acquittal, May 16th, at the White House, Washington, D.C.

Unidentified after James E. Taylor
Frank Leslie's Illustrated Newspaper, 06/06/1868
Wood engraving, black and white
7 ¼ x 9 ⅜ inches (18.4 x 23.8 cm)
Cat. no. 38.00378.001b

Washington D.C.—The Great Inauguration Ball on Tuesday Evening, the 4th of March, in the Temporary Building in Judiciary Square.

Unidentified after James E. Taylor
Supplement to Frank Leslie's Illustrated Newspaper, 03/22/1873
Wood engraving, black and white
14 ¼ x 19 ¾ inches (36.2 x 50.2 cm)
Cat. no. 38.00850.001b

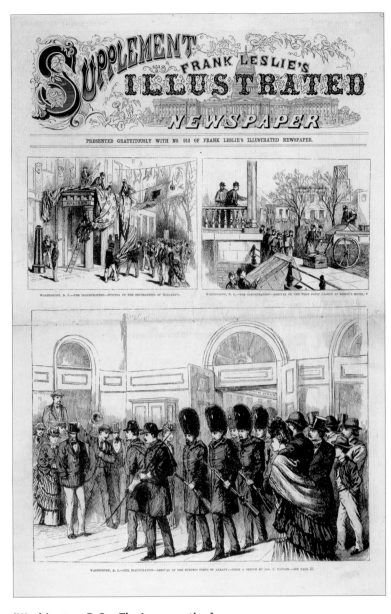

[Washington, D.C.—The Inauguration]

Unidentified after James E. Taylor
Supplement to Frank Leslie's Illustrated Newspaper, 03/22/1873
Wood engraving, black and white
11 ¼ x 9 ⅜ inches (28.6 x 23.8 cm)
Cat. no. 38.00850.001a

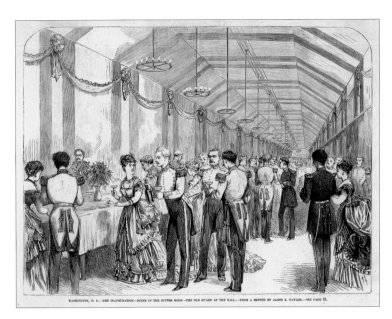

Washington, D.C.—The Inauguration—Scene in the Supper Room—The Old Guard at the Ball.

Unidentified after James E. Taylor
Supplement to Frank Leslie's Illustrated Newspaper, 03/22/1873
Wood engraving, black and white
7 ⅛ x 9 ¼ inches (18.1 x 23.5 cm)
Cat. no. 38.00850.001d

Washington, D.C.—Interview, at the White House, between President Grant and Secretary Belknap.

Unidentified
Frank Leslie's Illustrated Newspaper, 03/18/1876
Wood engraving, black and white
6 ³⁄₁₆ x 4 ½ inches (15.7 x 11.4 cm)
Cat. no. 38.00403.001b

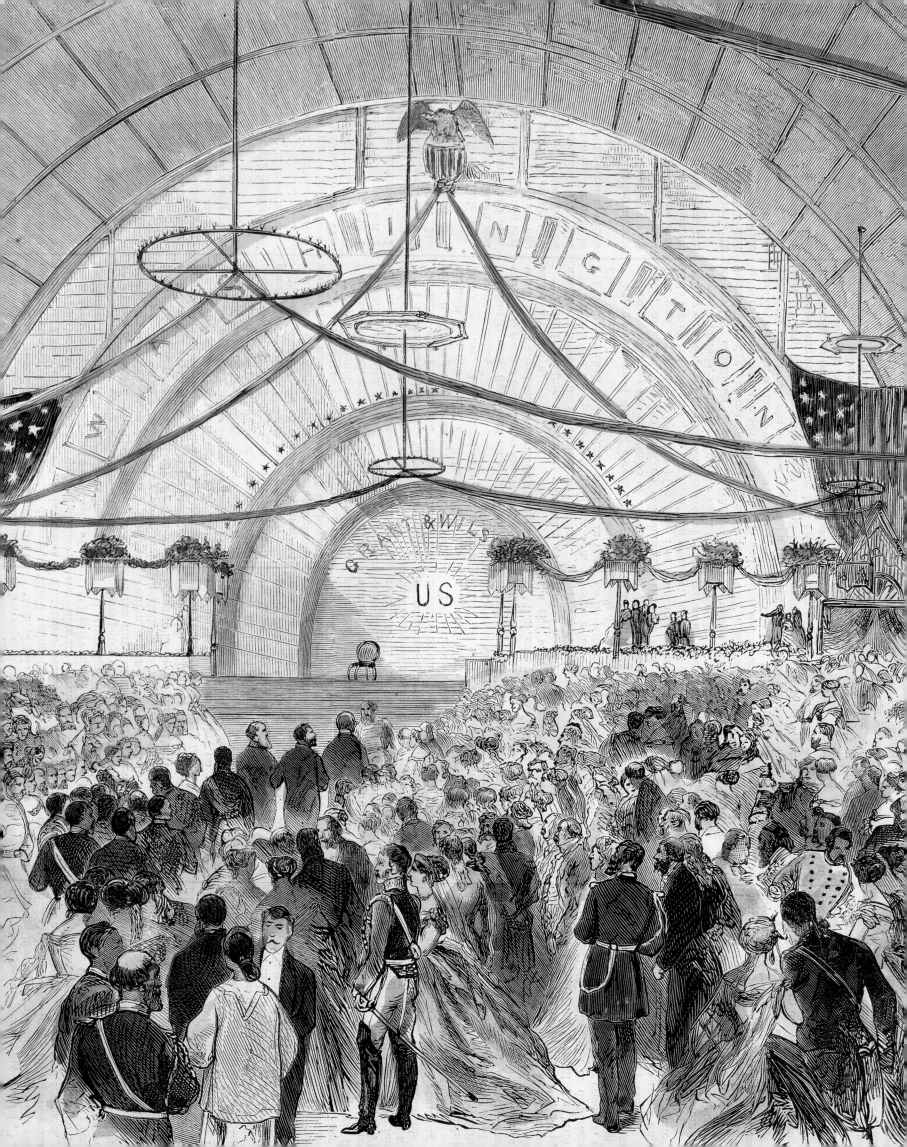

*P*resident Ulysses S. Grant's second inauguration on March 4, 1873, was the coldest on record, with near-zero temperatures, snow, sleet, and bitter winds. Despite the weather, the day's festivities continued, with the inauguration ceremony at the Capitol, the traditional parade review at the White House, a spectacular fireworks display, and the grand ball. The ball, however, was a disaster. It was held in a temporary structure on Judiciary Square, designed to house more than 6,000 guests. It was described as "gayly decorated and brilliantly lighted,"[1] however, no heating equipment had been installed. Women and men danced with their coats on, food and drink froze solid, and musicians were barely able to play their frigid instruments. Canaries had been imported to sing to the guests, but instead dropped dead in their cages from the cold. The president and his cabinet arrived about 11:30 p.m. to strains of the U.S. Navy Band's "Hail to the Chief," but stayed only a short time before being whisked into a nearby private, heated room for supper. Only about half the guests attended the ball, and by midnight everyone had gone home. Undoubtedly, this *Harper's Weekly* engraving is an idealized view of the festivities. ☙

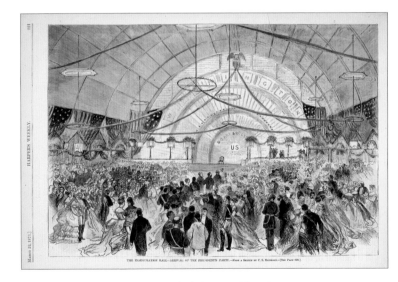

The Inauguration Ball—Arrival of the President's Party.

Unidentified after Charles S. Reinhart
Harper's Weekly, 03/22/1873
Wood engraving, hand-colored
9 5/16 x 13 1/2 inches (23.7 x 34.3 cm)
Cat. no. 38.00061.001

[1] "The Second Inauguration," *Harper's Weekly*, 22 March 1873, 980.

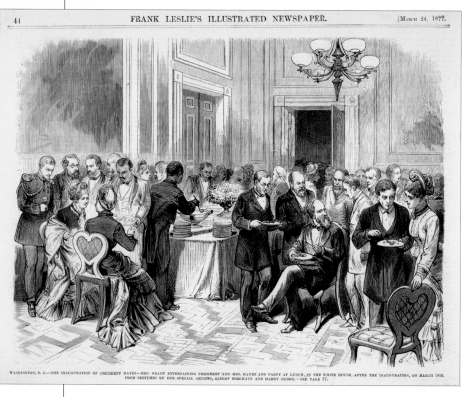

Washington, D.C.—The Inauguration of President Hayes—Mrs. Grant Entertaining President and Mrs. Hayes and Party at Lunch, in the White House, after the Inauguration, on March 5th.

Unidentified after Albert Berghaus and Harry Ogden
Frank Leslie's Illustrated Newspaper, 03/24/1877
Wood engraving, black and white
7 ⅜ x 9 ³⁄₁₆ inches (18.7 x 23.3 cm)
Cat. no. 38.00395.001

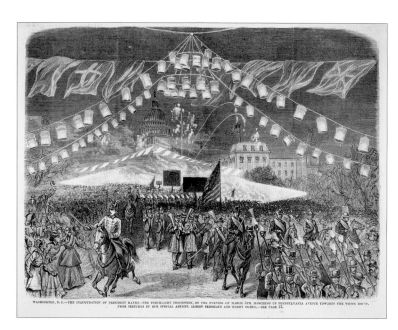

Washington, D.C.—The Inauguration of President Hayes—The Torchlight Procession, on the Evening of March 5th, Marching up Pennsylvania Avenue towards the White House.

Unidentified after Albert Berghaus and Harry Ogden
Frank Leslie's Illustrated Newspaper, 03/24/1877
Wood engraving, black and white
7 x 9 ³⁄₁₆ inches (17.8 x 23.3 cm)
Cat. no. 38.00402.001

Our New President—Pennsylvania Avenue at Night, March 5.

Unidentified after Theodore R. Davis
Harper's Weekly, 03/24/1877
Wood engraving, black and white
6 ½ x 9 inches (16.5 x 22.9 cm)
Cat. no. 38.00036.003b

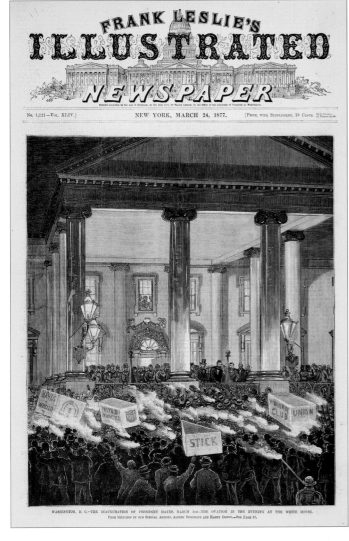

Washington, D.C.—The Inauguration of President Hayes, March 5th —The Ovation in the Evening at the White House.

Unidentified after Albert Berghaus and Harry Ogden
Frank Leslie's Illustrated Newspaper, 03/24/1877
Wood engraving, black and white
11 ⅛ x 9 ³⁄₁₆ inches (28.3 x 23.3 cm)
Cat. no. 38.00398.001

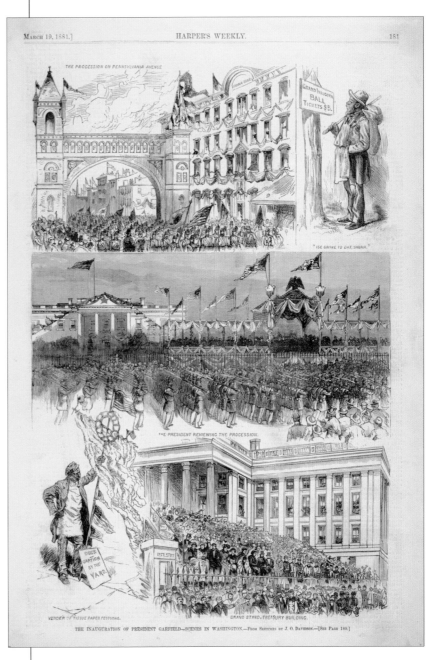

The Inauguration of President Garfield—Scenes in Washington.

Unidentified after J. O. Davidson
Harper's Weekly, 03/19/1881
Wood engraving, black and white
14 x 8 ¹⁵⁄₁₆ inches (35.6 x 22.7 m)
Cat. no. 38.00267.001

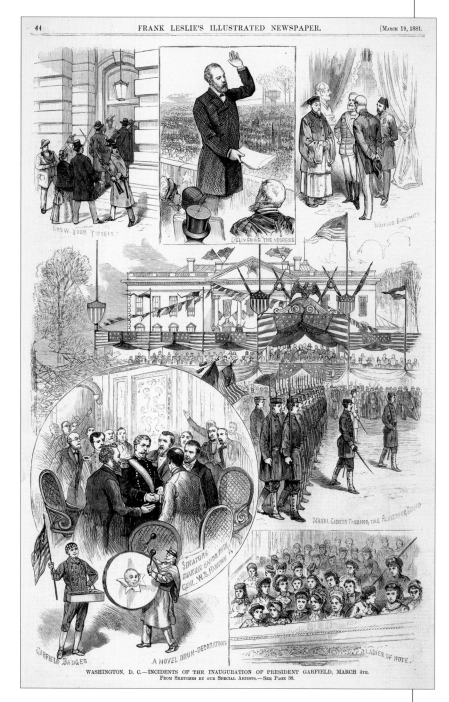

Washington, D.C.—Incidents of the Inauguration of President Garfield, March 4th.

Unidentified
Frank Leslie's Illustrated Newspaper, 03/19/1881
Wood engraving, black and white
14 ⅜ x 9 ¼ inches (36.5 x 23.5 cm)
Cat. no. 38.00102.001

The Inauguration—President Arthur and Mr. Cleveland Leaving the White House for the Capitol.

Unidentified after Thure de Thulstrup
Harper's Weekly, 03/14/1885
Wood engraving, black and white
11 ¼ x 9 1/16 inches (28.6 x 23.0 cm)
Cat. no. 38.00084.002

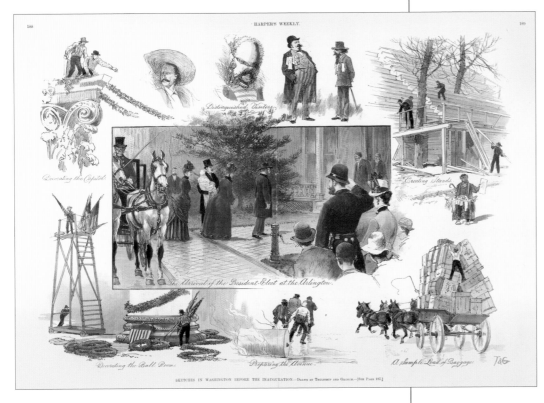

Sketches in Washington before the Inauguration.

Unidentified after Thure de Thulstrup and Charles Graham
Harper's Weekly, 03/09/1889
Lithograph, hand-colored
14 ⅛ x 20 inches (35.9 x 50.8 cm)
Cat. no. 38.00256.001

**Georgetown and the City of Washington[,]
the Capital of the United States of America.**

Unidentified
G. W. and C. B. Colton & Co., 1882
Engraving, hand-colored
13 x 16 inches (33.0 x 40.6 cm)
Cat. no. 38.00294.001

**The Statue of Daniel Webster
at Concord, New Hampshire.**

Unidentified after photograph
by W. G. C. Kimball
Harper's Weekly, 06/19/1886
Wood engraving, black and white
8 ¼ x 4 ½ inches (21.0 x 11.4 cm)
Cat. no. 38.00855.001

The Inauguration Ceremonies—President Cleveland and Ex-President Harrison Returning from the Capitol.—Drawn by T. de Thulstrup.

The Inauguration Ceremonies—President Cleveland and Ex-President Harrison Returning from the Capitol.

Unidentified after Thure de Thulstrup
Harper's Weekly, 03/11/1893
Wood engraving, hand-colored
13 ¾ x 18 ¾ inches (34.9 x 47.6 cm)
Cat. no. 38.00983.001

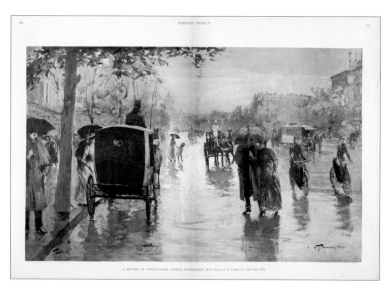

A Shower on Pennsylvania Avenue, Washington, D.C.

Unidentified after William T. Smedley
Harper's Weekly, 10/04/1890
Wood engraving, black and white
13 x 20 inches (33.0 x 50.8 cm)
Cat. no. 38.00149.001

Arlington.

Unidentified after Charles Graham
Harper's Weekly, 05/29/1886
Wood engraving, black and white
13 ¾ x 9 ⅛ inches (34.9 x 23.2 cm)
Cat. no. 38.00204.001

Grand Review of the Armies of the United States, at Washington, D.C., May 23, 1865.—Troops Marching up Pennsylvania Avenue, before Passing the Reviewing Stand.

Unidentified after W. T. Crane
The Civil War in the United States, ca. 1895
Wood engraving, hand-colored
14 ¾ x 20 ½ inches (37.5 x 52.1 cm)
Cat. no. 38.00257.001

The Closing Feature of Inauguration Day—The Ball in the Pension-Office Building, Washington.

Unidentified after Thure de Thulstrup
Harper's Weekly, 03/13/1897
Halftone, black and white
13 ½ x 18 ½ inches (34.3 x 47.0 cm)
Cat. no. 38.00441.001

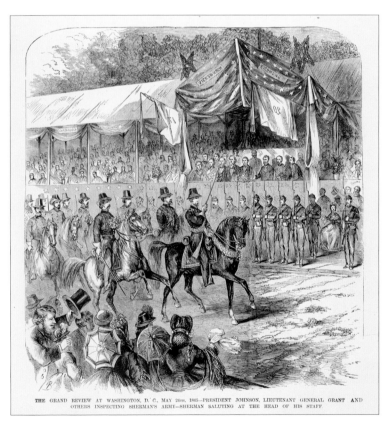

The Grand Review at Washington, D.C., May 24th, 1865— President Johnson, Lieutenant General Grant and Others Inspecting Sherman's Army—Sherman Saluting at the Head of His Staff.

Unidentified after B.
Frank Leslie's Illustrated History of the Civil War, 1895
Wood engraving, black and white
10 x 9 ¹⁄₁₆ inches (25.4 x 23.0 cm)
Cat. no. 38.00259.001

Early Morning in Washington, D.C.

Unidentified after William Allen Rogers
Harper's Weekly, 03/13/1897
Halftone, black and white
14 x 8 ¾ inches (35.6 x 22.2 cm)
Cat. no. 38.00366.001

The Inauguration of President McKinley—The Parade on Pennsylvania Avenue.

Unidentified
Harper's Weekly, 03/13/1897
Halftone, black and white
13 ¾ x 8 inches (34.9 x 20.3 cm)
Cat. no. 38.00442.001

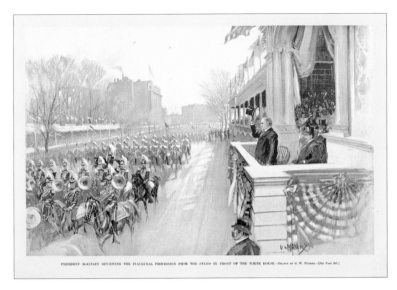

President McKinley Reviewing the Inaugural Procession from the Stand in Front of the White House.

Unidentified after G. W. Peters
Harper's Weekly, 03/13/1897
Halftone, black and white
8 ⅞ x 13 ¼ inches (22.6 x 33.7 cm)
Cat. no. 38.00287.001

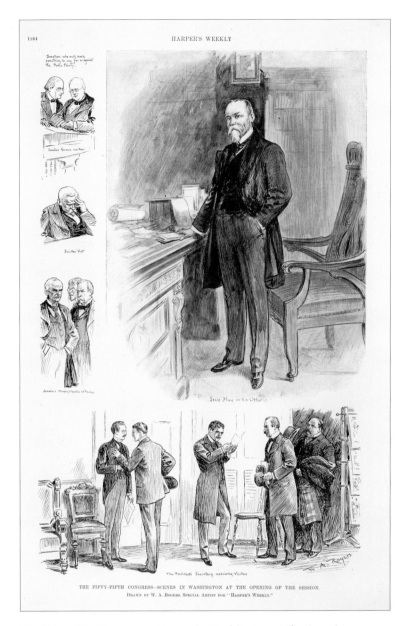

The Fifty-Fifth Congress—Scenes in Washington at the Opening of the Session.

Unidentified after William Allen Rogers
Harper's Weekly, 12/24/1898
Lithograph and halftone, black and white
14 ¼ x 9 ⅛ inches (36.2 x 23.2 cm)
Cat. no. 38.00285.001

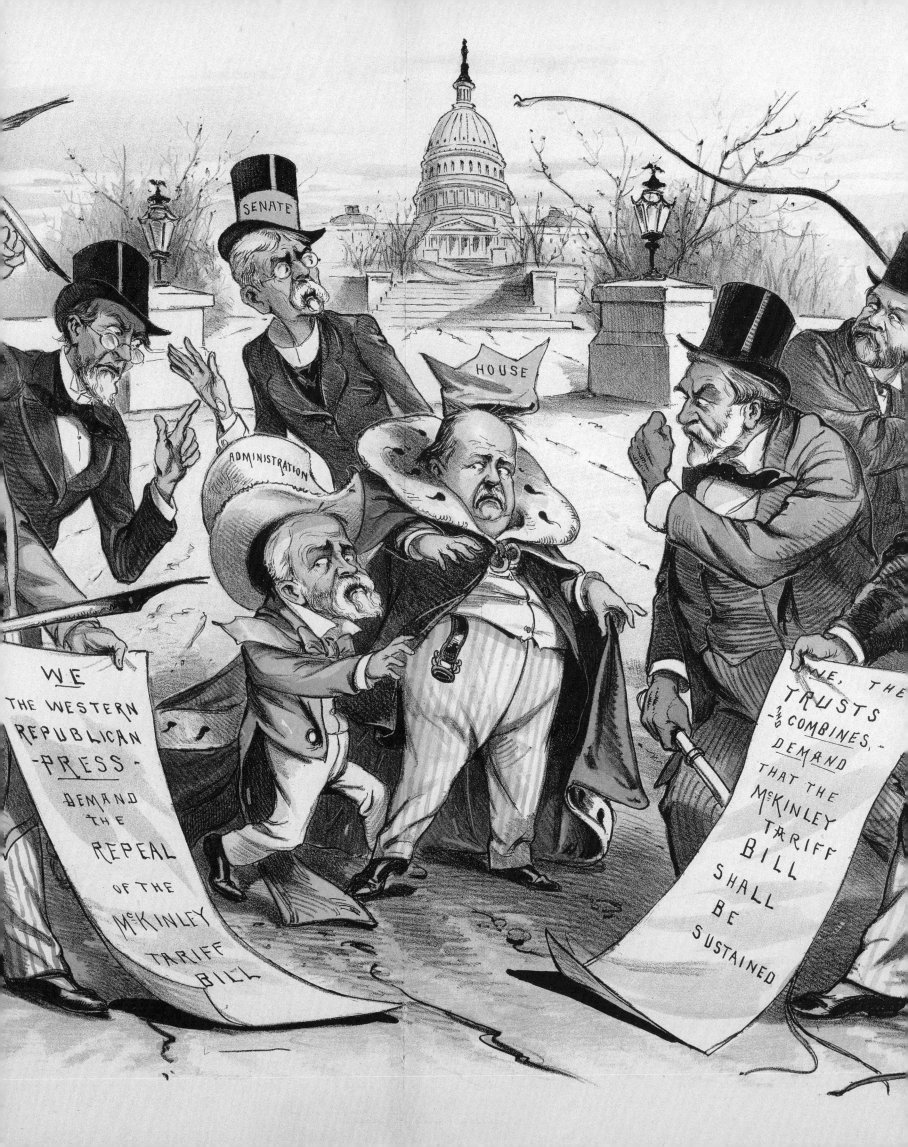

POLITICAL CARTOONS
& CARICATURES

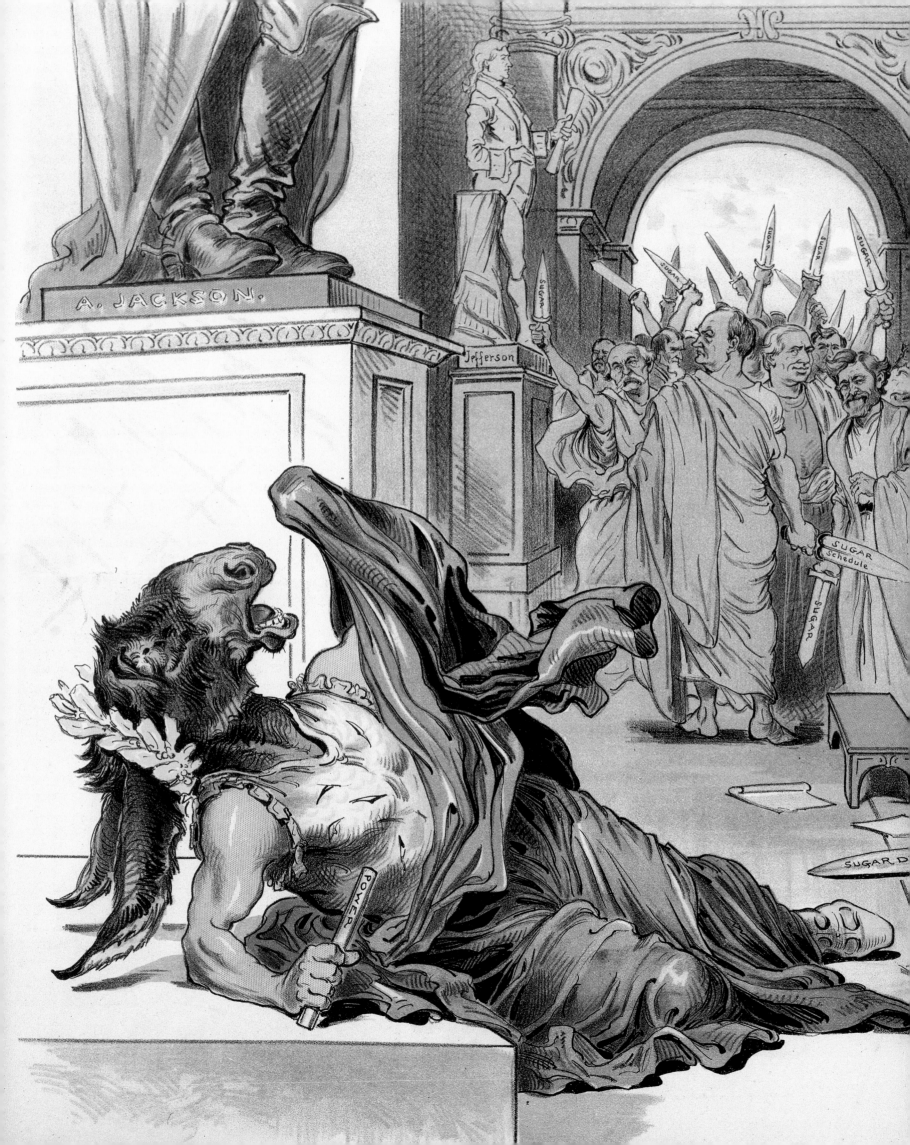

THE SENATE THEATRE:
19TH-CENTURY CARTOONISTS AND THE U.S. SENATE

Donald A. Ritchie

Political cartoons have been popular in America since before the Revolution. In 1754 Benjamin Franklin contributed the image of a snake cut into sections (one for each colony) and labeled it "Join, or Die." Technological limitations prevented newspapers from making use of these cartoons, however, so most were printed as broadsides and distributed by political parties during election campaigns. Not until 1855 did the British engraver Henry Carter, under the pen name Frank Leslie, launch America's first fully illustrated journal. *Frank Leslie's Illustrated Newspaper* was a 16-page weekly publication that made use of woodcuts and steel engravings to portray a wide range of current events, everything from politics to prizefighting. The magazine's prominent alumni included Thomas Nast, who joined its staff as a teenager in 1855, before taking his talents to *Harper's Weekly*, and Joseph Keppler, who drew for *Frank Leslie's* beginning in 1872. Keppler later launched *Puck*, the first magazine to use color cartoons. Other publications such as *Judge* and *Life* offered further outlets for cartoonists. Early in the 20th century, new magazines turned to muckraking and made their cartooning predecessors appear antiquated. By then, however, the newspapers were employing editorial cartoonists to carry on the tradition.[1]

Although many of the engravings are neutral or objective reproductions of scenes, some cartoonists used their drawings to hammer home their own political points of view. In fact, cartoonists often did their best work when they were attacking an individual, a group,

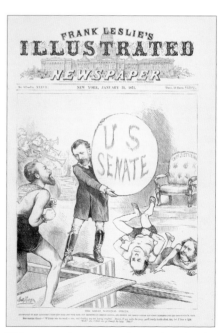

This cartoon shows a typical cover from *Frank Leslie's*, America's first fully illustrated journal that addressed current events. (See p. 327)

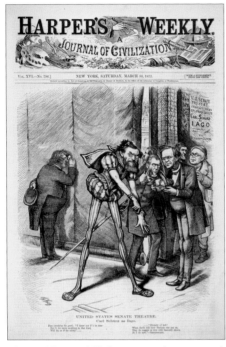

Thomas Nast used Shakespearean characters and stories to lampoon political figures and events of the time. (See p. 323)

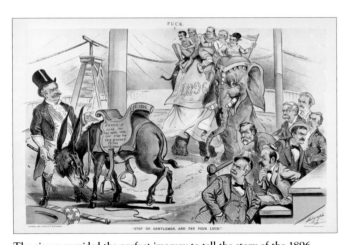

The circus provided the perfect imagery to tell the story of the 1896 election. (See p. 441)

or an idea. They were especially attuned to corruption, scandal, and political mischief. In seeking to capture the nub of a complex issue, cartoonists sought readily understandable visual images. They drew on nursery rhymes, classical legends, Shakespearean plays, the Bible, the old masters, the circus, or anything else that the average reader might recognize. With both gentle and ferocious humor, they dressed political figures incongruously and highlighted the peculiarities of their physiognomy. Over time, the people and situations that readers a century ago might have recognized have grown obscure. The names of the senators have faded from public memory, and schoolchildren no longer spend so much time studying ancient Greece and Rome, which would enable them to recognize images that once were commonplace. In some cases, the cartoonists created their own symbols, which remain vivid a century later. Uncle Sam, John Q. Public, the Republican elephant, and the Democratic donkey are all the creations of cartoonists' imaginations. [2]

While the quality of the illustrations varies widely depending on the artist and the medium, many have retained their power and visual appeal. In reviewing "The Making of Cartoons" in 1890, the *New York Times* noted that most of the prominent "pictorial humorists" of the day had received formal art training. "You must know how to draw an object before you are able to seize upon its points of distortion," the *Times* observed. "Furthermore, that peculiar sense of the

humorous that enables one always and without hesitation to perceive the ludicrous side of a case is accorded to few men. Literary humor cannot be acquired; it must be inborn, and it is exactly the same with regard to pictorial humor." [3]

In looking over the field of cartooning in the 19th century, the *Times* marveled over how many of the best cartoonists had come from abroad. The paper cited Thomas Nast, a Bavarian, and Joseph Keppler, an Austrian, along with others from elsewhere in Germany and the United Kingdom, where humor magazines had flourished before they grew popular in America. Yet while Nast and Keppler were both immigrants, they were entirely different in their artistic styles, their politics, and their use of technology for reproducing their work. Between them, they highlight the major trends in 19th-century cartooning and account for a large share of the U.S. Senate's collection of engravings and lithographs.

The caricatures of Thomas Nast set the bar high for all competitors who followed. Nast was born in a Bavarian military barracks in 1840, the son of a trombone player for a military band. Revolutionary upheaval in Germany in the 1840s caused his family to immigrate to New York City in 1846. The young Nast displayed such a talent for drawing in school that he was admitted to the Academy of Design. While still a teenager, he was hired as an illustrator for *Frank Leslie's Illustrated Weekly*, where he received technical training from experienced engravers and learned to work under the pressure of a weekly deadline. Finding that his talents were in demand, Nast took a better-paying job with the *New York Illustrated News*, where he sketched a variety of subjects, including prize fights, the trial of the abolitionist John Brown, and the inauguration of Abraham Lincoln. The Civil War cemented Nast's lifelong allegiance to the Republican Party, and he remained thereafter an avid supporter of

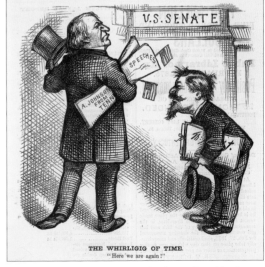

President Andrew Johnson was the first political leader to fall victim to Nast's gift for caricature. (See p. 331)

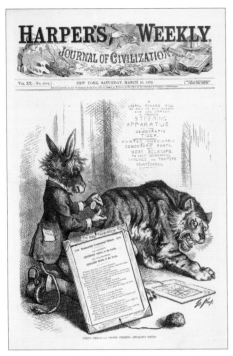

Here Nast employs a donkey to represent the Democrats and a tiger as the New York City Democratic political machine. (See p. 334)

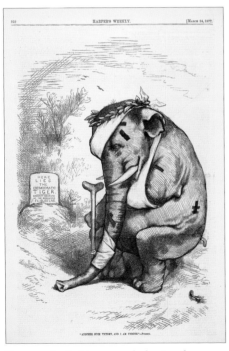

Nast was the first to use an elephant as the Republican image. (See p. 337)

the great Union General Ulysses S. Grant. Said President Lincoln of his highly patriotic, pro-Union sketches, "Thomas Nast has been our best recruiting sergeant."

In 1862 *Harper's Weekly* magazine hired Nast. Its publisher, Fletcher Harper, told Nast not simply to illustrate scenes that he saw but to use his imagination to make pictures that would tell a story. It was Nast who first used the elephant as the Republican image and popularized the donkey (which other cartoonists already had been using) for the Democrats. He also drew a ferocious Tammany tiger as an attack on New York City's Democratic political machine and, on a lighter note, he shaped the American image of Santa Claus through his annual Christmas drawings.

Thomas Nast drew things as he saw them. He insisted that his cartoons reflect his own thinking, not his publisher's. Generally, he and his editors shared similar political views, but at times Nast's cartoons put him at odds with his employer. For instance, *Harper's Weekly* backed the Democratic candidate, editor Horace Greeley, in the 1872 election, while Nast stayed loyal to President Grant. In Nast's cartoons, Greeley appeared as a fool and a traitor. As Nast explained his style, "I try to hit the enemy between the eyes and knock them down." In 1877 Fletcher Harper died, and other members of the Harper family began to shift the magazine away from politics to more family-friendly subjects in order to widen its audience. Nast's cartoons, which once had helped to sell the weekly, now appeared less frequently.

The complex political and economic issues of the Gilded Age dampened Nast's slashing style. However, the clash of political titans

Roscoe Conkling and James G. Blaine in 1881, during the tragically brief Garfield administration, revived his political passions. During the presidential election of 1884, when Blaine ran as the Republican candidate against New York Governor Grover Cleveland, both Nast and *Harper's Weekly* bolted from the "Grand Old Party" to support the Democratic candidate. Cleveland won, but *Harper's Weekly* suffered a loss of readers and advertisers, making its management even less tolerant of the temperamental artist. Two years later, just after he had drawn his regular Christmas picture, Nast resigned from *Harper's Weekly*. He founded *Nast's Weekly* in 1893, but by then his style and politics had fallen out of fashion, and the enterprise failed. He lectured and freelanced but faded so quickly from public view that people began referring to him as "the late Thomas Nast." Soon the cartoonist found himself in debt, so he accepted a political appointment from President Theodore Roosevelt to be American counsel in Ecuador. There Nast died of yellow fever in 1902.[4]

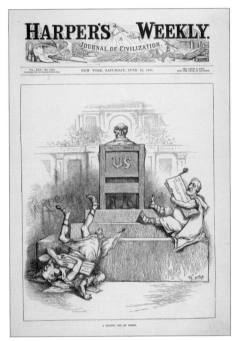

In this cartoon, Nast depicts the clash in 1881 between Senators Roscoe Conkling and James G. Blaine. (See p. 358)

Ironically, Thomas Nast fell out of favor just as the political cartooning he had pioneered took hold in the daily newspapers. The new style of cartooning was considerably different from Nast's dark, angry, moralistic woodcuts, however. The man who had set out to challenge Nast and change the nature of cartooning was Joseph Keppler. Although two years older than Nast, Keppler was in some ways a generation younger. He had endured neither the moral fervor nor the horrors of the Civil War, memories Nast could never shake. Keppler's cartoons, printed in color, treated politics less passionately and more humorously. While color images had been available in prints like those sold by Currier and Ives, they were too expensive to publish in magazine form until Keppler's magazine, *Puck*, appeared in 1877.

In this 1883 lithograph, cartoonist Joseph Keppler portrays members of Congress as plutocrats who drew their government salaries while also practicing law and lobbying for private claims before Congress. (See p. 362)

Tall, good-looking, theatrical, jovial, and witty, Joseph Ferdinand Keppler was born in Vienna, Austria, in 1838. He first demonstrated his artistic talents by decorating pastries in his family's bakery. After the failed revolution of 1848, Keppler's father and older brothers fled to America, but he remained behind with his mother and younger siblings. Keppler's talents at drawing got him admitted to the Academy of Fine Arts in Vienna. After he graduated in 1855, he went to Italy, painting scenery for a traveling theatrical company. (In later years the figures in his cartoons often resembled actors playing a scene on stage.) Before long, Keppler began acting in the company as well. Starting in 1865, he contributed cartoons to a Vienna humor magazine, *Kikeriki!* (German for the rooster's crow).

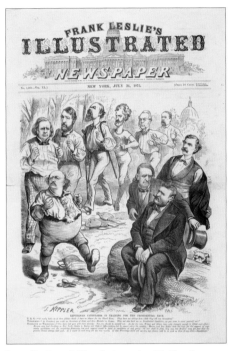

Initially, Joseph Keppler's work with *Frank Leslie's* in the early 1870s was intended to challenge Thomas Nast. (See p. 332)

Keppler's father, who had settled in Missouri, urged the young artist to come to America. In 1867 Keppler and his wife immigrated to St. Louis, joining its large German expatriate population. He planned to attend medical school, but instead began performing in a German-language theater and later became a theater manager. Meanwhile, Keppler started producing a weekly German-language humor magazine, *Die Vehme* (The Star Chamber). Where other American publications of the day employed woodcuts and steel engravings, *Die Vehme* relied on a lithographic press, which cut costs by eliminating the need for an engraver. The magazine folded after a year, sending Keppler out looking for work as "a half-starved Bohemian."

Frank Leslie's Illustrated Weekly had long been looking for someone to challenge its former artist, Thomas Nast, who was then at the height of his influence at *Harper's Weekly*. *Leslie's* hired Keppler, who

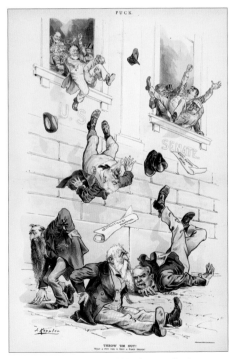

Eventually, Keppler would be known for his color lithography, as seen in this 1893 cartoon. (See p. 421)

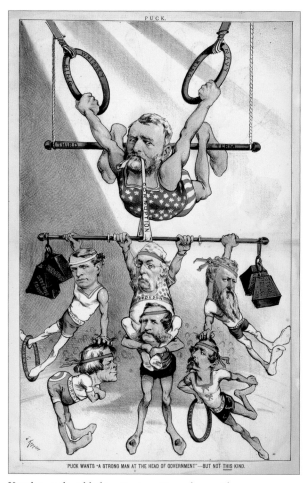

PUCK WANTS "A STRONG MAN AT THE HEAD OF GOVERNMENT"—BUT NOT THIS KIND.

Keppler employed light satire to critique the presidency
of Ulysses S. Grant. (See p. 344)

set out to unseat Nast as the nation's leading cartoonist. Joseph Keppler's style offered an immediate contrast with Nast's. Keppler looked to the future while Nast could not escape the past. Keppler was light; Nast was dark. Keppler was a satirist; Nast remained an angry partisan. Like Nast, however, Keppler employed recurring symbols and themes, such as making James G. Blaine the "Tattooed Man" or drawing the diminutive Benjamin Harrison in the hat of his grandfather, William Henry Harrison, which was far too big for him.[5]

Having arrived in the United States after the Civil War, Keppler did not share Nast's emotional attachment to the war and the Republican Party. *Leslie's* leaned Democratic, and Keppler followed its lead. In the 1872 election, Keppler's cartoons attacked President Grant and supported his Democratic opponent, Horace Greeley. He even made fun of *Harper's Weekly*'s "Nasty" cartoonist.

Keppler felt uncomfortable following *Leslie's* editorial line, however, and he became one of the founders of *Puck*—originally a German-language humor magazine that in 1877 began printing an English-language version as well. The magazine took its name from the blithe spirit of Shakespeare's *Midsummer Night's Dream*, along with its motto: "What fools these mortals be!" *Puck* looked different than other magazines of the day. It employed lithography in place of wood engraving and offered three cartoons in place of the usual one. The cartoons were initially printed in black and white, but later several tints were added, and soon the magazine burst into full, eye-catching color.

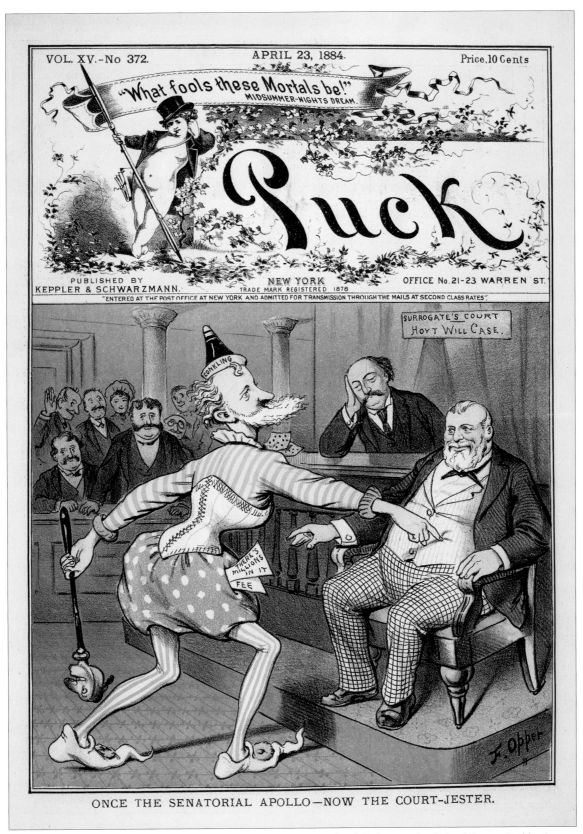

A typical cover from *Puck* featured a cartoon in full color. Here artist Frederick B. Opper makes light of Roscoe Conkling's decision to resume the practice of law after his resignation from the U.S. Senate. (See p. 363)

Puck began to add color tints in its first weeks of operation. A picture at the top of the page might be all red, while one at the bottom was all blue, and the center showed a blend of the colors. The tints were flat colors, unable to show light spots or dark shadows. Keppler, with a more highly developed sense of color, adjusted the printing process. A contemporary newspaper account recorded that "Joseph Keppler handles the lithographer's tools more skillfully than any other caricaturist of his standing in the country."[6] Other artists lacked Keppler's confidence and speed in lithography; they simply colored a black-and-white proof and handed it to the lithographer to use as a guide. Keppler's system started by making a pencil sketch on paper to group the figures and get a general sense of the picture. He then drew the final version of the cartoon on a lithographic stone with crayon and pen. The stone was polished and an impression was made. Keppler tinted the first proof to get a better idea of the color effect; then he prepared several other stones, each with a separate color. The impressions would be printed over one another to create a full-color effect. *Puck* needed to begin printing a full week before the release date, thus adding a sense of urgency to Keppler's work so his political cartoons could remain timely two weeks after he drew them.

This caricature of Vice President Hannibal Hamlin is an example of a "Puckograph." (See p. 346)

Aside from his talent and creative use of color, Joseph Keppler had a whimsical sense of humor. He once commented that to him almost every human being resembled some animal, bird, or inanimate object. "The secret of caricature is exaggeration of course," he explained, but the artist had to determine the key elements of a man's character in order to highlight and exaggerate them. In addition to his political cartoons, Keppler drew a series of "Puckographs," caricatures modeled after those that ran in the British journal *Vanity Fair*. Each profiled a different American politician.

As America's first political humor magazine, *Puck* attracted an appreciative audience. Its pro-Cleveland cartoons in 1884 may well have contributed to the Democratic candidate's narrow victory in the presidential election. The Republicans responded by buying *Puck*'s weak rival, *Judge*, and luring away some of *Puck*'s talented staff. Within a few years, *Judge* supplanted *Puck* as the leading humor magazine. Business concerns strained Keppler's naturally nervous temperament, and he died unexpectedly in 1894.[7]

As Joseph Keppler and Thomas Nast faded from the scene, Joseph Pulitzer's *New York World* and William Randolph Hearst's *New York Journal* began running regular cartoons, both political and humorous in nature. The newspapers employed the techniques that the earlier magazines had pioneered and preserved the legacy of Nast and Keppler in the form of daily editorial cartoons. ☙

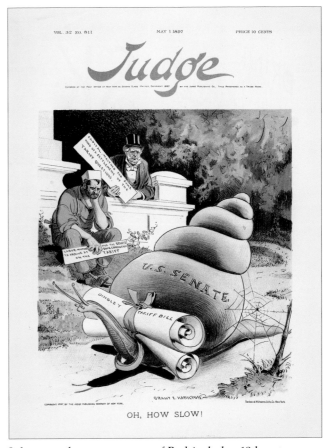

Judge emerged as a contemporary of *Puck* in the late 19th century.
(See p. 445)

1. Stephen Hess and Milton Kaplan, *The Ungentlemanly Art: A History of American Political Cartoons* (New York: Macmillan, 1968), 16–17, 76–77, 117; Donald A. Ritchie, *American Journalists: Getting the Story* (New York: Oxford University Press, 1997), 114–118.

2. Stephen Hess and Sandy Northrop, *Drawn and Quartered: The History of American Political Cartoons* (Montgomery, AL: Elliott and Clark, 1996), 24–35.

3. "The Making of Cartoons," *New York Times*, 20 July 1890.

4. For Nast's biography see Ritchie, *American Journalists*, 114–118; J. Chal Vinson, *Thomas Nast, Political Cartoonist* (Athens: University of Georgia Press, 1967); Morton Keller, *The Art and Politics of Thomas Nast* (New York: Oxford University Press, 1968); and U.S. Senate Commission on Art, *Between the Eyes: Thomas Nast and The U.S. Senate* (Washington, D.C.: Office of the Curator, 1993).

5. For Keppler's biography, see Richard Samuel West, *Satire on Stone: The Political Cartoons of Joseph Keppler* (Urbana: University of Illinois Press, 1988); and Hess and Kaplan, *The Ungentlemanly Art*, 102–109.

6. "The Making of Cartoons," *New York Times*, 20 July 1890.

7. "Death of Joseph Keppler," *New York Times*, 20 February 1894.

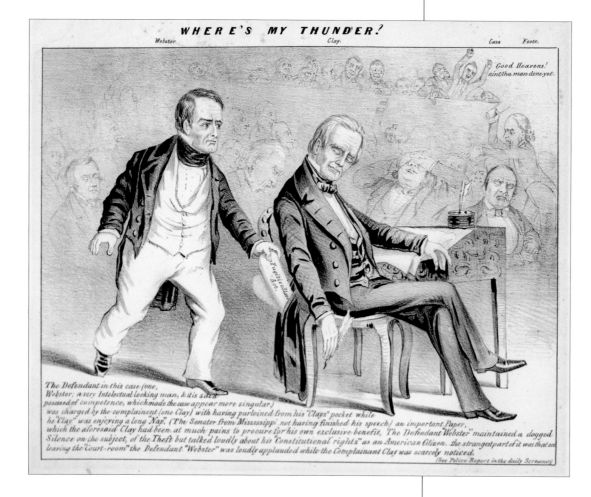

WHERE'S MY THUNDER?

Webster. Clay. Cass. Foote.

Good Heavens! aint tha man done yet.

The Defendant in this case (one, Webster; a very Intelectual looking man, & it is sd a possessed of competence, which made the case appear more singular) was charged by the complainant (one Clay) with having purloined from his "Clays" pocket while he "Clay" was enjoying a long "Nap". (The Senator from Mississippi not having finished his speech) an important Paper, which the aforesaid Clay had been. at much pains to procure for his own exclusive benefit, The Defendant "Webster" maintained a dogged Silence on the subject, of the Theft but talked loudly about his "Constitutional rights" as an American Citizen. the strangest part of it was that on leaving the "Court-room" the Defendant "Webster" was loudly applauded while the Complainant Clay was scarcely noticed.

(See Police Report in the daily Screamer)

Where's My Thunder?

Unidentified
The Old Soldier, ca. 1850
Lithograph, black and white
7 ⅜ x 8 ¾ inches (18.7 x 22.2 cm)
Cat. no. 38.00058.001

THE SAD PARTING BETWEEN TWO OLD FRIENDS.

CABINET WORK

SHOP OF THE SENATE

Life & Times of Thos. H. Benton for California.

Foote { So, yer goin ter leave us, ha Benton? well if I had my Pocket Hankercher about me I'de cry.

Benton. { Thank yer Foote! any other time will do, the fact is I wont work in no Shop where the Boss is all the time a findin fault with me work, & the Fellers in the Shop is all the time a Laughin at me.

The Sad Parting between Two Old Friends.

Unidentified after John L. Magee
Unidentified, ca. 1851
Lithograph, black and white
6 ⅝ x 8 ⅝ inches (16.8 x 21.9 cm)
Cat. no. 38.00981.001

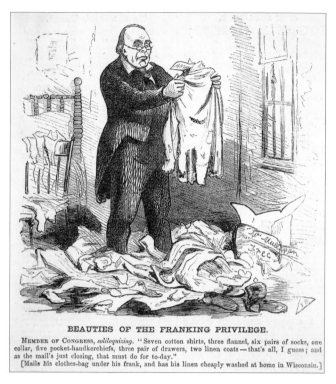

Beauties of the Franking Privilege.

Unidentified after F. B.
Harper's Weekly, 03/10/1860
Wood engraving, black and white
5 ¼ x 4 ¾ inches (13.3 x 12.1 cm)
Cat. no. 38.00536.001

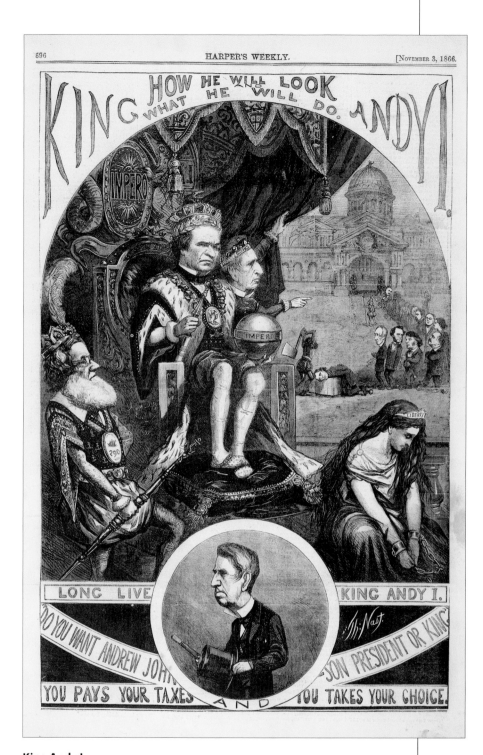

King Andy I.

Unidentified after Thomas Nast
Harper's Weekly, 11/03/1866
Wood engraving, black and white
13 ¾ x 9 ⅛ inches (34.9 x 23.2 cm)
Cat. no. 38.00688.001

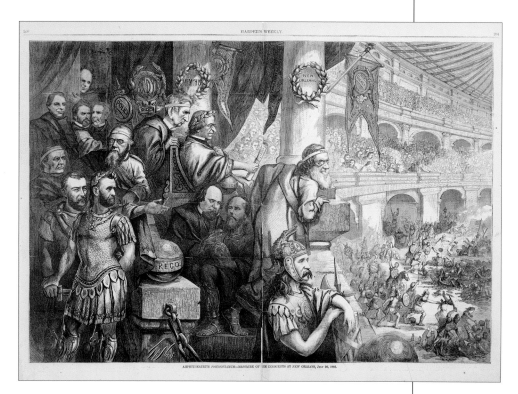

Amphitheatrum Johnsonianum—Massacre of the Innocents at New Orleans, July 30, 1866.

Unidentified after Thomas Nast
Harper's Weekly, 03/30/1867
Wood engraving, black and white
14 x 20 ¼ inches (35.6 x 51.4 cm)
Cat. no. 38.00678.001

A BRACE OF DEAD DUCKS.
Forney, D.D., to Andy. "How do you like it yourself—eh?"

A Brace of Dead Ducks.

Unidentified
Harper's Weekly, 03/14/1868
Wood engraving, black and white
6 ⅞ x 4 ½ inches (17.5 x 11.4 cm)
Cat. no. 38.00445.001

THIS LITTLE BOY WOULD PERSIST IN HANDLING BOOKS ABOVE HIS CAPACITY.

AND THIS WAS THE DISASTROUS RESULT.

This Little Boy Would Persist in Handling Books above His Capacity. / And This Was the Disastrous Result.

Unidentified
Harper's Weekly, 03/21/1868
Wood engraving, black and white
5 x 7 inches (12.7 x 17.8 cm)
Cat. no. 38.00194.001

Wash-Day in Congress.

Unidentified after Matt Morgan
Frank Leslie's Illustrated Newspaper, 12/30/1871
Wood engraving, black and white
9 x 12 ¾ inches (22.9 x 32.4 cm)
Cat. no. 38.00675.001

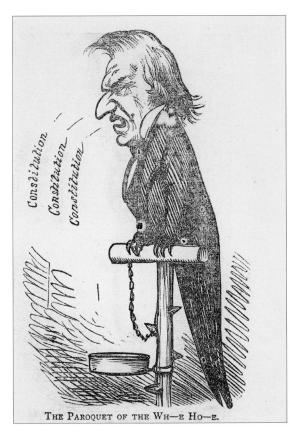

The Paroquet of the Wh—e Ho—e.

Unidentified
Harper's Weekly, 03/21/1868
Wood engraving, black and white
3 ¾ x 2 ½ inches (9.5 x 6.4 cm)
Cat. no. 38.00447.001

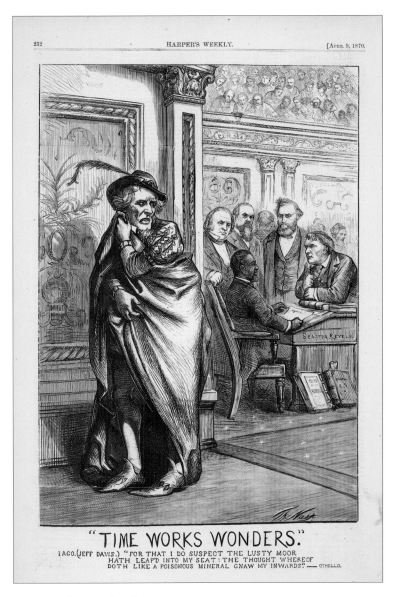

"Time Works Wonders."

Unidentified after Thomas Nast
Harper's Weekly, 04/09/1870
Wood engraving, black and white
13 ¾ x 9 inches (34.9 x 22.9 cm)
Cat. no. 38.00909.001

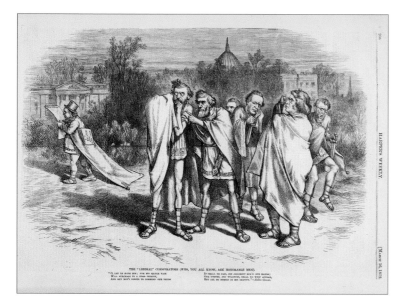

The "Liberal" Conspirators (Who, You All Know, Are Honorable Men).

Unidentified after Thomas Nast
Harper's Weekly, 03/16/1872
Wood engraving, black and white
9 ¾ x 13 ¾ inches (24.8 x 34.9 cm)
Cat. no. 38.00628.001

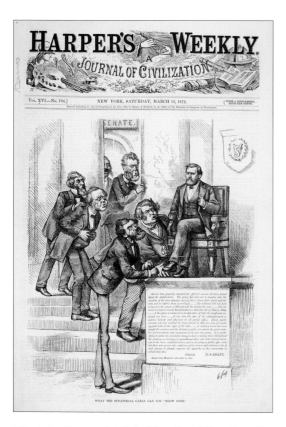

What the Senatorial Cabal Can Not "Blow Over."

Unidentified after Thomas Nast
Harper's Weekly, 03/16/1872
Wood engraving, black and white
11 ⁵⁄₁₆ x 9 ⅛ inches (28.7 x 23.2 cm)
Cat. no. 38.00531.001

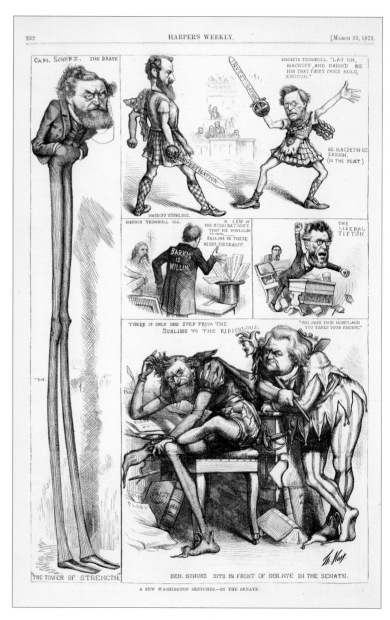

A Few Washington Sketches.—In the Senate.

Unidentified after Thomas Nast
Harper's Weekly, 03/23/1872
Wood engraving, black and white
13 ⅞ x 9 ⅛ inches (35.2 x 23.2 cm)
Cat. no. 38.00546.001

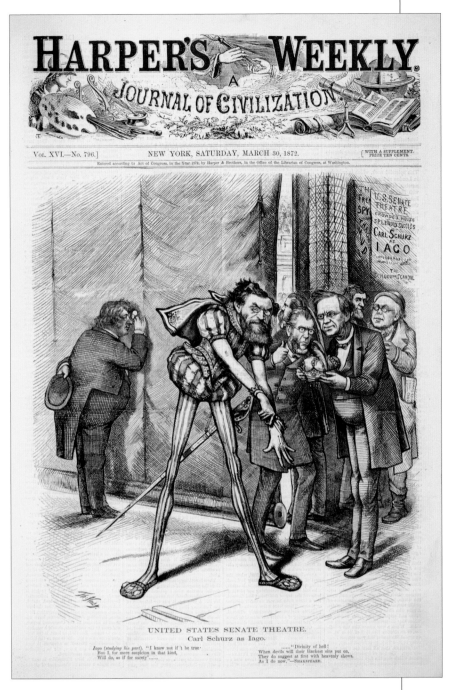

United States Senate Theatre.

Unidentified after Thomas Nast
Harper's Weekly, 03/30/1872
Wood engraving, black and white
11 ¼ x 9 ⅛ inches (28.6 x 23.2 cm)
Cat. no. 38.00371.003

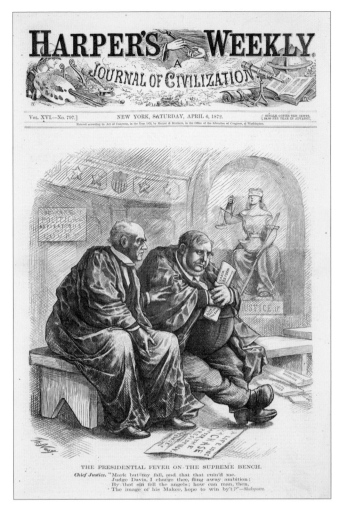

The Presidential Fever on the Supreme Bench.

Unidentified after Thomas Nast
Harper's Weekly, 04/06/1872
Wood engraving, black and white
11 ¼ x 9 ⅛ inches (28.6 x 23.2 cm)
Cat. no. 38.00877.001

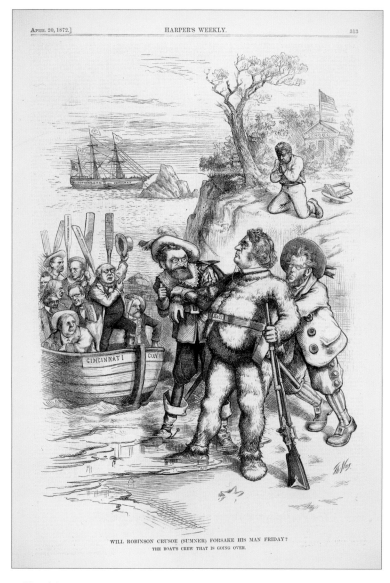

Will Robinson Crusoe (Sumner) Forsake His Man Friday?

Unidentified after Thomas Nast
Harper's Weekly, 04/20/1872
Wood engraving, black and white
14 x 9 ⅜ inches (35.6 x 23.8 cm)
Cat. no. 38.00125.001

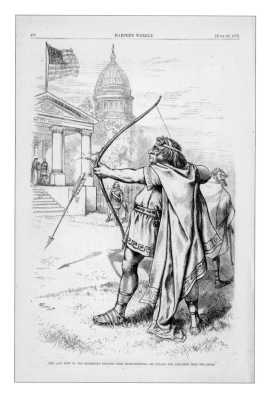

The Last Shot of the Honorable Senator from Massachusetts.—He Pulled the Long-Bow Once Too Often.

Unidentified after Thomas Nast
Harper's Weekly, 06/22/1872
Wood engraving, black and white
14 ¼ x 9 ½ inches (36.2 x 24.1 cm)
Cat. no. 38.00627.001

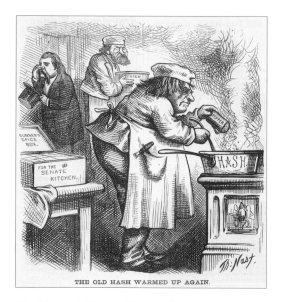

The Old Hash Warmed Up Again.

Unidentified after Thomas Nast
Harper's Weekly, 06/22/1872
Wood engraving, black and white
4 ¾ x 4 ⅝ inches (12.1 x 11.7 cm)
Cat. no. 38.00677.001

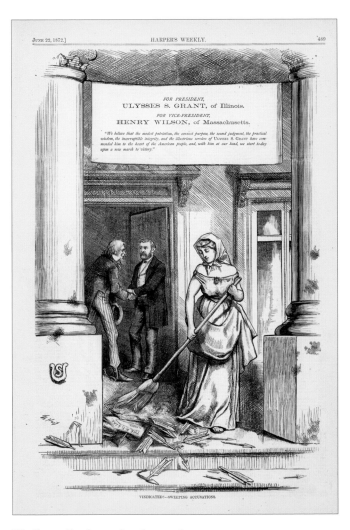

Vindicated!—Sweeping Accusations.

Unidentified after Thomas Nast
Harper's Weekly, 06/22/1872
Wood engraving, black and white
14 ¼ x 9 ¼ inches (36.2 x 23.5 cm)
Cat. no. 38.00626.001

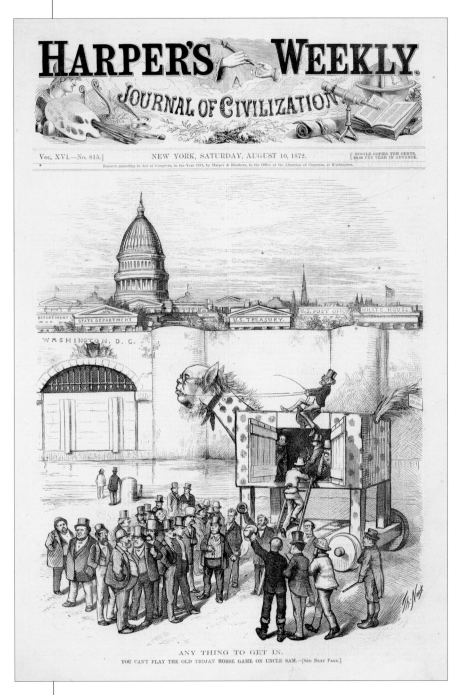

Any Thing to Get In.

Unidentified after Thomas Nast
Harper's Weekly, 08/10/1872
Wood engraving, black and white
11 ⁷⁄₁₆ x 9 ¼ inches (29.1 x 23.5 cm)
Cat. no. 38.00440.001

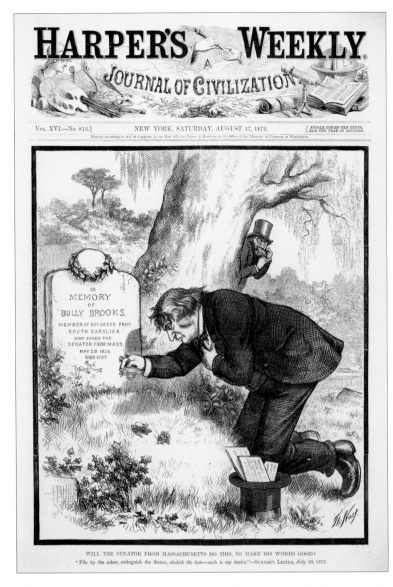

Will the Senator from Massachusetts Do This, to Make His Words Good?

Unidentified after Thomas Nast
Harper's Weekly, 08/17/1872
Wood engraving, black and white
11 ³⁄₁₆ x 9 ³⁄₁₆ inches (28.4 x 23.3 cm)
Cat. no. 38.00122.001

"Let Us Have Complete Restoration, While You Are about It."

Unidentified after Thomas Nast
Harper's Weekly, 12/28/1872
Wood engraving, black and white
13 ⁵⁄₈ x 9 ³⁄₁₆ inches (34.6 x 23.3 cm)
Cat. no. 38.00121.001

The Great National Circus

Unidentified after Matt Morgan
Frank Leslie's Illustrated Newspaper, 01/31/1874
Wood engraving, black and white
12 x 9 ¼ inches (30.5 x 23.5 cm)
Cat. no. 38.00637.001

Notice.—No Cartoon This Week.

Unidentified after Thomas Nast
Harper's Weekly, 01/31/1874
Wood engraving, black and white
4 ¾ x 4 ½ inches (12.1 x 11.4 cm)
Cat. no. 38.00679.001

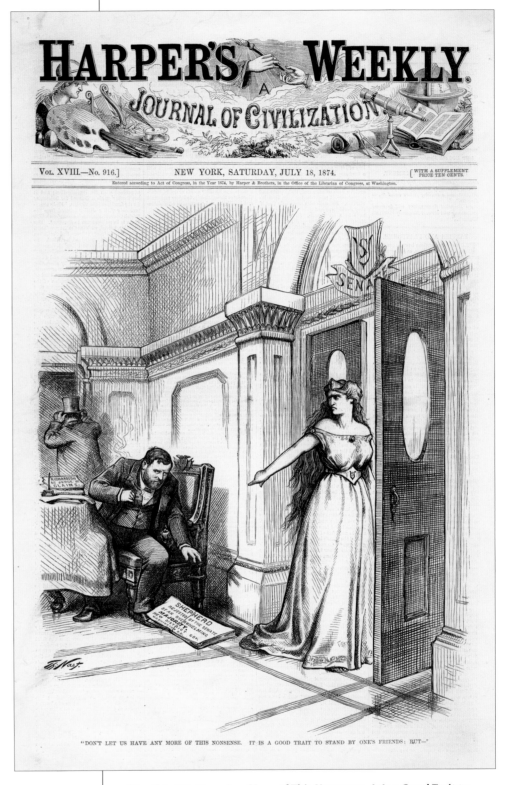

"Don't Let Us Have Any More of This Nonsense. It Is a Good Trait to Stand by One's Friends; But—"

Unidentified after Thomas Nast
Harper's Weekly, 07/18/1874
Wood engraving, black and white
11 ¾ x 9 inches (29.8 x 23.5 cm)
Cat. no. 38.00684.001

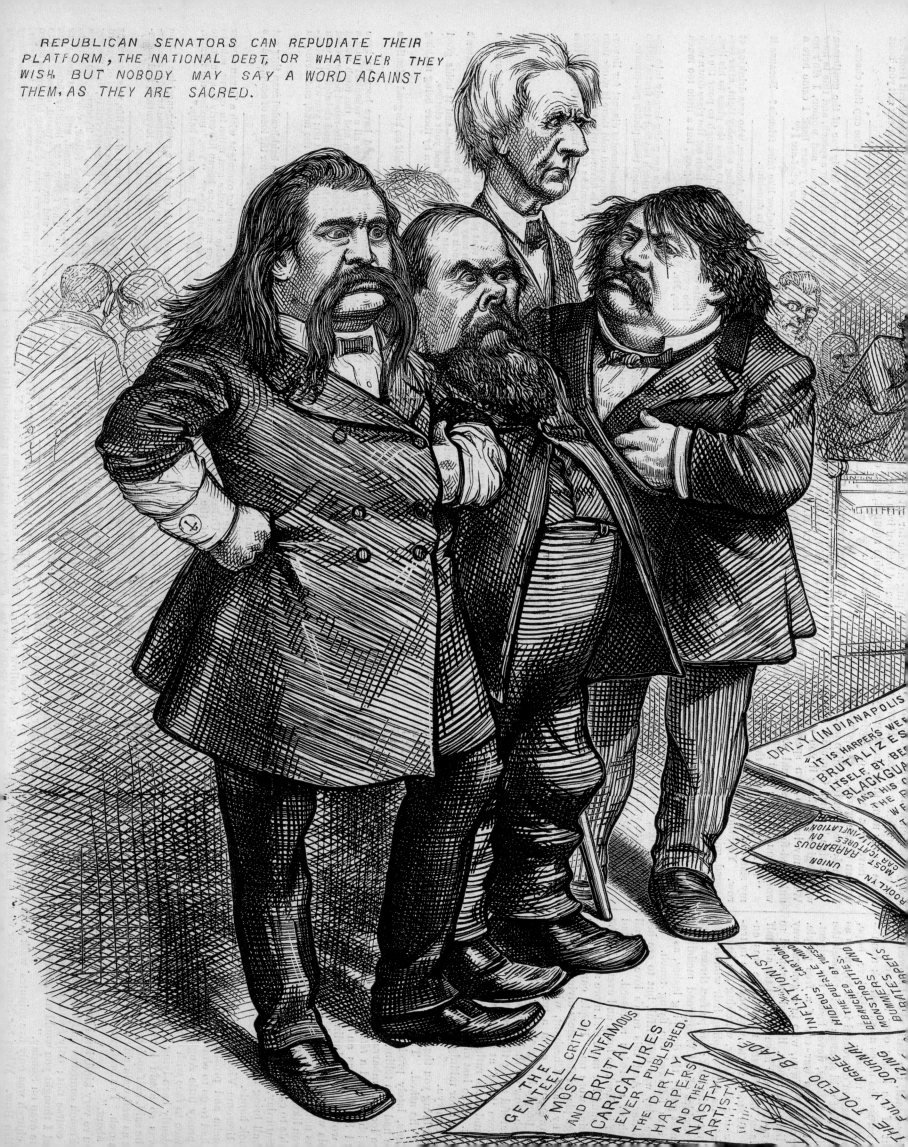

REPUBLICAN SENATORS CAN REPUDIATE THEIR PLATFORM, THE NATIONAL DEBT, OR WHATEVER THEY WISH, BUT NOBODY MAY SAY A WORD AGAINST THEM, AS THEY ARE SACRED.

A passionate Republican partisan, cartoonist Thomas Nast never hesitated to assail members of his own party who strayed from the Republican platform. The Panic of 1873 had led Congress to adopt an inflationary measure that increased the amount of greenbacks—paper money—in circulation. Nast's hero, President Ulysses S. Grant, vetoed the bill in April 1874. Nast, who shared the president's hard-money views, drew critical cartoons of Republicans who opposed Grant on the measure. Newspapers aligned with these senators then attacked *Harper's Weekly* for becoming "a pictorial blackguard." Nast confronted Republican senators by inserting himself in this cartoon that appeared in *Harper's Weekly* on June 6, 1874. Giving the impression that he is bowing, Nast stoops to read their "peevish" attacks on him, with the observation: "Republican senators can repudiate their platform, the national debt, or whatever they wish, but nobody may say a word against them, as they are sacred." ☙

"Peevish School-Boys, Worthless of Such Honor."

Unidentified after Thomas Nast
Harper's Weekly, 06/06/1874
Wood engraving, black and white
9 ½ x 13 ½ inches (24.1 x 34.3 cm)
Cat. no. 38.00114.001

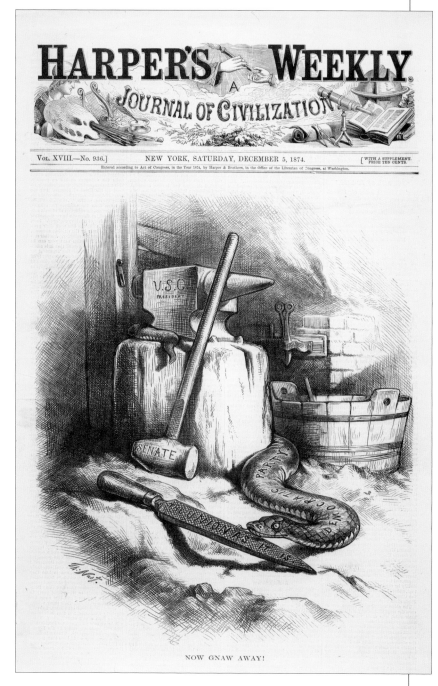

Now Gnaw Away!

Unidentified after Thomas Nast
Harper's Weekly, 12/05/1874
Wood engraving, black and white
11 ½ x 9 ⅛ inches (29.2 x 23.2 cm)
Cat. no. 38.00554.001

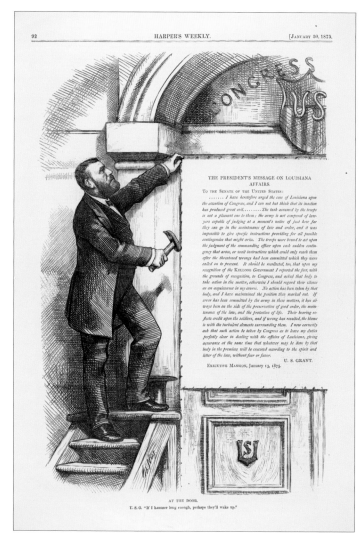

At the Door.

Unidentified after Thomas Nast
Harper's Weekly, 01/30/1875
Wood engraving, black and white
14 x 8 ⅞ inches (35.6 x 22.5 cm)
Cat. no. 38.00124.001

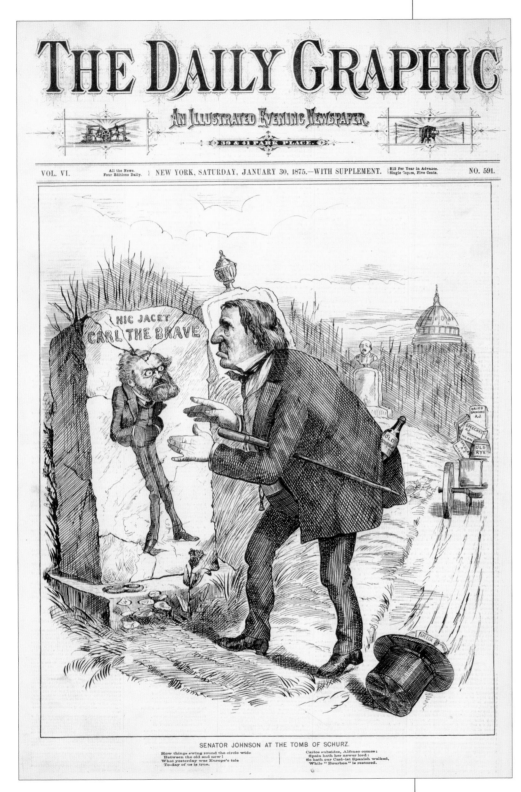

Senator Johnson at the Tomb of Schurz.

Unidentified
The Daily Graphic, 01/30/1875
Wood engraving, black and white
14 ¾ x 12 ¼ inches (37.5 x 31.1 cm)
Cat. no. 38.00636.001

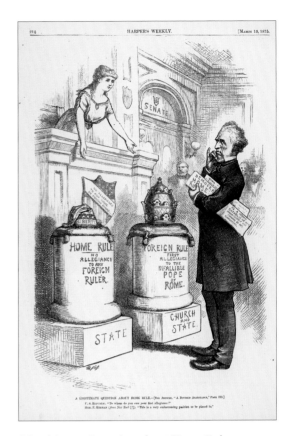

A Legitimate Question about Home Rule.

Unidentified after Thomas Nast
Harper's Weekly, 03/13/1875
Wood engraving, black and white
14 ⅛ x 9 ³⁄₁₆ inches (35.9 x 23.3 cm)
Cat. no. 38.00307.001

The Whirligig of Time.

Unidentified after Thomas Nast
Harper's Weekly, 02/20/1875
Wood engraving, black and white
5 x 5 inches (12.7 x 12.7 cm)
Cat. no. 38.00639.001

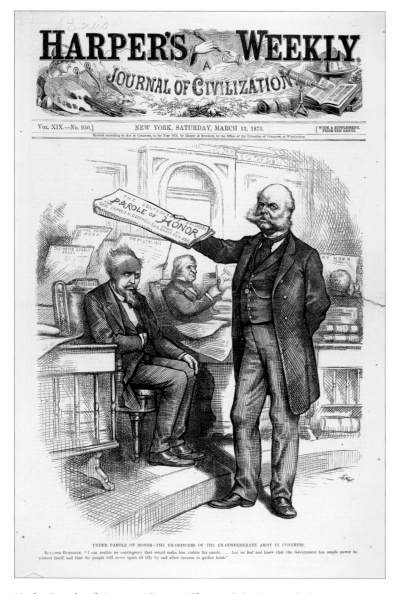

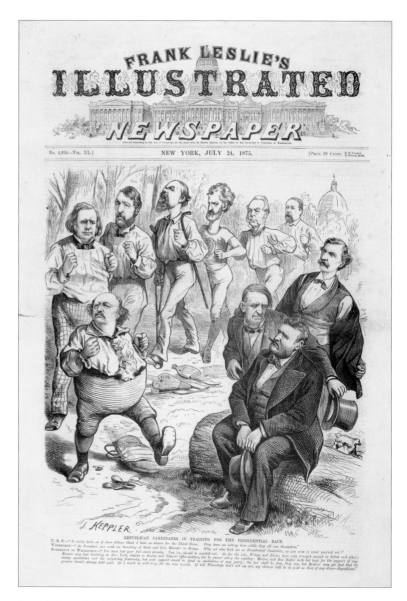

Under Parole of Honor—The Ex-Officers of the Ex-Confederate Army in Congress.

Unidentified after Thomas Nast
Harper's Weekly, 03/13/1875
Wood engraving, black and white
11 5⁄16 x 9 1⁄4 inches (28.7 x 23.5 cm)
Cat. no. 38.00116.001

Republican Candidates in Training for the Presidential Race.

Unidentified after Joseph Keppler
Frank Leslie's Illustrated Newspaper, 07/24/1875
Wood engraving, black and white
11 9⁄16 x 9 7⁄16 inches (29.4 x 24.0 cm)
Cat. no. 38.00544.001

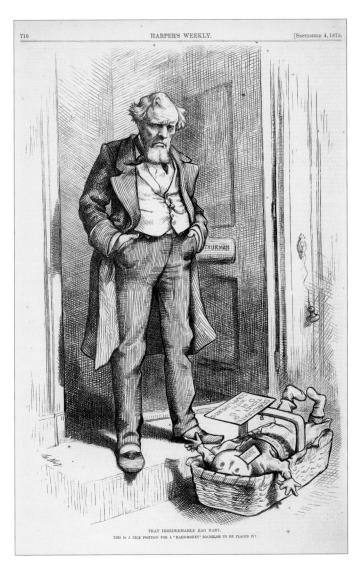

That Irredeemable Rag Baby.

Unidentified after Thomas Nast
Harper's Weekly, 09/04/1875
Wood engraving, black and white
14 x 9 ¼ inches (35.6 x 23.5 cm)
Cat. no. 38.00682.001

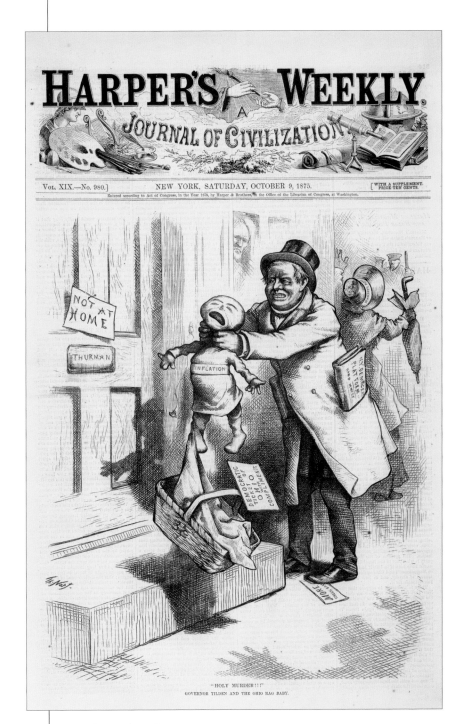

"Holy Murder!!!"

Unidentified after Thomas Nast
Harper's Weekly, 10/09/1875
Wood engraving, black and white
11 ⅜ x 9 ⅜ inches (28.9 x 23.8 cm)
Cat. no. 38.00681.001

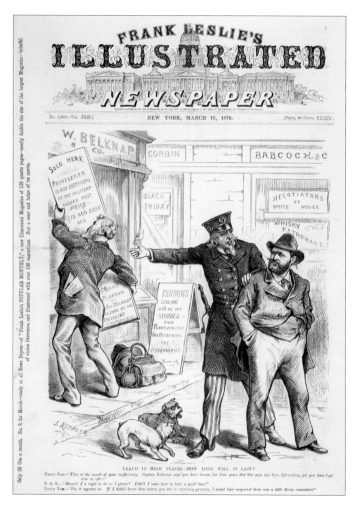

Fraud in High Places—How Long Will It Last?

Unidentified after Joseph Keppler
Frank Leslie's Illustrated Newspaper, 03/18/1876
Wood engraving, black and white
11 ⅝ x 9 ½ inches (29.5 x 24.1 cm)
Cat. no. 38.00472.001

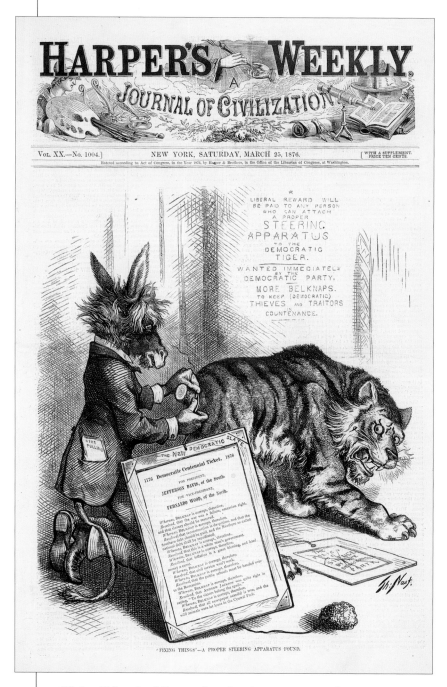

"Fixing Things"—A Proper Steering Apparatus Found.

Unidentified after Thomas Nast
Harper's Weekly, 03/25/1876
Wood engraving, black and white
11 ⅜ x 9 ¼ inches (28.9 x 23.5 cm)
Cat. no. 38.00458.001

Compromise—Indeed!

Unidentified after Thomas Nast
Harper's Weekly, 01/27/1877
Wood engraving, black and white
14 x 9 ½ inches (35.6 x 24.1 cm)
Cat. no. 38.00113.001

It Struck (in Blowing Over).—Picking Even the Poor Soldiers' Bones to Feather Their Nest.

Unidentified after Thomas Nast
Harper's Weekly, 03/25/1876
Wood engraving, black and white
20 ½ x 13 ⅝ inches (52.1 x 34.6 cm)
Cat. no. 38.00457.001

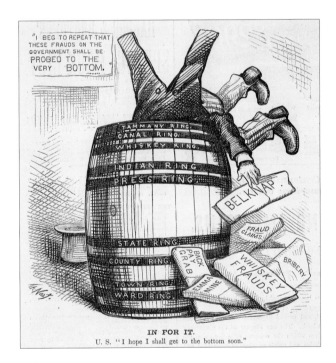

In for It.

Unidentified after Thomas Nast
Harper's Weekly, 03/25/1876
Wood engraving, black and white
5 x 4 ¾ inches (12.7 x 12.1 cm)
Cat. no. 38.00459.001

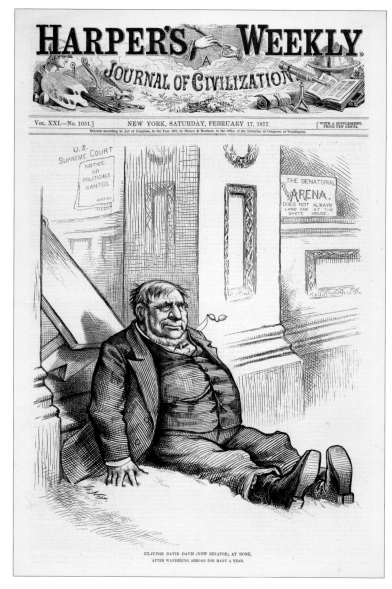

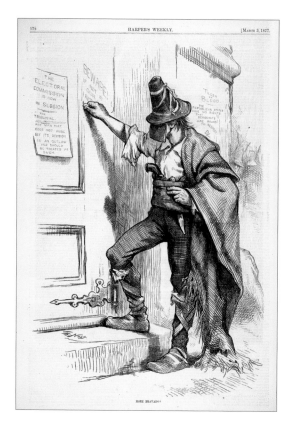

More Bravado?

Unidentified after Thomas Nast
Harper's Weekly, 03/03/1877
Wood engraving, black and white
14 x 8 ⅞ inches (35.6 x 22.5 cm)
Cat. no. 38.00117.001

Ex-Judge David Davis (Now Senator), at Home, after Wandering Abroad for Many a Year.

Unidentified after Thomas Nast
Harper's Weekly, 02/17/1877
Wood engraving, black and white
11 ½ x 9 inches (29.2 x 22.9 cm)
Cat. no. 38.00112.001

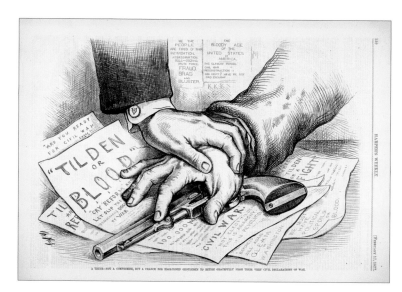

A Truce—Not a Compromise, but a Chance for High-Toned Gentlemen to Retire Gracefully from Their Very Civil Declarations of War.

Unidentified after Thomas Nast
Harper's Weekly, 02/17/1877
Wood engraving, black and white
9 ½ x 13 ⅜ inches (24.1 x 34.0 cm)
Cat. no. 38.00118.001

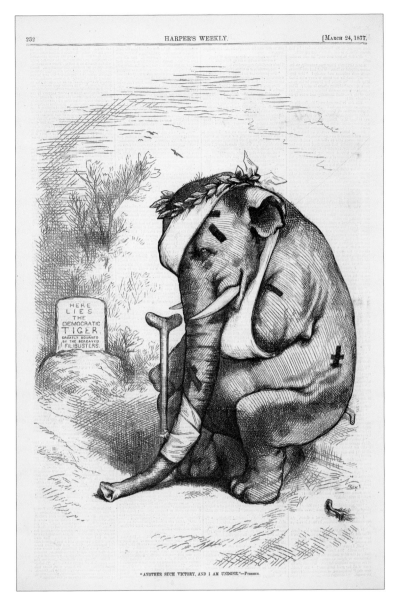

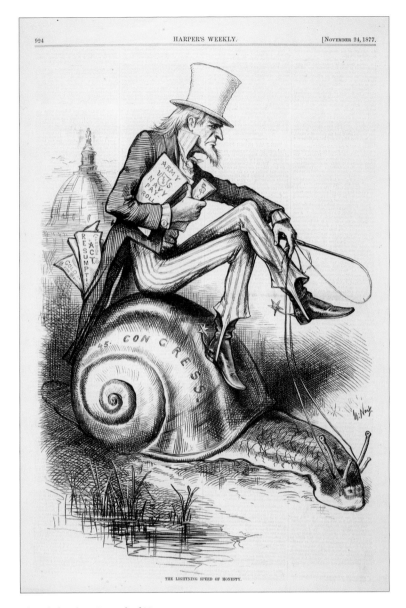

"Another Such Victory, and I Am Undone."

Unidentified after Thomas Nast
Harper's Weekly, 03/24/1877
Wood engraving, black and white
13 ¾ x 9 ¼ inches (34.9 x 23.5 cm)
Cat. no. 38.00115.001

The Lightning Speed of Honesty.

Unidentified after Thomas Nast
Harper's Weekly, 11/24/1877
Wood engraving, black and white
14 ¼ x 9 ⅞ inches (36.2 x 25.1 cm)
Cat. no. 38.00547.001

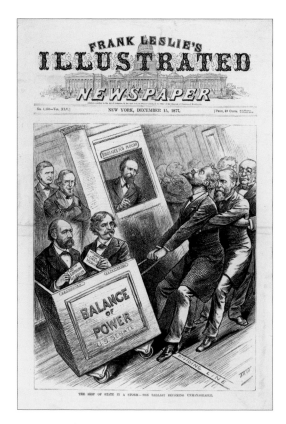

The Ship of State in a Storm—The Ballast Becoming Unmanageable.

Unidentified after James A. Wales
Frank Leslie's Illustrated Newspaper, 12/15/1877
Wood engraving, black and white
11 ½ x 9 ⅜ inches (29.2 x 23.8 cm)
Cat. no. 38.00734.001

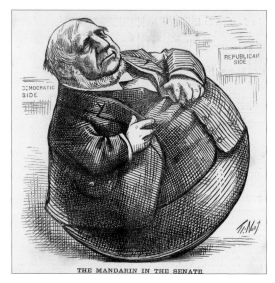

The Mandarin in the Senate.

Unidentified after Thomas Nast
Harper's Weekly, 12/22/1877
Wood engraving, black and white
4 ¾ x 4 ¾ inches (12.1 x 12.1 cm)
Cat. no. 38.00549.001

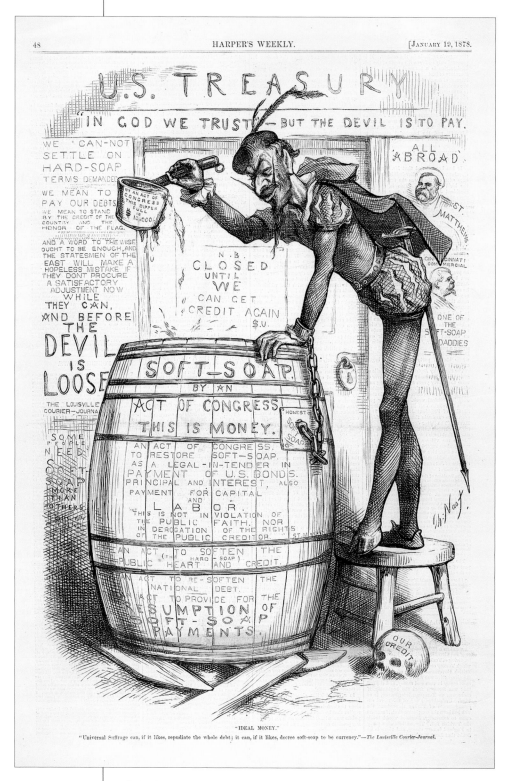

"Ideal Money."

Unidentified after Thomas Nast
Harper's Weekly, 01/19/1878
Wood engraving, black and white
14 x 9 ⅜ inches (35.6 x 23.8 cm)
Cat. no. 38.00119.001

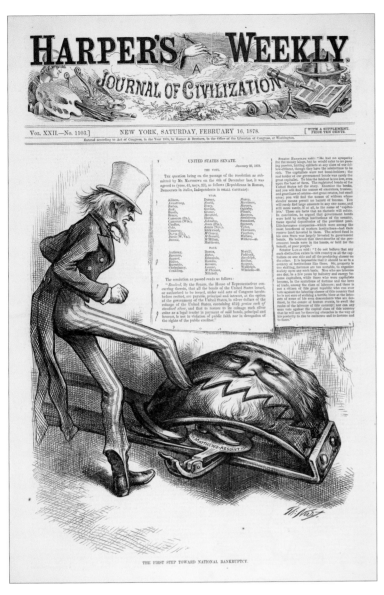

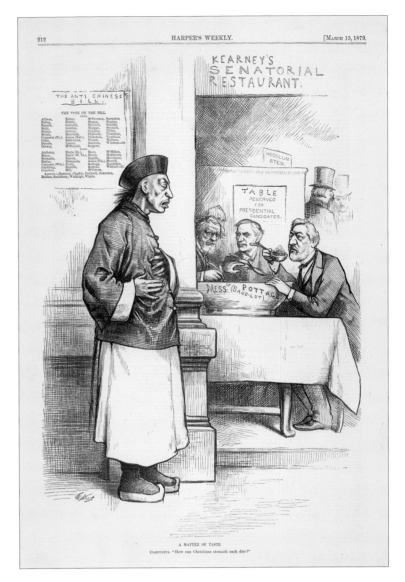

The First Step toward National Bankruptcy.

Unidentified after Thomas Nast
Harper's Weekly, 02/16/1878
Wood engraving, black and white
11 ⅜ x 9 ⅝ inches (28.9 x 24.4 cm)
Cat. no. 38.00123.001

A Matter of Taste.

Unidentified after Thomas Nast
Harper's Weekly, 03/15/1879
Wood engraving, black and white
14 ¼ x 9 ⅛ inches (36.2 x 23.2 cm)
Cat. no. 38.00659.001

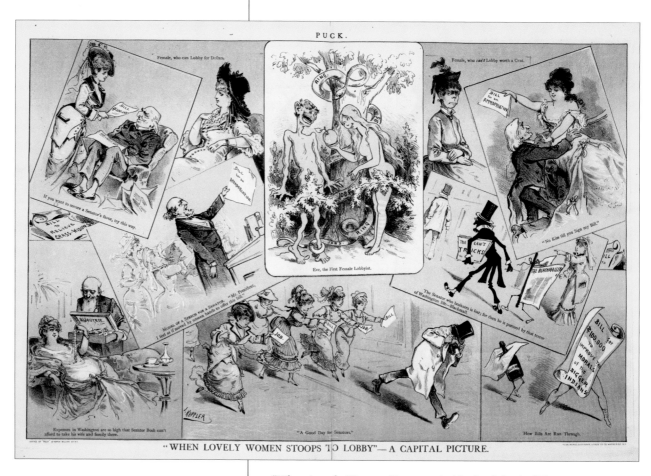

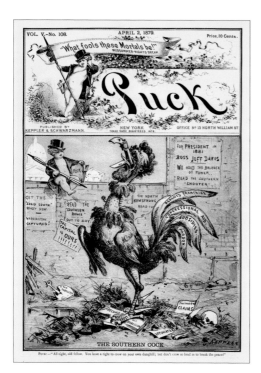

The Southern Cock.

Unidentified after Joseph Keppler
Puck, 04/02/1879
Lithograph, colored
8 ⅜ x 8 ½ inches (21.3 x 21.6 cm)
Cat. no. 38.00517.001

"When Lovely Women Stoops to Lobby"—A Capital Picture.

Mayer, Merkel & Ottmann Lithog. after Joseph Keppler
Puck, 04/02/1879
Lithograph, colored
12 ¼ x 18 ½ inches (31.1 x 47.0 cm)
Cat. no. 38.00518.001

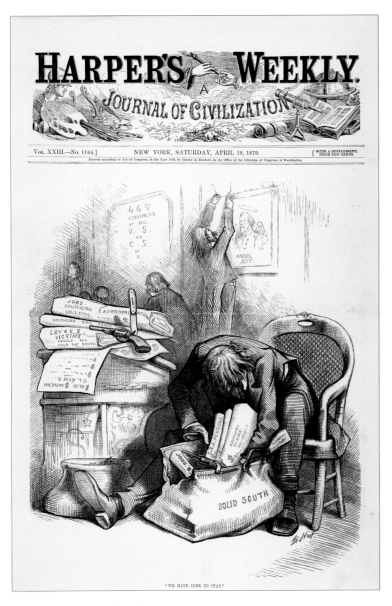

"We Have Come to Stay."

Unidentified after Thomas Nast
Harper's Weekly, 04/19/1879
Wood engraving, black and white
11 ¼ x 9 ½ inches (28.6 x 24.1 cm)
Cat. no. 38.00657.001

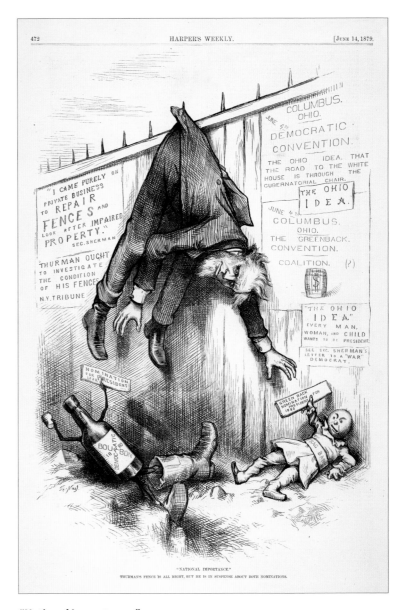

"National Importance."

Unidentified after Thomas Nast
Harper's Weekly, 06/14/1879
Wood engraving, black and white
14 ¼ x 9 ¼ inches (36.2 x 23.5 cm)
Cat. no. 38.00680.001

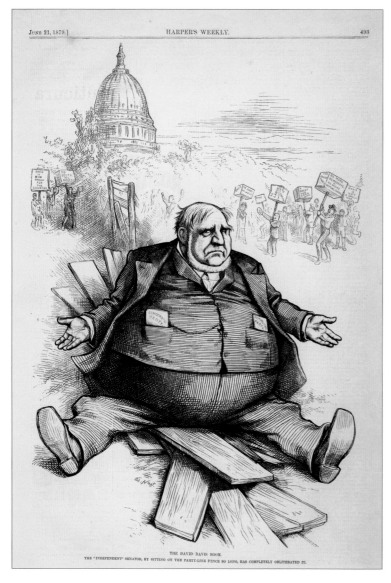

The David Davis Boom.

Unidentified after Thomas Nast
Harper's Weekly, 06/21/1879
Wood engraving, black and white
14 ⅛ x 9 ½ inches (35.9 x 24.1 cm)
Cat. no. 38.00656.001

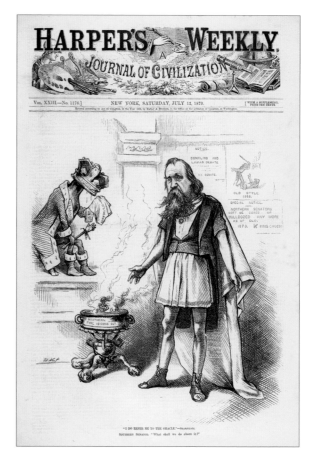

"I Do Refer Me to the Oracle."

Unidentified after Thomas Nast
Harper's Weekly, 07/12/1879
Wood engraving, black and white
11 ½ x 9 ⅛ inches (29.2 x 23.2 cm)
Cat. no. 38.00128.001

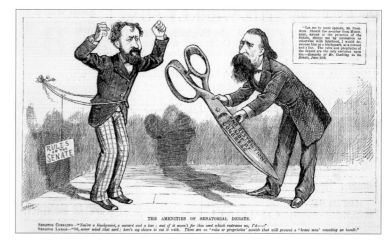

The Amenitites of Senatorial Debate.

Unidentified after Frederick B. Opper
Frank Leslie's Illustrated Newspaper, 07/05/1879
Wood engraving, black and white
5 ½ x 9 ¼ inches (14.0 x 23.5 cm)
Cat. no. 38.00898.001

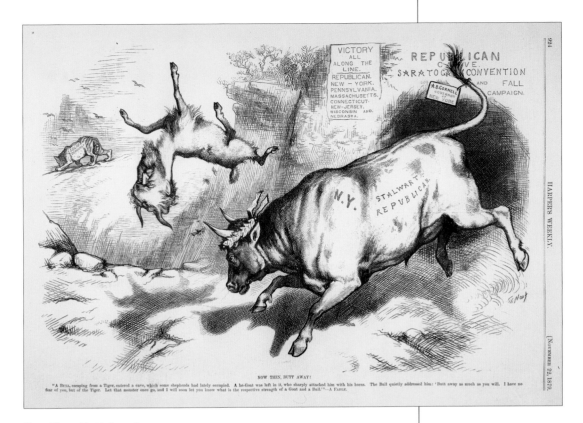

Now Then, Butt Away!

Unidentified after Thomas Nast
Harper's Weekly, 11/22/1879
Wood engraving, black and white
15 ½ x 13 ½ inches (39.4 x 34.3 cm)
Cat. no. 38.00728.001

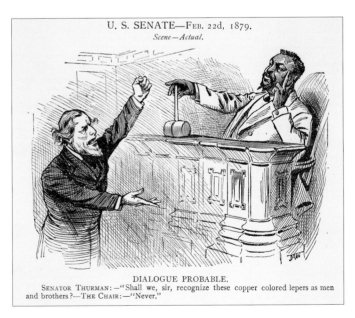

Dialogue Probable.

Unidentified after James A. Wales
Puck, 1879
Wood engraving, black and white
4 ¼ x 5 ¾ inches (12.1 x 14.6 cm)
Cat. no. 38.00610.001

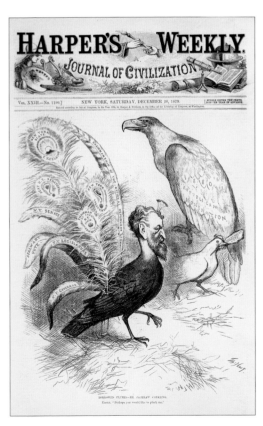

Borrowed Plumes—Mr. Jackdaw Conkling.

Unidentified after Thomas Nast
Harper's Weekly, 12/20/1879
Wood engraving, black and white
11 ⅛ x 9 ⅛ inches (28.9 x 23.2 cm)
Cat. no. 38.00685.001

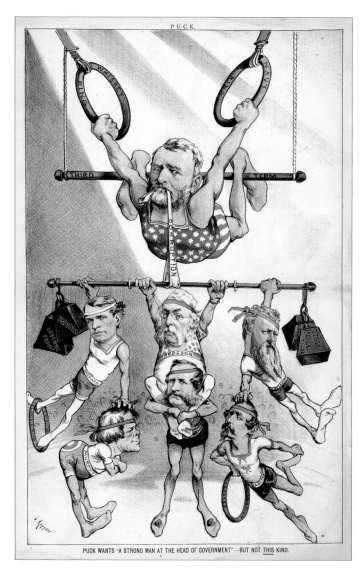

Puck Wants "A Strong Man at the Head of Government"—But Not This Kind.

Unidentified after Joseph Keppler
Puck, 02/04/1880
Lithograph, colored
18 ½ x 11 ¹¹⁄₁₆ inches (47.0 x 29.7 cm)
Cat. no. 38.00474.001

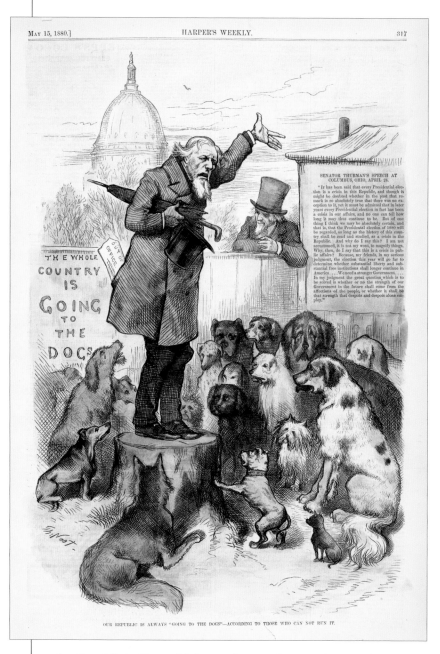

Our Republic Is Always "Going to the Dogs"—According to Those Who Can Not Run It.

Unidentified after Thomas Nast
Harper's Weekly, 05/15/1880
Wood engraving, hand-colored
14 ¼ x 9 ½ inches (36.2 x 24.1 cm)
Cat. no. 38.00646.001

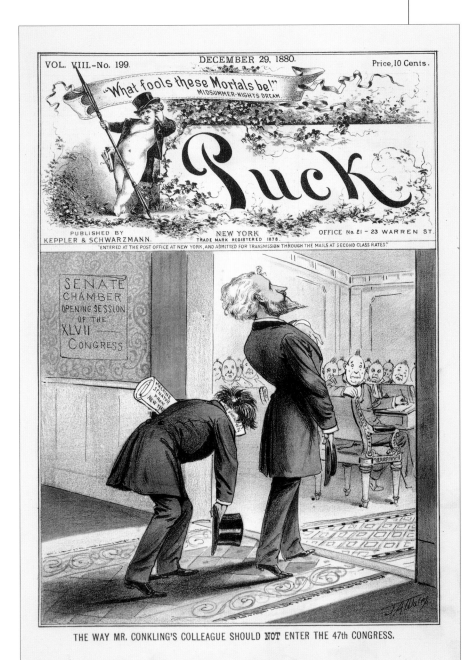

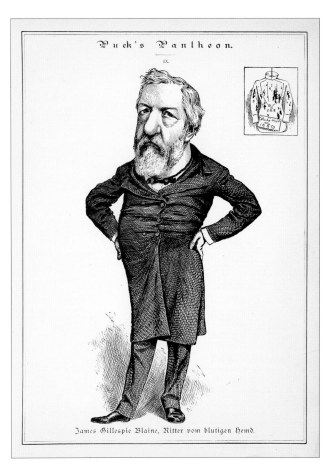

The Way Mr. Conkling's Colleague Should Not Enter the 47th Congress.

Unidentified after James A. Wales
Puck, 12/29/1880
Lithograph, colored
8 1/16 x 8 1/2 inches (20.5 x 21.6 cm)
Cat. no. 38.00566.001

James Gillespie Blaine, Ritter vom blutigen hemd.

Unidentified
Puck, ca. 1880
Wood engraving, black and white
11 1/4 x 8 1/2 inches (28.6 x 21.6 cm)
Cat. no. 38.00867.001

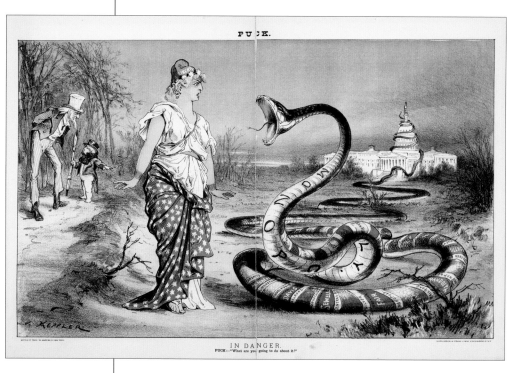

In Danger.

Mayer, Merkel & Ottmann Lithog. after Joseph Keppler
Puck, 02/09/1881
Lithograph, colored
11 ⅝ x 18 ⁹⁄₁₆ inches (29.5 x 47.1 cm)
Cat. no. 38.00514.002

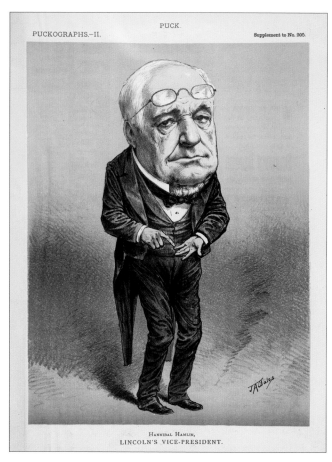

Hannibal Hamlin, Lincoln's Vice-President

Unidentified after James A. Wales
Puck, 02/09/1881
Lithograph, colored
11 ¾ x 8 ½ inches (29.8 x 21.6 cm)
Cat. no. 38.00515.001

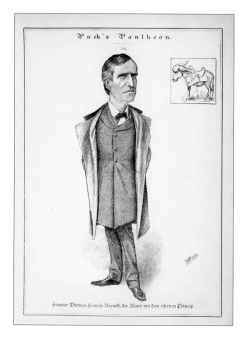

Senator Thomas Francis Bayard, der Mann mit dem eifernen Princip.

Unidentified after James A. Wales
Puck, ca. 1880
Wood engraving, black and white
11 x 8 ½ inches (27.9 x 21.6 cm)
Cat. no. 38.00868.001

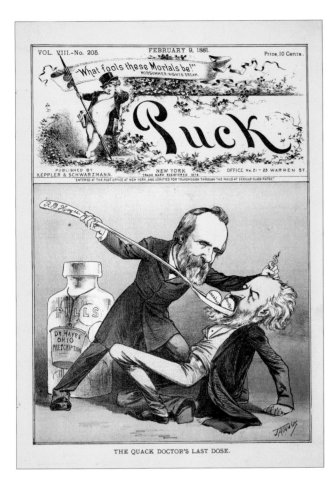

The Quack Doctor's Last Dose.

Unidentified after James A. Wales
Puck, 02/09/1881
Lithograph, colored
8 ⅛ x 8 ½ inches (20.6 x 21.6 cm)
Cat. no. 38.00513.001

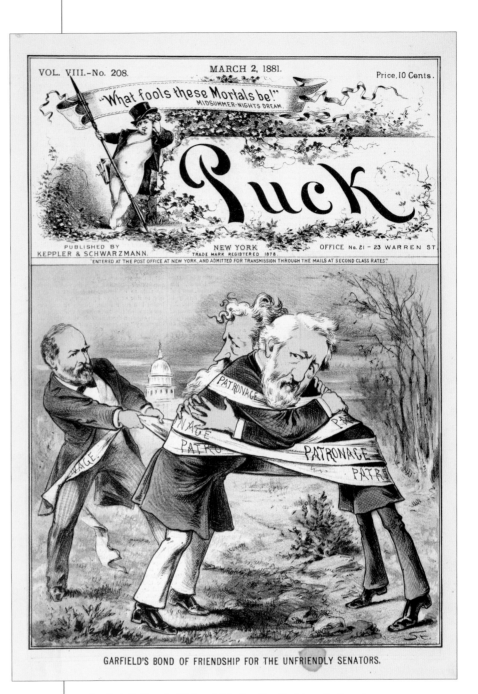

Garfield's Bond of Friendship for the Unfriendly Senators.

Unidentified
Puck, 03/02/1881
Lithograph, colored
8 x 8 ½ inches (20.3 x 21.6 cm)
Cat. no. 38.00832.001

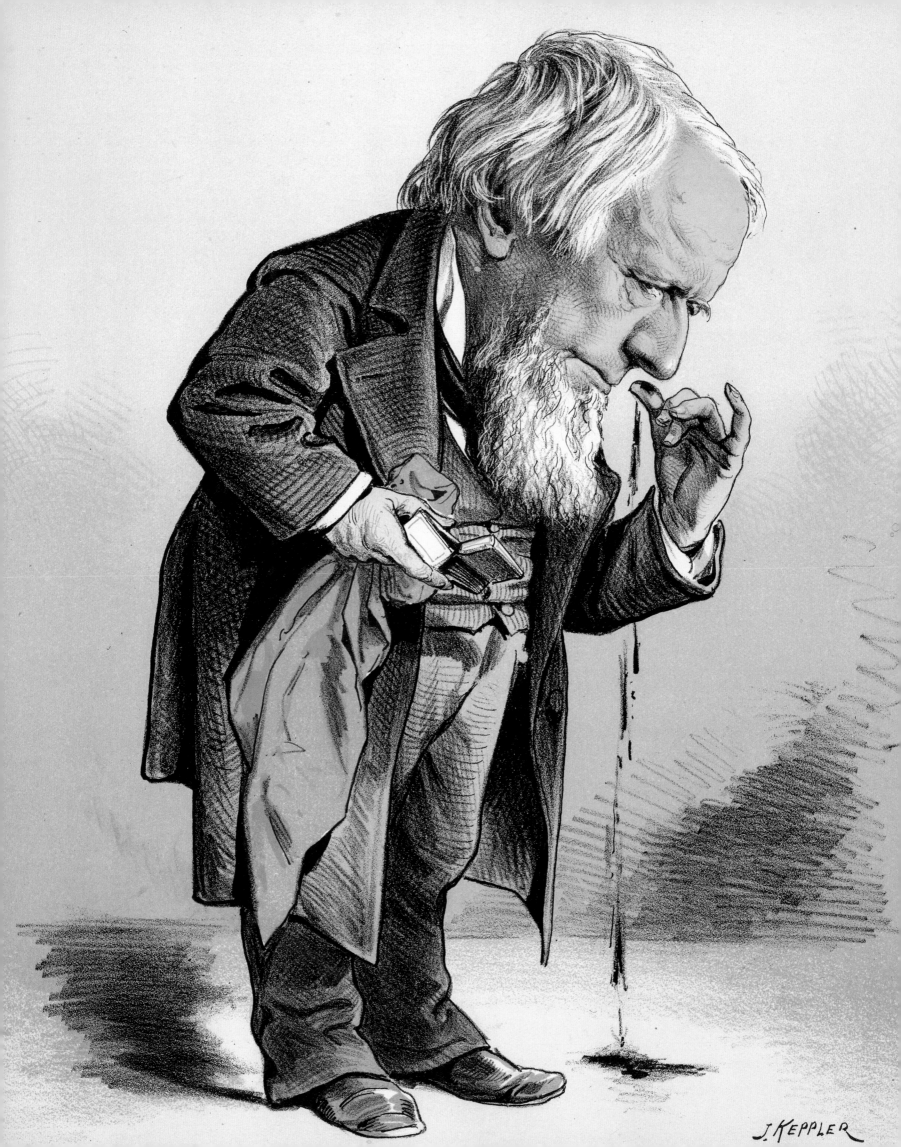

J. KEPPLER

nfluenced by the cartoon portraits printed in the British magazine *Vanity Fair*, Joseph Keppler drew a series of cartoons in the 1880s for *Puck* magazine that became known as "Puckographs." His portrait of Senator Allen G. Thurman appeared in *Puck* on April 13, 1881. A well-respected senator, the Ohio Democrat chaired the Judiciary Committee, served as president pro tempore, and was a member of the Electoral Commission that decided the presidential election between Rutherford B. Hayes and Samuel J. Tilden. When Thurman lost his reelection to the Senate in 1881, Republican President James Garfield appointed him a delegate to an international monetary conference in Paris.

Keppler sketched Thurman dipping snuff, a form of ground tobacco that was inhaled. Although more popular before the Civil War than after, snuff boxes remained in the Senate Chamber, and snuff inexplicably became linked with senators' public images. ☙

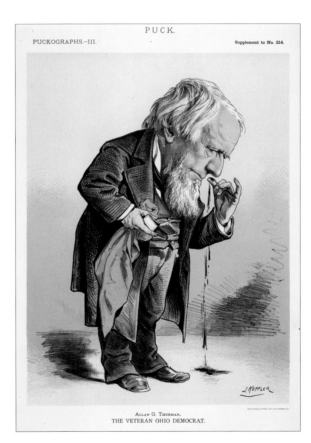

Allan G. Thurman, The Veteran Ohio Democrat.

Mayer, Merkel & Ottmann Lithog. after Joseph Keppler
Puck, 04/13/1881
Lithograph, colored
11 ⅝ x 8 ½ inches (29.5 x 21.6 cm)
Cat. no. 38.00190.001

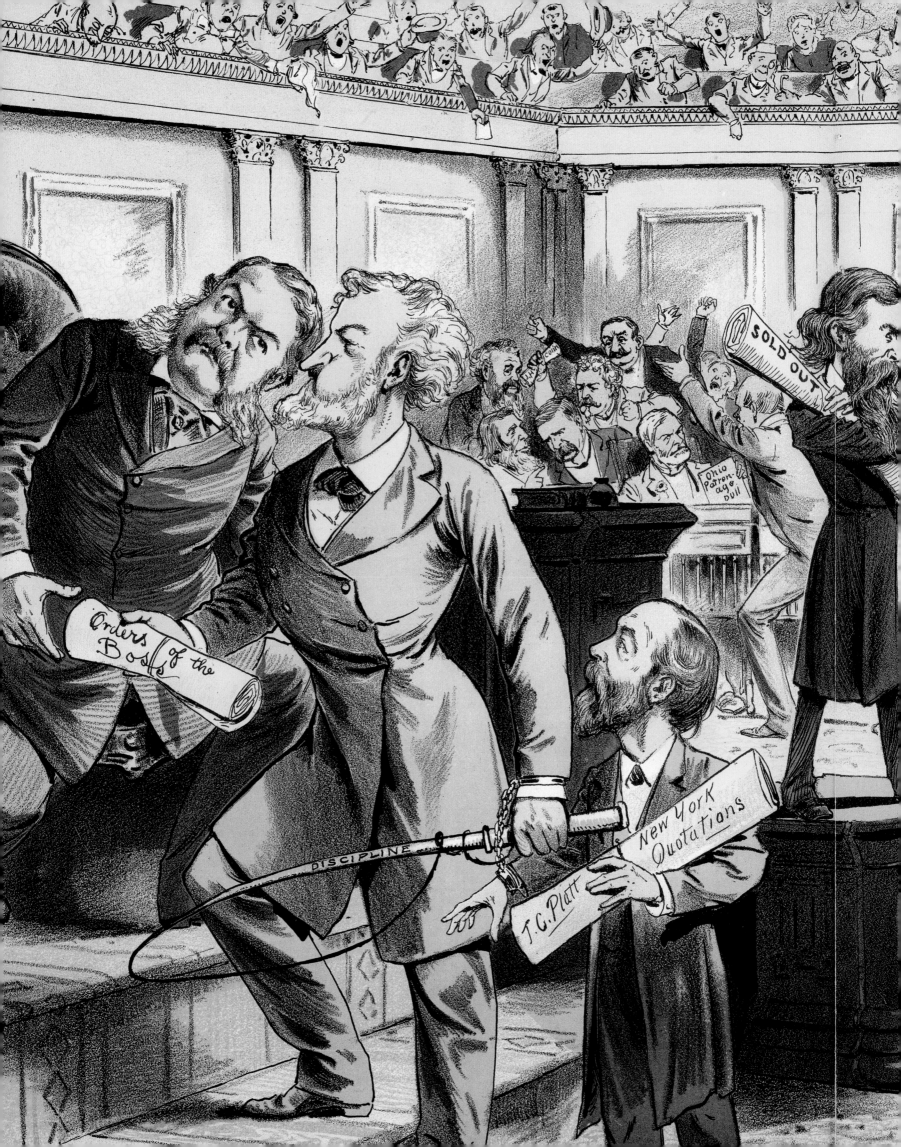

The Senate was evenly divided when it met in special session in March 1881, and both parties bid for the two independent senators. The portly David Davis, Independent from Illinois, seen seated at the right, announced that he would vote with the Democrats. Democrats could retain the majority if they also gained the vote of Senator William Mahone, an Independent who represented a faction of the Democratic Party in Virginia. Senate Republicans similarly wooed Mahone with patronage. On March 18, 1881, Mahone voted with the Republicans. Vice President Chester Arthur cast the tie-breaking vote that enabled Republicans to organize the Senate.

James Wales's cartoon about the unseemly bidding war appeared in *Puck* close to a month after the fateful vote. The cartoon remained timely, as the battle for control continued to disrupt Senate business until adjournment in late May of that year. Ominously, Republican New York Senator Roscoe Conkling, whip in hand, can be seen issuing orders to his faithful lieutenant, Vice President Chester Arthur. ❧

This Is Not the New York Stock Exchange, It Is the Patronage Exchange, Called U.S. Senate.

Unidentified after James A. Wales
Puck, 04/13/1881
Lithograph, colored
11 ¾ x 18 ¾ inches (29.8 x 47.6 cm)
Cat. no. 38.00519.001

Waiting.

Unidentified after James A. Wales
Puck, 04/20/1881
Lithograph, colored
8 ¼ x 8 ¾ inches (21.0 x 22.2 cm)
Cat. no. 38.00599.003

Rewards and Punishments in the United States Senate.

Unidentified
Frank Leslie's Illustrated Newspaper, 04/30/1881
Wood engraving, black and white
5 x 9 ⅜ inches (12.7 x 23.8 cm)
Cat. no. 38.00873.001

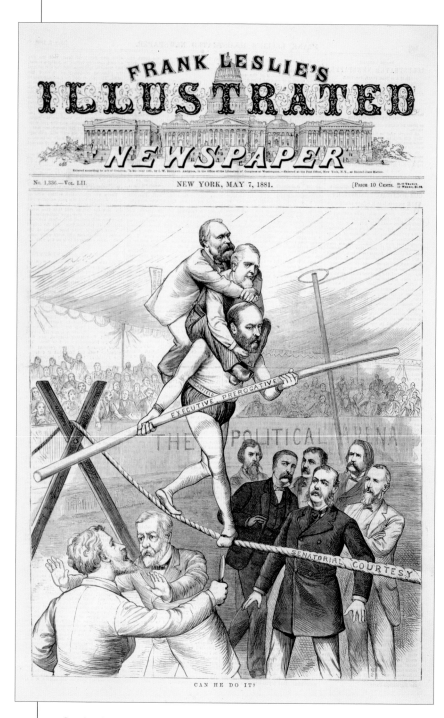

Can He Do It?

Unidentified
Frank Leslie's Illustrated Newspaper, 05/07/1881
Wood engraving, black and white
11 ⅛ x 9 ¼ inches (28.3 x 23.5 cm)
Cat. no. 38.00822.001

Is There to Be a Power behind the Throne?

Unidentified after Thomas Nast
Harper's Weekly, 05/14/1881
Wood engraving, black and white
11 x 9 ¼ inches (27.9 x 23.5 cm)
Cat. no. 38.00687.001

"This Puts Me in the Devil of a Position!"

Unidentified
Puck, 05/25/1881
Lithograph, colored
8 ¼ x 8 ½ inches (21.0 x 21.6 cm)
Cat. no. 38.00520.001

great patronage battle came to a head in 1881 when President James Garfield nominated William Robertson to become collector of the Port of New York. Senator Roscoe Conkling, Republican of New York, had depended on that patronage-rich post to maintain his political machine and saw Robertson as an opponent. As arrogant as he was handsome, Conkling resigned from the Senate on May 16 and convinced his quieter New York colleague, Republican Thomas Platt, to follow his lead. Their resignations swung the majority to the Democrats. Conkling expected the state legislature to reelect him and Platt as a rebuke to Garfield and Robertson. In fact, the legislature rebelled and elected neither man.

In this cartoon, which appeared in *Puck* on May 25, 1881, artist Joseph Keppler rejoiced in the resignation of Conkling, whom he portrayed as a balloon that has burst harmlessly, to the merriment of senators who dance below. ☙

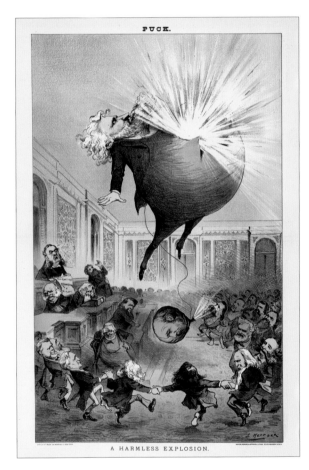

A Harmless Explosion.

Mayer, Merkel & Ottmann Lithog. after Joseph Keppler
Puck, 05/25/1881
Lithograph, colored
11 ½ x 18 ¼ inches (29.2 x 46.4 cm)
Cat. no. 38.00521.002

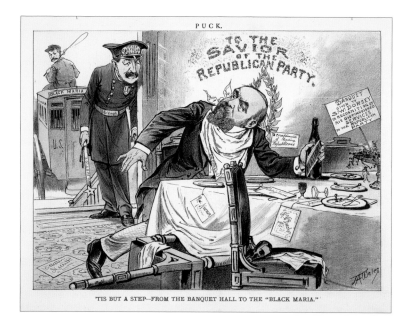

'Tis But a Step—From the Banquet Hall to the "Black Maria."

'Tis But a Step—From the Banquet Hall to the "Black Maria."

Unidentified after James A. Wales
Puck, 05/25/1881
Lithograph, colored
8 ¾ x 11 ¾ inches (22.2 x 29.8 cm)
Cat. no. 38.00522.001

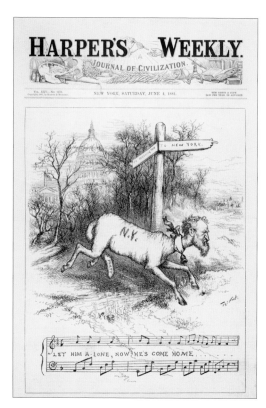

Let Him A-lone, Now He's Come Home . . .

Unidentified after Thomas Nast
Harper's Weekly, 06/04/1881
Wood engraving, black and white
11 ⁹⁄₁₆ x 9 ¼ inches (29.4 x 23.5 cm)
Cat. no. 38.00461.001

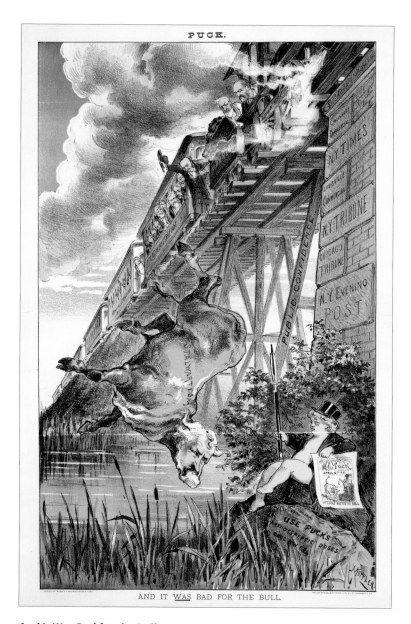

And It Was Bad for the Bull.

And It Was Bad for the Bull.

Mayer, Merkel & Ottmann Lithog. after Joseph Keppler
Puck, 06/08/1881
Lithograph, colored
18 ½ x 11 ½ inches (47.0 x 29.2 cm)
Cat. no. 38.00523.001

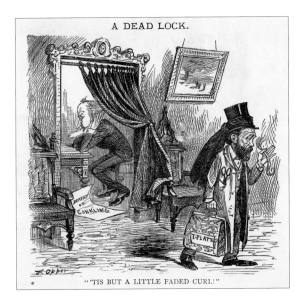

A Dead Lock. "'Tis but a Little Faded Curl!"

Unidentified after Frederick B. Opper
Puck, 06/08/1881
Wood engraving, black and white
5 ¼ x 5 inches (13.3 x 12.7 cm)
Cat. no. 38.00524.001

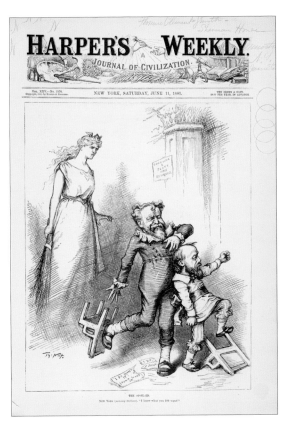

The Spoil-ed.

Unidentified after Thomas Nast
Harper's Weekly, 06/11/1881
Wood engraving, black and white
11 ⅞ x 9 ⅛ inches (30.2 x 23.2 cm)
Cat. no. 38.00683.001

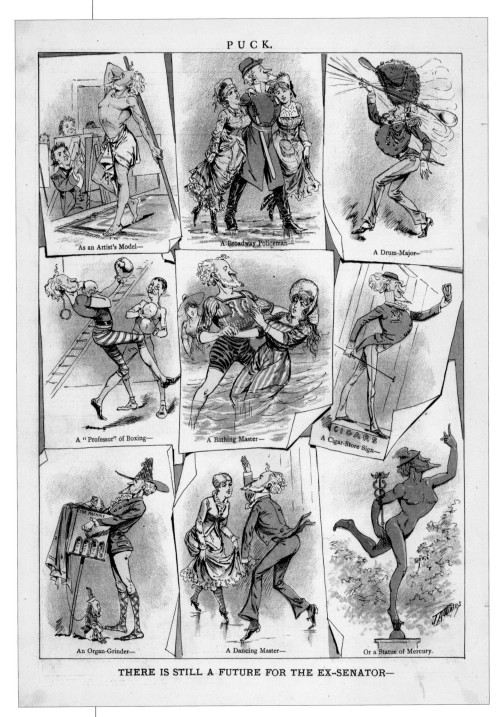

There Is Still a Future for the Ex-Senator—

Unidentified after James A. Wales
Puck, 06/15/1881
Lithograph, colored
12 ⅛ x 8 ½ inches (30.8 x 21.6 cm)
Cat. no. 38.00497.001

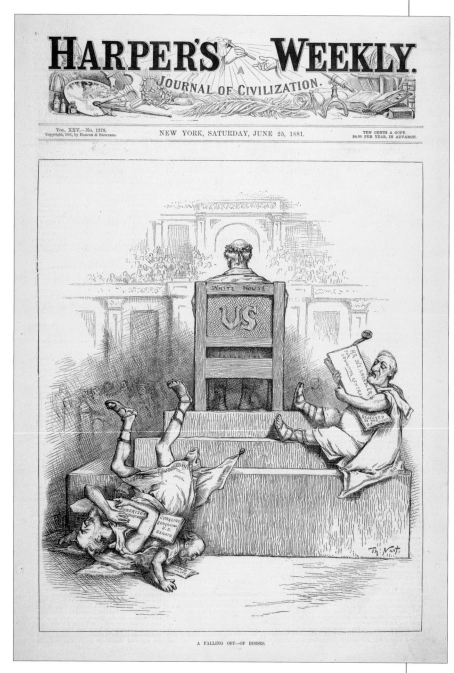

A Falling Off—Of Bosses.

Unidentified after Thomas Nast
Harper's Weekly, 06/25/1881
Wood engraving, black and white
11 ½ x 9 ⅜ inches (29.2 x 23.8 cm)
Cat. no. 38.00460.002

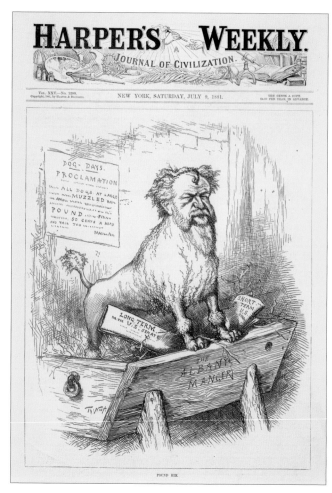

Pound Him.

Unidentified after Thomas Nast
Harper's Weekly, 07/09/1881
Wood engraving, black and white
11 ¼ x 9 ⅝ inches (28.6 x 24.4 cm)
Cat. no. 38.00548.001

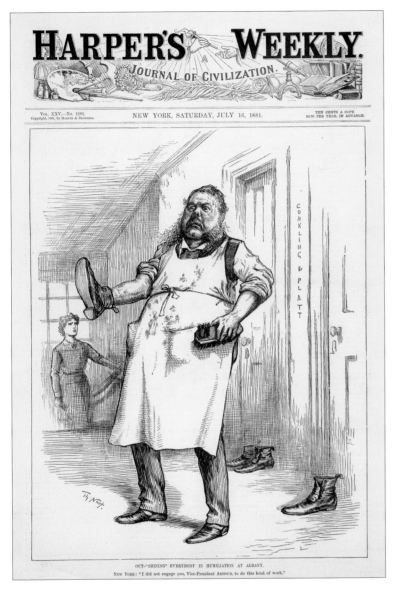

Out-"Shining" Everybody in Humiliation at Albany.

Unidentified after Thomas Nast
Harper's Weekly, 07/16/1881
Wood engraving, black and white
11 ⅞ x 9 1/16 inches (30.2 x 23.0 cm)
Cat. no. 38.00462.001

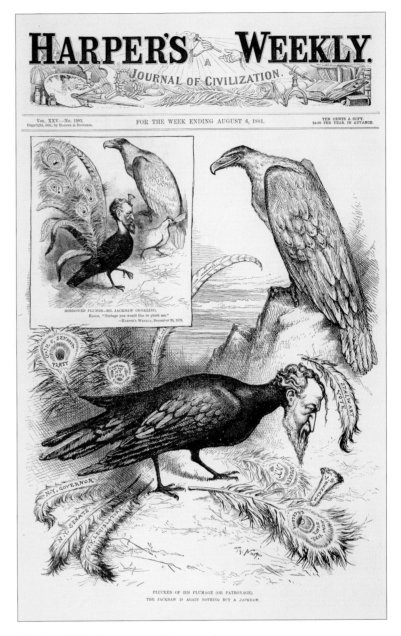

Plucked of His Plumage (or Patronage).

Unidentified after Thomas Nast
Harper's Weekly, 08/06/1881
Wood engraving, black and white
12 x 9 ¼ inches (30.5 x 23.5 cm)
Cat. no. 38.00686.001

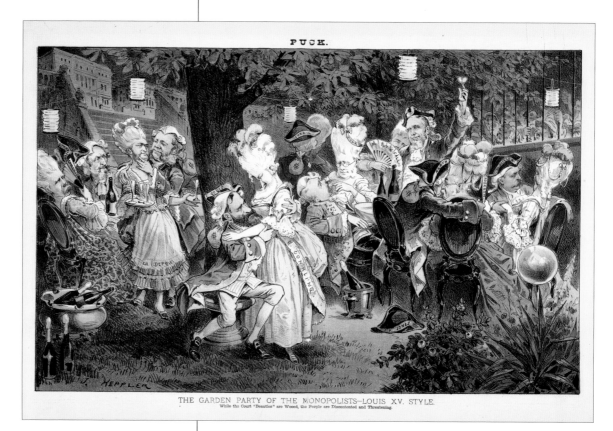

The Garden Party of the Monopolists—Louis XV. Style.

Unidentified after Joseph Keppler
Puck, 09/20/1882
Lithograph, colored
12 x 18¾ inches (30.5 x 47.6 cm)
Cat. no. 38.00633.001

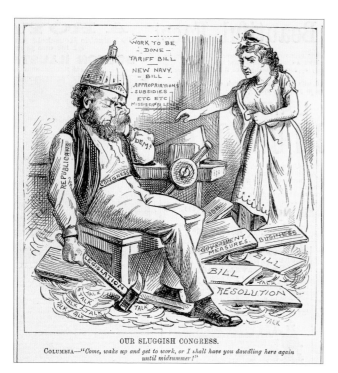

Our Sluggish Congress.

Unidentified
Frank Leslie's Illustrated Newspaper, 04/08/1882
Wood engraving, black and white
5 3⁄16 x 4 9⁄16 inches (13.2 x 11.6 cm)
Cat. no. 38.00407.001

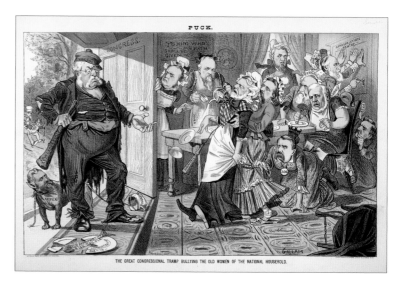

The Great Congressional Tramp Bullying the Old Women of the National Household.

Mayer, Merkel & Ottmann Lithog. after Bernhard Gillam
Puck, 07/12/1882
Lithograph, colored
11¾ x 18½ inches (29.8 x 47.0 cm)
Cat. no. 38.00903.001

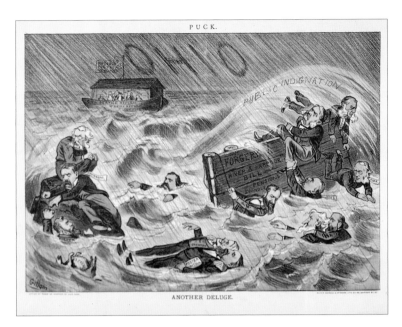

Another Deluge.

Mayer, Merkel & Ottmann Lithog. after Bernhard Gillam
Puck, 10/18/1882
Lithograph, colored
8 ⅝ x 11 ¾ inches (21.9 x 29.8 cm)
Cat. no. 38.00829.001

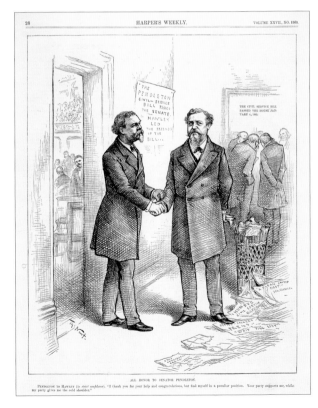

All Honor to Senator Pendleton.

Unidentified after Thomas Nast
Harper's Weekly, 01/13/1883
Wood engraving, black and white
12 x 9 ¼ inches (30.5 x 23.5 cm)
Cat. no. 38.00269.001

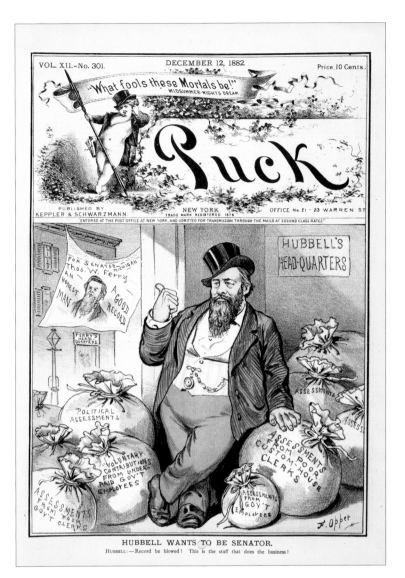

Hubbell Wants to Be Senator.

Unidentified after Frederick B. Opper
Puck, 12/12/1882
Lithograph, colored
8 x 8 ½ inches (20.3 x 21.6 cm)
Cat. no. 38.00614.001

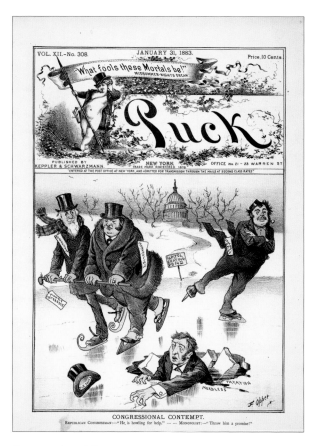

Congressional Contempt.

Unidentified after Frederick B. Opper
Puck, 01/31/1883
Lithograph, colored
8 ⅛ x 8 ⅜ inches (20.6 x 21.3 cm)
Cat. no. 38.00671.001

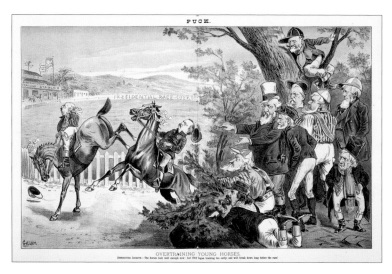

Overtraining Young Horses.

Unidentified after Bernhard Gillam
Puck, 01/31/1883
Lithograph, colored
12 x 18 ½ inches (30.5 x 47.0 cm)
Cat. no. 38.00672.001

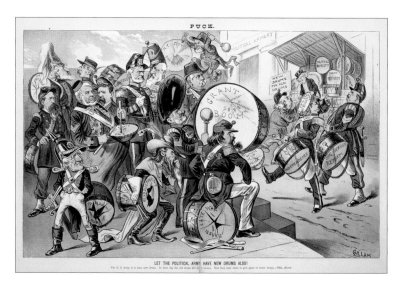

Let the Political Army Have New Drums Also!

Unidentified after Bernhard Gillam
Puck, 02/14/1883
Lithograph, colored
12 x 18 ½ inches (30.5 x 47.0 cm)
Cat. no. 38.00669.001

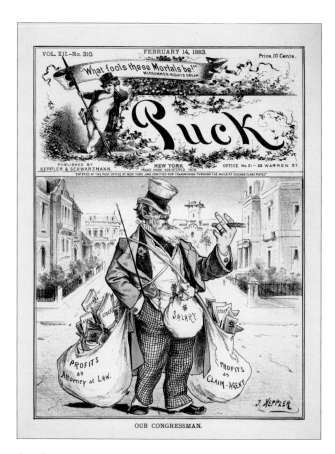

Our Congressman.

Unidentified after Joseph Keppler
Puck, 02/14/1883
Lithograph, colored
8 x 8 ¾ inches (20.3 x 22.2 cm)
Cat. no. 38.00670.001

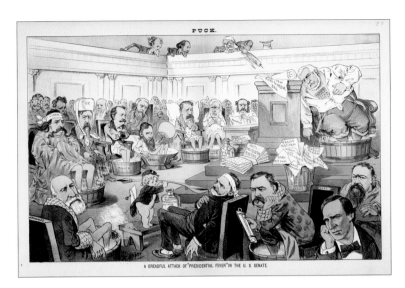

A Dreadful Attack of "Presidential Fever" in the U.S. Senate.

Unidentified after Frederick B. Opper
Puck, 02/21/1883
Lithograph, colored
12 x 18 ½ inches (30.5 x 47.0 cm)
Cat. no. 38.00607.001

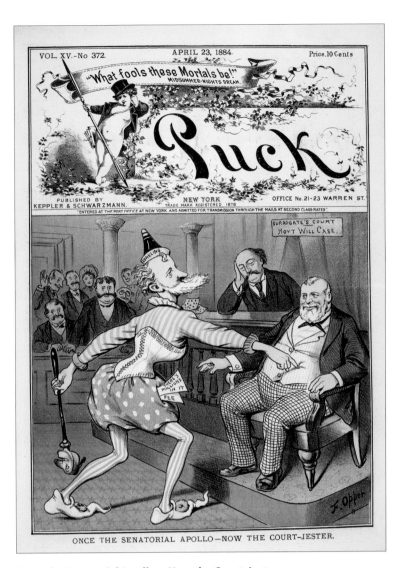

Once the Senatorial Apollo—Now the Court-Jester.

Unidentified after Frederick B. Opper
Puck, 04/23/1884
Lithograph, colored
8 x 8 ½ inches (20.3 x 21.6 cm)
Cat. no. 38.00349.001

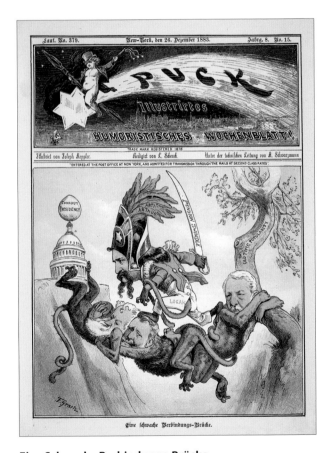

Eine Schwache Berbindungs-Brücke.

Unidentified after Friedrich Graetz
Puck, 12/26/1883
Lithograph, colored
8 x 8 ½ inches (20.3 x 21.6 cm)
Cat. no. 38.00978.001

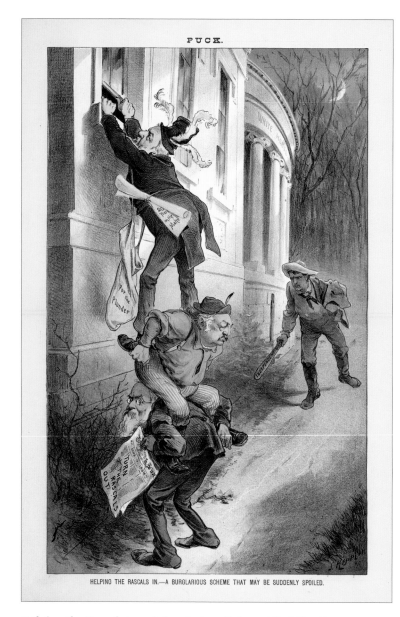

Helping the Rascals In.—A Burglarious Scheme That May Be Suddenly Spoiled.

Unidentified after Joseph Keppler
Puck, 10/22/1884
Lithograph, colored
18 ¾ x 11 ½ inches (47.6 x 29.2 cm)
Cat. no. 38.00667.001

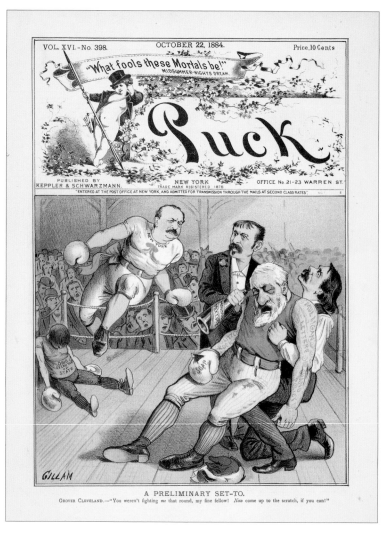

A Preliminary Set-To.

Unidentified after Bernhard Gillam
Puck, 10/22/1884
Lithograph, colored
8 ⅛ x 8 ½ inches (20.6 x 21.6 cm)
Cat. no. 38.00668.001

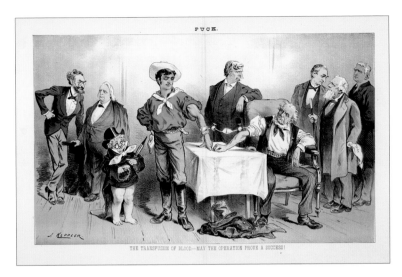

The Transfusion of Blood.—May the Operation Prove a Success!

Unidentified after Joseph Keppler
Puck, 12/03/1884
Lithograph, colored
11 ½ x 18 ¾ inches (29.2 x 47.6 cm)
Cat. no. 38.00665.001

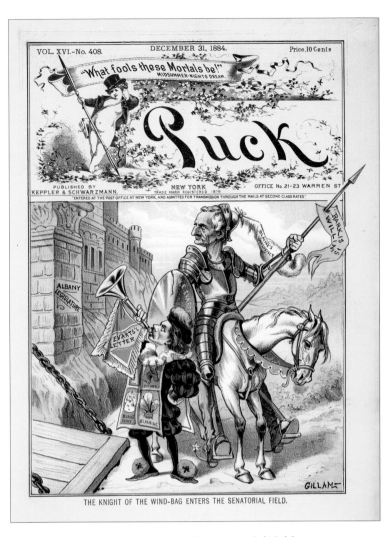

The Knight of the Wind-Bag Enters the Senatorial Field.

Unidentified after Bernhard Gillam
Puck, 12/31/1884
Lithograph, colored
7 ⅞ x 8 ½ inches (20.0 x 21.6 cm)
Cat. no. 38.00664.001

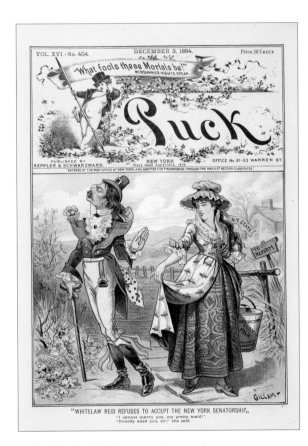

"Whitelaw Reid Refuses to Accept the New York Senatorship"

Unidentified after Bernhard Gillam
Puck, 12/03/1884
Lithograph, colored
8 ¼ x 8 ½ inches (21.0 x 21.6 cm)
Cat. no. 38.00666.001

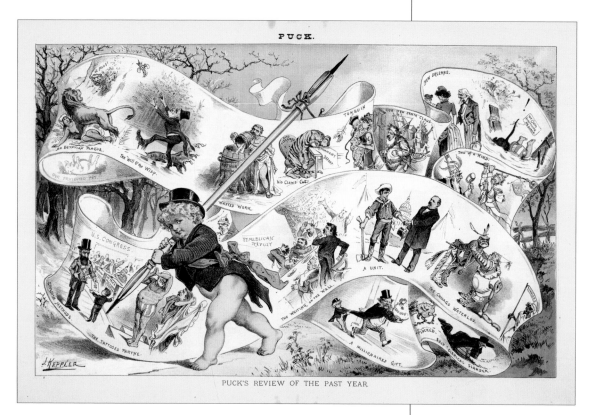

Puck's Review of the Past Year.

Unidentified after Joseph Keppler
Puck, 12/31/1884
Lithograph, colored
12 x 18 ⅝ inches (30.5 x 47.3 cm)
Cat. no. 38.00663.001

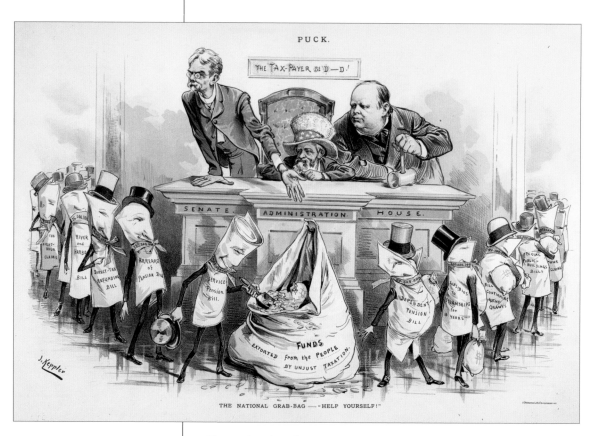

The National Grab-Bag— "Help Yourself!"

J. Ottmann Lith. Co. after Joseph Keppler
Puck, 1884
Lithograph, colored
12 ¼ x 19 inches (31.1 x 48.3 cm)
Cat. no. 38.00608.001

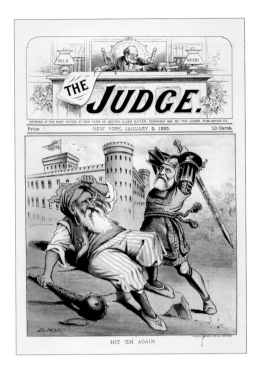

Hit 'Em Again.

Franklin Square Lith. Co. after D. Mac
The Judge, 01/09/1885
Lithograph, colored
8 ¼ x 8 ¾ inches (21.0 x 22.2 cm)
Cat. no. 38.00737.001

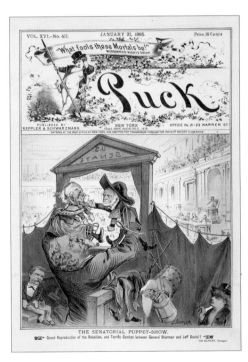

The Senatorial Puppet-Show.

Unidentified after Joseph Keppler
Puck, 01/21/1885
Lithograph, colored
8 x 8 ½ inches (20.3 x 21.6 cm)
Cat. no. 38.00594.001

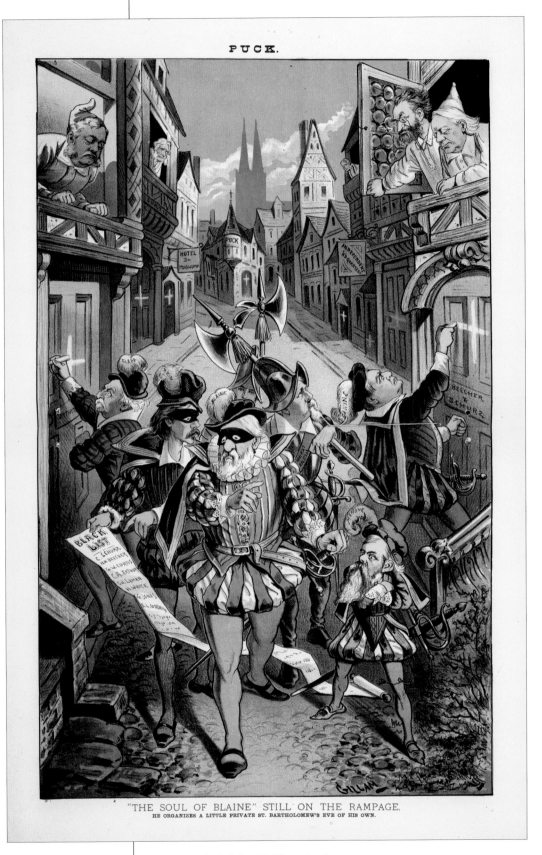

"The Soul of Blaine" Still on the Rampage.

Unidentified after Bernhard Gillam
Puck, 01/21/1885
Lithograph, colored
18 ⅞ x 11 ⅝ inches (47.9 x 29.5 cm)
Cat. no. 38.00662.001

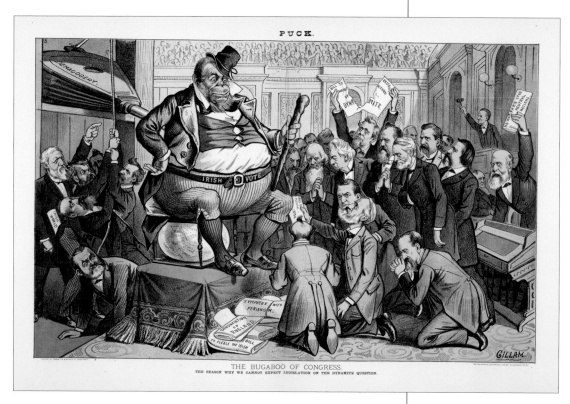

The Bugaboo of Congress.

Mayer, Merkel & Ottmann Lithog. after Bernhard Gillam
Puck, 02/04/1885
Lithograph, colored
12 x 18 ⅝ inches (30.5 x 47.3 cm)
Cat. no. 38.00660.001

From the Monument.

Unidentified after Thomas Nast
Harper's Weekly, 02/21/1885
Wood engraving, black and white
12 x 8 ¾ inches (30.5 x 22.2 cm)
Cat. no. 38.00315.001

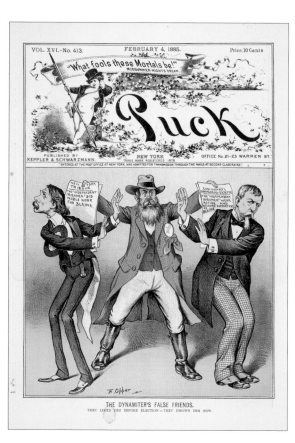

The Dynamiter's False Friends.

Unidentified after Frederick B. Opper
Puck, 02/04/1885
Lithograph, colored
8 ⅛ x 8 ½ inches (20.6 x 21.6 cm)
Cat. no. 38.00661.001

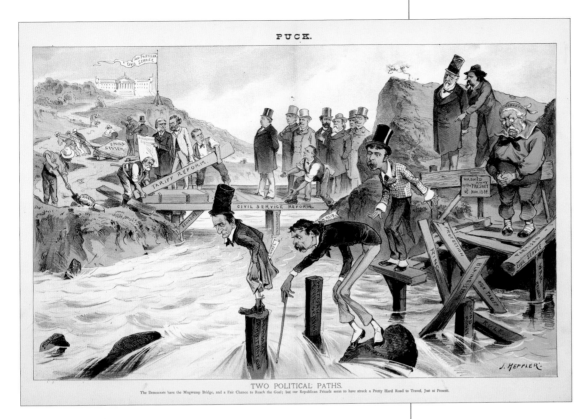

Two Political Paths.

Unidentified after Joseph Keppler
Puck, 06/10/1885
Lithograph, colored
12 x 18 ½ inches (30.5 x 47.0 cm)
Cat. no. 38.00945.001

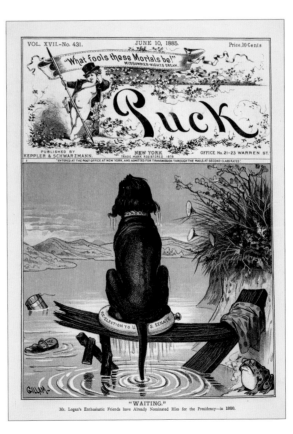

"Waiting."

Unidentified after Bernhard Gillam
Puck, 06/10/1885
Lithograph, colored
8 x 8 ½ inches (20.3 x 21.6 cm)
Cat. no. 38.00350.001

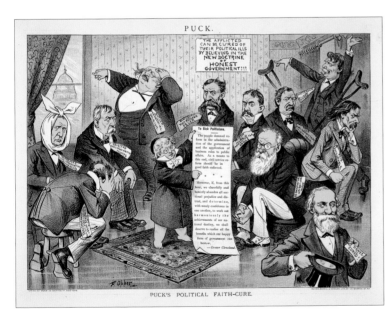

Puck's Political Faith-Cure.

Mayer, Merkel & Ottmann Lithog. after Frederick B. Opper
Puck, 05/20/1885
Lithograph, colored
8 ¾ x 12 inches (22.2 x 30.5 cm)
Cat. no. 38.00977.001

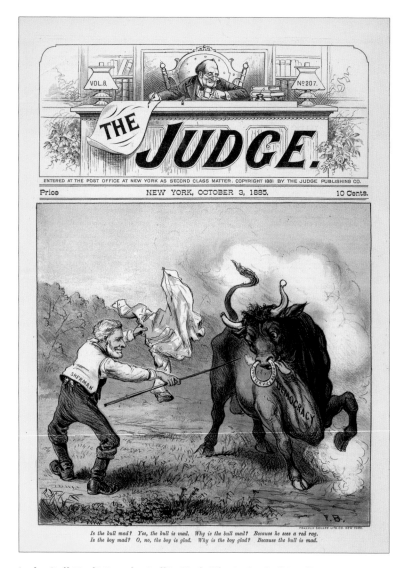

Is the Bull Mad? Yes, the Bull Is Mad. Why Is the Bull Mad? Because He Sees a Red Rag. Is the Boy Mad? Oh, No, the Boy Is Glad. Why Is the Boy Glad? Because the Bull Is Mad.

Franklin Square Lith. Co. after F. B.
The Judge, 10/03/1885
Lithograph, colored
8 ¼ x 8 ¼ inches (21.0 x 21.0 cm)
Cat. no. 38.00738.001

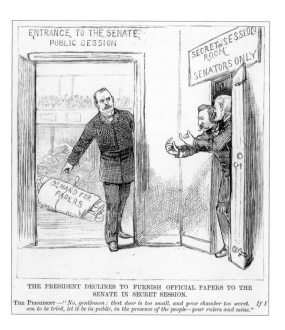

The President Declines to Furnish Official Papers to the Senate in Secret Session.

Unidentified
Frank Leslie's Illustrated Newspaper, 02/06/1886
Wood engraving, black and white
10 ⅞ x 4 ¾ inches (27.6 x 12.1 cm)
Cat. no. 38.00899.001

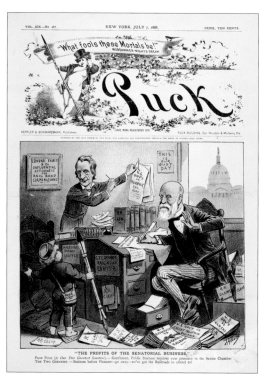

"The Profits of the Senatorial Business."

Unidentified after James A. Wales
Puck, 07/07/1886
Lithograph, colored
8 x 8 ⅜ inches (20.3 x 21.3 cm)
Cat. no. 38.00353.001

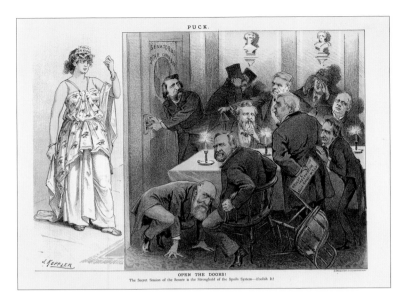

Open the Doors!

J. Ottmann Lith. Co. after Joseph Keppler
Puck, 03/03/1886
Lithograph, colored
8 ¾ x 12 inches (22.2 x 30.5 cm)
Cat. no. 38.00613.002

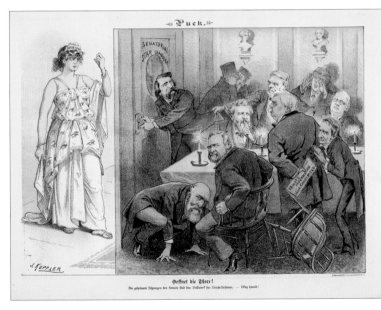

Oeffnet die Thore!

J. Ottmann Lith. Co. after Joseph Keppler
Puck, ca. 1886
Lithograph, colored
8 ¾ x 11 ⅞ inches (22.2 x 30.2 cm)
Cat. no. 38.00891.001

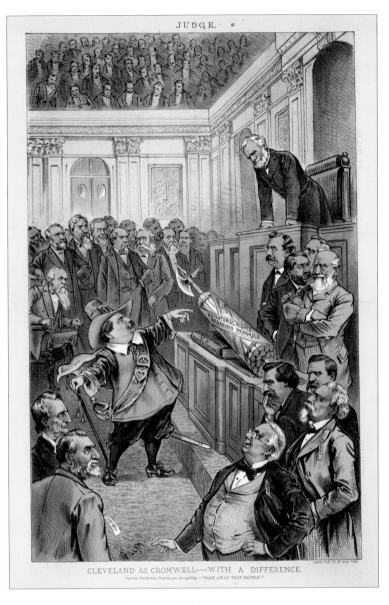

Cleveland as Cromwell—With a Difference.

Unidentified after Bernhard Gillam
Judge, 03/20/1886
Lithograph, colored
18 ½ x 11 ½ inches (47.0 x 29.2 cm)
Cat. no. 38.00906.001

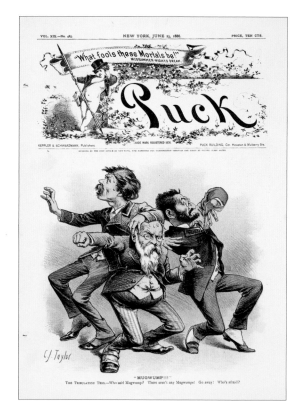

"Mugwump!!!"

Unidentified after Charles J. Taylor
Puck, 06/23/1886
Lithograph, colored
8 ¼ x 8 ½ inches (21.0 x 21.6 cm)
Cat. no. 38.00629.001

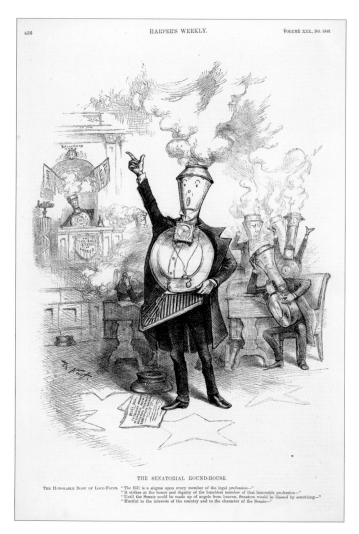

The Senatorial Round-House.

Unidentified after Thomas Nast
Harper's Weekly, 07/10/1886
Wood engraving, black and white
14 x 9 inches (35.6 x 22.9 cm)
Cat. no. 38.00094.002

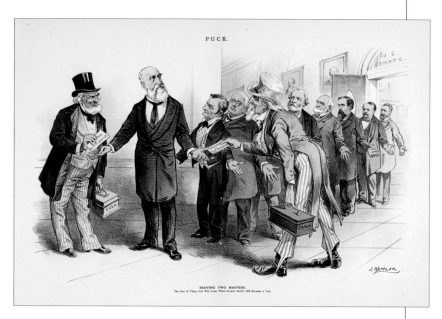

Serving Two Masters.

Unidentified after Joseph Keppler
Puck, 06/23/1886
Lithograph, colored
11 ¾ x 18 ½ inches (29.8 x 47.0 cm)
Cat. no. 38.00630.002

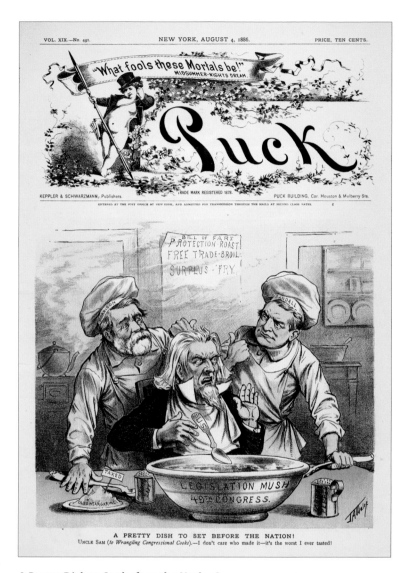

A Pretty Dish to Set before the Nation!

Unidentified after James A. Wales
Puck, 08/04/1886
Lithograph, colored
8 x 8⅜ inches (20.3 x 21.3 cm)
Cat. no. 38.00354.001

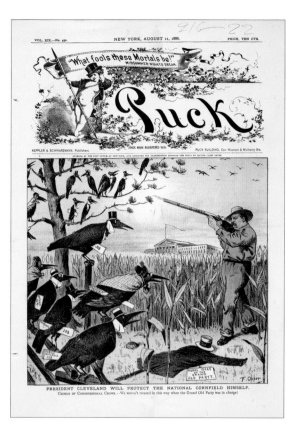

President Cleveland Will Protect the National Cornfield Himself.

Unidentified after Frederick B. Opper
Puck, 08/11/1886
Lithograph, colored
8¼ x 8½ inches (21.0 x 21.6 cm)
Cat. no. 38.00631.001

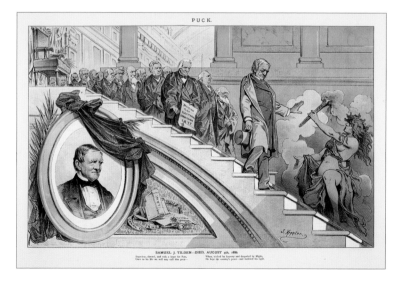

Samuel J. Tilden—Died, August 4th, 1886.

Unidentified after Joseph Keppler
Puck, 08/11/1886
Lithograph, colored
12¼ x 18½ inches (31.1 x 47.0 cm)
Cat. no. 38.00632.001

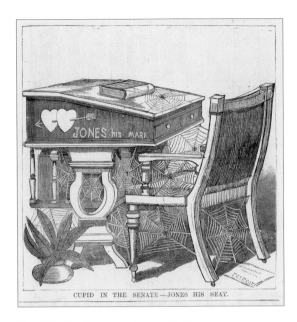

Cupid in the Senate—Jones His Seat.

Unidentified
Frank Leslie's Illustrated Newspaper, 12/11/1886
Wood engraving, black and white
4 ½ x 4 ½ inches (11.4 x 11.4 cm)
Cat. no. 38.00638.001

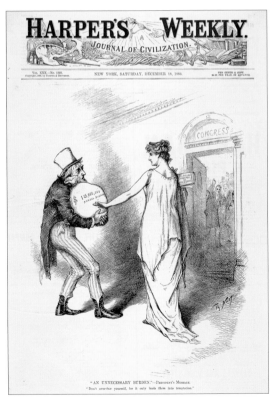

"An Unnecessary Burden."

Unidentified after Thomas Nast
Harper's Weekly, 12/18/1886
Wood engraving, black and white
16 ⅜ x 11 ¾ inches (41.6 x 29.8 cm)
Cat. no. 38.00120.001

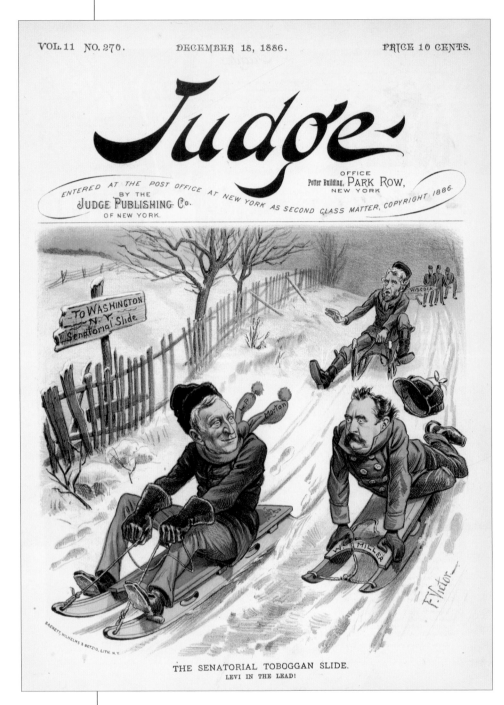

The Senatorial Toboggan Slide.

Sackett, Wilhelms & Betzig Lith. after F. Victor Gillam
Judge, 12/18/1886
Lithograph, colored
8 ⅞ x 8 ¾ inches (22.5 x 22.2 cm)
Cat. no. 38.00890.001

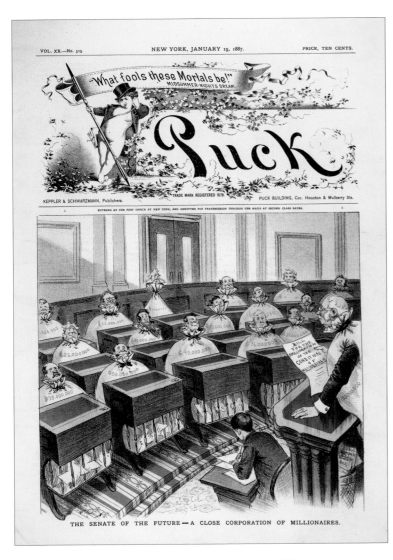

The Senate of the Future—A Close Corporation of Millionaires.

Unidentified after Frederick B. Opper
Puck, 01/19/1887
Lithograph, colored
8 x 8 ⅜ inches (20.3 x 21.3 cm)
Cat. no. 38.00322.002

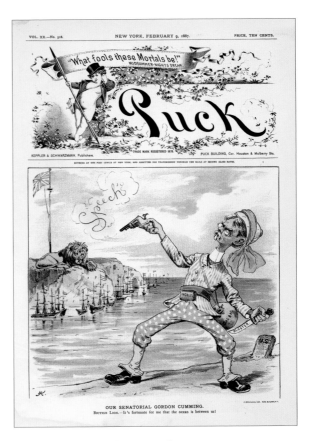

Our Senatorial Gordon Cumming.

J. Ottmann Lith. Co. after Joseph Keppler
Puck, 02/09/1887
Lithograph, colored
8 x 8 ⅜ inches (20.3 x 21.3 cm)
Cat. no. 38.00849.001

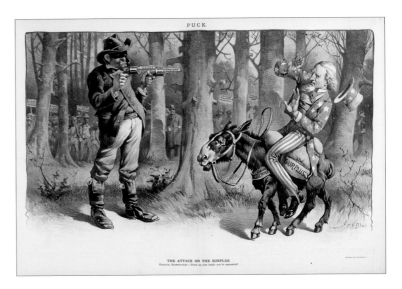

The Attack on the Surplus.

J. Ottmann Lith. Co. after E. N. Blue
Puck, 02/23/1887
Lithograph, colored
12 ¼ x 18 ½ inches (31.1 x 47.0 cm)
Cat. no. 38.00635.002

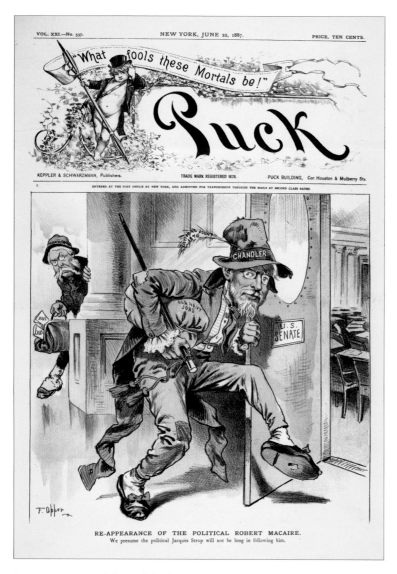

Re-Appearance of the Political Robert Macaire.

Unidentified after Frederick B. Opper
Puck, 06/22/1887
Lithograph, colored
8 ½ x 8 ⅜ inches (21.6 x 21.3 cm)
Cat. no. 38.00348.001

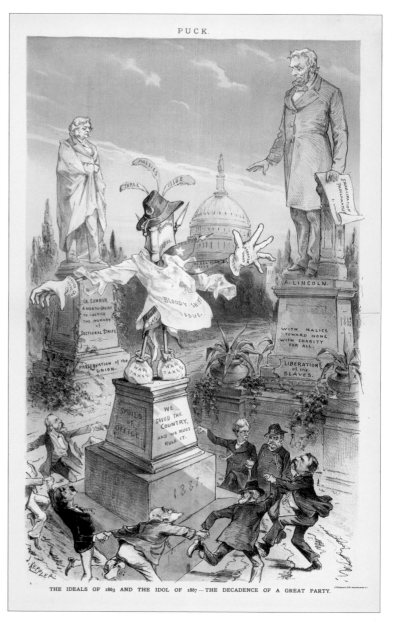

**The Ideals of 1863 and the Idol of 1887—
The Decadence of a Great Party.**

J. Ottmann Lith. Co. after Joseph Keppler
Puck, 10/19/1887
Lithograph, colored
18 ¾ x 11 ½ inches (47.6 x 29.2 cm)
Cat. no. 38.00654.001

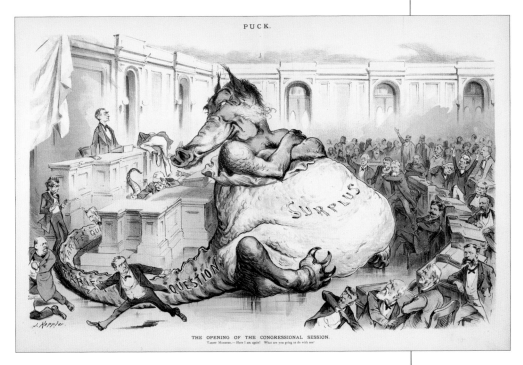

The Opening of the Congressional Session.

Unidentified after Joseph Keppler
Puck, 12/07/1887
Lithograph, colored
12 x 18 ½ inches (30.5 x 47.0 cm)
Cat. no. 38.00574.001

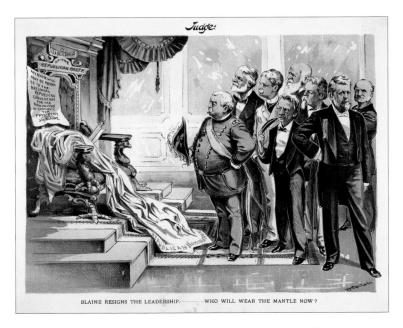

Blaine Resigns the Leadership.—Who Will Wear the Mantle Now?

Unidentified after Grant E. Hamilton
Judge, 02/25/1888
Lithograph, colored
9 ⅛ x 13 ½ inches (23.2 x 34.3 cm)
Cat. no. 38.00296.00

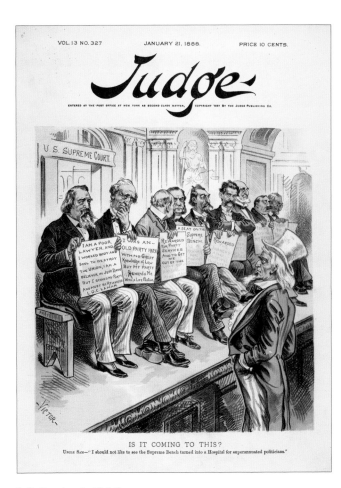

Is it Coming to This?

Unidentified after F. Victor Gillam
Judge, 01/21/1888
Lithograph, colored
9 ½ x 8 ¼ inches (24.1 x 21.0 cm)
Cat. no. 38.00342.001

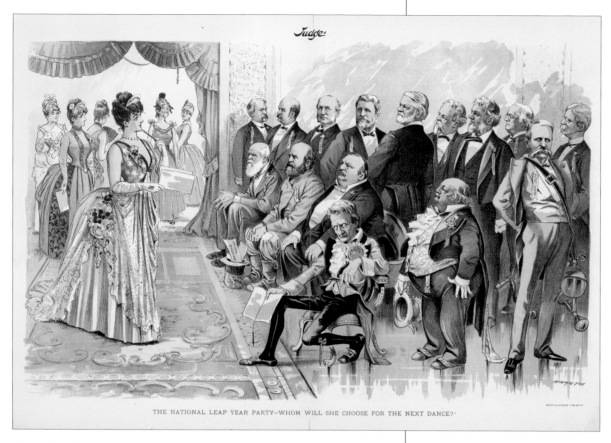

The National Leap Year Party—Whom Will She Choose for the Next Dance?

Sackett & Wilhelms Litho, Co. after Grant E. Hamilton
Judge, 03/03/1888
Lithograph, colored
12 ½ x 18 ½ inches (31.8 x 47.0 cm)
Cat. no. 38.00301.001

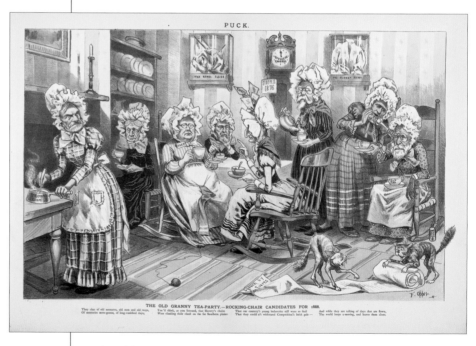

The Old Granny Tea-Party.—Rocking-Chair Candidates for 1888.

Unidentified after Frederick B. Opper
Puck, 03/14/1888
Lithograph, colored
12 ¼ x 19 ⅛ inches (31.1 x 48.6 cm)
Cat. no. 38.00578.001

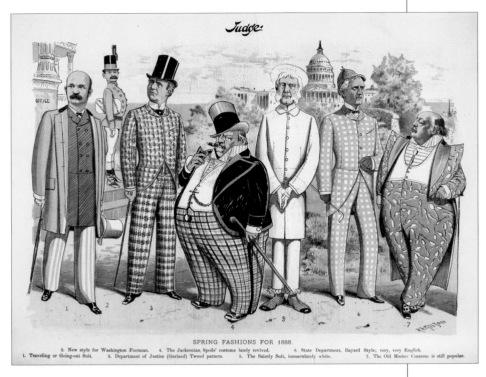

Spring Fashions for 1888.

Unidentified after Grant E. Hamilton
Judge, 04/21/1888
Lithograph, colored
8 ½ x 12 ⅝ inches (21.6 x 32.1 cm)
Cat. no. 38.00343.001

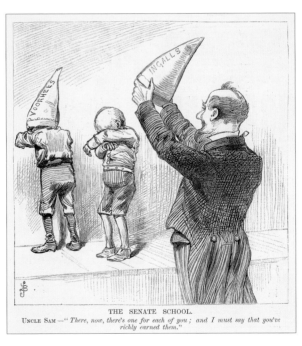

The Senate School.

Unidentified after J. B.
Frank Leslie's Illustrated Newspaper, 05/12/1888
Wood engraving, black and white
5 ⅛ x 4 ¾ inches (13.0 x 12.1 cm)
Cat. no. 38.00611.001

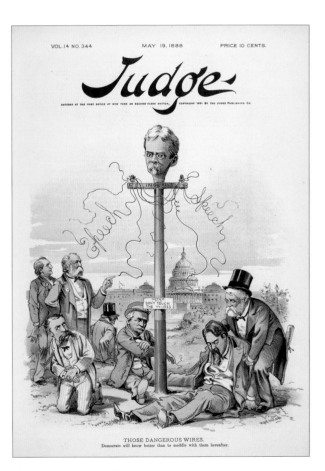

Those Dangerous Wires.

Unidentified after Grant E. Hamilton
Judge, 05/19/1888
Lithograph, colored
10 x 9 inches (25.4 x 22.9 cm)
Cat. no. 38.00297.001

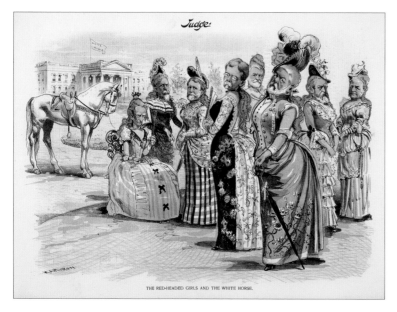

The Red-Headed Girls and the White Horse.

Unidentified after Grant E. Hamilton
Judge, 05/26/1888
Lithograph, colored
9 ⅛ x 12 ¼ inches (23.2 x 31.1 cm)
Cat. no. 38.00298.001

"The Lobbyist."

Unidentified after Paul Renouard
Harper's Weekly, 08/04/1888
Lithograph, hand-colored
11 ½ x 9 ¼ inches (29.2 x 23.5 cm)
Cat. no. 38.00726.001

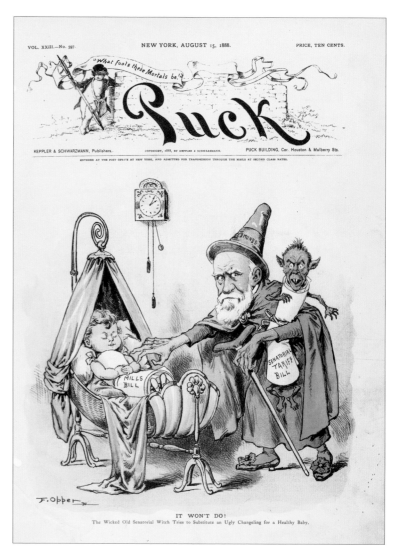

It Won't Do!

Unidentified after Frederick B. Opper
Puck, 08/15/1888
Lithograph, colored
9 ¼ x 8 ¾ inches (23.5 x 22.2 cm)
Cat. no. 38.00593.001

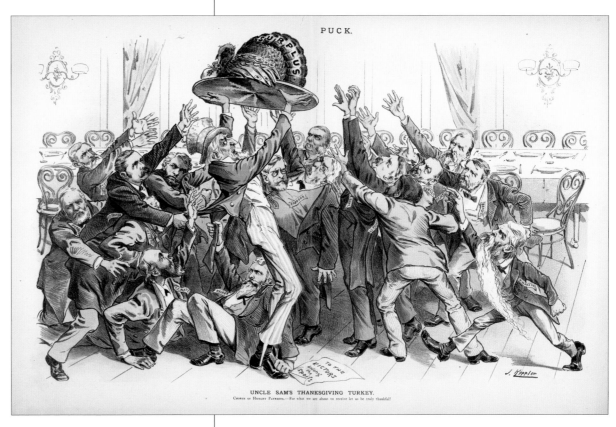

Uncle Sam's Thanksgiving Turkey.

Unidentified after Joseph Keppler
Puck, 11/28/1888
Lithograph, colored
12 x 18¾ inches (30.5 x 47.6 cm)
Cat. no. 38.00580.001

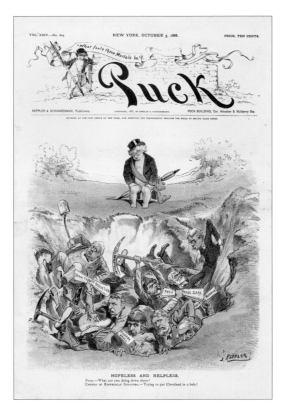

Hopeless and Helpless.

Unidentified after Joseph Keppler
Puck, 10/03/1888
Lithograph, colored
9¼ x 8½ inches (23.5 x 21.6 cm)
Cat. no. 38.00884.001

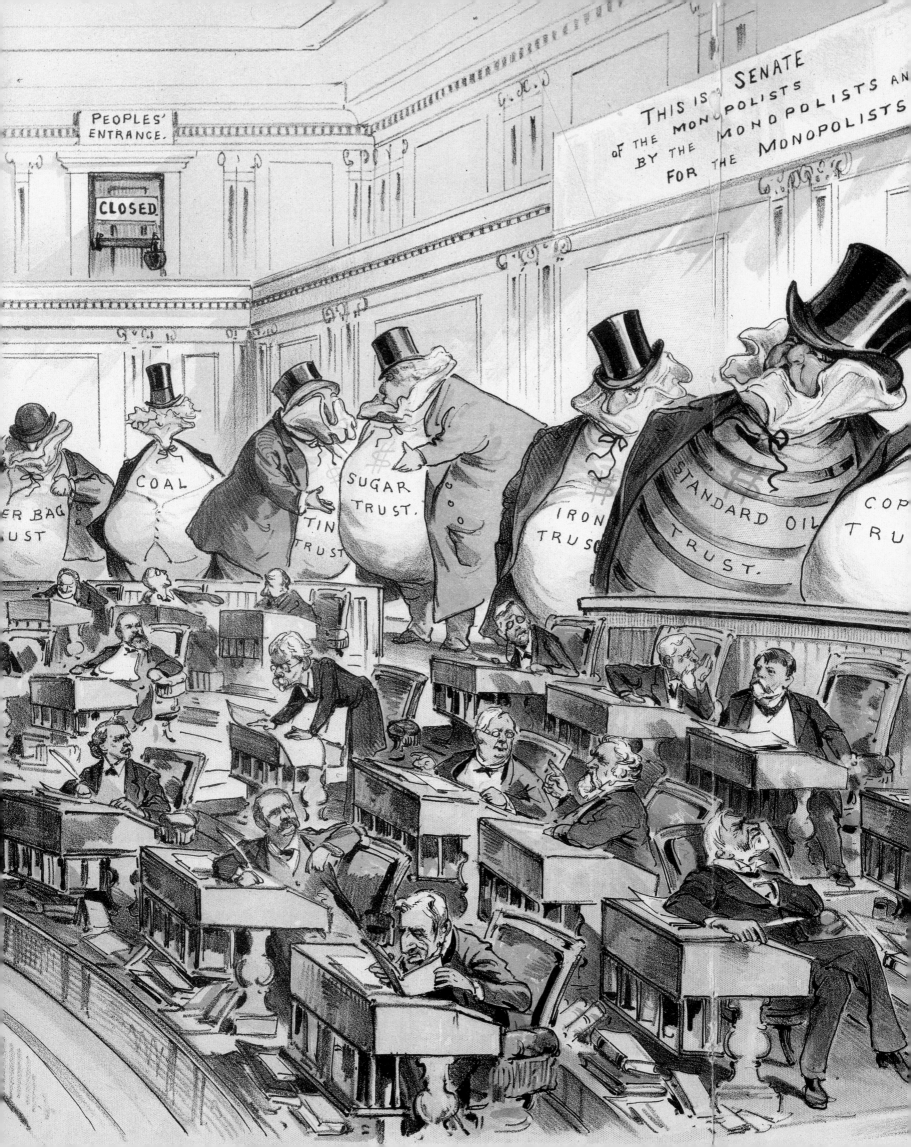

This frequently reproduced cartoon, long a staple of textbooks and studies of Congress, depicts corporate interests—from steel, copper, oil, iron, sugar, tin, and coal to paper bags, envelopes, and salt—as giant money bags looming over the tiny senators at their desks in the Chamber. Joseph Keppler drew the cartoon, which appeared in *Puck* on January 23, 1889, showing a door to the gallery, the "people's entrance," bolted and barred. The galleries stand empty while the special interests have floor privileges, operating below the motto: "This is the Senate of the Monopolists by the Monopolists and for the Monopolists!"

Keppler's cartoon reflected the phenomenal growth of American industry in the 1880s, but also the disturbing trend toward concentration of industry to the point of monopoly, and its undue influence on politics. This popular perception contributed to Congress's passage of the Sherman Anti-Trust Act in 1890. ☙

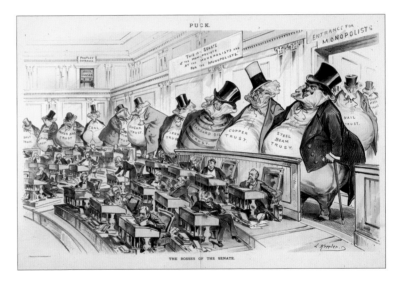

The Bosses of the Senate.

J. Ottmann Lith. Co. after Joseph Keppler
Puck, 01/23/1889
Lithograph, colored
12 x 18 ½ inches (30.5 x 47.0 cm)
Cat. no. 38.00392.001

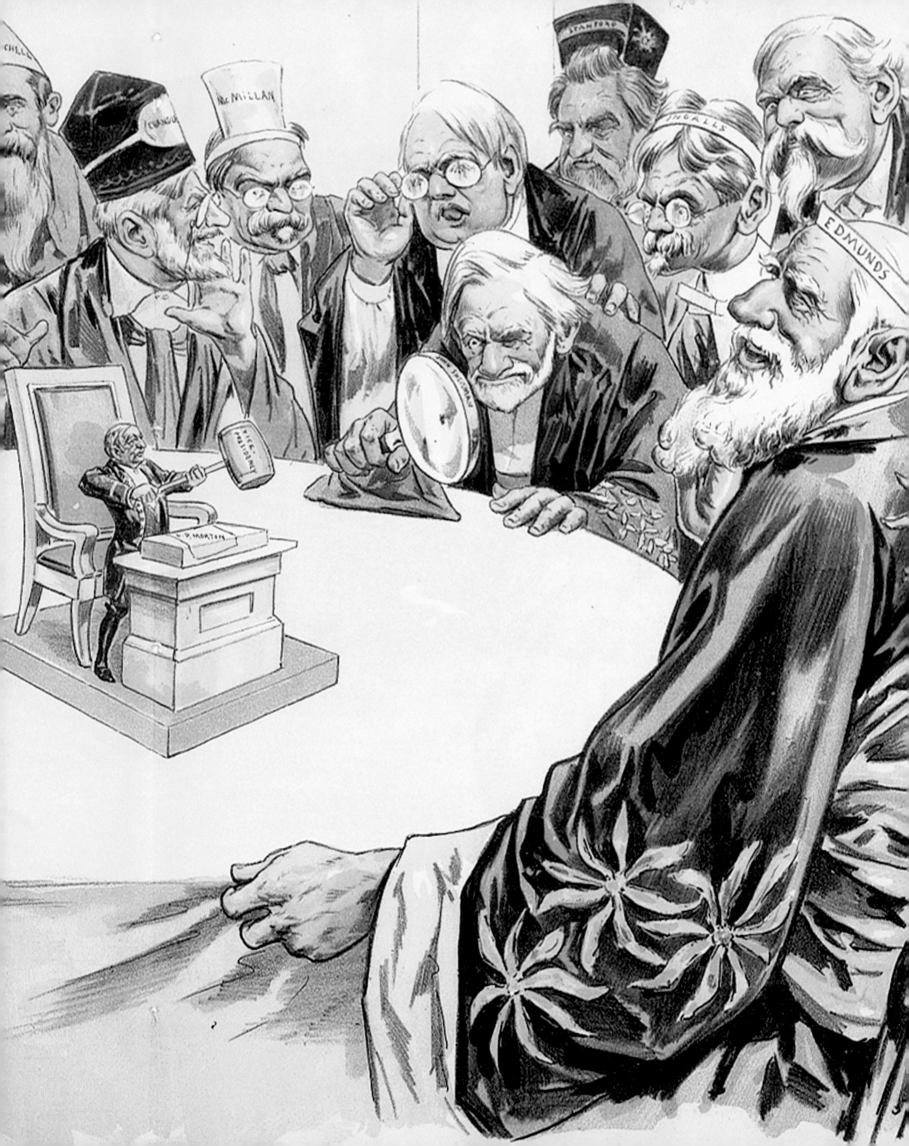

Nineteenth-century cartoonists felt sure that audiences would easily grasp references to Jonathan Swift's popular satire, *Gulliver's Travels*, published a century earlier. In this cartoon, which appeared in both the German and English-language versions of *Puck* in 1889, Charles J. Taylor plays on Gulliver's experiences with the Brobdingnagians, giants who treated him like a toy. Taylor's Gulliver is Levi Parsons Morton, one of America's leading bankers, who had just been elected vice president on the Republican ticket headed by Benjamin Harrison.

As vice president, Morton had the responsibility of presiding over the Senate, but the senatorial giants considered him a political novice and looked down on his clumsy attempts to wield the gavel on their debates. As the cartoonist anticipated, neither President Harrison nor the Republican senators thought much of Morton's abilities, and they unceremoniously dumped him from the party's ticket in the next election. ⁂

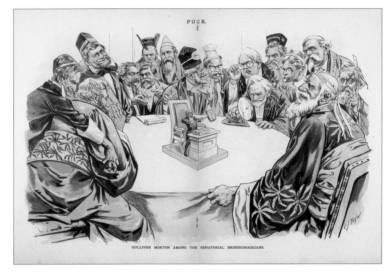

Gulliver Morton among the Senatorial Brobdignaggians [sic].

Unidentified after Charles J. Taylor
Puck, 03/27/1889
Lithograph, colored
12 ¼ x 19 inches (31.1 x 48.3 cm)
Cat. no. 38.00386.001

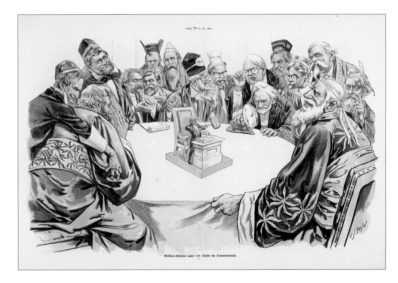

Gulliver Morton unter den Riefen im Senatorenland.

Unidentified after Charles J. Taylor
Puck, ca. 1889
Lithograph, colored
12 x 18 ¾ inches (30.5 x 47.6 cm)
Cat. no. 38.00605.001

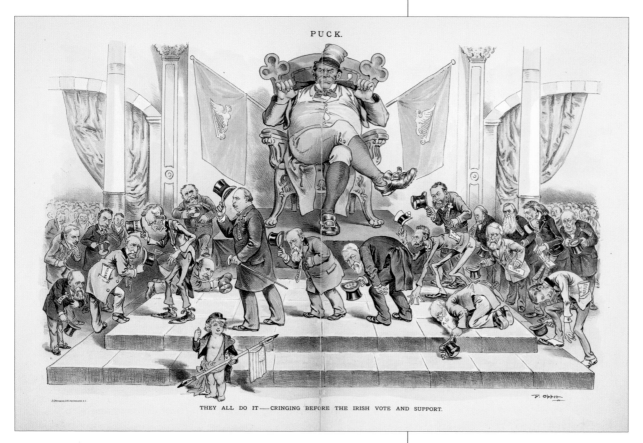

They All Do It—Cringing before the Irish Vote and Support.

J. Ottmann Lith. Co. after Frederick B. Opper
Puck, 04/03/1889
Lithograph, colored
11 ⅞ x 18 ½ inches (30.2 x 47.0 cm)
Cat. no. 38.00581.001

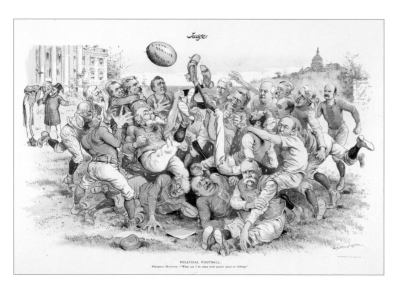

Political Football.

Sackett & Wilhelms Litho, Co. after Grant E. Hamilton
Judge, 10/26/1889
Lithograph, colored
11 ¾ x 18 ¾ inches (29.8 x 47.6 cm)
Cat. no. 38.00318.001

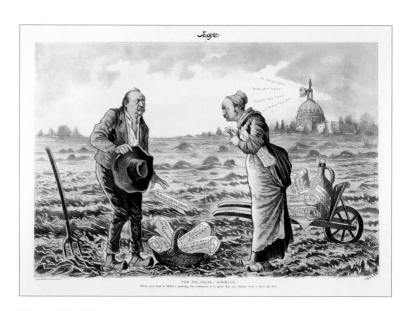

The Political "Angelus."

Sackett & Wilhelms Litho, Co. after Bernhard Gillam
Judge, 01/18/1890
Lithograph, colored
11 ½ x 16 ½ inches (29.2 x 41.9 cm)
Cat. no. 38.00362.001

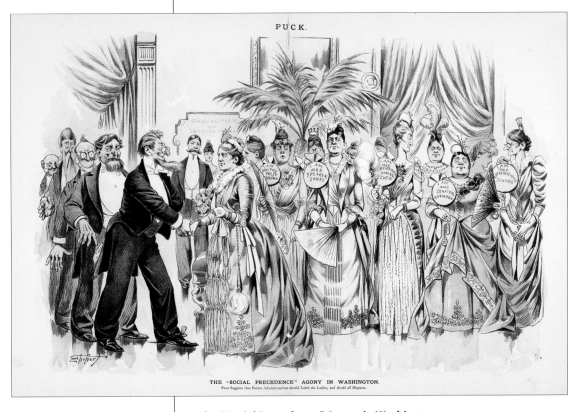

The "Social Precedence" Agony in Washington.

Unidentified after Samuel D. Ehrhart
Puck, 01/22/1890
Lithograph, colored
12 ¼ x 18 ¼ inches (31.1 x 46.4 cm)
Cat. no. 38.00603.001

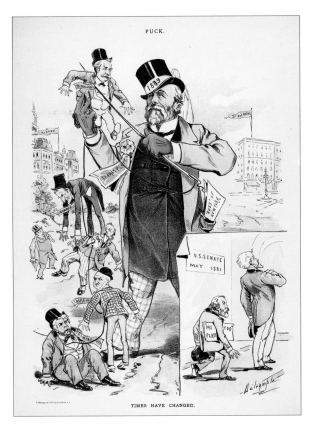

Times Have Changed.

J. Ottmann Lith. Co. after Louis Dalrymple
Puck, 10/23/1889
Lithograph, colored
12 ¼ x 8 ¼ inches (31.1 x 21.0 cm)
Cat. no. 38.00355.001

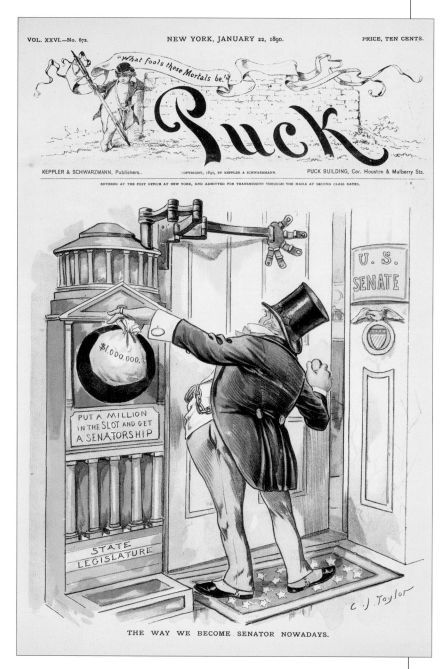

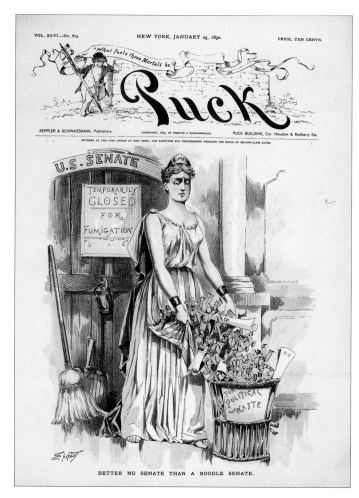

Better No Senate Than a Boodle Senate.

Unidentified after Samuel D. Ehrhart
Puck, 01/29/1890
Lithograph, colored
9 ⅜ x 8 ⅛ inches (23.8 x 20.6 cm)
Cat. no. 38.00323.002

The Way We Become Senator Nowadays.

Unidentified after Charles J. Taylor
Puck, 01/22/1890
Lithograph, colored
9 ¼ x 8 ½ inches (23.5 x 21.6 cm)
Cat. no. 38.00598.002

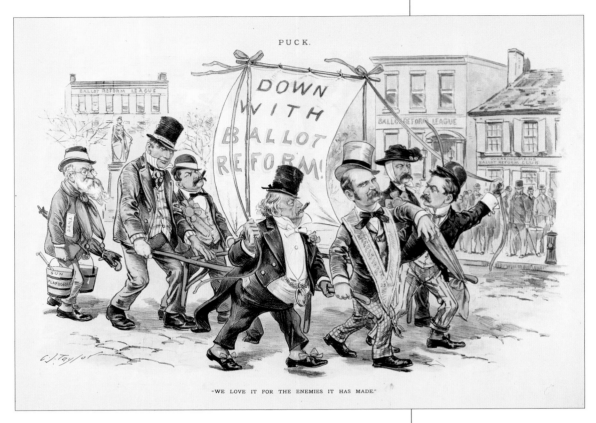

"We Love It for the Enemies It Has Made."

Unidentified after Charles J. Taylor
Puck, 01/29/1890
Lithograph, colored
11 ¾ x 18 ¾ inches (29.8 x 47.6 cm)
Cat. no. 38.00328.001

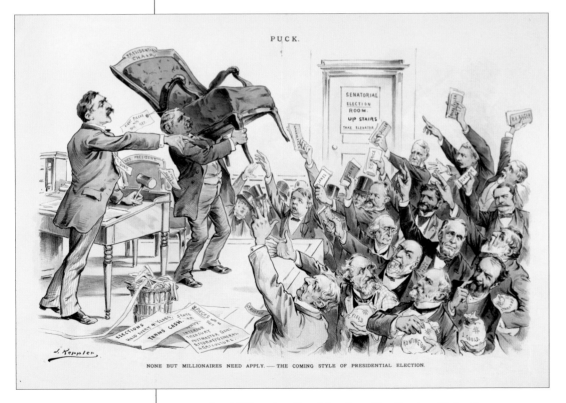

None but Millionaires Need Apply. —The Coming Style of Presidential Election.

Unidentified after Joseph Keppler
Puck, 03/12/1890
Lithograph, colored
13 x 20 inches (33.0 x 50.8 cm)
Cat. no. 38.00320.001

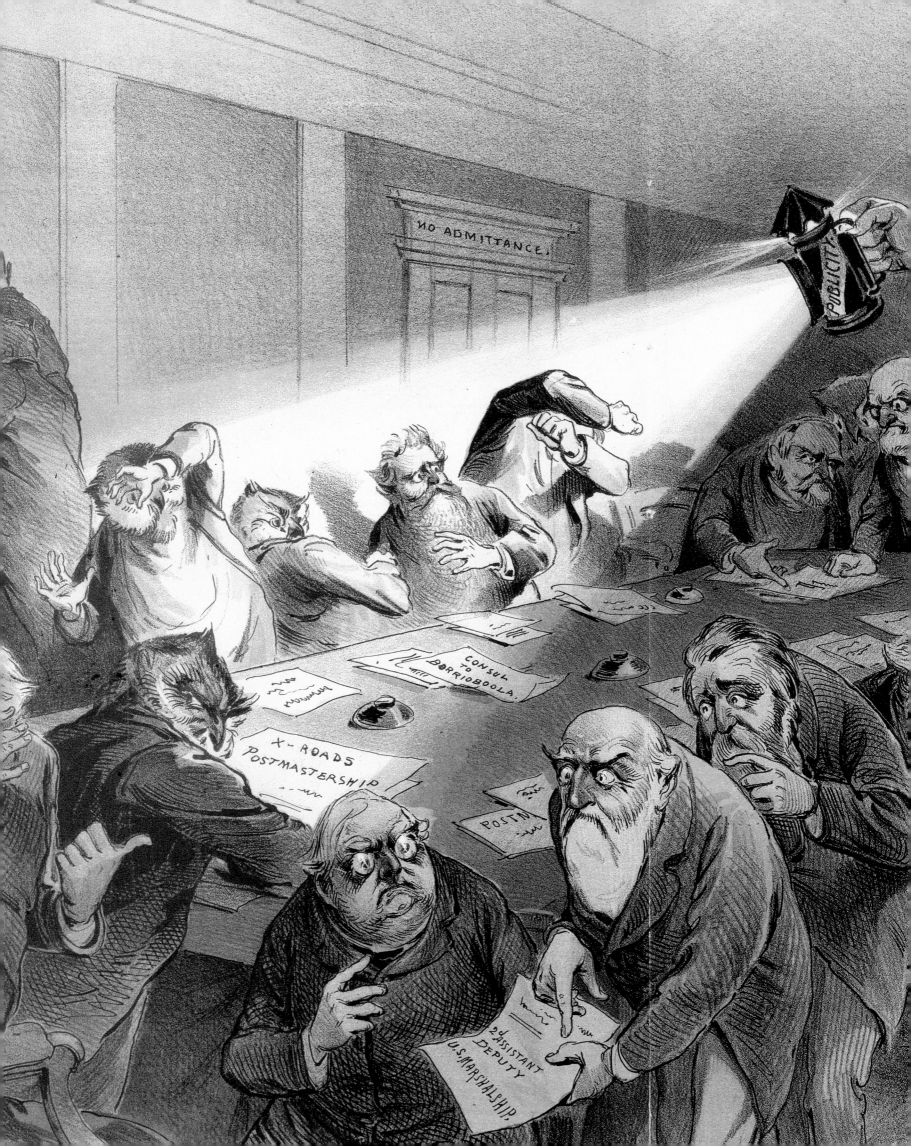

The U.S. Senate once debated all treaties and nominations behind closed doors in executive sessions. Committees also did much of their work away from public view, excluding both the public and the press. Nineteenth-century newspapers campaigned vigorously against senatorial secrecy.

"They Hate the Light, but They Can't Escape It" appeared in *Puck* on March 26, 1890. Cartoonist Joseph Keppler portrayed the press shining the light of publicity on senatorial owls, conducting public business in the dark. "No Admittance" signs appear on the doors, and senators huddle and whisper in a conspiratorial manner. Although Keppler credited the press with lighting the way, in reality reporters got access to secret information from cooperative senators who leaked it to them. After repeated embarrassment over such unauthorized releases, the Senate abandoned secret sessions almost entirely in 1929. Subsequent "sunshine legislation" allowed public access to most committee meetings as well. ◑

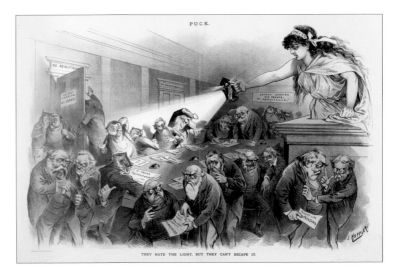

They Hate the Light, but They Can't Escape It.

J. Ottmann Lith. Co. after Joseph Keppler
Puck, 03/26/1890
Lithograph, colored
11 ¼ x 19 inches (29.8 x 48.3 cm)
Cat. no. 38.00321.002

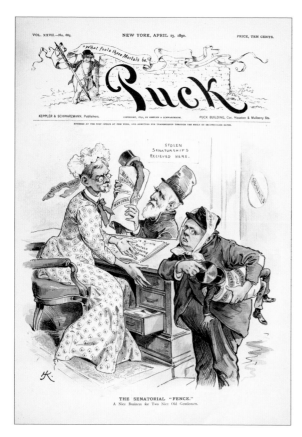

The Senatorial "Fence."

Unidentified after Joseph Keppler
Puck, 04/23/1890
Lithograph, colored
10 ¾ x 9 inches (27.3 x 22.9 cm)
Cat. no. 38.00551.001

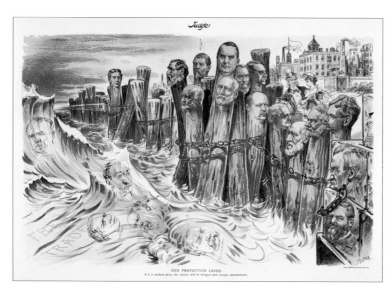

Our Protection Levee.

Sackett & Wilhelms Litho, Co. after F. Victor Gillam
Judge, 04/26/1890
Lithograph, colored
11 ½ x 17 ¼ inches (29.2 x 43.8 cm)
Cat. no. 38.00980.001

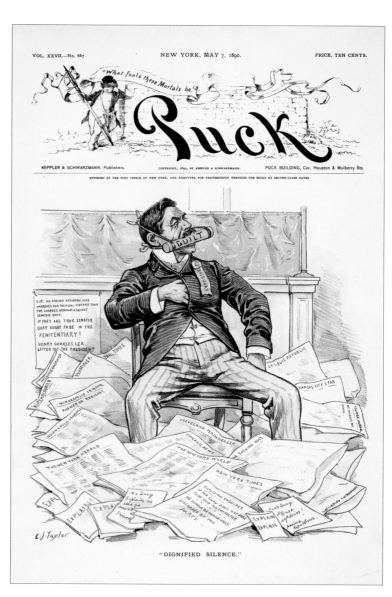

"Dignified Silence."

Unidentified after Charles J. Taylor
Puck, 05/07/1890
Lithograph, colored
9 ¼ x 8 ½ inches (23.5 x 21.6 cm)
Cat. no. 38.00743.001

Robin Hood with a Difference.

J. Ottmann Lith. Co. after Charles J. Taylor
Puck, 06/04/1890
Lithograph, colored
11 ¼ x 19 inches (29.8 x 48.3 cm)
Cat. no. 38.00750.001

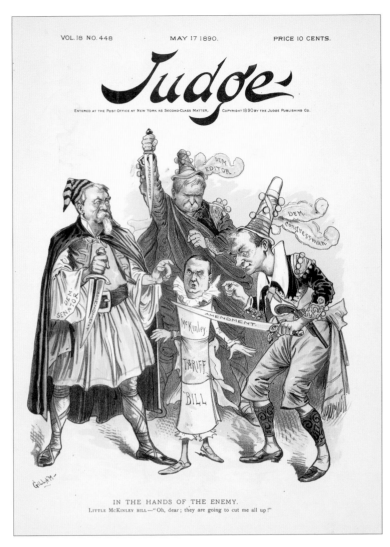

In the Hands of the Enemy.

Unidentified after Bernhard Gillam
Judge, 05/17/1890
Lithograph, colored
9 ⅝ x 8 ½ inches (24.4 x 21.6 cm)
Cat. no. 38.00889.001

Dangerous Doctors for a Desperate Case.

Unidentified after Joseph Keppler
Puck, 06/11/1890
Lithograph, colored
11 ⅝ x 17 ⁵⁄₁₆ inches (29.5 x 44.0 cm)
Cat. no. 38.00570.001

The Hopeless Appeal of New York Interests to Incompetence and Inefficiency.

Unidentified after Louis Dalrymple
Puck, 06/25/1890
Lithograph, colored
9 x 10 inches (22.9 x 25.4 cm)
Cat. no. 38.00745.001

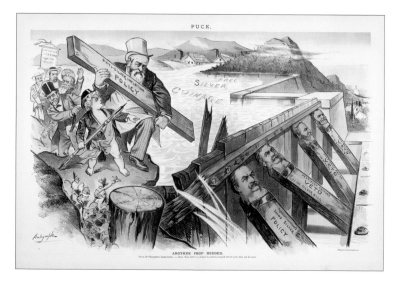

Another Prop Needed.

J. Ottmann Lith. Co. after Louis Dalrymple
Puck, 07/09/1890
Lithograph, colored
11 ⅞ x 18 ½ inches (30.2 x 47.0 cm)
Cat. no. 38.00576.001

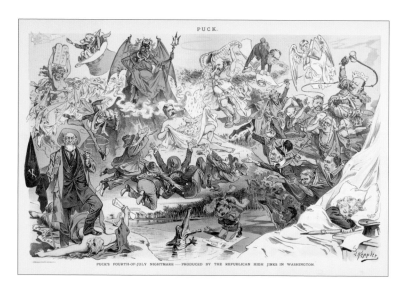

Puck's Fourth-of-July Nightmare—Produced by the Republican High Jinks in Washington.

J. Ottmann Lith. Co. after Joseph Keppler
Puck, 07/02/1890
Lithograph, colored
12 ⅛ x 19 inches (30.8 x 48.3 cm)
Cat. no. 38.00749.001

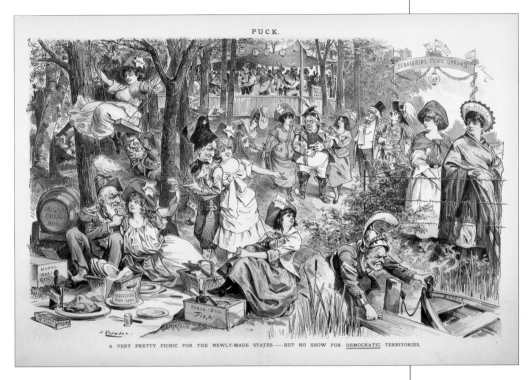

**A Very Pretty Picnic for the Newly-Made States—
But No Show for Democratic Territories.**

Unidentified after Joseph Keppler
Puck, 07/23/1890
Lithograph, colored
12 ⅞ x 18 ¾ inches (32.7 x 47.6 cm)
Cat. no. 38.00575.001

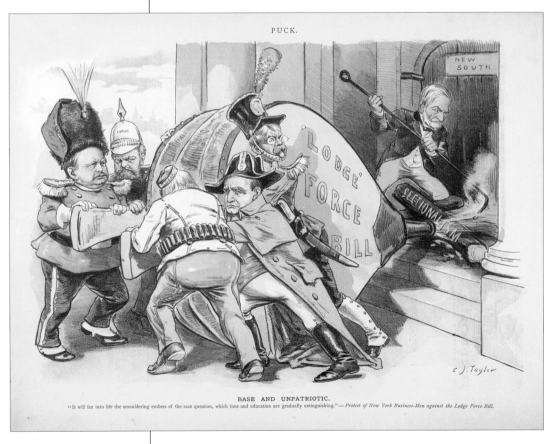

Base and Unpatriotic.

Unidentified after Charles J. Taylor
Puck, 08/20/1890
Lithograph, colored
9 x 12 ¼ inches (22.9 x 31.1 cm)
Cat. no. 38.00746.001

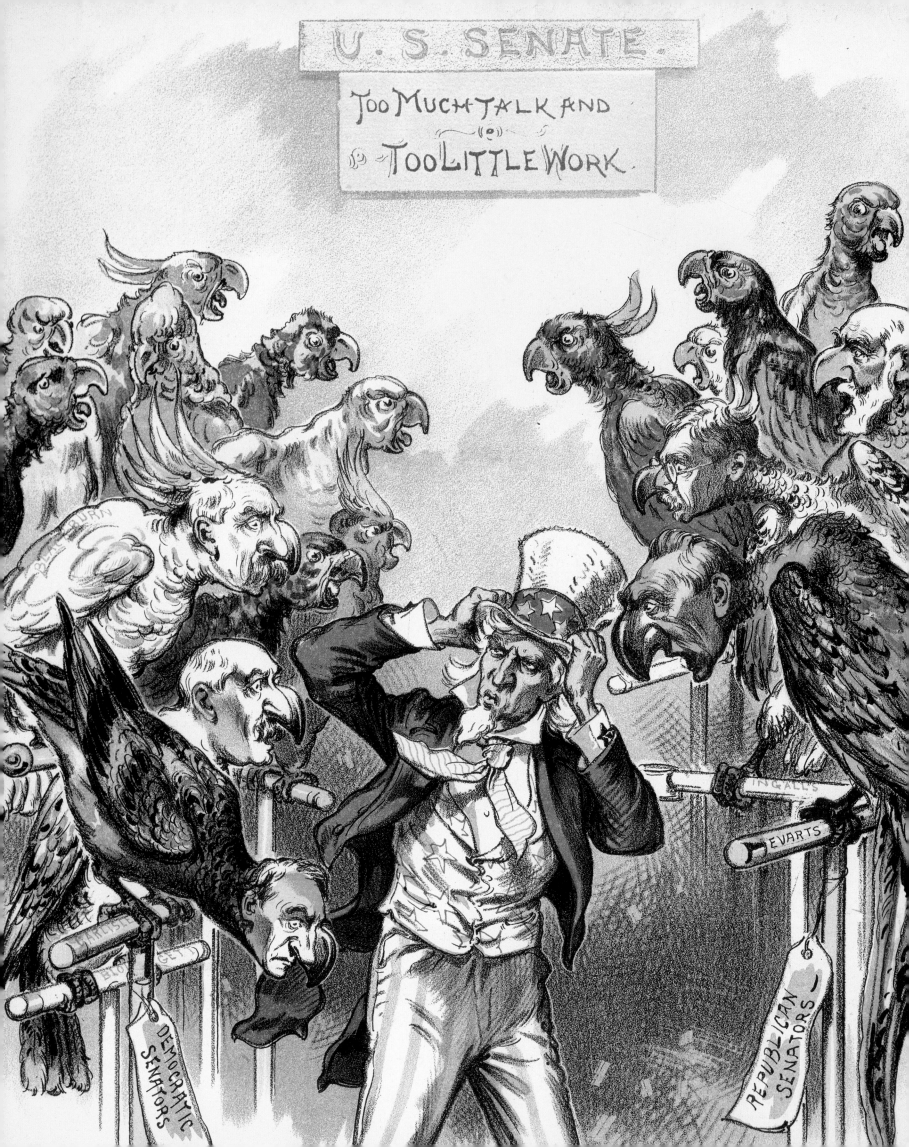

*J*udge first appeared in 1881, after cartoonist James A. Wales fell out with Joseph Keppler at *Puck*. In 1885 Wales sold *Judge* to William J. Arkell, who used his wealth to lure away several of *Puck's* cartoonists, including F. Victor Gillam (ca. 1860-1920), who signed himself "F. Victor" or "Victor" to distinguish himself from his older brother Bernhard Gillam.

Cartoonists often used birds and animals to represent their human targets. In "Senate Screeching," which appeared on September 6, 1890, Uncle Sam covers his ears and demands silence as senatorial parrots from both parties screech. The cartoon represented a Senate filibuster over the "Force bill." In June 1890 the House passed a bill requiring federal supervision of elections in the Southern states to ensure that African Americans could vote. States'-rights advocates filibustered against it in the Senate, and the Force bill was never enacted. ☙

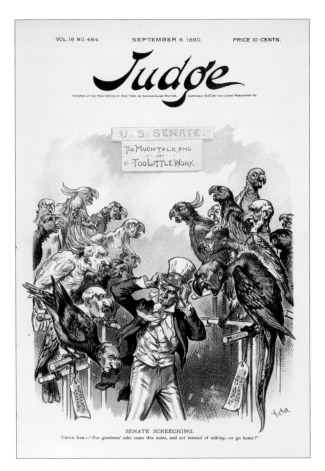

Senate Screeching.

Unidentified after F. Victor Gillam
Judge, 09/06/1890
Lithograph, colored
9 ⅜ x 8 ⅜ inches (23.8 x 21.3 cm)
Cat. no. 38.00848.001

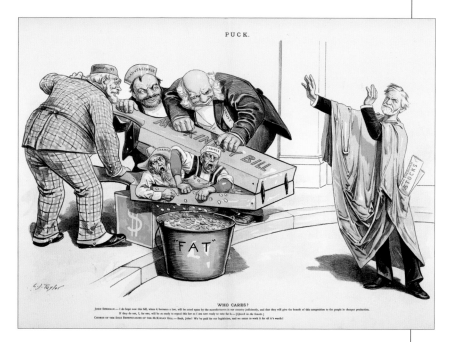

Who Cares?

Unidentified after Charles J. Taylor
Puck, 10/15/1890
Lithograph, colored
12 ⅛ x 18 ¾ inches (30.8 x 47.6 cm)
Cat. no. 38.00573.001

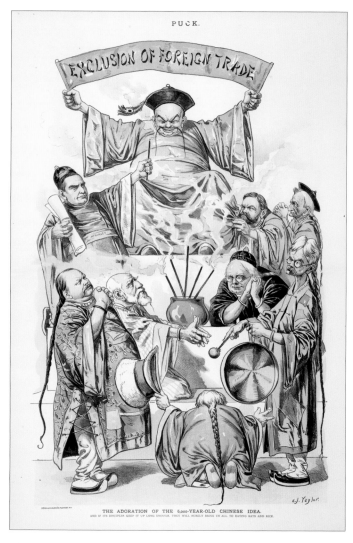

The Adoration of the 6,000-Year-Old Chinese Idea.

J. Ottmann Lith. Co. after Charles J. Taylor
Puck, 11/05/1890
Lithograph, colored
18 ½ x 11 ¾ inches (47.0 x 29.8 cm)
Cat. no. 38.00572.001

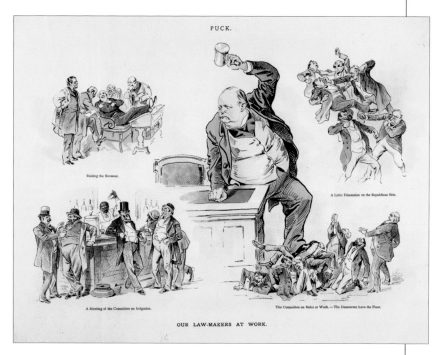

Our Law-Makers at Work.

Unidentified
Puck, 09/10/1890
Lithograph, colored
8 ⅜ x 11 ⅜ inches (21.3 x 28.9 cm)
Cat. no. 38.00351.001

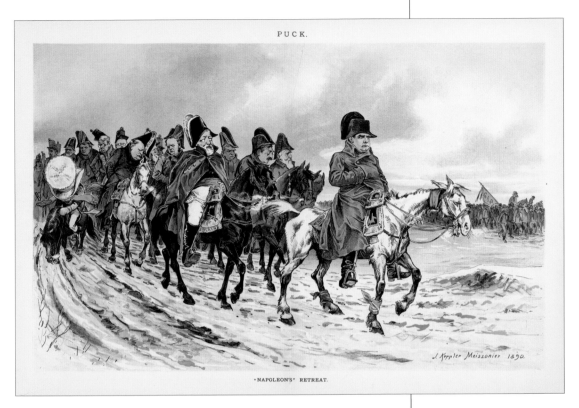

"Napoleon's" Retreat.

Unidentified after Joseph Keppler after Jean-Louis-Ernest Meissonier
Puck, 11/19/1890
Lithograph, colored
12 x 18½ inches (30.5 x 47.0 cm)
Cat. no. 38.00747.001

Their Only Utility.

Unidentified after Louis Dalrymple
Puck, 11/19/1890
Lithograph, colored
9½ x 8½ inches (24.1 x 21.6 cm)
Cat. no. 38.00742.001

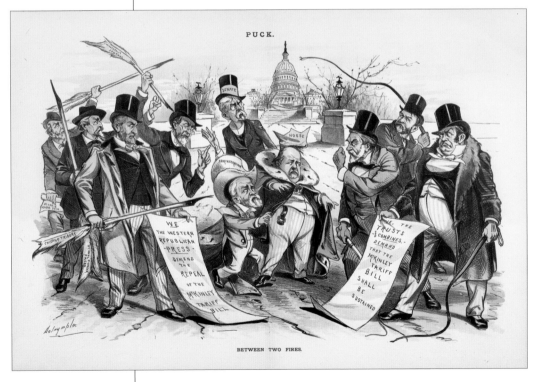

Between Two Fires.

Unidentified after Louis Dalrymple
Puck, 12/17/1890
Lithograph, colored
11¾ x 18¾ inches (29.8 x 47.6 cm)
Cat. no. 38.00577.001

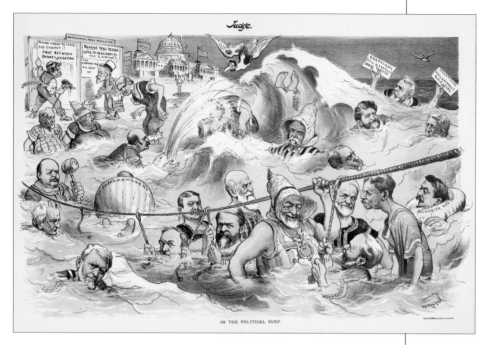

In the Political Surf.

Sackett & Wilhelms Litho, Co. after Grant E. Hamilton
Judge, ca. 1890
Lithograph, colored
11 ½ x 18 ½ inches (29.2 x 47.0 cm)
Cat. no. 38.00606.001

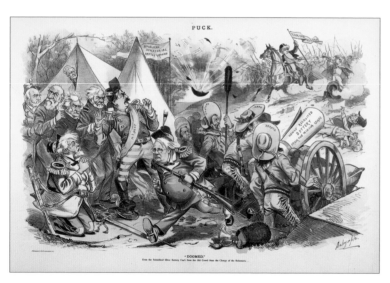

"Doomed."

J. Ottmann Lith. Co. after Louis Dalrymple
Puck, 01/07/1891
Lithograph, colored
12 ⅛ x 18 ½ inches (30.8 x 47.0 cm)
Cat. no. 38.00579.001

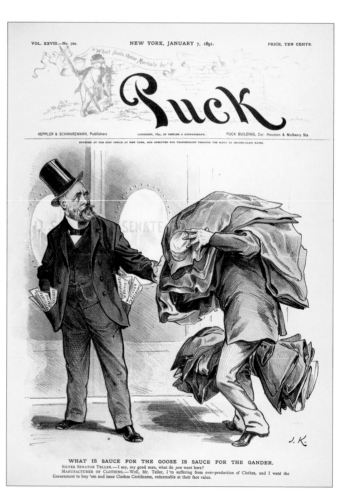

What Is Sauce for the Goose Is Sauce for the Gander.

Unidentified after Joseph Keppler
Puck, 01/07/1891
Lithograph, colored
8 x 8 ⅜ inches (20.3 x 21.3 cm)
Cat. no. 38.00352.001

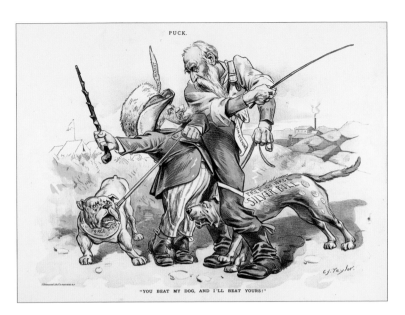

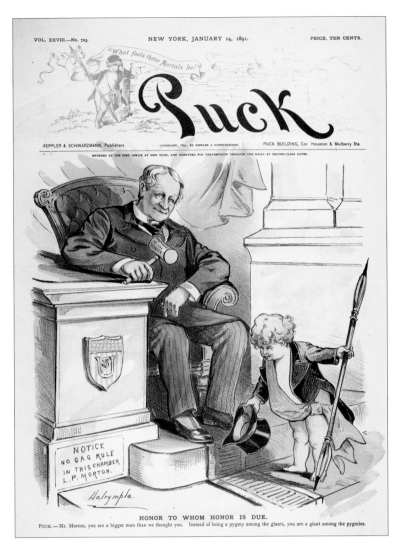

Honor to Whom Honor Is Due.

Unidentified after Louis Dalrymple
Puck, 01/14/1891
Lithograph, colored
9 ⅝ x 9 inches (24.4 x 22.9 cm)
Cat. no. 38.00347.001

"You Beat My Dog, and I'll Beat Yours!"

J. Ottmann Lith. Co. after Charles J. Taylor
Puck, 01/21/1891
Lithograph, colored
8 ¾ x 12 inches (22.2 x 30.5 cm)
Cat. no. 38.00567.001

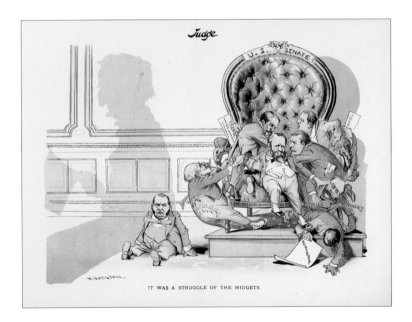

It Was a Struggle of the Midgets.

Unidentified after Grant E. Hamilton
Judge, 01/24/1891
Lithograph, colored
8 ½ x 11 ¼ inches (21.6 x 28.6 cm)
Cat. no. 38.00837.001

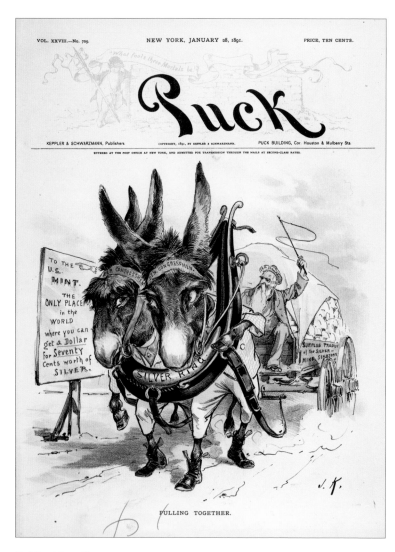

Pulling Together.

Unidentified after Joseph Keppler
Puck, 01/28/1891
Lithograph, colored
9 ⅛ x 9 inches (23.2 x 22.9 cm)
Cat. no. 38.00569.001

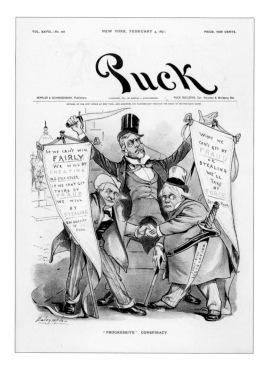

"Progressive" Conspiracy.

Unidentified after Louis Dalrymple
Puck, 02/04/1891
Lithograph, colored
9 ⅛ x 8 ⅞ inches (23.2 x 22.5 cm)
Cat. no. 38.00568.001

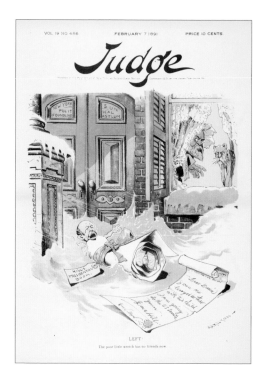

Left!

Unidentified after Grant E. Hamilton
Judge, 02/07/1891
Lithograph, colored
9 ¾ x 8 ¼ inches (24.8 x 21.0 cm)
Cat. no. 38.00885.001

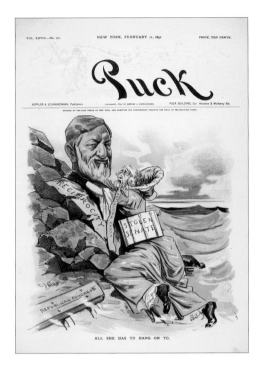

All She Has to Hang on To.

Unidentified after Charles J. Taylor
Puck, 02/11/1891
Lithograph, colored
9 ⅛ x 8 ⅝ inches (23.2 x 21.9 cm)
Cat. no. 38.00346.001

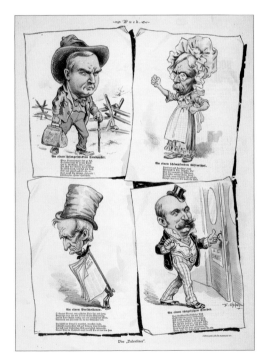

Vier "Valentines".

J. Ottmann Lith. Co. after Frederick B. Opper
Puck, ca. 1891
Lithograph, colored
12 ¾ x 9 inches (32.4 x 22.9 cm)
Cat. no. 38.00689.001

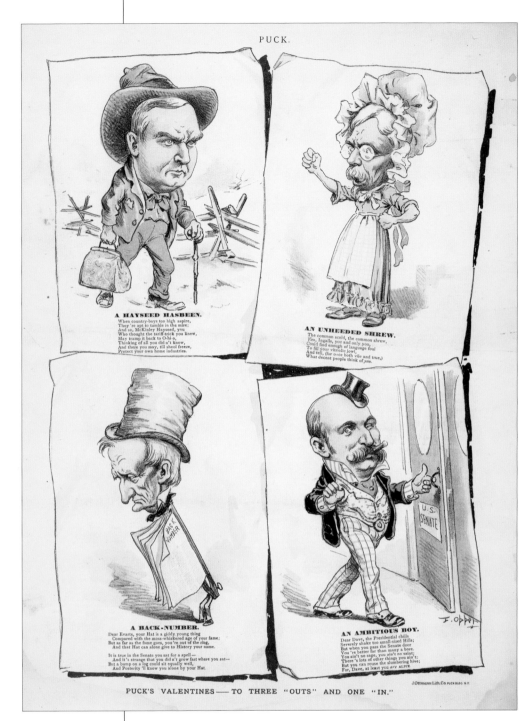

Puck's Valentines—To Three "Outs" and One "In."

J. Ottmann Lith. Co. after Frederick B. Opper
Puck, 02/11/1891
Lithograph, colored
12 ¾ x 9 inches (32.4 x 22.9 cm)
Cat. no. 38.00871.001

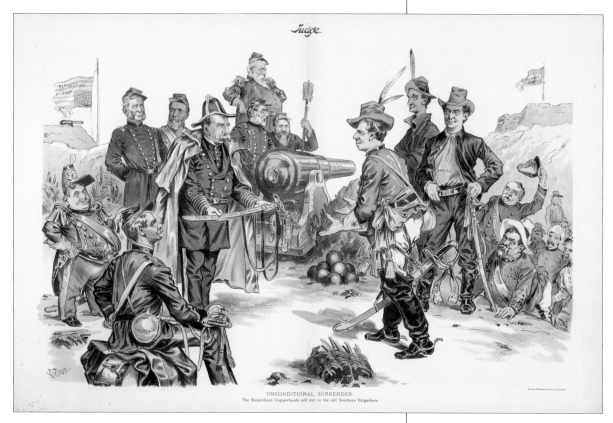

Unconditional Surrender.

Sackett & Wilhelms Litho, Co. after
F. Victor Gillam
Judge, 02/21/1891
Lithograph, colored
12 ¼ x 17 ¾ inches (31.1 x 45.1 cm)
Cat. no. 38.00947.001

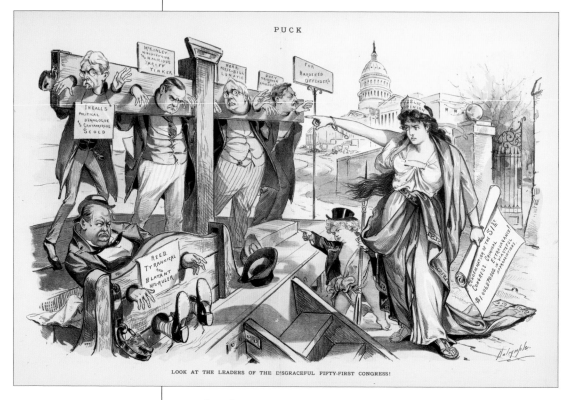

Look at the Leaders of the Disgraceful Fifty-First Congress!

Unidentified after Louis Dalrymple
Puck, 03/18/1891
Lithograph, colored
12 x 18 ¾ inches (30.5 x 47.6 cm)
Cat. no. 38.00648.001

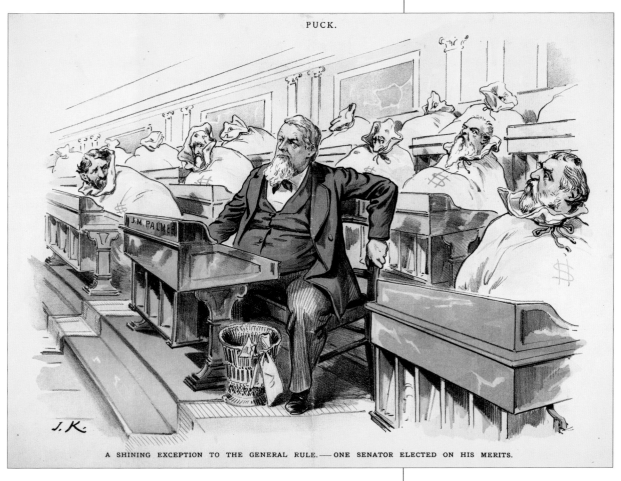

A Shining Exception to the General Rule.—One Senator Elected on His Merits.

Unidentified after Joseph Keppler
Puck, 03/25/1891
Lithograph, colored
9 ¼ x 12 ⅛ inches (23.5 x 30.8 cm)
Cat. no. 38.00345.001

A Mighty Poor Exchange.

Unidentified after F. Victor Gillam
Judge, 04/25/1891
Lithograph, colored
9 ¼ x 8 ½ inches (23.5 x 21.6 cm)
Cat. no. 38.00887.001

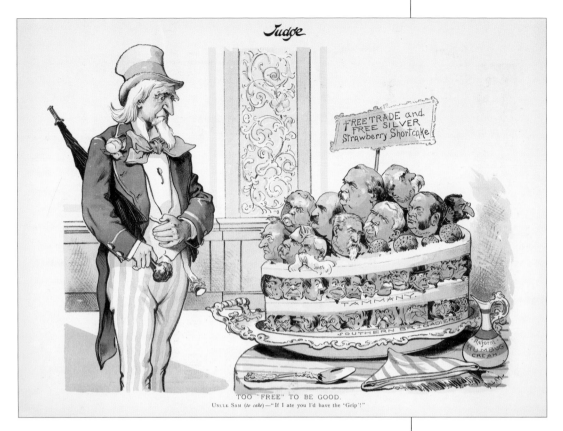

Too "Free" to Be Good.

Unidentified after Bernhard Gillam
Judge, 05/02/1891
Lithograph, colored
9 ¼ x 11 ¼ inches (23.5 x 28.6 cm)
Cat. no. 38.00966.001

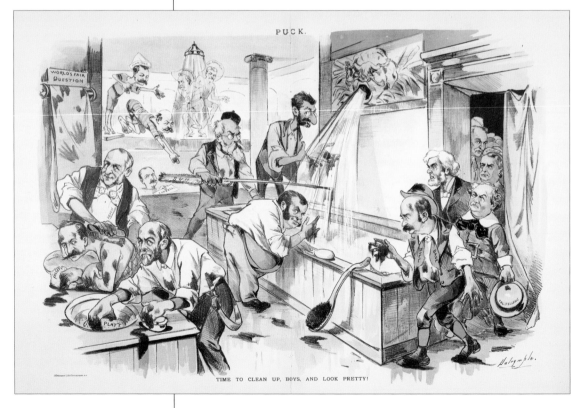

Time to Clean Up, Boys, and Look Pretty!

J. Ottmann Lith. Co. after Louis Dalrymple
Puck, 11/11/1891
Lithograph, colored
12 x 18 inches (30.5 x 45.7 cm)
Cat. no. 38.00907.001

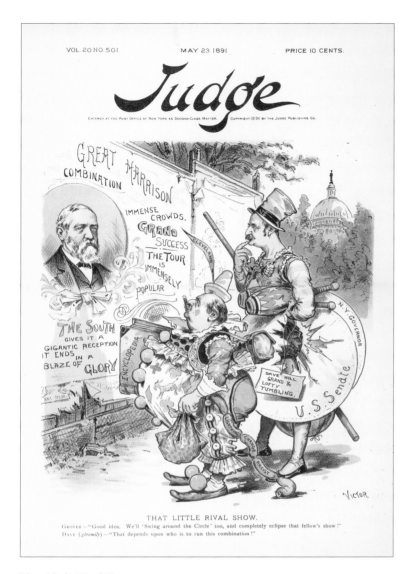

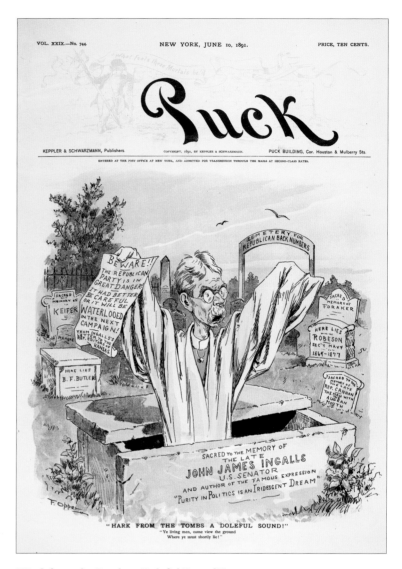

That Little Rival Show.

Unidentified after F. Victor Gillam
Judge, 05/23/1891
Lithograph, colored
9 ⅝ x 8 ¼ inches (24.4 x 21.0 cm)
Cat. no. 38.00888.001

"Hark from the Tombs a Doleful Sound!"

Unidentified after Frederick B. Opper
Puck, 06/10/1891
Lithograph, colored
9 ¼ x 8 ¾ inches (23.5 x 22.2 cm)
Cat. no. 38.00344.001

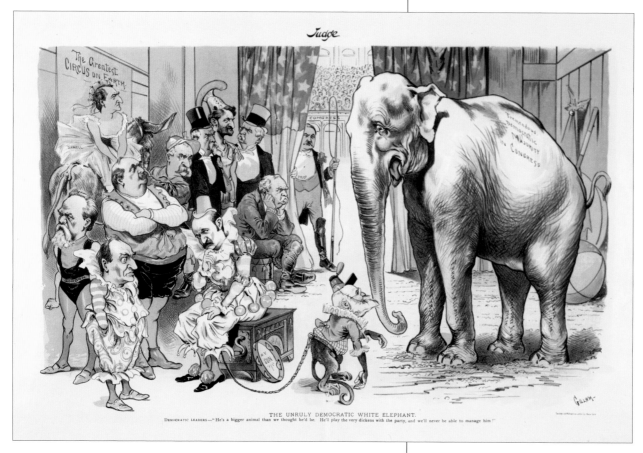

The Unruly Democratic White Elephant.

Sackett & Wilhelms Litho, Co. after Bernhard Gillam
Judge, 12/19/1891
Lithograph, colored
11 ⅜ x 17 ⅝ inches (28.9 x 44.8 cm)
Cat. no. 38.00316.001

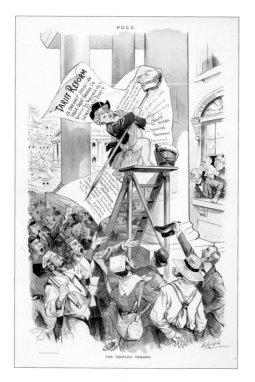

The People's Demand.

J. Ottmann Lith. Co. after Louis Dalrymple
Puck, 01/20/1892
Lithograph, colored
18 ¾ x 11 ¾ inches (47.6 x 29.8 cm)
Cat. no. 38.00905.001

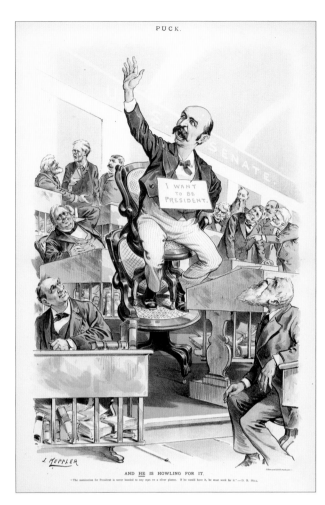

And He Is Howling for It.

J. Ottmann Lith. Co. after Joseph Keppler
Puck, 03/16/1892
Lithograph, colored
18 ¾ x 12 inches (47.6 x 30.5 cm)
Cat. no. 38.00692.002

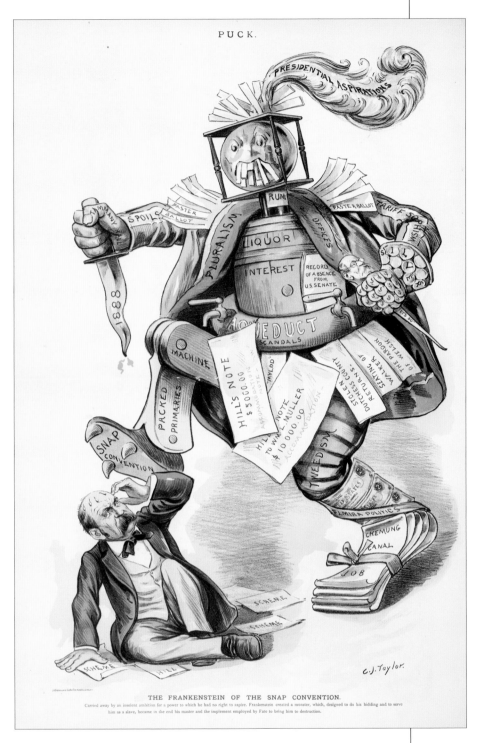

The Frankenstein of the Snap Convention.

J. Ottmann Lith. Co. after Charles J. Taylor
Puck, 03/02/1892
Lithograph, colored
18 ¾ x 11 ¾ inches (47.6 x 29.8 cm)
Cat. no. 38.00948.001

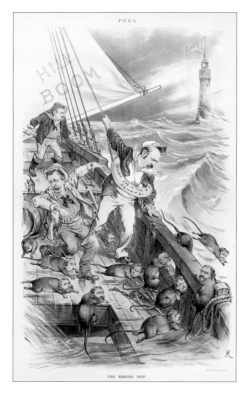

The Sinking Ship.

J. Ottmann Lith. Co. after Joseph Keppler
Puck, 04/20/1892
Lithograph, colored
19 x 12 inches (48.3 x 30.5 cm)
Cat. no. 38.00623.001

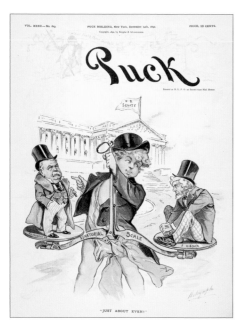

"Just about Even!"

Unidentified after Louis Dalrymple
Puck, 12/14/1892
Lithograph, colored
9 x 8¾ inches (22.9 x 22.2 cm)
Cat. no. 38.00651.001

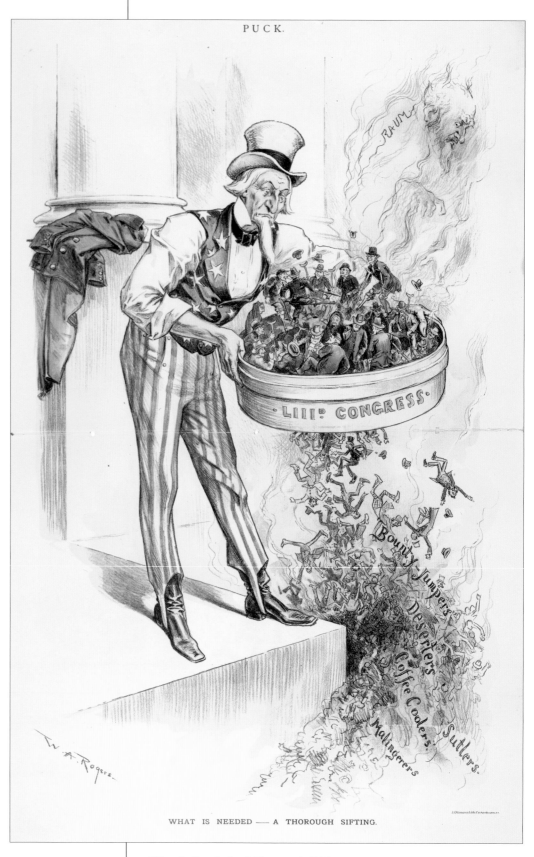

What Is Needed—A Thorough Sifting.

J. Ottmann Lith. Co. after William Allen Rogers
Puck, 12/28/1892
Lithograph, colored
18½ x 11½ inches (47.0 x 29.2 cm)
Cat. no. 38.00197.001

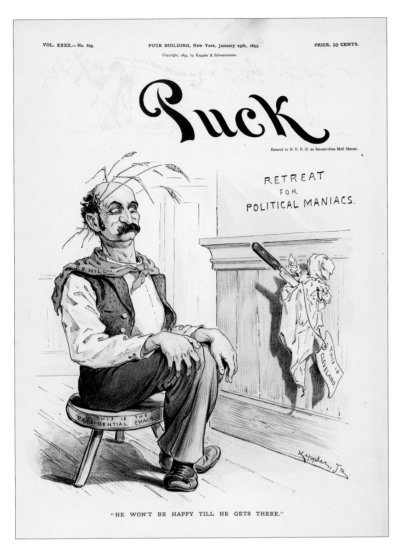

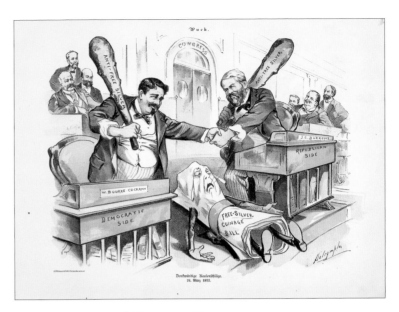

Denfwürdige Keulenfchläge. 24. März 1892.

J. Ottmann Lith. Co. after Louis Dalrymple
Puck, ca. 1892
Lithograph, colored
9 ¼ x 11 ¾ inches (23.5 x 29.8 cm)
Cat. no. 38.00967.001

"He Won't Be Happy Till He Gets There."

Unidentified after Joseph Keppler, Jr.
Puck, 01/25/1893
Lithograph, colored
9 ½ x 8 ¼ inches (24.1 x 21.0 cm)
Cat. no. 38.00740.001

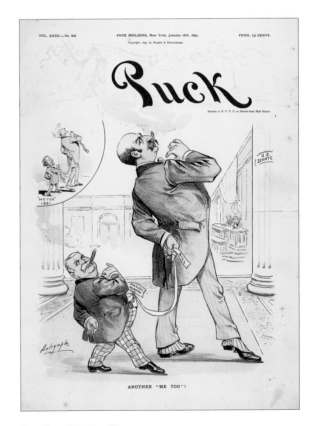

Another "Me Too"!

Unidentified after Louis Dalrymple
Puck, 01/18/1893
Lithograph, colored
9 ¼ x 8 ½ inches (23.5 x 21.6 cm)
Cat. no. 38.00391.001

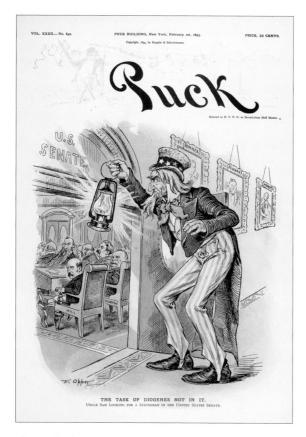

The Task of Diogenes Not in It.

Unidentified after Frederick B. Opper
Puck, 02/01/1893
Lithograph, colored
9 ¼ x 8 ⁵⁄₁₆ inches (23.5 x 21.1 cm)
Cat. no. 38.00530.001

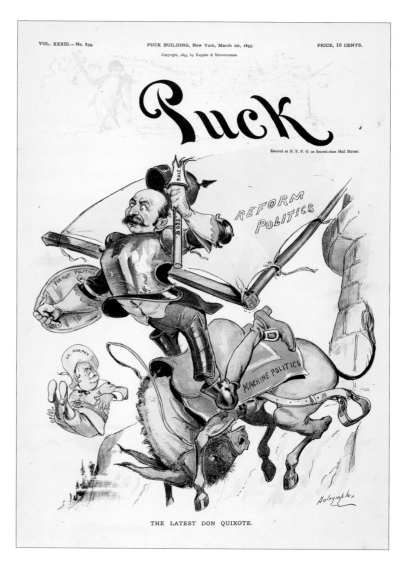

The Latest Don Quixote.

Unidentified after Louis Dalrymple
Puck, 03/01/1893
Lithograph, colored
9 ½ x 9 inches (24.1 x 22.9 cm)
Cat. no. 38.00739.001

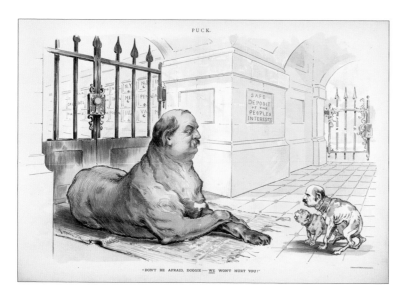

"Don't Be Afraid, Doggie— We Won't Hurt You!"

J. Ottmann Lith. Co. after Joseph Keppler, Jr.
Puck, 02/08/1893
Lithograph, colored
12 x 18 ½ inches (30.5 x 47.0 cm)
Cat. no. 38.00753.001

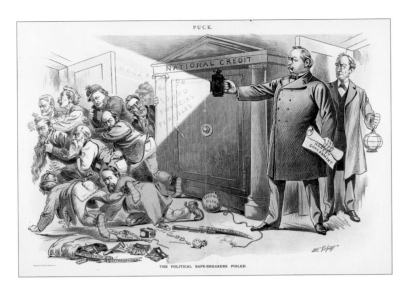

The Political Safe-Breakers Foiled.

J. Ottmann Lith. Co. after Samuel D. Ehrhart
Puck, 05/10/1893
Lithograph, colored
12 ⅛ x 18 ½ inches (30.8 x 47.0 cm)
Cat. no. 38.00752.001

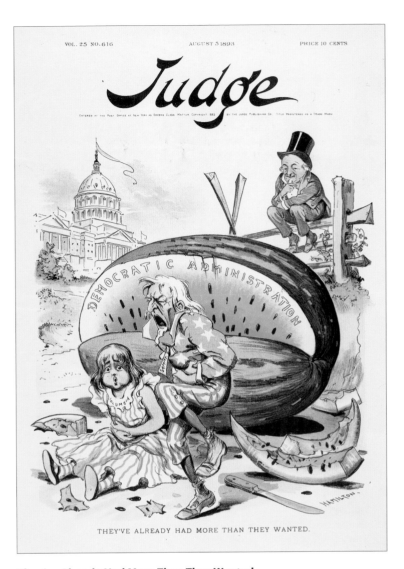

They've Already Had More Than They Wanted.

Unidentified after Grant E. Hamilton
Judge, 08/05/1893
Lithograph, colored
10 x 8 ½ inches (25.4 x 21.6 cm)
Cat. no. 38.00550.001

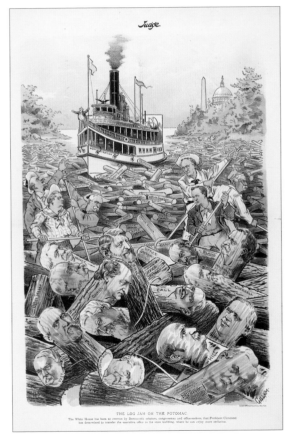

The Log Jam on the Potomac.

Sackett & Wilhelms Litho, Co. after Bernhard Gillam
Judge, 05/13/1893
Lithograph, colored
17 ¹³⁄₁₆ x 11 ⅜ inches (45.2 x 28.9 cm)
Cat. no. 38.00552.001

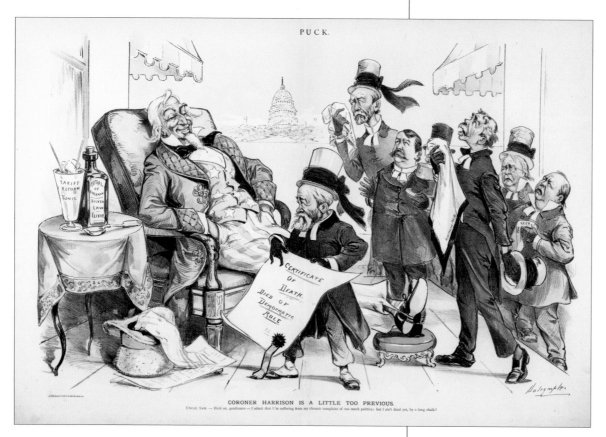

Coroner Harrison Is a Little Too Previous.

J. Ottmann Lith. Co. after Louis Dalrymple
Puck, 09/06/1893
Lithograph, colored
12 ⅛ x 18 ½ inches (30.8 x 47.0 cm)
Cat. no. 38.00751.001

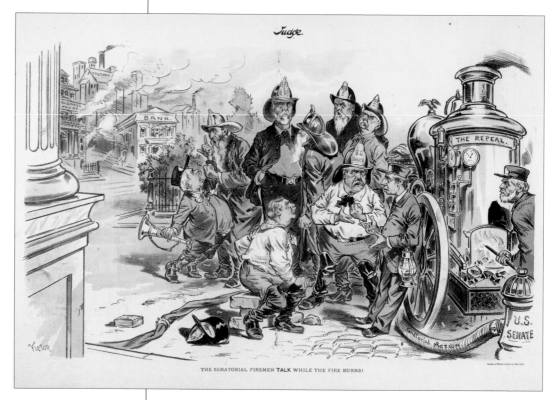

The Senatorial Firemen Talk While the Fire Burns!

Sackett & Wilhelms Litho, Co. after F. Victor Gillam
Judge, 09/09/1893
Lithograph, colored
18 x 11 inches (45.7 x 27.9 cm)
Cat. no. 38.00419.001

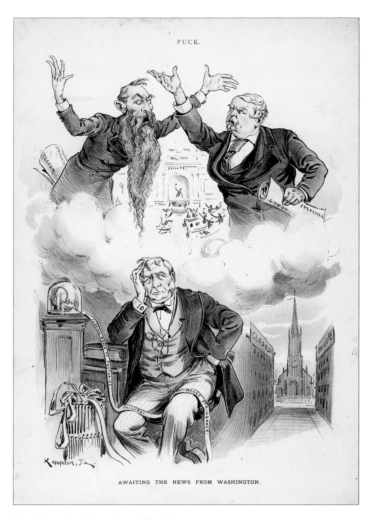

Awaiting the News from Washington.

Unidentified after Joseph Keppler, Jr.
Puck, 08/30/1893
Lithograph, colored
11 ½ x 9 inches (29.2 x 22.9 cm)
Cat. no. 38.00744.001

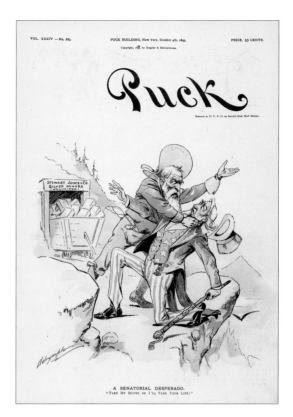

A Senatorial Desperado.

Unidentified after Louis Dalrymple
Puck, 10/04/1893
Lithograph, colored
9 ¼ x 8 ½ inches (23.5 x 21.6 cm)
Cat. no. 38.00741.001

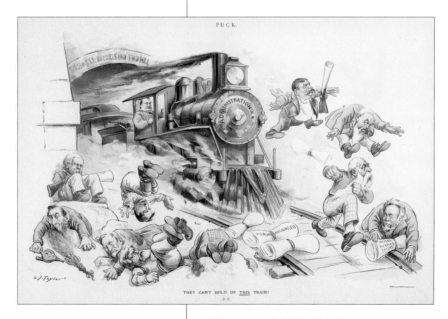

They Can't Hold Up This Train!

J. Ottmann Lith. Co. after Charles J. Taylor
Puck, 10/11/1893
Lithograph, colored
12 x 19 inches (30.5 x 48.3 cm)
Cat. no. 38.00748.001

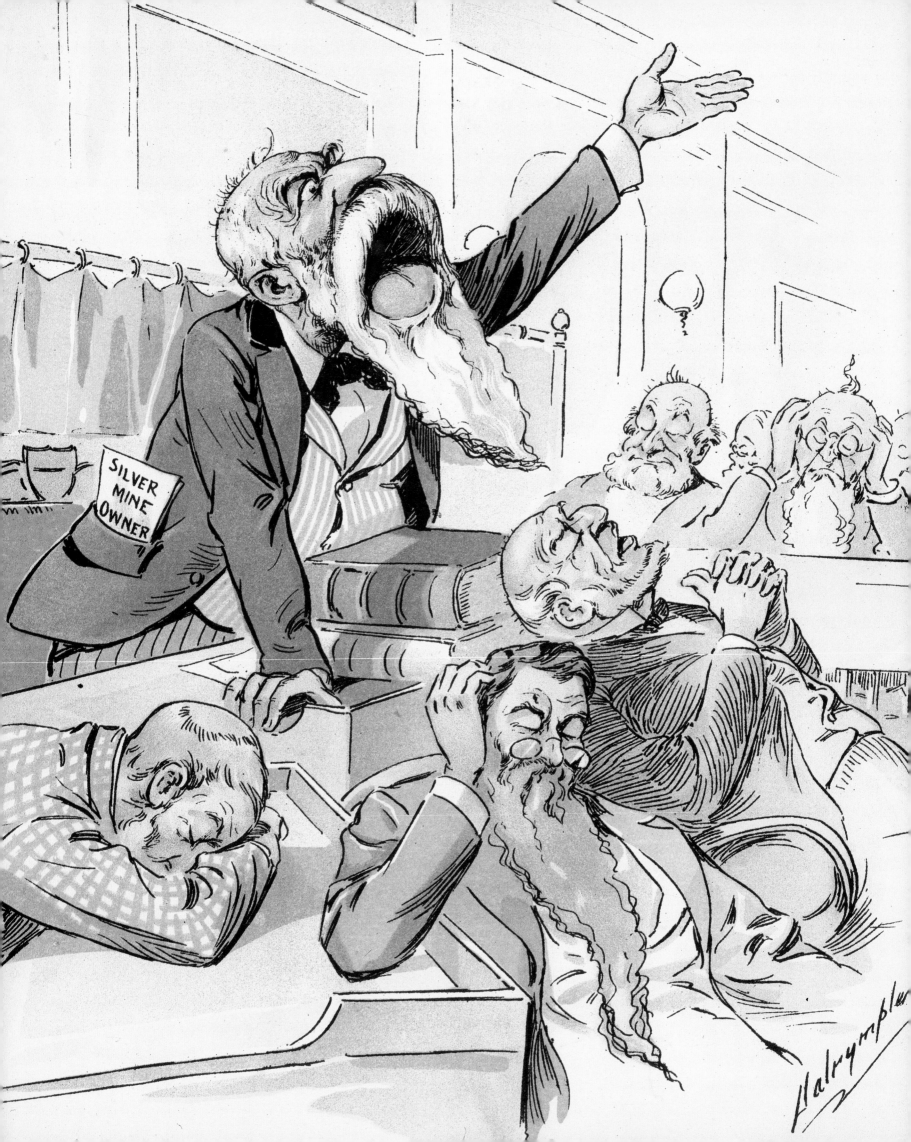

Technically, "senatorial courtesy" refers to a tacit agreement among senators not to vote for any presidential nominee who is opposed by the senators from the nominee's home state. In this cartoon that ran in *Puck* on October 18, 1893, cartoonist Louis Dalrymple expanded the term to include the willingness of senators to indulge long-winded colleagues. During the 19th century, the Senate had no cloture rule and therefore no means to cut off senators who wished to delay or kill a bill by talking it to death, better known as a filibuster. In this instance, William M. Stewart, a Republican senator from Nevada representing the silver mine owners, filibusters against repeal of the Sherman Silver Purchase Act. With a pile of reference books before him, the senator orates to a Chamber filled with sleeping legislators. ☟

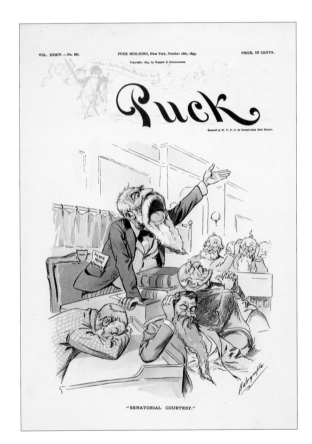

"Senatorial Courtesy."

Unidentified after Louis Dalrymple
Puck, 10/18/1893
Lithograph, colored
9 x 8 inches (22.9 x 20.3 cm)
Cat. no. 38.00652.001

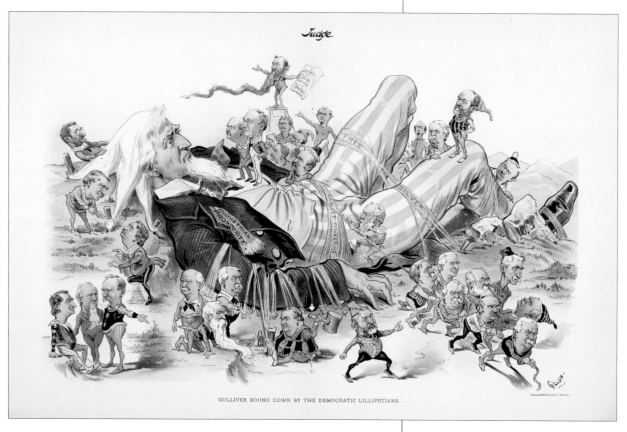

Gulliver Bound Down by the Democratic Lilliputians.

Sackett & Wilhelms Litho, Co. after Bernhard Gillam
Judge, 10/28/1893
Lithograph, colored
11 ½ x 17 ¾ inches (29.2 x 45.1 cm)
Cat. no. 38.00946.001

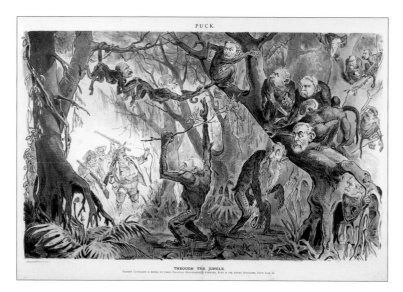

Through the Jungle.

J. Ottmann Lith. Co. after Joseph Keppler, Jr.
Puck, 11/22/1893
Lithograph, colored
12 ¼ x 18 ¾ inches (31.1 x 47.6 cm)
Cat. no. 38.00754.001

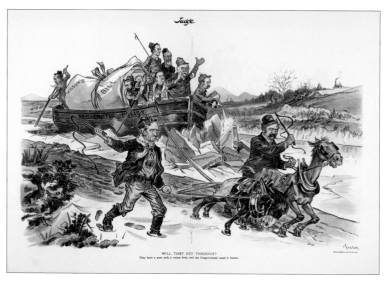

Will They Get Through?

Sackett & Wilhelms Litho, Co. after F. Victor Gillam
Judge, 12/30/1893
Lithograph, colored
11 ½ x 17 ½ inches (29.2 x 44.5 cm)
Cat. no. 38.00326.001

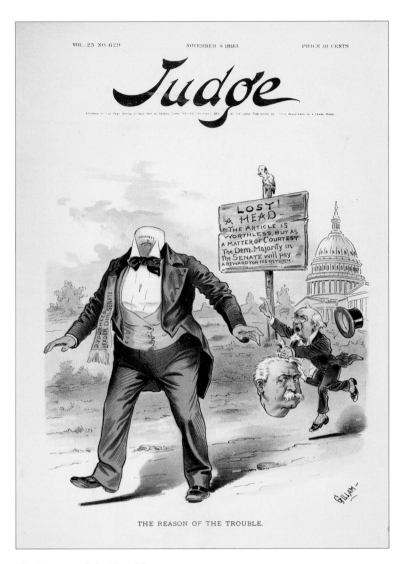

The Reason of the Trouble.

Unidentified after Bernhard Gillam
Judge, 11/04/1893
Lithograph, colored
9 ¼ x 8 ⅛ inches (23.5 x 20.6 cm)
Cat. no. 38.00324.001

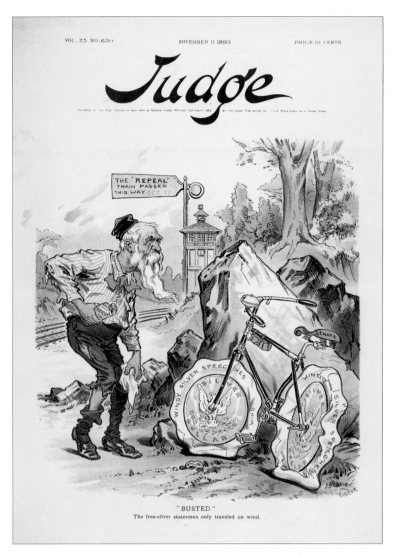

"Busted."

Unidentified after F. Victor Gillam
Judge, 11/11/1893
Lithograph, colored
9 ¼ x 8 inches (23.5 x 20.3 cm)
Cat. no. 38.00361.001

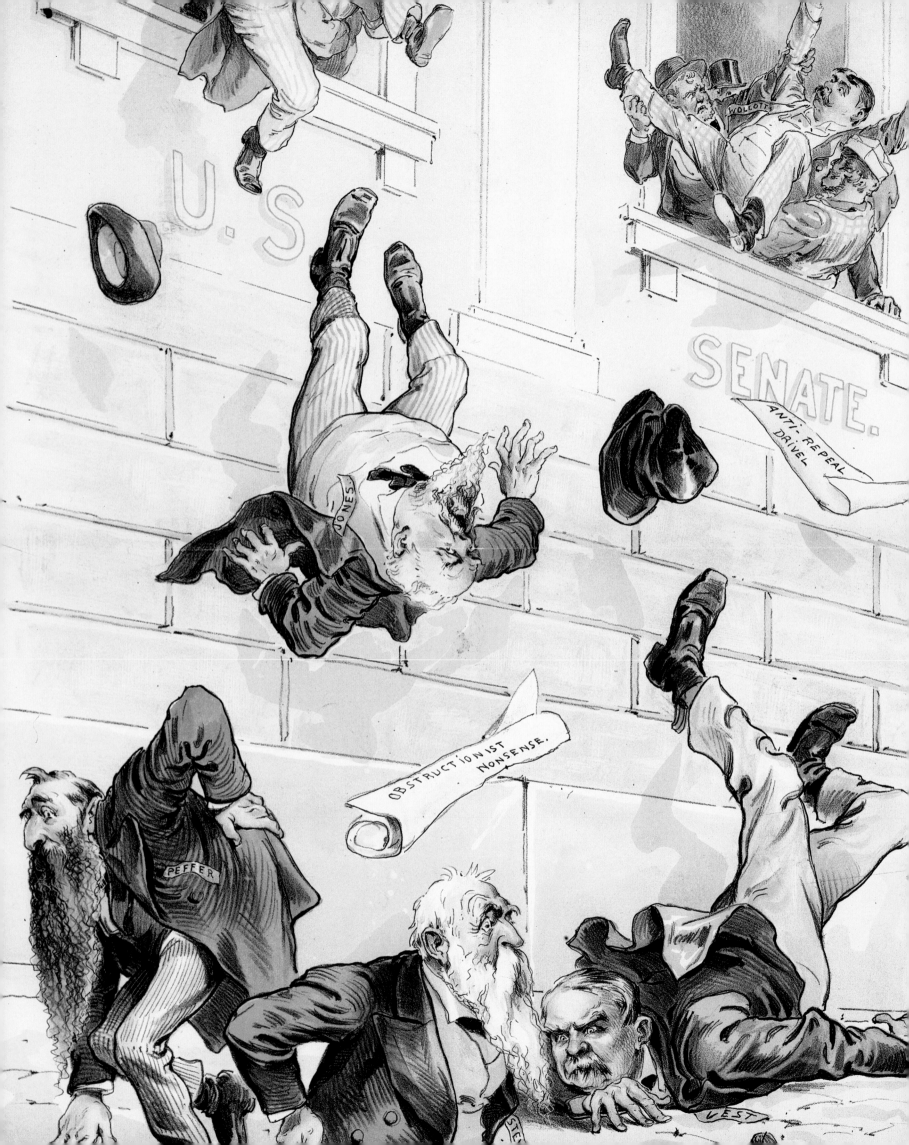

At the end of the 19th century, currency issues inflamed public opinion in America. Politicians divided into camps between hard and soft money. The soft money forces wanted inflation to expand the currency and ease the burden on debtors, while hard money supporters defended those who had lent the money, insisting they were owed a fair return. Little neutral ground existed between the poles. During the depression of 1893, hard money advocates blamed the economic woes on the inflationists and advocated repeal of the Sherman Silver Purchase Act. Soft money advocates, speaking especially for farmers, launched a filibuster that raged from late August until late October 1893, when the repeal finally passed. Fed up with the delaying tactics, Joseph Keppler used this cartoon, published in *Puck* on November 8, 1893, to suggest what to do with senators who had filibustered. ❧

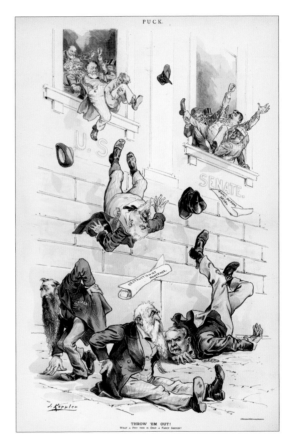

Throw 'Em Out!

J. Ottmann Lith. Co. after Joseph Keppler
Puck, 11/08/1893
Lithograph, colored
19 x 12 inches (48.3 x 30.5 cm)
Cat. no. 38.00571.002

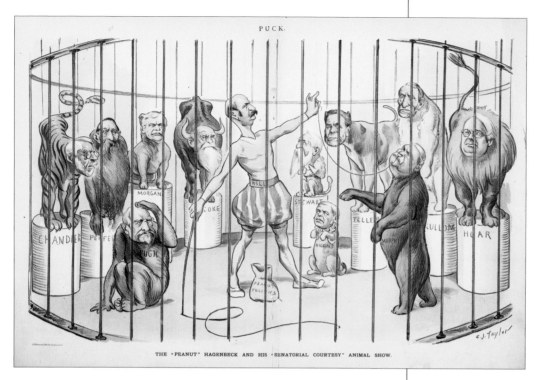

The "Peanut" Hagenbeck and His "Senatorial Courtesy" Animal Show.

J. Ottmann Lith. Co. after Charles J. Taylor
Puck, 02/07/1894
Lithograph, colored
12 x 18 ¾ inches (30.5 x 47.6 cm)
Cat. no. 38.00892.001

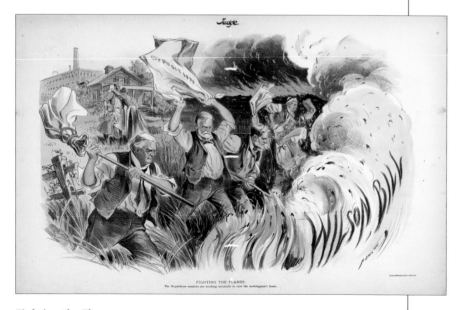

Fighting the Flames.

Sackett & Wilhelms Litho, Co. after Grant E. Hamilton
Judge, 02/17/1894
Lithograph, colored
12 x 17 ½ inches (30.5 x 44.5 cm)
Cat. no. 38.00620.001

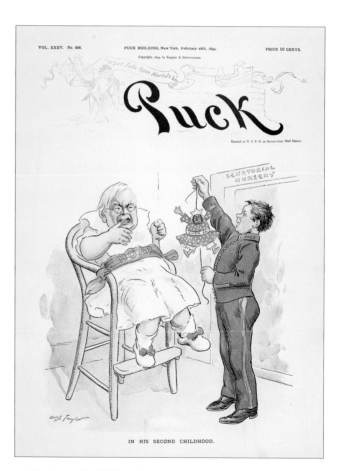

In His Second Childhood.

Unidentified after Charles J. Taylor
Puck, 02/28/1894
Lithograph, colored
8 ¾ x 8 inches (22.2 x 20.3 cm)
Cat. no. 38.00196.001

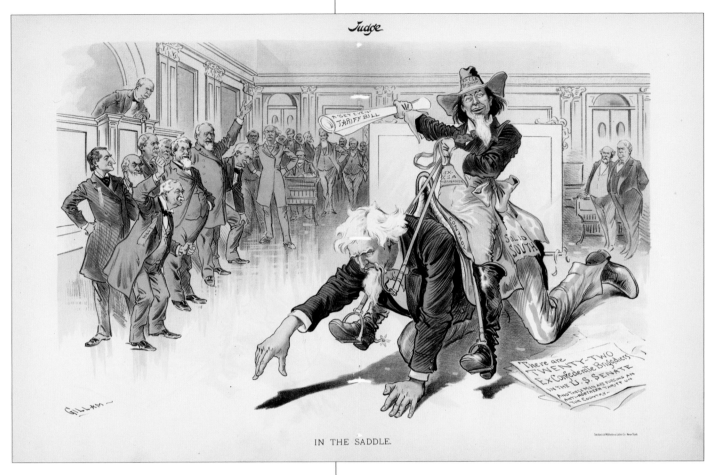

In the Saddle.

Sackett & Wilhelms Litho, Co. after Bernhard Gillam
Judge, 03/17/1894
Lithograph, colored
11 ½ x 17 ¼ inches (29.2 x 43.8 cm)
Cat. no. 38.00622.001

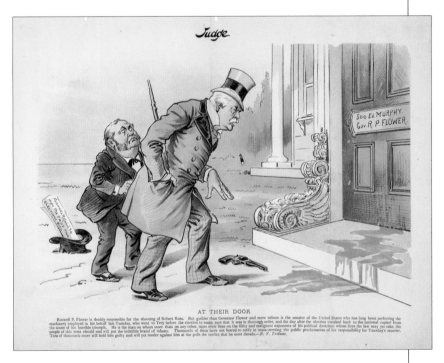

At Their Door.

Unidentified
Judge, 03/24/1894
Lithograph, colored
8 x 11 ½ inches (20.3 x 29.2 cm)
Cat. no. 38.00617.001

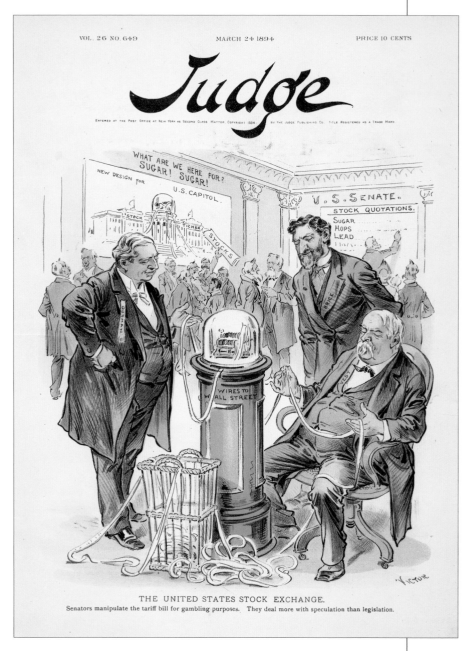

The United States Stock Exchange.

Unidentified after F. Victor Gillam
Judge, 03/24/1894
Lithograph, colored
9 ½ x 8 ½ inches (24.1 x 21.6 cm)
Cat. no. 38.00634.001

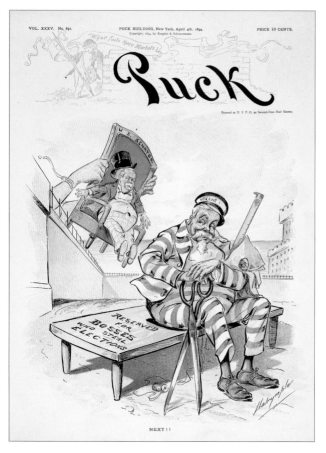

Next!!

Unidentified after Louis Dalrymple
Puck, 04/04/1894
Lithograph, colored
9 ½ x 8 ¾ inches (24.1 x 22.2 cm)
Cat. no. 38.00195.001

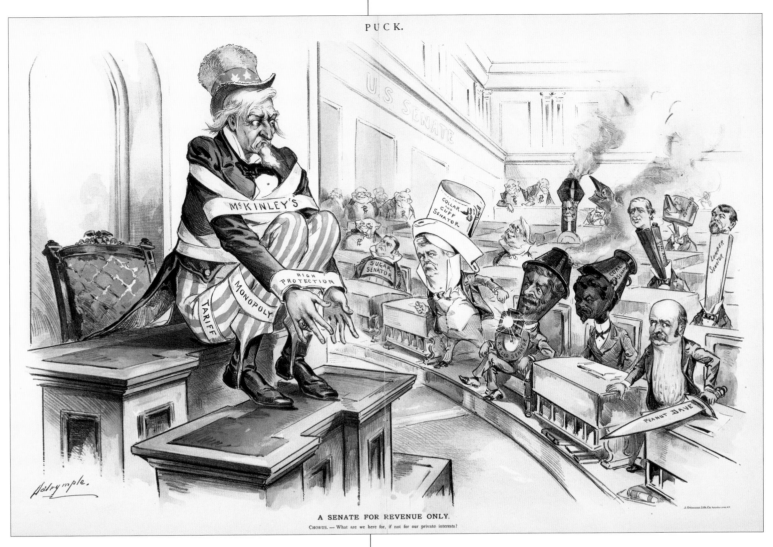

A Senate for Revenue Only.

J. Ottmann Lith. Co. after Louis Dalrymple
Puck, 03/28/1894
Lithograph, colored
12 ¼ x 18 ⅜ inches (31.1 x 46.7 cm)
Cat. no. 38.00388.001

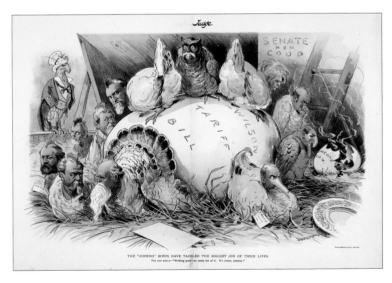

The "Cuckoo" Birds Have Tackled the Biggest Job of Their Lives.

Sackett & Wilhelms Litho, Co. after Grant E. Hamilton
Judge, 03/31/1894
Lithograph, colored
11 ½ x 17 ½ inches (29.2 x 44.5 cm)
Cat. no. 38.00420.001

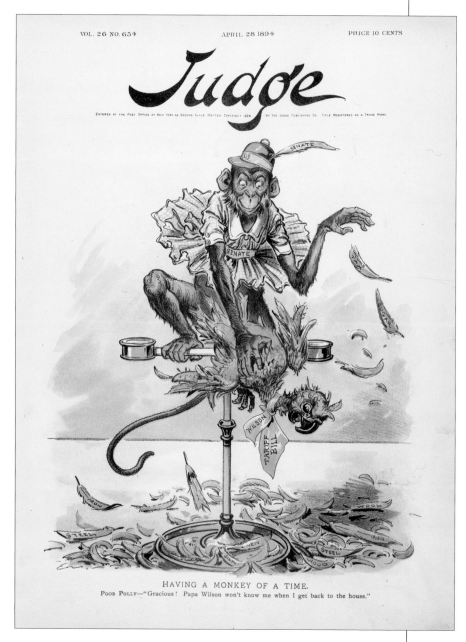

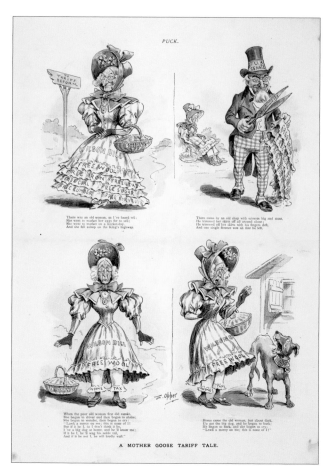

A Mother Goose Tariff Tale.

Unidentified after Frederick B. Opper
Puck, 05/23/1894
Lithograph, colored
12 x 8 ½ inches (30.5 x 21.6 cm)
Cat. no. 38.00883.001

Having a Monkey of a Time.

Unidentified
Judge, 04/28/1894
Lithograph, colored
9 ¾ x 8 ¼ inches (24.8 x 21.0 cm)
Cat. no. 38.00618.001

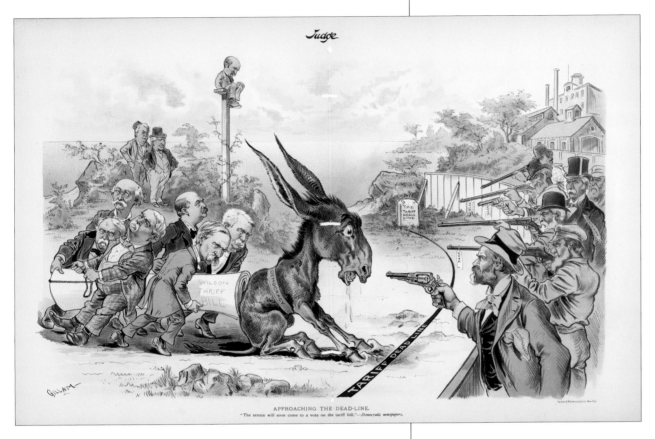

Approaching the Dead-Line.

Sackett & Wilhelms Litho, Co.
after Bernhard Gillam
Judge, 05/26/1894
Lithograph, colored
12 x 18 ¼ inches (30.5 x 46.4 cm)
Cat. no. 38.00619.001

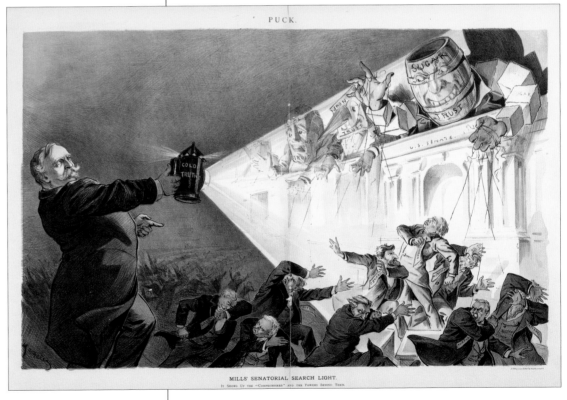

Mills' Senatorial Search Light.

J. Ottmann Lith. Co. after Joseph Keppler, Jr.
Puck, 05/30/1894
Lithograph, colored
12 ¼ x 18 ¾ inches (31.1 x 47.6 cm)
Cat. no. 38.00674.001

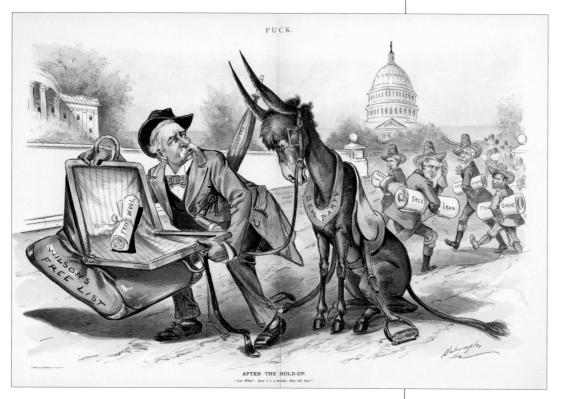

After the Hold-Up.

J. Ottmann Lith. Co. after Louis Dalrymple
Puck, 06/13/1894
Lithograph, colored
12 x 18¾ inches (30.5 x 47.6 cm)
Cat. no. 38.00673.001

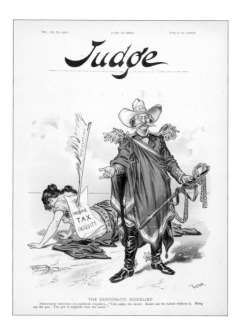

The Democratic Richelieu.

Unidentified after F. Victor Gillam
Judge, 06/16/1894
Lithograph, colored
9½ x 8¾ inches (24.1 x 22.2 cm)
Cat. no. 38.00615.001

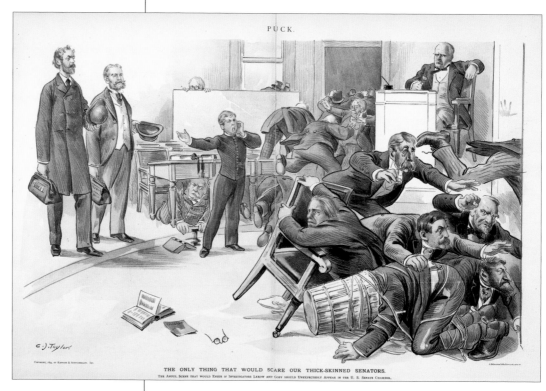

The Only Thing That Would Scare Our Thick-Skinned Senators.

J. Ottmann Lith. Co. after Charles J. Taylor
Puck, 06/27/1894
Lithograph, colored
12⅛ x 18¼ inches (30.8 x 46.4 cm)
Cat. no. 38.00389.001

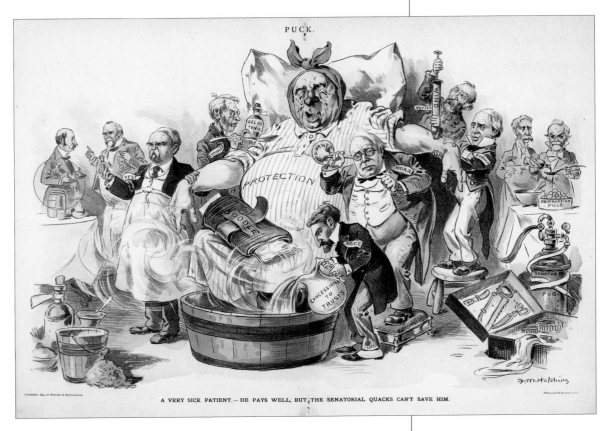

A Very Sick Patient.—He Pays Well, but the Senatorial Quacks Can't Save Him.

J. Ottmann Lith. Co. after Frank M. Hutchins
Puck, 07/18/1894
Lithograph, colored
12 ½ x 18 ¾ inches (31.8 x 47.6 cm)
Cat. no. 38.00415.001

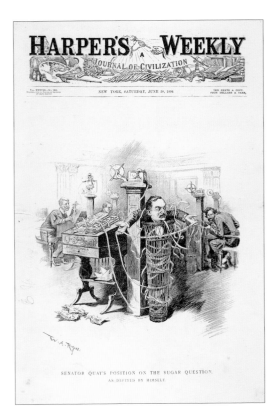

Senator Quay's Position on the Sugar Question.

Unidentified after William Allen Rogers
Harper's Weekly, 06/30/1894
Halftone, black and white
11 ¼ x 9 inches (28.6 x 22.9 cm)
Cat. no. 38.00733.001

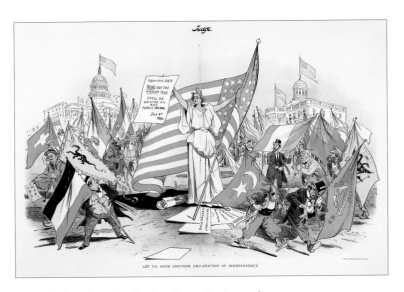

Let U.S. Have Another Declaration of Independence.

Sackett & Wilhelms Litho, Co. after Grant E. Hamilton
Judge, 07/07/1894
Lithograph, colored
12 ½ x 18 ¼ inches (31.8 x 46.4 cm)
Cat. no. 38.00360.001

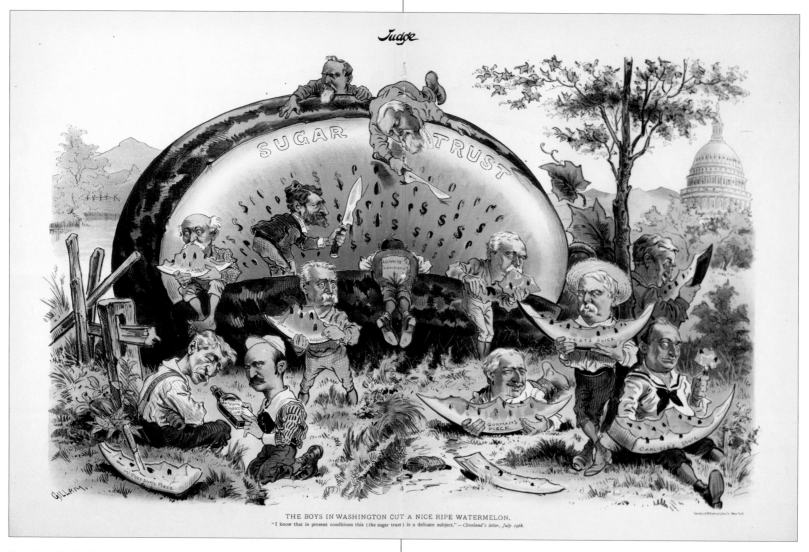

The Boys in Washington Cut a Nice Ripe Watermelon.

Sackett & Wilhelms Litho, Co. after Bernhard Gillam
Judge, 08/04/1894
Lithograph, colored
12 x 18 ¾ inches (30.5 x 47.6 cm)
Cat. no. 38.00319.001

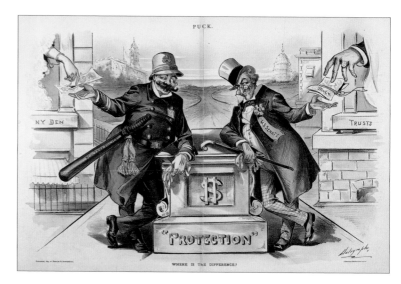

Where Is the Difference?

J. Ottmann Lith. Co. after Louis Dalrymple
Puck, 08/08/1894
Lithograph, colored
12 x 18 inches (30.5 x 45.7 cm)
Cat. no. 38.00438.001

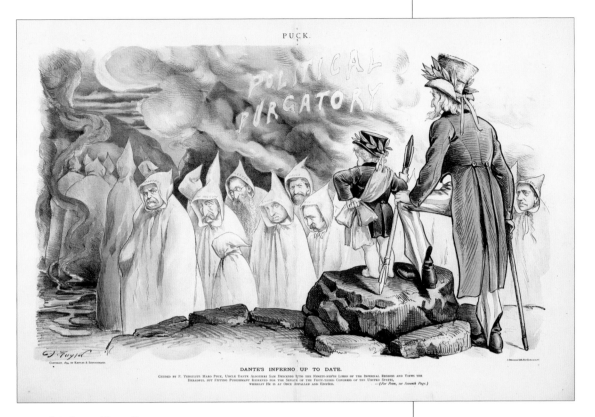

Dante's Inferno Up to Date.

J. Ottmann Lith. Co. after Charles J. Taylor
Puck, 08/22/1894
Lithograph, colored
12 x 18 ½ inches (30.5 x 47.0 cm)
Cat. no. 38.00904.001

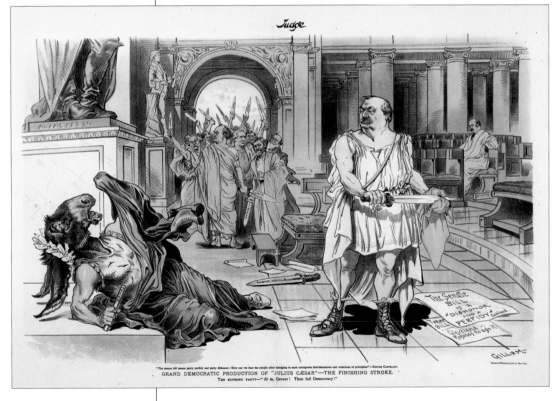

**Grand Democratic Production of "Julius Cæsar"—
The Finishing Stroke.**

Sackett & Wilhelms Litho, Co. after Bernhard Gillam
Judge, 09/22/1894
Lithograph, colored
11 ½ x 18 inches (29.2 x 45.7 cm)
Cat. no. 38.00437.001

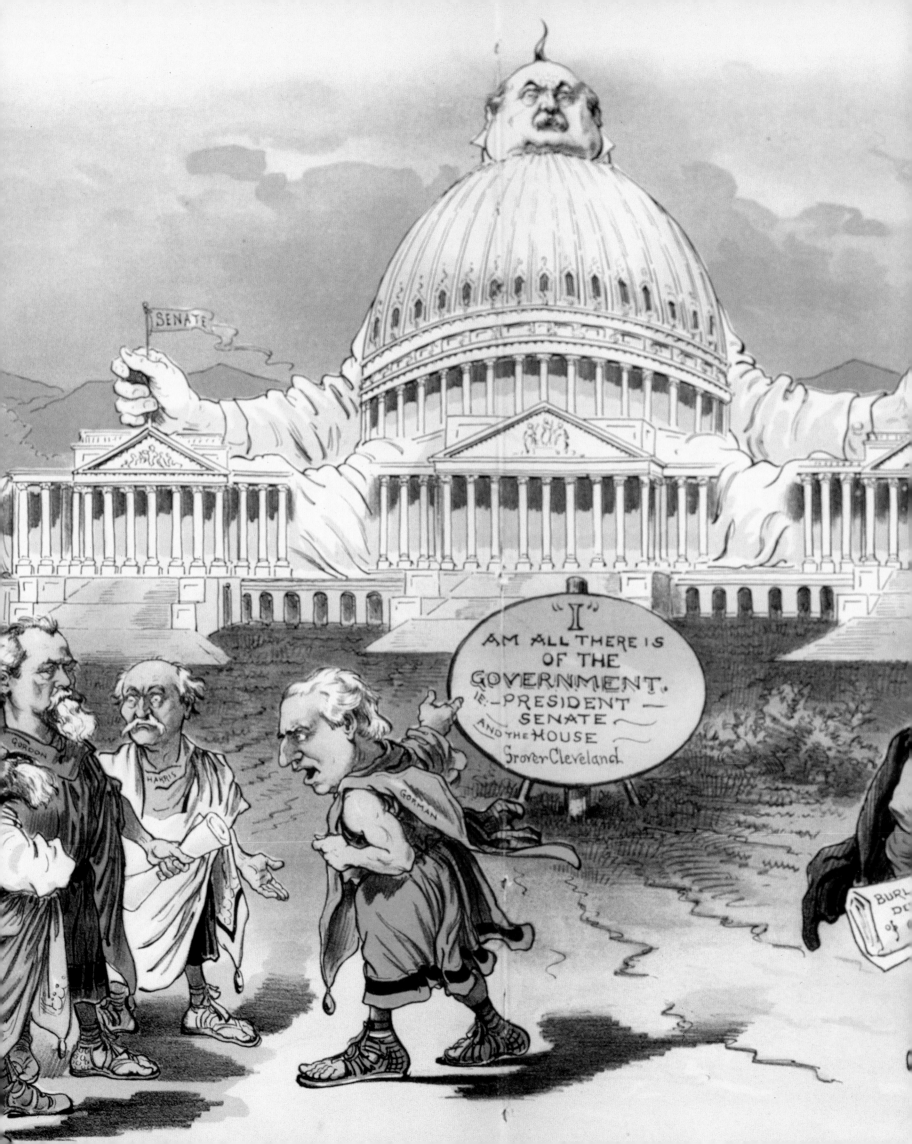

SENATE

"I AM ALL THERE IS OF THE GOVERNMENT. IE.—PRESIDENT — SENATE AND THE HOUSE
Grover Cleveland

GORDON

HARRIS

GORMAN

BURL DE of

hysically a large man, President Grover Cleveland metaphorically became the United States Capitol building in Bernhard Gillam's cartoon, "The New Capitol." This illustration, which appeared in *Judge* on August 11, 1894, portrayed Cleveland not simply astride the Capitol, but turned his chest into the dome and his legs into the Senate and House wings. Dressed in Roman togas, senators look on the scene in dismay, with Maryland Senator Arthur P. Gorman, a Democrat, citing Cassius's lines from Shakespeare's *Julius Caesar*.

Although Cleveland's Democratic Party had won sweeping majorities in Congress in 1892, it took the blame for the economic depression that struck the nation in 1893. Cleveland blamed the crisis on the inflationary Sherman Silver Purchase Act and demanded its repeal, rather than consider any other solutions. On June 30, 1894, Cleveland called a special session of Congress to repeal the Sherman Act, an action that triggered Gillam's cartoon. ๑๖

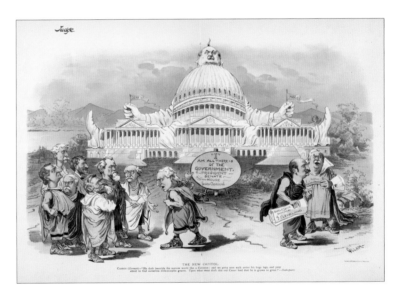

The New Capitol.

Sackett & Wilhelms Litho, Co. after Bernhard Gillam
Judge, 08/11/1894
Lithograph, colored
11 ¾ x 18 inches (29.8 x 45.7 cm)
Cat. no. 38.00317.001

The Graveyard Congress.

Unidentified after F. Victor Gillam
Judge, 12/15/1894
Lithograph, colored
10 x 8⅜ inches (25.4 x 21.3 cm)
Cat. no. 38.00329.001

Old Jokes in New Political Clothes.

J. Ottmann Lith. Co. after Charles J. Taylor
and Frederick B. Opper
Puck, 01/30/1895
Lithograph, colored
18 x 11¼ inches (45.7 x 28.6 cm)
Cat. no. 38.00893.001

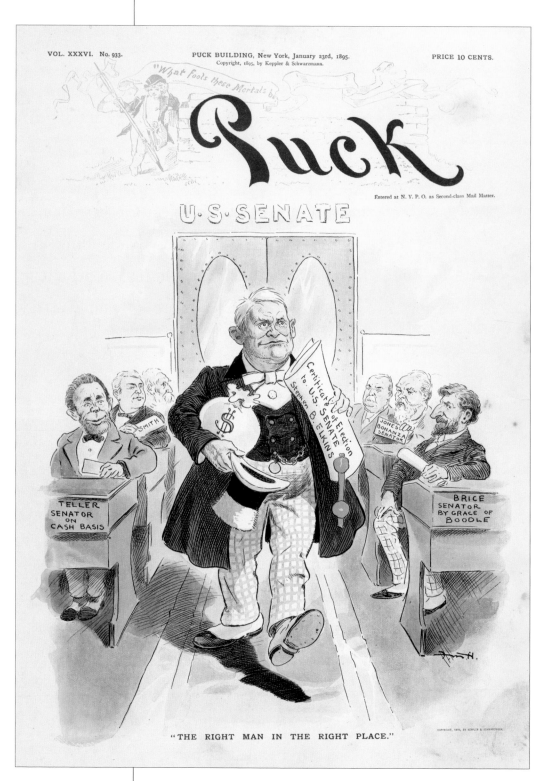

"The Right Man in the Right Place."

Unidentified after Frank M. Hutchins
Puck, 01/23/1895
Lithograph, colored
10⅜ x 8⅝ inches (26.4 x 21.9 cm)
Cat. no. 38.00432.001

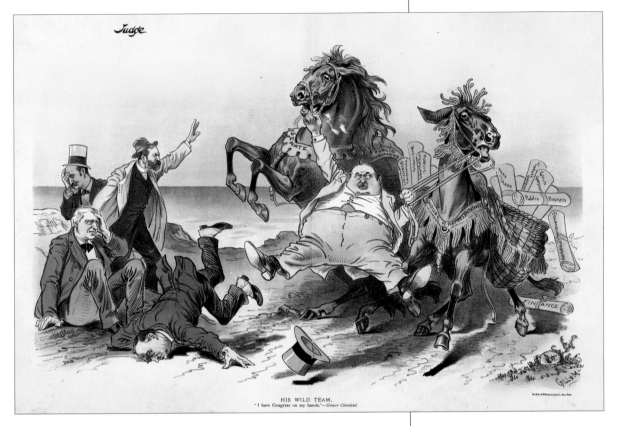

His Wild Team.

Sackett & Wilhelms Litho, Co.
after Bernhard Gillam
Judge, 02/09/1895
Lithograph, colored
11 ¼ x 17 ⅞ inches (28.6 x 45.4 cm)
Cat. no. 38.00416.001

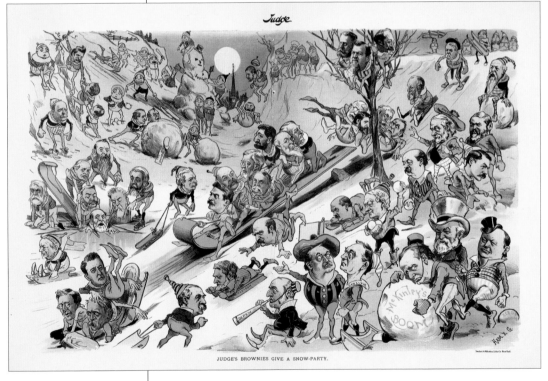

Judge's Brownies Give a Snow-Party.

Sackett & Wilhelms Litho, Co. after Grant E. Hamilton
and Bernhard Gillam
Judge, 12/29/1894
Lithograph, colored
11 x 18 inches (28.4 x 45.7 cm)
Cat. no. 38.00327.001

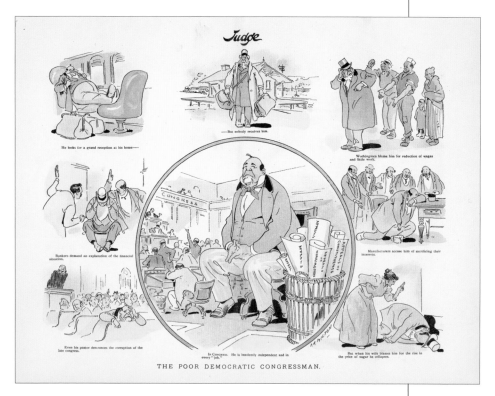

The Poor Democratic Congressman.

Unidentified after Grant E. Hamilton
Judge, 10/13/1894
Lithograph, colored
8 ½ x 11 inches (21.6 x 27.9 cm)
Cat. no. 38.00583.001

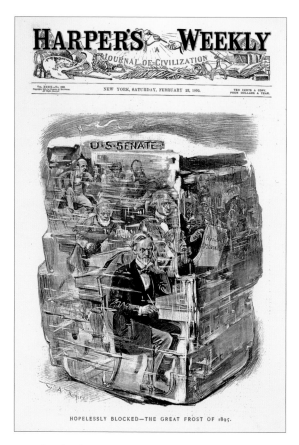

Hopelessly Blocked—The Great Frost of 1895.

Unidentified after William Allen Rogers
Harper's Weekly, 02/23/1895
Halftone, black and white
11 ½ x 9 inches (29.2 x 22.9 cm)
Cat. no. 38.00306.001

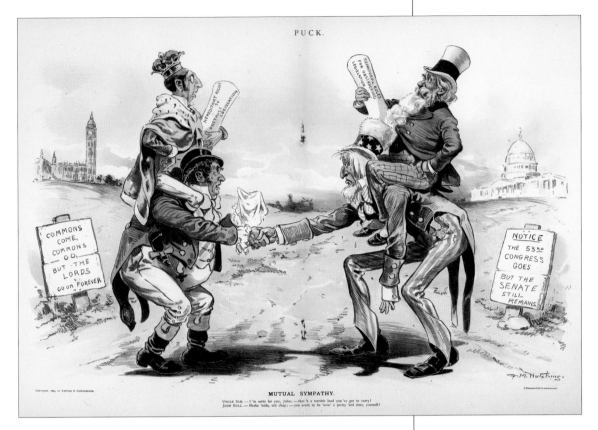

Mutual Sympathy.

J. Ottmann Lith. Co.
after Frank M. Hutchins
Puck, 02/27/1895
Lithograph, colored
12 ½ x 19 inches (31.8 x 48.3 cm)
Cat. no. 38.00604.001

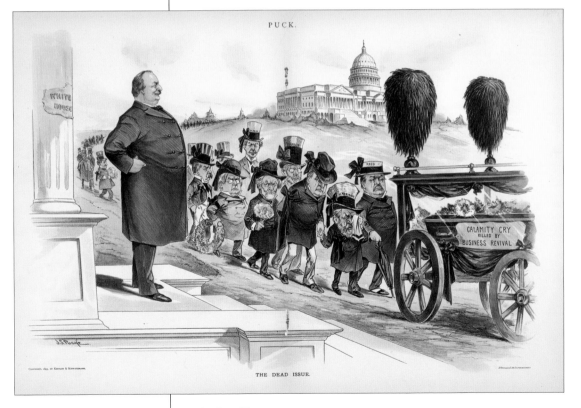

The Dead Issue.

J. Ottmann Lith. Co. after John S. Pughe
Puck, 06/05/1895
Lithograph, colored
12 ¼ x 18 ¾ inches (31.1 x 47.6 cm)
Cat. no. 38.00642.001

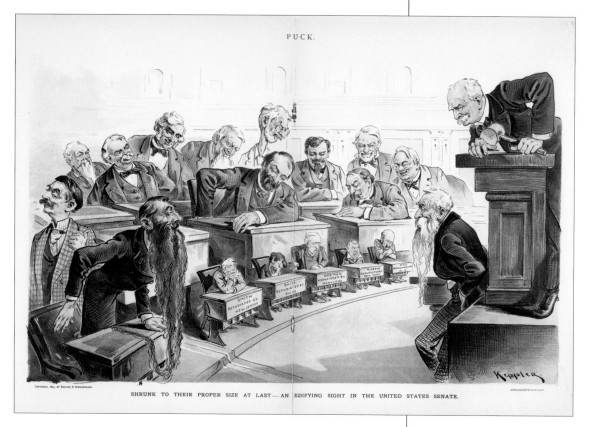

Shrunk to Their Proper Size at Last—An Edifying Sight in the United States Senate.

J. Ottmann Lith. Co. after Joseph Keppler, Jr.
Puck, 12/11/1895
Lithograph, colored
11 ½ x 18 ½ inches (29.2 x 47.0 cm)
Cat. no. 38.00653.001

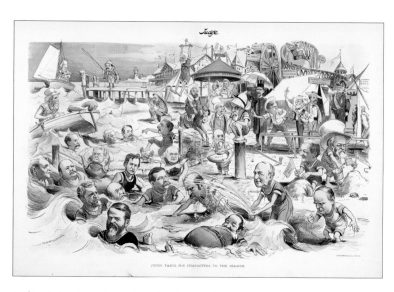

Judge Takes His Characters to the Seaside.

Sackett & Wilhelms Litho, Co. after Grant E. Hamilton
Judge, 08/03/1895
Lithograph, colored
12 ¼ x 18 inches (31.1 x 45.7 cm)
Cat. no. 38.00901.001

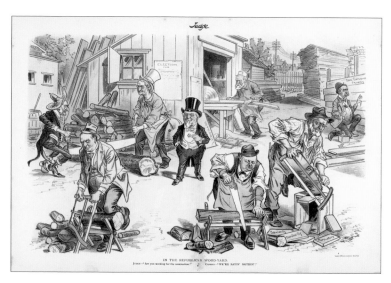

In the Republican Wood-Yard.

Sackett & Wilhelms Litho, Co. after F. Victor Gillam
Judge, 08/24/1895
Lithograph, colored
12 x 17 ½ inches (30.5 x 44.5 cm)
Cat. no. 38.00830.001

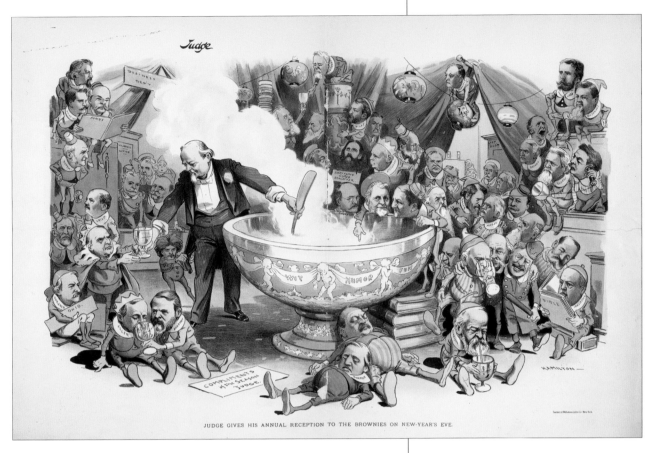

Judge Gives His Annual Reception to the Brownies on New-Year's Eve.

Sackett & Wilhelms Litho, Co. after Grant E. Hamilton
Judge, 01/04/1896
Lithograph, colored
12 x 18 inches (30.5 x 45.7 cm)
Cat. no. 38.00902.001

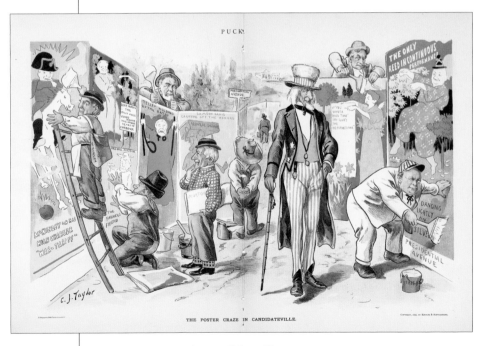

The Poster Craze in Candidateville.

J. Ottmann Lith. Co. after Charles J. Taylor
Puck, 03/11/1896
Lithograph, colored
11 ½ x 17 ⅞ inches (29.2 x 45.4 cm)
Cat. no. 38.00305.001

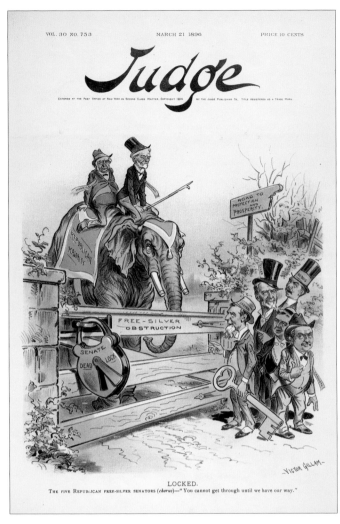

Locked.

Unidentified after F. Victor Gillam
Judge, 03/21/1896
Lithograph, colored
9 ¾ x 8 inches (24.8 x 20.3 cm)
Cat. no. 38.00325.001

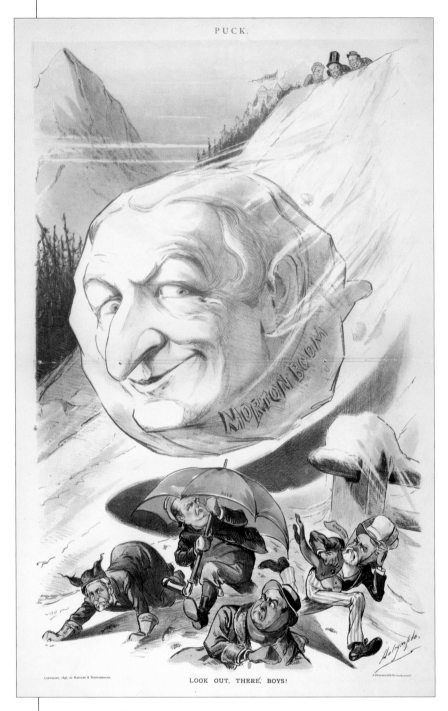

Look Out, There, Boys!

J. Ottmann Lith. Co. after Louis Dalrymple
Puck, 02/19/1896
Lithograph, colored
18 ⅝ x 11 ½ inches (47.3 x 29.2 cm)
Cat. no. 38.00304.001

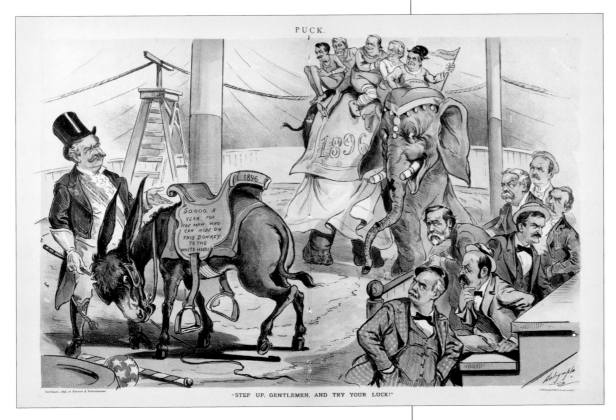

"Step Up, Gentlemen, and Try Your Luck!"

J. Ottmann Lith. Co.
after Louis Dalrymple
Puck, 04/15/1896
Lithograph, colored
11 ¾ x 18 ⅛ inches (29.8 x 46.0 cm)
Cat. no. 38.00302.001

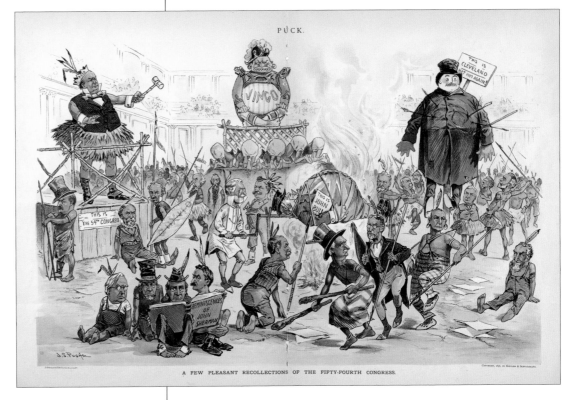

A Few Pleasant Recollections of the Fifty-Fourth Congress.

J. Ottmann Lith. Co. after John S. Pughe
Puck, 05/27/1896
Lithograph, colored
12 x 18 ½ inches (30.5 x 47.0 cm)
Cat. no. 38.00303.001

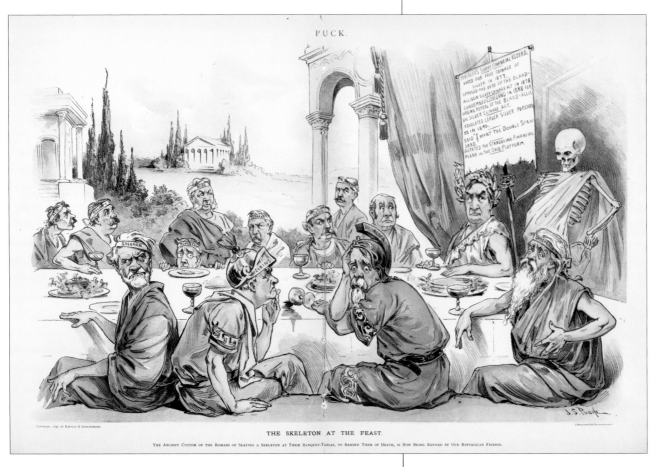

The Skeleton at the Feast.

J. Ottmann Lith. Co. after John S. Pughe
Puck, 06/10/1896
Lithograph, colored
12 x 18 ¾ inches (30.5 x 47.6 cm)
Cat. no. 38.00300.001

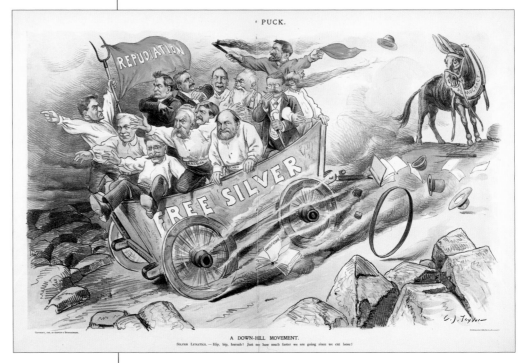

A Down-Hill Movement.

J. Ottmann Lith. Co. after Charles J. Taylor
Puck, 08/12/1896
Lithograph, colored
11 ⅞ x 18 ½ inches (30.2 x 47.0 cm)
Cat. no. 38.00299.001

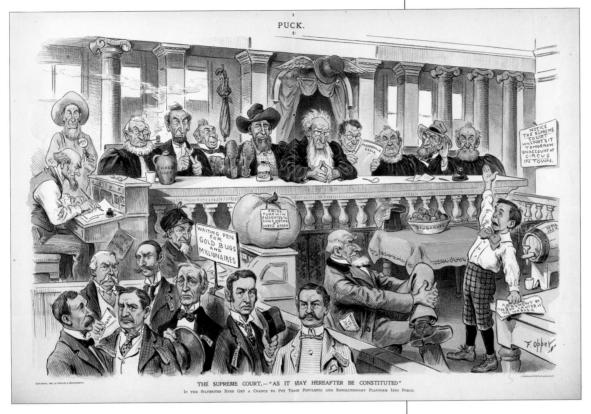

The Supreme Court,—"As It May Hereafter Be Constituted"

J. Ottmann Lith. Co. after Frederick B. Opper
Puck, 09/09/1896
Lithograph, colored
12 ¼ x 18 ¾ inches (31.1 x 47.6 cm)
Cat. no. 38.00356.001

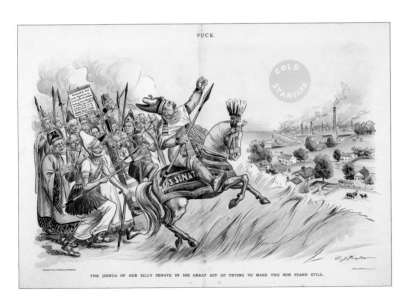

The Joshua of Our Silly Senate in His Great Act of Trying to Make the Sun Stand Still.

J. Ottmann Lith. Co. after Charles J. Taylor
Puck, 01/06/1897
Lithograph, colored
12 x 17 ¼ inches (30.5 x 43.8 cm)
Cat. no. 38.00417.001

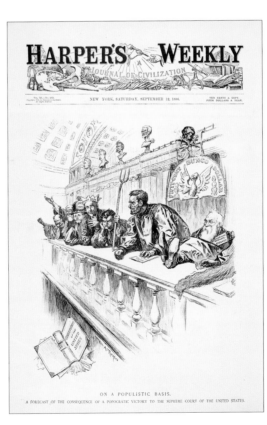

On a Populistic Basis.

Unidentified after William Allen Rogers
Harper's Weekly, 09/12/1896
Halftone, black and white
12 x 8 ¾ inches (30.5 x 22.2 cm)
Cat. no. 38.00879.001

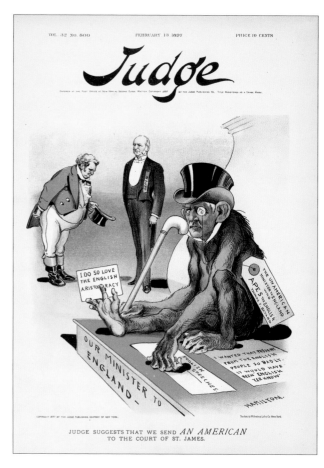

Judge Suggests That We Send an American to the Court of St. James.

Sackett & Wilhelms Litho, Co. after Grant E. Hamilton
Judge, 02/13/1897
Lithograph, colored
9 ¾ x 8 ¼ inches (24.8 x 21.0 cm)
Cat. no. 38.00949.001

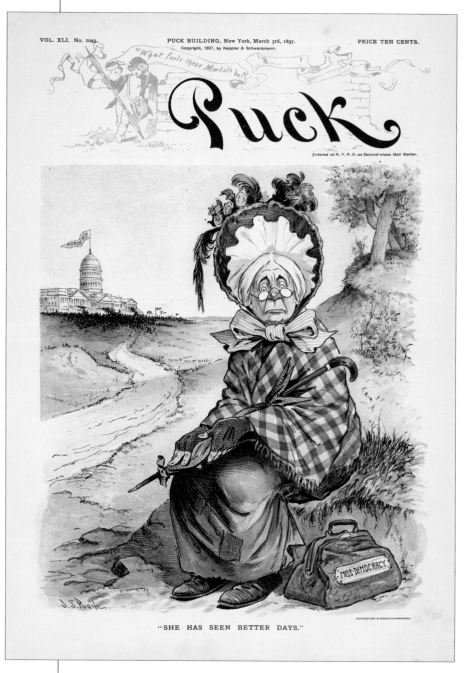

"She Has Seen Better Days."

Unidentified after John S. Pughe
Puck, 03/03/1897
Lithograph, colored
9 ¹¹⁄₁₆ x 8 ⅜ inches (24.6 x 21.3 cm)
Cat. no. 38.00433.001

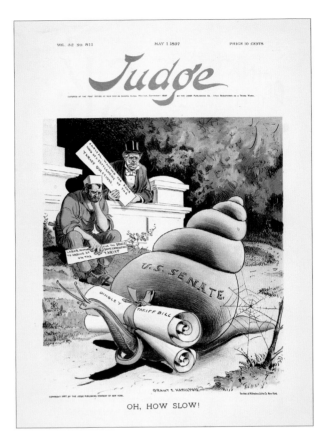

Oh, How Slow!

Sackett & Wilhelms Litho, Co.
after Grant E. Hamilton
Judge, 05/01/1897
Lithograph, colored
9 ¾ x 8 inches (24.8 x 20.3 cm)
Cat. no. 38.00641.001

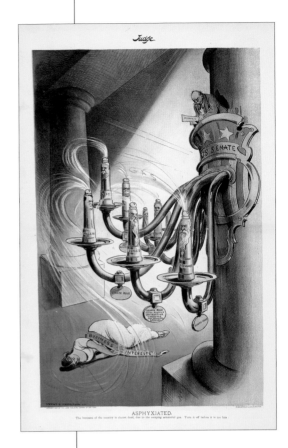

Asphyxiated.

Sackett & Wilhelms Litho, Co.
after Grant E. Hamilton
Judge, 06/05/1897
Lithograph, colored
19 ¾ x 11 inches (50.2 x 27.9 cm)
Cat. no. 38.00428.001

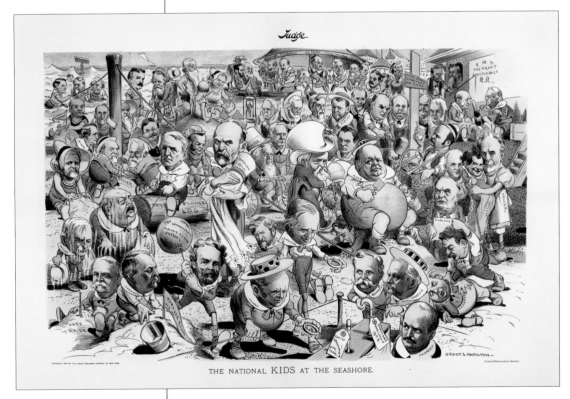

The National Kids at the Seashore.

Sackett & Wilhelms Litho, Co. after Grant E. Hamilton
Judge, 06/19/1897
Lithograph, colored
11 ½ x 17 ½ inches (29.2 x 44.5 cm)
Cat. no. 38.00643.001

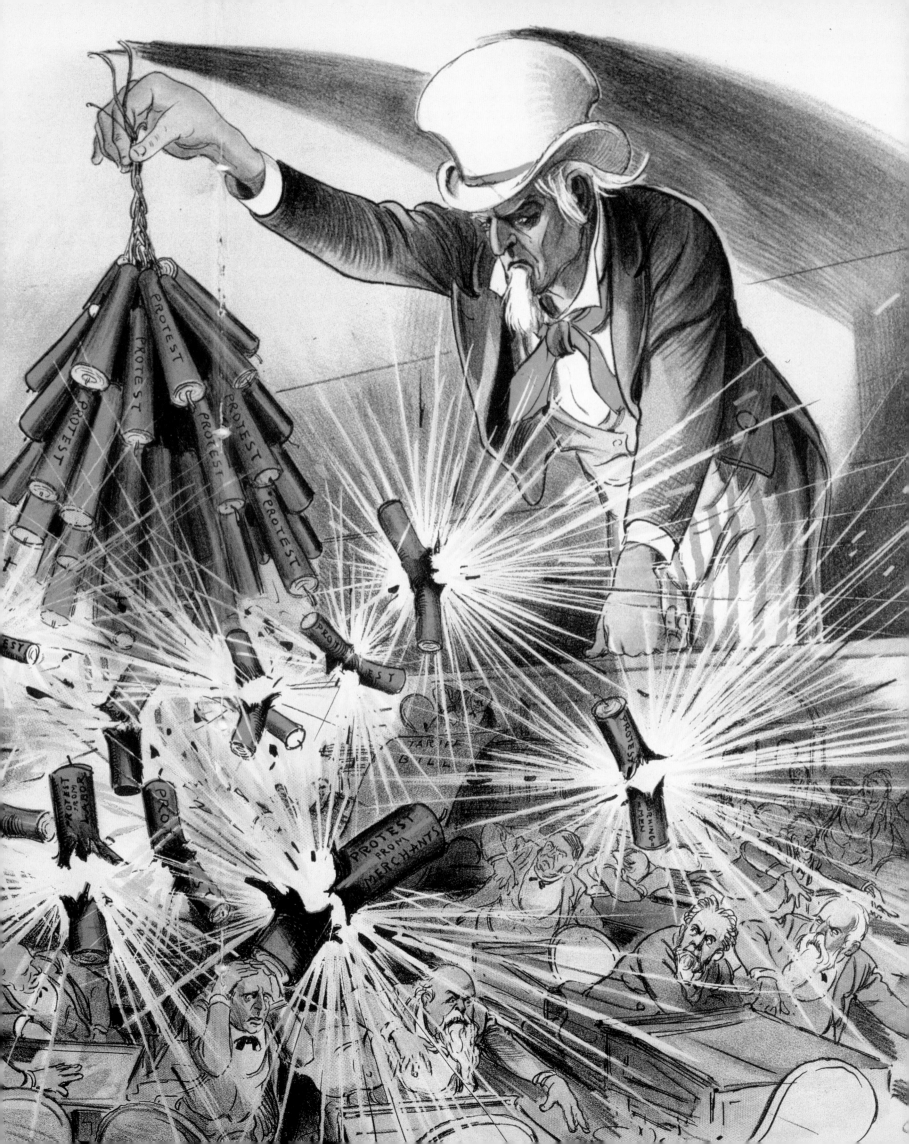

The sweeping victories of President William McKinley and congressional Republicans in 1896 had led inevitably to a reconsideration of tariffs as soon as the new Congress convened. Democrats and Republican insurgents favored lower tariffs, while McKinley, a former chairman of the House Ways and Means Committee, had made his name synonymous with protective tariffs. Early in 1897 the House speedily passed the Dingley Tariff, named after Republican Representative Norman Dingley of Maine, to both raise rates and encourage trade reciprocity.

In the Senate, opponents launched a filibuster, but the bill passed on July 7, 1897. In this cartoon by Grant E. Hamilton, which appeared in *Puck* just a few days earlier on July 3, Uncle Sam, who represents the American people, has clearly grown tired of the filibuster's delaying tactics and uses a few Fourth of July firecrackers to awaken the senators. ☙

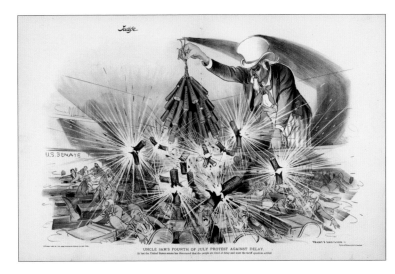

Uncle Sam's Fourth of July Protest Against Delay.

Sackett & Wilhelms Litho, Co. after Grant E. Hamilton
Judge, 07/03/1897
Lithograph, colored
12 x 18 inches (30.5 x 45.7 cm)
Cat. no. 38.00621.001

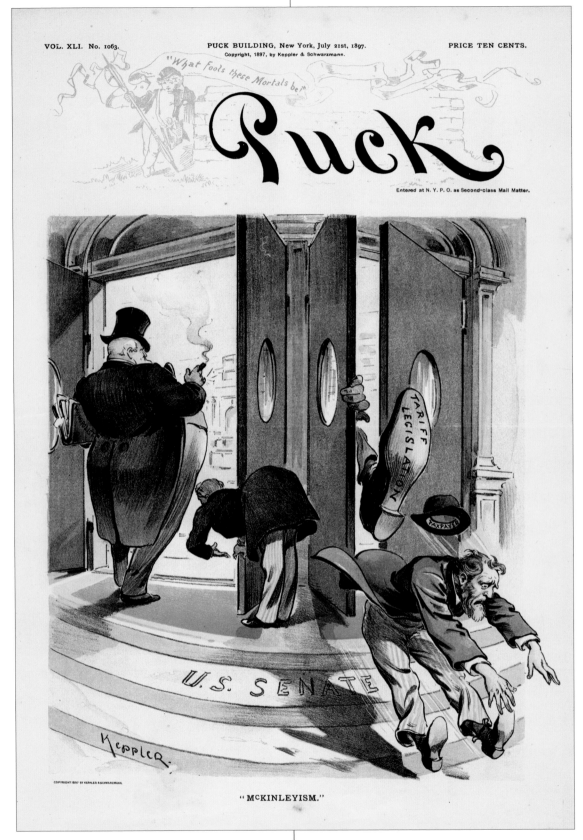

"McKinleyism"

Unidentified after Joseph Keppler, Jr.
Puck, 07/21/1897
Lithograph, colored
9 ⅝ x 9 inches (24.4 x 22.9 cm)
Cat. no. 38.00418.001

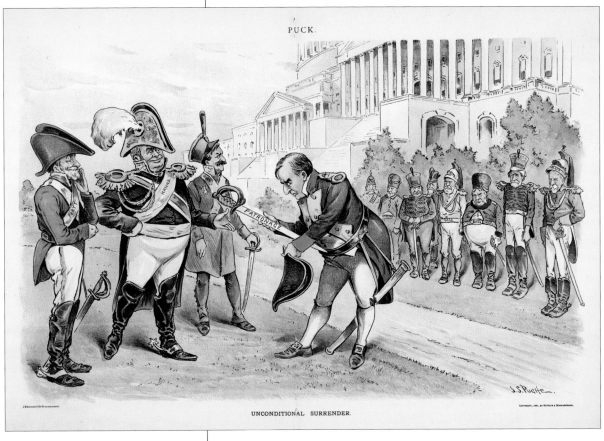

Unconditional Surrender.

J. Ottmann Lith. Co. after John S. Pughe
Puck, 08/11/1897
Lithograph, colored
11 ½ x 17 ¾ inches (29.2 x 45.1 cm)
Cat. no. 38.00436.001

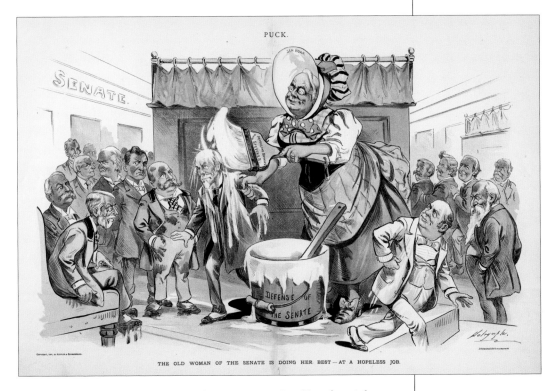

The Old Woman of the Senate Is Doing Her Best—At a Hopeless Job.

J. Ottmann Lith. Co. after Louis Dalrymple
Puck, 11/03/1897
Lithograph, colored
11 ½ x 18 inches (29.2 x 45.7 cm)
Cat. no. 38.00421.001

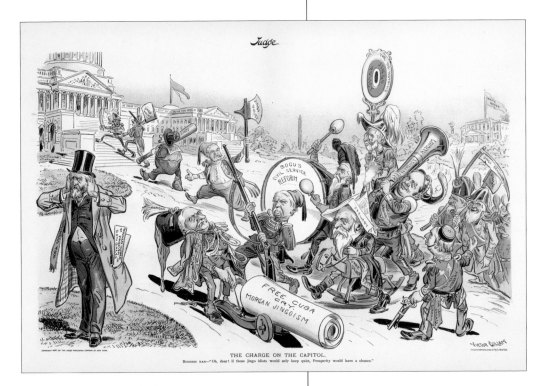

The Charge on the Capitol.

Sackett & Wilhelms Litho, Co. after F. Victor Gillam
Judge, 12/11/1897
Lithograph, colored
12 x 18 inches (30.5 x 45.7 cm)
Cat. no. 38.00644.001

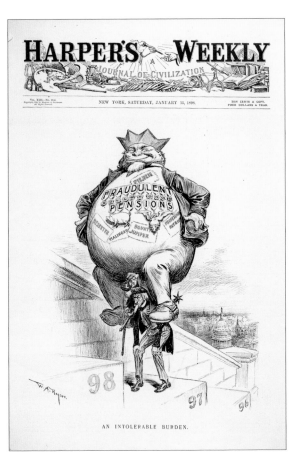

An Intolerable Burden.

Unidentified after William Allen Rogers
Harper's Weekly, 01/15/1898
Lithograph, black and white
11 1/16 x 8 1/2 inches (28.1 x 21.6 cm)
Cat. no. 38.00231.001

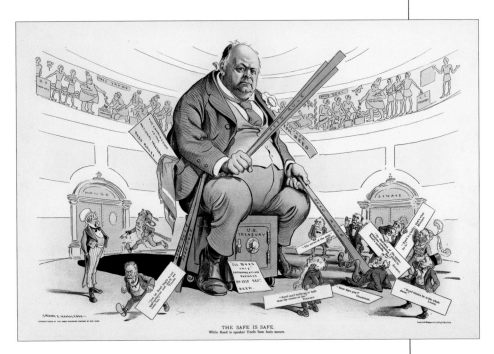

The Safe Is Safe.

Sackett & Wilhelms Litho, Co. after Grant E. Hamilton
Judge, 01/08/1898
Lithograph, colored
12 x 17 3/4 inches (30.5 x 45.1 cm)
Cat. no. 38.00647.001

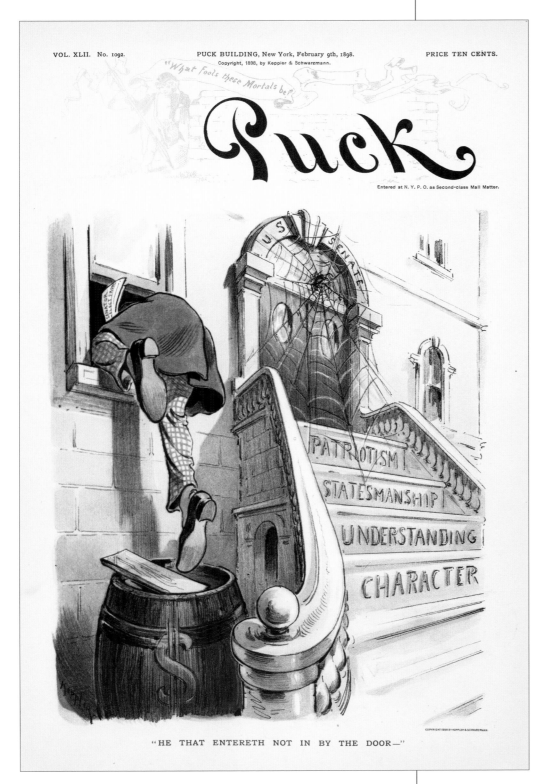

"He That Entereth Not in by the Door—"

Unidentified after Joseph Keppler, Jr.
Puck, 02/09/1898
Lithograph, colored
9 ½ x 8 inches (24.1 x 20.3 cm)
Cat. no. 38.00612.001

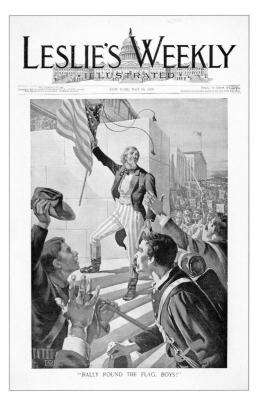

"Rally Round the Flag, Boys!"

Unidentified after E. N. Blue
Leslie's Weekly, 05/26/1898
Halftone, black and white
11 ⅜ x 8 ¼ inches (28.9 x 21.0 cm)
Cat. no. 38.00236.001

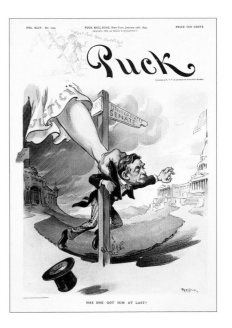

Has She Got Him at Last?

Unidentified after Joseph Keppler, Jr.
Puck, 01/25/1899
Lithograph, colored
10 x 9 inches (25.4 x 22.9 cm)
Cat. no. 38.00616.001

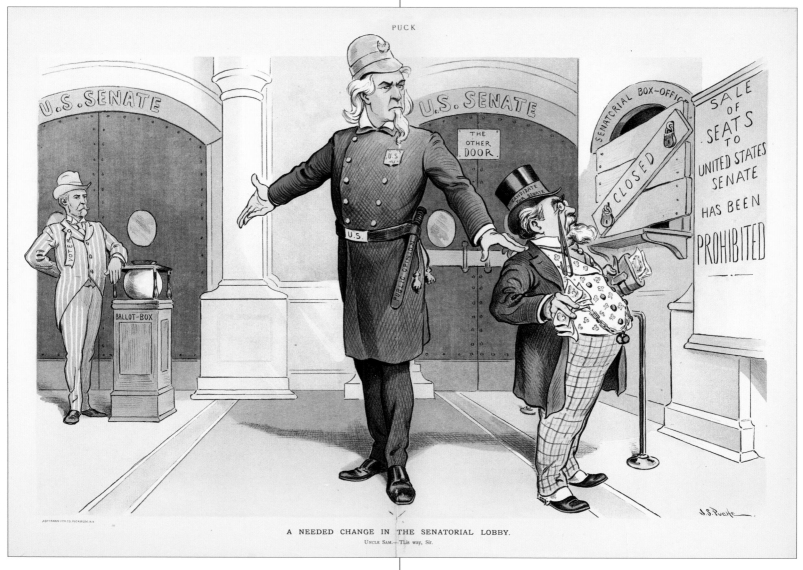

A Needed Change in the Senatorial Lobby.

Unidentified after John S. Pughe
Puck, ca. 1900
Lithograph, colored
12 ¼ x 18 inches (31.1 x 45.7 cm)
Cat. no. 38.00553.001

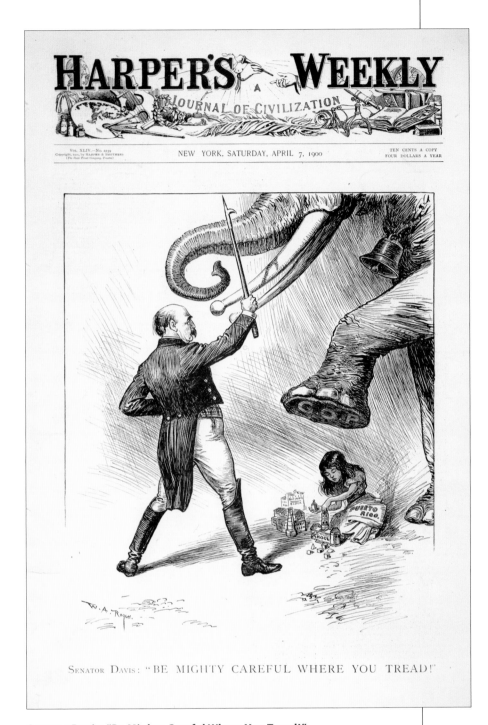

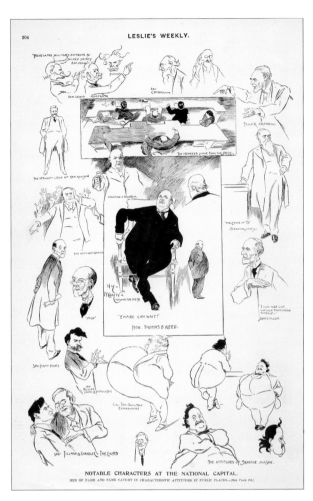

Notable Characters at the National Capital.

Unidentified after H. Y. Mayer
Leslie's Weekly, 03/16/1899
Lithograph, black and white
14½ x 9¼ inches (36.8 x 23.5 cm)
Cat. no. 38.00587.001

Senator Davis: "Be Mighty Careful Where You Tread!"

Unidentified after William Allen Rogers
Harper's Weekly, 04/07/1900
Lithograph, black and white
10¾ x 8½ inches (27.3 x 21.6 cm)
Cat. no. 38.00823.001

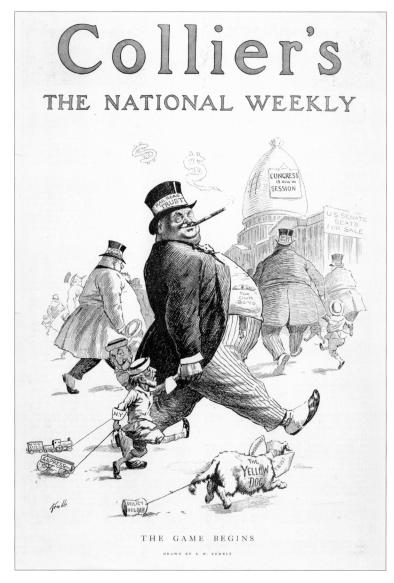

The Game Begins

Unidentified after Edward W. Kemble
Collier's, ca. 1900
Lithograph, black and white
11 ½ x 9 ¼ inches (29.2 x 23.5 cm)
Cat. no. 38.00640.001

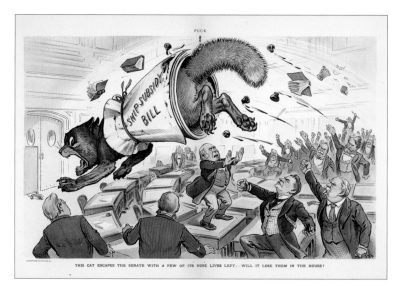

**This Cat Escapes the Senate with a Few of Its Nine Lives Left; —
Will It Lose Them in the House?**

J. Ottmann Lith. Co. after John S. Pughe
Puck, 04/02/1902
Lithograph, colored
11 ½ x 18 inches (29.2 x 45.7 cm)
Cat. no. 38.00602.001

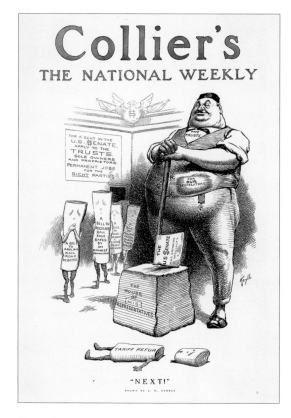

"Next!"

Unidentified after Edward W. Kemble
Collier's, 02/11/1905
Lithograph, black and white
11 x 8 ½ inches (27.9 x 21.6 cm)
Cat. no. 38.00655.001

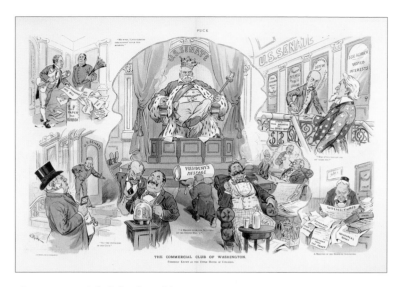

The Commercial Club of Washington.

J. Ottmann Lith. Co. after John S. Pughe
Puck, 10/25/1905
Lithograph, colored
12 x 18 inches (30.5 x 45.7 cm)
Cat. no. 38.00625.001

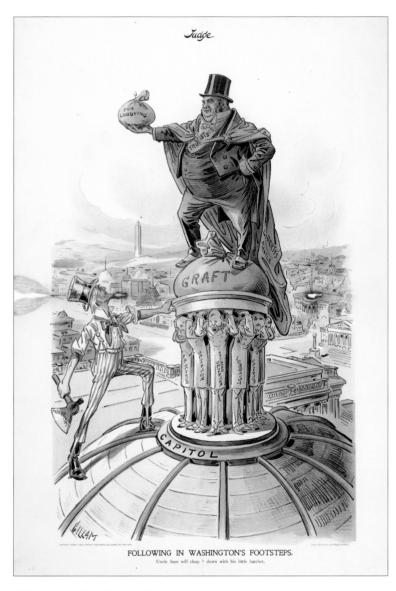

Following in Washington's Footsteps.

Sackett & Wilhelms Litho, Co. after Bernhard Gillam
Judge, 02/25/1905
Lithograph, colored
17 ½ x 11 ⅛ inches (44.5 x 28.3 cm)
Cat. no. 38.00693.001

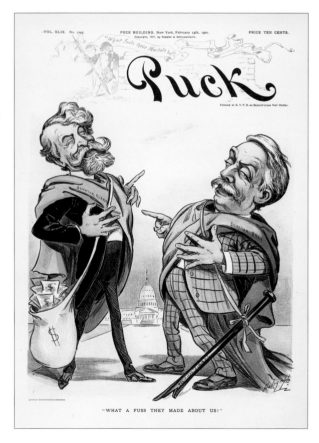

"What a Fuss They Made about Us!"

Unidentified after Louis Dalrymple
Puck, 02/13/1901
Lithograph, colored
10 x 8 ⅝ inches (25.4 x 21.9 cm)
Cat. no. 38.00886.001

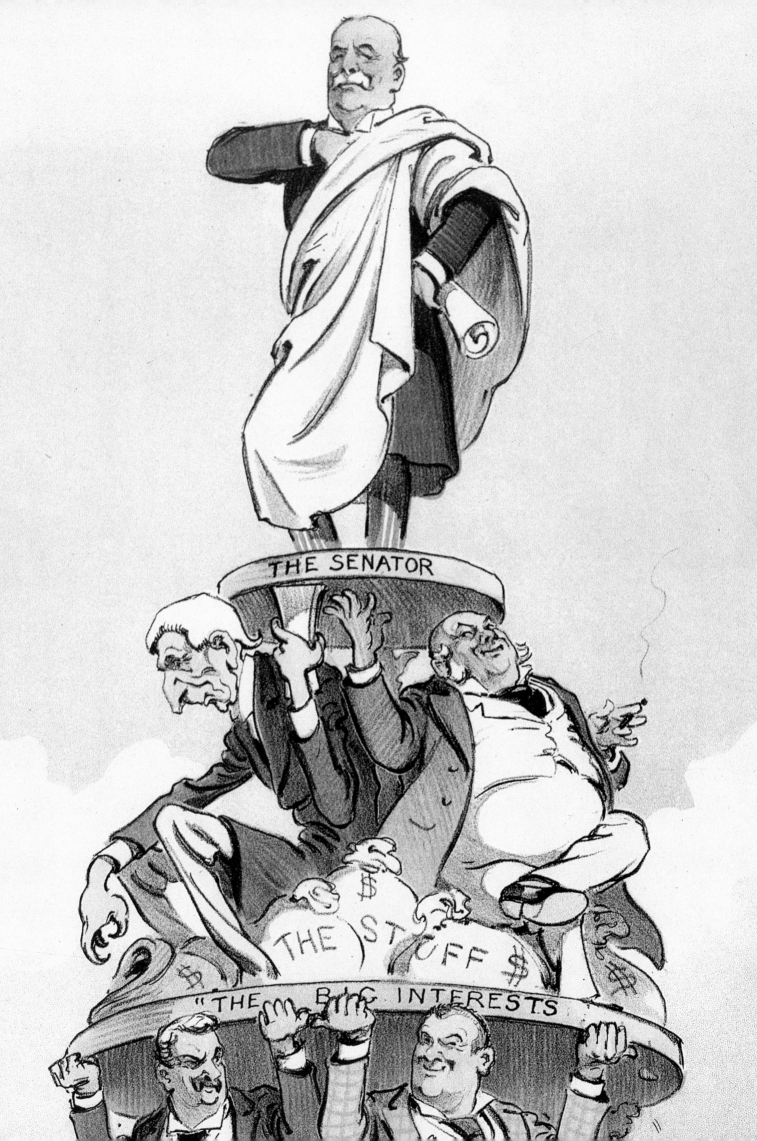

The "people" were at the bottom of the pile when it came to electing U.S. senators, when Joseph Keppler, Jr.'s cartoon, "The Making of a Senator," appeared in *Puck* on November 15, 1905. Voters elected the state legislatures, which in turn elected senators. Keppler depicted two more tiers between state legislatures and senators: political bosses and corporate interests. Most notably, he drew John D. Rockefeller, Sr., head of the Standard Oil Corporation, perched on moneybags, on the left side of the "big interests."

This cartoon appeared while muckraking magazine writers such as Ida Tarbell and David Graham Phillips were accusing business of having corrupted American politics. The muckrakers charged senators with being financially beholden to the special interests. Reformers wanted the people to throw off the tiers between them and directly elect their senators—which was finally achieved with ratification of the 17th Amendment in 1913. ☙

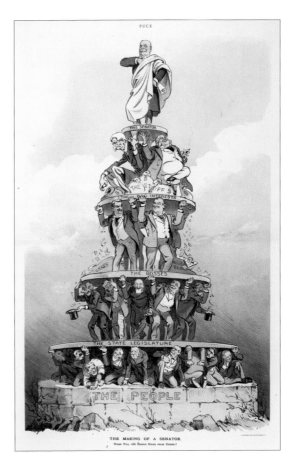

The Making of a Senator.

J. Ottmann Lith. Co. after Joseph Keppler, Jr.
Puck, 11/15/1905
Lithograph, colored
18 ½ x 11 ½ inches (47.0 x 29.2 cm)
Cat. no. 38.00624.001

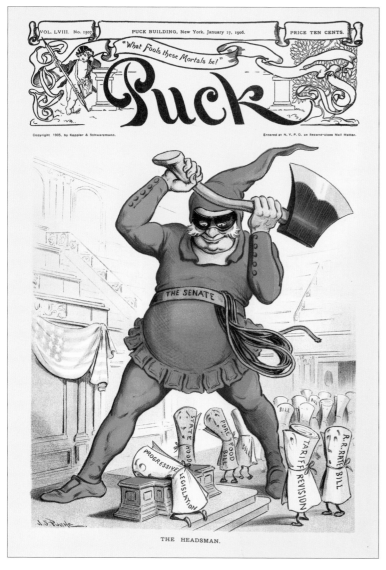

The Headsman.

Unidentified after John S. Pughe
Puck, 01/17/1906
Lithograph, colored
9 ¾ x 8 inches (24.8 x 20.3 cm)
Cat. no. 38.00600.001

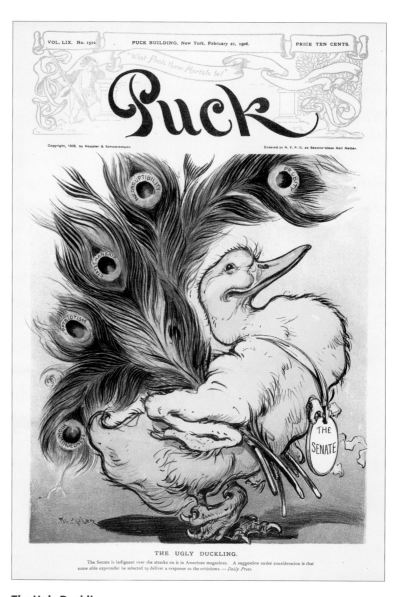

The Ugly Duckling.

Unidentified after Joseph Keppler, Jr.
Puck, 02/21/1906
Lithograph, colored
10 ⅛ x 8 ¼ inches (25.7 x 21.0 cm)
Cat. no. 38.00592.001

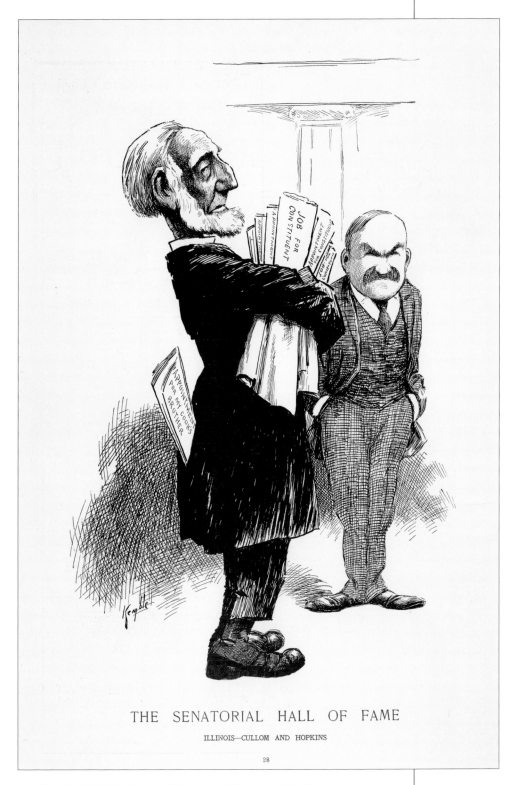

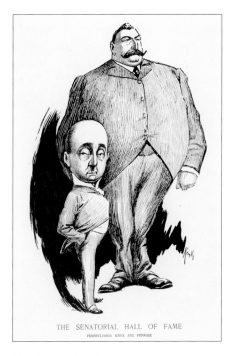

The Senatorial Hall of Fame / Pennsylvania—Knox and Penrose

Unidentified after Edward W. Kemble
Harper's Weekly, 01/09/1909
Lithograph, black and white
14 x 8 ¼ inches (35.6 x 21.0 cm)
Cat. no. 38.00158.001

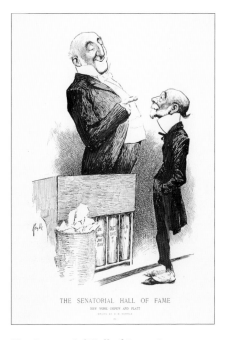

The Senatorial Hall of Fame / New York—Depew and Platt

Unidentified after Edward W. Kemble
Harper's Weekly, 01/30/1909
Lithograph, black and white
14 x 8 ½ inches (35.6 x 21.6 cm)
Cat. no. 38.00174.001

The Senatorial Hall of Fame / Illinois—Cullom and Hopkins

Unidentified after Edward W. Kemble
Harper's Weekly, 04/17/1908
Lithograph, black and white
14 ⅜ x 8 ¼ inches (36.5 x 21.0 cm)
Cat. no. 38.00172.001

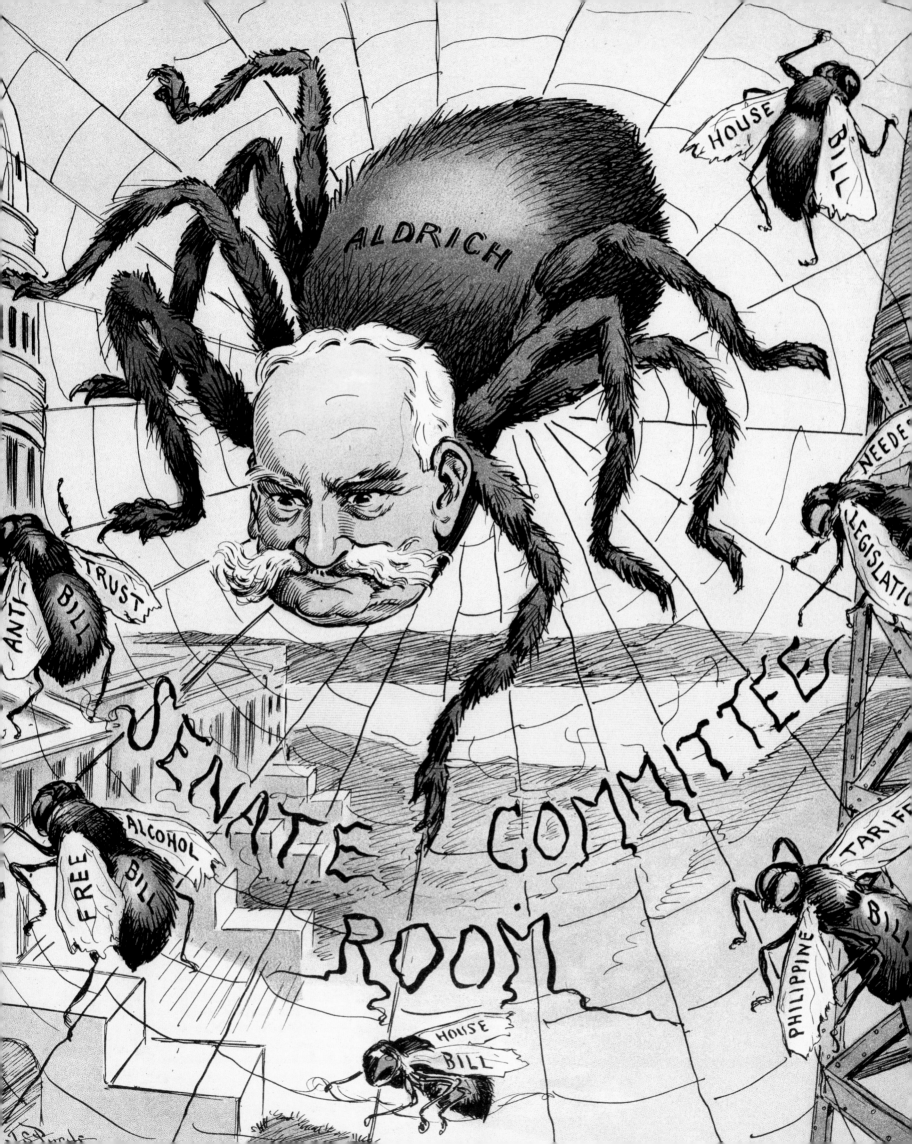

*I*n the first years of the 20th century, a small number of committee chairmen dominated the federal government. As one newspaper reporter observed, the four most powerful senators could "block and defeat anything that the president or the House may desire."[1] Among the "Senate Four," the unquestioned leader was Republican Senator Nelson W. Aldrich of Rhode Island, who chaired the Finance Committee. John S. Pughe, in a cartoon that appeared in *Puck* on May 16, 1906, portrayed Aldrich as a large, menacing spider who had trapped worthwhile legislation in the web of his Senate committee room, with the implication that these bills would be devoured rather than enacted. Aldrich's web is anchored both in the U.S. Capitol and in the Standard Oil Corporation, an allusion to the marriage of his daughter, Abby Aldrich, to John D. Rockefeller, Jr. ☯

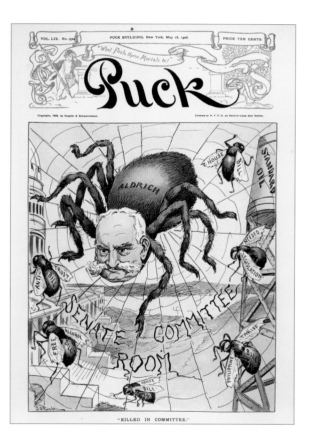

"Killed in Committee."

Unidentified after John S. Pughe
Puck, 05/16/1906
Lithograph, colored
9 ¾ x 8 ¼ inches (24.8 x 21.0 cm)
Cat. no. 38.00597.001

[1] Charles Willis Thompson, *Party Leaders of the Time* (New York: G. W. Dillingham, 1906), 27.

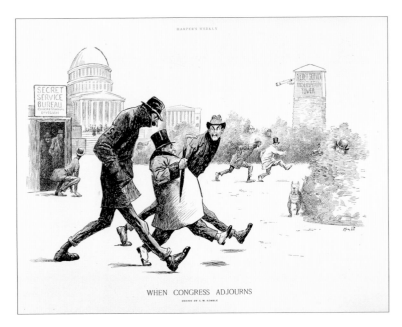

When Congress Adjourns

Unidentified after Edward W. Kemble
Harper's Weekly, 01/30/1909
Lithograph, black and white
14 x 19 ½ inches (35.6 x 49.5 cm)
Cat. no. 38.00164.001

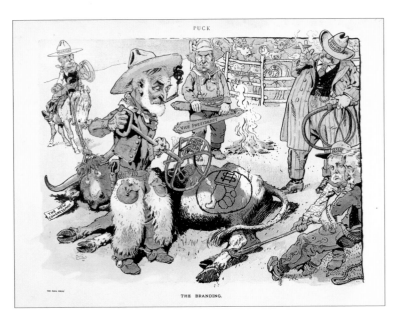

The Branding.

Unidentified after Will Crawford
Puck, 02/17/1909
Lithograph, colored
8 ¾ x 11 inches (22.2 x 27.9 cm)
Cat. no. 38.00596.001

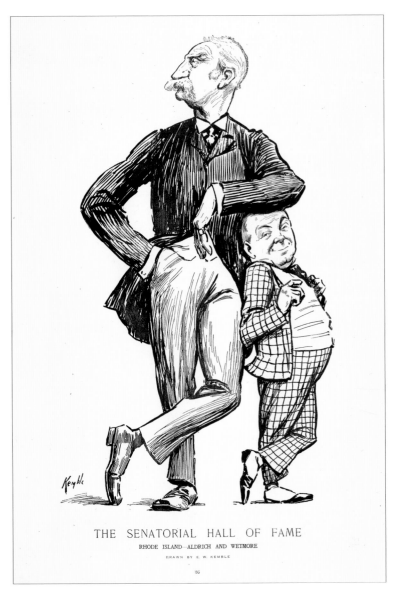

The Senatorial Hall of Fame / Rhode Island—Aldrich and Wetmore

Unidentified after Edward W. Kemble
Harper's Weekly, 02/06/1909
Lithograph, black and white
14 ½ x 7 ½ inches (36.8 x 19.1 cm)
Cat. no. 38.00175.001

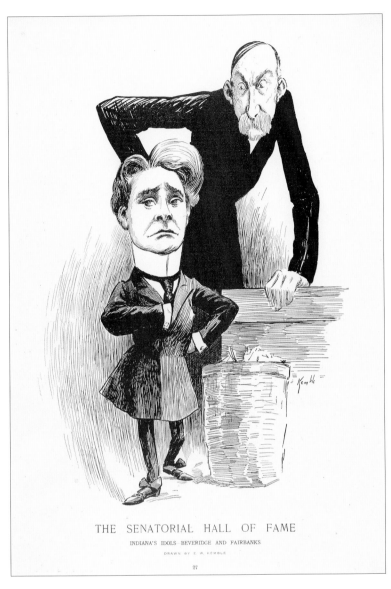

**The Senatorial Hall of Fame / Indiana's Idols—
Beveridge and Fairbanks**

Unidentified after Edward W. Kemble
Harper's Weekly, 02/20/1909
Lithograph, black and white
14 ½ x 9 inches (36.8 x 22.9 cm)
Cat. no. 38.00177.001

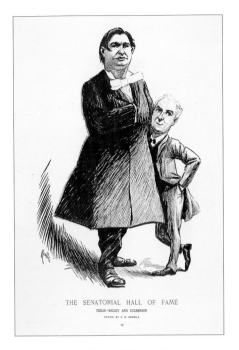

**The Senatorial Hall of Fame / Texas—
Bailey and Culberson**

Unidentified after Edward W. Kemble
Harper's Weekly, 02/27/1909
Lithograph, black and white
14 ⅛ x 8 ⅜ inches (35.9 x 21.3 cm)
Cat. no. 38.00169.001

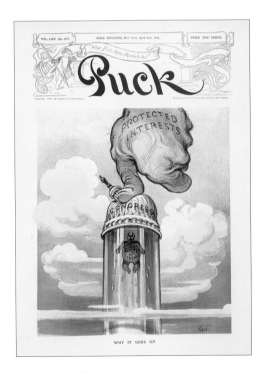

Why It Goes Up.

Unidentified after Joseph Keppler, Jr.
Puck, 04/21/1909
Lithograph, colored
9 ¼ x 7 ⅞ inches (23.5 x 20.0 cm)
Cat. no. 38.00595.001

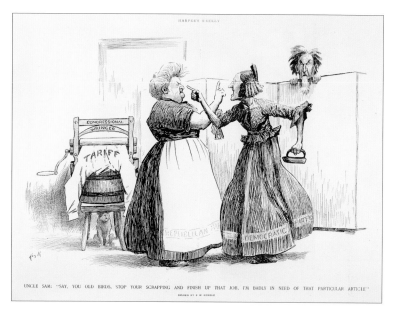

Uncle Sam: "Say, You Old Birds, Stop Your Scrapping and Finish Up That Job, I'm Badly in Need of That Particular Article"

Unidentified after Edward W. Kemble
Harper's Weekly, 04/24/1909
Lithograph, black and white
13 ¾ x 10 ¾ inches (34.9 x 27.3 cm)
Cat. no. 38.00157.001

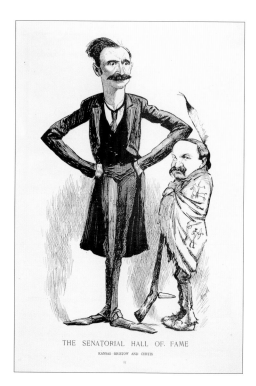

**The Senatorial Hall of Fame /
Kansas—Bristow and Curtis**

Unidentified after Edward W. Kemble
Harper's Weekly, 05/08/1909
Lithograph, black and white
14 x 8 inches (35.6 x 20.3 cm)
Cat. no. 38.00176.001

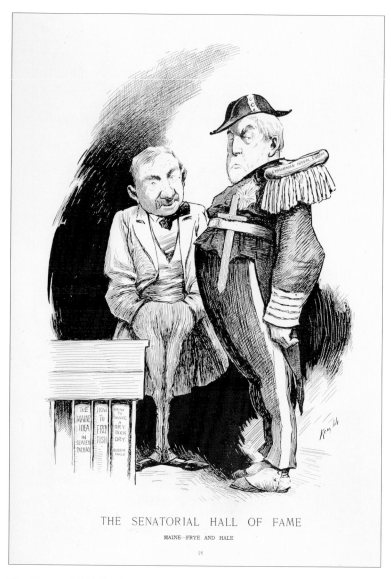

The Senatorial Hall of Fame / Maine—Frye and Hale

Unidentified after Edward W. Kemble
Harper's Weekly, 05/29/1909
Lithograph, black and white
14 ¼ x 8 ¾ inches (36.2 x 22.2 cm)
Cat. no. 38.00173.001

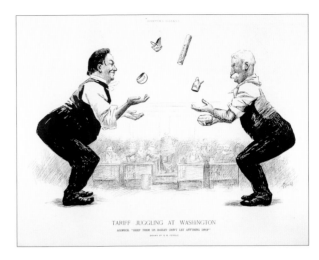

Tariff Juggling at Washington

Unidentified after Edward W. Kemble
Harper's Weekly, 07/10/1909
Lithograph, black and white
13 ½ x 19 ½ inches (34.3 x 49.5 cm)
Cat. no. 38.00160.001

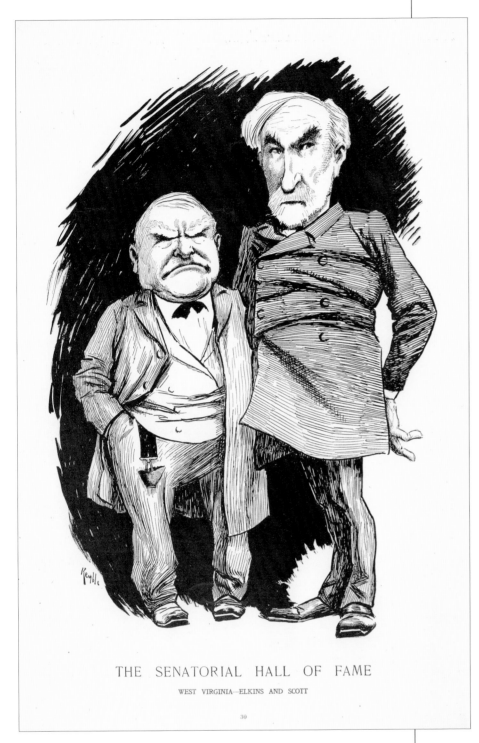

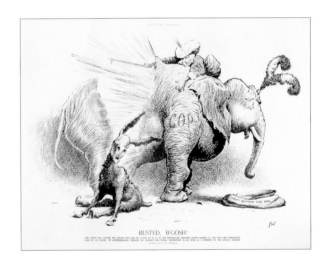

Busted, B'Gosh!

Unidentified after Edward W. Kemble
Harper's Weekly, 07/24/1909
Lithograph, black and white
14 ¼ x 19 inches (36.2 x 48.3 cm)
Cat. no. 38.00162.001

The Senatorial Hall of Fame / West Virginia—Elkins and Scott

Unidentified after Edward W. Kemble
Harper's Weekly, 06/12/1909
Lithograph, black and white
14 x 8 ¾ inches (35.6 x 22.2 cm)
Cat. no. 38.00171.001

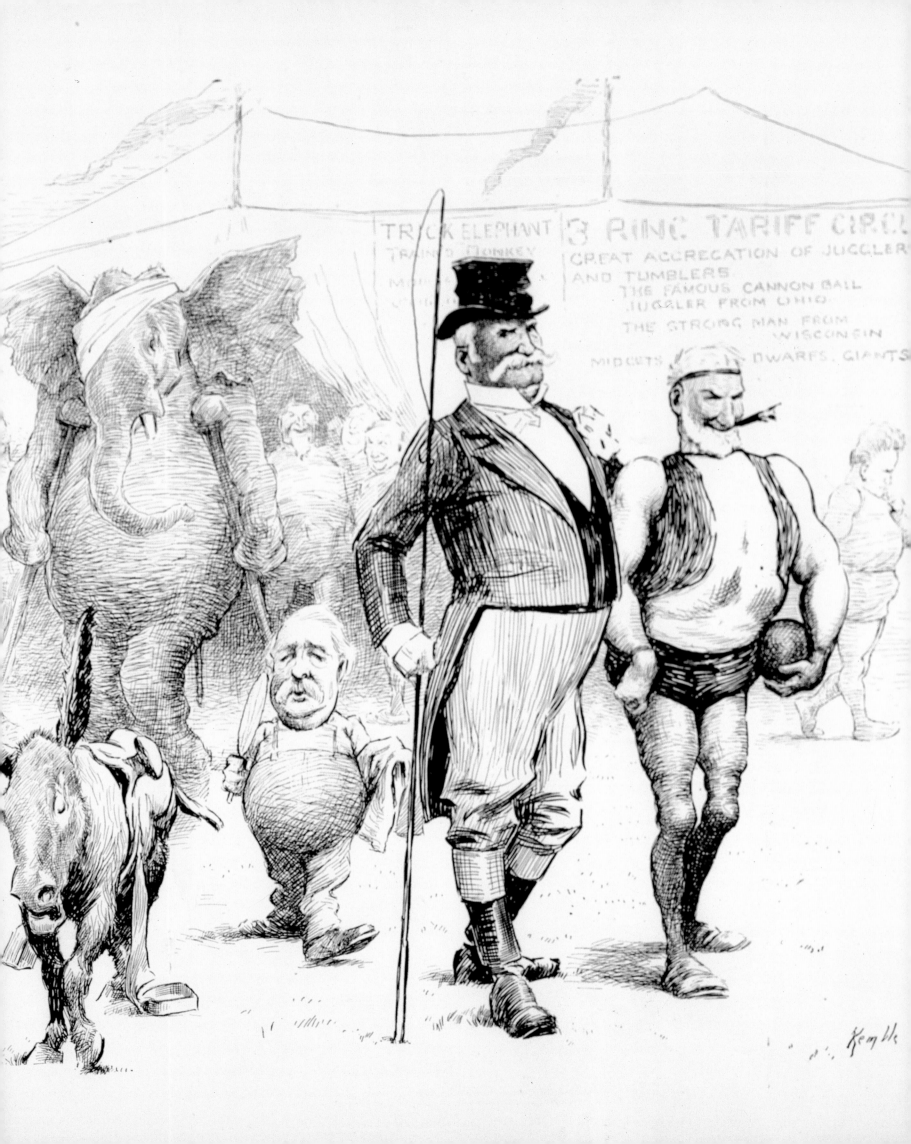

TRICK ELEPHANT
TRAINED DONKEY

3 RING TARIFF CIRCUS
GREAT AGGREGATION OF JUGGLERS
AND TUMBLERS
THE FAMOUS CANNON BALL
JUGGLER FROM OHIO
THE STRONG MAN FROM
WISCONSIN
MIDGETS DWARFS, GIANTS

Kemble

Portrayed as a circus, Congress has just adjourned in Edward W. Kemble's cartoon, which appeared in *Harper's Weekly* on August 14, 1909. President William Howard Taft, mopping his brow, has grabbed his golf clubs on the way out. Symbols of the two political parties appear bruised and tired after the fierce debates. The two dominant figures emerging are the strongman, House Speaker Joe Cannon, Republican of Illinois, and the ringmaster, the chairman of the Senate Finance Committee, Nelson W. Aldrich, Republican of Rhode Island.

Although President Taft had promised reformers that he would seek tariff reductions, Cannon and Aldrich engineered passage of the Payne-Aldrich Tariff of 1909, which raised tariff rates to record high levels. Three days after this cartoon appeared, Taft declared Payne-Aldrich "the best bill that the Republican party ever passed."[1] He thereby alienated Republican reformers and set the stage for a split in the party that would cause his defeat in the next election. ☙

[1] U.S. Senate, *Tariff Speech: Address of President Taft at Winona, Minnesota, September 17, 1909*, 61st Cong., 2d sess., 1909. S. Doc. 164, 11.

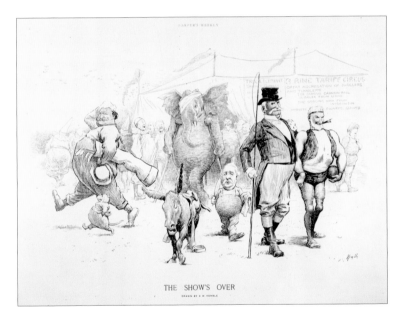

The Show's Over

Unidentified after Edward W. Kemble
Harper's Weekly, 08/14/1909
Lithograph, black and white
13 ¾ x 19 inches (34.9 x 48.3 cm)
Cat. no. 38.00161.001

Monopoly.

Unidentified after Louis M. Glackens
Puck, 12/15/1909
Lithograph, colored
11 ⁵⁄₁₆ x 17 ⅞ inches (28.7 x 45.4 cm)
Cat. no. 38.00439.001

A Bad Outlook for Harmony.

Unidentified after Louis M. Glackens
Puck, 12/22/1909
Lithograph, colored
11 ¾ x 17 ¾ inches (29.8 x 45.1 cm)
Cat. no. 38.00601.001

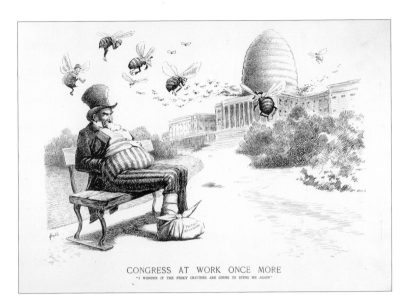

Congress at Work Once More

Unidentified after Edward W. Kemble
Collier's, 1909
Lithograph, black and white
9 ¼ x 12 ¼ inches (23.5 x 31.1 cm)
Cat. no. 38.00676.001

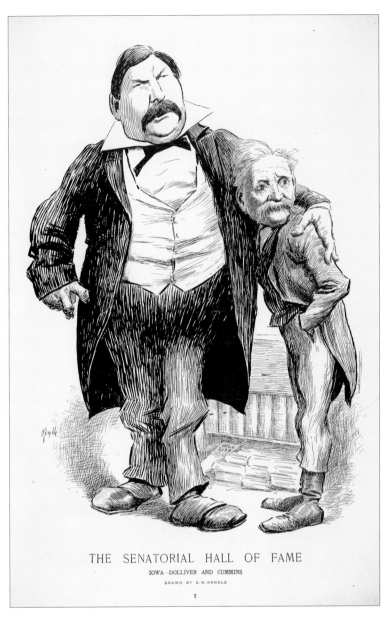

The Senatorial Hall of Fame / Iowa—Dolliver and Cummins

Unidentified after Edward W. Kemble
Harper's Weekly, 01/15/1910
Lithograph, black and white
14 x 9 ¼ inches (35.6 x 23.5 cm)
Cat. no. 38.00139.001

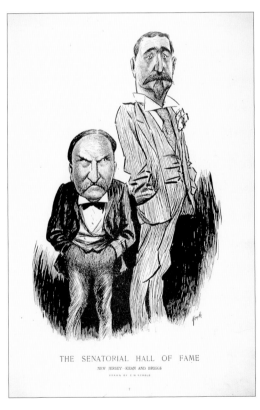

The Senatorial Hall of Fame / New Jersey—
Kean and Briggs

Unidentified after Edward W. Kemble
Harper's Weekly, 01/01/1910
Lithograph, black and white
13 ⅞ x 7 ⅝ inches (35.2 x 19.4 cm)
Cat. no. 38.00141.001

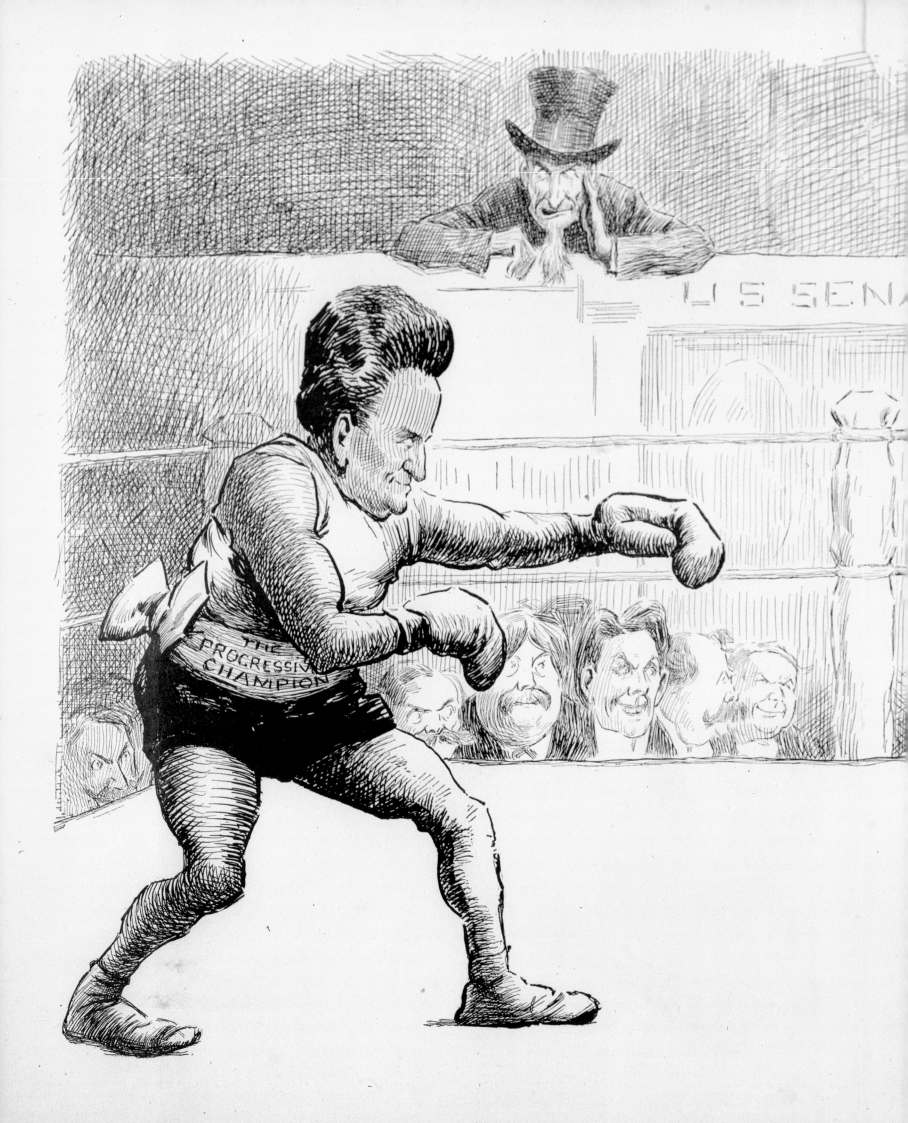

dward M. Kemble, the noted cartoonist and book illustrator, had no trouble taking sides in this prize fight between Republican Senators Robert M. La Follette of Wisconsin and Nelson W. Aldrich of Rhode Island. In this cartoon, which appeared in *Harper's Weekly* on February 26, 1910, Uncle Sam is calling down from the Senate gallery to urge La Follette on to victory.

Wearing a sash that identifies him as "The Progressive Champion," La Follette was still a freshman when he took on Aldrich, the chairman of the Senate Finance Committee, identified here as "The Machine Champion." La Follette fought against Aldrich's currency bill, which he saw as an unjustifiable financial boon to business interests. The little challenger lost the battle, but by the end of the year Aldrich retired from the Senate and the tide turned toward reform. ⤵

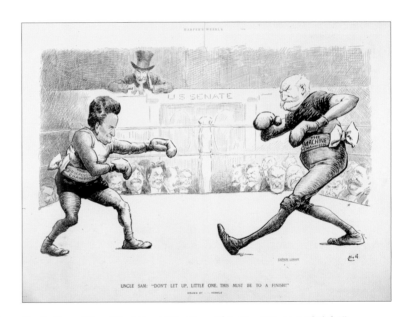

Uncle Sam: "Don't Let Up, Little One, This Must Be to a Finish!"

Unidentified after Edward W. Kemble
Harper's Weekly, 02/26/1910
Lithograph, black and white
13 ½ x 18 ¾ inches (34.3 x 47.6 cm)
Cat. no. 38.00181.001

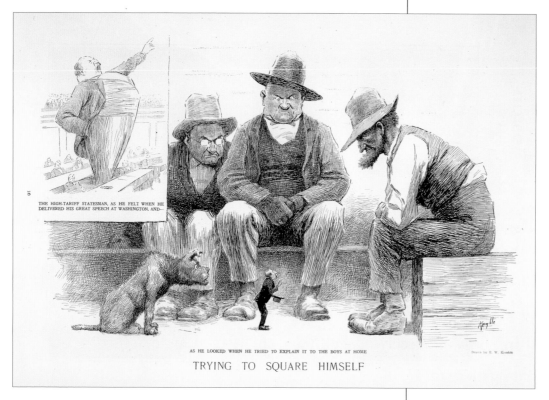

Trying to Square Himself

Unidentified after Edward W. Kemble
Harper's Weekly, 08/14/1910
Lithograph, black and white
9 ½ x 14 inches (24.1 x 35.6 cm)
Cat. no. 38.00183.001

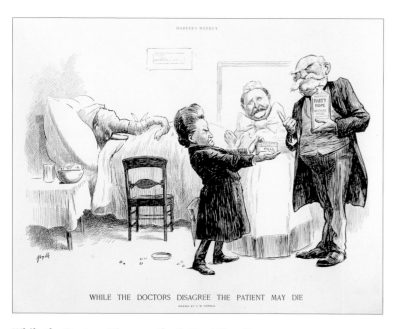

While the Doctors Disagree the Patient May Die

Unidentified after Edward W. Kemble
Harper's Weekly, 03/12/1910
Lithograph, black and white
13 ½ x 19 inches (34.3 x 48.3 cm)
Cat. no. 38.00182.001

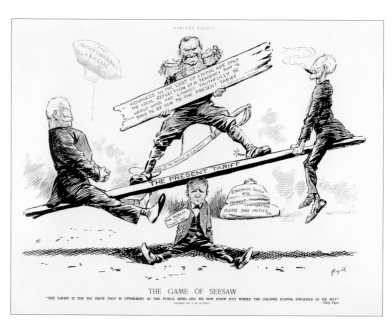

The Game of Seesaw

Unidentified after Edward W. Kemble
Harper's Weekly, 11/05/1910
Lithograph, black and white
14 ¼ x 19 ½ inches (36.2 x 49.5 cm)
Cat. no. 38.00163.001

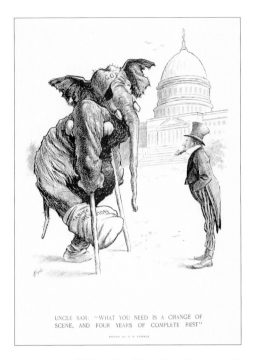

Uncle Sam: "What You Need Is a Change of Scene, and Four Years of Complete Rest"

Unidentified after Edward W. Kemble
Unidentified, ca. 1910
Lithograph, black and white
13 ⅛ x 8 ⅝ inches (33.3 x 21.9 cm)
Cat. no. 38.00138.001

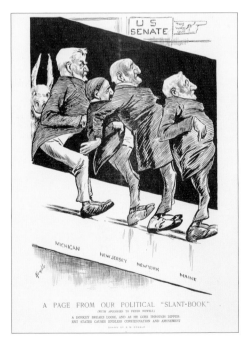

A Page from Our Political "Slant-Book"

Unidentified after Edward W. Kemble
Harper's Weekly, 01/14/1911
Lithograph, black and white
14 ½ x 8 ⅝ inches (36.8 x 21.9 cm)
Cat. no. 38.00186.001

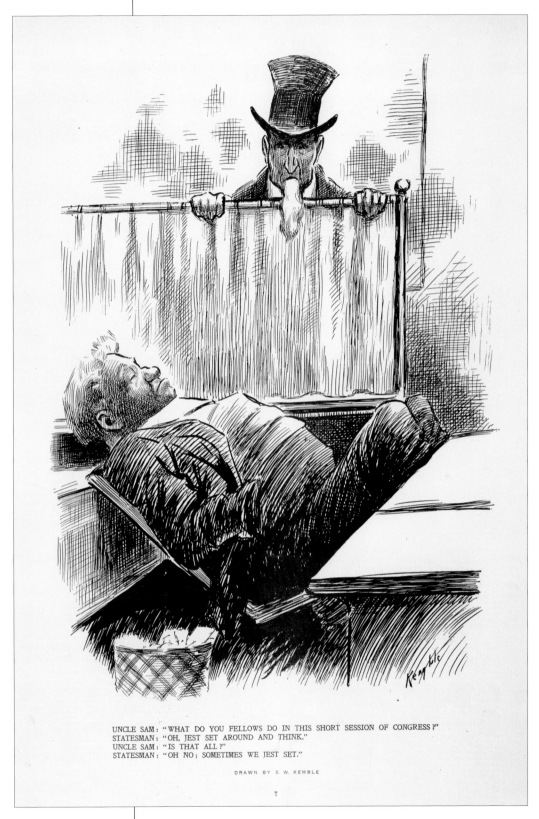

Uncle Sam: "What Do You Fellows Do in This Short Session of Congress?" Statesman: "Oh, Jest Set Around and Think. " Uncle Sam: "Is That All?" Statesman: "Oh No; Sometimes We Jest Set."

Unidentified after Edward W. Kemble
Harper's Weekly, 01/21/1911
Lithograph, black and white
14 x 9 inches (35.6 x 22.9 cm)
Cat. no. 38.00167.001

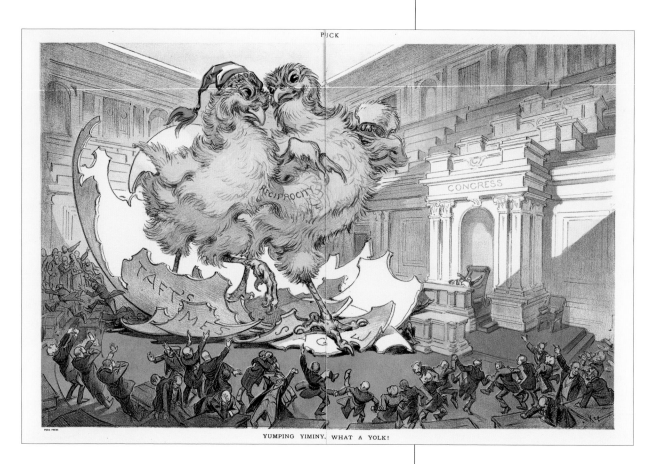

Yumping Yiminy, What a Yolk!

Unidentified
after Joseph Keppler, Jr.
Puck, 04/12/1911
Lithograph, colored
11 ½ x 17 ½ inches
(29.2 x 44.5 cm)
Cat. no. 38.00976.001

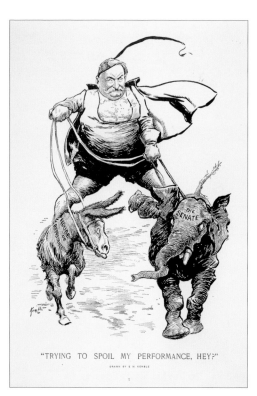

"Trying to Spoil My Performance, Hey?"

Unidentified after Edward W. Kemble
Harper's Weekly, 03/04/1911
Lithograph, black and white
14 x 8 ⅝ inches (35.6 x 21.9 cm)
Cat. no. 38.00184.001

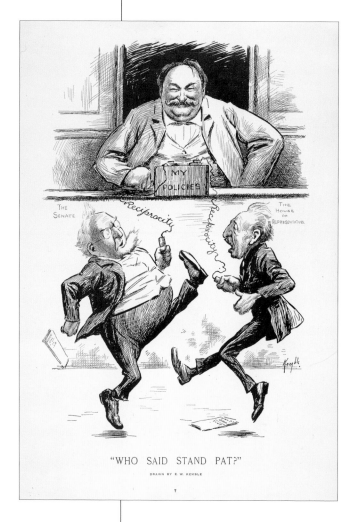

"Who Said Stand Pat?"

Unidentified
after Edward W. Kemble
Harper's Weekly, 02/25/1911
Lithograph, black and white
14 x 9 inches (35.6 x 22.9 cm)
Cat. no. 38.00168.001

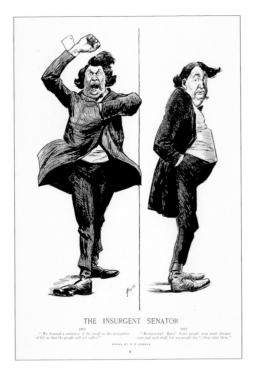

The Insurgent Senator

Unidentified after Edward W. Kemble
Harper's Weekly, 04/29/1911
Lithograph, black and white
14 ⅜ x 9 inches (36.5 x 22.9 cm)
Cat. no. 38.00170.001

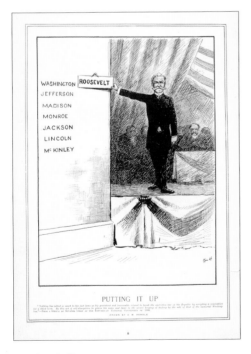

Putting It Up

Unidentified after Edward W. Kemble
Harper's Weekly, 03/16/1912
Lithograph, black and white
13 ⅜ x 9 9/16 inches (34.0 x 24.3 cm)
Cat. no. 38.00178.001

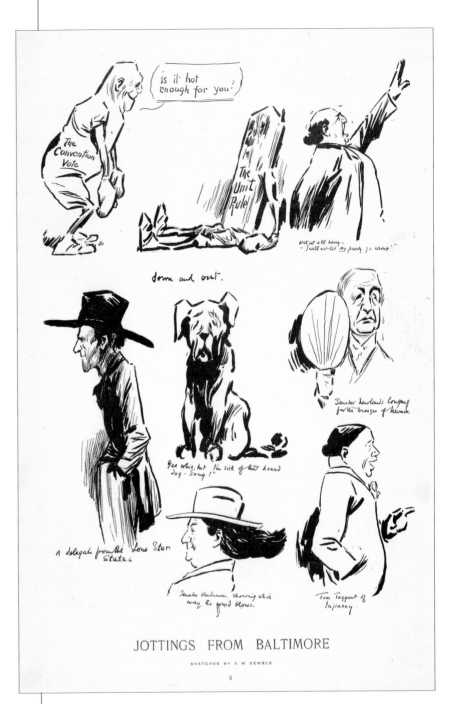

Jottings from Baltimore

Unidentified after Edward W. Kemble
Harper's Weekly, 07/06/1912
Lithograph, black and white
14 ⅛ x 9 inches (35.9 x 22.9 cm)
Cat. no. 38.00185.001

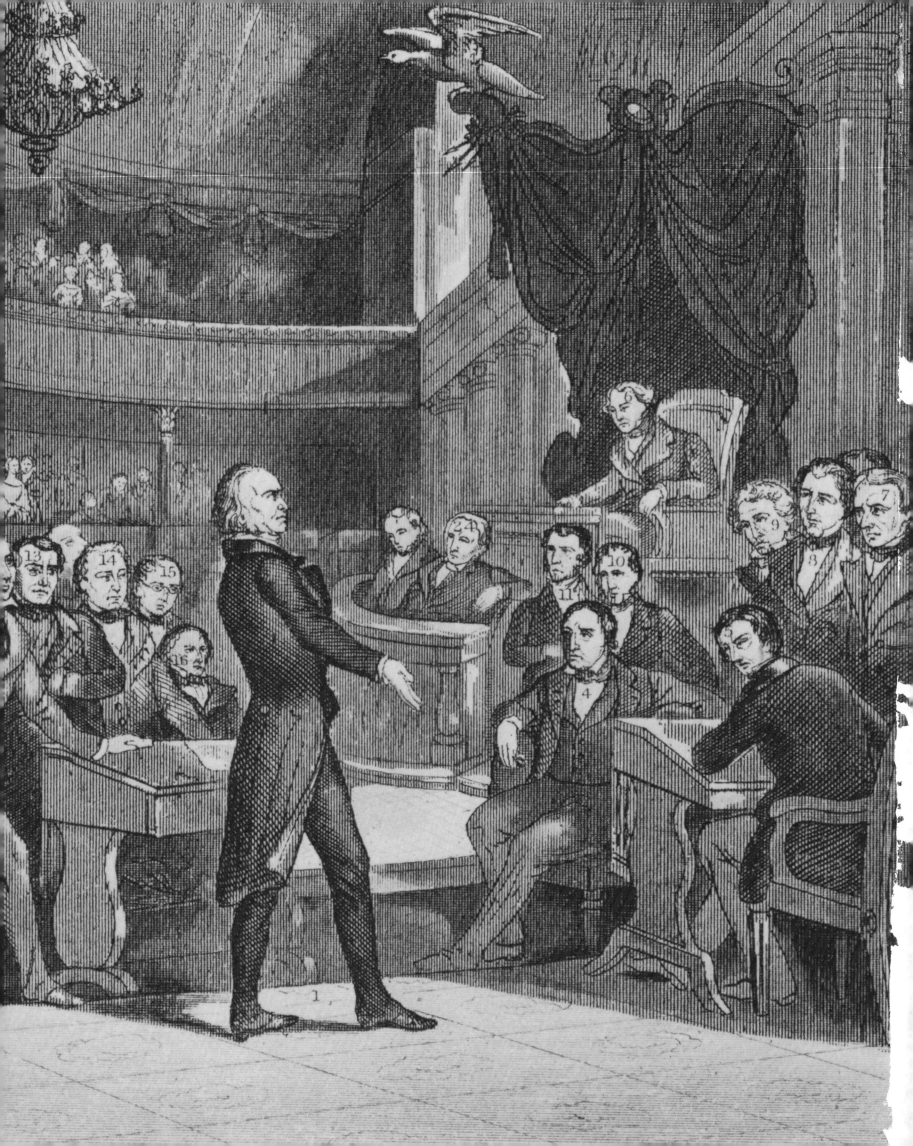

APPENDIX

[SENATE CHAMBER]

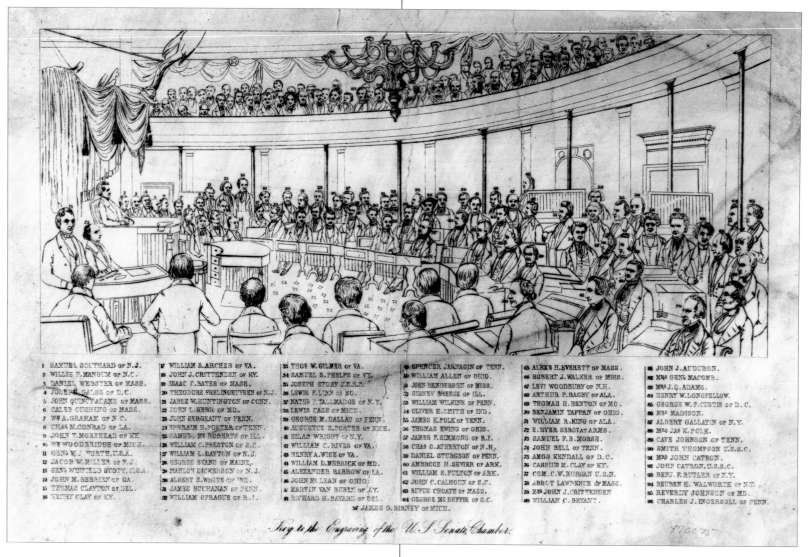

1 SAMUEL SOUTHARD of N.J.	17 WILLIAM S.ARCHER of VA.	33 THOS W.GILMER of VA.	49 SPENCER JARNAGIN of TENN.	65 ALEXR H.EVERETT of MASS.	81 JOHN J.AUDUBON.
2 WILLIE P.MANGUM of N.C.	18 JOHN J.CRITTENDEN of KY.	34 SAMUEL S.PHELPS of VT.	50 WILLIAM ALLEN of OHIO.	66 ROBERT J.WALKER of MISS.	82 MRS GENL MACOMB.
3 DANIEL WEBSTER of MASS.	19 ISAAC C.BATES of MASS.	35 JOSEPH STORY U.S.S.C.	51 JOHN HENDERSON of MISS.	67 LEVI WOODBURY of N.H.	83 MRS J.Q.ADAMS.
4 JOSEPH GALES of D.C.	20 THEODORE FRELINGHUYSEN of N.J.	36 LEWIS F.LINN of MO.	52 SIDNEY BREESE of ILL.	68 ARTHUR P.BAGBY of ALA.	84 HENRY W.LONGFELLOW.
5 JOHN QUINCY ADAMS of MASS.	21 JABEZ W.HUNTINGTON of CONN.	37 NATHL P.TALLMADGE of N.Y.	53 WILLIAM WILKINS of PENN.	69 THOMAS H.BENTON of MO.	85 GEORGE W.P.CUSTIS of D.C.
6 CALEB CUSHING of MASS.	22 JOHN L.KERR of MD.	38 LEWIS CASS of MICH.	54 OLIVER H.SMITH of IND.	70 BENJAMIN TAPPAN of OHIO.	86 MRS MADISON.
7 WM A.GRAHAM of N C.	23 JOHN SERGEANT of PENN.	39 GEORGE M.DALLAS of PENN.	55 JAMES K.POLK of TENN.	71 WILLIAM R.KING of ALA.	87 ALBERT GALLATIN of N.Y.
8 CHAS M.CONRAD of LA.	24 EPHRAIM H.PORTER of TENN.	40 AUGUSTUS S.PORTER of MICH.	56 THOMAS EWING of OHIO.	72 E.DYER SERGT AT ARMS.	88 MRS JAS K.POLK.
9 JOHN T.MOREHEAD of KY.	25 SAMUEL MC ROBERTS of ILL.	41 SILAS WRIGHT of N.Y.	57 JAMES F.SIMMONS of R.I.	73 SAMUEL F.B.MORSE.	89 CAVE JOHNSON of TENN.
10 WM WOODBRIDGE of MICH.	26 WILLIAM C.PRESTON of S.C.	42 WILLIAM C.RIVES of VA.	58 CHAS G.ATHERTON of N.H.	74 JOHN BELL of TENN.	90 SMITH THOMPSON U.S.S.C.
11 GENL W.J WORTH, U.S.A.	27 WILLIAM L.DAYTON of N.J.	43 HENRY A.WISE of VA.	59 DANIEL STURGEON of PENN.	75 AMOS KENDALL of D.C.	91 MRS JOHN CATRON.
12 JACOB W.MILLER of N.J.	28 GEORGE EVANS of MAINE.	44 WILLIAM D.MERRICK of MD.	60 AMBROSE H.SEVIER of ARK.	76 CASSIUS M.CLAY of KY.	92 JOHN CATRON, U.S.S.C.
13 GENL WINFIELD SCOTT, U.S.A.	29 MAHLON DICKERSON of N.J.	45 ALEXANDER BARROW of LA.	61 WILLIAM S.FULTON of ARK.	77 COM. C.W.MORGAN U.S.N.	93 BENJ. F.BUTLER of N.Y.
14 JOHN M.BERRIEN of GA.	30 ALBERT S.WHITE of IND.	46 JOHN MC LEAN of OHIO.	62 JOHN C.CALHOUN of S.C.	78 ABBOT LAWRENCE of MASS.	94 REUBEN H. WALWORTH of N.Y.
15 THOMAS CLAYTON of DEL.	31 JAMES BUCHANAN of PENN.	47 MARTIN VAN BUREN of N.Y.	63 RUFUS CHOATE of MASS.	79 MRS JOHN J.CRITTENDEN	95 REVERDY JOHNSON of MD.
16 HENRY CLAY of KY.	32 WILLIAM SPRAGUE of R.I.	48 RICHARD H.BAYARD of DEL.	64 GEORGE MC DUFFIE of S.C.	80 WILLIAM C. BRYANT.	96 CHARLES J. INGERSOLL of PENN.

97 JAMES G. BIRNEY of MICH.

Key to the Engraving of the U.S. Senate Chamber.

Key to "United States Senate Chamber."
(Library of Congress, Prints and Photographs Division)

United States Senate Chamber.

Thomas Doney after James Whitehorn
Powell & Co., 1846
Mezzotint, black and white
28 x 36 inches (71.1 x 91.4 cm)
Cat. no. 38.00027.001

[SENATE CHAMBER]

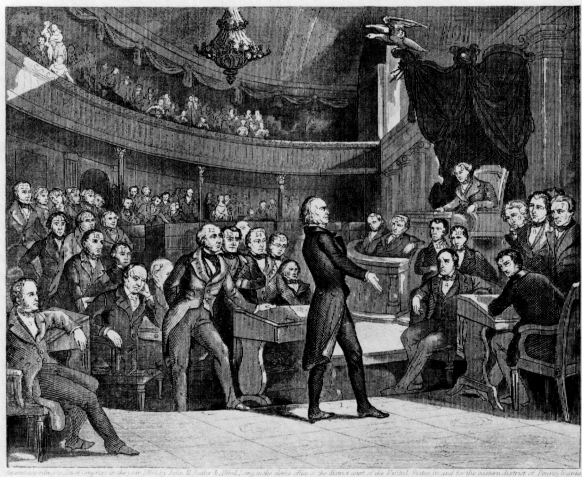

1 Henry Clay. 5 William H. Seward. 9 John C. Calhoun. 13 Stephen A. Douglas. 17 William R. King. 21 Willie P. Mangum. 25 Jeremiah Clemens.
2 Daniel Webster. 6 Millard Fillmore. 10 James A. Pearce. 14 Pierre Soule. 18 John Bell. 22 Samuel Houston. 26 Arthur P. Butler.
3 Thomas H. Benton. 7 William L. Dayton. 11 Robert F. Stockton. 15 Truman Smith. 19 James M. Mason. 23 John P. Hale. 27 John Davis.
4 Lewis Cass. 8 William M. Gwin. 12 Henry S. Foote. 16 Salmon P. Chase. 20 James Cooper. 24 Asbury Dickens. 28 Dodge (Wis.)

Key to "The United States Senate, A.D. 1850."
(Library of Congress, Prints and Photographs Division)

The United States Senate, A.D. 1850.

Robert Whitechurch after Peter Frederick Rothermel
William Smith, 1855
Engraving, hand-colored
28 ¼ x 33 ½ inches (71.8 x 85.1 cm)
Cat. no. 38.00029.001

[SENATE CHAMBER]

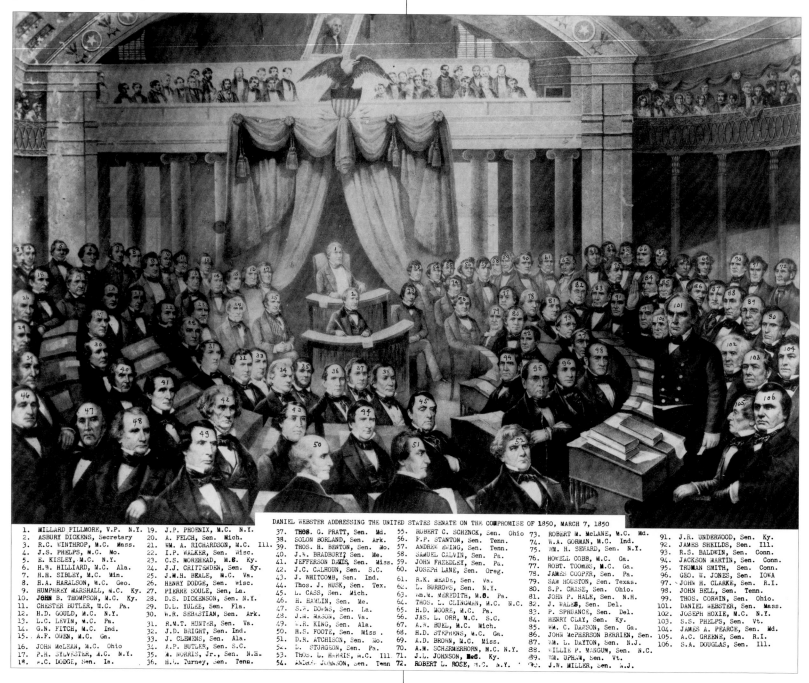

DANIEL WEBSTER ADDRESSING THE UNITED STATES SENATE ON THE COMPROMISE OF 1850, MARCH 7, 1850

1. MILLARD FILLMORE, V.P. N.Y.
2. ASBURY DICKENS, Secretary
3. R.C. WINTHROP, M.C. Mass.
4. J.S. PHELPS, M.C. Mo.
5. E. KISLEY, M.C. N.Y.
6. H.W. HILLIARD, M.C. Ala.
7. H.H. SIBLEY, M.C. Min.
8. H.A. HARALSON, M.C. Geo.
9. HUMPHREY MARSHALL, M.C. Ky.
10. JOHN B. THOMPSON, M.C. Ky.
11. CHESTER BUTLER, M.C. Pa.
12. H.D. GOULD, M.C. N.Y.
13. L.C. LEVIN, M.C. Pa.
14. G.N. FITCH, M.C. Ind.
15. A.F. OWEN, M.C. Ga.
16. JOHN McLEAN, M.C. Ohio
17. P.H. SYLVESTER, M.C. N.Y.
18. A.C. DODGE, Sen. Ia.

19. J.P. PHOENIX, M.C. N.Y.
20. A. FELCH, Sen. Mich.
21. WM. A. RICHARDSON, M.C. Ill.
22. I.P. WALKER, Sen. Wisc.
23. C.S. MOREHEAD, M.C. Ky.
24. J.J. CRITTENDEN, Sen. Ky.
25. J.M.H. BEALE, M.C. Va.
26. HENRY DODGE, Sen. Wisc.
27. PIERRE SOULE, Sen. La.
28. D.S. DICKENSON, Sen. N.Y.
29. D.L. YULEE, Sen. Fla.
30. W.R. SEBASTIAN, Sen. Ark.
31. R.M.T. HUNTER, Sen. Va.
32. J.D. BRIGHT, Sen. Ind.
33. J. CLEMENS, Sen. Ala.
34. A.P. BUTLER, Sen. S.C.
35. M. NORRIS, Jr., Sen. N.H.
36. H.L. TURNEY, Sen. Tenn.

37. THOS. G. PRATT, Sen. Md.
38. SOLON BORLAND, Sen. Ark.
39. THOS. H. BENTON, Sen. Mo.
40. J.W. BRADBURY? Sen. Me.
41. JEFFERSON DAVIS, Sen. Miss.
42. J.C. CALHOUN, Sen. S.C.
43. J. WHITCOMB, Sen. Ind.
44. Thos. J. RUSK, Sen. Tex.
45. L. CASS, Sen. Mich.
46. H. HAMLIN, Sen. Me.
47. S.W. DOWNS, Sen. La.
48. J.M. MASON, Sen. Va.
49. W.R. KING, Sen. Ala.
50. H.S. FOOTE, Sen. Miss.
51. D.R. ATCHISON, Sen. Mo.
52. D. STURGEON, Sen. Pa.
53. THOS. L. HARRIS, M.C. Ill.
54. ANDREW JOHNSON, Sen. Tenn.

55. ROBERT C. SCHENCK, Sen. Ohio
56. F.P. STANTON, Sen. Tenn.
57. ANDREW EWING, Sen. Tenn.
58. SAMUEL CALVIN, Sen. Pa.
59. JOHN FREEDLEY, Sen. Pa.
60. JOSEPH LANE, Sen. Oreg.
61. R.K. MEADE, Sen. Va.
62. L. BURROWS, Sen. N.Y.
63. WM.M. MEREDITH, M.C. Pa.
64. THOS. L. CLINGMAN, M.C. N.C.
65. H.D. MOORE, M.C. Pa.
66. JAS. L. ORR, M.C. S.C.
67. A.W. BUEL, M.C. Mich.
68. H.D. STEPHENS, M.C. Ga.
69. A.D. BROWN, M.C. Miss.
70. A.M. SCHERMERHORN, M.C. N.Y.
71. J.L. JOHNSON, M.C. Ky.
72. ROBERT L. ROSE, M.C. N.Y.

73. ROBERT M. McLANE, M.C. Md.
74. W.A. GORMAN, M.C. Ind.
75. WM. H. SEWARD, Sen. N.Y.
76. HOWELL COBB, M.C. Ga.
77. ROBT. TOOMBS, M.C. Ga.
78. JAMES COOPER, Sen. Pa.
79. SAM HOUSTON, Sen. Texas.
80. S.P. CHASE, Sen. Ohio.
81. JOHN P. HALE, Sen. N.H.
82. J. WALES, Sen. Del.
83. P. SPRUANCE, Sen. Del.
84. HENRY CLAY, Sen. Ky.
85. WM. C. DAWSON, Sen. Ga.
86. JOHN McPHERSON BERRIEN, Sen.
87. WM. L. DAYTON, Sen. N.J.
88. WILLIE P. MANGUM, Sen. N.C.
89. WM. UPHAM, Sen. Vt.
90. J.W. MILLER, Sen. N.J.

91. J.R. UNDERWOOD, Sen. Ky.
92. JAMES SHEILDS, Sen. Ill.
93. R.S. BALDWIN, Sen. Conn.
94. JACKSON MARTIN, Sen. Conn.
95. TRUMAN SMITH, Sen. Conn.
96. GEO. W. JONES, Sen. IOWA
97. JOHN H. CLARKE, Sen. R.I.
98. JOHN BELL, Sen. Tenn.
99. THOS. CORWIN, Sen. Ohio.
101. DANIEL WEBSTER, Sen. Mass.
102. JOSEPH HOXIE, M.C. N.Y.
103. S.S. PHELPS, Sen. Vt.
104. JAMES A. PEARCE, Sen. Md.
105. A.C. GREENE, Sen. R.I.
106. S.A. DOUGLAS, Sen. Ill.

Key to "Daniel Webster Addressing the United States Senate"
(Library of Congress, Prints and Photographs Division)

**Daniel Webster Addressing the United States Senate /
In the Great Debate on the Constitution and the Union 1850.**

James M. Edney
Jones & Clark, 1860
Lithograph, hand-colored
25 ¼ x 29 ⅞ inches (64.1 x 75.9 cm)
Cat. no. 38.00016.003

[SENATE CHAMBER]

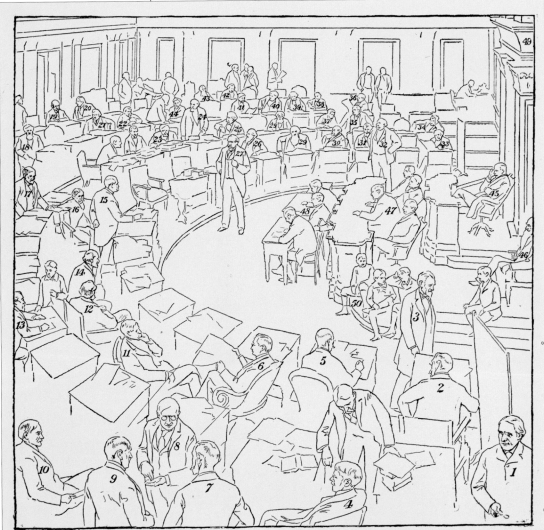

KEY TO DOUBLE-PAGE ILLUSTRATION, "THE UNITED STATES SENATE IN SESSION."

1. A. P. Gorman. 2. J. R. Hawley. 3. H. M. Teller. 4. W. E. Chandler. 5. J. H. Gallinger.
6. M. S. Quay. 7. H. C. Lodge. 8. G. F. Hoar. 9. E. Hale. 10. J. Sherman. 11. J. D.
Cameron. 12. J. S. Morrill. 13. C. F. Manderson. 14. O. H. Platt. 15. N. W. Aldrich.
16. W. P. Frye. 17 W. B. Allison. 18. J. M. Palmer. 19. D. B. Hill. 20. J. W. Daniel.
21. J. Smith, Jun. 22. C. J. Faulkner. 23. G. G. Vest. 24. J. K. Jones. 25. D. W. Voorhees.
26. F. M. Cockrell. 27. G. Gray. 28. J. Z. George. 29. R. Coke. 30. I. G. Harris. 31. J.
H. Berry. 32. R. Q. Mills. 33. E. Hunton. 34. J. L. McLaurin. 35. W. V. Allen. 36. E.
Murphy, Jun. 37. W. Call. 38. J. L. Pugh. 39. W. B. Bate. 40. W. Lindsay. 41. J. H.
Kyle. 42. P. Walsh. 43. J. L. Mitchell. 44. C. S. Brice. 45. Vice-President A. E. Stevenson.
46. Doorkeeper I. Bassett. 47. Clerks. 48. Reporters. 49. Newspaper Gallery. 50. Pages.

Key to "The United States Senate in Session."
(U.S. Senate Collection)

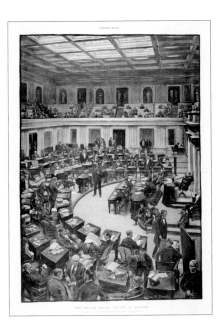

The United States Senate in Session.

Unidentified after George W. Breck
after photograph by William Kurtz
Harper's Weekly, 09/22/1894
Halftone, colored
28 ½ x 13 ¾ inches (49.5 x 34.9 cm)
Cat. no. 38.00032.005

[SENATE ART]

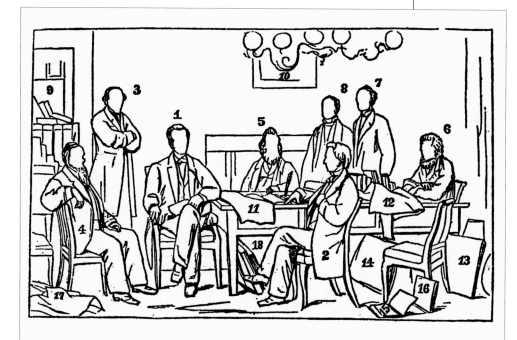

KEY TO THE PICTURE

THE MEN

1. PRESIDENT LINCOLN.
2. WILLIAM H. SEWARD, Secretary of State.
3. SALMON P. CHASE, Secretary of Treasury.
4. EDWIN M. STANTON, Secretary of War.
5. GIDEON WELLES, Secretary of Navy.
6. EDWARD BATES, Attorney-General.
7. MONTGOMERY BLAIR, Postmaster-General.
8. CALEB B. SMITH, Secretary of Interior.

The room is the Official Chamber of the White House, in which all Cabinet meetings are held, and in which the President receives calls upon official business.

ACCESSORIES

9. Photograph of Simon Cameron, Ex-Sec. War.
10. Portrait of Andrew Jackson.
11. Parchment Copy of the Constitution.
12. Map of Seat of War in Virginia.
13. Map showing Slave Population in gradulight and shade.
14. War Department Portfolio.
15. Story's ''Commentaries on the Constitution.''
16. Whiting's ''War Powers of the President.''
17. New York *Tribune*.
18. Two volumes *Congressional Globe*.

Key to "The First Reading of the Emancipation Proclamation before the Cabinet."
(Reproduced from Francis B. Carpenter, *Six Months at the White House with Abraham Lincoln.* Lincoln: University of Nebraska Press, 1995)

The First Reading of the Emancipation Proclamation before the Cabinet.

Alexander Hay Ritchie after painting by Francis Bicknell Carpenter
Derby and Miller, 1866
Metal engraving, black and white
23 ½ x 33 ½ inches (59.7 x 85.1 cm)
Cat. no. 38.00450.001

[GROUP PORTRAITS]

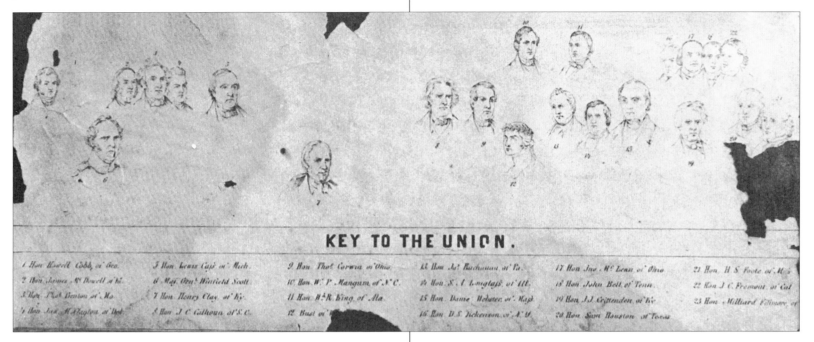

Key to "Union."
(Reproduced from Harold Holzer, *The Lincoln Image*. New York: Charles
Scribner's Sons, 1984)

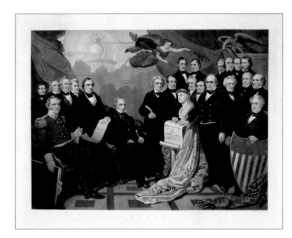

Union.

Henry S. Sadd after Tompkins H. Matteson
William Pate, 1852
Mezzotint, hand-colored
19 ½ x 26 ½ inches (49.5 x 67.3 cm)
Cat. no. 38.00019.001

[GROUP PORTRAITS]

1. Sprague, William
2. Howe, Timothy O.
3. Cowan, Edgar
4. Howard, Jacob M.
5. Sumner, Charles
6. Sherman, John
7. Clark, Daniel
8. Buckalew, Charles R.
9. Henderson, John B.
10. Morgan, Edwin D.
11. Johnson, Reverdy
12. Unidentified
13. Van Winkle, Peter G.

14. Brown, Benjamin G.
15. Chandler, Zachariah
16. Willey, Waitman T.
17. Doolittle, James R.
18. Williams, George H.
19. Anthony, Henry B.
20. Ramsey, Alexander
21. Fessenden, William P.
22. Wade, Benjamin F.
23. Conness, John
24. Trumbull, Lyman
25. Unidentified
26. Dixon, James

27. Lane, James H.
28. Morrill, Lot M.
29. Lane, Henry S.
30. Pomeroy, Samuel C.
31. Nesmith, James W.
32. Foot, Solomon
33. Foster, Lafayette S.
34. Wilson, Henry
35. Collamer, Jacob
36. Harris, Ira
37. Nye, James W.
38. Harlan, James

Key to [Civil War Senate]
(Digital reproduction by the Office of Senate Curator, 2005)

[Civil War Senate]

Unidentified
Unidentified, ca. 1863
Photograph, black and white
10 ⅛ x 8 ¾ inches (25.7 x 22.2 cm)
Cat. no. 38.00724.001

ACKNOWLEDGMENTS

SELECTED BIBLIOGRAPHY

INDEX

ACKNOWLEDGMENTS

This catalogue documents the Senate's entire collection of graphic art and builds on a 1995 volume by the Office of Senate Curator that illustrated all but the cartoon images then extant in the collection. Since then, more prints have been added to the collection, which now comprises almost one thousand images. A publication such as this could only be possible though the efforts of many individuals. First and foremost, thanks must go to the staff of the Office of Senate Curator. Jamie Arbolino led the project, overseeing the countless details with enthusiasm, humor, and commitment. He worked closely with everyone involved, from the writers to the designer and the printer. He and Theresa Malanum ensured the accuracy of the print data, reviewed each original print, confirmed the proper transcription of information, and conducted the requisite research to correct discrepancies and verify the completeness of each print record. Theresa also developed the extensive artist and sitter index. Amy Elizabeth Burton compiled the bibliography and was responsible for all photographic details, from the scanning of the images to the cropping and placement. Scott M. Strong contributed significantly to the writing, editing, and proofreading, and supervised the printing requirements and specifications. Clare Colgrove Hobson handled the administrative details, providing assistance in countless ways. Richard L. Doerner served as research assistant, fact checker, and proofreader, while Melinda K. Smith, Kelly Steele, and Deborah Wood assisted with review of the galley proofs. All of this work was accomplished in an extremely short time and with a full schedule of other commitments. The staff have my deepest gratitude—it has been a true team effort.

The catalogue was prepared under the direction of Emily J. Reynolds, secretary of the Senate and executive secretary to the Senate Commission on Art. The Office of Senate Curator is indeed indebted to her for her unfailing support, vision, and

constant encouragement on this project and all the work undertaken by the office. She has been indefatigable in her leadership and enthusiasm. Assistant Secretary of the Senate Mary Suit Jones similarly provided sympathetic guidance along the way, understanding the time constraints on the office and the complexities of producing such a publication.

Dr. Donald A. Ritchie, associate historian in the U.S. Senate Historical Office, provided the incisive introductory essay to the cartoon chapter, as well as the illuminating short essays in that section. He has graciously assisted the Curator's Office on innumerable occasions and has always been generous with his time and knowledge. Senate Historian Dr. Richard A. Baker provided guidance and encouragement throughout the project; others in the Historical Office who aided the effort were Assistant Historian Dr. Betty K. Koed and Beth Hahn, historical editor.

Nancy Kervin, reference librarian in the Senate Library, contributed her considerable talent in copyediting several sections of the catalogue. She undertook this work over and above her many other responsibilities; we thank her for her expert and generous assistance, and also Senate Librarian Gregory C. Harness and Kimberly Ferguson, head of information services, for their patient understanding.

Other staff of the secretary of the Senate were invaluable, assisting with numerous details and administrative support. Cheri Allen, webmaster, and especially Arin Shapiro, assistant webmaster, worked closely with the Curator's Office to convert the Senate's database information into a publishable document. This proved a challenging task. Adam Bramwell, general counsel for the secretary, coordinated the publication with the Joint Committee on Printing; Zoraida Torres, accounts administrator, handled all financial matters; and Karen Moore, director of Printing and Document Services, helped with the printing specifications and other technical

advice, while Kurt Stelter and Alfonso Roman provided additional assistance. All deserve special credit for their graciousness and support.

Several interns in the Curator's Office also provided much needed assistance, including Kristina Belich, Kimberly Robinson, and Caitlin Sweeney. Elizabeth Horrell deserves special thanks for her extensive help with the cartoon identification and the index, which she tackled with enthusiasm and commitment.

The preparation, design, and production of this catalogue would not have been possible without the talented staff of the Government Printing Office. GPO has created this magnificent companion volume to the 2002 publication, *United States Senate Catalogue of Fine Art*. Special thanks are due to Jerry Hammond and the Office of Congressional Publishing Services, particularly Gary Ford and Joe Benjamin for providing invaluable assistance with the day-to-day administrative details; to Deborah Roberts and Anthony Hooks in Agency Publishing Services, Customer Services, for ensuring that the printing specifications were followed; and to Chuck Jones and John McCleaf, Jr. in the Plant Operations Department, Postscript Service Section, who worked to specifications and schedule to scan all the images for pre-press. Janice Sterling and her staff in the Creative Services Division have my highest regard for their talent and dedication: Rebecca White designed this splendid publication and was enthusiastic and committed throughout the process, even during the most difficult moments; Rick Brzozowski, supervisor of Technical Review, provided expert advice with the printing specifications, while his staff spent countless hours overseeing the production. Sarah Trucksis deserves the highest commendation for all her work at the printers. Patrick Jacobs provided additional support as needed. Special thanks are due to Connie Linassi, associate director, Acquisition Policy and Planning Staff of Agency Publishing Services, who ensured the quality of the final bound books.

Colleagues from various institutions also must be thanked for their generous assistance and willingness to provide advice: William C. Allen, architectural historian for the Architect of the Capitol; Cecilia Wetheimer of the Bureau of Printing and Engraving; Katherine Blood, Sara W. Duke, George Laki, Mark Mattucci, Jim Schneider, and Mary Yarnall, of the Library of Congress; Helena E. Wright of the National Museum of American History, Smithsonian Institution; Wendy Wick Reaves and Amy Baskette of the National Portrait Gallery, Smithsonian Institution; and Richard Cote and Guy Munsch of the U.S. Department of the Treasury.

The Office of Senate Curator is proud to present this catalogue of the U.S. Senate's graphic art collection, which we hope will be a significant resource for those interested in the history of this institution. Curators, historians, and other scholars interested in further information on any of the prints should contact the Office of Senate Curator, Room S-411, U.S. Capitol, Washington, D.C. 20510. Telephone (202) 224-2955. ꙮ

Diane K. Skvarla
Senate Curator

SELECTED BIBLIOGRAPHY

Ames, Mary Clemmer. *Ten Years in Washington. Life and Scenes in the National Capital, as a Woman Sees Them.* Cincinnati, OH: Queen City Publishing, 1874.

Baker, William Spon. *The Engraved Portraits of Washington.* Philadelphia: Lindsay and Baker, 1880.

Bassett, Isaac. Papers. Office of the Curator, U.S. Senate, Washington, D.C.

Beam, Philip C. *Winslow Homer's Magazine Engravings.* New York: Harper and Row, 1979.

Brown, Joshua. *Beyond the Lines: Pictorial Reporting, Everyday Life, and the Crisis of Gilded-Age America.* Berkeley: University of California Press, 2002.

Byrd, Robert C. *The Senate, 1789–1989.* 4 vols. Washington, D.C.: Government Printing Office, 1988–94.

Carpenter, Francis Bicknell. *Six Months at the White House with Abraham Lincoln. The Story of a Picture.* New York: Hurd and Houghton, 1867.

Castagno, John. *Artists as Illustrators: An International Directory with Signatures and Monograms, 1800–the Present.* Metuchen, NJ: Scarecrow, 1989.

Clay, Henry. *Papers of Henry Clay.* Vol. 9. Edited by Robert Seager, et al. Lexington: University of Kentucky Press, 1991.

Collins, Kathleen. *Washingtoniana: Photographs.* Washington, D.C.: Government Printing Office, 1989.

Darrah, William Culp. *Cartes de Visite in Nin[e]teenth Century Photography.* Gettysburg, PA: W.C. Darrah, 1981.

"Death of Joseph Keppler," *New York Times*, 20 February 1894.

Dickens, Charles. *American Notes for General Circulation.* London: Chapman and Hall, 1842.

Dyer, Oliver. *Great Senators of the United States Forty Years Ago (1848 and 1849).* 1889. Reprint, Freeport, NY: Books for Libraries Press, 1972.

Ellis, John B. *The Sights and Secrets of the National Capital.* Chicago: Jones, Junkin, 1869.

Flint, Janet A. *The Print in the United States from the Eighteenth Century to the Present.* Washington, D.C.: Smithsonian Institution Press, 1981.

Fowble, E. McSherry. *Two Centuries of Prints in America, 1680–1880: A Selective Catalogue of the Winterthur Museum Collection.* Charlottesville: Published for the Henry Francis du Pont Winterthur Museum by the University of Virginia Press, 1987.

Gambee, Budd Leslie, Jr. *Frank Leslie and His Illustrated Newspaper, 1855–1860.* Ann Arbor: University of Michigan, 1964.

Groce, George Cuthbert, and David H. Wallace. *The New-York Historical Society's Dictionary of Artists in America, 1564–1860.* New Haven, CT: Yale University Press, 1957.

Hamilton, Sinclair. *Early American Book Illustrators and Wood Engravers, 1670–1870.* 2 vols. Princeton, NJ: Princeton University Press, 1958–68.

Hart, Charles Henry. *Catalogue of the Engraved Portraits of Washington.* New York: Grolier Club, 1904.

Hess, Stephen, and Milton Kaplan. *The Ungentlemanly Art: A History of American Political Cartoons.* New York: Macmillan, 1968.

Hess, Stephen, and Sandy Northrop. *Drawn and Quartered: The History of American Political Cartoons.* Montgomery, AL: Elliott and Clark, 1996.

Hunnisett, Basil. *A Dictionary of British Steel Engravers.* Leigh-on-Sea, England: F. Lewis, 1980.

"The Impeachment Trial," *Harper's Weekly*, 28 March 1868.

"The Impeachment Trial," *Harper's Weekly*, 18 April 1868.

"The Impeachment Trial, Washington, D.C.— Remarkable Scene in the U.S. Senate, May 6th," *Frank Leslie's Illustrated Newspaper*, 23 May 1868.

Jackson, Mason. *The Pictorial Press: Its Origin and Progress.* 1885. Reprint, New York: Burt Franklin, 1969.

Johnson, William S. *Nineteenth-Century Photography: An Annotated Bibliography, 1839–1879.* Boston: G.K. Hall, 1990.

Keller, Morton. *The Art and Politics of Thomas Nast.* New York: Oxford University Press, 1968.

Kelsey, Mavis Parrott. *Winslow Homer Graphics.* Houston: The Museum of Fine Arts, 1977.

Library of Congress. *American Printmaking before 1876: Fact, Fiction, and Fantasy.* Washington, D.C.: Government Printing Office, 1975.

"The Making of Cartoons," *New York Times*, 20 July 1890.

McCulloch, Lou W. *Card Photographs: A Guide to Their History and Value.* Exton, PA: Schiffer, 1981.

Miller, Lillian B., and Carol Eaton Hevner. *In Pursuit of Fame: Rembrandt Peale, 1778–1860.* Washington, D.C.: National Portrait Gallery; Seattle: University of Washington Press, 1992.

Mott, Frank Luther. *American Journalism: A History of Newspapers in the United States through 250 Years, 1690–1940.* New York: Macmillan, 1941.

———. *A History of American Magazines.* 5 vols. Cambridge: Harvard University Press, 1938–68.

Opitz, Glenn B., ed. *Mantle Fielding's Dictionary of American Painters, Sculptors and Engravers.* Poughkeepsie, NY: Apollo, 1986.

"Our Picture of the High Court of Impeachment," *Frank Leslie's Illustrated Newspaper,* 11 April 1868.

Peters, Harry Twyford. *America on Stone: The Other Printmakers to the American People.* Originally published as *America in Two Centuries: An Inventory.* 1931. Reprint, New York: Arno, 1976.

Pfister, Harold Francis. *Facing the Light: Historic American Portrait Daguerreotypes.* Washington, D.C.: Published for the National Portrait Gallery by the Smithsonian Institution Press, 1978.

"The Refectory of the Senate, Washington, D.C.—Senators and Their Friends at Luncheon" *Frank Leslie's Illustrated Newspaper,* 16 May 1868.

Reilly, Bernard F., Jr. *American Political Prints, 1766–1876: A Catalog of the Collections in the Library of Congress.* Boston: G.K. Hall, 1991.

Reps, John William. *Washington on View: The Nation's Capital since 1790.* Chapel Hill: University of North Carolina Press, 1991.

Ritchie, Donald A. *American Journalists: Getting the Story.* New York: Oxford University Press, 1997.

Roylance, Dale. *American Graphic Arts: A Chronology to 1900 in Books, Prints, and Drawings.* Princeton, NJ: Princeton University Library, 1990.

"The Second Inauguration," *Harper's Weekly,* 22 March 1873.

Slautterback, Catharina. "Charles Sumner and Political Prints in the Election of 1862." *Imprint: Journal of the American Historical Print Collectors Society* 29, no. 2 (autumn 2004).

Stauffer, David McNeely, Mantle Fielding and Thomas Hovey Gage. *American Engravers upon Copper and Steel.* 3 vols. 1907. Reprint, New Castle, DE: Oak Knoll Books, 1994.

Thompson, Charles Willis. *Party Leaders of the Time.* New York: G.W. Dillingham, 1906.

"The United States Senate Chamber." *The American Review: A Whig Journal of Politics, Literature, Art and Science* 4, no. 4 (October 1846).

U.S. Senate. Senator Henry Clay speaking on the Senate floor introducing a series of resolutions that became known as the Compromise of 1850. *Congressional Globe* (5–6 February 1850) 31st Cong., 1st sess.

———. *Tariff Speech: Address of President Taft at Winona, Minnesota, September 17, 1909.* 61st Cong., 2d sess., 1909. S. Doc. 164.

U.S. Senate Commission on Art. *Between the Eyes: Thomas Nast and the U.S. Senate.* Washington, D.C.: Office of the Senate Curator, 1993.

Vinson, John Charles. *Thomas Nast: Political Cartoonist.* Athens: University of Georgia Press, 1967.

West, Richard Samuel. *Satire on Stone: The Political Cartoons of Joseph Keppler.* Urbana: University of Illinois Press, 1988.

Young, William, ed. and comp. *A Dictionary of American Artists, Sculptors and Engravers.* Cambridge, MA: William Young, 1968.

INDEX

Subjects appear in roman font; artists whose work is included in this catalogue appear in blue italics. Not all subjects in the large group portraits have been identified.